THE
STORAGE BOX
OF TRADITION

THE
STORAGE BOX
OF TRADITION

KWAKIUTL ART, ANTHROPOLOGISTS, AND MUSEUMS, 1881–1981

IRA JACKNIS

SMITHSONIAN INSTITUTION PRESS
WASHINGTON AND LONDON

Copy editor: Vicky Macintyre
Production editor: Duke Johns
Designer: Janice Wheeler

Library of Congress Cataloging-in-Publication Data
Jacknis, Ira.
 The storage box of tradition : Kawkiutl art, anthropologists, and museums, 1881–1981 / Ira Jacknis.
 p. cm.
 Includes bibliographical references and index.
 ISBN 1-58834-011-2 (alk. paper)
 1. Kwakiutl art. 2. Anthropologists—British Columbia—History. 3. Ethnological museums and collections—History—Case studies. 4. Kwakiutl Indians—Museums. 5. Cultural property—Repatriation—Case studies. I. Title.
 E99.K9 J33 2002
 971.1004' 979—dc21 2001049281

British Library Cataloguing-in-Publication Data available

Manufactured in the United States of America
10 09 08 07 06 05 04 03 02 5 4 3 2 1

♾ The paper used in this publication meets the minimum requirements of the American National Standard for Information Sciences—Permanence of Paper for Printed Library Materials ANSI Z39.48-1984.

For permission to reproduce illustrations appearing in this book, please correspond directly with the owners of the works, as listed in the individual captions. The Smithsonian Institution Press does not retain reproduction rights for these illustrations individually or maintain a file of addresses for photo sources.

Yes, my children, I am the storage box of your thoughts, for I remember all the old tales, and in my young days I saw things which you young people never heard of. It is good that there is one old man who can show you all these things.

To'qwEmalis, speaker of A'Labala, Koskimo Kwakw<u>aka</u>'wakw, 23 November 1894, quoted in Boas's *The Social Organization and Secret Societies of the Kwakiutl Indians* (1897) and used as a label in the U'mista Cultural Centre, Alert Bay, B.C.

It is not good that these stories are forgotten. Friends, you are telling them from mouth to ear, and when your old men die they will be forgotten. It is good that you should have a box in which your laws and your stories are kept. My friend, George Hunt, will show you a box in which some of your stories will be kept. It is a book that I have written on what I saw and heard when I was with you two years ago. It is a good book, for in it are your laws and your stories. Now they will not be forgotten.

Franz Boas, letter to the Kwakiutl, 14 April 1897

This place built on the beach that you call the museum, we have not had such a thing among our people. It is like a storage box, like a box of treasures the old people used to have.

Agnes Alfred, Kwakw<u>aka</u>'wakw elder, speaking of the U'mista Cultural Centre

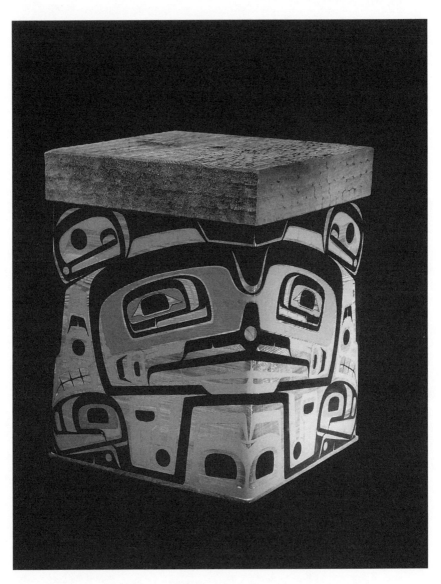

Storage box, by Bruce Alfred, 1979. RBCM cat. no. 16618.

FOR MY FATHER AND THE MEMORY OF MY MOTHER

CONTENTS

PREFACE

There is in New York a magic place where all the dreams of childhood hold a rendezvous, where century old trees sing or speak, where indefinable objects lie in wait for the visitor with an anxious stare; where animals of superhuman gentleness press their uplifted little paws, clasped in prayer for the privilege of constructing for the chosen one the palace of the beaver, of guiding him into the realm of the seals, or of teaching him, with a mystic kiss, the language of the frog and kingfisher. This region, to which disused but singularly effective museographic methods grant the supplementary prestige of the clair-obscur of caves and of the crumbling heaps of lost treasure, can be visited daily from ten to five o'clock at the American Museum of Natural History, New York. It is the vast gallery on the ground floor devoted to the Indians of the Northwest Coast.

Claude Lévi-Strauss (1943)

I was a child when I first encountered the art of the Northwest Coast Indians at the American Museum of Natural History, in a hall that was not so different from the one that enchanted Lévi-Strauss. Although I did not realize it until much later, this "magic place" had a profound effect on me. While in college I broadened my knowledge of the Northwest Coast as I spent a summer at the Smithsonian Institution working on an exhibition of boxes and bowls from the region (Sturtevant 1974). My reading of Franz Boas deepened my attraction, and I was fortunate to be at Chicago's Field Museum when its new Northwest Coast Hall was being prepared.

I embarked on this study to discover, in essence, how the Northwest Coast Hall at the American Museum had come to be. How had anthropologists gathered the artifacts of these peoples and what had they done to them in preparing this exhibition and many similar ones in museums around the world? How did their work come to influence the work of Western artists and how was it, in turn, influenced by their aesthetic action? I soon discovered that an important part of the story was the scholars and museum programs in the Northwest, and it was not long before I saw that I needed to account for the perspective of Native peoples on anthropological images of their culture. I chose to focus on the Kwakwaka'wakw precisely because, of all

coastal groups, they have had the longest and most intense relationship with anthropologists. Combining my interests in anthropology, history, and art, particularly within the museum setting, this study stresses the margins, the interconnections between cultures, disciplines, and people. Each is seen in terms of the other, as mutual influence and refraction.

This volume is a substantial revision of my doctoral dissertation in anthropology for the University of Chicago (1989). The earliest research for this study was conducted in museums and archives in Cambridge, New York, Philadelphia, Washington, D.C., and Chicago between 1975 and 1980. During this period, material subsequently used in this study was gathered as part of more general research on the history of museums and American anthropology, 1880–1920. After a brief initial survey trip in August 1979 to Vancouver, Victoria, and Seattle, the intensive dissertation research came in the eighteen months between April 1981 and September 1982. The first nine months were spent about equally in Vancouver and Victoria researching in archives and examining the local "scene" of museums, anthropologists, galleries, and Native artists. During the final nine months, beginning in January 1982, I lived in Alert Bay, an island fishing village off the northeast end of Vancouver Island, and the largest Kwakwaka'wakw community. This period was devoted to a combination of oral history, archival research, and participant observation. During the entire field period there were periodic trips to other sites such as Seattle, Calgary, and Campbell River, British Columbia. More recent developments were noted on several subsequent trips, the most recent in the fall of 1999.

This study is conceived historically, in terms of transformations over a century of interaction. Integrated into the diachronic structure is a diversity of evidence: correspondence, field notes, photographs, films, oral history and interviews, and participant observation. Each source and period has its relative strengths and weaknesses. Correspondence for the early or "classical" period often supplies evidence of motives that the author would not state to an interviewer, but conversely, in the present, one can address specific questions that go unmentioned in the documents. Sources are relatively full for the early period (primarily archival) and for the contemporary period (within living memory). The weakest documentation is for the middle years, what may be called the Dark Ages, c. 1920–1950. Several factors explain this; by all accounts, while potlatching continued, it did decline, owing to increased enforcement and the Native reaction to the worldwide Depression. There was a general perception among whites that Native culture was at or near death, and while this was not true, it is especially difficult to document what did occur. This lacuna remains an area for future research.

I would like to thank all the institutions—museums and archives, as cited in the notes—that allowed me to consult and to publish material (documents and photographs) from their collections and acknowledge the permission of the Native artists (or their descendants), whose work is illustrated here. So much of the recent story of the relationship between museums and Kwakwaka'wakw art centers in the Royal

British Columbia Museum; accordingly, I would like to extend a special acknowledgment to Peter Macnair, now retired, and his entire staff at the anthropology section. (Before 1987 the museum was known as the British Columbia Provincial Museum; in the interests of historical consistency, the former name is used in this volume.) Thanks must also go to the Nimpkish Band Council, Alert Bay, B.C., for allowing me to conduct research on their reserve. I would like to thank my dissertation committee—Raymond Fogelson, Nancy Munn, George Stocking—for their support of my project and comments on that report. For their reading and comments on the manuscript, I must also thank William Merrill and especially Curtis Hinsley, whose trenchant comments have greatly aided my organization of the material. The readings by Bill Holm and Peter Macnair were helpful for many points of detail. As always, only I am responsible for any errors of fact or interpretation. I must also single out Daniel Goodwin, former director of the Smithsonian Institution Press, for his persistent patience with my manuscript.

In conducting this study I have naturally incurred many debts. Following is a listing of those who generously shared information with me or aided in the conduct of my research.

In the United States: Margaret Blackman, Carolyn Blackmon, Karen Blu, Gerald Bolas, Helen Chandra, Richard Conn, Patricia Cosgrove, Joanne Factor, Diana Fane, Susan Golla, Laura Greenberg, Pamela Haas, Richard Handler, Steven Henrikson, Curtis Hinsley, Bill Holm, Michael Johnson, Aldona Jonaitis, Selig Kaplan, Belinda Kaye, Duane King, Barbara Kirshenblatt-Gimblett, Mary Jane Lenz, Lea McChesney, William Merrill, Lynette Miller, Ellen Pearlstein, Lori Reyes, Annibal Rodriguez, Ronald Rohner, Janette Sacquet, William Sturtevant, Ronald Weber, Robin Wright, Victoria Wyatt.

In Canada: Donald Abbott, John Adams, Bruce Alfred, Fah Ambers, Michael Ames, Martha Black, Randy Bouchard, Marilyn Chechik, Douglas Cole, Douglas Cranmer, Vera Cranmer, Leslie Dawn, Beau Dick, Karen Duffek, Barry Gough, Jim Hamilton, Lynette Harper, Harry Hawthorn, Alan Hoover, Tony Hunt, Joy Inglis, Richard Inglis, Vickie Jensen, Robert Joseph, Dorothy Kennedy, Michael Kew, Andrea Laforet, Peter Lando, Peter Macnair, George MacDonald, Peggy Martin, G. A. (Bud) Mintz, Robert Neel, Phil Nuytten, Jay Powell, Hindy Ratner, Vincent Rickard, Howard Roloff, Larry Rosso, Dan Savard, Audrey Shane, Carol Sheehan, Greg Shoop, Wedlidi Speck, Jay Stewart, Richard Sumner, Donald Tarasoff, Jeanette Taylor, Leslie Tepper, Gloria Cranmer Webster, Joyce Wilby, David Young. And in Paris, France: Marie Mauzé. Singling out anyone is difficult, but I owe much to Douglas Cole for his continual and extensive support, especially during my principal British Columbia research. I would like to dedicate this volume to his memory, along with my parents.

Financial assistance for this research is gratefully acknowledged from the following sources: Thomas J. Dee Fellowship at the Field Museum of Natural History, Phillips Fund of the American Philosophical Society, Melville and Elizabeth Jacobs Research Fund of the Whatcom Museum Foundation, Wenner-Gren Foundation for

Anthropological Research (the major source), and my parents. I am also appreciative for the support of the following institutions during the research and writing: Newberry Library, Field Museum, Smithsonian Institution (National Museum of Natural History), the Brooklyn Museum of Art, and the Phoebe Hearst Museum of Anthropology, UC Berkeley.

Versions of the following chapters were presented in several venues: chapter 1, Associates in Primitive and Pre-Columbian Art, Columbia University (1986); chapter 7, Annual Meeting of the American Folklore Society (1985); chapter 9, seminars at New York University and the University of Virginia (1988), and Annual Meeting of the American Historical Association (1992). I would like to thank the respective audiences for their helpful comments. Portions of the following chapters were previously published: chapter 1 (Jacknis 1991b), chapter 2 (Jacknis 1991a), chapter 4 (Jacknis 1990), and chapter 9 (Jacknis 1996a).

ABBREVIATIONS

The following abbreviations have been used in the photo captions and notes. If other collections are cited, that information is specified in the note.

Acc. Accession
AHSA Art, Historical, and Scientific Association, Vancouver
AMNH American Museum of Natural History (Department of Anthropology)
APS American Philosophical Society
BCA British Columbia Archives
BCPM British Columbia Provincial Museum [Royal British Columbia Museum]
BM Burke Museum, University of Washington
CFNP Charles F. Newcombe Papers, British Columbia Archives
CIHS Coastal Indian Heritage Society, Vancouver Museum
CMC Canadian Museum of Civilization
FBP Franz Boas Professional Papers, American Philosophical Society
FMNH Field Museum of Natural History (Department of Anthropology)
FWPP Frederic Ward Putnam Papers, Harvard University Archives
HMA Hearst Museum of Anthropology, University of California at Berkeley
MOMA Museum of Modern Art, New York
MPM Milwaukee Public Museum
NAA National Anthropological Archives, Smithsonian Institution

NGC National Gallery of Canada

NMAI National Museum of the American Indian, Smithsonian Institution

NIG *North Island Gazette,* Port Hardy, B.C.

PJ *Pioneer Journal,* Alert Bay, B.C.

PM Peabody Museum, Harvard University

RBCM Royal British Columbia Museum (Ethnology Division)

UBC University of British Columbia, Museum of Anthropology

UCC U'mista Cultural Centre

VAG Vancouver Art Gallery

VM Vancouver Museum

INTRODUCTION

In 1979 a Kwakwaka'wakw museum opened in Cape Mudge, British Columbia, and about a year later another opened in Alert Bay. Coming a century after the first large-scale, systematic collecting of Kwakwaka'wakw artifacts, the opening of these Native museums marked a new period in the history of Kwakwaka'wakw-white relations. Both the potlatch ban of 1884 and the massive collecting of anthropologists assumed—though in different ways—the eventual extinction of Kwakwaka'wakw culture, if not their race. Now the national museum of Canada was returning objects taken from the Indians under duress. This study demonstrates how this event and these institutions act as a point of culmination for a larger process of cultural and historical exchange.

THE ANTHROPOLOGICAL ENCOUNTER

The anthropological encounter with Kwakwaka'wakw art and artifacts, 1881–1981, forms my subject. The phrase "anthropological encounter" is intended to describe a cultural and social relationship centered on the anthropologist. The general term "encounter" is meant to encompass a range of activity. At the core of the anthropological encounter is the experience of ethnographic fieldwork, but it also includes all kinds of face-to-face relationships between anthropologist and Native. In the case of

1

artifacts, it applies most particularly to collecting, but recently the encounter has included preservation programs and commissions.

Despite the role of the anthropologist as point of reference, the encounter is not restricted to anthropologists and their informants. By defining the concept broadly, one can place the discipline in context by examining anthropology-like cultural concepts and social behavior. Because the encounter is being viewed through artifacts, artists in both cultures are key players. Yet they are only one of the many kinds of actors who make up an "art world" (Becker 1982). Artists, dealers, critics, curators, scholars, audiences are bound to one another in social networks of communication and interaction. By their attitudes and activities these actors together constitute the "work of art" over the course of its life: creation, distribution, evaluation, and preservation. This approach reveals the real interchange between anthropology and nonanthropology, between the discipline and other aspects of white and Native culture.

Yet the anthropological encounter is more than a face-to-face interaction. It is also a tradition, a cultural framework that develops over time. In addition to the synchronic relationships in which anthropologists exert an active influence over Native culture, the encounter includes a diachronic structure, in which the influence is passive, mediated by objects and the products of anthropologists. Images and actions are reproduced (with change) from anthropologist to anthropologist, and from Native to Native, along with cross influences from anthropologist to other whites, anthropologist to Native, and so on. Influence can also go the other way, as anthropologists take up attitudes first proposed by white artists or respond to demands from the Native community.

This study is a kind of history of anthropology, as well as an anthropology of anthropology. Unlike many histories of anthropology, it is a history of the discipline as "ethnohistory," a history of intersocial contact and influence between and within a Native society and the anthropologist's own society. As James Boon (1982:45) writes, "The history of anthropology and the anthropology of history happen symbolically. . . . Knowledge of other cultures and eras depends on the cultures and eras doing the knowing." Such reflexive views, seeing anthropology itself as a cultural process, have been advocated in many books and essays in recent years (e.g., Marcus and Fischer 1986).[1]

The anthropological encounter is a movement of acculturation, on both sides, but, clearly, this study is "anthropology-centric." For the most part, it portrays anthropologists as the active agents, encountering Kwakwaka'wakw; by and large Natives respond to anthropological initiatives. This is due partly to the available sources, but mostly to the historical fact that the anthropological encounter with the Kwakwaka'wakw has taken place within a situation of colonial imbalance. Though Kwakwaka'wakw have been important from the beginning (an example being George Hunt, Boas's collaborator), they have recently become more successful in defining the situation and in controlling their relationship with museums and anthropologists.

As Edward Bruner (1986) has noted, there has been a paradigmatic change in how both anthropologists and Indians view the vitality of Native American cultures. Moreover, Kwakwaka'wakw cultural activities maintain a persistent difference, despite some recent blurring.

Anthropological knowledge typically results in a process of objectification, in the form of notes, essays, lectures, photographs, films, sound recordings, museum displays, and the like. All these are attempts to document and then communicate the reality of another culture to an audience. Thus all products of the anthropological encounter are ultimately devoted to the task of cultural representation. For instance, ethnographic collection aims to construct a simulacrum, a *model of*, Native culture. The museum display that follows is then a simulacrum of the collection. All of these museum actions carried out or directed by anthropologists will follow from a more or less coherent image of Native culture. Because the anthropological encounter has privileged Kwakwaka'wakw culture, we must also examine Kwakwaka'wakw presentations of their own culture to whites, as they enter into this cross-cultural dialogue.

Of the entire anthropological encounter with the Kwakwaka'wakw, I focus here on that portion dealing with artifacts. The potlatch, for instance, has generated a huge literature, from Boas and Benedict to Goldman and Walens, yet because such writings have had little impact on Kwakwaka'wakw culture, it is not as fruitful a theme. Of all Native cultural expressions, artifacts have survived until the present most directly. With some exceptions (as in conservation), they are unmediated by anthropological transcription or translation. Methodologically, this acts as a kind of control, allowing us to juxtapose a single object with diverse interpretations of it. Moreover, artifacts have been central to the Kwakwaka'wakw and other traditional Northwest Coast societies as well as to Western conceptions of these societies.

This study thus considers the movement of Kwakwaka'wakw artifacts in space and time, with the spatial motion more precisely a movement between cultures. The investigation is explicitly cross-cultural. Not a study of object construction or use within a single culture, it considers objects as they leave their originating culture or as that culture is presented to outsiders.

The anthropological encounter with Kwakwaka'wakw objects takes place within the specific institutional context of the museum. Kwakwaka'wakw artifacts first became incorporated into Western culture through the process of collecting, and they have remained ever since a responsibility of museums—to preserve, research, display, and interpret. Recently, museums have emphasized the function of outreach with commissions, loans, and, at times, with the repatriation of objects.

The "storage box of tradition" is an appropriate and resonant Kwakwaka'wakw idiom for a museum. Boxes were central to the Northwest Coast emphasis on ranking and the accumulation of wealth, and they were regarded as receptacles, concretely, for inherited artifacts, and, metaphorically, for the transmission of ancestral privileges. The box idiom was used in potlatch oratory to stress the preservation of

customs. Boas employed the phrase in trying to explain his work with George Hunt to the Kwakwaka'wakw, and it has also been used by contemporary Kwakwaka'wakw to refer to their Native cultural center (see the epigraph to this volume).

Metaphorically, the museum as a box is a *context* for objects, defining them to such an extent that it may be said to create them (e.g., ritual objects vs. ethnological specimens vs. works of art). As a study of cross-cultural objects, those that leave their original contexts, this book is essentially about the process of recontextualization. In this process of re-boxing, objects move out of an original container and into new ones and, sometimes, back again to former boxes. Though the museum and storage box share many fundamental features, they also reveal significant and enduring differences between Kwakwaka'wakw and white notions of cultural preservation.

As containers, museums hold more than physical objects; these boxes serve for the storage of time, duration, of *tradition*. Tradition is a cultural structure binding past and present, new objects and old. Yet like all of culture, it is valenced; traditions cannot connect all of the past to the present. Like most concepts in anthropological discourse, it is a Native category as well as an analytic construct. Actors use it strategically to emphasize certain aspects of the past and neglect others. In fact, some objects are defined as traditional, while others are not.[2]

If culture is inherently in flux, changing, redefined by actors for particular ends, preservation is problematic. The notion of storage, for Kwakwaka'wakw but especially for whites, tries to freeze time. Anthropologists are familiar with this in a textual vein as the creation of the ethnographic present; an ongoing flow is reified, made into an object, first conceptually and then literally (see Handler 1988:13–16). Franz Boas was merely the first and most important ethnologist to make the preservation of Kwakwaka'wakw culture his basic concern.

In this process of reification, one part of Kwakwaka'wakw culture (especially the objects and cultural data from a particular time, 1850–1920, and place, Fort Rupert and Alert Bay) was made to stand for all of Kwakwaka'wakw culture in the productions of anthropologists: exhibitions, photographs, films, essays, and books. Collectors at the turn of the century were motivated by a conscious set of desiderata, selecting some objects and ignoring others. With the cessation of large-scale collecting and ethnography around 1920, their products formed the primary substance of the Western (or at least anthropological) image of the Kwakwaka'wakw, thereby privileging one phase of Kwakwaka'wakw culture as a "classical" or more "authentic" period (one, however, created at a time of severe culture change). While much of the volume is devoted to documenting how this process occurred, it also deals with the more recent critique, questioning, and dissolution of this "classical" reification. Gradually, Kwakwaka'wakw were seen as coeval, sharing the same time, with the concomitant recognition of autonomy, leading to a partial repatriation of their heritage.

In considering the temporal motion of Kwakwaka'wakw artifacts since their creation, it is helpful to bear in mind Kopytoff's (1986) proposal that we regard objects as having biographies, life histories, or careers. Appadurai (1986:16–29) has explored

the interplay of paths and diversions: paths are the expected circuits for object movement, while diversions are the formation of new paths brought on by crisis or creativity. This study examines the diversions of Kwakwaka'wakw classical artifacts, often their repeated diversion from context to context, and the creation of new paths.[3] Different things are done to them by different people in different settings, as they are conceptually redefined and even physically reconstructed.[4]

In addition to having life histories, objects reproduce. As part of formal and stylistic systems, all objects derive their properties from preexisting objects (Kubler 1962). Since their collection, Kwakwaka'wakw artifacts have continued to influence the creation of new objects, and when the relationship is especially close, we may call them "meta-objects," or objects about other objects. With control of these original models and their reflections in display, photography, and publication, anthropologists have played a significant role in the creation of new Kwakwaka'wakw artifacts within an intercultural context.

This study places objects in time in two ways. First, it traces the biographies of classical period artifacts, as they leave Kwakwaka'wakw culture and are preserved by museums; second, it considers the influence these older objects have had on the creation of new ones, again, usually in a museum context. The classical raises the issue of renaissance, and of the role of anthropologists and museums in the recent revival of Northwest Coast art.

The Storage Box of Tradition covers developments over a century marked by two symbolic events. The systematic collecting of Kwakwaka'wakw artifacts began in 1881, when Johan Adrian Jacobsen set out for the Royal Ethnographic Museum in Berlin. In 1980, an even century later, a Kwakwaka'wakw-run museum opened in Alert Bay. It is argued here that a structured intercultural movement occurred between these two points, but of course the cultural movements begun in that century have not ended. Subsequent changes in people, institutions, and events discussed in the narrative have been noted, but, for the most part, I have not comprehensively considered major undertakings that occurred after 1980. While each section and chapter moves the story along, they are also addressed to various actors (anthropologists, artists, or Natives) or museum functions (collection, display, or outreach).

The book traces the underlying "story" of the movement—incorporation, presentation, repatriation—of Kwakwaka'wakw artifacts into and out of museums over the past century. This narrative describes a kind of circle, from the Native culture to white culture, and then back to Native culture. Yet it may be more accurately regarded as a spiral, for the return is to a different level. The objects are not returned to their original makers, but to their descendants, and, similarly, those giving are not the original takers. This movement of return metaphorically characterizes efforts to bring the museum to Native communities, as in training and loan programs but is literally involved in recent acts of repatriation. Not unique to Kwakwaka'wakw artifacts, this process has been applied to many of the "exotic" objects that entered Western museums around the turn of the century.[5]

It is precisely this gap between collecting and return—a temporal span—that is the focus of the present study. The subject of tradition, the relation of present to past, invokes the issues of authenticity, reification, the classical, and revival. The book revolves around doubleness and multiplicity—a clash of states, versions, definitions—concerns inevitably generated by a situation of cross-cultural exchange. Authenticity involves a privileging of one version out of a multiplicity of related versions and contexts, and thus the authentic is always contrasted with the inauthentic. The issue is raised when cultural forms move across time and space and as anthropologists reproduce and represent these forms. One is then confronted by the existence of multiple versions or various relations to a given context, and the question is inevitably raised, Which version is closer to an original state?[6]

Authenticity is an example of the social construction of value, as it is a rhetorical privileging of something, making it significant in a hierarchy of value. As this study shows, the value of an object can change, as when objects move from the status of ethnography to art. As the creation of value, authenticity also raises questions of legitimacy and authority. Who has the power to grant authenticity? For much of the past century, these objects have lived in white worlds, and authenticity has been attributed largely by non-Natives such as anthropologists and artists, not the Kwakwaka'wakw. Finally, authenticity is always a reflexive issue, as it is inherently a comparative judgment.[7]

While this study draws upon a body of anthropological theory devoted to issues of tradition, authenticity, and the like, it is not primarily an application of a particular analytic approach, with ethnographic illustrations. Rather it is a historical case study that illuminates one of the densest interactions between anthropologists and a Native culture.

THE KWAKWAKA'WAKW

When first encountered by British trader James Strange in 1786, the Kwakwaka'wakw Indians were living along the beaches and rivers of the northern half of what is now known as Vancouver Island, the mainland of British Columbia, opposite, and on many of the smaller islands in between, from about Salmon River in the south to Rivers Inlet in the north (Galois 1994). Like many ethnic labels, the term by which they are best known—"Kwakiutl"—is based on a misunderstanding, symbolic of the entire anthropological "creation" of this culture. The group of related peoples called Kwakiutl by anthropologists were loosely organized at contact and had no name for themselves. When necessary, they expressed their cultural solidarity, primarily against other Northwest Coast peoples, by calling themselves Kwakwaka'wakw, meaning Kwak'wala-speakers.[8] Kwak'wala or Southern Kwakiutl is a branch of the Wakashan language stock, which also includes the Heiltsuk (Bella Bella) and Haisla (Kitamaat, Kitlope) to the north, as well as the more distantly related Nuu-chah-nulth (Nootka)

peoples to the east and south of Vancouver Island. "Kwakiutl" was an attempt by early whites to transcribe the name of one tribe, the kwagu'ł from Fort Rupert. Other variant spellings were Kwakiool and Kwawkewlth (chosen by the Department of Indian Affairs for the agency dealing with these people). "Kwakiutl," a garbled name for one subgroup, became embedded in the anthropological literature through its use by Franz Boas (Codere 1990:376).

Each of the twenty-five or so (depending on how they are counted) tribal subgroups—such as the 'Namgis (Nimpkish), Mamalilikala (Mamallilikulla), Ligwiłda'xw (Letwiltok), and Gusgimaxw (Koskimo), among those mentioned in this study—was associated with a winter village. Around 1915 the Indian Department attempted to organize these groups into formally recognized bands, each occupying a reserve, but their divisions did not always correspond to Native distinctions (Duff 1965:20–22).

Unhappy with the inaccurate "Kwakiutl," an increasing number of these people since about 1980 have sought to popularize "Kwakwaka'wakw." This term, which has been widely accepted in scholarly and popular usage, is employed here, with two exceptions. In direct quotations, Native terms and tribal names will always be given as found in the original. To do otherwise would be to obscure those ethnic conceptions that are the object of this study. In fact, the books and many of the exhibitions (e.g., in the Royal British Columbia Museum) cited in my study still use "Kwakiutl" and other established names, despite intentions to change them.

After a great deal of consideration, I have also decided to retain "Kwakiutl" in the title. One reason, of course, is clarity of reference, as these are "long-established English names" (Suttles 1990:15; see also Rohner 1967:5–6; Jonaitis 1991). Yet what is much more important for a historical work devoted to tracing changes in interethnic relations before 1980, when the term began to come into common English usage, I wanted to highlight these conceptions. "Kwakiutl" in the title alerts the reader to a disjunction. Focusing on the anthropological encounter, my subject is not so much the living people calling themselves Kwakwaka'wakw, as it is this foreign image, constructed over the past century, with all its misunderstandings, in Berkhofer's (1978) phrase, "the White Man's Indian." There are a number of precedents in recent analyses for the use of outmoded ethnic terms. In his study of the New York avant-garde artists and Native American art, Rushing (1995:xii) employs the term "primitive" for historical reasons ("primarily to preserve the historical language of the period being narrated"), even though he says that it lacks validity. A study similar in many respects to this volume is Fienup-Riordan's investigation of Eskimos as depicted in movies. She retained the problematic term "Eskimo" because her "subject concerns image as much if not more than 'reality.' The Eskimo, like the Indian, is not an ethnographic fact but a complicated and contradictory idea" (1995:xviii). An analogous issue is present in Dilworth's (1996:23–24) investigation of images of Southwestern Indians around the turn of the century in which she reproduces images of the Hopi Snake Dance in order to offer a critique. Like the present work, hers is largely an analysis of metropolitan, not Native, culture, or perhaps more accurately, of Native culture *in*

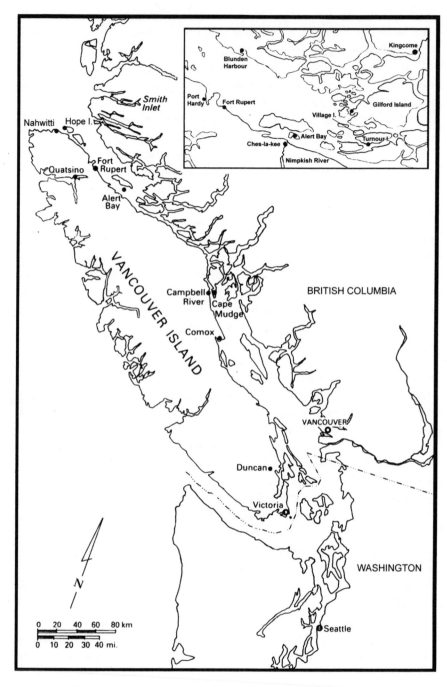

Locations mentioned in the text.

relation to the dominant culture. Finally, like a related study, Marvin Cohodas's (1997) history of Klamath River basket weaving, this work does not attempt to speak for Native people. They can and will tell their own story.[9]

Before turning to this specific story, I must briefly sketch out a Kwakwaka'wakw history and art history. Unfortunately, the history of the Kwakwaka'wakw before contact in 1786 is little understood, but as Codere (1961:434) claims, all our records suggest that the Kwakwaka'wakw, like any people (and contrary to initial ethnological assumptions), have been in a constant state of change. An important case in point is the southern expansion of the Kwakwaka'wakw during the early nineteenth century. In 1792, when Vancouver stopped at a village on Cape Mudge, at the southern point of Quadra Island, it was held by the Comox people (Northern Coast Salish). It was not until the mid-1840s that the Weewiakay, a Kwakwaka'wakw tribe, settled in the area (Galois 1994:274; see also Codere 1990:359).

The most important period, because it was the one documented in Boasian ethnography, was what Codere (1961:435) has called the potlatch period, 1849 to 1921. Its boundaries were marked at the beginning by the founding of the Hudson's Bay Company fort and trading post at Fort Rupert and at the end by a great potlatch given by Daniel Cranmer at Village Island. One of the largest held up to that time, this potlatch resulted in severe prosecutions the following year.

Not coincidentally, this period is the same as the ethnographic present, as defined by Boasian ethnography (Codere 1990). As is generally true throughout Native North America, the so-called traditional period was in fact the "contact-traditional" period defined by Lurie (1971). These putatively pristine cultures described in standard ethnographies were actually accounts of societies that had already undergone substantial change. A process of continual change was conceptually halted and reified in the form of ethnography.[10]

By no means could the potlatch period be considered "typical" or traditional. The Kwakwaka'wakw reacted strongly to the impact of Western culture. As Codere pointed out, potlatches increased in size, frequency, and lavishness as wealth increased and the population decreased. Throughout the nineteenth century Kwakwaka'wakw numbers dwindled, especially after the great smallpox epidemic of 1862, from an estimated high of about 8,000 to a low of 1,088 in 1929 (Codere 1990:367). After about 1880 the center of acculturation, and the site of the largest Kwakwaka'wakw community, shifted from Fort Rupert to Alert Bay, about 25 miles away. Like Fort Rupert, Alert Bay was not a traditional village but was founded in the early 1870s with the establishment of a cannery. With this access to a trade economy, Kwakwaka'wakw soon added wage labor in fishing and timber to their subsistence base (Knight 1978). The manufactured goods that had long been traded became much more common: flannel blankets began to replace cedar bark; and metal pails, wooden bowls. In art, metal-tipped tools allowed an expanded production of larger, more precise carvings, which were increasingly painted in commercial paints. An Anglican mission was established in Fort Rupert in 1878, moving over to Alert Bay two years later. Largely as a result of

Kwakwaka'wakw Villages, Tribes, and Locations

Locale	Village Name	Tribe
Fort Rupert	Tsaxis	Kwagu'ł
Village Island	'Mi'mkwamlis	Mamalilikala
Alert Bay	'Yalis	'Namgis
Turnour Island	Kalugwis	Ławitsis (earlier Kwagu'ł)
Knight Inlet	Dzawadi	A'wa'etłala
New Vancouver	Tsadzis'nukwaame'	Da'naxda'xw
Kingcome	Gwa'yi	Dzawada'enuxw
Gilford Island	Gwa'yadams	Kwikwasutinexw
Hopetown	Hegams	Gwawa'enuxw
Wakeman Sound	Ałałxu	Haxwa'mis
Blunden Harbour	Ba'a's	'Nakwaxda'xw
Quatsino	Xwatis	Gusgimaxw
Winter Harbour	Oyagam'la	Gwatsinuxw
Hope Island	Xwamdasbe' [Nahwitti]	Tłatłasikwala
Smith Inlet	Takus	Gwa'sala

Source: After Jonaitis (1991:17)

missionary influence, the Canadian Parliament banned the potlatch and all associated ceremonials in 1884. Although the law was fitfully enforced, it nevertheless curtailed the ritual (Cole and Chaikin 1990).

Many of these forces were accelerated in the twentieth century, as the Kwakwaka'wakw became gradually integrated into the white economy. Daniel Cranmer's 1921 ceremony was the last large-scale potlatch to be held in public for many years, but during the Depression potlatching continued surreptitiously. The church became important to many Kwakwaka'wakw. Since the 1920s, the Kwakwaka'wakw population has been increasing and now numbers about 5,500. In 1951 the clause banning the potlatch was finally dropped from the Indian Act, and the same year a new system of locally elected governance was introduced to the Native reserves. While interregional migration had long characterized the Kwakwaka'wakw, it was accelerated in the 1950s as many left small, isolated villages for the larger communities in Alert Bay, Port Hardy, Campbell River, and the cities of Vancouver and Victoria. Since the early 1950s there has been a steady artistic and ceremonial revival. While this has brought increased pride to Kwakwaka'wakw, their dependence on the extractive industries of the province means that many still live a precarious existence (Webster 1990a).

Finally, it is necessary to sketch the history of Kwakwaka'wakw art during the century ending in 1980. Only recently have scholars begun to get a sense of the development of Northwest Coast Indian art before 1880 (Carlson 1983; Brown 1998), and the growth of Kwakwaka'wakw art styles in particular is still unclear. Although a twentieth-century art history has yet to be fully written, its main outlines have been delineated by Peter Macnair (Macnair et al. 1980) and Bill Holm (1983).[11] According to Macnair (Macnair et al. 1980:71–72), "More than two dozen Southern Kwakiutl artists who

practiced when ceremony and ritual was at its zenith are still remembered and examples of their work identified."[12] Kwakwaka'wakw art of this period can be grouped into several regional substyles: Fort Rupert–Alert Bay, Blunden Harbour–Smith Inlet, Kingcome, and Campbell River–Cape Mudge. There are others, but they are still poorly known. What follows is a biographical introduction to the leading masters of the past century and the younger artists who had achieved prominence by the early 1980s (essentially those artists born before 1960).

The founder of the Fort Rupert style of Kwakwaka'wakw painted sculpture, Charlie James (c. 1867–1938) was "the first to establish a reputation, both among and outside his people" (Macnair et al. 1980:72). James was born in Port Townsend, Washington; his mother was Kwakwaka'wakw, his father a white sawmill owner. Before he was ten, his mother died, and he was raised by his maternal grandmother, first in Victoria and then in Fort Rupert. Having injured his left hand in a shotgun blast while still a young boy, Charlie James turned to one of the few careers open to him, that of full-time carver. Around 1915 he settled in Alert Bay. A stylistic innovator, James made many ceremonial objects and was especially noted for his large feast dishes and totem poles. He also played a large role in fostering the commercial market for Kwakwaka'wakw artifacts—in his later years he produced a vast quantity of model totem poles (Nuytten 1982:13–41).

The most important artist for this account was Mungo Martin (c. 1885–1962).[13] Martin was born in his mother's home village of Fort Rupert; his father was from Gilford Island. Around 1895, after his father's death, Mungo's mother married Charlie James, who became Martin's teacher. In a carving career that began around 1900, Mungo Martin continued and extended James's styles. His first major commissions were totem poles around 1910, and he made several important masks during the teens. His most active period of carving lasted little more than a decade, for in the 1920s he turned to commercial fishing, owing to the decline in ceremonialism. During these years, however, he continued to carve on a reduced scale and was active as a songmaker (or composer). Martin's life and career changed dramatically in 1949, when he was invited by the University of British Columbia Museum in Vancouver to restore totem poles. In 1952, after carving two new poles, he moved with the carving program to the British Columbia Provincial Museum in Victoria. Here he spent the rest of his life replicating totem poles and carving new ones. He died in 1962, covered with honors, and was posthumously awarded the Canada Council Medal.[14]

Ellen Neel (1916–1966), the granddaughter of Charlie James, carried forth his tradition of commercial production. Ellen Newman Neel was born in Alert Bay. Both of her parents were half white; her mother was James's daughter and Mungo Martin her uncle. By the age of twelve she was selling model totem poles to tourists. In 1939 she married a white metalworker, Edward Neel, and in 1943 the couple moved to Vancouver. After her husband's stroke in 1946, Neel turned to carving to support her family, working out of a home-studio. The year 1948 was important for Neel, especially for her relation with the University of British Columbia (UBC): she gave a speech at

a conference on Native affairs, dedicated a totem pole carved for the student union, and did some preservation work on the university's totem poles. Virtually all her production was sold to whites; she evidently made nothing for ceremonial use. Ellen Neel was extremely important in developing the market for Native art. She demonstrated carving, filled many commissions for totem poles for hotels, shopping malls, and civic sites. Her creativity was cut short by increasing illness during the last five years of her life (Nuytten 1982:43–73).

Mungo Martin had three important students, all of them relatives: Henry Hunt, Tony Hunt, and Douglas Cranmer. The son of Jonathan Hunt and the grandson of George Hunt, Henry Hunt (1923–1985) was born in Fort Rupert. His father was a boatbuilder, and young Henry made miniature canoes and paddles, which he sold to tourists. An early influence was the work of Kingcome carver Arthur Shaughnessy. At the age of seventeen Hunt married Helen Nelson, who had been raised by Mungo and Abayah Martin, and he went to work as a logger to support his family. Hunt began carving part-time in 1954 and started working full-time with Martin the following year. When Martin started work at the Provincial Museum in the 1950s, his son David was his principal assistant, but following his son's death in 1959, he turned to Hunt. Hunt's years of forestry experience stood him in good stead, and totem pole carving soon became his forte, first with Martin and then with his son Tony. Henry Hunt was appointed chief carver in 1962, after Martin's death. Among his more important works were the pole for the Montreal Expo in 1967 and the Mungo Martin memorial pole for Alert Bay (1970), in addition to many fine poles in Great Britain, eastern Canada, Mexico, and South America. Hunt also created a small but important group of masks commissioned by the Provincial Museum for ceremonial use. After his retirement in 1974, Henry Hunt spent his last years in independent carving (Ashwell 1975; Henrikson 1995).

Born in Alert Bay in 1927, Douglas Cranmer was the son of 'Namgis chief Daniel Cranmer and Agnes Hunt (the daughter of Martin's second wife Abayah and David Hunt). Cranmer spent part of his childhood living with Mungo Martin and as a youth participated in potlatches. He also tried his hand at carving, inspired by artists Arthur Shaughnessy and Frank Walker. After an early career in fishing and logging, in the mid-1950s Douglas Cranmer learned to carve from Mungo Martin. His first important project was assisting Haida carver Bill Reid with the Haida village at UBC, 1959–1962. In 1963 Cranmer opened a Native art shop in Vancouver, but it met with little financial success and closed two years later. Since then he has carved on independent commissions, devoting much of his time to teaching—at 'Ksan in 1970, the Vancouver Museum in the early 1970s, and since his return to Alert Bay in 1977, at the U'mista Cultural Society. Important among his students are Bruce Alfred (b. 1950), Fah Ambers (b. 1955), and Richard Sumner (b. 1956). Since 1975 Cranmer has produced a series of abstract paintings marked by a strong northern influence. A memorial pole for his father, carved with his apprentices, was raised in Alert Bay in 1978. All Cranmer's mature work is notable for his pronounced personal style (Macnair 1978).

Tony Hunt (b. 1942) was born in Alert Bay and lived in Fort Rupert until the age of ten, when his family moved to Victoria. As a teenager, he learned carving not from his father, but from Mungo Martin. Hunt differs from many of his younger colleagues in that he grew up speaking Kwak'wala and participating in Native ceremonials. In 1962 he became assistant carver at the Provincial Museum, where he worked until 1972. Resigning to devote more time to his own work, he ran a shop, Arts of the Raven, in Victoria from 1969 until 1990. A prolific artist, Tony Hunt works in silkscreens and jewelry, as well as wood carving. Hunt is especially known for his many totem poles, including the pole raised in honor of his grandfather Jonathan in Alert Bay in 1976. Since opening his shop/studio Tony Hunt has become an active teacher, and it is probably safe to say that he has taught more of the current generation of Kwakwaka'-wakw artists than anyone else.

Though born in Alert Bay, Tony's younger brother Richard Hunt (b. 1951) has lived most of his life in Victoria. Throughout his childhood and youth his father was carving for the Provincial Museum, and at the age of thirteen Richard began learning from him. After working with his brother for a year, in 1973 Richard Hunt became the museum's apprentice carver. From 1975 until 1986 he worked as chief carver. While at the museum, he produced many masks and other ceremonial items; since becoming independent he has created in a wide range of forms, from totem poles to silkscreen prints (Neary 2000).

Another member of the extended Hunt family is Calvin Hunt (b. 1956). (Calvin's grandfather, David, and Tony's grandfather were both sons of George Hunt.) Born in Alert Bay, Calvin Hunt was the son of chief Thomas Hunt of Fort Rupert and Emma Hunt, daughter of Dr. Billy, a Nuu-chah-nulth chief and shaman. He began carving at the age of twelve under the informal guidance of Henry and Tony Hunt; in 1971 he apprenticed with his second cousin and also worked with Tony Hunt's partner, John Livingston. In the earlier part of his career, Calvin Hunt specialized in complex ceremonial mask and costume ensembles; today he carves mostly monumental sculpture. Among the most notable works are two poles in Fort Rupert: a memorial grave figure for his father and a Hunt family pole, owned by his brother, Chief George Hunt Sr. When this pole was raised in May 1988, it was the first to be erected in the village in seventy years. Calvin Hunt is also an important teacher, working out of his studio-workshop, "The Copper Maker," in Fort Rupert, where he has lived since 1982.

The most important alternative to the Fort Rupert style was associated with the northern, conservative villages at Blunden Harbour and Smith Inlet. The leading artist here was Willie Seaweed (c. 1873–1967). Born in Blunden Harbour, Seaweed learned from his half-brother Johnny Davis. His earliest dated work, from about 1910, was relatively restrained in matte paints and simple shapes, but by about 1920 Seaweed was using shiny enamels, and his style gradually became more exuberant and baroque. His use of the compass, especially for the eyes, gave his work a crisp symmetry. Willie Seaweed produced a wide range of artifacts—totem poles, masks,

headdresses, model totem poles, screens, rattles, drums, and whistles. More than 120 extant objects have been attributed to the artist (Holm 1983). Few of his carvings were made for sale for non-Natives. Though he lived all his life in his natal village, Seaweed traveled widely to other Kwakwaka'wakw villages to fulfill commissions. His most active period came in the early 1940s, but he continued to create until the mid-1950s. Like Mungo Martin and many other leading carvers, Chief Seaweed was also noted as a composer and performer (Holm 1974, 1983).[15]

In addition to the Fort Rupert–Alert Bay and Blunden Harbour–Smith Inlet communities, other Kwakwaka'wakw tribal groups produced important artists. Among the leading Kingcome artists were Tom Patch Wamiss, Arthur Shaughnessy, Dick Hawkins, and James Dick. Arthur Shaughnessy (1880–1946), active in the early part of this century, was especially noted for his ceremonial carvings, creating several of the totems erected in the Alert Bay cemetery in the 1920s, and he also worked in silver. The family tradition of James Dick (1900–1979) was handed down to his sons Benjamin (Blackie) and Adam and to his grandson Beau, who has become one of the more important carvers of his time.

Born in Alert Bay in 1955, Beau Dick was taken as a young child to his ancestral village of Kingcome, where he spent his first six years, speaking only Kwak'wala (Tutton 1994:29). Dick began his artistic career with school-boy doodles but wanting to learn more studied with his father, Benjamin Dick, and grandfather, James Dick. His other instructors have included several of the leading Kwakwaka'wakw artists of the previous generation, Henry Hunt (with whom he lived for a year and half), Tony Hunt, and Douglas Cranmer, as well as Nuu-chah-nulth artists Joe David and Art Thompson. Stylistically eclectic, Dick often works in non-Kwakwaka'wakw styles, especially Bella Coola (Nuxalk), as well as representational paintings depicting ceremonial and supernatural scenes.

Another important artist of the early to mid-twentieth century was Henry Speck, from Turnour Island. Speck (c. 1909–1971) had learned carving as a boy from his grandfather, but he was not very active during his mature years. Around 1960 he began to live part-time in Alert Bay, and it was during the last decade of his life that he was heavily promoted by the Vancouver art dealer Gyula Mayer. Chief Speck become famous for his hundreds of paintings (watercolors in the 1930s and 1940s and later acrylics),[16] which were important precursors for the subsequent silkscreen print market.

Sam Henderson (1905–1982), from the Blunden Harbour area, lived in Campbell River for most of his life. Self-taught, he carved his first pole in 1935 and spent much of his early career producing dugout canoes and other utilitarian objects. Henderson, who worked mostly as a fisherman and logger, began to carve seriously in the 1950s. From the mid-1960s until his death he created a number of poles and masks for Campbell River patrons, white as well as Native. Beyond his own work, Sam Henderson was important for his teaching of his many prolific sons—among them Dan, Bill, Ernie, and Mark (who was also influenced by Speck and Ben Dick).[17]

The most pointed way of formulating the question of the anthropological encounter of the Kwakwaka'wakw is to ask what has been the influence of anthropologists on Kwakwaka'wakw art? As the creators of some objects (texts, photographs, etc.) and as controllers of access to Native objects, anthropologists have assumed a position of great power in forming the image of classical Kwakwaka'wakw culture for others. The career of the classical objects, as mediated in the museum context, is my subject and the rationale for chapter divisions. Museums are uniquely suited for the study of "classical" artifacts, as the act of collecting artifacts has created a continuing legacy and a fixed corpus. This study traces the career of these objects since their creation, as they have been collected, bought and sold, studied, conserved, displayed, and have influenced artists as models or inspiration. All these actions grow out of changing images of "classical" Kwakwaka'wakw culture, and its changing relationship to those in the present, Native and white. The following investigation should make it possible to evaluate the relation between this classical material and the work of contemporary Kwakwaka'wakw artists in what has been widely regarded as a "renaissance."

PART ONE

CREATING THE CLASSICAL IMAGE OF KWAKWA̱KA̱'WAKW ART AND CULTURE (1875–1950)

PART I

CHAPTER II: THE DEFENSE OF TRADE
OR FINANCIAL AS A POLITICAL
SPHERE OF INTEREST

1

COLLECTING

A ll collecting is an act of reproduction, the creation of miniature worlds, in which the set of accumulated objects is regarded, metonymically, as standing for the larger whole. In the case of "ethnographic artifacts," my concern here, that whole is the culture that generated them. Despite the intentions of the more scientifically inclined, these acts of cultural representation are never neutral samples, especially when they occur across cultural boundaries. The anthropologists who hoped to document Kwakwaka'wakw culture ended up creating what they collected, literally, with commissions and conservation treatment, but also more subtly, as they gathered some things and left out others (Kirshenblatt-Gimblett 1991; Pearce 1992:38–39; Elsner and Cardinal 1994). In all cases, they were motivated by a particular image of that culture, one that has changed over the century. For an anthropology based on objects, collecting was obviously the foundation for all other activity— the initial encounter with Kwakwaka'wakw artifacts—and it was fundamentally by this means that the classic image of Kwakwaka'wakw culture was created.[1]

WHO WERE THE COLLECTORS?

Whites have been collecting Kwakwaka'wakw artifacts for over two hundred years, but for the first century this collecting was sporadic and casual.

EARLY COLLECTORS (1778–1875)

Although Captain Cook never visited Kwakw<u>aka</u>'wakw territory on his voyage of 1778, he or his crew may have acquired some Kwakw<u>aka</u>'wakw objects at Nootka Sound.[2] Even the objects collected on Vancouver's voyage of 1792, the first major expedition to contact the Kwakw<u>aka</u>'wakw, are poorly documented. In contrast to Cook, Vancouver was directed to gather "artificial curiosities" (King 1981:11; see also Fisher 1992:41–44). Still, no official collection was made, though several of his crewmen—George Goodwin Hewitt, Spelman Swaine, and Archibald Menzies—recorded purchases of Native goods. Unfortunately, few pieces survive. In the Hewitt collection in the British Museum reposes a bow from the Knight Inlet area and a sling of indeterminate Kwakw<u>aka</u>'wakw origin (Gunther 1972:97–98).

Although it is likely that some traders or Hudson's Bay Company agents did purchase Kwakw<u>aka</u>'wakw pieces, the first well-documented objects seem to be a 30-foot canoe from Fort Rupert and an Alert Bay totem pole, both collected for James G. Swan in 1875 (by Indian Commissioner Israel Wood Powell and missionary Thomas Crosby, respectively). Swan's corpus, the first systematic collection of Northwest Coast artifacts, was intended for the U.S. Centennial Exposition of 1876, from which it was accessioned into the Smithsonian. Though he did attempt to secure a representative sampling of Kwakw<u>aka</u>'wakw artifacts from Alert Bay residents R. H. Hall and Westly Huson, such collections never materialized (Cole 1985:31).

JOHAN ADRIAN JACOBSEN (1881–1885)

The first large-scale, systematic collection of Kwakw<u>aka</u>'wakw material culture was made by Johan Adrian Jacobsen in late 1881 and early 1882, under the auspices of the Museum für Völkerkunde in Berlin. The museum's director, Adolf Bastian, was voraciously building his institution into the largest ethnological collection of his day. Bastian (1884:n.p.) was driven by the belief that Native cultures were doomed:

> Night is drawing near for the study of primitive races; is shrouding them in darkness, with all the treasures that would shed any light upon their history and will soon bury them in the blackness of oblivion. Let there then be no delay in the fulfillment of a duty which we cannot, if we would, leave to our successors, as it must be performed now or not at all.

This conception of ethnography as salvage formed the basis for the Jacobsen collection, as well as the work of Franz Boas, a protégé of Bastian.

Stopping in Oregon in 1880, Bastian (1884:n.p.) had been left with an "anxious desire to know what is the condition of the bordering tribes to the north," and he arranged to send Jacobsen on an ethnological expedition to British Columbia, Alaska, and the Yukon (Cole 1985:55–73). Though he had little formal schooling, the Norwegian-born Jacobsen (1854–1947) had extensive nautical experience and on several occasions had procured troupes of "exotics" (Eskimo and Lapps) for exhibition at fairs in Germany.

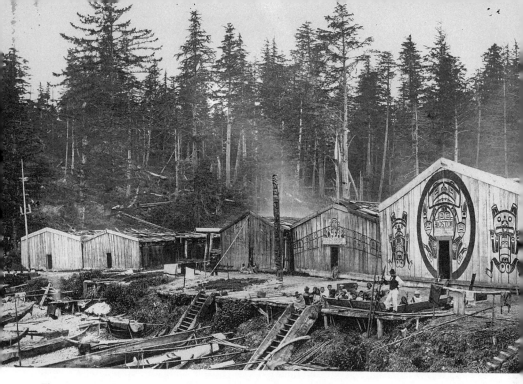

Figure 1.1. Kwakw<u>a</u>ka'wakw village of Nahwitti. Photo by Edward Dossetter, 1881. AMNH neg. no. 42298.

Jacobsen's trip, funded by a voluntary committee of Berlin businessmen, lasted two years, but he spent relatively little time with the Kwakw<u>a</u>ka'wakw—most of his collecting coming in three weeks in October 1881. For a home base Jacobsen chose Fort Rupert, "because it had a central station of the Hudson's Bay Company from which I could make excursions in various directions" (Jacobsen 1977:29). Here he was helped by the local trader, Robert Hunt, and greatly assisted by Hunt's son George, who acted as a guide and interpreter. Jacobsen's strategy was inclusive: he wanted to visit "as many Kwakiutl-speaking villages as [he] could" (ibid.). With a rented sloop, Jacobsen visited the villages at Alert Bay, Hope Island (Nahwitti), Village Island, and Turnour Island, in addition to Fort Rupert, and made an overland trip to the Koskimo settlement at Quatsino Sound on the west coast of Vancouver Island.

Jacobsen's collecting was not particularly informed. Little was then known about the Northwest Coast Indians, and he himself had no scholarly interests. On the other hand, his observations, as told to a journalist, seem quite factual and are significant as the earliest accounts of many Kwakw<u>a</u>ka'wakw customs, the hamatsa dance, for instance (Holm 1977:5). (The most important of the Kwakw<u>a</u>ka'wakw winter cere-monials, the hamatsa dance was performed by initiates of a secret society. With its invocation of man-eating spirits and simulated cannibalism, it became a frequent sub-ject of interethnic representation.) Jacobsen's comments betray the matter-of-fact attitudes of a sailor. At times he found the Kwakw<u>a</u>ka'wakw objectionable; the Kwa-

kiutl "are some of the wildest and most robust specimens of mankind known today" (ibid.:29). At Fort Rupert "they have become lazy and sullen, impertinent and impolite toward strangers" (ibid.:32). Yet at other times he remarks on the kindness and generosity of the Natives; on several occasions Jacobsen was offered food and a comfortable bed.

In late February 1882 Jacobsen was asked to return to Kwakwaka'wakw territory to gather a troupe of Natives to be exhibited in Germany. Going back to the Quatsino-Koskimo area in order to find individuals with the artificially deformed "sugar-loaf" head, Jacobsen spent almost two months at the task. However, he did relatively little collecting this time, having his hands full in persuading the people to go with him. In the end, he was able to persuade no one (see chapter 2). Jacobsen returned to Germany in November 1883 with about 2,400 Northwest Coast specimens, about 400 of these being Kwakwaka'wakw, with the others from the Coast Salish, Nuu-chah-nulth (Nootka), Heiltsuk (Bella Bella), Haida, and Tsimshian (Bolz and Sanner 1999:168–182).[3]

Johan Adrian and his brother Johan Fillip were soon given an assignment by Carl Hagenbeck of Hamburg to try again to bring a troupe of Coast Natives to Germany. Fillip went over in the summer of 1884 and gathered a collection from the Kwakwaka'wakw, Heiltsuk, and Nuxalk (Bella Coola). The following July, Adrian met up with his brother in Fort Rupert and while waiting for the steamer supplemented their Kwakwaka'wakw collection. This private assemblage, displayed in a nearby room during the German tour, was not originally intended for a museum. After its use, however, much of it was exhibited at the Chicago World's Fair in 1893 and then sold to the Field Columbian Museum, with the rest being dispersed to institutions in Germany and Norway (Haberland 1987:368–69). As Cole (1985:73) notes, the Jacobsen collection was about the last (also among the first) major Coast collection to go to a European museum. Henceforth, North American institutions were the prime acquisitors.

GEORGE M. DAWSON (1878–1885)

A small but important Kwakwaka'wakw collection made in these early years was gathered by George M. Dawson (1849–1901). The son of the geologist Sir William Dawson, George Dawson followed his father into the profession, joining the Geological Survey of Canada in 1875, becoming assistant director in 1883, and appointed director in 1895, a post he held until his death. Not unlike Smithsonian scientist John Wesley Powell in his combination of geological and ethnological interests, Dawson spent a good deal of time on his geological surveys gathering data on the Natives. In the inclusive nineteenth-century style, he collected minerals, plants, and animals, along with human curiosities.

Dawson explored Kwakwaka'wakw territory on two trips: mid-September to mid-October 1878, and a little over two months between late July and early October 1885.

On both expeditions, geological survey (specifically, the search for coal deposits) was his explicit goal, and any ethnological research was conducted in off-hours. While Dawson's interest was keen, his artifact collecting was quite casual. He never sought out particular items; if he stumbled across an interesting object and the owner was amenable, he would pick it up. In this manner he accumulated a small collection in 1878 (now in the McCord Museum at McGill University), when his major focus was on the Haida and the Queen Charlotte Islands, and forty-five items on his major Kwakwaka'wakw survey in 1885 (in the Museum of the Geological Survey, now the Museum of Civilization). Most of the pieces in the 1885 collection came from the villages at Quatsino, his principal scene of activity, and Alert Bay, the regional transportation junction. Except for three masks and a copper, the collection was completely domestic: cedar bark baskets, capes, food dishes, spindle whorls, adzes, and the like.

As his time in the field was so short, Dawson relied heavily on George Blenkinsop, the Indian agent, Reverend Alfred J. Hall, the missionary, and Robert Hunt, the local merchant. Dawson did not have a very high opinion of the Kwakwaka'wakw. Of the Fort Rupert people he wrote: "They appear to be a dirty, ugly, & degraded lot." Sympathizing with the efforts of the missionary, Dawson observed that "the Indian is discouragingly obstinate & refuses to see the Error of his ways."[4] Nevertheless, the data Dawson was able to accumulate were quite important. His 1887 monograph, "Notes and Observations on the Kwakiool People," was the first ethnography of the Kwakwaka'wakw, preceded only by Jacobsen's more superficial travel memoir.

FRANZ BOAS (1886–1900)

Ironically, because of his great importance in the study of Northwest Coast Indian art, Franz Boas was a relatively minor collector of these objects, and many of the specimens that he did collect were gathered incidentally to other ethnological pursuits. Boas's most important collection, predominantly Kwakwaka'wakw, was made on his first trip to the region, in 1886. Although he went out with several goals, material culture was perhaps his main preoccupation. First, Boas wanted to document the collection that J. Adrian Jacobsen had earlier brought to Berlin, and, second, he planned to make his own artifact collection, which he hoped to sell at a profit to finance the self-sponsored expedition.

Boas spent most of his two-and-a-half-week stay among the Kwakwaka'wakw in the conservative village of Nahwitti, a favorite of collectors.[5] After his arrival on October 6, Boas waited a week before purchasing anything, using his time to establish friendly relations with the community, which he marked by sponsoring a feast. The time was also well spent in the acquisition of contextual information on the items he intended to collect later. Feeling he had acquired all the available artifacts, Boas completed his collection, though he left an "order" with a local trader for specified items to be sent on. By the time he left Alert Bay on October 23, he had amassed sixty-five objects from Nahwitti and another five from Alert Bay.

Because the Natives were engaged in feasts and dances when he arrived, Boas left with a largely ceremonial collection. Jacobsen's collection had also been largely ceremonial, but Boas lamented its lack of documentation. Thus he was especially pleased that he had "obtained all the ornaments that belong to one dance. . . . It is the only collection from this place that is reasonably well-labeled" (Boas 1969:40). The collection was ultimately purchased by the Berlin Ethnographic Museum (Kasten 1992; Bolz and Sanner 1999:183).

In 1888 Boas started several years of summer research in British Columbia, sponsored by the British Association for the Advancement of Science (BAAS). Though it was intended as a general ethnological survey, collecting was not a vital concern. However, Dawson and Edward B. Tylor, chairman of the BAAS committee, managed to find funds for modest collections. Tylor's commission arrived too late for the 1888 season, but Boas took the opportunity to outline his plans for such research: "I do not doubt, although I am at present unable to prove it, that the arts and industries of the various races of that region were originally distinct. Indications that such was the case are not wanting, but a decisive answer can only be given by collecting systematically. . . . It is my opinion that a collection of this character showing the arts and industries of the various tribes and the style peculiar to each would be of great value to the student."[6]

Boas assured Tylor that while such a collection would not be expensive, it would take time. "It is impossible to make a collection of this character in a month or two, as it is necessary to study the distribution of each object, the principal places of manufacture, and so on, in order to exact reliable results" (ibid.). In fact, Boas estimated that three years would be required for a complete study.[7] None of the relevant institutions—the BAAS committee, Tylor's Pitt Rivers Museum at Oxford, the Canadian Geological Survey—were then able to sponsor such an ambitious program. Boas did eventually carry out much of this on the Jesup Expedition of the American Museum of Natural History.

By the 1899 season Dawson was able to offer Boas $300 to collect for the Geological Survey, allowing Boas to be the best judge of what to get. However, Dawson specifically instructed him "to exclude the Kwakiool, as I managed to get a pretty good representative lot of their things myself in 85."[8] In the week he spent in Alert Bay, Boas was able to make only minor and miscellaneous Kwakwaka'wakw collections for Ottawa and Oxford (thirty and ten items, respectively).

Boas did not collect any more Kwakwaka'wakw artifacts until 1894, though he did some scattered collecting for the American Museum and the U.S. National Museum. These two museums were also the joint sponsors (with the BAAS funding another portion of the expedition) of his 1894 trip to Fort Rupert. For the first time Boas came in the winter (November), when he could witness the elaborate Kwakwaka'wakw ceremonials. Accordingly, for the National Museum he agreed to make a winter dance collection that could be used to form exhibits. Exhibits were also the concern of the New York museum, but here Boas chose to portray domestic crafts. Despite these

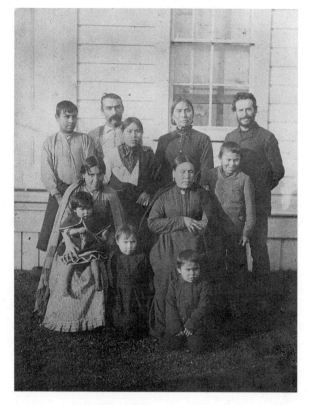

Figure 1.2. Franz Boas with George Hunt and his family, Fort
Rupert. Photo by Oregon C. Hastings, November
1894. APS neg. no. 466.

artifactual missions, Boas's collecting was, again, relatively minor: sixteen pieces for
Washington, thirteen for New York (plus another twelve from the Tsimshian [Nis-
ga'a] of the Nass River). Clearly, Boas bought just enough to be used in the displays.[9]
Moreover, his Kwakwaka'wakw assistant, George Hunt, was paid to help him gather
the objects; Boas himself spent relatively little time collecting. Instead, most of his
days and nights were devoted to recording the feasts, dances, and speeches. Another
collection at the U.S. National Museum—consisting almost entirely of cedar bark para-
phernalia and intended as a supplement to the previous set—was listed under Boas's
name in the museum records, although collected wholly by Hunt.[10]

 This reliance on Hunt continued for the rest of Boas's collecting trips. During his
tenure at the American Museum of Natural History, 1895–1905, Boas vastly expanded
its Northwest Coast collections, especially from the southern peoples—Kwakwa-
ka'wakw, Nuu-chah-nulth, and Nuxalk. In 1897 he organized the Jesup Expedition to
determine the relationship of the peoples of the Northwest Coast of America to
those of Northeast Asia, crucial evidence for which were artifact collections. During

its first season Boas did no Kwakwaka'wakw research, but the Nuxalk collection, listed jointly in American Museum records, was mostly the work of Hunt (Boas 1969:215, 232). Boas's last collecting of any kind, and thus of the Kwakwaka'wakw as well, came in 1900, also as part of the Jesup Expedition. Feeling a need for more research on Kwakwaka'wakw "arts and industries," Boas spent part of the summer interviewing women about food and medicines. For the illustrative artifacts, he gave Hunt a list of desired items, which were attributed to Boas when they were accessioned.[11]

Although Boas continued to research and publish on material culture for the rest of his career, his collecting activity was, not surprisingly, restricted to his period of museum employment. Yet this was more than a practical situation. All of his ethnography, whether in the form of texts or artifacts, had an objective character, but ultimately Boas found artifacts to be a limited source for the documentation of the Native mental worlds that were his real interest (Boas 1907a:928; cf. Jacknis 1984:43–50, 1985: 103–8, 1996b).

GEORGE HUNT (1879–1924)

In contrast to the pattern of Boas's career of Kwakwaka'wakw collecting—an initially systematic collection, followed by increasing casualness and reliance on others—that of George Hunt (1854–1933) shows a growth in sophistication and comprehensiveness (Jacknis 1991b). Over his twenty-four years of active collection, 1891–1915, Hunt's teacher and mentor was Franz Boas, and it was the success of his student that allowed Boas to slacken his own efforts.

Though his father was English, George Hunt's mother was a Tlingit, and having grown up in Fort Rupert, he seems to have regarded himself as an Indian, if not a Kwakwaka'wakw (Berman 1996:226-31). Still, his early education in English and literacy proved invaluable in his subsequent career as an ethnographer. Hunt's first exposure to artifact collecting came in 1879, when he acted as an interpreter for the B.C. Indian Commissioner, Israel Wood Powell, then collecting for the Federal Department of Indian Affairs (Cole 1985:77–79). By 1881, during the Jacobsen expedition, Hunt was playing a more active role as guide, pilot, interpreter, and collection assistant. Of his visit to the conservative village of Nahwitti, Jacobsen (1977:32) wrote: "Only the persuasiveness of George Hunt, . . . who was well regarded in the whole region, finally convinced the chief that in return for a goodly amount he should sell some outstanding ethnological pieces." Hunt continued to assist Jacobsen, in 1882 during the abortive attempt to bring a Kwakwaka'wakw troupe to Germany, and in 1885 when Adrian and his brother Fillip were again collecting in the region.

The first collection made by George Hunt on his own was destined for the Chicago World's Fair of 1893. Having decided to feature the Kwakwaka'wakw, both in person and in artifact, Boas met with Hunt in Victoria in August 1891 to settle his plans. By February 1892 Hunt had already purchased a large house, ten masks, dishes, and numerous other items, and by September had completed his collection. After exhibi-

tion in the Anthropology Building, 360 specimens were accessioned, along with the other collections, in the new Field Columbian Museum, which opened in June 1894.

Hunt's experience with the fair was radically transforming. Now, with Boas's instruction in a Kwak'wala orthography, Hunt could transcribe Native texts, to be sent to New York. So imbued was he with his mission that in early 1894, on his own initiative, he offered to collect more artifacts and texts for the new Field Museum. Still preoccupied with its installations, the museum was unable to accept the offer, and within months Boas had resigned. Yet when Boas visited Fort Rupert that fall, Hunt was at his side. As already mentioned, the modest collections from that trip were largely Hunt's work.

Without a doubt, the major collection made by Hunt, arguably the largest and finest Kwakwaka'wakw collection in existence, was amassed for the American Museum of Natural History from 1897 to 1902 (Jonaitis 1991). These 1,044 artifacts were acquired as part of the Jesup Expedition. Before the field season of 1897, Boas sent Hunt several letters of instruction. Hunt was to work for four months this first year: from mid-May to mid-June among the Kwakwaka'wakw, mid-July with Boas among the Nuxalk, and two more months after this with the Kwakwaka'wakw. For this he would receive a salary of $75 a month plus board and travel expenses. Boas began by explaining, "Our museum . . . has no collections whatever from the Kwakiutl, therefore any thing that you may obtain will be welcome."[12] Along with general instructions to obtain old artifacts, together with their crest "stories," Boas added a list of specific items to secure. Beyond these general instructions, Boas tended to leave the actual method of execution to Hunt's better judgment: "You know best, of course, what kind of things we want; and if you collect in the same way as you did for the World's Fair, you will do just what we want." Though there were a few specific requests, most of Boas's guidance consisted of goading and encouragement: "I have not heard from you for a very good long time." And, by and large, Boas was happy with Hunt's collections: "I think you have succeeded in getting together a great deal of very interesting material."[13] As the Jesup Expedition came to an unofficial close in 1902, Hunt began to wind up his Kwakwaka'wakw collecting for the museum, though he continued to send in Kwakwaka'wakw material through to 1905. Those last two years were devoted in large part to collecting from the neighboring Nuu-chah-nulth.

With Boas's resignation from the American Museum, Hunt's days of large-scale collecting were over, and he relied more on text-based research. However, over these years he made one more large collection for George G. Heye (1906–1910), assisted with the collecting of Edward S. Curtis (1911–1914) and Samuel A. Barrett (1915), and he made one final, minor collection for Pliny E. Goddard and the American Museum (1922–1924).

In February 1906 Boas wrote to the wealthy New Yorker George Gustav Heye, whose collection became, in 1916, the Museum of the American Indian. Heye agreed to fund a general Kwakwaka'wakw collection, and thus Hunt set out to duplicate his

American Museum collection, though, necessarily, on a smaller scale. Hunt's instructions were much like his earlier ones; he was to get "good, old" material, along with the texts, which would go to Boas. In all, Hunt obtained 231 Kwakwa̱ka̱'wakw artifacts.

This marked the end of Hunt's own serious collecting. By the time photographer Edward S. Curtis arrived on the Northwest Coast to gather material for his set of illustrated volumes on the American Indian, George Hunt was widely regarded as *the* local expert on the Kwakwa̱ka̱'wakw, his fame spread largely through Boas's publications. For Curtis's volume dedicated to the Kwakwa̱ka̱'wakw, as well for his film *In the Land of the Head-Hunters,* Hunt helped to assemble the necessary props. This artifact collecting was thus not at all systematic—only those pieces necessary to make an attractive effect before the camera were collected. Neither Curtis nor Hunt appear to have been concerned about their ultimate disposition. Although some research was begun in 1911, most of the collection and fabrication of artifacts came in 1913, with final preparations and filming in 1914. Records show that Hunt collected twenty-one masks, some of which, along with other artifacts, were donated by Curtis to the Washington State Museum (Holm and Quimby 1980:44–57, 127–128).[14]

Hunt's last collecting activity came as he was nearing seventy. In the summer of 1922 Hunt was visited by Pliny Earle Goddard, a curator for the American Museum. Goddard was making modest collections to "finish off" the Northwest Coast Hall at the museum, and when he left he asked Hunt to obtain several more Kwakwa̱ka̱'wakw totems. In the end, these had to be commissioned, and a set of four houseposts was sent to New York in 1924.

The collections made by Hunt himself in the Field Museum, the U.S. National Museum, the American Museum of Natural History, and the Museum of the American Indian establish him not only as the largest single Kwakwa̱ka̱'wakw collector, but also as the one probably responsible for the majority of the extant Kwakwa̱ka̱'wakw specimens from the classical period. The total goes even higher when one includes the collections of others he assisted: Powell (Ottawa), Jacobsen (Berlin), Boas (Washington and New York), Curtis (Seattle), Barrett (Milwaukee), and Goddard (New York). He monopolizes the textual sources to an even greater degree. Thus the role of George Hunt in Kwakwa̱ka̱'wakw studies cannot be overestimated.

CHARLES F. NEWCOMBE (1899–1924)

After the team of Boas and Hunt, the team of Newcombe and Nowell amassed the largest and most significant Kwakwa̱ka̱'wakw collections. Charles F. Newcombe (1851–1924), an English physician, settled in Victoria in 1889 (see Low 1982). Gradually his hobby of natural history supplanted his career in medicine until he found himself, around the turn of the century, a free-lance collector, working principally on commissions from museums. His first ethnological collecting trip was in 1897 to the Haida, and although the Haida remained his first love, the Kwakwa̱ka̱'wakw were a strong second.

In October 1899 Newcombe made his first Kwakwa̱ka̱'wakw trip, in three weeks

Figure 1.3. Charles F. Newcombe with Henry Moody (Haida), Tanu, Queen Charlotte Islands, June 1923. RBCM pn 5429.

visiting the villages of Nahwitti, Fort Rupert, and Alert Bay.[15] On this first trip he set the pattern that characterized almost all his subsequent Kwakwa̱ka'wakw collecting. Unlike the self-sponsored trips of his colleague, the collector George T. Emmons, Newcombe was usually on a commission, and this trip was for Dawson's Canadian Geological Survey and George Dorsey's Field Columbian Museum. Already he was being assisted by Charles Nowell, a high-ranking Kwakwa̱ka'wakw from Fort Rupert. Nowell acted as informant and as a guide when the two searched through caves. After several dinners at Nowell's home, Newcombe advanced Nowell some money for future purchases, as well as payment for helping collect some totem poles.

Also established by this time was Newcombe's basic collecting modus operandi. As a resident collector, he felt less need to make spur-of-the-moment and final decisions. Instead he carefully noted the existence of particularly promising sites, informants, and specific artifacts. Newcombe was continually asking what was available, whether the owner would sell, and what the asking price was. Depending on his circumstances, he would either leave instructions with Nowell to send it down to Victoria, or he would wait until some time in the future when he received a specific request for such an item.

Throughout his Kwakwa̱ka'wakw research, Newcombe was guided by the prior work of Boas. On this first encounter with the Kwakwa̱ka'wakw, Newcombe expressed disappointment at "the tameness of the dances" and "the squalid dress and surroundings of the performers." Nearly all wore white man's clothes, and relatively few were decked out in the theatrical paraphernalia "so nicely pictured by Boas."[16]

Their appearance must have been especially shocking for someone who did not re-alize the salvage character of Boas's ethnography, especially his photography (Jack-nis 1984:45–48). Like Boas, Newcombe found that an arrival during active potlatches and feasts was not the time most conducive to negotiating purchases. Still, he was able to make a valuable collection of approximately 300 items, which was later dispersed, mostly to the Canadian Geological Survey, and to the Field Museum and University of Pennsylvania Museum.

Newcombe's trip to Nahwitti had been due largely to a request from George Dorsey of the Field Museum for help in gathering material for a diorama depicting the return of the hamatsa initiate, and over the next several years Newcombe con-tinued to send in the requisite props and costumes. But Dorsey's appetite for artifacts could not be limited to exhibits, and by March 1901 Newcombe had been engaged to expand and fill out the Northwest Coast collections, a two-year tenure that stretched to four. Although, again, the emphasis was on the Haida, especially in light of the Field's existing strength in the Kwakwaka'wakw, between 1901 and 1906 Newcombe added 342 specimens from the latter. This total includes 148 items gathered for display at the 1904 Louisiana Purchase Exposition, as well as 36 pieces made at the fair by Nowell and Bob Harris.

After 1905, as museums slackened their purchases of Northwest Coast artifacts, Newcombe found himself making fewer and shorter trips. In 1906 he sold his personal collection (including 273 Kwakwaka'wakw objects), built up over his decade of col-lecting, to the Museum of the Canadian Geological Survey. The previous year Stew-art Culin of the Brooklyn Museum had purchased portions of this collection, includ-ing 29 Kwakwaka'wakw pieces. Newcombe continued to guide the Northwest Coast acquisitions of Brooklyn, in 1908 selling them another 40 Kwakwaka'wakw objects. However, many of these objects were from previous trips (Fane et al. 1991:233–279).

This slump was arrested in 1911 when Newcombe received a commission from the B.C. Provincial Museum. Greater prosperity and a declining Native population com-bined to allow the province at last to make a systematic effort to document its "van-ishing" Native cultures. Until the Great War cut off his project in 1914, Newcombe traveled up the coast each summer, spending 1913 and 1914 in Kwakwaka'wakw ter-ritory (although he did get some Kwakwaka'wakw artifacts in 1911 and 1912). By this time "traditional" items like stone hammers and spindle whorls were harder to find, so Newcombe's Provincial Museum collection was mostly ceremonial.[17]

Newcombe's final significant Kwakwaka'wakw collection was made in the sum-mer of 1917 for Harvard's Peabody Museum of Archaeology and Ethnology (Holm 1990a). Director Charles Willoughby was motivated largely by a desire for a compre-hensive display, and he thus needed material from the Kwakwaka'wakw, Nuu-chah-nulth, and Coast Salish to balance the museum's existing strength in the Tlingit. Using Boas's 1909 monograph on Kwakwaka'wakw material culture as a guide, New-combe was quite successful in making his 140-piece collection represent the range of traditional artifacts. Two years later he sent the Peabody two houseposts and a large

thunderbird and whale figure. In fact, he devoted his later years in large part to finding and shipping totem poles, and he was so engaged in Alert Bay in October 1924 when he was stricken with his final illness.

CHARLES NOWELL (1899–1924)

The partnership between Charles Nowell and C. F. Newcombe lasted from October 1899, Newcombe's first Kwakwaka'wakw collecting trip, to October 1924, his last. Their most intensive involvement came in the first years, through 1905, when Newcombe was working primarily for the Field Columbian Museum. These were not only the most active years for the team, but also for all museum collecting of Northwest Coast specimens.

Charles Nowell (c. 1870–1956) was well-suited for the job of collecting assistant. The son of a "song-maker" or composer, young Charles acquired a knowledge of the various ranks and ceremonial privileges of his people. Around 1880 he spent several

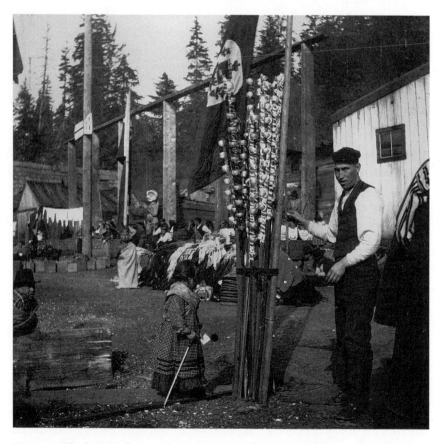

Figure 1.4. Charles Nowell, at a potlatch, Alert Bay. Photo by Charles F. Newcombe (?). RBCM pn 1071.

years learning to read and write English at the mission school in Alert Bay. Growing up in Fort Rupert, he was exposed to the Hudson's Bay Company fort and store. A model for Nowell was his older brother, who worked first for the local merchant, Robert Hunt (the father of George), and then for the local Indian agent, R. H. Pidcock. In the early 1890s Charles Nowell began to assist his brother, acting as a canoeman and interpreter on Pidcock's trips around the agency (Ford 1941:167).

Unlike George Hunt, who to a large extent made his own acquisition decisions, Nowell acted more as an intermediary for Newcombe. With frequent stops in Alert Bay, if only to and from his trips to Haida country, Newcombe himself was able to maintain a list of promising sites and vendors. Nowell's task was to make the final sale and then pack and ship the item to Victoria. At times Newcombe would leave a list of desiderata with Nowell, to be filled as he came across them. At other times Nowell alerted his boss to the existence of especially good finds. When necessary, Nowell would subcontract work out to assistants for transporting large items such as totem poles and canoes.

In describing his efforts of 1917 to the director of the Peabody Museum, Newcombe wrote of Nowell:

> My success in digging them out was largely due to my guide and interpreter, who had throughout the winter months been in close contact with the particular tribes from which we got the greater part of the material. He ran a small store at the winter village of the Kingcome Indians who gave a series of potlatches inviting all of their neighbors, and so, he was able to make quick negotiations for what there was to be had.[18]

In addition to functioning as canoeman, packer, and local purchasing agent, Nowell helped with documentation, supplying translations and data on use and iconography. Nowell was always Newcombe's prime informant. If he did not know the answer, then Newcombe expected him to find out. Nowell occasionally came down to Victoria, often to help identify specimens, but also to get lists of desired objects (Ford 1941:186).

Newcombe's financial arrangements with Nowell varied. Typically, Nowell received a salary in addition to his expenses. In his memoirs he reported a bonus of $365 a year, "besides the wages I was getting" (Ford 1941:167). During their most active years Nowell kept a running account, with Newcombe sending him advances as necessary. However, Newcombe, always a careful man with money, found he could not fully trust his Kwakwaka'wakw assistant. In 1906 he complained to Dorsey: "My half-breed correspondents have all gone back on me at once. . . . Nowell is still silent since I called him to task for over-charging us for the Kwakiutl blankets."[19] When the issue came up again several years later, Nowell was not so silent. Newcombe had instructed Stephen Cook, the local Kwakwaka'wakw merchant, to give Nowell the money for a shipment only after it had been sent off. Nowell was offended: "If you cant trust me to have the money, don't ask me to do anything for you, for it made me shame when Cook told and showed me the note you gave him."[20] By 1917 Newcombe had tightened his procedure: "I could not trust my Indian friends to make the right

selection or to pay over the money themselves as I have suffered more than once by over confidence in them."[21]

Despite this, Nowell and Newcombe maintained close relations. Over the years Nowell received numerous gifts from Newcombe, such as abalone shells from California (for costumes), a gramophone, and a camera. In 1921, after Nowell was jailed for giving a potlatch, "Dr. Newcombe came to see me and got me a parole from the Governor of Victoria, and they let me out" (Ford 1941:224). Apparently, Nowell never did ethnological work for anyone else, and thus after the death of his mentor, Nowell's collecting came to an end.

ALFRED J. HALL AND D. F. TOZIER (c. 1880–1910)

In addition to these major collectors of Kwakwaka'wakw artifacts, a host of others carried away prizes at the turn of the century. Two who stand out were the Reverend Alfred J. Hall and Captain Dorr Francis Tozier. Unfortunately, little is known about the collecting of Hall, the Anglican missionary at Fort Rupert (1878–1880) and Alert Bay (1880–1911). Hall, adamantly opposed to the potlatch (Gough 1982), persuaded the Fort Rupert Kwakwaka'wakw not to go with the Jacobsens to Germany in 1885 and complained about the performances of the Kwakwaka'wakw in Chicago in 1893 (Cole 1985:67, 129–30). Accordingly, his motives for making a collection could not have been very sympathetic, but his activity was significant enough for Hunt to worry: "Mr. Hall, his gone Home to England and taken 4 large case of new made carving with him."[22] The Reverend sent some pieces to the Church Missionary Society in London and to Arthur W. Vowell, Indian Commissioner of British Columbia (Cole 1985:186). The Missionary Society had a substantial collection of heathen artifacts, mostly religious, as a kind of example of the bygone practices they hoped to overcome, and Hall's collections were probably made in this spirit.

Captain Tozier was infamous on the coast for his heavy-handed collecting methods. He was accused of stealing things, plying the Natives with drink, and even using his gunboat to intimidate them (Cole 1985:219). Tozier arrived in the Northwest in 1891 and commanded the U.S. Revenue Cutter *Grant,* out of Port Townsend, Washington, from 1894 until he retired and left the region in 1907. His collection, while generally of mediocre quality, included many large and fine Kwakwaka'wakw feast dishes and posts (Brown 1998:42–43). In fact, he had expressed an "intention to have a specimen of everything acquired by Dr. Boas if possible."[23] After residing for some time in a small museum in Tacoma, the Tozier collection was acquired by that collector of collections, George G. Heye, in 1917.

SAMUEL A. BARRETT (1915)

The last major systematic collection of Kwakwaka'wakw material culture was made in 1915 by Samuel A. Barrett for the Milwaukee Public Museum.[24] Although in its range of artifact types it resembled the Kwakwaka'wakw collection that Newcombe made for Harvard two years later, the greater scale of Barrett's collection, almost

1,000 pieces, greatly eclipsed the latter's 140. Samuel Barrett (1879–1965), the first to earn a Ph.D. in anthropology at Berkeley, came to the Milwaukee Public Museum in 1909. His Northwest Coast expedition was meant primarily to net material for exhibits. As he wrote to Edward Sapir (then director of Canada's Anthropological Survey), he was going for specimens, not research, and asked where he could obtain "the best and most complete series of specimens which will show the most typical conditions of life among the people of the Northwest Coast."[25] Sapir proposed the Kwakwaka'wakw and recommended that Barrett seek out Newcombe's advice.[26] Newcombe, in turn, suggested George Hunt in Fort Rupert. Because Hunt was preoccupied in 1914 with Curtis's Kwakwaka'wakw film, Barrett scheduled his trip for early 1915.

Arriving at the end of January, Barrett set right to work and within days was "busy as a beaver."[27] Barrett's strategy was inclusive: "I . . . collected everything that I could get my hands on, both in the way of material and in the way of information on the old customs" (Ritzenthaler and Parsons 1966:17). And his efforts were rewarded: "Everything is moving off nicely all around and am meeting with very fair success along most lines. Some classes of material are extremely hard to get, but on the whole I can not complain."[28] Despite the apparent decline of the potlatch, Barrett was able to witness and photograph a rather large Fort Rupert potlatch. From his base in Fort Rupert Barrett searched the neighboring Kwakwaka'wakw villages, with Hunt as his guide and interpreter. Toward the end of his stay he sent for the museum's artist, and together they prepared a model of their proposed diorama. By June Barrett had packed up his prizes and departed.

Barrett's collection was fairly representative of late-nineteenth-century Kwakwaka'wakw culture, including quite a range of domestic items such as adzes, wedges, tongs, kelp bottles, raw materials (fibers, sweet grass, eagle down), canoe bailers, and shredded cedar bark. He collected items for food preparation such as twenty-four cooking stones, and a set of fish-cutting boards, as well as samples of food (fish eggs, dried clams, dried berries, and fern roots). But the most important part of the collection consisted of fifty-seven Kwakwaka'wakw masks, with fairly good documentation. Many of these masks came in sets, their owners having decided to give up entirely the ceremonials (Ritzenthaler and Parsons 1966:21). For many years, the Milwaukee Kwakwaka'wakw collection was underappreciated because Barrett never "wrote it up." In the last years of his life he began to prepare a catalog, which was published posthumously (Ritzenthaler and Parsons 1966).

LOCAL COLLECTORS OF THE EARLY TWENTIETH CENTURY

Collecting after Barrett was quite different. By 1906 the most intense period of Northwest Coast, including Kwakwaka'wakw, collecting was over; the major museums had comprehensive holdings from the region, and their interests turned to other continents (Cole 1985:212–15). However, important Kwakwaka'wakw collections were

still accumulated for smaller museums: Heye's institution, the Milwaukee Public, and the Harvard Peabody. Soon the Depression brought an end to even these reduced efforts. The symbolic end to the period of classical collecting for the Kwakwaka'wakw was the 1922 confiscation of dance regalia, following the potlatch of Daniel Cranmer (see chapter 9). Thereafter collecting was more casual and focused almost exclusively on ceremonial objects that might be construed as "art." Moreover, these pieces were acquired singly or in small groups, no longer as large representative samples of the Kwakwaka'wakw material inventory. Yet despite the fact that these collections were made largely for personal enjoyment, almost all have found their way to museums.

Most collectors have always made smaller, more personal collections, but only in this century is there adequate documentation on them. They may be grouped into two categories: local residents and urban aficionados. Among the more important locals in the Kwakwaka'wakw area were William May Halliday, an Indian agent; the Cadwallader family of merchants; and Alec McDonald, a mill owner. Halliday, who came to British Columbia as a youth, spent a decade as an assistant principal at the Residential School at Alert Bay before becoming Indian agent in 1906, a post he held until his retirement in 1932. Halliday was a controversial figure because of his potlatch prosecutions, and his memoirs (1935) present a generally negative view of Kwakwaka'wakw character. Despite this, upon his retirement, he was given gifts by the Kwakwaka'wakw. The *Vancouver Province* reported that each tribe gave him a totem pole, and from the nation as a whole he received "an Indian rug and a carved chest."[29] In 1950 the Provincial Museum bought his small collection (thirty-six items), consisting mostly of model totem poles, carved wooden spoons, and the like. Some of these pieces were probably his Kwakwaka'wakw retirement gifts.

The McDonald collection is also devoted mostly to model totem poles, the kinds of things made for tourists. Alec McDonald came to the north end of Vancouver Island in 1910, where he remained until his death in 1968. After working in the sawmill at Alert Bay, he moved across the strait to become a partner at the mill at Telegraph Cove. His collection of model poles, especially well represented with the work of Charlie James, was acquired by the Alert Bay Museum. Both the Halliday and McDonald collections were formed casually, as mementos or souvenirs, and thus consist of objects that were widely available to those with superficial relations with the Natives.

Although Halliday certainly spent much time with the Kwakwaka'wakw, his dealings with them were not intimate. The same cannot be said for Harry T. Cadwallader and his family. Cadwallader came to Fort Rupert from Missouri in 1897 and soon married a daughter of George Hunt. Cadwallader then took over the store started by Hunt's father. Over the decades the Cadwallader family accumulated a number of fine items, including masks, headdresses, food dishes, boxes, baskets, rattles, blankets, and jewelry. Though some of this material may have been purchased or acquired as gifts, much of it, particularly the jewelry, was taken in during the 1920s and 1930s as collat-

eral for loans at the store and was never reclaimed. In the late 1950s and early 1960s the Cadwallader family collection was purchased by the three principal museums in the province: the Vancouver (Centennial) Museum, the UBC Museum of Anthropology, and the Provincial Museum.

Urban collectors had diverse motivations. One, William L. Webber, though a resident of Vancouver, was much like his merchant colleagues from up north (Nuytten 1982:31–32). Webber, owner of a souvenir and curio shop near the Canadian Pacific station, commissioned Charlie James to decorate his shop. James designed Webber's thunderbird trademark, as well as an illustrated booklet on totems. Through his personal contact, Webber built up one of the largest collections of Charlie James's model totem poles, along with other miscellaneous Kwakwaka'wakw pieces, all of which were sold to the Vancouver Museum in 1952.

INTERCOLLECTOR RELATIONS

Kwakwaka'wakw collectors may now be viewed as a group in interaction. Each took part in two kinds of social relations: vertical relations, in that collectors were linked in a hierarchy of authority, and horizontal relations, in that they affected each other in cooperation and competition. First, though, we must examine their roles and professional identification. The principal roles were ethnologist (Boas, Dorsey), "professional" collector (Newcombe, Emmons), scientist (Dawson), Native assistant (Hunt, Nowell), private collector (Heye, Webber), local resident (Cadwallader, MacDonald), Indian agent (Vowell, Halliday), missionary (Hall), tourist, and dealer (see chapter 3). Clearly, these people played more than one role; this roster is constructed around their relation to artifact collection.

The most important variable is whether collecting was their prime occupation or was incidental to other tasks. This motivation took precedence over their professional orientation. Certainly transient collectors like tourists would not be expected to make systematic documentations of Native culture, but, interestingly enough, the collections of ethnologists were often limited, as they delegated their work to Native assistants. Dawson's scientific background might have suggested a meticulous approach to collecting, somewhat like that of Newcombe, when, in fact, his Kwakwaka'wakw collecting was rather casual and superficial.

Even within categories there are differences. Hunt and Nowell were both Natives, but they differed vastly, partly because of Hunt's white ancestry and partly because of the difference between their supervisors, Boas and Newcombe. Though both full-time collectors, Newcombe and Emmons also diverged. The former, a physician with naturalist leanings, rarely collected without a mandate, while the latter, a retired naval officer, was something of a wheeler-dealer, offering his collections to the highest bidder. Still, as the following section on collecting desiderata shows, anthropologists and those inspired by ethnological aims did differ from the others in the kinds of collections they made.

Rarely was collecting a simple transaction between a single collector and a Native

owner. More often, the decision to purchase any particular piece was mediated by a chain of interested parties. At one end might be a patron, such as Morris K. Jesup, President of the American Museum of Natural History and private benefactor for the Boas-Hunt Kwakwa̱ka'wakw collections. A retired banker, Jesup gave block grants to Boas, and in return expected to see spectacular artifacts. Boas, on the other hand, regarded these specimens as supplements to the research he was conducting on the Northwest Coast (Jacknis 1985:89). In turn, Boas delegated virtually all his collecting to Hunt. Finally, while Hunt made the actual purchase from the Native owner, he was often alerted to pieces by friends and relatives, some of whom he delegated to make purchases for *him*.

As this suggests, each actor in the chain will have different priorities and opinions and will modify a superior's instructions as that superior further instructs the subordinate. By and large, the decision to buy an object corresponds nicely to a chain of generality. The person at the furthest end will be content with Indian artifacts, the next with Kwakwa̱ka'wakw ones, the one after with Kwakwa̱ka'wakw masks, and so on down the line. Of course, in any specific transaction, these chains may be longer or shorter. Curators like Boas or George Dorsey of the Field Museum, empowered to make the ultimate decisions, subject to the limits of trustees, could and did make direct purchases from Natives. However, their time in the field tended to be limited, and most of their collecting, from Northwest Coast cultures and others, was delegated.

In practice, each hierarchical chain was different. The two most important, between Boas and Hunt, and Newcombe and Nowell, form an interesting contrast. Boas gave his Kwakwa̱ka'wakw assistant much more autonomy and responsibility. His instructions tended to be open-ended, trusting Hunt to build a worthy collection. As he wrote his colleague at the beginning of the Jesup collecting, "You know best, of course, what kinds of things we want." In 1906 he offered this opinion to George Heye: "I have always found him faithful in carrying out his work."[30] Newcombe, on the other hand, played a more active role in his collecting. He often asked Nowell what was available in a particular type, and Nowell would make his own suggestions of specific pieces, but perhaps because he lived closer to Kwakwa̱ka'wakw territory, Newcombe made all the final purchase decisions. Accounts mirrored this situation. Boas trusted Hunt with large sums of money, hundreds of dollars, while Newcombe kept Nowell on a much tighter leash. Nowell's running accounts were in the forty- to sixty-dollar range and tended to be tied closely to specific orders and purchases. This caution probably resulted from the several occasions when Newcombe felt that Nowell had overcharged him.

Thus, for the Boas-Hunt Kwakwa̱ka'wakw collections, Hunt was the real collector; he made the decisions. For the Newcombe-Nowell collections, on the other hand, Newcombe, and not his Kwakwa̱ka'wakw assistant, selected the pieces. This said, what is interesting is how similar both sets of collections are. As I discuss later, this can be explained largely through Newcombe's use of Boas as a model.

In addition to these vertical relations, collectors could be linked by horizontal net-

works of two kinds: competition and cooperation. Befitting an age of imperialism and entrepreneurial capitalism, collectors in the field were driven by a competitive spirit. Nowhere is this better seen than in the rivalry between Franz Boas, representing the American Museum in New York, and George Dorsey, curator at Chicago's Field Museum (Cole 1985:167–169). Their enmity stemmed largely from Dorsey's replacement of Boas as curator at the Chicago institution, and was spurred by the radically contrasting personalities and methods of the two men. Although the New York museum had a head start in Northwest Coast collections, the Field Museum was fairly well endowed and vowed to be second to none. In the decade between 1896 and 1906, the competition between these two museums was at the heart of Northwest Coast, and specifically Kwakwaka'wakw, collecting.

From the two curators, the rivalry spilled over to their agents in the field, Hunt against Newcombe and Nowell. Collectors were quite aware of each other's activities. A typical comment by Newcombe is that "the other villages have been fairly stripped by Dr. Boas, Mr. Vowell, G. Hunt, etc., not least by Capt. Tozier."[31] When a Kwakwaka'wakw woman decided to sell her feast dishes, Nowell knew they had to act fast: "If you want them send the money, so that I could buy it before George Hunt knows that she want them."[32]

Hunt and Nowell, the Kwakwaka'wakw assistants in the field, were not above manipulating the situation to their best advantage. Newcombe accused Hunt's sister, mistress at the Alert Bay post office, of detaining one of his letters for Nowell. She must have read it, he claimed, for Hunt promptly bought the very sisiyutł seat he had asked Nowell to get.[33] At least twice, disinformation was given out to foil successful collecting. In 1899 an unnamed collector (probably George Dorsey) came to Alert Bay and announced to Hunt that "the museum people would not send [Boas] out here again for they say his to Expensive man to them. and now he said I am send in his Plase."[34] And in 1905, in a move to have Hunt collect for the Field Museum, Nowell told the Kwakwaka'wakw that Boas would no longer deal with Hunt.[35]

Most Kwakwaka'wakw collectors of the classical period can be grouped into two clusters. One, associated first with Berlin, was started by J. Adrian Jacobsen, and was continued by Boas. Boas, in association with George Hunt, then shifted to the American Museum. Hunt assisted later Boasians Samuel Barrett and Pliny Goddard. A second cluster was centered in the team of Charles F. Newcombe and Charles Nowell. They worked most closely with George Dorsey of the Field Museum but also collected for other museums, such as the Brooklyn Institute, the Harvard Peabody, and the B.C. Provincial Museum. The vast bulk of classical Kwakwaka'wakw collections were gathered by these two clusters, though there were smaller, isolated collectors, such as Dawson, Vowell, Hall, Tozier, and Curtis.

Although most cooperation worked within these clusters, they were not rigid, especially later in the period. When Barrett wrote to Sapir for suggestions of suitable collecting sites, Sapir referred him to Newcombe, and Newcombe, in turn, recommended George Hunt, with his own Kwakwaka'wakw assistant, Charles Nowell, as

an alternative.[36] There was also a certain sharing of facilities. When Edward Curtis was filming in Fort Rupert in 1914, he rented a house from George Hunt's brother, Eli. Barrett used this same house in 1915, and in 1922 Newcombe and Pliny Goddard of the American Museum occupied it during their brief Kwakwaka'wakw visit in 1922.[37] Boas (1969:177), in his 1894 work in Fort Rupert, stayed in a house owned by George Hunt. Though probably not the same one occupied by Curtis, Barrett, Newcombe, and Goddard, there is a suggestion of an architectural marking of the almost institutionalized relationship between the Kwakwaka'wakw and anthropologists.

Although he made only a small Haida collection for Boas, Newcombe always acknowledged Boas's priority. As he wrote to Boas: "I so strongly admired the thoroughness of your work, and was proud to be associated in any way with it." From his earliest Kwakwaka'wakw trip in 1899 he sought out George and the rest of the Hunt family as informants and relied on Boas's publications as guides to collecting and annotation. Newcombe was quite modest about his own abilities: "It will be a great change and a great pleasure to work in cooperation with a trained Anthropologist. My own expeditions have been mostly solitary ones also, and I have always been conscious of my ignorance of the higher branches of the science."[38]

On the other hand, Boas did not reciprocate the feelings. As he wrote to John Swanton: "I do not like to get specimens through Dr. Newcombe because he has not the scientific knowledge that you have, and . . . his [specimens] will not be explained."[39] As Cole (1985:151) has pointed out, Boas was willing to use nonscientists such as Hunt, James Teit, and even Jacobsen's brother Fillip, over the retired physician Newcombe, not so much because of their superior abilities, but because he trusted them as a result of his personal relation with them.

Newcombe's respect for Boas was an acknowledgment of a genuine priority. Boas and Hunt both had head starts in the study of Northwest Coast ethnology. In 1886 Boas, eight years older than Newcombe, started his ethnography nine years before Newcombe's and twelve years before Newcombe first visited a Kwakwaka'wakw community. Similarly, Hunt, sixteen years older than Nowell, had been assisting collectors for nearly two decades before Nowell began to work for Newcombe. While Nowell did have some training in the Reverend Hall's Kwak'wala orthography, Hunt had been instructed by Boas in a more precise linguistic system. Although they tried to get the best pieces for themselves, Newcombe and Nowell could not ignore the greater experience of Boas and Hunt.

WHAT DID THEY COLLECT?

Artifacts are crucial for the task of cultural representation: of all sources, only they are a direct Native product. Yet this does not mean that ethnographic collections are direct reflections of Native culture. Few collectors acquired pieces indiscriminately. All serious collectors operated according to a collecting strategy, which rested on a

particular image of Kwakwaka'wakw culture, and, if they were anthropologists, on assumptions of the fundamental tasks of ethnology. Most collectors were motivated by their search for the "real," the "authentic" cultural document, passing over a range of objects thought to be inauthentic.

In turn, the individual collector's strategy was heavily circumscribed by the institutional collecting policy in effect at the museum with which he / she dealt. Most museums try to collect fully in some areas while ignoring others, and these strengths and weaknesses will be refined over time. Naturally, once a major collection is accumulated the pace of collecting will slacken. The criteria for purchase for most classical collectors were worked out between the curators and their trustees and patrons. As laymen, and wealthy ones at that, most trustees desired large and spectacular items, but they were generally willing to listen to curatorial counsel.

The changing aims of collecting can be marked by the shift in terms used to refer to material objects from the Northwest Coast (Cole 1985:281–282). At the beginning of collecting, in the late 1700s, these objects were "artificial curiosities," simultaneously differentiating and relating them to natural objects casually amassed on voyages. By the mid-nineteenth century these were seen as "curios" or "relics," odd objects with only forgotten meanings, if any. As museums began to send out expeditions, they became "artifacts" and "specimens," evidence to be used in reconstructing the history of mankind. Finally, in our modern period they have been transformed into works of "art."

AGE: THE OLD AND THE ACCULTURATED OBJECT

Without doubt, the most important criterion for collection was the age of the artifact. Collectors were constantly being asked to acquire the oldest specimens available. Newcombe was instructed by Dawson, "the antiquity of the object is also in all cases a recommendation in its favor," while George Dorsey told him, "the older, the better." Boas echoed the sentiment: "We cannot get enough of these [large carvings]; and the older they are, the better."[40] The motive of ethnographic salvage lay at the heart of turn-of-the-century anthropology (Gruber 1970). Franz Boas accepted the urgings of his mentor, Adolf Bastian, to collect before it was too late (Jacknis 1984:45–48), for he was convinced that within a few decades Kwakwaka'wakw culture would be irrevocably transformed, if not extinct (Boas 1969:13).

For Boas, at least, there seems to have been a merging of the old and the beautiful, perhaps because he believed that the Natives had done their best work before contact. As he told Hunt, "The few old masks from Koskimo, and the old skull rattles, are also very good. I wish you could get more of these old carvings. They are much finer than the new ones. . . . What we need most are good old carvings." In reminding Hunt to get "a number of good old planks, roof boards, etc.," he added, "if there is anywhere a nice painted bedroom, particularly if it is made of old planks, I should like to have it."[41]

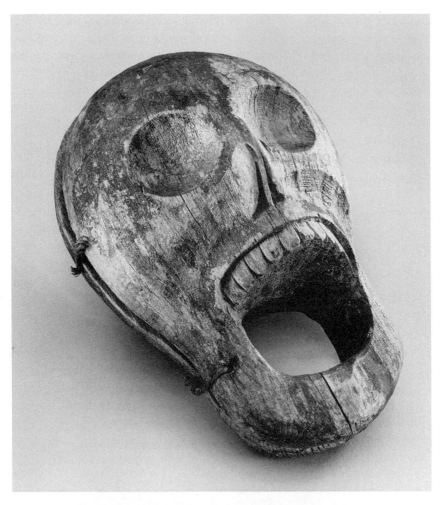

Figure 1.5. Skull rattle, collected by George Hunt in Quatsino, 1899, American Museum of Natural History. Photo by Lynton Gardiner. AMNH cat. no. 16/6897, neg. no. 2A 19017.

The "old," conflated with the "good," was opposed to contemporary objects. George Heye stressed to Boas, "Of course you will let Mr. Hunt know that I only wish for good old material and none of the commercial specimens the Indians are now making." In repeating these desires, Boas admonished, "You must not take any new and shabby mask. We only want good old carvings with good painting." Dawson, too, had little interest in the new: "Masks will also be acceptable, particularly if not too modern."[42]

But there was a difference between objects made recently in traditional, if perhaps aesthetically inferior, styles and objects having no precontact pedigree. Boas and his

colleagues were ambivalent toward the "arts of acculturation" on the Northwest Coast—argillite sculpture, button blankets, and metal jewelry (Blackman 1976). Boas commented on argillite: "Almost all the slate carvings are made for sale and therefore many of them are not genuine designs though characteristic and specimens of Native art. Particularly those made in our days do not always represent traditions as the original wood carvings do."[43] Yet he went on to discuss designs on argillite dishes and boxes, as well as silver bracelets and cloth leggings, in his *Primitive Art* (Boas 1927: 246–250, 245, 189).

Realizing that Natives had integrated some of these forms into their cultures, Boas suggested to Hunt that he collect button blankets and bracelets among the Kwa-

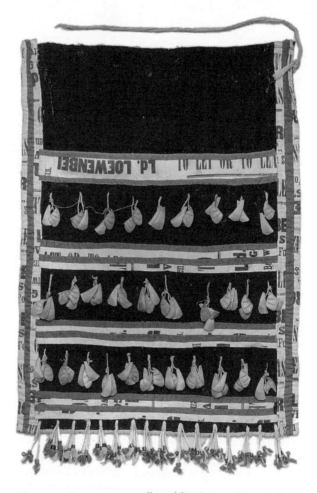

Figure 1.6. Dance apron, collected by George Hunt in Fort Rupert, 1897, American Museum of Natural History. Photo by Lynton Gardiner. AMNH cat. no. 16/2356, neg. no. SA 18957.

kwak̲a̲'wakw.[44] The Hunt collection at the American Museum does contain brass and copper bracelets (significantly, the earlier style of metal bracelets), and may contain some silver ones as well. There is also a hunter's flask for gunpowder. Newcombe's Kwakwak̲a̲'wakw collections are quite similar in this respect—bracelets of brass, copper, and silver, a gunpowder container (National Museum, Ottawa); woolen blanket (Harvard); iron tools and model totem poles (Field Museum). Jacobsen collected a wool dance apron decorated with glass beads and thimbles (Haberland 1979:126). In their quest for comprehensiveness, these collectors acquired some of these arts, but not nearly as many as their importance in contemporary Kwakwa̲ka̲'wakw society would warrant.

MATERIAL CULTURE: COLLECTING AS SCIENCE

While J. A. Jacobsen was the first collector of Kwakwak̲a̲'wakw artifacts to acquire his objects as the result of a mission dedicated solely to that purpose, his criteria for purchase still tended to be somewhat arbitrary. In 1886 Franz Boas became the first to gather his specimens as part of a program of systematic research into Kwakwa̲ka̲'wakw material culture. As Boas explained to his superior at the American Museum, "Although there are a great many beautiful specimens, it is almost impossible to arrange the material in a thoroughly scientific manner because the common everyday things are missing."[45] Boas and Hunt were not content with the artifact alone but gathered as well notes on construction and use. To a great extent, the subject of their research was not the material in material culture, but the culture.

Although much of his own collecting tended to be quite haphazard, Boas constantly instructed George Hunt to collect a full range of material culture. The Kwakwak̲a̲'wakw collection at the American Museum is particularly distinguished by its cultural scope and depth. After a year or so of Hunt's activity, Boas noted, "It strikes me that we have not yet a full collection of the simple every day implements." Boas's suggested solution rested on his fundamental belief that cultures should be described as seen by a Native. "The best thing you can do would be to sit down and think what the Kwakwak̲a̲'wakw used for cooking, including every thing from beginning to end, then what they used for wood-working, for painting, for making basket-work, for fishing, for hunting, etc."[46] Adopting this plan, Hunt began to write out basic Kwakwak̲a̲'wakw technologies, concentrating on subsistence (Boas 1909, 1921).

The systematic character of Hunt's collection for New York is evident from the range of items. Rather than a random assemblage, specimens have a principled relationship to one another. Hunt collected varieties, whether by use (work boxes of a fisherman, hunter, girl, and woman) or by material (bracelets of brass, shell, and horn). Objects were collected in sets: a male and female version of a mask, or the head, neck, ankle, or wrist cedar bark rings. Hunt also gathered rings from different dances, and different Kwakwak̲a̲'wakw tribes. The sequence of construction is represented, from raw material (abalone shell, cedar bark, goat wool, spruce root, paints) to uncompleted objects (boxes, adzed planks, split cedar bark), to the finished product. In

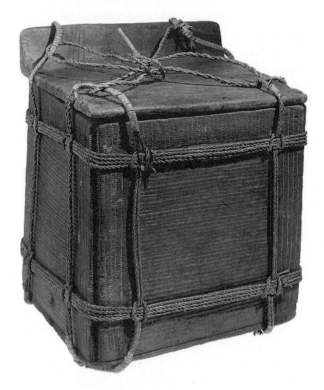

Figure 1.7. Storage box, collected by Charles F. Newcombe
in Gwa'yi, Peabody Museum, Harvard University.
Photo by Hillel Burger. PM cat. no. 17–17–10/87134,
neg. no. N32265.

1900 Hunt and Boas commissioned "samples" of distinctive Coast technology: for ex-
ample, five pieces of matting, each with a different weave, or chunks of wood sewn
with root in different ways to show alternative methods of repairing cracks. Finally,
there are records of otherwise uncollectable items—models of canoes and Boas's
drawings of face and body painting.

This comprehensive mode became the goal of all who aspired to the status of "sci-
entific" collectors. As early as his first Kwakwaka'wakw trip, Charles Newcombe was
acquiring everyday items—spindle whorl, gambling sticks, netting needle, stone
hammer, bone knife—as well as samples of raw materials such as nettles.[47] Two of
the more unusual objects collected on this trip were a housepost from X̱wamdasbe'
(Nahwitti) and an old grease dish, both depicting men with erect phalluses. As New-
combe characterized the latter, "It is a fine work of art & illustrates a certain phase
of Indian character—so I thought it best to pick it up with the expectation that some

comprehensive museum would not dispise it." If necessary, he added, it could be "set at the back of a show case" and thus "escape observation."[48]

One indication of a scientific collection was its inclusion of "duplicates." As George Dawson wrote to Newcombe: "I scarcely feel however that any good carved work is really duplicate material particularly if old, for each special object has, to me at least, an individuality of its own." He went on: "Of course the same thing does not apply, or at any rate not to the same extent, to mere implements and particularly to ordinary household articles always much the same, such as mats, paddles, etc., etc."[49]

For some kinds of objects, at least, Boas instructed Hunt, "We cannot get enough of these" (large carvings), or of Bella Coola (Nuxalk) masks and rings, urging him to collect "as many . . . as you can get."[50] Boas's justification for in-depth collecting was that "the series alone can give us what is characteristic, while, when only an individual is available, characteristic traits may be overlooked, or we may be liable to consider an accidental trait as a characteristic for a whole group" (Boas 1907a:930). From this perspective, duplicates did not exist. For the museum purposes of display and exchange, however, Boas was willing to recognize them, but only after the artifacts had been studied and "properly worked up."[51]

ART AND AESTHETICS

Another variable of collecting was the singling out of some Kwakwa̱ka̱'wakw artifacts as "art," and some of that art as better or worse. Like many collectors, George Dawson felt that objects were more desirable "particularly if ornamented by carving, painting or otherwise."[52] Later enthusiasts, many of them artists, would make great claims for these artifacts as art. However, with predominantly scientific backgrounds and motivations, most of the collectors tended to see their aesthetic qualities in quite circumscribed, if not downright derogatory, terms. Unfortunately, among their patrons and assistants collectors operated with implicit aesthetic criteria, assuming that the "good" or "fine" (terms used more commonly than "beautiful") object was self-evident. Thus in the following discussion one often has to piece together passing comments, reading between the lines.

Captain George Vancouver, one of the first European visitors to the Kwakwa̱ka̱'wakw, in July 1792, was also the first recorded non-Native critic of their art. The captain thought that the village of Cheslakees, at the mouth of the Nimpkish River, "presented a very picturesque appearance," when seen from the opposite side of the creek. Like many commentators after him, he compared Kwakwa̱ka̱'wakw artifacts with those of other coastal tribes, commenting that Cheslakees' house was "much inferior" to those he had seen in Nootka. Yet Vancouver was mystified by the designs on housefronts:

> The houses . . . were arranged in regular streets; the larger ones were the habitations of the principal people who had them decorated with paintings and other ornaments, forming various figures, apparently the rude designs of fancy; though it is by no means

improbable, they might annex some meaning to the figures they describe, too remote or hieroglyphical for our comprehension. (Vancouver 1798, cited in Codere 1961:453)

Of the women he had observed making watertight baskets, Vancouver noted that they "were not less industrious than ingenious" (Healey 1958:16).

European comments on Kwakwa̲ka̲'wakw art over the next century are rarely recorded in print. George Dawson, reporting on his 1885 trip to their country, was not appreciative of Kwakwa̲ka̲'wakw styles. Of the interior houseposts, he wrote: "The designs are frequently grotesque and the carving generally very rude." Of the house-frontal paintings, he had a slightly higher opinion: "These are in the usual conventional or heraldic style—involved, but often neatly executed" (Dawson 1887:76). Critics often praised Northwest Coast workmanship, even when they did not care for the styles. Dawson also unfavorably compared the Kwakwa̲ka̲'wakw to the Haida, a Western preference that is still widely prevalent. He found the Kwakwa̲ka̲'wakw houses not as large or well constructed, and the totem poles not as numerous, large, or as artistic as the Haida versions.

J. Adrian Jacobsen, with little education, reacted in a common fashion to Native artifacts. He noted a "skillfully woven" Chilkat blanket and a "beautifully carved" death's-head mask figure (Jacobsen 1977:34, 35). In Victoria in 1881 he found many of the artifacts exhibited in the Powell collection to be "handsome pieces, especially several well-carved and well-painted houseposts." (ibid.:43). From his own collection, Jacobsen felt that many of the pieces were "good," while others, which he had been forced to buy, were "trash" (ibid.:73). Beyond these simple evaluative terms, we have little insight into Jacobsen's aesthetic attitudes, but in any case, it was usually not aesthetics, but ethnological rarity that motivated him: "I bought a number of rare and original items, among others the prized blankets of cedar bark, as well as one invaluable blanket of mountain goat wool" (ibid.:40).

The distinctive styles of Northwest Coast cultures appealed to Franz Boas from first exposure. In his first published writing on the region, an 1886 newspaper review of the Nuxalk troupe in Berlin, Boas commented, "Here we behold with amazement a wonderful technique in the use of carver's knife and paintbrush and a finely developed artistic sense," and he went on to praise the "grace" and "cultivation" of the dancing (Cole 1982b:119). The tone throughout is highly appreciative; Boas found the carved houseposts to be "wonderously beautiful."

Although he never explicated it, Boas brought this definite aesthetic standard to his first coastal collecting. His family letters are peppered with references to "the best masks available" or to masks that were "handsome" or "not very well carved or painted" (Boas 1969:38–39, 41, 34). As noted, when Boas uses the term "good" in his letters to Hunt, he usually links it with the word "old." The fact that these are all passing comments in personal letters indicates their position in Boas's anthropology. Aesthetic criteria should not be a primary criterion for choosing objects in the field.

These brief remarks can be supplemented with Boas's extensive scholarly publi-

cations. Defining art, Boas (1927:10) wrote: "When the technical treatment has attained a certain standard of excellence, when the control of the processes involved is such that certain typical forms are produced, we call the process an art." Like other late Victorians, he distinguished between the fine and applied arts:

> Almost all the plastic art of the Indians of the North Pacific Coast is decorative art. While some primitive people—for instance, the Eskimo—produce carvings which serve no practical ends, but are purely works of art, all the works of the Indian artists of the region which we are considering serve at the same time a useful end; that is to say, the form of the object is given, and the subject to be represented is more or less subordinate to the object on which it is shown. (Boas 1897b:123)[53]

Although he rarely used evaluative terms in his professional writing, when discussing realistic art, they do creep in: "The artists have acquired a high technique, which proves that realistic representations of animals are not beyond their powers. The following are a few exquisite examples of realistic carvings" (Boas 1897b:124). His revised version of this passage is even more appreciative, where he talks of "the technical perfection of carvings and paintings, the exactness and daring of composition and lines." (Boas 1927:183–184). One plate in *Primitive Art* is called "a human figure of rare excellence" (ibid.:184).

While Boas felt the forms of "primitive art" and the art of Western culture were different, the basic aesthetic sense, the ability to feel aesthetic pleasure in beauty, was universal. Northwest Coast art, like any primitive art, would differ from Western art because "the complexity of our social structure and our more varied interests allow us to see beauties that are closed to the senses of people living in a narrower culture. It is the quality of their experience, not a difference in mental make-up that determines the difference between modern and primitive art production and art appreciation" (Boas 1927:356).

Given these aesthetic preferences, it is difficult to account for their effect on the ethnographic sample. One suggestion, raised by several observers, is that "very little great art ever leaves a tribe. Its owners burn it or let it rot before they let strangers see it or take it" (Carpenter 1975:23). Boas (1927:130) also noticed this: "We find often that people will use inferior wares for exchange with neighboring tribes, while they keep the good material for themselves." As an example, he cites Kwakwaka'wakw cakes of dried berries, made with lesser grades for trade. Unfortunately, there is hardly any way to verify such suggestions or relate them to extant collections. We should expect, though, that Native aesthetic systems will not match Western perspectives, if only because those Western concepts themselves have changed so radically over the decades. And for the Kwakwaka'wakw there has been the persisting Western tendency to judge them according to the canons of northern coastal tribes.

As we shall see, curators choosing artifacts for exhibition are faced with the inevitable problem of selecting a few out many; invariably they pick the "most beautiful." But this selection begins in the field—the most important disjunction is between

Native categories and those of the collector. From then on, each time the object is selected from its peers and placed in a new context it moves a little closer toward the exhibitor's culture and that much further from its Native culture.

DOCUMENTATION AND TEXTS

To varying degrees, all the collectors who aspired to the status of ethnologist documented their collections. Tourists and art lovers need not concern themselves with such records, but as the museum ethnologist Tom McFeat wrote, *"object + data = specimen,* where by 'data' one means notes, measurements, drawings, charts, graphs, photographs, and models, and by 'object' one means something not too big to send back to the museum by freight" (McFeat 1965:93).

With a background in medicine and natural history, Charles Newcombe readily accepted the need for documentation. Instructing him on his first collecting trip, Dawson wrote, "Particularly in the case of objects of some antiquity, any details regarding their history or the meaning attached to them or ceremonial etc. connected with them will add greatly to the interest of the objects obtained."[54] By 1900 Newcombe was exclaiming to Dorsey, "No pole without its story shall be my motto."[55]

The records for Newcombe's first Kwakwaka'wakw collection, in 1899, are already fairly detailed. Recorded in field notebooks, diaries, and accounts are English and Native names for the artifact, its material and use, and often the seller or maker, or both. Uncertainties are noted with a question mark, and occasionally he added evaluative comments such as "good" and "nearly perfect."[56] As Newcombe increased his familiarity with the material, his notes naturally reflect this, with greater use of Native names and references to associated crests, stories, and ritual use. The verbal notes were frequently supplemented with Newcombe's own photographs, sometimes of a given site taken repeatedly over the years. Like Boas with Hunt, Newcombe delegated his Kwakwaka'wakw assistant Charles Nowell to record such data. In asking Nowell to get the names for the parts of a loom with descriptions of blanket manufacture, he emphasized, "Do this even if you have to pay the woman for telling you."[57]

Naturally, documentation was important to Boas and Hunt. Boas's own catalog for his first Kwakwaka'wakw collection, in Berlin, contains fairly extensive notes, with entries on Native names, subtribal provenance, location, use, and iconography. The objects are grouped in functional complexes, such as by winter ceremonial units. Included are references to the existing Berlin collections.[58] In his instructions to Hunt, Boas told his friend to keep a notebook, and then "put a tag with the name of the specimen on each, and then write in your notebook again the name of the specimen, and the number, and what you have learned about it."[59] Generally, Hunt's later collections are much better documented than his earlier ones, though not all his documentation survives. A typical label might include catalog number, original field number, Native and translated name, use, location, and date of collection.[60]

Yet Boas's approach to documentation went beyond records of provenance. A major desire for his first trip to the coast had been his desire to document the Jacobsen col-

lection. Using a set of meticulous drawings and photographs, Boas attempted to discover the meanings and uses of the artifacts. He was largely unsuccessful, however, as he rarely encountered the local owners who would have had this knowledge (1890). With the poor documentation of the Jacobsen collection in mind, Boas determined that for his collection each piece would come with its "story." In fact, having the story could be a motivation for collecting the object. After hearing a tale of the Kwakwa̱ka̱'wakw cannibal spirit, he wanted "to buy a number of pipes that belong to the tale" (Boas 1969:45). For Boas the value of a specimen rested largely on its documentation. In Kincolith, British Columbia, in 1894 he "bought a very expensive headpiece." But "the money is well spent," he felt, "because I obtained the myth that goes with it" (Boas 1969:171).

Believing that full texts in the Native language were the firmest foundation for ethnographic description (Stocking 1977), Boas instructed Hunt to obtain complete stories and Native accounts for the objects he collected. "Only we must remember that we want to have the tales and songs belonging to all of them," insisted Boas. "It is better for us to get a few pieces less and the story belonging to each. We do not want to grab everything, and then not know what the things mean."[61] Here Boas's interest in texts for methodological reasons coincided with the cultural emphasis of the coast in associating many artifacts with a validating tradition, explaining its mythic origins and the right of the owner to possess it.

After Boas's instruction in a Kwak'wala orthography at the Chicago Fair in 1893, Hunt started sending to New York a steady stream of texts, ending only with his death in 1933. The collecting of artifacts and texts was interdependent; sometimes Hunt got the story before the object, sometimes the other way around, and at times they came together. In justifying his delays, Hunt often protested that it "takes times to Do it Right," and "only one thing I see it will be harder for me this year, then it was at the World's Fair, for I got to get the stories and songs," and later, "it is slow work for me to write the stories and buying at the same time."[62] As for Boas, a factor in Hunt's decision to buy depended on whether he could get the story. At one point he had not spent all his money because he "wont buy unless they have a storie with it," and in another instance he bought a mask because he already had the story.[63]

The redefinition of the Native artifact into a scientific specimen is a process of transformation, as the object is cataloged and its social data transcribed. Boas was aware of this process, as he fought with museum administrators for the time to fully "work up" his collections (Jacknis 1985:103–105). In the museum the specimen is an object out of context, but its associated documentation is meant to restore its context, so that it may be used as a representation of the Native culture.

CONSERVATION

Before entering museum storerooms, the artifacts gathered by the great collectors were often physically altered. Thus even if their initial selection had been unbiased, by the time they entered their final resting places many no longer accurately repre-

sented their final state in Native hands. Yet within this group of collectors one can find a range of motives and methods. Examples may be drawn from the Kwakwa̱ka'wakw collecting teams of Boas and Hunt, Newcombe and Nowell, and from the Tlingit collector George T. Emmons.

Collectors' transformations were of two kinds: subtractions and additions. Almost all the collectors had to make concessions to the limits of transportation systems—for example, by cutting large totem poles in two. When Hunt tried to ship a grease pole that was a few feet over the maximum the railroad could ship, Boas instructed: "I think it will be best to cut off that part of the grease-pole that is not carved at all." On another occasion when Hunt left out some pieces of a chief's seat, Boas reassured him, "Of course you were right in not sending the sides that were made of sawed boards." The sections removed—uncarved wood and milled boards—did not show, for Boas and Hunt, aspects of Native culture and could thus be safely omitted.[64]

Newcombe and Nowell often collected totem poles, usually old and weathered, for exhibition. Of a pole collected for Samuel Barrett in 1914, Newcombe reported: "I therefore got three northern Indians to go over the surface carefully with Native adzes and had the rotten parts removed."[65] But some treatment went beyond the removal of these plain or damaged portions. In 1906 Newcombe asked his assistant about a large Kwakwa̱ka'wakw cradle that "seemed to be rather newly painted. If you could do away with most of the white man's paint, and white man's fittings, and make it look as old-fashioned as possible, I think we should be glad to have this specimen."[66] Their subsequent correspondence indicates that this action was not carried out, and, although they considered it, there is no clear evidence that the team ever resorted to such radical action.

Newcombe and Nowell often took an active role in "improving" or adding to specimens. For Barrett's pole, Newcombe had "parts missing replaced and carved where necessary. . . . I also had the Raven which sits on the top of the pole remade." Apparently, the Kwakwa̱ka'wakw artist Dick Price was hired to carve the new raven for this Haida pole.[67] Though he was unable to get Native pigments, Newcombe had the pole repainted. Yet paradoxically, the new raven was *too* new: "Naturally, being a new piece, it has not got the same colour tone as the rest of the carvings, and ought to be reduced by some process such as was followed in similar cases at the Field Museum."[68]

Because the large cradle was evidently not collected, four years later Nowell told Newcombe that he had found another: "If you think the cradle is too big I could get a smaller one made and get it smoke to look old."[69] It is unclear from the evidence how much of this "antiquing" the team actually did and if Newcombe endorsed Nowell's plan for smoking the wood. So, some of the treatments by Newcombe and Nowell were done to make specimens look new, while other actions made them look old-fashioned, if not old. The goal of both approaches was to make the object look "Native," and the implementation of this aim depended on the circumstances.

Most of the Newcombe-Nowell treatment consists of such cleaning, repairing,

and repainting of specimens intended for exhibition. This context was mentioned explicitly when Newcombe justified to George Dorsey his trimming of a lengthy pole: "for Museum purposes it could be spliced onto another & show quite well the intention of the apparatus."[70] Obviously, appearances were more important for objects on exhibition than for those destined for the study collection.

Once collectors had decided that a piece needed treatment, there was the question of who would do it, Natives or themselves. Usually when Newcombe bought items that he felt were incomplete, he commissioned Natives to add the necessary features.[71] In addition to the pole cited above, Newcombe asked for "appropriate carvings to be added [to a canoe], with proper paddles, bailer, tackle boxes, &c., &c." Another time Nowell told his boss that he could get the two small canoes he wanted but would have to pay extra to have designs painted on them.[72] It is thus evident how such requests to have Natives "repair" artifacts could merge with full commissions to produce artifacts or important parts of artifacts that did not otherwise exist.

In one instance, George Hunt blurred the line between his status as an impartial collector and as an active creator of Kwakwaka'wakw culture. When Pliny Goddard of the American Museum could not obtain extant houseposts, he asked Hunt to commission a set. After the completion of the work, Hunt was dissatisfied, claiming that there were two right hands on the figures, that they were not put on properly, and that the fine adzing had been omitted. So Hunt himself spent two and a half days removing the offending members and replacing them with proper ones, though he felt he could live with the adzing, as "they looks alright."[73]

George Thornton Emmons took a more active stance toward "repair"—he did all his own work. Although almost all his pieces ended up in institutions, Emmons was a self-supporting collector who tended to evince the attitudes of a private art collector. He loved all the pieces that passed through his hands and wanted them to look their best. Thus he replaced missing parts and mixed his own paints according to Native recipes.[74]

Curators themselves were not averse to similar treatments. In Berkeley, Alfred Kroeber was unhappy with the oil paint on his totem pole, even though the work had been done by a Native. He suggested several alternatives: "toning down" the surface with a turpentine mixture or scraping off the present coat and repainting either with "American or with native colors." The director of the Peabody Museum at Harvard wanted to obtain marmot skins to repair some of his fur robes and opercula to fix up his Tlingit masks.[75]

As salvage ethnographers, the classical collectors were stimulated by the same preservationist attitudes that motivated the environmental conservationists of the Progressive Era. They often felt that an object's condition at the time of collection was not what *they* thought it *should* have been, and their somewhat bold treatments were carried out in an attempt to make their collections the best possible representation of traditional Native culture, as they believed it to be.

COMMISSIONS

Museum patronage has been present from the earliest collecting expeditions. In 1875 James Swan commissioned a Haida totem pole because he could not collect one (Cole 1985:24, 29–30). Similarly, in 1881 J. Adrian Jacobsen ordered a new Heiltsuk chief's seat, most likely because the owner valued the original too highly to part with. "From the most renowned wood-carver among the Bella Bella," Jacobsen ordered "a similar one" (Jacobsen 1977:110). Not only is this one of the earliest recorded museum commissions on the Coast, but, unlike Swan's pole, it is a clear example of what we may call a "meta-object," an object bearing a particularly close relationship to another. The B.C. Provincial Museum has a Heiltsuk settee closely resembling the Berlin piece (collected by Newcombe in 1911), leading Hoover and Neary to suggest that the Berlin seat was either modeled after the Victoria one, "or the two were inspired by the same original" (Macnair et al. 1980:149).[76] Jacobsen thus purchased a newly made artifact, but one looking very much like an older one. The anthropological fostering of archaic styles had already begun.

Although it was not quite museum patronage, the Jacobsen-led tour of the Nuxalk to Germany in 1885 also resulted in the creation of Native artifacts "out of context." The group produced many objects, ranging from substantial houseposts and masks to small trinkets that could be sold as souvenirs. In Leipzig they constructed a house, complete with crest paintings (Haberland 1987:364, 352). Among other items, in Hamburg they carved a hamatsa mask, and in Leipzig, fool and eagle masks, which then entered museum collections as part of the ethnographic record (Haberland 1979:254, 180–181, 77).

When given the choice, most collectors preferred to purchase an already existing piece. Boas felt that "it is not safe to base our arguments on models or on objects made for trade. I shall use, therefore, exclusively, older specimens which have been in use" (Boas 1927:209). This sentiment was echoed by the director of Harvard's Peabody Museum: "I should, of course, prefer the older objects rather than full size models of them." But collectors were not averse to commissioning: "If the originals cannot be obtained, copies would be desirable."[77] The motive, in almost every case, was to produce a piece that was unavailable, either because it no longer existed or because the owner would not part with it. In 1886 Boas "put two women to work to weave mats and baskets. . . . They are all intended for the museum collection" (Boas 1969:39). Although he does not give his reasons, perhaps he could not locate such cedar crafts during the short time he had available to him. In 1894 Boas also arranged for cedar crafts so that he could photograph and collect them for an exhibit at the American Museum (Jacknis 1984:14, 16, 33–36). In his last Kwakwaka'wakw collecting trip, in 1900, Boas commissioned a series of partly finished mats in order to show Native techniques. While it might have been possible to collect such items, especially in earlier times, commissioning was certainly the most efficient method.[78]

George Hunt resorted to commissions on several occasions. For his early collection of cedar bark rings for the U.S. National Museum, Hunt found that he had to

get them made "in the old fasion way." At the same time he ordered a set of house-posts and commissioned an (unnamed) painter to fill a book with designs.[79] Boas intended these commissions to produce more than mere artifacts: "If you do not find any, I wish you could get one of the old men to make a real good arrow and bow for you; and when you do so, please ask them very particularly what kind of arrow-heads they used before they had any iron."[80] Boas hoped Hunt could get a record of traditions and beliefs of arrow-making to parallel his earlier set of canoe-building customs.

Reproductions were quite acceptable to Boas: "In regard to other things, I understand perfectly well that they are reproductions of older implements that have gone out of use, and that your friends are making them in order to show what the Indians used to do in olden times. In cases of this sort, I should even be satisfied if you had made them yourself, as long as they are made correctly."[81] Hunt did indeed make some pieces when he could not find anyone else with greater expertise. In 1904 he volunteered to construct a part of a Nuu-chah-nulth sea otter hunter's shrine, consisting of two men and sea otters made of ferns and hemlock branches, with a cone formed out of small sticks. Hunt wrote: "I could not see any thing that make it worth so much so I will make one at Fort Rupert and sent it to you."[82]

Later in life, Hunt played a more active role in commissions. When he found that he could not get a set of houseposts because the owner was charging too much, Hunt got permission from the American Museum of Natural History to have a similar set commissioned from the artist who had carved them—Arthur Shaughnessy. Hunt carefully instructed Shaughnessy to use Native paints, "for I Dont like white mans Paint on the Indian poles."[83] Although Native pigments had not been widely used for several decades, Hunt apparently felt that objects destined for the museum, even if newly made, needed to be in an old style. As already mentioned, Hunt was dissatisfied with the final result and took it upon himself to replace the two right hands on one of the posts. As in some of the early conservation work in this period, the line between collector/patron and artist was often blurred.

Commissions were quite acceptable to Dorsey and Newcombe at the Field Museum. (In chapter 2 I discuss the hamatsa display, with a cedar screen and costumes modeled after Boas's National Museum exhibit.) While Charles Nowell and Bob Harris were demonstrating crafts at the St. Louis Fair in 1904, they were also adding to collections at the Field Museum. As Dorsey justified it to his superior:

> Immediately on their arrival in St. Louis I asked Dr. Newcombe to set them at work preparing certain masks, ceremonial paraphernalia in general, and objects of utilitarian nature which we did not have in our collections in the Museum, and which for one reason or another it had never been possible to secure from the Indians direct up to the present time. As a consequence, none of these specimens duplicate those already in our possession. All of them are of the highest importance in making more complete our series from the lower tribes of the Northwest Coast, and are therefore absolutely indispensable for the scientific value of our collections.[84]

After the fair, Harris and Nowell continued their work at the museum. Along with the specimens, they contributed drawings on cedar and paper, all accompanied by explanations. Bob Harris was the creator of most of these objects, the most notable of which were two elaborate dance costumes (figure 1.8). The principal motive for Newcombe's commissions continued to be the desire for pieces that could not be purchased. For instance, he asked Nowell to have a drum and a cradle made in an old style.[85] Another motivation was size. Models were frequently resorted to for such large items as totem poles, houses, and canoes.[86]

One of the largest commission projects in this period was not for collection. Photographer Edward S. Curtis used newly made objects as well as heirlooms for his 1914

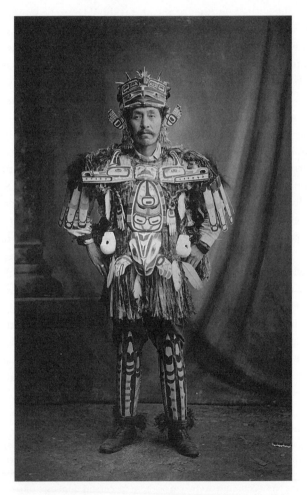

Figure 1.8. Hamatsa dance costume, by Xexa'niyus ("Bob Harris"), 1904, Field Museum of Natural History. Photo by Charles Carpenter. FMNH neg. no. 13583.

film of the Kwakwaka'wakw, *In the Land of the Head-Hunters.* Curtis was after surface effect. Using old objects when he could, he often needed to have old-style pieces made in order to realize his goal of presenting precontact culture.[87] Some of these were mere expedients—several false front houses or loosely made "cedar bark" clothing of raffia. Others were respectable, well-crafted examples of Kwakwaka'wakw artistry. These include three totem poles and a pair of houseposts.

One of the most impressive is a copy of the famous Wakas pole of Alert Bay (one of the poles moved down to Stanley Park in Vancouver in 1922). Unlike the coarsening of many copies, this one "was more expertly carved than its predecessor in Alert Bay and lacks only Wolf and Killerwhale to be a virtual copy" (Holm and Quimby 1980:47). Another of the totem poles is attributed to George Hunt (Holm and Quimby 1980:44; see also Hawthorn 1979:66, fig. 48). While the carving is shallow, evidence perhaps of a lack of time, it is quite credible, especially for an amateur. Perhaps the most important commission for the film is the pair of houseposts, probably by Charlie James (Holm and Quimby 1980:53–54).

Paradoxically, while Curtis generally went to great lengths to achieve an old-style appearance, in some of his commissions, at least, he accepted the style current at the time. While the Wakas pole follows its model in general form, its style appears much closer to its c. 1913 date, and the James houseposts are not archaic at all, but good examples of his contemporary, mature style.

After 1920 or so as anthropologists retreated from the Northwest Coast in the belief that Native traditions were virtually extinct, commissioning of new objects terminated. It was not until the early 1950s, when a group of local anthropologists made a last effort to shore up Native traditions, that museum patronage began again.

HOW DID THEY COLLECT?

Artifact collections have two kinds of value—intellectual and economic. Just as they transform the ontological values of Native objects, so do collectors appropriate these artifacts as goods in the Western economic order (Appadurai 1986). Although it obviously meant different things in each society, the abstract medium of money allowed the two economic systems to function as one. Yet these economic transactions were embedded in a social interaction, one that until very recently took place in a colonial context of power differences as well as economic interdependence (Knight 1978).

MODES AND MEDIA OF EXCHANGE

Of the several kinds of collecting transactions, barter and sale were the two that involved an exchange between buyer and seller. In the beginning, of course, money was meaningless to the Natives. Vancouver's crew in 1792 bought curios from the Kwakwaka'wakw with beads and small trinkets, only to find that they wanted firearms, copper sheets, broad blue cloth, woolen trousers, and jackets (Gunther 1972:98, 100).

On his first trip in 1886 Boas did bring some tobacco and cotton to trade, but most of his acquisitions came through purchase (Boas 1969:30). By about 1900 trade goods were disdained by the Kwakwa̲ka̲'wakw. Newcombe supposed that one collector, Captain Tozier, had gotten such inferior totem poles because he had offered barter instead of cash.[88]

The vast majority of Kwakwa̲ka̲'wakw artifacts collected during the classical period came through purchase and the exchange of money. With the establishment of the Hudson's Bay Company post in Fort Rupert in 1849 and the cannery and store at Alert Bay in the early 1870s, Kwakwa̲ka̲'wakw were offered both a source of cash and a place to spend it in. Until early in the twentieth century, there was no monetized market for artifacts within Kwakwa̲ka̲'wakw society. They were either made by the owner or produced on commission, with payment in subsistence or valuables. Yet the Kwakwa̲ka̲'wakw experienced little trouble in setting a monetary value on their objects. The more an owner wanted to hold onto an item, the higher its price, and the prices they got seem reasonable enough. At a time when Boas was making an annual salary of $3,000, Hunt paid $65.50 for a large feast dish set (figure 1.9). Justifying the price to Boas, he noted that a rival collector had just offered $100 for either the same dish or a similar one, and "the owner would not sell it for that Price."[89]

The funds for purchases came from several sources. Boas's first Kwakwa̲ka̲'wakw collection was self-financed. In fact, it was largely made to be sold at a profit in order

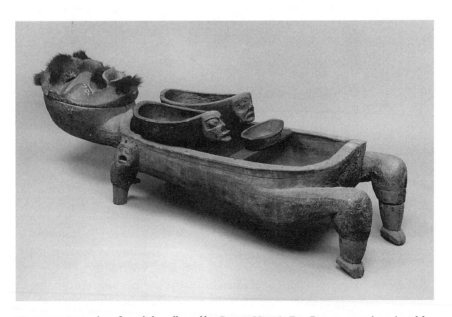

Figure 1.9. Dzunu̲kwa feast dish, collected by George Hunt in Fort Rupert, 1902, American Museum of Natural History. Photo by Lynton Gardiner. AMNH cat. no. 16/9013–14, neg. no. 2A 19020.

to cover the expenses of his more general ethnographic research. Bought for $70 in the villages, and estimated by Boas to be worth $200 in Victoria, it was finally sold for $500 to the Berlin museum (Cole 1985:108–109). While Tlingit collector George T. Emmons may have financed his acquisitions in similar fashion, most of the classical collections were commissioned by museums, with the funding advanced to the agent in the field. In addition to the price of the artifacts, the collector was usually compensated for his travel and living expenses, and often, as with Hunt for the American Museum and Newcombe for the Field Museum, given a salary as well. Such systematic collecting was thus subject to all the bureaucracy of large institutions, with relatively small advances and the necessity for vouchers. As Boas always admonished Hunt, it was necessary to show results in order to continue receiving money.

At times collectors did acquire Kwakwaka'wakw artifacts in which little or nothing was exchanged. These exchanges were not all disreputable. For instance, in 1930 the Kwakwaka'wakw at Fort Rupert gave Franz Boas "a nice mask with ermine skins and a carved cane" (Boas 1969:292). However, this exchange was a personal one; when he returned home, Boas reciprocated with gifts for his Kwakwaka'wakw friends, and the artifacts did not go to a museum. A small number of objects were acquired as penalties on unclaimed pawns or loans. Such was the source for most of the collection of the Cadwallader family of Fort Rupert. In many cases the owners had never returned to claim their collateral.[90]

Force was used in other cases. A celebrated instance was the prosecution for Daniel Cranmer's 1921 potlatch (see chapter 9). In exchange for dropping the charges against them, some of the accused were compelled to hand over their masks and ceremonial paraphernalia. Although the government maintains that the owners were paid $1,400, the Natives claim that they were paid nothing (Cole 1985:252–253). While most of these artifacts were accessioned by the Victoria Memorial Museum, some were transferred to the Royal Ontario Museum and others sold to the Heye Foundation.[91]

More common than loan penalties or confiscation was the taking of Native objects without the owner's knowledge. There was a fine line, often blurred, between outright theft and the collecting of abandoned objects. Northwest Coast Natives habitually changed residences several times over the year, temporarily leaving sites unguarded. Coppers, masks, feast dishes, and the like were often placed in graves with the deceased, and it was quite common for winter dance masks to be stored in caves when not in use. Sometimes through lack of knowledge, other times out of greed, collectors took what they could. Finding he could not get certain figures and masks in Comox, Jacobsen (1977:70) remarked, "I had already seen that I could buy none of these from the Indians, so I thought the rule here is: 'Help yourself.'" But there were also second thoughts. Newcombe advised Nowell, "You might also pay for that vessel we stole from the old house" at Koskimo.[92]

George Hunt felt that he obtained some of his best material from caves. His primary motivation was to find old artifacts. "I got most of the people to go and look for old Emeges and dishes and masks out of the graves and caves. . . . I think it is the

best old collection I ever made." Price was another consideration. Although he had to pay his informants and assistants, evidently Hunt did not pay for any objects he picked up in caves: "I think if I go there I might get things cheeper than buying them from the Indians."[93] Finally, caves and graves were the only source for skeletons. Boas himself had resorted to theft for bones (Cole 1985:119–121), but after amassing his collection in the early 1890s, he was able to delegate this work to others.

Although Hunt clearly did not want to call attention to his rummaging through caves, it appears that in many, if not most, cases, his investigations had the (at least tacit) approval of the Natives. Working with Hunt in 1898, Harlan Smith of the American Museum wrote to Boas, "George Hunt got permission to take these bones. We are doing it secretly however, leaving no traces behind us and will use the permission to cover a possible detection."[94] As he had been "learning how to go and look into this greaves and caves," in mid-1901 Hunt asked Boas if he would secure from A. W. Vowell, Indian Commissioner for British Columbia, permission to remove material from old graves. He was particularly excited about a cache in a cave at Nimpkish Lake. As Hunt explained:

> There is no man old Enough in Fort Rupert to tell when there where Put there, now it will Pay you to ask Mr. Vowel, for I Dont want to tuch anything less than (80) years old. The Indians I know will let me go and get it. But the mission People telling them to lay complaint against me. so you see I got to look out what I am Doing.[95]

Boas requested permission for the collection of skeletal material as long as it was no longer cared for or claimed by any living Indian. The motives of Boas and Hunt were undoubtedly mixed—scientific and practical. They were trying to describe Kwakwa̱ka'wakw culture before white contact, so wished for material as old as possible. These would also be the very things most likely to be unclaimed, thus causing little disturbance if removed. Vowell gave his official permission, though he wanted to be informed of what went on.

TRICKS OF THE TRADE: ACTIVE AND PASSIVE

In his history of Northwest Coast collecting, Douglas Cole has called attention to the "tricks of the trade"—shortcuts and special knowledge that facilitated collecting (Cole 1982a, 1985:299–311). For the purposes of this discussion, it is useful to introduce the distinction between active and passive tricks. Some factors acted on the Native apart from the buyer's efforts, such as the annual salmon cycle. The astute collector discovered such states and exploited them. But the collector was also able to actively influence the seller, such as by giving a feast. And some collecting was a little of both, such as buying from one's friends or relatives.

Given the desires of the collectors to buy, their success depended on the corresponding desires of the Natives to give up their artifacts. Not all Natives were equally

disposed to sell, nor was any particular Native at all times so disposed. A large part of the art of making a good collection lay in finding the right person at the right time. A number of contextual variables affected the Native desire to sell. As expressions of the two kinds of artifactual value, these variables fall into two categories: the degree to which the artifact was being used in traditional contexts, and the degree to which the artifact's monetary value fit into the general economic situation of its owner.

For both variables, much lay in proper timing. Different seasons and different years were better than others. Economically, late winter was a good time for collecting because the Natives were usually out of cash by then. As Hunt wrote to Boas:

> I been thinking if I had some money now I can get things very cheap, for the Indians have no money to sell to the stores, for all the stores shut down on blanket trade, so we can get things at our own price. [F]or if we let it alone tell June then there will all go and work for the cannerys and get cash for sell, then we cant get things at low price from the Indians, so quicker it is done, better it will be.[96]

Late winter was traditionally the time when stored food stocks became depleted, a further incentive to raise extra cash.

Beyond these seasonal cycles, prosperity also waxed and waned by year. Among the Koskimo in 1900 Hunt found the prices high, "for they got lots of money among the Indians."[97] At times Natives were eager to sell particular items in order to fulfill obligations in the ceremonial system. Of some old houseposts, Hunt wrote in 1923: "I think that we will get them for I know that the chief is Poor now, yet he wants to get married to a chief's Daughter, and he has to get some money, to Do this, so I think he will be glad to sell anything he has in his House."[98]

Natives were also reluctant to part with artifacts when they were actively using them. For example, in April 1897 Boas had asked Hunt to get some good posts he had seen in a house in Nahwitti. Hunt replied that it would be hard to get these posts as the owner "got to give Blanket in the house this Coming Winter."[99] Even though he subsequently purchased the poles, Hunt was not able to take possession of them as the owner continued to give potlatches in the house. It was not until December 1899, two years later, that the poles began their trip to New York.

Most artifacts were not in constant use throughout the year. While trying to make his cedar bark collection for the U.S. National Museum, George Hunt found that "I cant get any cedar Bark yet for the Indians would not sell them for there are useing them yet in there winter Dance. [A]s soon as there Done with the Dance and use of the cedar Bark then there will sell it for Half the Price."[100] The height of the winter ceremonial season, from November to March, was thus not very productive.

But the summer was even worse. Many collectors took advantage of the mild summer weather to visit Native villages, only to find them deserted, with the Indians dispersed on the fishing and berrying grounds or working in the canneries and hop fields. As Hunt wrote Boas, "Now Dont you think if I began sometime in February

When all the Indians are together in there Villages, to go Round and collecting is Better then the summer trade for all the Winter Dances LagEq [cedar bark] is showing. [F]or after there finish with them then they Put them away then We cant get them."[101] Thus the best time was late winter, while the Indians were no longer using their paraphernalia, but before they had put them away.

Beyond these cyclical changes, over the decades of classical collecting there were also more linear changes, as Natives abandoned items of traditional material culture. Pressures from white society acted differently on the two spheres of the sacred and secular, but to the same end. Iron blades replaced blades of bone and stone early in the nineteenth century, and throughout the century Western clothing was supplanting bark and skins. Containers of metal and ceramics were adopted in place of wooden ones. Few of these changes were made through enforced acculturation; Natives themselves saw the virtues of Western technology and gradually stopped making certain items in traditional styles.

The collector was faced with an unpleasant dialectic. As the Natives gave up traditional items, they would be correspondingly more willing to sell them, but, on the other hand, be less likely to have them on hand. This was Jacobsen's experience, when he sought out the relatively conservative village of Nahwitti, on Hope Island, where "the old Indian ways continued unchanged." But so unacculturated were the people that they "were not inclined to sell me their dance masks and rattles" (Jacobsen 1977:32). The dialectic had a geographical gloss. The remoter areas were much harder for members of Western societies—merchants, government officials, missionaries—to reach. The Natives here would be more conservative and their artifacts more appealing to collectors. Yet this very remoteness also made it harder for the collector to reach and to arrange for the shipment out of his purchases.

As in any other social relationship, collectors knew they would meet with greater success if they maintained good relations with the Natives. Expressing regret to Newcombe over an unfortunate grave-robbing conducted by George Dorsey (Cole 1985:170–176), Boas wrote: "It is too bad that Dorsey should have proceeded with so little regard to the feelings of the Indians and the interests of future work."[102] Perhaps the simplest device open to collectors was patient waiting. On his first trip to the Kwakwaka'wakw, Boas spent a whole week in Nahwitti—observing, sketching, taking notes—before making his first purchase. Not only did he establish his credibility during this time, but his pieces were much better documented. Waiting could also result in a lower price, but as Boas instructed Hunt, it did have its dangers: "If you can get them cheaper by waiting, so much the better [but at the] same time if they are required in order to make our collections complete, and if they cannot be gotten cheaper we have to pay high for them. If you should wait any longer the prices would only go up still higher."[103]

A much more effective device, especially in a culture dominated by reciprocity and gift-giving, was the sponsorship of a feast. Jacobsen in 1882 evinced a keen understanding of the system:

> I had lived among Indians so long that they began to consider me more or less one of their people, and for some time it had been hinted that I should give an Indian feast. It was clear that this was a kind of begging, a way of getting return value for their hospitality. But for me it had other importance, for in order to be able to purchase valuable objects from them I must have a good reputation among them. (Jacobsen 1977:73)

After a meal with donated pilot bread and molasses, and singing and dancing that included an appearance of Jacobsen in wig and Indian mask, the Norwegian collector was given an Indian name by the head chief at Fort Rupert. But as Jacobsen noted, along with the "few good pieces" he was able to secure, he had to buy "a large amount of trash" (ibid.).

Perhaps armed with the knowledge of this transaction, Franz Boas on his 1886 trip to the Kwakwaka'wakw also sponsored a feast, with gifts of rice and tobacco. He had promised to give one in exchange for the performance of dances. The chief at Nahwitti praised the visitor from Germany, with the comment that none of the Americans or British had ever given them a feast: "But his people must be good and he shows that he has the heart of a chief. Whoever of us shall meet him, will be glad and recognize him as a great chief. . . . If he wants anything from us we shall do our best to do what he wants" (Boas 1969:37).

Meeting with such success, Boas instructed George Hunt to call the Kwakwaka'wakw to a feast in 1897, when beginning his collecting for the Jesup Expedition. Boas wrote out a letter in a florid style that he meant to be translated into Kwak'wala. Apparently this letter, spelling out the purpose of Hunt's collecting, was well received.[104] A few years later when Hunt's collecting did run into opposition from the Kwakwaka'wakw, Boas again sent a letter to be read in Kwak'wala, accompanied by a feast.[105] There is no mention of similar feasts in the Newcombe-Nowell correspondence. While the device did seem to be effective, Newcombe's relations with the Indians tended to be much more distant.

Sometimes more active measures were called for. George Hunt wanted a particular chief's seat owned by a Nahwitti man, so he

> got a man to ask him to go and get this man to pay his debt to another man so there pressed him so much that he had to come and beg me to buy the seat for 40.00 dollars but I told him that I cant pay him more than 8.00 dollars for it, then he told me to give him another dollar then he will take the price, so I give him 8.75 dollars for it, so you see the way I have to work it?[106]

Hunt often bargained with owners until he got a favorable price. As this example shows, Native middlemen like Hunt and Nowell were able to exploit resources closed to the outsider. In 1904 when negotiating to purchase a Nuu-chah-nulth whaler's shrine, Hunt was required to use his shamanistic powers to cure a sick man and to offer as part of the price ten Kwakwaka'wakw hamatsa songs.[107]

Nowell and Hunt both relied upon a wide circle of relatives and friends. Many of

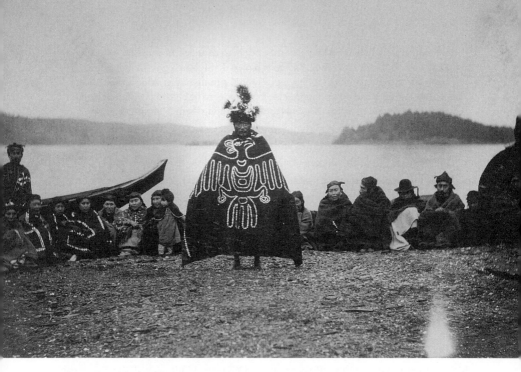

Figure 1.10. Feast sponsored by Franz Boas, Fort Rupert. Photo by Oregon C. Hastings, 28 November 1894. NAA neg. no. 3947.

the items purchased by Newcombe, especially on his first trips, came from Nowell's wife and brothers. While Hunt received a great number of texts from his first wife's family, he got relatively few artifacts through them. However, his siblings and children often assisted with the location, packing, and shipping of objects. Most of Hunt's collection did come from local contacts. Of the owner of a stone head, Hunt wrote to Boas: "The man that got it Promese to let me Buy it, so you see I have lots of friend and that is where we get the best of all."[108]

Unfortunately, there are few indications in the historical record of Native reactions to the collectors in their midst. However, several reports from Jacobsen indicate that some the Kwakwa̱ka̱'wakw were quite eager to sell to him: "Even though it was late at night the inhabitants had heard of my coming and brought many objects they wanted to sell," and "the next morning my little boat was overrun with Indians who all wanted to sell me any purchasable object" (Jacobsen 1977:34–35, 74). There is also some mention of Natives who refused to sell because they were still using their artifacts and valued them too highly to let them go. And Hunt records opposition from Christianized Natives. In 1898 school children from the mission school harassed Hunt for sending stories to Boas, and several years later Hunt reported objections from the "mission people" to his searching through graves.[109] Still, it seems that most of the Kwakwa̱ka̱'wakw did not object to most of the collecting most of the time.

COLLECTING AND NATIVE TRADITIONS

In this final section I examine the relationship between collecting and Native artistic traditions, focusing especially on the viability of these traditions, the impact of collecting on the creation of new objects, and the status of these collections as a sample of Kwakwaka'wakw material culture. It closes with a look at the movement of pieces between collections and the redefinition of Kwakwaka'wakw artifacts.

THE SURVIVAL OF NATIVE ARTIFACTS

From the very beginning, a constant refrain of collectors was that Native cultures were rapidly fading, making it difficult to find "traditional" artifacts. In 1888, when suggesting a collecting program to Oxford's Edward B. Tylor, Boas noted "that the inquiry, if to be done at all, must be done at the earliest possible date, as what little there is left of Native culture is disappearing rapidly." And a decade later, Boas wrote to Tylor that "it is rather difficult nowadays to obtain good works of art of these [Kwakiutl] Indians. During my last few trips I have hardly seen any thing that can compare with the good old carvings." In reviewing the collections at the American Museum, Boas wrote, "The Indians of the present time are so much influenced by contact with Europeans that only few good old carvings and paintings can be obtained."[110]

In 1918, reporting on the prospects of securing cedar bark for a mask, Newcombe wrote: "Owing to the suppression of the potlatch and other causes no bark outfits have been made of late years and it is very difficult to get people to chew alder bark as they used to for the red dye. They have been using artificial dyes for some years."[111] A decade later Harlan Smith, whose experience on the coast spanned over thirty years, wrote, "I guess the days for getting specimens are drawing to a close rapidly." And a few years later he noted, "What one could see when I was last there was a fraction of what I saw in 1897. . . . Most seems to be gone now." Philip Drucker in 1937 was quite disappointed: "I really believe that it won't be long before there'll be no more NWC [Northwest Coast] ethnology. . . . It's getting so it's hard to find good informants. . . . I've kinda kept an eye out for material—there isn't much any more. . . . In most places, all you see is a lot of junk."[112]

Yet, despite this widespread and persistent perception, over the decades many researchers could point to the continuing availability of Kwakwaka'wakw artifacts, especially if one knew where to look (Cole 1985:244–247). When discussing collecting in 1888, Boas noted that there were "remote villages in which the chances to obtain valuable specimens are still very good." And a decade later Harlan Smith wrote: "I cannot agree with Dr. Dorsey, that there is nothing of interest left on the Northwest Coast. Fine ethnological specimens may be seen at every turn. I have hardly been in a place where there were not shell heaps, burials, and village sites."[113]

Over the years villages within Kwakwaka'wakw territory differed in their value to collectors. Conservative X̱wamdasbe' (or Nahwitti) was the first to be exploited; by 1900 Newcombe thought it "played out," and the following year he was proposing

"to visit Blunden Harbour, which is quite out of the beaten track, & where I was credibly informed, there is a better chance of picking up good things than almost anywhere in the Kwakwa̱ka'wakw country—Quatsino Sound, perhaps excepted." Blunden Harbour continued to be a fruitful source, and even as late as 1915 Barrett was finding "a lot of good old material" there.[114]

In fact, Samuel Barrett's 1915 trip was quite successful. He witnessed a large potlatch in Fort Rupert and noted that "all of the various arts and crafts, such as basketry, the making of mats, woodworking, including the carving of totem poles, and the carving of masks and that sort of thing, was in progress not only in Fort Rupert but also on the mainland" (Ritzenthaler and Parsons 1966:17). As he concluded, "Everything is moving off nicely all around and am meeting with very fair success along most lines. Some classes of material are extremely hard to get, but on the whole I can not complain." A clue to the persistence of Kwakwa̱ka'wakw ritual was his statement that "they still celebrated their old time dances and other ceremonies and therefore still needed their masks, rattles, head rings and other items."[115]

Before setting out in 1917, Charles Newcombe thought that "the prospects of making a large collection from [the Kwakwa̱ka'wakw, Nuu-chah-nulth, and Southern Coast Salish] are slim; still there are always some things of interest to be picked up in the older and more remote villages." Newcombe noted that "there are several other villages not far away [from Fort Rupert] which have not been so devastated by George Hunt &c."[116] This statement was as much a reflection of the relative retention of art and ceremony among the Kwakwa̱ka'wakw as it was a comment on Hunt's activities. Upon his return Newcombe admitted, "It was a surprise to me to find that so many of them [artifacts desired by the museum] still existed." In fact, Newcombe and Nowell had not exhausted all possibilities: "There are also some of the rarer things in the remoter villages according to report, but I did not think it good policy to go there until I had exhausted the nearer places where we could purchase reasonably."[117]

In response to a 1928 request from Newcombe's son, Charles Nowell claimed that "there are lots of masks at Kingcome Inlet, and some totem poles at Tlawitsis." Despite his pessimism, Philip Drucker admitted in 1937 that artifacts could still be found "in some of the isolated inlets in Kwagiutl territory" and that "Quatsino Sound is still a good place to pick up masks, etc." As early as 1908 the Kwakwa̱ka'wakw seemed to be an exception. Wrote Stewart Culin: "Except amongst the Kwakiutl and the West Coast people I do not think that there are any old things left."[118]

As late as the 1950s there were still many fine masks in Kwakwa̱ka'wakw hands, but as the decade proceeded their number declined drastically.[119] Dealers seem to have been responsible for most of the purchases, but this was also the period of the formation of the substantial Kwakwa̱ka'wakw collection at the University of British Columbia Museum, as well as the activity of private collectors such as Seattle's Sidney Gerber (chapter 6). Many of these masks depicted in contemporary photographs can now be located in museum collections, with accession records noting their ar-

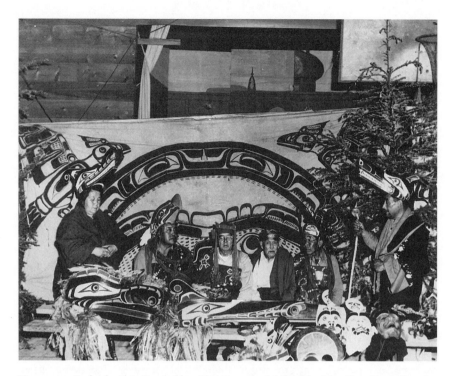

Figure 1.11. Potlatch, Alert Bay, held at Christmas, 1958. left/right: Mrs. Tom Patch Wamiss, Charlie George, Jr., George Scow, Charles Nowell, Willie Seaweed, Tom Patch Wamiss. All carvings except Charlie George's headdress (his own) are by Willie Seaweed; note his crooked beak mask (fig. 1.13). NMAI neg. no. 41305.

rival in the 1950s and 1960s.[120] From stylistic criteria, most of these masks can be dated to the early twentieth century.

Why did Kwakwaka'wakw lose much of their material heritage at this time when they had retained it up until then? The 1950s were a crucial, precarious decade—after a period of isolation, when much "traditional" culture could survive intact, and before the period of the positive white evaluation of Native art and culture, which allowed carving and ceremonialism to be revived. Paradoxically, as Native culture was less oppressed, even praised, many Indians felt inclined to trade their old ways for white "advancement." This was a time of ameliorating social conditions. The ban on the potlatch had been dropped in 1951, and for the first time there was a strong white movement toward integration. Native children were no longer restricted to Native schools, and there seemed to be a strong Native desire for assimilation. This final divestment of much (but not all) Native material culture was a further impetus to the carving of new objects when the revival did come.

PRODUCTION AND LOSS

In their discussion of changes in ceremony and art on the Northwest Coast, Cole and Darling (1990:132) note that, "like most other changes in native life, fur-trade era alterations were evolutionary rather than revolutionary in nature," and such trends characterized subsequent periods. Among the first items demanded by the Northwest Coast Natives in trade were iron-tipped tools, yet even at contact, coastal peoples had iron blades (Holm 1990b:603). Thus it is likely that, despite the salvage goals of collectors, the vast majority of artifacts in museum storerooms were made with metal blades. Naturally, greater quantities of metal blades, along with introduced paints, greatly spurred the production of artifacts of all kinds. But beyond sheer quantity, artistic styles were pushed toward stylistic extremes—carvers could create finer and more delicate objects, as well as larger and bolder pieces. A likely example is the freestanding totem pole, absent among the Kwakwaka'wakw until the last quarter of the nineteenth century (Holm 1990b:618). And as Natives joined the white cash economy, the new-found wealth of many allowed increased potlatching, and thus of art production (Codere 1961:467).

But what Western culture gave with one hand, it took with the other. Although the Kwakwaka'wakw may have been able to create more artifacts, by the end of the century there were fewer people to appreciate them. Largely because of disease, by 1898 the Kwakwaka'wakw population had declined to the point where "there were more potlatch positions than men to fill them" (Codere 1950:87). Extending this argument, Cole (1985:295) suggests that this "must have created a surplus of many objects at precisely the period of most intense organized collecting." While it is impossible to verify such a proposition, it was probably true. At the same time, Natives were replacing their domestic crafts with trade goods, further stimulating their desire to sell old-style artifacts.

The act of collecting artifacts from what was perceived as a dead or dying tradition carried serious consequences, which were not lost on some collectors. Franz Boas noted that, "with every specimen that is removed from the tribe the tribal tradition is weakened."[121] In explaining why he was collecting so few specimens among the Nuxalk, Thomas McIlwraith admitted that this was partly "through my unwillingness to take away many of the few which remain; practically no new ceremonial objects are being made, and any losses curtail the already too much curtailed sacred life to that extent."[122] However, the Kwakwaka'wakw and Nuxalk artistic traditions differed in their viability. By the 1920s, as McIlwraith noted, the carving of new Nuxalk pieces had virtually ceased, while Kwakwaka'wakw masters such as Mungo Martin, Willie Seaweed, and Arthur Shaughnessy (along with many others) were still in their prime. When Boas surveyed the scene in 1902 he was convinced that it was only a matter of time before Kwakwaka'wakw tradition disappeared. Rather than refraining from collecting, however, he called for higher standards of collection. The making of poorly documented collections, he felt, was "destructive," for it made it "more

difficult to obtain information on the culture." Collecting must and should continue, but in the future it should be done by better-trained ethnologists.[123]

Such massive collecting had two consequences. Not only did it remove from the Native community objects that had a social and ceremonial use, but it deprived later carvers of models for their own work. While these actions might constrict Native tradition, hampering young carvers in their learning of traditional styles, it might also encourage stylistic innovation. The removal of artifacts could be expected to stimulate production in two ways, as carvers replaced old objects with new examples for their Native clientele, and as they produced still more items for sale to whites. Although little firm evidence is available, it seems that while the former was a factor in Kwakwaka'wakw art history, the latter was not.[124]

There is little evidence that Kwakwaka'wakw artists, unlike those among the Haida, were particularly stimulated to produce items for general sale to whites. The major exception is that of model totem poles for tourists. Almost all the master carvers—Charlie James, Mungo Martin, Willie Seaweed, Arthur Shaughnessy, Charlie George, Charlie and George Walkus—created these items, but most were made by beginning carvers, and tourism was not nearly as widespread among the Kwakwaka'wakw as among the Haida and Tlingit in Alaska.[125] (To a lesser extent, silver bracelets were a part of this market, but they were also used within Kwakwaka'wakw culture as adornment and potlatch gifts.) In the present day, there is a great deal of production specifically for sale: carvings, jewelry, and silkscreens (see chapter 5). While there was direct production for collectors, this was never a major source of commissions.

When collecting for the B.C. Provincial Museum in 1914, Charles F. Newcombe bought two hamatsa masks from famed Kwakwaka'wakw artist Willie Seaweed. Both had been carved around 1910, one by Seaweed himself, the other by Mungo Martin. About ten years later Seaweed replaced them with "copies." Holm (1983:88–93) has discussed the many differences between the two sets.[126] What is important here is that this replacement was quite acceptable to the Kwakwaka'wakw. This points to a distinction important to Northwest cultures that has a bearing on their relative receptivity to collectors. Edward Malin (1978:77) claims that the Tlingit and the Kwakwaka'wakw differ in their "attachment" to artifacts.

> The Kwakiutl . . . often sold their ritual masks to visiting collectors, charging what for those days seemed exorbitant prices. They then turned about, pocketed some of the profit in order to enhance their future potlatching prospects, and then commissioned carvers to make more masks. But for the Tlingit the original mask was the treasure and heirloom; no copies could be tolerated. For the Kwakiutl, it was the symbol or the idea of the crest that was owned, and so that was what counted. The object could be duplicated again and again, the more unusual and different the better.

While this characterization is basically accurate, in fact, the Tlingit were a little more ready to replace crests and the Kwakwaka'wakw a little less. Both cultures made a distinction between personal and "clan" or corporate property, but among

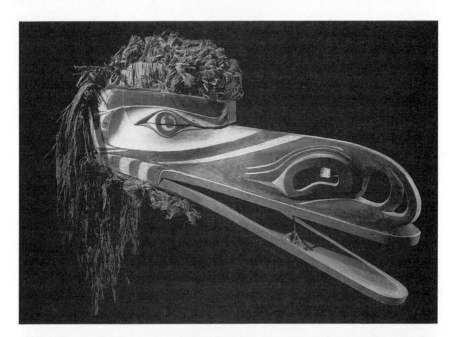

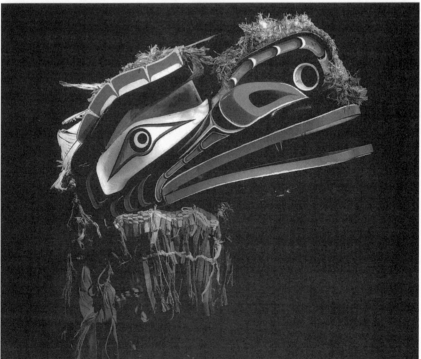

Figure 1.12. Willie Seaweed's first crooked beak mask, c. 1910, Royal British Columbia Museum. RBCM cat. no. 1917. **Figure 1.13.** Willie Seaweed's replacement crooked beak mask, c. 1935, Royal British Columbia Museum, acquired in 1973. RBCM cat. no. 15055 (v. 2).

the Tlingit, who had an elaborate clan and moiety system, it was more marked. Tlingit individuals could own tools, weapons, clothing, products of their own enterprise, as well as ceremonial objects (masks, robes, and rattles). Clan property, such as the house of the clan chief and special crest emblems such as the clan hats, could not be alienated from the clan and was passed from uncle to nephew (Oberg 1973:30, 35). The more often a crest object was displayed at a potlatch the more valuable it became. But, according to de Laguna (1972:453, 455), not all crest objects were heirlooms:

> Just as we have seen old lineage houses replaced by modern structures that bore the same names, so old crest hats or blankets that wore out or were destroyed at a funeral were replaced by new items called by the same names, such as the Mount Saint Elias Blanket or the Thunderbird Blanket. The new object was not necessarily a duplicate of the old; it was only a symbolic equivalent. . . . It was the right to the crest, that is, to use the emblem, that was most valuable.

Similarly, stressing the social contexts of clan treasures, Dauenhauer (1995:26) describes how newly made objects may in time become *at.óow*, ancestral property, through repeated display at potlatch ceremonies. These views accord more with the Kwakwaka'wakw custom. Both de Laguna (1972:460–461) and Oberg (1973:63) agree that in modern times the Tlingit ban on alienation of clan property broke down, as the objects became more valuable than the rights to them, as population declined, and as collectors beckoned.

The Kwakwaka'wakw also made a distinction between individual property and communal property such as the economic resource areas (fishing, berrying, and hunting grounds), the lineage house, and intangible property (names, potlatch positions, songs, the right to use crest items, etc.), which could not be alienated. These lineage properties, tangible and conceptual, were held in trust by the chief, who was viewed as the reincarnation of the founding ancestor (Goldman 1975:44–45). In addition to these, which were passed down lineally, other ceremonial objects were transferred by marriage, from father-in-law to the husband, and held in trust for the children. These were the crests of the winter ceremonials (Rosman and Rubel 1971:134). Thus, according to Kwakwaka'wakw ideology, the lineage patrimony could not be sold to collectors, as it was held in trust.

Yet as Malin indicates, the Kwakwaka'wakw distinguished between an object and the right to it. Usually when crests were transferred in marriage, it was the rights that moved, not the actual artifacts (Holm 1983:28). This emphasis on intangibles is not unlike the Kwakwaka'wakw stress on names. Things with names—such as people, houses, or feast dishes—were regarded as temporary material substantiations of the enduring and eternal entity. Thus different biological individuals could be the same *person* in the same way that different wooden structures could be the same house. As Malin suggests, Kwakwaka'wakw tended not to be as upset as Euro-Americans might be if a particular object were sold outside the tribe. As long as the privilege remained,

another manifestation could be created, as was the case with Willie Seaweed's mask. Clearly, this was a culture "preadapted" for collectors.[127]

Although one can only speculate, the massive classical collecting may have stimulated the production of Kwakwaka'wakw ceremonial artifacts in general, and their stylistic dynamism in particular. With so many older objects gone, a demand was created for new masks or rattles for use in the potlatch, which as Codere (1961:467) points out continued to expand until the early 1920s. The greater degree of formal innovation and personal style in Kwakwaka'wakw art has often been noted (e.g., Duff et al. 1967:n.p.), and the collecting of older pieces could have only contributed to it.

Although collection tended to alienate objects from Native society, an important, though much reduced, movement took place in the other direction. Most directly, Natives have repurchased objects. George Hunt's sister, Elizabeth, amassed a diverse collection of Native objects and Oriental and Western antiques.[128] Kwakwaka'wakw artist Tony Hunt has a personal collection, part of which he displayed in his Arts of the Raven gallery in Victoria. While some of it was acquired from Natives, much of it was bought from white dealers. Other modes are repatriation (see chapter 9) and the Provincial Museum exchange and loan programs (chapters 6, 7). An indirect form of repatriation also exists, as Natives creatively repossess artifacts by copying museum specimens and book illustrations (chapter 7).

SPATIAL SAMPLING: THE RESTRICTION OF SOURCES

Because no artifact collection can be a complete record of the material assemblage of a culture, issues of sampling inevitably arise. One is then faced with problems of metonymic representation—what is the relation between what is taken and what remains? Despite their efforts at inclusion, the classical collectors had distinct biases of selection. In addition, they favored some places and people over others. While not at all surprising or reprehensible in itself, these biases have not been sufficiently noted.

To a great extent, Boas was documenting the material culture of Hunt and his friends and relatives and Newcombe was doing the same for Charles Nowell. Collecting was not limited to these sources, as each was motivated by a desire to get "good, old things," from whatever source, but especially at the beginning of their respective efforts, they began at home. Nowell often supplied Newcombe with objects from himself and his family—selling him in 1899 a bow that he owned, and his son's potlatch cradle in 1910.[129] George Hunt, in his search for old things, seems to have relied less on his family for artifacts than he did for textual data.

Perhaps the collectors' favorite spot, at least in the period c. 1880–1905, was Nahwitti, famed for its conservatism.[130] Jacobsen, Boas, and Newcombe, each went to the village for their first Kwakwaka'wakw collecting—in 1881, 1886, and 1899, respectively; the latter two, no doubt because of their familiarity with the reports of their predecessors. Fort Rupert and Alert Bay were compromises. Probably much in Kwakwaka'wakw collections comes from these two sites because of their large Native populations, their central location in transportation networks, and, not least, their own resident

collectors—Hunt and Nowell. But working against this was their more acculturated status, and collectors often avoided them in favor of more untouched villages.[131]

This tension between tarnished accessibility and the desire to salvage an always elusive culture has been captured nicely by Lévi-Strauss:

> I wished I had lived in the age of *real* journeys, when it was still possible to see the full splendour of a spectacle that had not yet been polluted, plighted and spoilt. . . . And so I am caught in a circle from which there is no escape: the less human societies were able to communicate with each other and therefore to corrupt each other through contact, the less their respective emissaries were able to perceive the wealth and significance of their diversity. (Lévi-Strauss 1974:43)

By far the most striking and interesting case of restricted sources is the collecting related to the world's fairs. It is likely that many of the Kwakwaka'wakw artifacts in Berlin and the Field Museum were made by a small group of people. In 1893 Boas reported that the Kwakwaka'wakw whom he had invited to the Chicago World's Fair had made many of the specimens that Jacobsen had collected (and because he had retraced some of Jacobsen's steps, perhaps many in his Berlin collection as well). Then in 1904, the two Kwakwaka'wakw who went to the St. Louis exposition recognized many of their pieces (specifically those by one of them, carver Bob Harris) in the Field Museum collection, which at that time came largely from the collecting for the Chicago exposition (by Hunt and the Jacobsen brothers) (Cole 1985:131, 206). These claims may have been exaggerated, but there is reason to think that indeed anthropologists were constantly returning to favorite and amenable informants and suppliers. That these same individuals also represented the Kwakwaka'wakw at the fairs only compounds the concentration in sources.

SECONDARY COLLECTION AND THE REDEFINITION OF KWAKWAKA'WAKW ARTIFACTS

"Today nearly all surviving Northwest Coast material culture is in public hands." This statement of Edmund Carpenter (1975:16) is an accurate characterization of a dominant trend of the twentieth century. What was not collected directly by public institutions has now come to rest in them. In classical times, most museums wishing a Northwest Coast collection commissioned their own, and even when they did not, they were able to purchase collections made on speculation: for example, Boas's first Kwakwaka'wakw assemblage, and most of Emmons's collections. Secondary acquisition, in which collectors buy other collections, has long been practiced, but it has become increasingly prevalent. At times, it operated on a grand scale, as in Heye's purchase of the Tozier collection. Today, those museums desiring objects from the classical period can only get them by acquiring existing collections. At the same time, material can also go the other way, with artifacts leaving collections. Though more common around the turn of the century, museums often exchanged parts of their collections, trading what they defined as "duplicates." In the 1940s the Heye collec-

tion deaccessioned many of its Northwest Coast and Eskimo artifacts; today many museums have pieces on extended loans, and sometimes there are special situations like the repatriation of the so-called Potlatch Collection by the Canadian Museum of Civilization.

Such movements of artifacts make problematic the task of ethnographic representation. To take two examples, while Boas sent most of his 1886 collection to Berlin, part of it came to the Smithsonian Institution, and Newcombe's 1889 collection was split between Ottawa, Philadelphia, and Chicago. Whether artifacts are grouped or split, every time an object changes hands it moves another step away from its original home, and its usefulness as an ethnographic document is compromised. In such secondary movements, related sets, series, and ensembles are often broken up. Yet even more significant is the common tendency to lose the associated documentation—provenience data, texts, and so on—which in turn allows, if not encourages, non-Natives to reformulate the meaning of the object.

These processes alert us to the fact that at heart collecting is a trafficking in fragments (Stewart 1984:151–169; Halpin 1991). In lovingly gathering them up, all these collectors have been motivated by a desire to restore these fragments to a lost whole, for only with a sense of an original totality can one pick and choose from the fragments available. Much of Boas's own anthropology was caught between his interests in collecting discrete cultural traits and in replacing them in their contextual wholes (Jacknis 1996b). Given their ethnographic project, for Boas and his colleagues this search for a lost Eden was almost literal, as they attempted to salvage a state of precontact aboriginal culture.

The initial act of collection was merely the first move in a continual process of estrangement. For the ethnographic objects of interest here, the first rupture was the loss of a Native use value. As these Kwakwaka'wakw objects moved into Western museums, they could no longer be used as they had been by their creators and original owners. Yet the private concerns of their collectors, their aims and collecting desiderata, were also obscured. As art museums secondarily acquired Kwakwaka'wakw objects, their uses and meanings changed yet again. Over the century, secondary collection has acted as a transformative winnowing process, constructing a canon by successive generations of curators, critics, and artists.

Despite the revival of collecting in the 1950s, the collecting of the classical period was on such a massive scale and the gap in collecting so long, that the earlier material has come to define our image of Kwakwaka'wakw culture. In the chapters to come, I consider the implications of this collecting imbalance for the appreciation, study, exhibition, preservation, and creation of Kwakwaka'wakw artifacts.

2

ANTHROPOLOGICAL
REPRESENTATIONS

Following their collection, Kwakwaka'wakw artifacts were glossed in words or juxtaposed in display cases, acts that painted a particular picture of those objects and, by extension, the broader culture. The cultural images that guided the collectors were thus externalized for a scholarly and lay public. Through publication and display at expositions and museums, anthropologists created an image of Kwakwaka'wakw culture as a coherent, changeless "classical" entity—a time thought to antedate Western contact. Thus began the process of placing Kwakwaka'wakw objects in the boxes of Western fairs, museums, and libraries. Ironically, the images so created—although historical constructions themselves—proved to be remarkably enduring in their own right.

SCHOLARSHIP

Anthropology, like all scholarly disciplines, may be said to possess an intellectual structure, a tradition of question and answer—a discourse, in other words—that forms and changes over time. Scholarly research is then diffused through publication and teaching, the primary social or behavioral component that carries the intellectual tradition. Serious scholarship on Northwest Coast Indian art began in the 1880s, the same time as systematic collection, and this linkage is no coincidence. As Alsop

(1982:293–297) maintains, these two ways of relating to art objects stem from the same cultural inclination, a sense of historical consciousness. The desire to possess an object is naturally allied with the desire to understand its varieties and history. Then, too, though collecting is not a prerequisite for scholarship, it greatly facilitates scholarship. Certain questions, of construction and use, could only be studied in the field, while others, of a more formal and stylistic nature, could only be considered by viewing large numbers of objects. Only after a sufficient corpus had accumulated in museums could scholars begin these kinds of studies.

Without a doubt, Franz Boas must be considered the father of Northwest Coast art studies (Suttles and Jonaitis 1990; Jonaitis 1992b, 1995). Before his two monographs of 1897, there was virtually no scholarly literature in the field.[1] In the course of his roughly four decades of publication on the subject (c. 1890–1930), Boas established many of the basic analytic approaches. His first major publication on the subject was an 1897 study of Northwest Coast decorative art, which was revised toward the end of his life as a chapter in his *Primitive Art* of 1927. Boas's work tended to stress technical and formal issues, though he also laid the groundwork for the basic iconographic and functional approaches to the region's art.

Much of Boas's work on Kwakwaka'wakw material culture was devoted to materials and techniques. In fact, his two monographs of 1909 and 1921 are primarily studies of these topics. While Boas himself investigated materials and techniques in his field research, especially in 1900, most of this work was carried out by George Hunt. Following Boas's instruction, Hunt wrote out accounts in Kwak'wala (with interlinear

Figure 2.1. Franz Boas demonstrating the pose of the Kwakwaka'wakw hamatsa initiate for a diorama at the U.S. National Museum, February 1895. NAA neg. no. 8304.

translations) for those procedures with which he was familiar and sought out Native experts for topics such as canoe-making or cooking, when he was not.

Boas's 1897 study began the formal investigation of Northwest Coast decorative design—with its concern for the identification of symbolic motifs, their disposition on the design field, and the relation of graphic and plastic elements—but there are very few Kwakwaka'wakw examples. In his revision of 1927 he added more Kwakwaka'wakw pieces and extended his analyses of the design system. Boas addressed the problem of iconography in both of his 1897 monographs, as well as in his 1927 revision. Invariably, however, he focused his attention on the lowest level of meaning—the identification of representational motifs. In his comments on the Chilkat blanket (Boas 1907b), for example, he pointed out the ambiguity in informants' readings. Boas treated the social context of Kwakwaka'wakw artifacts principally in terms of ritual use (Boas 1890, 1897a).

Franz Boas also investigated two aspects of Northwest Coast art that later became prime scholarly concerns: the historical development of the region's art and the study of individual artists. Boas's first writings on Northwest Coast art were addressed to evolutionary issues. Even when objecting to evolutionary theories, his early work was necessarily couched in terms of a developmental framework (Thoresen 1977). His 1897 study of Northwest Coast decorative design, for example, while dealing mostly in formal analysis, moves toward the question of the historical relation of realistic and geometric design. Boas was interested in tracing cultural developments that extended over long periods of time, not in reconstructing a more local level of change dealing with specific individuals and change over a lifetime.[2] To a great extent, in fact, Boas's research contributed to the common contemporary perception that primitive arts were anonymous. While this view was sometimes due to the shallow quality of the fieldwork, more fundamentally it was the result of basic scholarly attitudes. Many ethnographers, including Boas and Charles F. Newcombe, gathered data firsthand from individuals but never dreamed of recording their names. Beginning around 1910, Boas suggested a new approach, examining the relation of Salish basket weavers to their art (Jacknis 1992a). This study was based on the field research of James Teit, with Herman Haeberlin doing the final analysis (Haeberlin et al. 1928).

Finally, Boas accorded the Kwakwaka'wakw a significant but circumscribed place in his studies of Northwest Coast art. A fundamental interest of Boas at the turn of the century was to trace the distribution of culture traits as a possible clue to reconstructing tribal histories. In his first writings Boas attributed great importance to the Kwakwaka'wakw. Thinking that they were the originators of the totem pole as well as the cannibal dance complex, he concluded: "One of the results of our inquiry is the discovery of the deep influence wrought by the Kwakiutl upon the development of their neighbors. It may be that this influence is still more important than it seems at present" (Boas 1888:196). As he later discovered, however, artistic influence on the coast generally went in the other direction, from north to south. In any case, throughout his career, Boas advocated a flexible approach to cultural typologies and the defini-

tion of culture areas (Suttles 1990:11–12). Although he published a study of Kwakwa-ka'wakw ceremonial art in 1897, Boas's other 1897 monograph, the formal analysis of Northwest Coast design, is virtually devoid of Kwakwaka'wakw examples. At first this is puzzling, given the amount of his fieldwork with the people, but the omission can be explained by noting that this study was based almost wholly on objects in the collections of the American Museum, which at that time still had few Kwakwa-ka'wakw pieces. By the time Boas revised the essay in 1927, he was able to draw upon firsthand Kwakwaka'wakw fieldwork (e.g., the series of eye motifs, Boas 1927:202).

Franz Boas was not the only scholar of Kwakwaka'wakw material culture during his time, of course, but his research vastly eclipsed the others in bulk and thorough-ness. The work of these others does, however, include some important corrections and supplements. Most important were those of Charles F. Newcombe, working with Charles Nowell. Much of Newcombe's research was destined for long labels to Field Museum exhibits and was thus never published.[3] The photographer Edward Curtis published important primary material on the ritual uses of artifacts (Curtis 1915), but most of this was actually gathered by his assistant, William E. Myers. Samuel Barrett's Kwakwaka'wakw study, published posthumously, consists virtually of unaltered field notes from 1915 (Ritzenthaler and Parsons 1966). Although Curtis and Barrett may have had differing perspectives from Boas, their reliance on George Hunt as principal informant could not help but restrict the range of scholarly sources on Kwakwaka'wakw culture.

In fact, to an extent only now becoming apparent, Boas's research was based upon George Hunt's own field research, as transmitted in text and letter. A native Kwa-kwaka'wakw ethnographic tradition starts with George Hunt and the nature of his special relationship with Boas.[4] George Hunt (1854–1933) lived in Fort Rupert and Alert Bay, the successive centers of acculturation among the Kwakwaka'wakw, and his life was thus firmly within the Potlatch period, 1849–1921, as defined by Codere (1961). During this period, the Native population declined drastically, while at the same time thriving economically. Throughout his life, Hunt was involved in recov-ering and recording a past he could never know directly—a time before the coming of the white man.

Hunt was part of a small but significant interracial community in Fort Rupert, many of them—like his father—associated with the Hudson's Bay Company. Hunt's ethnic identity was shifting and complex (Berman 1996:226–231). Neither of his par-ents were Kwakwaka'wakw, although he was raised among them. His father was an English trader who spoke Kwak'wala and even potlatched. Hunt's native tongue was apparently Tlingit, which he would have learned from his high-ranking Tlingit mother. Hunt seems to have adopted an Indian status, although neither he nor the local Kwakwaka'wakw considered him one of them. Following Tlingit tradition, he received some of his ceremonial privileges from his mother. According to Kwakwa-ka'wakw custom, he received most of his ceremonial privileges through marriage, and his in-laws were always among his prime informants. A career as an ethnogra-

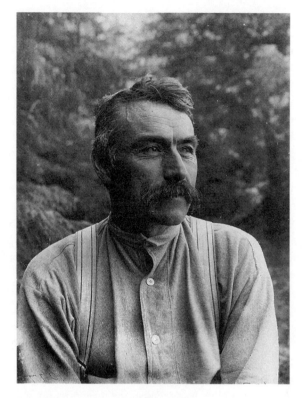

Figure 2.2. George Hunt. Photo by Harlan I. Smith, 1898.
AMNH neg. no. 11854.

pher was made possible by his bilingual command of English and his literacy, which he learned from his father and the local missionary.

George Hunt's early work for Jacobsen and Boas was as an interpreter and informant. It was only after Boas had taught him a Kwak'wala orthography at the Chicago World's Fair that he took on more of the role of independent ethnographer. While Boas generally initiated the topics of research, especially at the beginning, he always allowed Hunt to investigate the questions as he saw best (Boas wanted to document the culture as the Native saw it, in the Native language; see Boas 1909:309). Hunt found his own sources and reported to New York in the form of letters and transcribed Native texts. Hunt's career as an ethnographer was impelled by a balance of insider and outsider statuses. Not of Kwakwaka'wakw ancestry himself, literate, with an English father, he gradually committed himself to that Native culture. Hunt was often the first to admit that he was learning new things: "Now I have some fine old things that I Did not know any thing about Before."[5] Though he often relied on his Indian in-laws, he always attempted to seek out appropriate experts throughout Kwakwaka'wakw territory. Gradually Hunt began to work on his own initiative, sug-

gesting his own projects, such as a Native dictionary (anticipated by Boas) or a study of Native medicines.

Like his mentor, Hunt was interested in the Kwakwa̲ka̲'wakw past, which he tried to thoroughly document. By the end of his life, as he was welcoming Boas back to Fort Rupert for what would be their last time together, Hunt wrote: "I dont know weather you will find any one of these People to talk the old fashean language. for the most of them, one word for every thing instead of using the different word for the different way of answer. one thing I know that lost about two third of their language for there lots of the Indians comes and ask me the meaning of the words."[6] As this last comment reveals, Hunt was considered by the Kwakwa̲ka̲'wakw themselves to be an expert in their ways. Through his own work as well as the work with which he assisted (that of Powell, Jacobsen, Boas, Newcombe, Curtis, Barrett, and Goddard), George Hunt is probably the dominant source of anthropological knowledge of the Kwakwa̲ka̲'wakw, in textual documentation as well as artifacts. Few of his successors approached Hunt's enduring and single-minded devotion to ethnographic recording, but many carried on in his tradition.

Though from a high-ranking Fort Rupert family, Charles Nowell (c. 1870–1957) was also suited for a career as an anthropological middleman. As one of the first students in Hall's mission school, Nowell acquired the crucial skill of English literacy. His father, a song maker, had encouraged the young boy's studies. Like most Kwakwa̲ka̲'wakw, the elder Nowell believed it important to remember the old ways, and so when he was dying he called to his son and said, "I know you have been to school, and I think the only way for you to remember the main positions and all the ancestors is for you to write them down, because it seems to me that everybody is forgetting all their ancestors and names. I have often heard people make mistakes. The first thing, you will write down our ancestors till now" (Ford 1941:105). Although Charles did as his father instructed, over the years the papers became lost. Still, his writing skills allowed him to assist Charles Newcombe in his ethnographic projects. Paradoxically, literacy, which some thought would be responsible for hastening the end of Kwakwa̲ka̲'wakw culture, in fact, extended it. The same might be said of other Western media such as photography and sound recording.

A high point for Nowell's anthropological "career" came in 1904 with his trip to the St. Louis Exposition and his work at the Field Museum. Later in his life, the Anglican Church was important to Nowell. Active as a preacher and interpreter, he also translated hymns into Kwak'wala. Though his days as an active assistant to anthropologists ended with Newcombe's death in 1924, Nowell, along with Ed Whonnock, later served as a major informant for Philip Drucker during his 1937 and 1953 trips to the region. Toward the end of his life, he had the honor and satisfaction of assisting at Mungo Martin's house-opening potlatch at the Provincial Museum (see chapter 4).[7]

While such ethnographic scholarship was initially a Western mode of comprehending Native culture, from the beginning Kwakwa̲ka̲'wakw individuals have played key roles in constructing the white image of their culture, and more recently they

have become scholars in their own right. Thus the work of Boas with Hunt and Newcombe with Nowell represented the beginning of a tradition on the Native side, just as much as the white. Coming from a mediating social position—Hunt more so than Nowell—they began to treat their culture as an object, as something apart from their own lives (see Handler 1988; Kirshenblatt-Gimblett 1991). For both Hunt and Nowell, this sense of distance was encouraged by the substantial changes through which they were living. And as all these scholars began to formulate an image of pre-contact Kwakwaka'wakw culture, they naturally inflected it, by stressing some things and not others. As they prepared books and museum exhibits, they re-presented the original acts of inscription in the field, whether collecting or note-taking. All ethnographic activity is a positioned cultural activity, of course, but as one moves to these secondary representations, the concerns of the culture doing the describing assume an even more dominant shape than those of the ostensible culture at hand.

INTERNATIONAL EXPOSITIONS

A review of the changing ways Northwest Coast Indian artifacts have been displayed provides some of the clearest insights into how these objects have been (literally) viewed. The exhibit is a kind of "super-artifact," formed out of many smaller ones (Skramstad 1978). As in a collage, the objects displayed are "found objects," artifacts from one culture that then become part of another culture's object, the exhibit. As all exhibits are explicitly concerned with defining and explaining these Native artifacts for the viewer, they are among our most immediate sources for the ways anthropologists and art historians construe Native culture. And unlike changing genres of scholarship, which commingle with or supplement previous forms, exhibits often physically incorporate their predecessors. Thus we often have a kind of "control"—seeing the same object treated differently over the decades.[8] And for a genre that seems so ephemeral at first glance, museum exhibits have proven to be surprisingly enduring.

U.S. CENTENNIAL EXPOSITION (1876)

Like the great museums that would grow out of them (Harris 1978), the international expositions of the nineteenth century brought together in one metropolitan center the goods and peoples of colonial hinterlands (Benedict 1983; Rydell 1984). The principal message they taught was the triumph of Western technological progress. As one young ethnologist noted: "From the first to the last the exhibits of this department will be arranged and grouped to teach a lesson; to show the advancement or evolution of man" (Smith 1893:117).

In an age before widespread travel and electronic media, these expositions were one of the most important cultural forums. The first significant public exhibition of Northwest Coast artifacts occurred at the exposition marking the American Centennial. At Philadelphia in 1876, Easterners could see totem poles—those icons of the

region—for the first time. Along with these Haida and Tlingit examples was a Kwa-kwaka'wakw totem pole from Alert Bay, apparently the first ever collected (Cole 1985:29). These and many other Northwest Coast artifacts had been gathered by James G. Swan as part of an American Indian presentation organized by the Smithsonian Institution, with the assistance of the U.S. Office of Indian Affairs.

Spencer F. Baird, the assistant secretary of the Smithsonian, thought it important to include "a series of objects illustrating the habits, customs, peculiarities, and general condition of the various tribes, and also of such relics of their predecessors as may be procurable" (quoted in Trennert 1974:118, 120). After the fair, the National Museum would become the repository for these collections. Baird also hoped for an "exhibition of living representatives of the principal Indian tribes" (Trennert 1974:120), with the ultimate aim of improving the mutual understanding between the races.

Swan's trip was just one of many throughout the continent. The "ethnological" collectors had to be supplemented by various Indian agents, but the agents, by and large, saw little merit in collecting objects of traditional craft from the very people they were trying to "civilize." This tension between the positive evaluations of Native culture on the part of the ethnologists, on the one hand, and the negative attitudes of those whose mission was to eradicate them, on the other, continued to characterize presentations of the Indian at world's fairs (Hoxie 1979). James Swan "hoped that the Canadian government would authorize the transportation of several tribes from British Columbia and predicted a fine show should all these tribes be present" (Trennert 1974:125). He did persuade Baird to include some Aleuts and Makah, but, in the end, the lack of support from the Indian Office led Congress not to appropriate the necessary funds to bring the "living representatives" to Philadelphia. Thus the first display of Indian culture at an American exposition had to be a mute, static one.

These Indian artifacts took up about a third of the space allotted to the Smithsonian in the U.S. Government Building (Miner 1972). The display methods left much to be desired. Objects were generally crowded into heavy walnut cases, with hardly any labels. Many large items were simply piled on the tops of cases. A full-size Arapaho tipi competed for attention with Swan's tall totems and a 59-foot canoe, so large it had to be placed in the aisle. Size also meant that the immense Tsimshian housefront (without the rest of the structure) had to be erected outside, at the rear of the building, where many visitors ignored it.[9] Along with a diverse lot of artifacts were models of dwellings and a large display of Indian photographs. Although an attempt was made to arrange the objects by evolutionary sequence (Rydell 1984:25), little order was apparent.

Reactions to these strange art styles were mixed. Some commentators were positive, finding the Indian exhibits "instructive" and "large and most interesting," with "carvings [on pipes], in many cases quite artistic and representing a rather high degree of art idea" (quoted in Zegas 1976:166). Because of its size, Swan's Northwest Coast exhibit could not help but draw much attention. Yet one commentator felt the

poles' carvings showed "most conclusively that the moral standard of the aborigines must have been of the lowest possible grade" (quoted in Zegas 1976:167). This correspondent went on to deplore the repulsive Tsimshian housefront, especially the "surrealistic figures" with their "fearfully distorted limbs" and eye motifs painted on outstretched palms.

Despite the desires of its arrangers, many of the exhibits fed the racist fears of the visitors. Costumes were innovatively deployed on mannequins, but the public found that the tomahawks and war shirts made their owners "repulsive looking" and "ready to pounce on some unsuspecting victim" (quoted in Trennert 1974:128). To the novelist William Dean Howells, "The red man, as he appears in effigy and in photograph in this collection, is a hideous demon, whose malign traits can hardly inspire any emotion softer than abhorrence" (quoted in Zegas 1976:169). When we recall that the Custer battle at the Little Bighorn occurred during the run of the Centennial, such attitudes should not surprise. And so, Baird's noble aim of increased racial and cultural understanding was dashed.

TRAVEL TO GERMANY (1881–1885)

Before the first successful performance of the Kwakwaka'wakw away from their homeland, at the Chicago World's Fair of 1893, there were several false starts. Unlike the Philadelphia Centennial, the situation seemed more promising in Europe, where tours of visiting exotics were a centuries-old tradition (see Altick 1978). During the first systematic collecting trip among the Kwakwaka'wakw, by J. Adrian Jacobsen in 1881–1882, an attempt was made to gather a troupe of the Natives for presentation to the German public. By then Jacobsen was an old hand at such ventures, for in 1877 he had "collected" a group of six Greenland Eskimo for Carl Hagenbeck's series of "ethnic expositions" (*völkerschauen*), and the following year he secured a group of Lapps. Although this 1881 trip was funded primarily by Berlin's Royal Ethnographic Museum for the purpose of collecting specimens, Jacobsen accepted a commission from Hagenbeck for a party of Kwakwaka'wakw "longheads." These were members of the Koskimo, Quatsino, and Nahwitti (subgroups of the Kwakwaka'wakw) who deformed the head during infancy into a distinctive sugarloaf shape.

Before gathering his Native charges, however, Jacobsen got a chance to practice his talents as an impresario. Desiring to witness the famous winter ceremonials, Jacobsen asked a Mamalilikala chief to put on a dance. The chief refused, saying that as it was not the proper season: "If he were to allow dancing before that time the neighboring tribes would be very angry and might start a war" (Jacobsen 1977:33). Instead, Jacobsen was able to persuade the next ranking man to do so, under the condition that his retainers be given tobacco. The German collector supplied the dancers with masks that he had already acquired at Nahwitti. However, it appears from his description that the Kwakwaka'wakw danced the more secular tła'sala dances, and not the more sacred dances of the winter ceremonial (Holm 1977:19). So already at the

beginning of the ethnographic record we encounter anthropologists creating what they hope to study. Given his demands and his supplying of the masks, Jacobsen was in no position to evaluate the authenticity of what he was watching.

When Jacobsen set out to gather his Kwakwaka'wakw group in early 1882, he was again accompanied by George Hunt and his brother William. At Koskimo he managed to persuade three men and two women to make the long journey, but by the time they had traveled the short distance to Fort Rupert, the entire party had deserted him (Jacobsen 1977:70–78). Some of the Natives were unsure about such a long sea voyage; others were concerned that they might never see their relatives again. In the end, this first potential group of Kwakwaka'wakw performers disbanded because of the pressure brought to bear on them by their kinsmen and neighbors. Travel to another continent was still a great unknown. In any event, Jacobsen received word from Hagenbeck to cancel the tour, owing to the death in Europe of Tierra del Fuegians on a similar visit (Cole 1985:63).

Hagenbeck and Jacobsen did not abandon the idea, however, and in the summer of 1885 they tried again. In July Adrian Jacobsen met up in Fort Rupert with his brother Fillip, who had been collecting in the area for a year. Again, they recruited a party of Kwakwaka'wakw, this time a group of eleven, including two "longheads." It is unclear whether George Hunt was to go on the first proposed European trip, but he did volunteer for the second, as an interpreter. But again, the Kwakwaka'wakw succumbed to doubts, this time encouraged by the missionary, Reverend Alfred J. Hall. According to the Victoria *Colonist*, "The missionary told them that they would be sold as slaves in Europe and never see the shores of their native land again" (July 21, 1885, cited in Cole 1985:68).

In place of the Kwakwaka'wakw, the brothers were able to make an arrangement with nine Nuxalk men, who happened to be in Victoria (Haberland 1987). During their year-long tour of Germany, the troupe usually gave two performances a day: "The normal program included about seven dances and ceremonies, accompanied by six drums, tambourines, and songs and interspersed with demonstrations of bow and arrows, gambling stick games, and a mock potlatch. A hamatsa dance and the illusionist burning of a shaman provided the most excitement" (Cole 1982b:115). The shaman would miraculously appear after the wooden box he was in had been thrown on the fire. This bit of theater would be employed by several Kwakwaka'wakw troupes at subsequent expositions. And as Edward Curtis would later do, the impresarios supplied props for dramatic display, images that were then made permanent in well-known photographs.[10] The Nuxalk's elaborate masks and costumes—mostly Kwakwaka'wakw with a profusion of Tlingit Chilkat blankets—were taken from the large stock gathered by the Jacobsens, as the Natives had little if any ceremonial attire when they signed up in Victoria. Although Hagenbeck and Jacobsen were disappointed with the financial return on the tour, the German public seems to have been friendly and interested. And it was his attendance at the Berlin performances in early 1886 that first attracted Franz Boas to the art and culture of the Northwest Coast. De-

spite their exhaustion toward the end of the tour, the Nuxalk seemed to have enjoyed the experience. Upon their return, news of their travels reached their Kwakwaka'wakw neighbors, and when the next such "ethnic exposition" was suggested, this time to Chicago in 1893, the Kwakwaka'wakw did not need persuading (Cole 1985:131).

WORLD'S COLUMBIAN EXPOSITION (1893)

Although by 1893, when an exposition was staged in Chicago to celebrate the quadricentenary of Columbus's discovery, the ethnology of the American Indian had made great progress, the popular attitude toward Native Americans had changed little since 1876. At the World's Columbian Exposition, for the first time at a fair, anthropology was given its own building. This was due to the efforts of Frederic W. Putnam, professor at Harvard and director of its Peabody Museum. Putnam's plan called for the collection and display of artifacts and living representatives from Native groups throughout the Americas. After the fair, as he had hoped, the collections formed the nucleus of the Field Columbian Museum, which opened in 1894.[11]

Putnam's second in command was Franz Boas, who naturally enough chose to feature the people of the Northwest Coast. As he summarized this display in his final report, "The general plan of this exhibit was to illustrate the culture of one of the tribes of this region most fully, and to bring together supplementary collections from neighboring tribes, in order to bring out the local differences of culture as clearly and as strongly as possible" (quoted in Johnson 1898:344). The group Boas chose to emphasize was the Kwakwaka'wakw, particularly those from Fort Rupert, home to his assistant, George Hunt. It was Boas's belief that the Kwakiutl "have exerted an influence over all the tribes on the North Pacific coast." The best evidence for this, he thought, was "that the names of all the ceremonies which play so important a part in the customs of these tribes are borrowed from the Kwakiutl language" (ibid.).

To gather these collections, Boas commissioned a team of seven, most of them long-time residents of the area. George Hunt was delegated to gather the Kwakwaka'wakw material and to bring with him a troupe of Kwakwaka'wakw. Boas instructed Hunt to obtain "a complete outfit to show the daily life of the Indians, and everything that is necessary to the performance of their religious ceremonies."[12] The 360 pieces that Hunt managed to acquire formed the largest Northwest Coast collection in the Anthropology Building. There were other Northwest Coast exhibits at the fair: George T. Emmons presented a Tlingit collection in the Alaska display in the U.S. Government Building, and the Jacobsen brothers displayed a general Northwest Coast collection as part of the Hagenbeck exhibit. Washington State and British Columbia also sent Indian material.

Unfortunately, the Anthropology Building was nondescript, opened a month late, and was placed in an awkward corner of the grounds—all of which conspired to weaken its impact (Cole 1985:126). Among its Northwest Coast exhibits was a model of the Haida village of Skidegate, with scale models of the houses and totem poles constructed by Native carvers. Although Putnam and Boas strove for a geographical

arrangement (by tribe) of the ethnological material, the display was somewhat confused and unsystematic owing to a lack of time, money, and personnel. The result was not far removed from that of the Centennial: many crowded cases, with little order and minimal labels (Fagin 1984:255–262).

Once it had been decided to feature encampments of American Natives at the fair, the idea of displaying their typical habitations became obvious. George Hunt collected a larger, 45-foot-square structure decorated with frontal paintings (a thunderbird over the door and a moon crest on each side; figure 2.3). More than a mere display, the Kwakwaka'wakw house was home to the troupe during their stay in Chicago. The Natives erected the structure themselves and then staged a housewarming ceremony when they moved in. As a former dwelling (it had come from the Nakomgilisala tribe of Nahwitti), the house had a name. In fact, it had two; according to one source, it was called "Qua-Qua-Kyum-Le-Las" ("the house so large that you cannot see the people on the other side"), while another had it as "Na Gagith" ("house of the waves").[13] James Deans brought a slightly smaller Haida house (about 29 feet square), in addition to his elaborate display of Haida house models. Both houses were fronted by a row of totem poles, and canoes were drawn up in the shallow lagoon nearby.

In the U.S. Government Building, the Smithsonian introduced a new kind of ethnological exhibit to America. Artifacts were grouped by culture area, highlighted with "life groups": costumed mannequins acting out a scene, such as pottery making

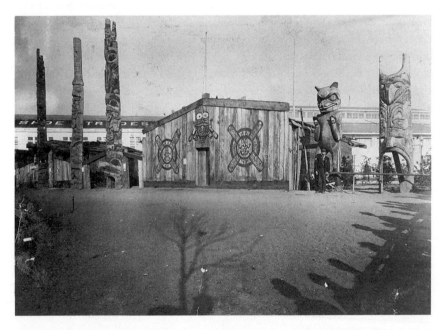

Figure 2.3. Kwakwaka'wakw house (center) and Haida house, World's Columbian Exposition, Chicago, 1893. AMNH neg. no. 322897.

or weaving. An important alternative to these displays, which portrayed the Indian as a vanishing specimen of traditional culture, was the presentation of the Bureau of Indian Affairs. As at Philadelphia, the government wished to demonstrate its success in civilizing and uplifting the Indian. A model boarding school was erected, in which "boys and girls, with their instructors, will live, study, recite, sew, prepare meals, work at their trade, and carry on all the industrial and educational life and training which pertain to a boarding school upon an Indian reservation" (Handy 1893:156). Indian crafts decorated the rooms, and the windows were filled with transparencies of reservation life.

Despite the government's attempt to show the improved status of the Indian and the aim of the ethnologists to demonstrate the complexity and achievement of Native cultures, the popular reaction was, again, racist. The official guide noted, "The handiwork of the Alaskan Natives showed a degree of skill with which they were not generally credited, especially the carvings in ivory, horn, and wood, and the sample of ingenious metal work" (Handy 1893:506), but news accounts referred to such items as "Indian curiosities and bric-a-brac."[14] Under an engraving entitled, "Simple as Children," an article went on to quote James Deans, who had accompanied the Kwakwaka'wakw to the fair: "They are a contented, honest race. . . . Their everyday life is simple, and would be rather monotonous to any other race."[15] Of the Kwakwaka'wakw totem pole, the Chicago Times commented, "From an aesthetic standpoint the totem is not altogether a scintillating success, but it is a monument of the bygone history of savagedom, and Prof. Putnam, the head of the fossiology department, estimates its price far above rubies."[16] The American of Baltimore was not impressed with the Haida house: "The frame building of the Haidas would probably attract but little attention were it not for the hideous decorations and the intensely crude and ugly carvings of their totem poles."[17] And the Chicago Tribune found the Haida house models "curiously and hideously carved," with "frightful carvings of dragon heads protruding from the eaves."[18]

The Chicago World's Fair displayed many groups of living peoples besides the Kwakwaka'wakw. The great model, in the minds of American ethnologists, was the gathering of primitives and peasants at the Paris International Exposition of 1889 (Rydell 1984:55–56). At all such events, visitors could watch the Natives work at their distinctive crafts and experience their ceremonial dance, music, and song. Little serious communication took place, however; the audience simply observed and, more often than not, came away with the prejudices they had brought with them.

At Chicago, the various Native groups performed under radically different auspices. The Kwakwaka'wakw troupe—in addition to George Hunt as manager and interpreter, numbering nine men, five women, and two children—was part of the "scientific" display of the Department of Ethnology.[19] Included in the group were Hunt's oldest son David, his brother William (and his wife), and his father-in-law. Most of the other performers were part of the commercial "Midway" operation, arranged in national pavilions—the Streets of Cairo, the Dahomey Village, Old Vienna, and so

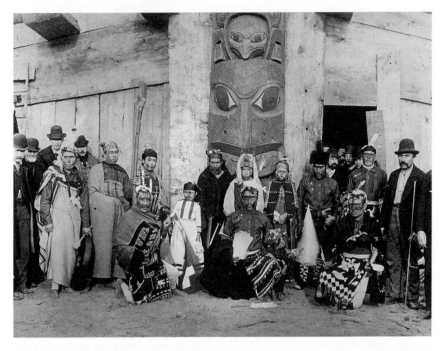

Figure 2.4. Kwakwa̱ka'wakw in front of the Haida house (George Hunt, extreme right),
World's Columbian Exposition, Chicago, 1893. Chicago Historical Society neg.
no. ICHi–25062.

on—presented with little pretense to ethnological edification. Other Native groups
were sponsored by states; New York had its Iroquois, and Colorado its Navajo.

Native performance at the fairs, as in many interethnic settings, included both
work and ceremony (see Kirshenblatt-Gimblett 1991). An important part of the Na-
tives' daily activities was craft production, partly as a demonstration, but also as a
much-needed source of income. In applying for permission from the fair adminis-
tration, Frederic Putnam argued that "there is no doubt that this sale of native man-
ufactures by the natives themselves, dressed in native costume and living in their
habitations and largely negotiating by sign language, will form a special attraction to
visitors."[20] However, he went on to ask that the Natives be allowed to bring dupli-
cates of such crafts to sell, "as in many cases (as for instance the Navajo blanket-
weavers) it would take nearly the whole time of the fair to complete one specimen
of their handiwork and they would thus be unable to realize anything toward their
support or to accommodate visitors who after watching the process of manufacture
should wish to purchase a finished article."

Putnam needed to reassure the director-general that these sales would not com-
pete with the commercial concessions, and he thus promised that all sales would be
"within or at the doors of their respective habitations and that nothing of the char-
acter of a booth or shop shall be allowed, nor shall white men be permitted to make

the sales." For the Natives, of course, this *was* an operation like a "booth or shop," but Putnam was striving for an illusion of exoticism: "My object is simply to allow the sale of native manufactures by the natives in the same way that a traveler going to their respective countries would purchase a few articles from their wigwams or teepees." Any profits made were to be split between the Kwakwaka'wakw (one-half), George Hunt (one-fourth), and the Ethnology Department (one-fourth).[21] Despite these arrangements, one finds relatively little mention of Kwakwaka'wakw craft work at the fair, perhaps because they were paid $20 per month, for seven and a half months, in addition to their living and traveling expenses. This must have been a fairly generous offer, for when Johnny Drabble returned home to Alert Bay with his wife, he gave a potlatch with his earnings.[22]

The performances of the Kwakwaka'wakw, a people known for their drama and stagecraft, attracted a great deal of attention. Yet these very talents for illusion and spectacle were not always appreciated. The Chicago troupe began its series of regular performances (often for invited guests) with a festive housewarming. On the afternoon of May 6, shortly after the opening of the fair, the Kwakwaka'wakw marched in procession from their temporary quarters to their plank house, where they dedicated the house and totem with dancing. A Kwakwaka'wakw "princess" sponsored a formal feast, complete with orators for the host and guests.[23] A week later they danced for a party including Prince Roland Bonaparte of France (noted by the newspaper as "an ethnologist of international fame"). There were selections from the repertoire of the winter ceremonial, including the dances of the hamatsa, the tuxw'id (a woman's dance demonstrating supernatural powers), and one with a raven mask. "Professor [Frederick] Starr had to move out of the way of the big beak as it whirled around and Prince Bonaparte looked a trifle scared as the warrior pranced toward him," reported the paper. George Hunt and James Deans acted as masters of ceremonies.[24]

As the summer wore on, the Kwakwaka'wakw drew greater crowds, but press reaction, probably an accurate mirror of popular sentiment, was not sympathetic. For instance, on June 12, the Natives danced for the Infanta Eulalia of Spain, who claimed to have enjoyed the performance. According to the newspaper, however,

> A band of Quoc Queth Indians, gorgeous in red and blue blankets and gayly bedizened head dresses, burst into the cave singing one of their atrocious melodies. One detachment of them pounded away at the tam-tams, while the rest, bucks, squaws, and papooses, danced and howled. It seemed to please the Spaniards. The Quoc Queths, screeched, rolled in the sand, and fought imaginary insects. That was the mosquito dance and the mosquitoes seemed to have all the best of it. They hopped and cavorted around, clawed at each other, and squealed like hyenas. That was the laughing dance to celebrate a victory over foes of the tribe.[25]

Such racist misunderstanding of Kwakwaka'wakw performances was quite similar to the reactions to their artifacts.

The ceremonial use of violence, or the illusion of violence, had caused problems for the Kwakwaka'wakw back in Canada, and it continued to create controversy in Chicago. Shocked news correspondents reported bites into living flesh, ropes being pulled through slits on dancers' backs, and what appeared to be cannibalism. Most notable among the complainants were the Reverend A. J. Hall of Alert Bay and Emma Sickles, a self-styled "friend of the Indian." As he had done earlier with the Kwakwaka'wakw party invited to Germany, the reverend did his utmost to persuade "his" Indians not to go, and, in fact, only two of the Kwakwaka'wakw came from Alert Bay. On his way to London, Hall stopped in Chicago, where he was so upset at this "display of paganism" that he wrote to several Canadian officials, asking them to cancel further performances. While they all concurred with him, there was little that could be done, as "the Indians, like white men, are free to make arrangements with whomsoever they please, and the Department [of Indian Affairs] cannot prevent their doing so. And, as you are aware, the law prohibiting Potlatch feasts or Tamana-was dances in Canada cannot be enforced in the United States."[26] Miss Sickles criticized the performances on much the same grounds as Reverend Hall, saying that they portrayed the worst in the Indian and gave no indication of the great progress he was making in acquiring the benefits of civilization.[27] As she complained to the *New York Times*, "The exhibit of Indian life now given at the fair is an exhibit of savagery in its most repulsive form, participated in by only the lowest specimens of the Indian race or by those noted for bloodthirsty deeds."[28]

In his defense of the Kwakwaka'wakw performances, Putnam explained the illusionistic stagecraft habitually employed. When they appeared to bleed from a blow on the head, the "blood" was in fact red paint contained in a hollow kelp tube. "But even this exhibition, which is pure jugglery and of the same class as the jugglery of Hindoos and others, is in itself of considerable scientific importance and interest as illustrating a custom which has been in existence with these people from time immemorial."[29] Still worried about public reaction, Putnam went on to claim that this display had been given without the knowledge of the Ethnology Department, had only been performed once, and would not be repeated.

Although the anthropology display was probably a failure on the popular level, the exposition proved to be important to the development of anthropology and Northwest Coast studies. The Northwest Coast collection, which Boas judged as "the most systematic one that ever has been presented," formed the core of the Field Museum's distinguished holdings in this area. Boas also believed that it had "materially increased our knowledge of the ethnology of the whole Pacific Coast" (quoted in Johnson 1898:344). While it may have been "the most systematic" collection yet gathered, it did have limits. First, the presence of the Kwakwaka'wakw, Hunt, and Boas at the Chicago fair was no accident. To some extent, the precursor for the display of Northwest Coast Indian culture at the fair was Jacobsen's 1881–1882 expedition. Boas had worked with the Nuxalk when they were in Berlin in 1886, and one of his aims in going to British Columbia later that year was to document the Jacobsen collection.

George Hunt had worked intimately with the Norwegian explorer as a collecting assistant in 1881, and the favorable reports of the Nuxalk had encouraged the Kwakwaka'wakw to finally make the trip. The Columbian Exposition was a reunion, as both the Jacobsen brothers came with collections they had made. Finally, "Boas discovered that almost all the Kwakiutl material in Berlin had been bought from members of the Chicago troupe" (Cole 1985:131). This strong connection was a prime factor in limiting scholarly sources of Northwest Coast culture to the Kwakwaka'wakw, and within Kwakwaka'wakw culture to George Hunt, his family, and Fort Rupert.

The Chicago fair was in fact important in featuring Kwakwaka'wakw culture, as it was the first major exhibition of Kwakwaka'wakw artifacts (eclipsing in scale and audience the mid-1880s Jacobsen display in Berlin). Until then, major American museums like the Smithsonian Institution and American Museum had focused their Northwest Coast collections on the Haida and Tlingit. There was a persisting general interest in the northern, "classical" styles of Haida and Tlingit art, to which the more theatrical and flamboyant Kwakwaka'wakw styles were a great contrast.

At the fair, Boas witnessed for the first time dances from the Kwakwaka'wakw winter ceremonial, to which he was to devote so much later study. Kwakwaka'wakw music was recorded for the first time, by Boas and the musicologist John C. Fillmore and by Benjamin I. Gilman. For George Hunt, it marked the beginning of his work as a collector and scholar of the Kwakwaka'wakw, and during his stay in Chicago Boas taught him an orthography by which he could transcribe his Native language, allowing the compilation of the volumes of Native texts that would follow. For the Kwakwaka'wakw Natives, it was their first experience in presenting their culture to the white man.

LOUISIANA PURCHASE EXPOSITION (1904)

The great success of the Chicago Exposition led to a similar fair in St. Louis in 1904. The organizers of the Louisiana Purchase Exposition explicitly tried to match and exceed the earlier show. Anthropology, this time under the direction of W J McGee (formerly of the Smithsonian's Bureau of American Ethnology), again had its own building and an associated village of ethnic groups from all over the world. Evolutionary concerns for this fair were consciously intended by its organizers: "The development of man from his primitive condition to the present height of achievement was illustrated . . . by object lessons. The Department of Anthropology concerned itself with the presentation of these object lessons in such sequence as would show the evolution of industrial art, and the expansion of those mental and moral forces which obtain in modern civilization" (Bennitt and Stockbridge 1905:673; see also Rydell 1984:160–167).

The living peoples at St. Louis, displayed on an even grander scale than in Chicago, were arranged by McGee into a "Congress of the Races." Present this time were representatives from the Ainu of Japan, the pygmies of the Congo, the Patagonians, as well as fifteen American Indian tribes. By far the largest display was the U.S. govern-

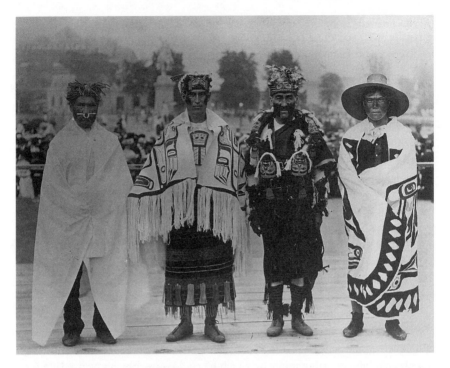

Figure 2.5. Northwest Coast Indian dancers (left/right): Dr. Atliu (Nuu-chah-nulth), Charles Nowell and Xexa'niyus ("Bob Harris") (Kwakwa̱ka'wakw), Jasper Turner (Nuu-chah-nulth), Louisiana Purchase Exposition, St. Louis. Photo by Jesse Tarbox Beals, 1904. AMNH neg. no. 3337533.

ment's Philippines exhibit, covering forty-seven acres and including 1,100 costumed Natives (Bennitt and Stockbridge 1905:673–685). Again as in Chicago, Natives participated in the commercial "Pike" as well as their "official" display arranged by the Department of Anthropology. Here were assembled an Eskimo village, a group of Pueblo "Cliff Dwellers," and an Indian Congress and Wild West Show, complete with the defeated Apache chief Geronimo (Bennitt and Stockbridge 1905:716–719).

The Northwest Coast presence at St. Louis was modest. There were two Kwakwa̱ka'wakw: Charles Nowell from Fort Rupert and Bob Harris from Knight Inlet.[30] Collector Charles F. Newcombe recruited and supervised them, along with a party of five Nuu-chah-nulth. Along with them, Newcombe brought a small collection of Kwakwa̱ka'wakw artifacts. Although he had tried to collect an "impressive" Kwakwa̱ka'wakw house at Koskimo, he found out that "the cost of getting it would have run up to a very high figure."[31] Instead, he brought a Nuu-chah-nulth house, measuring 53 by 42 feet, from Clayoquot, home to three of his party. After the house was erected late in the summer (transportation difficulties had delayed it), the Natives used it as an exhibition, performance, and living space. In addition, the Territory of

Alaska erected two plank houses and a group of Haida totem poles, while inside its pavilion a display of baskets and other Native "curios" joined the mounds of minerals, furs, and other natural resources on view (Bennitt and Stockbridge 1905:443–445).[32]

The Kwakwaka'wakw at St. Louis did not do as well financially as their Chicago cousins. In Missouri, the Nuu-chah-nulth women wove basketry, mats, and hats, while the Kwakwaka'wakw men carved and painted. However, Nowell and Harris derived most of their income from the admissions paid to see their dances. Money was a reason so few Natives were recruited. While he had tried to entice parties from the Makah and Haida, in addition to the Nuu-chah-nulth and Kwakwaka'wakw, Newcombe reported that "the great trouble has been in getting them to believe that they can make enough from their basketry and woodwork to be the equivalent of what they would get from fishing and hop-picking, etc."[33] The Natives at St. Louis did get their expenses covered, but they got no additional wages.

Although they caused less outrage than in Chicago, similar "violent" acts were performed at St. Louis, as recounted by one of the participants, Charles Nowell (Ford 1941:186–190). The Kwakwaka'wakw conspired to apparently kill and eat a pygmy (from the visiting Congo delegation), when in fact the flesh consumed was mutton, rigged up with a carved head to resemble the little man. Blood was simulated with paint, and his cry was a hidden whistle. All, including Dr. Newcombe, were amazed when they brought the pygmy back to life. Newcombe was also quite relieved, as he feared criminal charges for these acts, or so said Nowell. Despite Newcombe's efforts, the scientific significance of the St. Louis Fair was not up to the level of Chicago. Certainly, the Kwakwaka'wakw representation was an echo of the earlier event.

KWAKWAKA'WAKW ON STAGE

The world's fair performances proved to be a privileged forum for displaying the complex mixture of religious fact and dramatic illusion in Kwakwaka'wakw ceremonialism. These distinctions, however, were not always appreciated by the general public. One perceptive and sympathetic observer, New York journalist Henry Krehbiel, described an evening's performance in the Kwakwaka'wakw big house at Chicago:

> All the dances performed were dramatic in character, and required what it is no verbal impropriety to speak of as theatrical "properties." This fact, and the obvious intellectual attitude of the Indians toward the performances, as betrayed by the nature of the pantomimes and their reception, showed plainly as possible that however the Indians may once have thought of these dances, they are now chiefly performed for the sake of diversion. Dr. Boas described them as semi-religious in character, and explained that though the performers have become skeptical about their efficacy, they are yet believers in the spiritual agencies that are supposed to play a part in them. . . . [Krehbiel describes the exorcism of a disease spirit.] It was all play-acting, clever mimicry, performed and witnessed in a spirit of amusement. Back of it, of course, was some ancient superstition, possibly some mythological occurrence, which is now forgotten, or but half remembered.[34]

Although it is impossible to determine precisely, some of this violence might have been real. Clearly newspaper accounts exaggerated what occurred, but some contemporary Kwakwaka'wakw ceremonials did involve bloodshed. Charles Nowell reported taking part in rites in Alert Bay around the turn of the century where dancers were hung by ropes (Ford 1941:115–117), a ritual Boas described as the Hawi'nalaL, or war dance (Boas 1897a:495–497). Similar bloody acts were performed in St. Louis, and Nowell recounted some of the illusionistic tricks involved (Ford 1941:186–190). Kwakwaka'wakw acts of ritual violence are well documented in the ethnohistorical literature, but this violence was increasingly replaced with theatrical illusion, especially as the Indians were subjected to British colonial pressure during the nineteenth century (Holm 1977:15, 19). Whatever their status, such seemingly grisly shows were prime evidence for those who viewed Indians as savages (and whose principal experience with American Indian performance was the Wild West Show). As far as one can tell, these—the first Kwakwaka'wakw performances in an intercultural setting—generated more disgust than appreciation.

One journalist noted the incongruity of a roaring fire in the Kwakwaka'wakw big house on a sweltering Chicago summer's evening, reportedly used for illumination

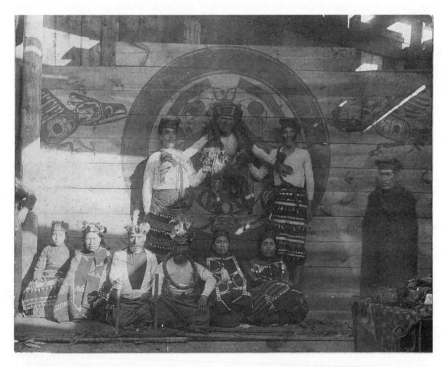

Figure 2.6. Kwakwaka'wakw hamatsa dancers and singers before a painted screen: George Hunt (seated, third from left), David Hunt (standing, left of dancer coming through screen), World's Columbian Exposition, Chicago. Photo by John H. Grabill [?], 1893. AMNH neg. no. 338326.

and as a "ceremonial agent" for the winter dances. He felt that the hamatsa dance he had seen was "evidently much abridged and modified."[35] Citing Boas's publications, he concluded that "it is manifest that the Chicago performance was but a feeble imitation of the real dance, in which corpses are used, not effigies." For this observer, authenticity lay in Fort Rupert, not Chicago. However, if he had been present in Fort Rupert, he would not have seen winter dances in the summer, but he very well might have seen effigies and other forms of "jugglery" used. The line between ritual and theater was not rigid among the Kwakwaka'wakw, particularly at the turn of the century.[36]

Despite the degree of ritual illusion, these exposition performances did represent a fundamental shift in context, for this was the first known instance in which the Kwakwaka'wakw had performed their sacred winter ceremonials during the secular summer season and for a non-Native audience.[37] It would not be the last, nor would the Kwakwaka'wakw be the only Native American group to theatricalize their rituals (Sweet 1983). The displays of the Midway and the related anthropological exhibits amounted to a simulated tourist site (Hinsley 1991), as suggested by Putnam's reference to the "special attraction to visitors" of buying crafts from costumed Natives living in their Native habitations. One can only speculate on the modifications the Kwakwaka'wakw made in their dances. Certainly they changed the time of year and undoubtedly shortened the entire proceeding. Without access to their stores of food and wealth, the feasting and potlatch gift-giving was limited. And with such a small group—many of whom may have lacked the requisite ceremonial knowledge—and a primarily non-Kwak'wala-speaking audience, the full range of dances must have been curtailed and condensed. However, as Krehbiel suggested, these dances were, on the whole, less ritual action and more secular demonstrations of inherited privilege. According to Raibmon (2000:187–188), the participants did possess the inherited privileges for the dances they performed. So, in the end, the question of authenticity must be moot; some things changed, others did not. What was actually happening was that an altogether new cultural form was being created.

The ethnographic documentation—in photography and sound recording—of these performances at Chicago played an important role in forming an image of Kwakwaka'wakw culture. Franz Boas commissioned frontier photographer John H. Grabill to take a series of pictures of the Kwakwaka'wakw performers (Jacknis 1984:6, 36–39). When he used them to illustrate his 1897 monograph on Kwakwaka'wakw ceremonialism, he combined them with field photos taken by Oregon C. Hastings in the fall of 1894. However, someone retouched the backgrounds out of the Grabill images, leading the viewer to infer that they, too, were field photos. While not as apparent, the cylinder recordings made at the fair were also constrained. First, there was the "unnatural" context for the singing, which probably was done in an office. More serious were the absence of the common Kwakwaka'wakw choral singing and the severe restriction of extended singing into the two- or three-minute "songs" that could fit onto the cylinder (Jacknis 1991a:107–109, 1998). There was no comparable body of Kwakwaka'wakw recordings until Boas returned to Fort Rupert in 1930–1931.[38] Thus

the special circumstances of the fair became inscribed in the enduring ethnographic record.

In 1893 Chicago, the cultures of the Kwakwaka'wakw, other Northwest Coast groups, and, in fact, all participating non-Western peoples were displaced, their representation controlled by whites. It was the representation of a culture that was out of its spatial and temporal context; or more precisely, a culture that had been placed in a new context (Halpin 1983). This estrangement resulted in a process of cultural objectification. The transformation from living subject to ethnographic object is borne out by some of Putnam's comments. Writing at the close of the fair to the Canadian Pacific Railroad, which had agreed to pay for the return shipping of all exhibits, Putnam argued that they should accordingly cover the cost of sending the Kwakwaka'wakw troupe back to British Columbia. As he complained, they should "be returned free like other exhibits, as they were exhibits in every sense of the term" (Dexter 1966:328).[39] One scholar has noted that the White City was a city without residences (Trachtenberg 1982:209), but the Kwakwaka'wakw and other visiting ethnic groups *did* live on the fairgrounds, always on view.

EXHIBITIONS IN ANTHROPOLOGY MUSEUMS

Although artifacts of exotic Others had been represented in cabinets of curiosities for centuries, the first specialized museums of anthropology were not established until the early nineteenth century.[40] In America, museum anthropology began at about the same time as a professional anthropology, around 1880 (Hinsley 1981). Founded at Harvard in 1866, the Peabody Museum of American Archaeology and Ethnology was the first specialized anthropology museum in the United States. Most other anthropological collections have been included in natural history museums. In 1894 Frederic W. Putnam, the Peabody's director, revived the Anthropology Department at the American Museum of Natural History, founded in 1873, four years after the museum itself. Putnam's assistant and successor in New York, from 1895 to 1905, was Franz Boas, who was succeeded by Clark Wissler. From the inception of the U.S. National Museum in 1881, ethnology and archaeology were important parts of the Smithsonian Institution, where Otis T. Mason was the first curator of ethnology, from 1884 to 1908. Although Chicago's Field Columbian Museum was founded relatively late—in 1894 from the collections of the previous year's fair—under the curatorship of George A. Dorsey (1896 to 1915), it rapidly reached the ranks of the major anthropological collections in the country. Another important institution was the Milwaukee Public Museum, founded in 1882, which became important to anthropology with the appointment of Samuel Barrett as curator in 1909. Barrett served in that position until 1920, and as director from 1920 to 1940.

This general history of museum anthropology was mirrored in the case of the artifacts of the Northwest Coast Indians (Cole 1985). After the age of exploration and

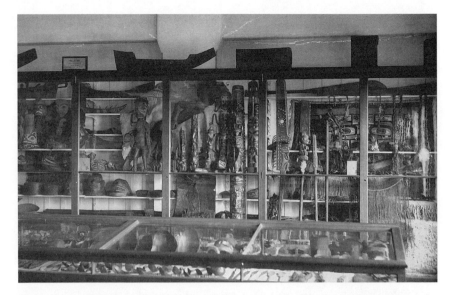

Figure 2.7. Northwest Coast Indian exhibit, Warren Ethnological Gallery, Peabody Museum, Harvard University, 1899. PM N 1784.

initial settlement (post 1774), the first interest in Northwest Coast artifacts formed around 1875 in the eastern United States and Europe (especially Germany). In America the leading museums with anthropological collections—American Museum, U.S. National Museum, Field Museum—all competed fiercely for Northwest Coast artifacts. The most important for the Kwakw_aka_'wakw were those in New York and Chicago. After 1905, interest in the Northwest Coast suffered a decline among these large metropolitan museums, a state of inactivity that has characterized much of the past century.

U.S. NATIONAL MUSEUM (1880–1895)

For the first three-quarters of the nineteenth century, displays of Northwest Coast artifacts were rather insignificant, for two reasons: collections from the region were still small and spotty, and museum audiences were restricted mainly to small numbers of scientists and "gentlemen." However, even these early exhibits were arranged according to one of two basic schemes: geography, or some universal plan of comparative types.[41] By the latter part of the century, the geographical order had been adopted by the majority of ethnological museums, among them the British Museum, the Royal Ethnographical Museum in Berlin, and the Peabody Museum at Harvard. The most famous museum arranged according to the typological plan was the Pitt Rivers Museum at Oxford. In America Otis T. Mason of the U.S. National Museum adopted and popularized the comparative mode as employed by Gustav Klemm in his Leipzig Museum (Hinsley 1981:83–123).

Although the Smithsonian had received some Northwest Coast artifacts from the Wilkes Expedition (1838–1842), its first major accession from the region came in 1876—the general collection, mostly Haida, made by James Swan for the Centennial Exposition. Primarily because of territorial considerations, the U.S. National Museum has always had much stronger collections from the Haida and Tlingit of Alaska than from tribes of British Columbia. Their only important Kwakwaka'wakw collection was made in 1894 by Boas and Hunt, and that is rather modest.

When the new National Museum Building was opened in 1881, its exhibits followed several comparative approaches. Many displays "illustrated the great variety of forms of a single class of objects that existed among the Indians—whether the subject was bows and arrows, harpoons, throwing sticks, pottery, textiles, sculpture, pipes, or necklaces" (Ewers 1959:318). Thus specimens from the Northwest Coast were separated out and grouped by artifact type. "The second type of exhibit purported to show the evolution of common tools, such as those used for cutting, sawing, drilling, etc. These exhibits portrayed assumed technological advances, from the simple to the complex, without regard for the history of the actual objects selected" (ibid.). These developmental series included the full range of objects, including Asian and contemporary American manufactures.

However, in the course of preparing for the Chicago World's Fair, Otis Mason was led to consider the influence of the environment on Indian cultures and thus arranged his material according to "culture areas." Never abandoning his earlier typological and evolutionary concerns, Mason had long regarded tribal and regional schemes as only one of several classifications and had adopted them partly for practical reasons: a geographical display was only possible with the arrival in the Smithsonian of more extensive and better documented collections (Jacknis 1985:77–83). In the 1890s Mason began to reorder the ethnological halls at the National Museum according to this new plan. Appropriately, but coincidentally, Northwest Coast collections were placed in the "Northwest Range," one of the halls devoted to American ethnology. Here, sharing space with Eskimo works, they occupied most of the wall cases and several cases in the middle. Relevant transparencies filled the windows. Unfortunately, as no good pictures or descriptions of this exhibit survive, little more can be said about it.

The Chicago Exposition was also significant for the introduction of "life groups." Now along with rows of relatively flat artifacts were large cases containing costumed figures, which one could walk around. Life-sized mannequins had been used as early as the Centennial Exposition, and even earlier in Europe, but until the Smithsonian's William Holmes put together his seven groups for the 1893 fair, American displays had not been "representational"—showing a group of figures acting out a scene. Many of Holmes's groups told a story, described in the labels, with the narrative climax depicted in the display.

In May 1894 Franz Boas offered to collect for Mason sufficient material to allow the construction of a life group illustrating the Kwakwaka'wakw winter ceremonials. That fall in Fort Rupert, Boas witnessed for the first time these dances in their natu-

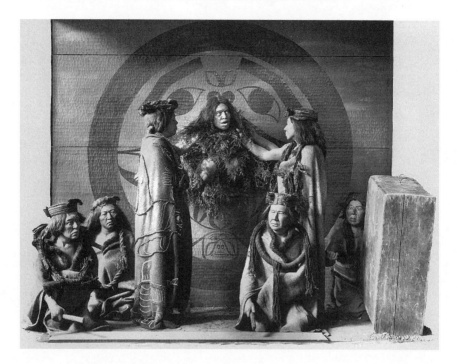

Figure 2.8. Diorama illustrating the return of the Kwakwa̲ka'wakw hamatsa initiate, U.S. National Museum, c. 1896. NAA neg. no. 9539.

ral habitat (those he had seen the previous summer were in the context of the Chicago fair) and, with the help of George Hunt, took notes and collected the necessary artifacts. During the months of January through March 1895, Boas reviewed the Smithsonian's collections and directed the work of the modelmakers (Hinsley and Holm 1976). This display, depicting the dramatic moment when the hamatsa initiate reappears through the screen at the rear of the house, was exhibited at the Cotton States Exposition, held in Atlanta later that fall, and soon thereafter was placed in the halls of the National Museum. Boas must have been quite impressed with the dances at Chicago, as the wooden screen in his exhibit closely resembles the screen used at the fair (figures 2.6, 2.8).[42] As we shall see, this was only the first time that this screen would be reproduced in a museum display. We do not know when the hamatsa diorama was dismantled, but evidence suggests that it did not make the move into the new Natural History Building in 1911.

AMERICAN MUSEUM OF NATURAL HISTORY (1895–1905)
Almost from the beginning of its Anthropology Department in 1873, collections from the Northwest Coast have been important in the American Museum of Natural History. Yet until Boas's arrival in 1895 they were predominantly northern—Haida, Tsimshian, and Tlingit. With no adequate anthropological supervision, the display of

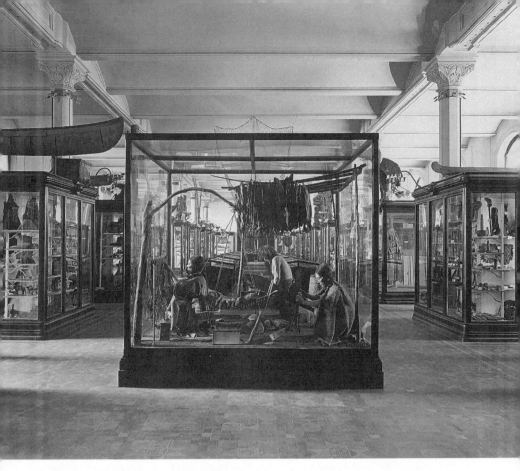

Figure 2.9. Diorama illustrating Kwakwaka'wakw cedar crafts, Northwest Coast hall, American Museum of Natural History. Photo by E. G. Keller, c. 1900. AMNH neg. no. 351.

these objects was not especially noteworthy; items were grouped largely by collector, and thus usually in regional clumps.

Franz Boas began his exhibit career at the American Museum (for a review, see Jacknis 1985) with a life group similar to the one he had done for Washington. Accordingly, he spent time during the same fall field trip gathering artifacts for a group illustrating the uses of cedar. After coming to New York in the fall of 1895 to supervise his displays, Boas was able to parlay this assignment into a permanent position. In the decade he spent at the museum, Boas's greatest achievement was the direction of the Jesup North Pacific Expedition, which, among its other results, produced a great deal of highly exhibitable material. Boas and Hunt were able to balance the museum's holdings with large collections of Kwakwaka'wakw, Nuxalk, and Nuu-chah-nulth specimens.

Boas spent much of his time during these years arranging exhibits, and his pet project was, naturally, the Northwest Coast Hall. The Ethnology Hall was opened on November 30, 1896, in the same hall as the present Northwest Coast exhibit. Along

with material from that region, it held Eskimo, northern Mexican, and Melanesian artifacts. Already on display were a model of a Kwakwaka'wakw village, the life group depicting cedar crafts, and busts of physical types. When the new West Wing was completed in 1900, the other ethnological specimens were moved out, leaving the entire hall for the Northwest Coast. Though Boas was trying to arrange a more or less permanent display, each year more material came in, and it was placed on exhibit as it was processed and researched. Items too large for the hall—tall totem poles, grave- and houseposts, petroglyph casts—were placed in the adjoining Western Vestibule, but still there was a constant shortage of exhibit space. In 1901 the previous arrangement of artifacts by collector was replaced by a fully tribal order. Although the Annual Report for 1902 stated that the North Hall was "completed in its main features," work on the hall continued for several years.

Like all the ethnology halls in the American Museum, this hall was based on a geographical rationale, a direct implementation of Boas's argument in his 1887 debate with Mason and Powell (Stocking 1974:1–20). As he had suggested, material could be arranged in two series: "First, a general or synoptic collection of specimens obtained from the entire area, designed to illustrate the culture of the people as a whole; Second, several independent collections, each illustrating the peculiarities of the culture of a single tribe" (Hovey 1904:41). These first synoptic cases followed a plan popular in ethnographic monographs of the period, running from matter to spirit: natural products and materials, industries and tools, house furnishings, dress and ornament, trade and barter, hunting and fishing, travel and transportation, armor and weapons, musical instruments, decorative art, and clan organization.

The tribal series followed, starting with the northernmost Tlingit and proceeding south in order through the Tsimshian, Haida, Nuxalk, Kwakwaka'wakw, Nuu-chah-nulth, and Coast Salish. At the end was a group of exhibits from the interior Plateau tribes. Though neighboring, they have a culture distinct from that of the coastal tribes, and Boas was juxtaposing these two areas in the hall to drive home his point about the effects of local geography and history. The material within each tribal set basically followed the order of the synoptic series, with local omissions and additions as they occurred. Historical concerns were evident in the cases of archaeological remains, and in labels stating, for example, that Bella Coola "culture is considerably affected by that of the inland tribes, with whom they have always traded" (Boas 1900:8).

Visually, the hall was typical for its period, while firmly revealing the concerns of its arranger. A large, rectangular space, the hall was divided into two longitudinal series of alcoves formed by alternating polygonal and flat cases. The bulk of the collections were contained in these ethnology cases, but the synoptic series occupied only the first four alcoves, on the east side. The tribal series snaked down the rest of the east side and looped back up the west side. Running down the center were two parallel rows of waist-high table cases for the archaeology. Suspended from the ceiling were oversize nets and bulky canoes; totemic sculptures and large boxes were piled around columns on the tops of cases.

The focal point was a large case containing the life group, Boas's first work at the museum. In his guide to the hall Boas described its action:

> The importance of the yellow and red cedar is illustrated in the group case in the center of the hall. A woman is seen making a cedar-bark mat, rocking her infant, which is bedded in cedar-bark, the cradle being moved by means of a cedar-bark rope attached to her toe. Another woman is shredding cedar-bark, to be used for making aprons. A man is taking red-hot stones out of the fire with tongs made of cedar-wood, and is about to place the stones in a cedar box. The Indians have no kettles or pots, but cook in boxes, heating the water by means of red-hot stones. A second man is engaged in painting a box. A young woman is drying fish over the fire. (Boas 1900:3–4)

Although Boas was able to arrange the Northwest Coast Hall largely as he wished, his insistence on the priority of research and publication over exhibition was not received sympathetically by the museum administration, and by 1905 he felt he had to resign (Jacknis 1985:105–108).

FIELD COLUMBIAN MUSEUM (1894–1905)

Just as museums of the period competed to acquire collections, so they often clashed in presenting these artifacts in displays. A fascinating case in point concerns a life group depicting the reappearance of the Kwakwaka'wakw hamatsa initiate, following a period of ritual seclusion and his first dance. In response to Boas's suggestions for life group subjects, Putnam discouraged his colleague from repeating in New York the same winter ceremonial scene he was forming for Washington.[43] While Putnam felt it "would not be at all advisable," George Dorsey, of the Field Columbian Museum, had no such qualms. Dorsey had been an assistant at the Chicago fair and had witnessed the Kwakwaka'wakw dances along with Boas. Joining the Chicago museum in 1896 (and becoming curator the following year), Dorsey soon set out to duplicate Boas's exhibit.

Though Dorsey was able to collect some material and cast several plaster models on his 1899 trip to the region, the bulk of the specimens for the exhibit were collected by Charles Newcombe over 1901 and 1902. The featured item was the mawił, or ceremonial screen, constructed out of several painted planks. Although most of the Northwest Coast collections exhibited at the fair had come to the new museum, apparently the screen did not, which is why Dorsey needed to collect another. Ironically, the fair's screen may have been constructed in Chicago and considered just an exhibit prop. Not finding anything suitable in Native hands, Dorsey commissioned a screen from Tom Haima'selas, a Nahwitti Kwakwaka'wakw who had been at the Columbian Exposition (and who, in fact, may have made that screen). Instructing Newcombe, Dorsey wrote: "The picture of the group in Boas's book will suggest what we require" (Boas 1897b:pl. 29, cf. fig. 2.8). Dorsey suggested that if Haima'selas had not yet made the planks, they should be 12 by 7 feet, to fit the case on hand. If Newcombe had any money left over, he should "expend it in any accessories which

would go with this group, as suggested by the pictures in Boas's book, such as cedar bark head rings, cedar aprons, etc."[44]

As Tom Haima'selas was away sealing when Newcombe arrived, Newcombe arranged for a Fort Rupert artist to produce the boards, according to specifications. Newcombe ensured that the mawił would follow traditional styles: adz-hewn smoke-stained planks were painted with Native pigments mixed with the traditional salmon egg binder, with an archaic design. In order to get the unnamed artist to produce the pieces within the offered price, Newcombe's Kwakwa̱ka'wakw assistant, Charles Nowell, had to agree to help him. The mawił was finished in the spring of 1901, and the other paraphernalia—cedar bark rings, hemlock branches, blankets, batons—all had arrived by the fall of 1902 (figure 2.10). Newcombe was not content to simply follow Boas's book but carefully checked into the details with his informants. During July 1903 he spent some time in Alert Bay researching the hamatsa ritual—what the dancers wore, their roles, the use of various artifacts, and so on. In many cases his data go beyond what Boas and Hunt presented in their publications.[45]

In 1901 the life groups were installed, though they were continually modified (Dorsey 1901:748). In September 1904 Charles Nowell and Bob Harris came up to Chicago from St. Louis, where they had been performing at the Louisiana Purchase Exposition. At the Field Museum they made additional artifacts for the display,

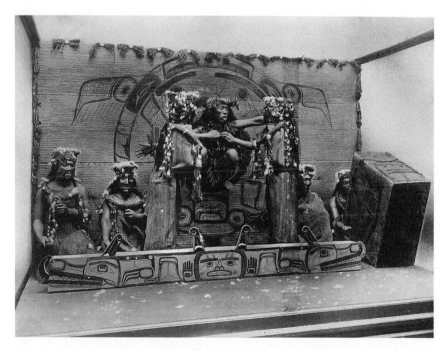

Figure 2.10. Diorama illustrating the return of the Kwakwa̱ka'wakw hamatsa initiate, Field Columbian Museum, 1904. FMNH neg. no. 16242.

painted the figures, and gave the curators supplemental information on their exhibits. Nowell reported that they helped clothe naked figures; he may have been referring to some of the related hamatsa mannequins (Ford 1941:191).

Dorsey was quite aggressive in acquiring his exhibits, desiring them to be second to none, despite the Field Museum's relatively late inception (1894). From its start, the museum's ethnology displays were ordered by culture areas, and it was one of the leaders in the use of life groups. During these early years of the century, the Northwest Coast exhibits, like those of the American Museum, were in a constant state of flux, as new artifacts came in and as knowledge grew. In 1900 the Northwest Coast halls were reinstalled in two rooms, and by the time they were next installed, in 1905 under the direction of Newcombe, the number had grown to five.

The popular hamatsa scene continued to interest museums in later years. In 1913 Newcombe, then representing the B.C. Provincial Museum, wrote to Dorsey about an earlier promise to have duplicates made of the diorama figures for a similar display in Victoria, but funds ran out before this duplication could be carried out.[46] A scene so similar that it must have been modeled on the same Boas exhibit was used in a miniature diorama installed by Samuel Barrett in 1927 at the Milwaukee Public Museum (Ritzenthaler and Parsons 1966:19, fig. 2). Although Barrett visited Kwakwaka'wakw territory in 1915 and may have witnessed such scenes himself, the resemblance of his model to the Boas exhibit is too close for coincidence.

AMERICAN MUSEUM OF NATURAL HISTORY (1905–1930)

Upon Boas's departure from the museum in 1905, his former student Clark Wissler assumed his position. A former school teacher, Wissler was more committed to making the exhibits appealing to the general public. For instance, in 1907 he separated out the "study series" from those specimens on display in public corridors. Wissler's exhibits were visually less cluttered, and marked by a greater reliance on habitat-like dioramas.

These trends were dramatically evident in the renovation of the Northwest Coast Hall. Although scientific direction of the project was given to Harlan Smith, Boas's young colleague from the Chicago fair and the Jesup Expedition, the central museum administration played an active role in its formation. In an effort to simplify the hall, Wissler and Smith removed Boas's initial synoptic series and arranged all the material geographically, "so that the visitor in passing from south to north through the hall encounters the tribes as if he were actually traveling from south to north in the country" (AMNH Annual Report for 1909:38). In 1908 they removed the low center cases of archaeological specimens, replacing them with a 64-foot Haida canoe (figure 2.11) that had been previously suspended from the ceiling. Boas's cedar life-group was broken up and moved to side and back cases.

In 1910 several further efforts were made to simulate the coast habitat. At the suggestion of Director Hermon C. Bumpus, and under the scientific supervision of George T. Emmons, about twenty mannequins were constructed for the canoe, representing

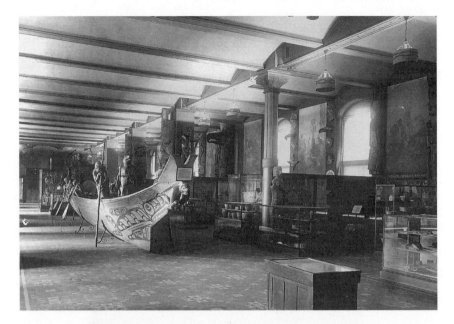

Figure 2.11. Haida canoe with figures, Northwest Coast Indian hall, American Museum of Natural History. Photo by Julius Kirschner, c. 1919. AMNH neg. no. 37672.

a traveling chief and his retainers (Dickerson 1910, figure 2.11). More side cases were removed, as were artifacts from the remaining cases. Totem poles were placed around the columns, giving "the final ethnic touch to the whole exhibit" (AMNH Annual Report for 1917:91). Also about this time the artist Will S. Taylor was commissioned to paint a series of sixteen murals depicting typical scenes from tribal life (Fassett 1911).

Until about 1930 the Northwest Coast Hall continued to undergo refinements. Details were changed in the canoe group, the Eskimo exhibits were removed in 1916, and curator Pliny Goddard collected more totem poles in the summer of 1922, which when added to the hall completely covered the columns. "The totem poles and other objects in the hall have been adjusted so as to give the mural panels an artistic setting. These very important secondary features of the North Pacific Indian exhibit add greatly to the habitat function of the installation" (Annual Report for 1918:87). These were the years when the great Akeley Hall of African Mammals was taking shape and full-scale habitat groups were very much on the minds of the museum administration.

NATIONAL MUSEUM OF CANADA (1910–1925)

During these decades, the Canadian government had very little interest in supporting ethnological collecting and exhibition. The national anthropological collection grew out of the museum of the Geological Survey, founded in 1841. The earliest collections were of geological and archaeological material; ethnological specimens

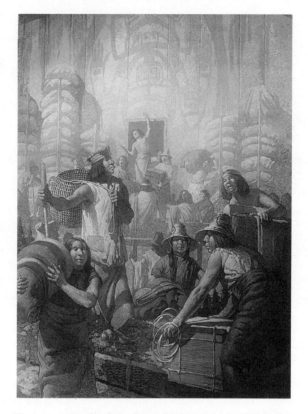

Figure 2.12. Kwakwaka'wakw potlatch painting by Will Taylor,
Northwest Coast Indian hall, American Museum
of Natural History. Photo by Julius Kirschner.
AMNH neg. no. 36079.

were added in 1877. In 1881 the Survey's museum moved from Montreal to Ottawa. Although the museum held George M. Dawson's Kwakwaka'wakw and Haida objects, display was inadequate until 1910, when the Survey formed an Anthropology Division—under the direction of Edward Sapir—and moved into the Victoria Memorial Museum Building in Ottawa (Richling 1998).

As a student of Boas, Sapir displayed the collections by culture area. The Hall of Canadian Anthropology opened in 1913, featuring the Eskimo, Eastern Woodlands, and Northwest Coast (Fenton 1986:227). Because of limited exhibition space, however, displays were representative and selective. Sapir's goal was "to give the public a general idea of the culture of the more important tribes of Canada, and of the range of implements and other objects in use among the natives" (cited in Darnell 1990:61). The preparatory staff was small, and the display style conservative. Rows of closely spaced, upright glass cases were intermingled with a few table cases, with room for storage below. There were no mannequins or life groups. Large objects covered the

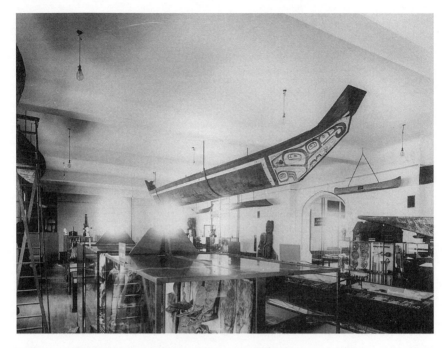

Figure 2.13. Northwest Coast Indian hall, Victoria Memorial Museum, Ottawa, c. 1915. CMC neg. no. 29153.

tops of cases, and canoes hung from the ceiling (Darnell 1990:61–62). Two totem poles were erected outside, and a special exhibit of British Columbia baskets was placed in the entrance hall in 1915.

The museum suffered severely during the First World War. The ethnology hall was closed because it could not be cleaned regularly (Darnell 1976:105), and when the Parliament Building was damaged in a fire, the legislature occupied the museum from 1916 to 1920. When the exhibits opened after the war, Anthropology added another hall for the Plains and Plateau-McKenzie areas, making one hall devoted to the Ethnology of the West Coast Tribes and Eskimo and one for the Eastern and Central Tribes of Canada (Hall 1983:53). Sapir managed to rearrange and relabel the display during 1924–1925, before leaving for the University of Chicago in 1925 (Darnell 1990:83–84). The Ottawa displays, however, were to remain unchanged for many years.

OBJECT AND CONTEXT: THE DISPLAY OF THE CLASSICAL KWAKWAKA'WAKW ARTIFACT

For many, a museum is synonymous with its exhibits, and never was this truer than in Victorian America, a society convinced that the surest route to knowledge lay in

the observation and comparison of objects (Jenkins 1994; Conn 1998). As the prime medium of communication with the public, the exhibit was, and still is, a tangible and visible expression of a museum's fundamental concepts and values. In interpreting these products, however, one must remember that an exhibit is a super-artifact, created by group labor, and while the curator may serve as director, he or she must cooperate with a range of superiors and subordinates. Thus unlike scholarly texts, the museum display allows anthropological ideas to be mediated by those with other professional aims, and it is in their cooperation with exhibit designers that anthropologists are most influenced by the visual art world of their time.

In discussing the transformative power of museums, André Malraux noted that museums "have tended to estrange the works they bring together from their original functions and to transform even portraits into 'pictures'" (Malraux 1967:9). Now these objects take their meaning more from the other objects and setting around them than from their place in their original culture. It is common to speak of a museum taking the object out of context. While this may be true from the standpoint of the originating culture, all museum displays create some kind of context, some kind of surrounding, for the object. In an anthropology museum, the curators are using this context to say something about generic human culture or a specific culture.

In the museum environment, it is the logic of juxtaposition that largely gives meaning to the object, or more precisely, suggests which of an object's many possible meanings will be stressed. Unlike a film, an exhibit creates meaning flexibly as the visitor chooses where to turn in the museum corridors, a process that exhibit designer Michael Brawne (1982:9–37) has characterized as "the icon and the route." The spaces in a museum may be considered according to a hierarchy, from the form of the building, to the relation of the halls, to the arrangement within the hall, to the order within the case. These formal questions of order and arrangement help control visitor perception.

On the highest level, the architecture of a museum carries a symbolic meaning (Searing 1982). For the pavilions at the expositions as well as the natural history museums considered here, the model was of great temples or palaces, with little relation between the building and the objects it housed. In fact, this contradiction was part of its point; it was an indication that these exotic artifacts had been "captured" and domesticated by Western culture, in a setting embodying that culture's most prestigious goals.

A more particular kind of meaning is created by the juxtaposition of objects within galleries. In the temporary format of the Chicago exposition, Northwest Coast artifacts were presented in several radically different surroundings. The pavilions of political entities (nation, state, and territory) demonstrated civic pride and encouraged commercial development. In most of these buildings, for example, the Alaska section, Northwest Coast artifacts were juxtaposed with raw materials on the one hand, or with the glories of manufactured goods and fine arts on the other. Hagenbeck's presentation harked back to an earlier exhibit style, as Coast Indian artifacts were

linked to exotic animals and were something of a miscellaneous sideline. Although there was no Northwest Coast presence in the pavilions of the U.S. Department of Indian Affairs in either Chicago or St. Louis, both displays demonstrated the "progress" Natives were making toward civilization when contrasted with the salvage presentations of the anthropologists.

In permanent museum displays during the period 1880–1920, Northwest Coast Indian artifacts were generally presented in natural history museums, where they shared space with animals, plants, and minerals. The clear message was that Native peoples were "natural," a production of exotic lands, to be collected, preserved, and displayed by metropolitan scientists. Only the several university anthropology museums at Harvard, Pennsylvania, and Berkeley presented them in a strictly human context. (With a few exceptions, noted in chapter 3, they were absent from art museums). Rarely were Native American artifacts juxtaposed with those of Asian civilizations such as China, India, or Japan, and almost never with European or American objects. When they were, as in the U.S. National Museum, they were displayed in a putative evolutionary series. In all cases, a wide gulf between Native American and Euro-American artifacts was expressed.

At the Chicago Fair, both of the anthropological displays (anthropology, curated by Boas, and the Smithsonian, curated by Mason) innovatively attempted to invoke a Native context, a context that lay in far-off Alaska and British Columbia. Both employed a culture area approach, placing objects together with others of the same tribe or geographic region. This was the position advocated by Boas in his 1887 debate with Mason over the principles of museum classification and display (Boas 1887a, 1887b; Mason 1887). By 1893 Mason seemed to have rejected his earlier use of cross-cultural, typological, and evolutionary case displays and adopted Boas's position. But, as Boas observed, like effects can have unlike causes, and these seeming resemblances to a Boasian position are largely the result of convergence from differing theoretical assumptions (Jacknis 1985:77–83). In this case, Mason was grouping cultures by environmental similarities, while Boas differentiated them by style. Moreover, both exhibits were compromised by practical problems: those in anthropology were somewhat jumbled and poorly documented, while the Smithsonian ran out of time and space (especially for the Northwest Coast).

With the vast increase in collecting from 1880 on, most museums arranged their halls geographically, with one often dedicated to the peoples of the Northwest Coast. The halls were arranged according to two interrelating principles of organization: by tribe (Kwakwaka'wakw, Haida, or Tsimshian) and by cultural domain (subsistence, clothing, transportation, and so forth). This system has remained to this day the fundamental principle of order for ethnological displays.

Beyond the classificatory shift, the Northwest Coast exhibits at the Chicago fair *looked* different. The contextual approach was depicted, mimetically, by means of houses and life group dioramas. According to the official history, "Here the groups of Native American peoples were to be arranged geographically, and to live under

normal conditions in their natural habitations during the six months of the Exposition" (Johnson 1898:315). There was a Tsimshian housefront at the Centennial Exposition, but this was the first time that a group of houses and poles were combined (even more so, along a shore) to invoke a Northwest Coast environment, the model for many more totem pole parks to follow in British Columbia and Alaska. However, the conditions of the fair were hardly "normal" or "natural." Moreover, this assemblage displayed a great deal of anthropoetic license, combining poles with diverse functions from different tribes, before a village of only two houses, also with distinct styles and structures. In any case, it is unlikely that the average visitor was in a position to grasp the extent of the creative recombination involved. The Skidegate house models represented an interesting and different attempt at re-creating a village plan context. Paradoxically, while they were Native-made displays, they were a kind of tourist art. Like argillite sculpture, they were a portable reduction of Haida culture commissioned by a white man (Wyatt 1984:46–52).[47]

Like the period room in history or art museums, life groups often employ houses, parts of houses, and houselike spaces. Period rooms and life groups have a parallel with natural history dioramas, all introduced to museums around the same time. It was perhaps not coincidental that the life group made its debut in America along with the display of living peoples. As Holmes noted, "for exposition purposes," these live groups were superior to mannequins: "the real family, clothed in its own costumes, engaged in its own occupations, and surrounded by its actual belongings, would form the best possible illustration of a people" (Holmes 1903:201). However, besides the great trouble and expense, the real people would have to scatter at the close of the fair. On the other hand, "the creation of a set of adequate and artistic lay-figure groups forms a permanent exhibit, which, set up in a museum, continues to please and instruct for generations" (ibid.). While the life group appeared to be more realistic and contextual than older exhibit styles, it still involved a great deal of anthropological and artistic construction.

Paradoxically, Franz Boas, who would have been expected to support life group dioramas, was critical of them in practice (Jacknis 1985:97–103). While they excelled at reproducing the local context of an object, in Boas's mind life groups were not worth their great cost in money and effort. First, he felt that the limitations of technique and setting would undermine a realistic effect, and thus their depiction of exotic cultural settings. As a man of science, Boas was worried that their undeniable "element of impressiveness" might "overshadow the scientific aim which they serve"; in other words, that visitors might be so interested in the display techniques of the group that they would lose sight of the curatorial point.[48] And, even when they were useful, he feared that their effect was dulled through repetition within a gallery or museum. Other curators, however, such as Dorsey and Barrett, eagerly exploited the medium.

Dependent as they are on reconstruction, life groups and period rooms leave much more room for curatorial creativity. For instance, in Boas's cedar crafts dio-

rama, the combination of so many diverse types of behaviors in one scene would have been highly unlikely in "real life." This issue of the general versus the specific was addressed by George Dorsey in his critique of the exhibits of the American Museum (Dorsey 1907; cf. Boas 1907a). Analogous to habitat dioramas with "too many" birds (Parr 1963:326), life groups often indulge in the creation of a didactic fiction. Unfortunately, as in their selection of the best (rather than average), museums rarely inform the visitor of the extent of their manipulation. Even more seriously, innumerable problems can arise when a curator decides to combine artifacts and props into such representational scenes. Inaccurate combinations may result because the museum does not have enough artifacts from a particular region to construct an entire display, or the curator does not possess enough detailed information.

In a literal sense, curators were creating what they were displaying. As Boas had done with his two life groups, Dorsey and Newcombe collected objects specifically for exhibition. But they then went a step beyond this, by actually commissioning new artifacts for their cases. Boas started by copying the Nahwitti screen displayed at Chicago, which was in turn duplicated by Dorsey and others. Taking great pains to make their exhibit ethnographically authentic, Dorsey and Newcombe went so far as to age and antique their object with features no longer current, if not gone altogether. Although the pair were basing their actions on what was sound evidence for the time, their exhibit depicted not the state of contemporary Kwakwaka'wakw culture, but their preconceptions of it, based on prior anthropological images. In turn, their work "contaminated" the representation of Kwakwaka'wakw culture for future generations, in the sense that we know the culture largely by means of these representations.

The reproduction of the hamatsa diorama was an expression of the strong competitive spirit in turn-of-the-century museums. Just as each museum needed to have a totem pole in the rotunda, so Chicago needed to be up to date with its older East Coast rivals. The fact that the hamatsa display was considered or taken up by museums in Milwaukee and Victoria tells us more about contemporary anthropological culture than about Kwakwaka'wakw life at the time. Spread through Boas's prestige in the field and the undeniably dramatic nature of the scene, the hamatsa life group, to the exclusion of many other possible subjects, became for many whites a primary representation of Kwakwaka'wakw culture. Just as the cedar crafts display was about gender presentations, domesticity, and closeness to nature, the hamatsa diorama was a depiction of ritual violence, as was noted in the performances at the Chicago fair. Even though the image of the reappearance of the hamatsa initiate was not especially violent, it was visually arresting and alluded to the theme of spirit possession and the eating of human flesh.[49]

The exhibit is the prime museum medium for the anthropologist's basic task of cultural representation, yet except in rare cases, museums never have enough space to exhibit their entire collection. On what basis do they select their artifacts for display? Just as the collector in the field passes over a large range of possible items before he

or she makes his/her limited purchases, so, too, the curator at the museum will choose only a small sample, typically less than 10 percent, from the total inventory. At both points the collector/curator is strongly guided by a personal sense of aesthetics and typicality. The object she finally selects will more likely be relatively rare, because to her it will most embody the styles and types of which the common bulk are only approximations. In evaluating the exhibit as a representation of Native culture, one must always bear in mind the constant winnowing, from field to storeroom. The exhibited artifact is apt to be archetypal rather than typical.

Despite his early efforts in the museum presentation of Kwakwaka'wakw culture, Franz Boas soon came to feel that artifacts could represent only limited aspects of a culture (Boas 1907a:928). Of these aspects, it is the material rather than the conceptual that museum displays will tend to stress. As Marjorie Halpin (1978b:44) noted, speaking of an exhibit at the Provincial Museum: "the intellectual jump from 'fishhook' to 'fishing' is much easier and more direct than the jump from 'mask' to 'cosmology.'" The fishing display in Victoria actually *showed* fish being caught in a trap, while social structure was represented by costumed mannequins of Nisga'a and Thompson headmen. While some of the cultural conceptions and social practices "responsible for" the artifacts can be explained in labels, they do a much more partial and unsatisfactory job for Society than does the fish trap model for Fishing. Anthropological displays, from Mason to the present, have stressed the role of environmental adaptation. This bias, encouraged by their setting in natural history museums, was also due to this restriction on artifacts in the task of cultural representation.

The venues of temporary expositions and permanent museum displays were critical in forming an image of Kwakwaka'wakw culture in the non-Native mind. Objects from Kwakwaka'wakw culture were detached from their originating context and made to tell a story about that culture. Most fundamental, therefore, was their shift in context and meaning across cultural boundaries. Next was their reduction to a limited, valenced version. For example, the many aspects of acculturation were left out of museum display, as in collection, in order to present a timeless "ethnographic present" before contact. These display media became perhaps the primary mode by which anthropological conceptions were diffused to the general public. As chapter 3 shows, artists were among the most receptive visitors to these displays.

3

AESTHETIC APPROPRIATION

Just as the ethnographic collecting of Kwakw<u>aka</u>'wakw artifacts effectively ceased around 1920, the corpus of these objects in the world's museums was about to begin a new life. As the interests of anthropologists moved elsewhere, the interpretation of these artifacts underwent a disciplinary shift. More or less simultaneously, American anthropology's institutional home moved from museums to the academy, its principal field site departed Native America for foreign countries, and its theoretical focus shifted from material culture and historic reconstruction to more behavioral and functional studies (Stocking 1976).

Meanwhile, movements in modern art were sensitizing Westerners to the aesthetic values of non-Western artifacts. In addition to being ethnographic specimens, classical Kwakw<u>aka</u>'wakw objects were given added significance as works of art. Although anthropological concern for these objects was relatively diminished between 1920 and 1950, the interchange between artists and anthropologists was dense and complex. As a result, the way the public views Kwakw<u>aka</u>'wakw artifacts has changed fundamentally: today an overwhelming percentage of the objects made by the Kwakw<u>aka</u>'wakw and many of those made by them in the past are considered "art," both by whites and the Kwakw<u>aka</u>'wakw themselves. Whether they inspire New York painters, are displayed in a Chicago art museum, or are sold in Vancouver galleries, these Kwakw<u>aka</u>'wakw objects live now in the art worlds created for them by whites (Becker 1982; Kopytoff 1986). At the same time, some Kwakw<u>aka</u>'wakw

have resisted this aestheticization, particularly for those objects created for a ritual context (chapter 5).

ANTHROPOLOGICAL NEGLECT

Teaching is the most direct and most important way in which the anthropological tradition dealing with Northwest Coast artifacts/art has been developed and transmitted. And just as Boas's writings, in effect, began the literature, so, too, his students and students of his students have been the most influential scholar-teachers.

SCHOLARSHIP

This being noted, it is curious that the achievement of Boas's students was generally not up to the level of their teacher. One could have imagined that his students, building upon his work, would have taken off from there and carried it further. However, most of their work was either a restatement and consolidation of his or held a minor place in their own oeuvres. While true of the region as a whole, the case is even stronger for the Kwakwaka'wakw, for not a single student of Boas did any original research on the Kwakwaka'wakw, including their art (with the minor exception of Julia Averkieva, who did not publish this research).

Reasons for this situation come readily to mind, though they remain speculations. Given Boas's long scholarly life and the fact that he and Hunt were attempting to document all of Kwakwaka'wakw culture, his students would have most likely felt their own work preempted by his, which was still in progress at his death in 1942. Moreover, the great bulk of the Boasian corpus must have appeared to answer most if not all relevant ethnographic questions. Beyond this, there was Boas's conception of anthropology as founded on salvage ethnography. Many students, like Margaret Mead, carried this belief, imbibed in the 1920s, that "the materials on which the new science [of anthropology] depended were fast vanishing, and forever. . . . The time to do the work was *now*" (Mead 1972:127). From the earliest days of collecting, the white perception had been that Native coastal cultures were shadows of their former selves, and during the 1920s, 1930s, and 1940s, many felt that the art, if not the cultures, were dead. When Boas began to encourage his students to adopt participant-observation, the Natives of the American Southwest must have seemed more thriving than those in the Northwest. Finally, when we note that even Boas's most active years of material culture research came during his decade at the American Museum, and the subsequent shift of the discipline from the museum to the academy, the relative inattention of his students to the visual arts is not surprising. The fact that none of his most important students to work on visual art—Ruth Bunzel, Gladys Reichard, and Melville Herskovits—followed him to the Northwest bears out the above suggestions.

Of Boas's students, John Swanton, Herman Haeberlin, Frederica de Laguna, Viola Garfield, Melville Jacobs, and Erna Gunther devoted themselves to the arts of the

Northwest Coast. Strictly speaking, John Swanton was a Harvard graduate, but he wrote his 1901 thesis on the Chinookan verb under Boas. In the first decade of the century Swanton made several trips to Haida and Tlingit country, making modest collections and researching the social context of their crest art (Jonaitis 1992b). Yet after this initial work his interests shifted to other topics and regions. Of Boas's first generation of students at Columbia, only Edward Sapir worked on the coast; among the Chinook in 1905, from whom he made a minor artifact collection, and after coming to Canada in 1910, among the Nuu-chah-nulth, where his collecting was more extensive. Buried within his rich textual materials is much contextual information on Native artifacts. Still, Sapir always resisted material culture research for his first love, language, and he contributed virtually nothing to the artifactual literature.

Herman Haeberlin, one of Boas's most brilliant students, conducted fieldwork among the Puget Sound Salish, worked on the 1928 monograph on Salish coiled basketry begun by James Teit (Jacknis 1992a), and managed to publish a very important and perceptive essay, "Principles of Esthetic Form in the Art of the North Pacific Coast" (Haeberlin 1918), before he died that year at the age of twenty-seven. If he had not died so young, Haeberlin's importance and influence would probably have been great.[1]

Frederica de Laguna's 1932 dissertation was a comparison of Eskimo and Paleolithic cave art, and she has remained as much a student of the Eskimo as of the Tlingit, the coastal group to which she has devoted most time. Although she is an accomplished archaeologist, in her comprehensive ethnography of the Yakutat Tlingit (de Laguna 1972) she does include much valuable data on material culture, particularly its social setting.

Viola Garfield did some important research on Tsimshian art, though she left most of it unpublished.[2] Under Boas's direct instruction, she set out in 1934 to discover how the Tsimshian artists went about their work. In the late 1930s she was a consultant for the U.S. Forest Service in its totem pole renovation project among the Alaskan Haida and Tlingit. Her task consisted mostly of ethnohistory—documenting the poles in photographs, ascertaining ownership and crests, and gathering the associated clan stories. A University of Washington colleague, Melville Jacobs concentrated on linguistics and verbal art in his research among the Salish and Chinookan peoples of Oregon and Washington.

Without a doubt, the most important of Boas's students to work with Northwest Coast material was Erna Gunther (1896–1982). However, her field research in the region was restricted to the southern peoples, Makah and Puget Sound Salish, groups not commonly recognized for their visual art. She did no original research among the Kwakwaka'wakw or more northerly groups. Rather, her significance comes from her great efforts in codifying the earlier literature, arranging many exhibitions of the art, and initiating ethnohistorical research on the artifacts (Garfield and Amoss 1984; Ziontz 1985).

From her base in Seattle, Erna Gunther was a tireless popularizer of Northwest Coast art. As Garfield and Amoss (1984:394–395) put it: "In those early years [1930s]

Gunther was always on the 'Chautauqua Circuit' speaking to Cub Scout packs, businessmen's associations, women's clubs, church groups, or lecturing to extension classes, organizing special training sessions for local Bureau of Indian Affairs employees, and the like." Her promotion of the university museum was constant: "On the local scene she brought the museum to life by sending displays to schools, giving innumerable public lectures, and by her classes, both on campus and through extension" (ibid.:395). She had a radio show, "Museum Chats," which grew into an influential television series.[3]

These students of Boas spread throughout the country to universities where they, in turn, taught others. At Columbia, Ruth Benedict, who had popularized Boas's Kwakwaka'wakw research in her 1934 *Patterns of Culture,* was the teacher of Helen Codere, who did do important research on the Kwakwaka'wakw (though nothing explicitly on art). Among Alfred Kroeber's students at Berkeley, those who worked with Northwest Coast peoples were Samuel A. Barrett, Homer G. Barnett, Ronald L. Olson, and Philip Drucker. Drucker carried out some of the only Kwakwaka'wakw fieldwork during these years. Concerned mainly with ceremonialism, in 1937 he conducted a very brief salvage survey of Fort Rupert and the Quatsino area. Yet the most important concentration of scholars, not surprisingly, was at the University of Washington in Seattle. Here Gunther, Garfield, Jacobs, and Verne Ray taught, with their first doctoral degree granted in 1951 to Salish specialist Wayne Suttles.

Until recently, the scholarship of Northwest Coast Indian artifacts has been carried out overwhelmingly by anthropologists. From time to time, those trained in the arts have examined this material, but because they have not done original field research their analyses have depended upon the prior work of anthropologists. A pioneer of a distinctly aesthetic approach was Paul Wingert, who started teaching primitive art at Columbia University in 1949. His studies of Salish (1949) and Tsimshian (1951) sculpture were the first art historical analyses of this material.

In the place of original research, this period saw several summaries based on the published ethnographies. The artist and museologist Robert Inverarity published his important compendium of photographs, *The Art of the Northwest Coast Indians,* in 1950. This was the first widely available book that treated the region's art apart from the rest of the continent. The summation of such work was Erna Gunther's *Art in the Life of the Northwest Coast Indians* (1966).

DISPLAY

The Depression hit museums particularly hard. The private philanthropists who had formerly funded them now had less to give, and the foundations that took their place were not interested in museums. New media—films, radio, and then television—replaced expositions and museums as sources of entertainment, particularly as a way of learning about distant lands. And, to a great extent, ethnographic museums had already accumulated massive collections, particularly from the Northwest Coast.

Contemporary Indians, bereft of much of their traditional material culture (or so it appeared), were no longer considered picturesque.

With the world's largest Northwest Coast collection, the displays of the American Museum of Natural History set the styles for other, smaller institutions. Almost all were arranged by culture area, and within them by tribe if there was sufficient material. Labels attempted to describe the cultural setting of the artifacts, and during the period c. 1880–1920 the visual design was generally crowded. Most Northwest Coast exhibits did not involve anything more elaborate than a few life groups, and even these were largely restricted to the large, public museums. Although a few museums employed photographs of murals, these were likewise rare. Most artifacts were fitted into a series of modular cases, and the lighting was usually dim and diffuse.

With few exceptions, these basic styles and approaches laid out in the early years of the century remained unchanged for another fifty years or more. At the American Museum, at some point all the windows in the hall were blocked up, leaving the lighting very dark. Whether intentional or not, this had the effect of further simulating the shadowy coastal forest suggested by the totem poles. For some visitors this had become a "magic place." Claude Lévi-Strauss (1943:175) referred to the "disused but singularly effective museological methods" that gave the hall "the supplementary prestige of the clair-obscur of caves and of the crumbling heap of lost treasure." The most substantial change from about 1930 to the present came in 1960, when the Haida canoe was moved into the lobby, just outside the hall.[4] Two years later, a few objects were rearranged within the cases and the graphics partly redesigned (Gardner 1985; see also Jacknis 2001).

When the Field Museum moved to a new building in 1922, the Northwest Coast exhibits were transferred relatively intact, but between 1930 and 1932 curator Ralph Linton reinstalled the collection in a large new hall. The exhibit content, however, was still basically as Newcombe had left it. Material was presented by tribe and then broken down into functional complexes. Thus there was much repetition, as fishing, for example, was presented for each tribe in turn. Unlike the more streamlined displays at the American Museum, cases at the Field Museum still offered the bulk of the museum's holdings. In the Kwakwaka'wakw section one could find the full ceremonial collection, with rather long labels based on Boas's publications. Again, the light was dim and cases crowded. This presentation remained essentially unchanged until 1975, when it began to be dismantled for the new installation.

The modest Northwest Coast displays in the U.S. National Museum were part of two halls devoted to American Indians. These, too, were little changed from the time they were first installed in the new building in 1911 until the renovation began in 1954, under the direction of John Ewers (1955). However, even then much was saved. The Chilkat Tlingit exhibit, designed by Emmons and William H. Holmes at the turn of the century, was recycled, though it went from a family group to a single figure weaving (Lohse and Sundt 1990:91).

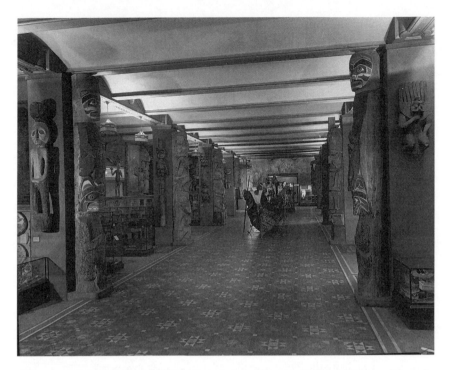

Figure 3.1. Northwest Coast Indian hall, American Museum of Natural History. Photo by Thane L. Bierwert, c. 1930. AMNH neg. no. 318931.

The Canadian national collection suffered much the same fate. Following Sapir's 1925 departure, Diamond Jenness led the Anthropology Division, with Harlan Smith supervising the exhibit program. Although the institution was officially renamed as the National Museum of Canada in 1927, little else changed. The Northwest Coast collections were modestly expanded and cared for by Marius Barbeau and Harlan Smith. In 1937–1938 Jenness instituted several changes; he combined separate tribal displays into a unified culture-area arrangement, created special temporary exhibits, added mannequins, and made better use of space and lighting (Richling 1990:250). Closed again during the Second World War (not reopening until 1947), the exhibition halls remained essentially untouched through the 1960s (Hall 1983:56; McFeat 1976:162).

On the other hand, the Depression years actually saw change in the displays of Toronto's Royal Ontario Museum (ROM). The largest metropolitan museum in Canada, the ROM has maintained important archaeological and ethnological collections since its founding in 1912. There was little Northwest Coast material, however, until the 1920s, when the museum began to acquire collections from Barbeau and curator Thomas McIlwraith (Cole 1985:289–290). When the museum added a new building in 1933, it was finally able to display its four giant Tsimshian totem poles in the stairwell off the rotunda (Dickson 1986:68).

The smaller museums in the Northwest faced similar neglect. Many museums in the region were founded fairly early, but, befitting their location on the edges of the frontier, they remained small and ignored for many decades. While the initial staff of the British Columbia Provincial Museum (1886) and the Washington State Museum (1885) were naturalists, the Vancouver City Museum (1894) was begun mostly for historical and cultural reasons. Although it is a general natural history institution, the Washington State Museum has stressed anthropology since the time of Erna Gunther's directorship (1930–1962). Often saddled with small, untrained staffs, displays at these institutions followed styles that were decades behind the East Coast. Space tended to be severely inadequate, and labeling was likely to be nonexistent. Still, curators did what they could.[5]

One must beware of taking museum displays as direct reflections of contemporary attitudes, for the construction of a permanent exhibition is so laborious and time-consuming that it can take years to build it in the first place, and many more years to change it. As Collier and Tschopik (1954:774) note, this conservatism is due "in part to the high cost of exhibits, their rapid obsolescence, and the lag between the planning and execution, which in turn results from understaffing and lack of money." But beyond these practical problems, they point out that "museums have vested interests—financial, intellectual, and occasionally, sentimental as well—in their collections and exhibits."

Like the museums of which they were the visible expression, these displays were conservative not so much out of intention as much as neglect. The great period of collecting had dissipated as curators discovered new areas of the world and fewer old objects remained on the coast. With no new collections coming in, there was less need to renovate an exhibit, and interest shifted to new kinds of display, such as the animal habitat groups. All museums suffered from the Depression, which coincided with anthropology's institutional shift from museums to academia, and with the correlated shift from research based on material culture to those less tangible aspects of society and culture.

FROM ETHNOLOGY TO ART: THE CREATION OF AN ART WORLD

Because the natural history museum was the major collector and custodian of Northwest Coast artifacts, before art museums could begin to seek them out, there had to be a transitional period when their aesthetic status was polemically proposed. As in the case of African art, artists led the way, as these exotic works resonated with their own. Avant-garde artists came to know such objects through several means—their own collecting, books, and photographs, but most importantly, museum displays—and as artists altered ways of seeing, curators began to express their changed aesthetics in new forms. Not surprisingly, these new visions, initiated by the artists,

preceded by many years any serious scholarship by art historians, who until recently have ceded the study of Northwest Coast Indian artifacts to anthropologists.

The vanguard of changing attitudes toward Native arts has consistently been the temporary exhibition. Unlike the "permanent" museum display—locked into costly institutional structures—the temporary exhibit could respond quickly to shifting points of view. The temporary exhibition had several media at its disposal. Paradoxically for a form that was supposed to be limited in time and space, it typically exerted an influence vastly out of proportion to the number of its actual visitors. Again in contrast to the permanent hall, the temporary display most often was accompanied by a catalog that for years to come could spread its message to distant readers. The display of Kwakwaka'wakw artifacts as art was accomplished by a variety of visual styles, and styles that were later employed in permanent museum halls were introduced in temporary exhibits.

EARLY ARTISTS' INTERESTS: THE STIEGLITZ CIRCLE AND INDUSTRIAL DESIGN

Although the discovery of African and Oceanic art by the Parisian artists around 1905 has been often noted, less well known is the similar discovery of American Indian art that occurred in New York just a few years later, among the painters associated with Alfred Stieglitz, the photographer and gallery owner (Levin 1984; Rushing 1995:41–96).[6] Two of these—Max Weber and Marsden Hartley—had spent time among Parisian artists and studied tribal artifacts in European museums. Upon returning to New York in 1909, Max Weber frequented the Pueblo and Northwest Coast collections at the American Museum of Natural History. Similarly, Marsden Hartley had admired the archaic works at the Trocadéro in Paris, only to discover American Indian art in the Berlin ethnographic museum in 1914–1915. While both artists were attracted to the flatness and strong decorative sense of Indian art, Hartley in particular was also drawn to the pacific, integrated society he felt had given rise to such art. Motifs from Plains and Southwestern Indian art are obvious in their paintings from this period (Rose 1967: 42–43, 55; Homer 1977:74, 129–130, 160, 227). Upon his return to the United States at the outbreak of war, Hartley traveled to Taos and Santa Fe, New Mexico, where he participated in the flourishing artists' colony, which included John Sloan, John Marin, and later, Georgia O'Keefe. Some of these artists, notably Sloan, collected and otherwise patronized Native artists, encouraging the nascent easel painting movement. In fact, Southwestern, specifically Pueblo, art made much more of an impact on this first generation than did the art of the Northwest Coast. Weber synthesized his interest in Native American art with influences from a wide range of African, pre-Columbian, Asian, and modernist art (Rushing 1995:44), and Hartley noted Northwest Coast art only in a few paintings and comments (Levin 1984:459–461). The dense personal ties that so many of these artists had to the Southwest seems to have overwhelmed any interest they may have had for the northern region.

Northwest Coast art found a somewhat more direct expression in the decorative arts. In the wake of the Arts and Crafts movement, which had stimulated a passion for collecting Indian baskets, pots, and other crafts, came an effort to adapt Native American motifs on industrially made goods. One of its leading proponents was Morris De Camp Crawford, at one time editor of *Women's Wear Daily* and a keen student of ethnic textiles. Around 1916 he helped arrange exhibits at the American Museum of Natural History demonstrating the adaptability of Native designs. Art from the Northwest Coast was again overlooked, but one show included a ceramic candlestick decorated with patterns taken from Tlingit art (Coster 1916:306). In 1918 William Laurel Harris contributed to *Good Furniture* an essay focusing on the Kwakwaka'wakw— "Native Sources for American Design: What We Can Learn from Our Northwest Indians." While praising their skill and craftsmanship, Harris (1918:232) drew moral lessons from the Kwakwaka'wakw: "The art of the wood-carving Indians of our Northwest can still teach us of today many truths concerning tenacity of purpose to overcome all obstacles in this troubled world." Underlying much of the turn to American motifs was the disruption of European sources during World War I.

In Canada this movement was anticipated by at least a decade. The earliest known application of Northwest Coast Native designs in Western art was in the decoration of the lieutenant governor's mansion in Victoria. In 1903 James Bloomfield had covered the walls of the ballroom with a creative art nouveau mélange that included Haida coppers and crest motifs. Although this striking display seems to have been little imitated, it remained untouched until the building was renovated in 1951 (Cotton 1981:103–104).

Aware of these trends, Harlan Smith (who by the teens was the curator of archaeology at Canada's National Museum) tried to arouse his adoptive countrymen to this opportunity. Writing during the war, Smith (1917; see also 1923) was especially concerned that Canada discover a source of native—that is, non-European—designs for its products. He felt that one of "the most successful of these products of distinctively Canadian design" was a ceramic bookend, inspired by a copper object from British Columbia (Smith 1918:153, pl. V). His article also offered the example of tiles developed from a B.C. blanket design (pl. X) and another copper object (pl. XIII). Although motifs from Plains and Southwestern artifacts were later adopted by Art Deco designers, these efforts by Smith and others to promote Northwest Coast patterns were largely ignored by the commercial world.

ARTIFACT AS ART: TEMPORARY EXHIBITIONS IN THE 1920s

Since 1920 a number of temporary exhibitions have claimed to be the first to show Northwest Coast artifacts as art. At each of these successive events—in 1920, 1927, 1931, 1941, and 1967, great claims for priority were often made, ignoring the important work of predecessors. Some of these exhibitions have included Northwest Coast ar-

tifacts as part of a larger display of American Indian art; others have been restricted to the region. Some have been shown at galleries, while others have been set up in museums. Finally, there is the distinction between temporary exhibits, which for these objects has usually been in art museums, and permanent installations, more often in anthropology museums.

The first public exhibition of Northwest Coast artifacts as art, in any format, seems to have occurred in London in 1920, when the Burlington Fine Arts Club presented *Objects of Indigenous American Art*. This priority was duly noted by C. H. Read of the British Museum in his preface to the catalog. Read claimed that art was universal and that each art was "the outcome of the inherent genius of the country" (BFAC 1920:vii). Even here the art of the Mesoamerican civilizations predominated over the Northwest Coast. Twenty-one objects, mostly Haida, lent by museums and private collectors, filled three cases (Cole 1985:284).

The first such North American exhibition came in December 1927, at the National Gallery of Canada in Ottawa.[7] This *Exhibition of Canadian West Coast Art: Native and Modern* was especially noteworthy, for not only were Indian artifacts displayed in an art museum, but they were shown next to paintings by white artists. This radical juxtaposition was not merely sentimental, for the primary reason for displaying the Native art was to commend it to white artists as a source of inspiration. Thus was it hoped that a genuinely Canadian art would be fostered. Eric Brown, director of the National Gallery, explicitly set out its purpose: "to mingle for the first time the artwork of the Canadian West tribes with that of our more sophisticated artists in an endeavor to analyse their relationships to one another, if such exist, and particularly to enable this primitive and interesting art to take a definite place as one of the most valuable of Canada's artistic productions" (NGC 1927:2). Just as the art of the Indian was "deeply rooted in his national consciousness," so "enough . . . remains of the old arts to provide an invaluable mine of decorative design which is available to the student for a host of different purposes and possessing for the Canadian artist in particular the unique quality of being entirely national in its origin and character" (NGC 1927:2).

The National Gallery show, sponsored jointly with the National Museum, was an outgrowth of the Skeena River totem pole preservation project (see chapter 4). In the mid-1920s, Marius Barbeau, anthropologist at the National Museum, had attracted to the area several painters—W. Langdon Kihn, A. Y. Jackson, Edwin Holgate, and others. Barbeau, as coordinator of the exhibit, selected their paintings, along with a group of Native artifacts. Following his aesthetic preferences, Barbeau's choices were overwhelmingly Haida and Tsimshian: "The Haida, the Tsimsyan and the Tlingit, to the north, were by far the best carvers and weavers. Their style was smooth, elaborate and refined. Their most accomplished artists have left works of art that count among the outstanding creations of mankind in the sphere of plastic or decorative beauty" (NGC 1927:3). Yet Barbeau could not appreciate the art of the Kwakwaka'wakw:

The southern tribes [the Kwakwa̱ka'wakw and Nuu-chah-nulth], on the other hand, could not boast of like refinement. The beings they represent on their belongings often are monsters; their features are highly conventional and grotesque. When they depict animals, the contortions of the face and the body usually belong to caricature rather than sincere realism. This contrast between the northern and southern areas on the coast is fundamental, and it is based upon cultural differences that are racial and ancient. (NGC 1927:3)

The Kwakwa̱ka'wakw artifacts chosen were mostly carved houseposts, painted screens, and masks, though the show ranged quite widely among coastal artifact types—canoes, headdresses, boxes and chests, spoons, amulets, blankets, argillite sculpture, costumes, rattles, bracelets, and hats.

Beyond the mere juxtaposition of Native and Western art, what is so distinctive about the display is the very stark and modern look of the installation. Photographs show that Native artifacts were hung on walls or placed on pedestals (figures 3.2, 3.3).[8] There were few cases and minimal labels. Such exhibit techniques clearly allied the show to art rather than anthropological museums. Because of poor publicity, the exhibit opened to somewhat low attendance in Ottawa, but it was much more popular when it traveled to the Art Gallery of Toronto and then to the Art Association of Montreal. Although Douglas Leechman (1928:331) called the exhibit a "decided success" and "a revelation," apparently the display's message fell on barren ground, as it seems not to have led to anything.

In late 1931 a group of aficionados organized an *Exposition of Indian Tribal Arts*. As they prominently stated in the catalog's subtitle, they thought it to be "the first exhibition of American Indian art selected entirely with consideration of esthetic value" (Sloan and LaFarge 1931). As all the organizers (among them the painter John Sloan, the author Oliver LaFarge, and the patron Amelia Elizabeth White) had extensive experience in the Southwest, the arts from this region were stressed. However, the exhibit was inclusive of all major types and regions of Indian art. Since the early 1920s Sloan and his friends had been exhibiting contemporary watercolors from the Southwest in art galleries, but this was the first showing in America of Indian "ethnographic" artifacts—functional weavings, bowls, pots, and so on—as art. By exhibiting these older crafts with recent easel paintings, the organizers hoped to demonstrate the living traditions of Indian artistry, with the intention of stimulating an informed, eager market.

Sponsored by the College Art Association, the Exposition of Indian Tribal Arts opened in New York's Grand Central Art Galleries. The critical reception was enthusiastic. Walter Pach, the art critic for the *New York Times*, wrote that this art was "American art, and of the most important kind."[9] As in Canada, there was a perception that Indian art should be a crucial component of an authentically American art. After a month's stay, the show traveled, with great success, to locales in the United States and Europe (Schrader 1983:49–50).

Figure 3.2. Gallery view, *Exhibition of Canadian West Coast Art,* National Gallery of Canada, 1927. NGC. **Figure 3.3.** Native artifacts and paintings by Emily Carr, *Exhibition of Canadian West Coast Art,* National Gallery of Canada, 1927. NGC.

SAN FRANCISCO WORLD'S FAIR (1939)
AND THE MUSEUM OF MODERN ART (1941)

According to many accounts (e.g., Inverarity 1950:vii; Feder 1962:1; Altman in Gunther 1966:viii), the turning point for the public appreciation of Northwest Coast artifacts as art was the two shows arranged by René d'Harnoncourt and Frederic Douglas—the American Indian exhibits at the San Francisco World's Fair in 1939 and New York's Museum of Modern Art (MOMA) in 1941 (Rushing 1992). Though they resembled in many ways the Tribal Arts show of 1931, it was these latter exhibitions that seem to have had the greatest impact. In fact, the way to their greater appreciation was paved precisely by the Tribal Arts show and critical discussion of the decade. As Rushing (1995:119) argues, it was the MOMA show especially that caught the tenor of the times, with its advocacy of a uniquely *American* art.

Although the 1941 exhibit was presented in an art museum with a different selection of artifacts, it was largely an amplified version of the 1939 show. D'Harnoncourt was the general manager of the Indian Arts and Crafts Board that sponsored the exhibit as part of the U.S. Federal Building. The Arts and Crafts Board had been created in 1935, within the Department of the Interior, with the explicit mission to encourage Native arts, mainly by education and market development (Schrader 1983). The San Francisco show was conceived in this spirit (d'Harnoncourt 1939; Schrader 1983: 163–198). Along with the positive presentation of Indian artifacts as art, part of the gallery contained a more commercial setting—a sales area and several model rooms showing how Indian crafts could harmonize with modern home décor.

Befitting its sponsorship by a New Deal agency, d'Harnoncourt's displays attempted to balance aesthetic appreciation with cultural understanding:

> Esthetics in this exhibition are therefore not an end in themselves but a means of gaining the public's attention and of creating a better understanding of the Indian's problems and talents than now exists among the public at large. . . . The exhibit must do more than show the beauty or the skillful methods of production of individual Indian works of art. It must endeavor to link these objects together in a way that gives the visitor a unified picture of the people who produced them, and some conception of the future possibilities of these people. (d'Harnoncourt 1939:164)

Using display techniques that have since become the norm for ethnographic art, d'Harnoncourt employed a variety of formal devices to symbolize the Native culture. "Color scheme, manner of lighting, and type of display have been chosen in every case to bring out the individuality of the respective culture. It is hoped that in this way the visitor will find himself in a setting that makes it easy for him to approach systematically the exhibits of the particular cultural area he is inspecting" (d'Harnoncourt 1939:165). The Northwest Coast, one of eight culture area groupings, was given two halls—a general space for "The Northern Fishermen," and a 50-foot-high tower for the totem poles. Placed under a diffuse gray light (perhaps suggested by the dis-

play in the American Museum of Natural History), the totems evoked a forest, while the darkened main room suggested a plank house interior.[10]

Cultural documentation came in the form of labels, maps, murals, and photographs, especially in the introductory room. And, of course, the use of mimetic lighting and spaces carried information. But aesthetics was not neglected: "Through limitation of the number of objects to insure generous display space and by careful selection of objects, their aesthetic merit is allowed to speak for itself. For the finest pieces of painting and sculpture a special hall has been prepared where they will be shown simply as works of art" (d'Harnoncourt 1939:167).

This was not the fair's only display of Northwest Coast artifacts. Anthropologist Erna Gunther selected 132 pieces, mainly from the Washington State Museum, for the Pavilion of Pacific Cultures, Department of Fine Arts. Northwest Coast art was displayed with art from the Pacific Rim—China, Japan, Southeast Asia, Oceania, and Middle and South America. The criteria here were even more aesthetic than in the government building. As a curator instructed Gunther: "We are striving for quality rather than for quantity. Perfection of workmanship and striking beauty are the two points we want especially to emphasize."[11] Though she was appreciative in her catalog essay (1939), Gunther kept fairly close to basic description.

The Indian Arts and Crafts exhibit was a great success. Calling it "completely authentic," with a "superb aesthetic quality," Alfred Kroeber proclaimed it "far and away the best display exhibit of Indian material or any other ethnological material which I have ever seen" (quoted in Schrader 1983:193). So arrangements were made to bring a version of it to New York.

Indian Art of the United States, opening at the Museum of Modern Art in 1941, took up the entire museum.[12] This time archaeology was added to ethnology. Although in both shows the Tlingit arts from southern Alaska were stressed, essentially for political reasons, Haida, Kwakwaka'wakw, and other cultures from British Columbia were not excluded. Outside the building stood a 30-foot totem pole carved by the Haida John Wallace at the San Francisco fair (Douglas and d'Harnoncourt 1941:160), and before the entrance to the Northwest Coast section stood a collection of mortuary poles. Again the dramatic lighting in the Northwest Coast hall suggested a house interior, with carefully placed spotlights picking out special objects, as if by firelight. Horn spoons and bowls were lit from below to bring out their translucence. D'Harnoncourt employed a wide range of display styles; while some artifacts were grouped in functional complexes—for instance, as parts of a costume—others were singled out for their aesthetic value. Labeling was generally brief and inconspicuous. This show was also a great success; an average of 1,350 visitors a day toured the installation, and the reviews were highly favorable.

Part of the power of the exhibit and its catalog, according to Rushing (1995:118), was the ambivalence between "conceptions of Native American art as either universal and understood aesthetically or as culture-specific and functionally responsive to societal needs." The latter perspective comes out strongly in the catalog. Rejecting

Figure 3.4. Northwest Coast section, *Indian Art of the United States,* 1941, Museum of Modern Art, N.Y. MOMA. **Figure 3.5.** Mask display, Northwest Coast section, *Indian Art of the United States,* 1941, Museum of Modern Art, N.Y. MOMA.

the term "primitive art," Douglas and d'Harnoncourt (1941:12) claim that "some of it reaches a level that compares favorably with the products of any of the great pre-mechanic civilizations," certainly great praise, but tempered. A better term, they think, is "folk art" because "traditional Indian art . . . is always an inextricable part of all social, economic and ceremonial activities of a given society. It creates within a collectively established scope of forms and patterns, and always serves a definite utilitarian or spiritual purpose that is accepted by the entire group."

The attitude of Douglas and d'Harnoncourt was fundamentally rooted in the Arts and Crafts movement, associated with William Morris in England and Gustav Stickley in America. They praised unalienated art that brought fine design to useful products: "The close relationship between esthetic and technical perfection gives the work of most Indian artists a basic unity rarely found in the products of an urban civilization. . . . The Indian artist, whose simple tools have always forced him to study his raw material in order to discover just what treatment will best utilize its inherent characteristics, has developed a sense of the fitness of form and material that gives distinction to all his work" (Douglas and d'Harnoncourt 1941:13). This attitude, which also was the dominant ideology of the Indian Arts and Crafts Board (note the phrase), found a welcome setting in the Museum of Modern Art, which from its founding had featured quality design in the useful, industrial arts. Douglas and d'Harnoncourt were not saying that Indian art, as good as it may have been, was the same as our own art: "Fine art in the sense of art for art's sake is a concept that is almost unknown in Indian cultures. . . . Artistic merit is simply considered a necessary by-product of good workmanship" (ibid.:13). On the other hand, the display style, with its careful arrangement and lighting, vividly encouraged visitors to appreciate these objects as works of great formal beauty. *Indian Art of the United States* had a powerful impact on many of the leading artists of New York, who went on to seriously incorporate Northwest Native styles in their own art.

SURREALISTS AND ABSTRACT EXPRESSIONISTS

From the beginning of their movement, in the early 1920s, the Surrealists were attracted to artifacts from the Northwest Coast.[13] They were among the first to value Northwest Coast Indian art on the level of mankind's greatest achievements. The painter and theorist Wolfgang Paalen (1943:6) claimed that its "expressive power . . . is second to none." The American abstractionist Barnett Newman (1946:n.p.) called this art "a valid tradition that is one of the richest of human expressions." Comparing the art favorably to that of ancient Greece and Picasso, Lévi-Strauss (1943:175) wrote prophetically: "Certainly the time is not far distant when the collections of the Northwest Coast will move from anthropological museums to take their place in art museums among the arts of Egypt, Persia and the Middle Ages."

Like most enthusiasms for primitive art by twentieth-century artists (Goldwater 1967), the Surrealists' perceptions of the art were based more on what they brought to it than on an understanding of the realities of the cultures. The Surrealists re-

garded this art as fulfilling their aesthetic ideals: an art true less to surface appearance and more to unconscious imperatives, a subconscious that was collective and universal; an art that united all Western dualities of mind/body, male/female, emotion/reason, and an art that was not alienated from daily life (Jonaitis 1981:8–17).

Collections from the Northwest Coast were not plentiful in France, but some of the group were familiar with the Musée du Trocadéro in Paris and the Museum d'Histoire Naturelle in Boulogne. André Breton, Louis Aragon, and Paul Eluard frequented the British Museum in the 1920s, and the important German collections were brought to them in a number of lavishly illustrated publications. In fact, the Surrealists were probably more familiar with Northwest Coast pieces from books than from viewing actual examples. They differed, however, in their use of anthropological research. According to Lévi-Strauss, Breton "distrusted it, he didn't like having scholarly matters get between him and the object. Max Ernst collected objects but also wanted to know everything about them" (Lévi-Strauss and Eribon 1991:34).

The Surrealists assiduously collected what few Northwest Coast artifacts did come on the market in Europe. During these years Breton and Eluard, especially, built modest collections of masks, figures, carved horn spoons, model totem poles, as well as argillite sculpture. Two of their number, the painters Kurt Seligmann and Wolfgang Paalen, actually visited the Northwest Coast, both in 1939. The Austrian-born Paalen spent four or five months there amassing one of the largest and finest collections among the group (Winter 1992). Though he favored the Haida and Tlingit, his collection did include a Kwakwaka'wakw potlatch figure (which seems to have become the most-often illustrated Kwakwaka'wakw artifact, see figure 6.25).

When many of these artists fled to New York during the war, their passions for the art blossomed in the museums of the city. Arriving mostly in 1941, the émigrés included Max Ernst, Kurt Seligmann, André Breton, Yves Tanguy, Roberto Matta, Georges Duthuit, Robert Lebel, Enrico Donati, and Claude Lévi-Strauss, the only ethnologist among them. They competed with each other in building collections—carefully selecting their gems from the curio and "junk" shops on Third Avenue, and racing each other up to George Heye's Museum of the American Indian when he casually offered to sell parts of his collection.[14] Max Ernst's first New York find was a full-size Kwakwaka'wakw interior housepost, purchased from the Brooklyn Museum via the dealer Julius Carlebach (Stokes 1987:91).

While the greatest impact of the Surrealists' enthusiasm for Northwest Coast art was in their work, as inherent publicists, they tried to spread their radical tastes in the form of exhibits and manifestos. A Paris show of 1927 combined paintings of Tanguy with "objects from America," including carvings from the Northwest Coast and Pueblos. This was the same year as the Ottawa-Toronto-Montreal show combining Northwest Coast artifacts with contemporary Canadian paintings. Of an exhibition organized by Charles Ratton in 1931 or 1932, Cowling (1978:488) has written: "It was certainly one of the first—if not the first—exhibition of Eskimo and Northwest Coast art to be held in Paris in a gallery, rather than in a specialist museum, and, hence, to lay

stress upon the artistic qualities, rather than the ethnographic interest, of the exhibits." While photographs and short pieces on Northwest Coast art ran occasionally in Surrealist "little magazines," perhaps the most substantive expression of their views came in 1943 in *Dyn*, a magazine edited by Paalen from Mexico. In a special double issue Paalen published a long, profusely illustrated essay, "Totem Art."

In the same year Lévi-Strauss contributed to an art journal an appreciation of the Northwest Coast collections of the American Museum of Natural History. Although drawing upon ethnological researches, Lévi-Strauss's essay is thoroughly a piece of poetic art criticism. Applying Surrealist tenets, he wrote: "This dithyrambic gift of synthesis, the almost monstrous faculty to perceive as similar what all other men have conceived as different undoubtedly constitutes the exceptional feature of the art of British Columbia" (Lévi-Strauss 1943:180). He marveled at the punning nature of coastal design—two creatures sharing one body, one mask face transformed into another, an animal merged with a box. Lévi-Strauss also credited his artist friends with forming his artistic sense: "Contact with the surrealists enriched and honed my aesthetic tastes. Many objects I would have rejected as unworthy appeared in a different light thanks

Figure 3.6. Cover of the Amerindian issue of *Dyn*, no. 4–5, December 1943; painting of a killer whale by James Speck (Kwakwaka'wakw).

to Breton and his friends" (Lévi-Strauss and Eribon 1991:35). Lévi-Strauss and the Surrealists also shared an interest in myths and the irrational: "The surrealists taught me not to fear the abrupt and unexpected comparisons that Max Ernst liked to use in his collages" (ibid.). The French ethnologist invoked this combinatorial freedom of the *bricoleur* in his books on mythology and the savage mind (1966).

The American Abstract Expressionists—stimulated by the Surrealists—were also inspired by Native American and other forms of "primitive art" (Varnedoe 1984; Rushing 1986, 1995:121–190). Among those who responded to Northwest Coast art during the 1940s and early 1950s were Barnett Newman, Adolph Gottlieb, Richard Pousette-Dart, and Jackson Pollack. Also attracted to the region's art were the New York painters of "Indian Space" or "Semeiology": Will Barnet, Robert Barrell, Peter Busa, and Steve Wheeler (Gibson 1983). Museums were again an artistic resource. While the displays of the American Museum of Natural History were most often frequented, these artists were also familiar with the Museum of the American Indian and the Brooklyn Museum (Weiss 1983:82; Rushing 1986:273). Most read and acquired scholarly volumes on the subject; Newman owned copies of Boas's *Primitive Art* and his 1921 monograph on Kwakwa̲ka'wakw material culture. Like the Surrealists, many (e.g., Gottlieb, Pousette-Dart, Newman) owned Northwest Coast art.

Barnett Newman, "of all the American avant-garde, demonstrated the most overt interest in Northwest Coast art" (Rushing 1988:188). Through his reading of Boas, several of whose works he owned, and Benedict's *Patterns of Culture* (1934), he singled out Kwakwa̲ka'wakw art and culture in his work. He was especially attracted to the violent side of Kwakwa̲ka'wakw ceremonialism, as expressed in the hamatsa dances. Like Paalen, Newman was an active theorist and curator. In 1946 he arranged an exhibit of "Northwest Coast Indian Painting" at the Betty Parsons Gallery in New York. While four of the twenty-eight objects came from Max Ernst's own collection, most of the others were lent by the American Museum, where they were exhibited not as art, but as ethnology.

Significantly, in this show Newman chose to focus on painting, not the more familiar sculpture. Its attraction for him lay in its abstraction. These peoples "depicted their mythological gods and totemic monsters in abstract symbols, using organic shapes, without regard to the contours of appearance" (1946). Newman directly linked Native work to that of "our modern American abstract artists," who by working with a "pure plastic language," were "creating a living myth for us in our own time." These painters appreciated Northwest Coast art for its all-over composition, bidimensionality, and its abstracted realism, and, like other artists, seem drawn to the omnipresent eye design. Yet, on the whole, they were more attracted to the *idea* of Northwest Coast art, with its perceived spiritualism, than to specific Native motifs.

Only recently has the Surrealists' passion for Northwest Coast art been widely commented upon, now that their battle has been won, with these objects entering art museums. In their own time they had little influence outside their own circle and were not quoted by subsequent scholars or the art world.[15] Yet their movement was

significant for two reasons. They were among the first to value these artifacts as art, art of the highest quality, and their movement was an expression of the fluidity between artistic and ethnological circles, at least in their place and time (Clifford 1981). The artists avidly seized upon ethnological products—books and exhibits (at times literally, with their purchases from museums), while the basic attitudes of ethnologists such as Lévi-Strauss were formed by Surrealist aesthetics.

EARLY NORTHWESTERN ARTISTS

While most of the earliest artistic appreciation of Northwest Coast Indian objects was centered in the East, painters of the region also found much to admire in these styles. In the early years of the century, Emily Carr, a young woman from Victoria, became one of the first local artists to "discover" Northwest Native art. On a tourist trip up the Inside Passage in 1907 she became possessed by the totem poles, assuming a mission to record in watercolors a vanishing lifestyle. After Kwakwaka'wakw trips in the summers of 1908, 1909, and 1912, she showed her paintings to Charles Newcombe, who was generally supportive. From then on she began to consult the collections and library at the Provincial Museum, the Vancouver City Museum and library, and the National Museum, as well as Newcombe himself. These ethnological sources were incorporated into hooked rugs and pottery she crafted with Native motifs. Though not very important, even to Carr, these were early adaptations of Native styles. Emily Carr's works, including her crafts, were given their first major public exhibition at the National Gallery exhibit in 1927, after which her art became much more symbolic and stylized.[16] Although Carr never moved far from a realistic base, and thus was not formally indebted to Northwest styles, her work brought artistic notoriety to the region's Native culture.[17]

Erna Gunther was central to the Northwest art scene. Consistently supporting the view that these Native artifacts were art, Gunther actively encouraged local Seattle artists—among them Mark Tobey (1890–1976), Guy Anderson (1906–1998), and Morris Graves (1910–2001)—to find inspiration in Native cultures. For instance, Anderson's interest in Northwest Coast art was sparked by his childhood visits to the University of Washington's museum. In the late 1940s or early 1950s, Anderson went to see the Salish dances on the Swinomish Reservation near La Conner, Washington. Accompanying him was Gunther, who had been taking her graduate students there for years, as well as Morris Graves and Eleanor King, a dancer friend of Gunther who wanted to use Native styles in her work (Kingsbury 1978:38). Anderson's later work is often marked by coastal-style eye motifs. Soon after his arrival in Seattle in 1922, Mark Tobey began collecting Northwest Coast artifacts, which found their way into his paintings as subject matter and stylistic influence (Seitz 1962:18, 47, 66). Another important artist, not as well known at the time, was Helmi Juvonen (1903–1985). Her first show, a 1934 exhibition of watercolors, was devoted to Native American subjects, and in her paintings and prints from the 1950s she made an extensive and fairly literal use of Northwest Coast graphic styles (Conkelton et al. 2000:24, 28, 42).

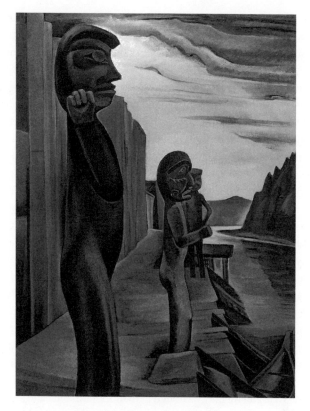

Figure 3.7. "Blunden Harbour," oil painting by Emily Carr, c. 1930. National Gallery of Canada. NGC cat. no. 4285.

There was a good bit of artist-anthropologist interchange in this circle. In the 1930s, another node was the son of the collector Charles F. Newcombe. Shy and retiring, William Newcombe was for many years the handyman for Emily Carr. Gunther visited him regularly in Victoria, often sending her friends to see him and the Newcombe collection (sold to the Provincial Museum in 1960). William Newcombe, forced out of a job at the Provincial Museum in the early 1930s, published relatively little, but was widely acknowledged as a leading expert on the material culture of the region. Anthropologists like Homer Barnett, Philip Drucker, and Harlan Smith often consulted him, he acted as an agent for collector George G. Heye; and he was the principal local guide / mentor for Wolfgang Paalen (Winter 1992:20).

Some of the artists turned to scholarship. In 1929 painter Frederic Douglas became curator of Indian Art at the Denver Art Museum, and soon was one of the country's leading experts in the subject. Douglas frequently consulted with Newcombe and Gunther regarding the Northwest Coast. Alice H. Ernst, a professor of English at the University of Oregon, spent many years in the 1930s researching the wolf rituals of

the Nuu-chah-nulth, Makah, and Quileute. Although her work grew out of her intense aesthetic attraction to their theater and the use of masks, Ernst's (1952) final report was sober and Boasian. In fact, Boas himself reviewed her manuscript with favor. But one of the most important of the artist-scholars was Robert Bruce Inverarity. A student of Mark Tobey, Inverarity was an art teacher (1927–1937), then a director of WPA art programs (1937–1941), and later a museum director. Some of this WPA work involved model making at Gunther's museum. For a good part of the 1940s, Inverarity collected photographs of Northwest Coast objects in major collections. When his book was finally published in 1950, it was the first comprehensive visual survey of the art.

More recent artists in British Columbia were also inspired by Northwest Native art. Raised in Victoria, Jack Shadbolt (1909–1998) was excited by Emily Carr's work early in his career and started sketching Native art at the Provincial Museum in the mid-1930s. However, it did not become an important subject in his paintings until after World War II. One of the leading painters in British Columbia, Shadbolt had a particular attraction for Kwakwaka'wakw styles, which is to be expected given his expressionism (Halpin 1986). Quite unlike Shadbolt's sophistication was the personal style of Dudley Carter (1891–1992). Carter grew up in family logging camps in British Columbia, and for several years in his childhood lived in Alert Bay. After a career in logging, in 1932 he turned to carving monumental wood sculptures inspired by totem poles as well several "Haida houses." Carter, who worked until his death, was known for his many sculptures in malls and other public spaces. As a self-taught artist, he had an idiosyncratic style and themes. "Though in their monumental and sculptural character, and sometimes in their themes, they resemble poles of the Northern Coast, Carter was clearly not trying to mimic the Northern tradition" (Averill and Morris 1995:155–156). With Carter as a sort of "outsider artist" exception, one notices in the work of most of these Northwestern artists a much more literal use of Native motifs than in the work of Eastern artists. One can only guess at the reasons, but perhaps the regional artists were more concerned with creating a sense of place and home.

PRIMITIVISM AND KWAKWAKA'WAKW ART

The creation of an art world for "classic" Kwakwaka'wakw artifacts is a textbook instance of what has come to be known as "primitivism."[18] This movement of twentieth-century Western art includes, first, the appreciation of tribal artifacts as art, and, second, the influence of these objects on white artists. These movements are not unrelated, of course, for it was often the artists who were in the vanguard of the aesthetic appreciation of Native "art," in our case the Surrealists in particular.[19]

By originally acquiring these objects from the Natives, the early explorers and classical anthropologists were the first to redefine and change the context of Native artifacts. Most of them regarded this material as crude art, if they viewed it as art at all.

The later artists redefined the same objects firmly as "art" rather than "artifact," and as fine art, at that. As Western concepts of art changed, with the blurring of the distinction between fine and decorative art and the appreciation of abstraction, Native arts naturally were seen in a different light. Which came first, the appreciation of exotic art or the changes in Western art, is a moot point; certainly the two stemmed from a shared cultural sensibility. Now almost all Native-made objects (both historic and contemporary) are considered art. This change in perception is perhaps the most important that has occurred to classical Kwakwaka'wakw artifacts since their initial collection.[20] Such redefinitions are by no means unique to Native American or even "primitive" art, as they apply to a great proportion of the objects in the world's art museums, from medieval crucifixes to Arts and Crafts chairs (Malraux 1967). Maquet (1979) has dubbed this phenomenon "art by metamorphosis," as opposed to work intended by its creator as art, "art by destination."

This chapter has dealt with one of the most dramatic examples of the anthropological encounter—the influence of anthropologists on the art world (museums, artists, and the market). This appropriation of Native culture by the art world parallels the creation of a separate, yet analogous one by anthropologists. Although the two disciplines have been and are distinct, they operate in parallel (collecting and marketing), if not identical modes (display and scholarship). In both cases, the net effect is the same—the incorporation of Native objects into a Western context. As James Clifford has noted, primitivism is an adjustment between two discourses in Western culture—anthropology and art—and the discovery of primitive "art" occurred at the same time as the formation of the anthropological concept of culture: "Since the early years of modernism and cultural anthropology, non-Western objects have found a 'home' either within the discourses and institutions of art or within those of anthropology. The two domains have excluded and confirmed one another, inventively disputing the right to contextualize, to represent these objects" (1985:171). While such connections are at the core of the anthropological encounter, the movement also goes in the reverse direction; artists have influenced anthropologists—in scholarship and exhibit style. Despite their differences, there has been movement between the two: "Within an institutionalized polarity, interpenetration of discourses becomes possible. Science can be estheticized, art made anthropological" (1985:172).

Western artists have reacted to Native art in two separate yet interrelated ways: First, of course, they have incorporated Native influences in their own art, and second, they have acted as propagandists. Often at the forefront in appreciating Native styles, their own interest is expressed in their private collecting, in exhibitions, and in writings. Similar examples of an art world appropriation come from the American Southwest (Eldredge et al. 1986) and American folk art (Rumford 1980).

Although all the white artists discussed above have been inspired by Indian styles, they have adopted radically different stances to it. White artists may be grouped into three categories, based on the relation of their art to Native art. First, there are the artists who use Native art as illustration or subject matter (such as Carr). These il-

lustrators reflect the first form of Western artistic appropriation. Second, there are those who have formally incorporated Native styles into their own work (such as Tobey). A third category is the conceptual; it consists of those whose relation to "primitive" art is not expressed formally at all but comes from a feeling of kinship with Native cultures and styles (this category includes many of the Surrealists and abstractionist Barnett Newman).

As a forum of social interaction, the art circles examined here are only a special subset of a larger art world, including collectors and patrons. Playing critical roles are trained anthropologists like Gunther and Lévi-Strauss and amateur ethnologists like William Newcombe. Such mediators of anthropological expertise guided artists to Native objects in museums, books, galleries, and, at times, even to reservations.

Museums and publications have been the primary medium for artistic experience with Native art. As in the Southwest, many of these artists were collectors of Indian objects (Eldredge et al. 1986:75). By constant, most of the artists inspired by Northwest Coast Indian art had very little direct contact with Natives. Not surprisingly, the Surrealists and Abstract Expressionists of New York came to know this work from museums and books, yet this was also true for many of the artists in the Northwest. Of course, there were exceptions, such as those guided by Erna Gunther (Toby, Graves, and Anderson).

Despite this access, most of these Western artists became interested in tribal art only because their own art had made it relevant (Rubin 1984:11), and, more often than not, they "creatively misread" in their understanding and adaptation of Native styles (1984:32). Speaking mostly about those influenced by African art, William Rubin claims that until the 1920s these artists were not familiar with anthropological writings (1984:1). Although they often misunderstood those writings, many of the artists considered here were certainly conversant with anthropological products. Yet, like Native artists (considered in chapter 7), these white artists tended to exploit the pictorial resources (illustrations and exhibits) and not the contextual research of anthropologists.

Regardless of these "family battles" between art and anthropology, as James Clifford reminds us, both discourses "assume a primitive world in need of preservation, redemption and representation" (1985:171). For both, classical Kwakwa̱ka'wakw culture has been the reference point, thus illustrating the colonial basis of the anthropological encounter. As explained in chapters 5 and 7, Kwakwa̱ka'wakw artists have been let into this discourse only very recently. In the aesthetic arena, while there is a structural parallel between Native and white culture, it is unbalanced. On the one hand, there is the influence of Native art on white artists, and on the other, the influence of whites on Native artists. Note that for the latter it is the influence not of white art, but of Native art as presented by whites. When working in Western art worlds, Kwakwa̱ka'wakw artists have often found themselves confined by cultural assumptions not of their making.

PART TWO

THE "RENAISSANCE" OF
KWAKWA̲KA̲'WAKW ART AND
CULTURE (1950–1980)

———————

4

MUNGO MARTIN AND THE RENAISSANCE OF KWAKWA̲KA̲'WAKW ART

W hen the Canadian Indian Act was revised in 1951, its ban against the potlatch was silently dropped. This marked—at least symbolically—the beginning of a new vitality in Native culture and of a changing white response to it. Systematic field collecting had all but ceased, and in their publications and exhibitions, Eastern artists and anthropologists were redefining classical Kwakwa̲ka̲'wakw artifacts. At the same time, professional anthropology was being established in British Columbia. Despite this local activity, there was little change in the perceived viability of Native culture. Anthropologists still regarded Kwakwa̲ka̲'wakw traditions as moribund, if not near death. But the scene had begun to change in 1949, when Kwakwa̲ka̲'wakw carver Mungo Martin agreed to come down from his home in Fort Rupert to Vancouver. There, at the University of British Columbia, he helped restore some Kwakwa̲ka̲'wakw totem poles for an intended totem pole park, which, in turn, led to similar work at the Provincial Museum in Victoria. Mungo Martin's collaboration with these museums became one of the most decisive turning points in the anthropological encounter with Kwakwa̲ka̲'wakw art.

TOTEM POLE PARKS BEFORE 1950

The totem pole park at the university was by no means the first such display in the Northwest, which goes back to the turn of the century. Before considering Mungo

Martin's experiences, it is appropriate to review these prior efforts at totem pole preservation and display, for, despite some evolution in technology and philosophy over the century, the basic approaches have changed little since the first work in Alaska. In fact, almost every method employed by Martin had been introduced prior to his Vancouver and Victoria projects.

In the development of these parks, the motives of display and preservation have been intimately entwined. Strictly speaking, a totem pole park is a form of display, whether of old poles or new, yet the initial impetus for virtually all the region's totem pole parks was preservation—generally by cleaning, repairing, and re-erecting the poles in new foundations, often on new sites. Preserved poles could have been stored indoors; in fact, that would have preserved them all the better, but storage space for monumental sculpture was quite limited and such large-scale displays were favored as the most vivid and impressive form of public show, for tourists or students. The basic rationale was to simulate the "natural habitat" of the poles—by erecting them outdoors amid trees, grass, and often water, sometimes in combination with a re-stored or re-created community house or houses. The ultimate image was a Native village.

EARLY ALASKAN EFFORTS (1900–1910)

The first attempt to restore and exhibit totem poles within the Northwest Coast region came in 1901, when Alaska's Governor John G. Brady began collecting poles with the hope of establishing a National Historic Park. Haida Indians "restored" these poles, mostly by painting. Receiving a commission to create a display for the St. Louis World's Fair, Brady was able to gather many more for his projected park. As part of the Alaska pavilion, the governor brought twenty poles and two houses, mostly from the Haida. All the poles and houses were treated by Natives, working on site before the opening of the fair. The poles were patched, recarved, and repainted, "according to their own ideas," wrote Governor Brady (Wyatt 1986:20).

After the fair, most of these poles were erected in a park in Sitka, the former capital of Alaska. The location chosen, the site of a Tlingit fort and battlefield, had been declared a public park in 1890, but as none of the poles had come from the town or immediate area, the display was not quite in situ.[1] When the poles were erected in Sitka in 1905, they were again "restored" by a local artist and photographer, E. W. Merrill. Since then many of the Sitka poles "have been patched with insert work, rotted surfaces have been trimmed away, features have been reshaped to eliminate decayed areas, and fresh coats of paint have been applied" (Knapp 1980:n.p., pole 5). It is evident how, over time, the appearance of the pole, as a representation of Native culture, could have changed radically.

In 1907 the Haida village of Kasaan, abandoned about 1900, was declared a national monument, with the intention of protecting its totems and house ruins. This was the first white attempt to display totems on an original site, but despite the plans

for a tourist attraction, its location, on Prince of Wales Island, was too remote from scheduled ship routes, and nothing ever came of the project (Keithahn 1963:115).

STANLEY PARK, VANCOUVER (1915–1925)

Bit by bit, sentiment was growing in the Northwest for the preservation and display of the region's Native heritage. The year 1915 saw the first proposal to collect a Native village and re-erect it in a city.[2] R. C. Campbell-Johnston, a mining engineer with extensive experience in Indian country, proposed to the people of Vancouver that "a whole Indian village, complete in its primeval artistic status, should be transplanted." Campbell-Johnston suggested that the interiors be used to display artifacts, arrayed as in daily life. Outside would stand a row of totem poles. A primary motivation seems to have been tourism: "All this replica [sic] of the simple grand dignity of these early native people would be an endless source of interest to all, our children and the strangers within our gates. Tourists would throng to see it."[3]

The Art, Historical and Scientific Association (AHSA), parent body of the Vancouver Museum, responded positively to Campbell-Johnston's plan, but little happened until 1920, no doubt because of the war. Serious planning for the village began in the spring of that year when Campbell-Johnston purchased in Fort Rupert a pair of houseposts, the same pair carved by Charlie James for Curtis's 1914 film.[4]

Plans for the village consistently outran achievement. Although many board members expressed general support in principle, its implementation foundered owing to a combination of lack of interest and difference of opinion. The major disagreement was whether to re-erect and restore an original house, as Campbell-Johnston advocated, or to construct a replica of new wood, stained to look old. Campbell-Johnston wanted to preserve real Native artifacts, "as replicas of olden times," while those opposed complained about the expense and the inevitable rot and decay of the wood.[5] There was also discussion over the tribal status of the village—whether it should be a generalized Northwest Coast display, of one particular tribe, or several. Campbell-Johnston first suggested a Haida example, but later held out for a village of several tribes. The consensus was that it should portray only one tribe, at least at the beginning, but the matter was settled by default, as the first poles collected were Kwakwaka'wakw, and little was accomplished beyond this.

In the end, the AHSA adopted the replica plan, and Campbell-Johnston resigned. The association then went about consulting experts and gathering sufficient information to construct a model house. Charles Newcombe told the board to contact George Hunt, and not only did Hunt send down some sketches, but he offered to come to Vancouver and superintend the construction, in exchange for his expenses and a salary of $150 a month. In May 1923 Director H. E. Carry traveled to Fort Rupert and Alert Bay to consult Natives and examine old houses (Carry 1926). Early plans called for a group of Kwakwaka'wakw to live on the site while they constructed the house and, perhaps, even new poles and artifacts for the interior. Looking to the future,

planners called for detailed records to be kept to allow reconstruction of the complex when the wood had decayed and Native artists were no longer available.[6]

Although several Kwakwaka'wakw poles were erected in Vancouver's Stanley Park, none of the houses were ever built. The Charlie James pair finally arrived in the spring of 1921, and the following year two more Kwakwaka'wakw poles came down— the pole of Sisakaulas and that of Wakas, both from Alert Bay. After much debate, a site was finally selected, near Lumberman's Arch, and after being repaired and re-painted, these four poles were erected in January 1924.

Meanwhile the AHSA struggled to secure funding. Though corporate sponsors such as the Hudson's Bay Company and the Canadian Pacific Railroad expressed some interest, very little money was ever collected. Evidently the time had not yet arrived when the local business community accepted Native culture as a project wor-thy of support. Scaled-back plans called for the construction of one house at a time, but there was never enough for even one. At the same time, Campbell-Johnston, still opposed to the board's plans, was engaged in his own efforts to construct a village, publishing in 1924 a rival to the board's fund-raising guide book (Goodfellow 1924).

Hopes for a complete Native village finally collapsed at the end of 1925 when it was discovered that the local Squamish Indians objected to having a village of their traditional enemies, the Kwakwaka'wakw, erected on the site of their potlatching grounds. Though the Squamish supported the idea of a village on another site, the AHSA had had enough and turned the poles over to the Vancouver Parks Board. Dur-ing the 1936 Vancouver Golden Jubilee celebration, several more poles were added, including an Oowekeeno example from Rivers Inlet (the Nhe-is-bik pole). A com-posite Northwest Coast style house was finally erected, but it was removed at the end of the celebration. These poles, moved to a new site in 1963 and repaired and painted many times over the decades, are all that remain of Campbell-Johnston's 1915 dream of an Indian village in Vancouver.[7]

THE SKEENA RIVER RESTORATION (1923–1930)

Soon after British Columbia's first totem park came another, this time the region's first totem park built on a Native site. Concern had been growing since the early 1920s over the decay of totems and their removal from the province. By 1923 Marius Barbeau and Harlan Smith, both of the national museum in Ottawa, were recom-mending that the most likely candidates for the effort were the poles in the Tsimshian villages along the Skeena River, and, not coincidentally, along the enormously popu-lar Canadian National Railroad (CNR) line. By June of the following year a "Totem Pole Preservation Committee" had been formed, with representatives from the Vic-toria Memorial Museum, the Department of Indian Affairs, and the Parks Branch.

Harlan Smith, chosen as field director, started the project in the summer of 1925. Work went well for the first two seasons, but in 1927 problems arose (see Darling and Cole 1980). The troubles came from a combination of Native resistance and intra-mural squabbling among the whites. The funding came about equally from the CNR

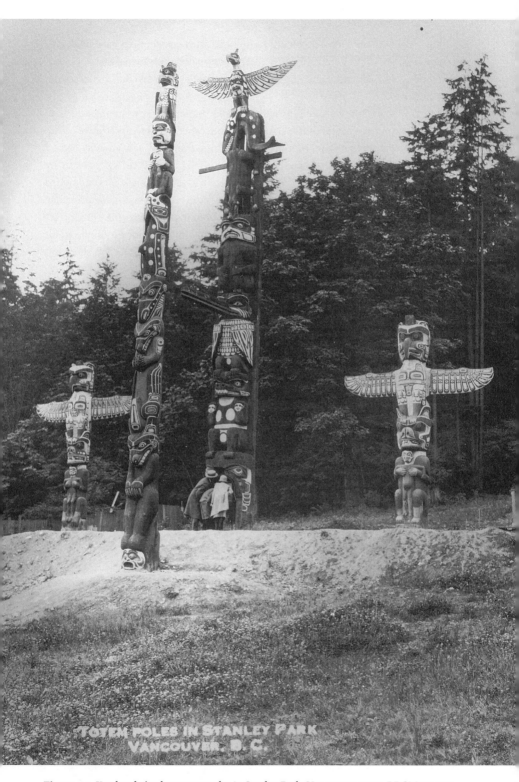

TOTEM POLES IN STANLEY PARK
VANCOUVER. B. C.

Figure 4.1. Kwakwaka'wakw totem poles in Stanley Park, Vancouver, 1930s. RBCM pn 3194.

and the Indian Affairs Department. Although the railroad seems to have been reasonably satisfied, the two federal departments concerned with Indians were continually at odds, adding to the personal friction between Barbeau and Smith, within the same institution.

Yet Native objections were still stumbling blocks. As Darling and Cole (1980:47, 48) note, "The impulse to preservation came from concerned whites appreciative of the commercial or heritage value of the poles and not from the natives who owned them. . . . The natives were obstacles to overcome—by appeals to self-interest, by employment, by purchase or 'gift.'" Smith had tried to use Native workers and hoped that Natives would prosper from the tourist trade, yet decisions were made primarily on the basis of the benefits for tourists, not the potential value to the Natives, let alone science. Smith reported a Native complaint that has remained a refrain in intercultural relations: "A few years ago, they [white men] had prohibited the erection of totem poles; why did they wish now to preserve them?"[8]

A stimulus for action in the 1920s was the widely reported removal of several totem poles from Alert Bay in 1923 (Darling and Cole 1980:30), and at least one of these poles may have gone to Stanley Park (Cole 1985:271, n. 63).[9] There was nothing special about the preservation of the Stanley Park poles; they were treated much as the Sitka poles had been. However, the Skeena restoration was a major preservation project. The motives involved in this effort link totem pole preservation with the collecting of the same time. Unlike the Sitka and Stanley Park poles, these were neither collected nor moved. The treatment applied was meant to allow the poles to remain on Native land, in the province, and in the country. But the program was an act of salvage, just like collecting. Whereas foreign collectors like Boas and Canadian collectors like Dawson both worried about the losses due to rot, fire, replacement with white goods, and so on, the Canadians felt that removing the poles from the country would have been just as much a loss, even if they had been physically preserved. The belief that the Natives would no longer be able to create new works lent even greater urgency to the project.

Although Natives were certainly the ones most directly affected by the loss of these exemplars of tradition, the many proposals instead expressed repeated concern for the possible losses to touristic display. As Harlan Smith wrote: "I think you know that I am in favour of all poles, etc., being preserved, but I wish that most of them could be preserved in situ where tourists could go and see them, and where they would be of economic advantage to our railroads, steamships, hotels, guides, etc."[10] It is unclear how much such reasoning was based on fundamental beliefs and how much on expediency, in order to get funding. Undoubtedly the project combined several motives: "The preservationist interest of the Indian Department in the poles as examples of Indian art and that of the Victoria Memorial Museum as ethnological specimens were quite compatible with the tourist interest of the railway" (Darling and Cole 1980:32).

Darling and Cole (1980:37) summarize the techniques used on the Skeena River poles: "The poles which had rotted at ground level were cut off at their bases and bolted to new well-seasoned uprights which were then creosoted and set in concrete. The concrete base was stopped short of the surface by a couple of inches and covered with sand and gravel so that no cement was visible."

As usual in totem pole preservation projects, painting turned out to be the biggest problem. Smith wanted the poles to be repainted in the old styles and with Native pigments, but there was disagreement among the few old people who could remember how they had looked, and as Newcombe had found, there was no ready source for the old colors. In the end he used toned-down commercial paints. But Smith's aesthetic choices differed from those of the Natives: "Painting is the hardest. I could not make Indians do right. They said paint or dont touch—Well, they did not understand antique painting and wanted all to look new. I three times antiqued and three times they newed it [sic]."[11] There must have been more sentiment on Smith's side, for despite his best efforts, the repainting was widely criticized for being too bright and garish. There was also criticism of the layout—all the poles were placed in straight rows. Evidently some wanted something more picturesque.

But the primary failing of the project, ironically, was not over aesthetics but preservation. The treatment did not last. In fact, it probably speeded up the fall of the poles, for they rotted at the bases of the new supports and split along the bolts. During the 1937 Skeena River floods, the Indians cut down the Kitwanga poles in order to save them, but they were poorly stored and re-erected. Above all, the poles decayed because there was no plan made for their continual care. No treatment of paint or chemicals could forestall indefinitely the effects of weather without repeated applications and constant monitoring. Neither the Natives nor the white officials supplied this (Ward 1978:6).[12]

In all, thirty poles were renovated, about half the number recommended for action in Barbeau's survey report (though not the same thirty poles). The poles were erected near their original sites (in Kitwanga and the deserted village of Kitselas), but in straight rows within view of the train tracks. The Native villages nearby were left untouched. Over the decades the poles treated by the preservation committee have suffered under the elements, and few survive in any integral shape.

ALASKAN TOTEM PARKS BETWEEN THE WARS (1938–1942)

After this burst of activity in British Columbia during the 1920s, little was done with the outdoor display of totem poles until the late 1930s. Some years of desultory efforts in Alaska finally led to a decision in 1937 to preserve and repair the surviving poles in Alaska. A year of planning and research prefaced a project initiated, directed, and carried out by the U.S. Forest Service as a program of the Civilian Conservation Corps. Though all the carving and painting was done by Native hands, the level of expertise was not high. Viola Garfield, at the University of Washington, was chosen

to collect Native traditions relevant to the poles and to edit the handbook of the project (1948, revised in 1961). From July 1938 to June 1942, approximately 250 Indians worked on a total of 121 poles: "In all, 48 old poles were restored, another 54 beyond restoration were duplicated by Native artisans, and 19 poles which existed only in memory were carved anew" (Keithahn 1963:117). This multisite effort, notable for its combination of techniques, marked the first time that replicas had been used as a form of preservation (with the originals to be stored indoors). The method was subsequently adopted as the major mode of preservation at the Provincial Museum's Thunderbird Park, and later at UBC's Totem Park.

Serious efforts were made for the work to be as "authentic" as possible, but results fell somewhat short of the mark. Again commercial paints were used, and although they were matched as closely as possible, they were matched against the weathered paint, not the paint as originally applied. A colorless preservative was used over the surface to protect against weathering. The work was done by Natives using Native tools. Yet as Garfield admits, "Because of deterioration of many poles questions concerning authentic restoration constantly arose. These were referred to older Natives, and their decision was followed" (Garfield and Forrest 1961:10).

Unfortunately, in many cases these Native experts themselves were not well-informed. "Only a few of the men who worked on the project had had any previous carving experience, though most of them had worked on houses and boats and were therefore familiar with woodworking tools" (Garfield and Forrest 1961:10). For example, one of the most experienced carvers was John Wallace of Hydaburg (Brown 1998:144). Wallace, following the path of his father, had been a carver as a boy, but had turned from this to church work. "He encouraged his people to destroy their fine carvings and helped cut down and burn totem poles in Klinkwan" (Garfield and Forrest 1961:10). Near eighty, Wallace had demonstrated carving at the San Francisco World's Fair in 1939. Charles Brown, the head carver at Saxman, though an experienced canoe and boat builder, had never carved before. Many of the younger men had little knowledge or interest in the work, and even those with talent and enthusiasm were inexperienced. The result was that the replicas varied widely from their models (see Ostrowitz 1999:42). As Steven Brown (1998:142) notes, however, "Such artists created the best Northwest Coast art that they knew how to do, during a time in which many people of today believe that no work of any traditional quality was being made at all."[13]

Unlike the later Provincial Museum program, the originals were not adequately cared for. For a time they were kept outside along the trail (those in Sitka, at least), and though stored inside after 1942, they continued to decay, owing to the lack of temperature-humidity controls (Knapp 1980).[14] Following the model of the Sitka totem park, most poles were removed from abandoned and isolated spots and placed in clusters where the descendants of their makers lived—New Kasaan, Saxman, Totem Bight near Ketchikan, Hydaburg, Klawock, Wrangell, and Sitka (the program even

replaced the Tongass pole in Seattle's Pioneer Square). Some isolated poles were also erected, as well as three community houses—at Totem Bight, Kasaan, and Shakes Island in Wrangell's inner harbor.

Plans called for an elaborate village at Mud Bight, seventeen miles north of Ketchikan. Set into the Tongass National Forest, a traditional Tlingit campsite, this was to be "a village of dwellings, smokehouses, grave houses, and totem and mortuary poles" (Garfield and Forrest 1961:71). The poles, in the form of replicas and newly created designs, were to be drawn from a number of Haida and Tlingit villages. Though the war prevented the completion of the village, a house, entrance pole, and pole near the front were finished, working from original designs of the chief carver.

THUNDERBIRD PARK AT THE B.C. PROVINCIAL MUSEUM (1940–1952)

Campbell-Johnston's vision of a "model" Indian village for a city in British Columbia finally came to fruition in 1940. Just as he was about to retire, Director Francis Kermode supervised the construction of a totem park on a site a block away from the Provincial Museum, then still housed in the Legislative Buildings. Dubbed "Thunderbird Park," the display officially opened on Empire Day, May 24. Little documenta-

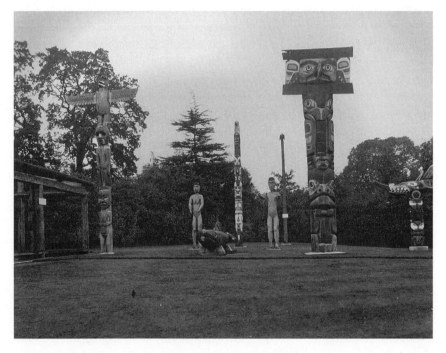

Figure 4.2. Totem poles, Thunderbird Park, Victoria. Photo by Trio Crocker, c. 1942. RBCM pn 11690.

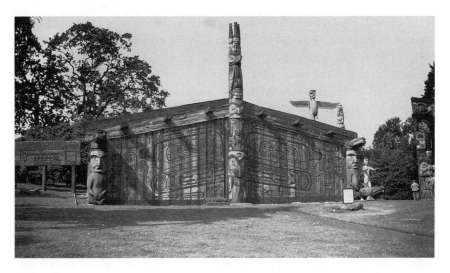

Figure 4.3. Composite Northwest Coast Indian house, Thunderbird Park, Victoria, 1940s. RBCM pn 6456.

tion has survived that can account for this project at this particular time and place, but we do know that it coincided with the founding of the Society for the Furtherance of Indian Arts and Crafts, and that Alice Ravenhill, its founder, helped Kermode in setting up the park and in composing the initial guide pamphlet.[15] One source credits its genesis to discussions between W. Kaye Lamb, the provincial archivist, and Tom Parsons, the chief constable of the provincial police, who was storing the poles in his armory (Corley-Smith 1989:101–102). Finally, it is also quite likely that the extensive Alaskan activity was a stimulus, for one frequently finds on the coast cross-influences between the state and the province.

The poles, posts, and housefronts set up in the park were the museum's existing collection of monumental sculpture, formerly stored in a warehouse. Unlike the unfulfilled plans for the Native village in Stanley Park, two Native-style "houses" were featured in Thunderbird Park. As the museum had no complete Native house in its collection and chose neither to collect one (several were still standing in Kwakwaka̱'wakw villages) nor to commission a new one, the two houses were composites. The larger one had Coast Salish frontal boards with a recently added Kwakwaka̱'wakw design,[16] a Haida frontal pole, and a Koskimo Kwakwaka̱'wakw interior post. The sides, roof, and back were open, and the frontal planks and pole were placed along the longest edge (what in a Native house would be the side). Next to this was a smaller shed with three Kwakwaka̱'wakw houseposts in the front and three Nuu-chah-nulth houseposts at the back. A panel with a Kwakwaka̱'wakw sisiyuł figure ran along the front roof edge. The house had no sides, but was roofed. With a few minor changes, this was how Thunderbird Park remained throughout the 1940s.

MUNGO MARTIN AMONG
THE ANTHROPOLOGISTS

In 1947 the University of British Columbia acquired an anthropologist—Harry Hawthorn—and a significant collection of Native artifacts—totem poles and carvings gathered that year by Marius Barbeau in Kwakwaka'wakw villages. Hunter Lewis, an English professor with an interest in Indians, initiated the latter action, and he may have been responsible for the former as well. Hawthorn's appointment marked the inception of academic anthropology in western Canada.[17]

TOTEM POLE REPLICATION AT THE
UNIVERSITY OF BRITISH COLUMBIA

A New Zealander by birth, Harry Hawthorn (b. 1910) had taken his Ph.D. at Yale in 1941 under Bronislaw Malinowski. With his arrival also came the founding of an anthropology museum, which inherited university collections dating back to 1927. Cramped for space, the museum opened in the basement of the library in 1949, with Audrey Hawthorn as curator (honorary until 1968). Audrey Engel (1917–2000)—who married Harry Hawthorn in 1941—had obtained her bachelor's and master's degrees in 1939 at Columbia. There she had studied primitive art under Ralph Linton, although Boas was still around as an emeritus professor (Inglis 1975:2; see also Hawthorn 1993).

By the fall of 1949 the President's Committee on Totem Poles had been established under the chairmanship of Lewis, with Hawthorn, German professor–turned archaeologist Charles Borden, President Norman A. M. MacKenzie, and Chancellor Eric Hamber (the source of the funds for the purchase) filling out the committee. Their task was "to be responsible to the President for the care, repair, maintenance and siting of the University collection of totem poles."[18] Lewis felt that the display should be systematic. The university, he wrote, "intends to make the collection as representative as possible of the half dozen different functional types of totem poles, of the different historical stages of totem pole carving, and of the different carving styles developed by tribes or bands scattered throughout the province."[19]

Given the decision to use the Fort Rupert poles collected by Barbeau for an outdoor totem park, it soon became obvious that almost all would need some kind of restoration work—for the sake of both appearance and preservation. In April 1948 the Vancouver-based Kwakwaka'wakw carver Ellen Neel participated in a conference on Native affairs at the UBC campus, and shortly thereafter Harry Hawthorn asked her to look over the poles and suggest ways to repair them. Neel spent some of that summer restoring the poles, but the exacting work was slow and took time away from her commercial work. The following year her uncle Mungo Martin agreed to take on the work, which he did from late 1949 to early 1950.[20]

There were no innovations in preservation techniques for the UBC project; the originals were still repaired and re-erected. Perhaps the most important feature was that, in contrast to the inexperience of the Alaskan carvers of 1938–1942, UBC em-

ployed workers who were quite intimate with the objects. Not only were they Kwa-kwaka'wakw working on Kwakwaka'wakw poles, even from their own villages, but they were working on poles by their relatives—Ellen Neel and Mungo Martin treated poles carved by Charlie James (their grandfather and stepfather, respectively), and Martin worked on a pole that he himself had carved decades earlier. In fact, he had already repaired one of these poles before. Like the sisiyutł figure, the Charlie James pole had been singed in a fire, and Barbeau had it "partly re-adzed and redecorated before shipping by Mungo Martin" (Barbeau 1950:374).

Despite this continuity, there were numerous differences between the poles as orig-inally carved and their restored versions. Martin was given the task of restoring the Sea-Raven pole, one of his first major commissions, erected c. 1912 in Alert Bay.[21] From Hunter Lewis's detailed record of the treatments,[22] one can see what was involved:

(1) This pole had to be entirely re-adzed in order to get the paint off so that it could be treated with preservatives.
(2) The raven . . . was decayed and had to be fully recarved. This work was done by Spruce Martin of Fort Rupert.
(3) The figure immediately below the Raven—a head framed by the sea-lion's tail . . . was decayed and had to be recarved.
(4) Because of rot and insect borers the D'sonoqua . . . figure had to be reconstructed with inlays and largely recarved.
(5) The missing arms had to be recarved.
(6) A large number of miscellaneous inlays (35 to 40) had to be made to replace de-cayed or insect-infested wood which was cut out.
(7) Re-painted.

Photographs of the Sea-Raven pole in Alert Bay and after restoration in Vancou-ver clearly reveal the changes possible during preservation (figures 4.4, 4.5). The most noticeable difference is in the raven figure at the top. Originally its wings were out-stretched, lending an impressive air to the piece, while the restored figure has wings drawn up to its side. Numerous differences can be seen between the two painting schemes. Generally, Martin had taken the opportunity to make the new version more "decorative"; in most areas he added design units—in eyes, joints, ears, noses—where before there had been a uniform painted area.

Similarly drastic action was performed on the sisiyutł figure. Because of the fire it was re-adzed and repainted before coming down to Vancouver, but this treatment had to be repeated—the paint would not bind to the pole, and it had been placed over decayed wood. The core was so decayed that it was sawn open longitudinally, cleaned out, the upper half of the top figure replaced, and the bottom figure recarved and spliced to the pole. After numerous inlays, the pole was painted.

All the poles were treated with wood preservative after the holes and cracks had been packed with caulking compound and the exposed end-grain surfaces had been protected with buttering compound. They were then erected on a cement base in-sulated from the pole's base.

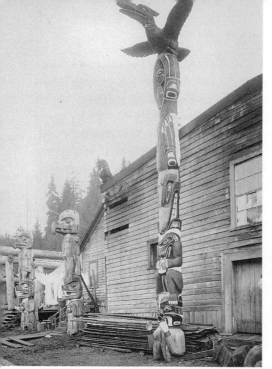

Figure 4.4. House with sea raven pole by Mungo Martin, Alert Bay, 1920s? RBCM pn 11711.
Figure 4.5. Sea raven pole by Mungo Martin, after restoration (left), University of British Columbia. Photo by William McLennan, 1999. UBC cat. no. A50037.

Hunter Lewis had definite ideas about the proper siting for the poles. Perhaps mindful of the negative criticism directed at the Skeena restoration, where the poles were mechanically lined up in straight rows, Lewis recommended that the poles be sited on the basis of appearance and Native practice. Fearing an obtrusive approach that "cheapens them, weakens their effect, and decreases the distinction which the University should acquire," Lewis planned for an ample site of four acres to be set aside.[23] The site was to be "selectively cleared" so that the poles would have a natural background. This would be done in stages as the collection grew, with the poles to be grouped by tribal units.[24] Lewis tried to implement an "ethno-botanical park" of flora native to the province, with signs indicating their use by the Indians. This would "form a pleasing spot in itself, and provide a reasonably naturalistic, attractive setting for the poles." While some work was begun on the native flora garden, it was ultimately carried out in another part of the campus.[25]

The Kwakwa̱ka̱'wakw section was the first part of the UBC totem park to open. During the spring and summer of 1950 the site was cleared, and by August of that year the Kwakwa̱ka̱'wakw poles that had been repaired were erected. Although the opening was planned for the fall, the illness of Chancellor Hamber postponed it until May 6, 1951. Martin was also commissioned to create two new poles, which were

erected in the spring of 1952. In addition to the poles, the park contained a Kwakwa-
ka'wakw house frame. Erected without a roof or side, the house thus followed some-
what the model of the "house" at Victoria's Thunderbird Park. No enclosed, Native-
style house had yet been installed in an urban area of the province.

Although the original intentions were to add Haida, Tsimshian, Nuu-chah-nulth, and
Coast Salish sections to the UBC totem park, after the opening of the Kwakwaka'wakw
section, little was accomplished. In part, this was due to Hawthorn's preoccupation
with the province-wide totem pole preservation program. Until this activity, 1953–1958,
the university had few poles from any of the other tribes. By the time it had built up
a sufficient collection of Haida poles, staff found that the best way to preserve them
would be to follow the example of the Provincial Museum—to keep the originals in-
doors and set up replicas outside. Simultaneously with this activity and rethinking,
the Haida artist Bill Reid was perfecting his skills. Reid, desiring to try his hand at
monumental wood sculpture after earlier training in jewelry, suggested in 1955 that

Figure 4.6. Totem pole of Chief Kalilix, carved by Mungo
Martin at the University of British Columbia,
totem pole park, 1951. Photo by William McLen-
nan. UBC cat. no. A50040.

he be allowed to fulfill the university's plan. But it was not until 1959 that funding came through, from the Canada Council, and work started. Reid searched for qualified Haida apprentices, but when none could be found, Douglas Cranmer, a Kwakwaka'wakw, was chosen. At this time, Cranmer was working informally with Mungo Martin at Thunderbird Park. There was also significant non-Native collaboration: artist John Smyly designed the exhibit and John Barnes of the Physical Plant Department constructed it under Reid's direction. When the village was completed in early 1962, it consisted of two houses and six poles, some of them free copies of poles in the collection, others original compositions by Reid in traditional styles.

While these totem poles, both restored and original, were Martin's preoccupation at UBC, in off-periods he produced a number of small items for the museum. Most were in the nature of didactic samples—paint brushes, paddles, a canoe model, bent boxes in several stages of construction (Hawthorn 1979:14–15). He also made a loom and a pattern board so that his wife Abayah could weave (a small "Chilkat" blanket and two aprons, along with a cedar bark basket and mats). These were the kinds of artifacts museums had always commissioned, artifacts that were especially hard to collect in the 1950s.

As Mungo Martin completed his two new poles, the Totem Pole Committee discussed his status. For Harry Hawthorn, Martin was "the outstanding carver in this region of formerly great carving." Given his advanced age, "presumably he has only a few years' work of this quality left in him." Accordingly, there were two possibilities. Continuing work at UBC, Martin could carve three or four additional poles. While this would result in more poles of Fort Rupert style than planned for, the museum could sell some at cost to other museums, using the money to buy poles from other tribes. The alternative was to have Martin work for the Provincial Museum, based at the carving shed at the university.[26] It was at this point that museum patronage shifted from the commissioning of specific objects to an ongoing program of support. No one at the time could have foreseen that this program would last for four decades, but the feeling was widespread that Mungo Martin was a precious resource who needed to be supported to the limit.

MUNGO MARTIN'S HOUSE AT THUNDERBIRD PARK

Harry Hawthorn and his colleagues chose the second alternative but now shifted to Victoria. In May 1952 Mungo Martin and his family arrived in the provincial capital for what was to be a three-year program of renovating Thunderbird Park. Thus the carving program at the museum was not an independent operation, but was meant as a direct continuation of the work started at the university. The anthropology curator at Victoria was Wilson Duff (1925–1976), who had studied with Hawthorn at UBC (B.A., 1949) and with Gunther at the University of Washington (M.A., 1951). Serving from 1950 to 1965 as the first trained curator of anthropology at the B.C. Provincial Museum, Duff soon sat on the B.C. Totem Pole Preservation Committee, which coordinated all such work in the province (Abbott 1981; Anderson 1996).

While Mungo Martin was renovating the totems at UBC, Wilson Duff was surveying his collections and programs. The original houses and poles erected in Thunderbird Park were continuing to decay, and Duff felt uncomfortable with their composite character. As Martin was finishing up his work at UBC, it occurred to Duff and Hawthorn that a perfect use of his talents would be to have him carve replicas of the Victoria poles, which could then be re-erected outdoors and the originals preserved inside. At the same time, it was hoped that Mungo Martin would be able to teach younger apprentices the art of totem carving.

As Hawthorn (1961:70) acknowledged, the motives of both museums were "complex: to revive the craft and replace its ceremonial base with a commercial one, to duplicate decayed carvings, perhaps to lay the foundation for new growth of the art." After Martin had been working at Victoria for two years, Duff delineated three values for maintaining the workshop: "(1) As a 'school for carving' it tends to perpetuate the art of fine totem carving. (2) As an educational and tourist attraction it is without parallel. (3) It provides permanent copies (for display outdoors wherever needed) of the best original poles, which must themselves be kept indoors."[27]

In addition to the replication work, Duff agreed to let Martin construct a new house and an original pole to replace the several composite houses in the park.[28] While the house followed basic traditional forms, concessions were made for permanence—concrete footings for the walls and houseposts and concealed supporting structural steel. The colorless preservative cuprinol was brushed on the exterior, as it was on the surfaces of all the park's exhibits. The house was also outfitted with electric lights. After about ten months of work by Martin, his son David, and a staff carpenter, the house was ready, and on December 14–16, 1953, Mungo Martin dedicated with a series of potlatches and performances.

Unlike the earlier composites, Martin's new building was to be a "real" Kwakwaka'wakw house. As Duff (1963:20) commented:

> This is an authentic replica of a Kwakiutl house of the nineteenth century. More exactly, it is Mungo Martin's house, bearing on its houseposts some of the hereditary crests of his family. This is a copy of a house built at Fort Rupert about a century ago by a chief whose position and name Mungo Martin had inherited and assumed—Naka'penkim [Nakap'ankam]. The house of old chief Naka'penkim was twice as large, but its general style of construction and the carvings on the houseposts have been faithfully copied.

Martin was reportedly born in the house of old chief Nakap'ankam, the uncle of Martin's mother (Nuytten 1982:86). However, when this house and the old house are compared, Duff's definitive statement about an "authentic replica" becomes ambiguous.

One important trait of a "real" house is having a name. Chief Nakap'ankam owned two house names, of which Martin picked Wa'waditla, or "he orders them to come inside," meaning that "the chief in this house is so powerful that he can order anyone else to come in and be his servant" (Duff 1963:21). At Martin's dedicatory potlatch, Chief Tom Omhid explained the importance of the name:

Figure 4.7. Mungo Martin house, Thunderbird Park, Victoria. RBCM pn 13195–10.

You all recognize this house, chiefs. This house is not just a made up house. Take a look at this, and that, and that (the carved houseposts). It is a copy of the first house that all you tribes used to gather in; the house that belonged to my chief; the house that belonged to Naqa'penk'em. That is the reason he can't take just anything up. After all, this house was planned long ago. This house has a story.[29]

While the creatures on Martin's houseposts are the same as in Nakap'ankam's house, they look quite different (figures 4.8, 4.9). First, the artist has reversed some of the figures. Nakap'ankam had a pair with huxwhukw (a cannibal crane) on top and a grizzly holding a copper on the bottom. The opposite pair had a dzunukwa (wild woman of the woods) on top and a grizzly holding a man on the bottom. In Martin's house, the grizzly holding the copper has been matched with the dzunukwa, and correspondingly, the grizzly with the man is under the huxwhukw. Second, whereas the man is held upside down in Nakap'ankam's house, he is right-side up in Martin's. Finally, and perhaps most significantly, the visual style of the two houses differs radically. This can be seen especially in the painting on the wings, which in Martin's version

are in the more florid style popular in the first several decades of this century. Numerous differences can also be seen in the eyes and jaws of the grizzlies (see also Nuytten 1982:87–90).

If the houseposts show some divergence, the frontal painting is even more problematic. It is hard to match up Duff's description of it with the earlier house:

> Mungo Martin's huge painting on the front of the house serves to represent yet another of the two dozen Kwakiutl tribes—the Tenaktok [Da'naxda'xw] of Knight Inlet. The design shows Tse'akis, a supernatural sea-monster shaped like a bullhead (sculpin). This design was formerly painted on the front of the house of a chief called Kwaksistala, at the village of Kalokwis [Kalugwis]. This man was a distant "uncle" of Mungo Martin. (Duff 1963:22)

Although there is no evidence of such a painting at the village of Kalugwis (on Turnour Island), there is a very similar one at Tsadzis'nukwame' (also known as New Vancouver, on Harbledown Island; see figure 4.10). Charles Newcombe's notes indicate that Kwaksistala at some point moved from Kalugwis to Tsadzis'nukwame', so Martin and Duff were probably referring to this painted house.[30] In yet a further twist, around the turn of the century there was another Kwakwaka'wakw house with a frontal painting similar to Martin's 1953 version—the Sea Monster house of John Scow, in the village of Gwa'yasdams on Gilford Island (PSC 1981; see figure 4.11). Martin's father had come from this village, and in 1908 his second totem pole was erected in front of the house.

The general configuration of Martin's Victoria facade does seem patterned after the Kwaksistala house at Tsadzis'nukwame'. Although some features of the Victoria house are close to those of this house (e.g., the eyes), other features link it to the Gwa'yasdams house (e.g., the nose). Former curator Peter Macnair speculated that Martin may have been claiming some "right" to this Gilford Island house through his paternal relation.[31] Inasmuch as the Nakap'ankam house in Fort Rupert, the one that Martin was overtly copying, may have had no frontal painting, he would have been a little "creative" in adding one to his version. But Martin acknowledged this "borrowing." As Duff reported, "He thinks this is OK because the house and especially the pole outside represent all the Kwakiutl tribes."[32] He was also aware of the stylistic differences between the sets of houseposts. He pointed out that his were "spread out more" than Nakap'ankam's and were "full size."

Several comments can be made about this synthesis of forms and crests, each reinforcing the other. First, to a great extent Kwakwaka'wakw tradition allowed such free combinations of crest and design, as long as one had legitimate rights to do so. For instance, Bill Holm was "often told by Mungo and others that something or other was a 'copy' of another object. To those old timers, 'copy' meant that the same creatures or beings were represented. Rarely did those 'copies' resemble closely the prototype" (pers. comm. 1998). Second, according to Duff, Martin based his new house on his personal knowledge of nineteenth-century houses, with no reference to pub-

Figure 4.8. Mungo Martin painting huxwhukw/grizzly bear houseposts, Thunderbird Park, Victoria. BCA cat. no. HP99438, neg. no. H–3376. **Figure 4.9.** Huxwhukw/grizzly bear houseposts, Nak̲ap'ank̲am house, Fort Rupert. Photo by Charles F. Newcombe. RBCM pn 10027.

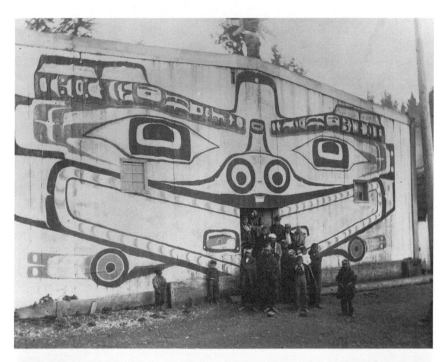

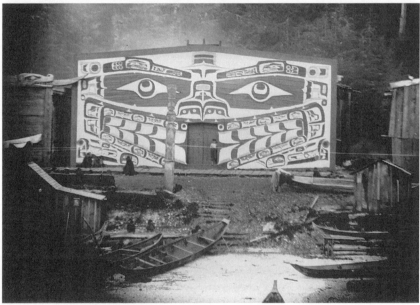

Figure 4.10. House at Harbledown Island, close-up of facade. Photo by Charles F. Newcombe. RBCM pn 949. **Figure 4.11.** House at Gilford Island, close-up of facade. Photo by Charles F. Newcombe. RBCM pn 240.

lications (and probably not to photographs, either). Thus if the models for Martin's house were transmitted by memory, they were more likely to have been creatively merged. Finally, in this non-Native context, for a house that he feared might be the last of its kind, Martin may have felt encouraged to synthesize diverse Kwakwaka'wakw forms into a kind of "super-artifact" that would represent all the Kwakwaka'wakw to the white world.

Since Mungo Martin's potlatch, the house has continued to be used. Still regarded as Martin's privilege, permission to use the house must be obtained from his grandson Peter Knox. Although other tribal groups have used it, the Kwakwaka'wakw, specifically the Hunt family, have used it most often. Martin's funeral was held there in 1962, Tony Hunt has given dances there, and the family used it in 1980 for a potlatch to mark the dedication of Richard Hunt's totem pole in the museum courtyard.

Martin's house and potlatch were so successful that there was a general outpouring of plans for an expanded Indian village. The mayor, Duff, journalists, groups such as the Victoria Chamber of Commerce and the B.C. Indian Arts and Crafts Society— all called for a new museum building and several more Native houses. While details of the plans varied, almost all stressed the tourist value of a Native village, not unlike Campbell-Johnston's original plan for Stanley Park.[33] Although a new museum building was ultimately built, a cooling of enthusiasm, and, more important, a lack of funding seem to have curtailed plans for the village.

MUNGO MARTIN'S HOUSE-OPENING POTLATCH (1953)

In December 1953 an unusual performance took place in Victoria. Within the shadow of the Parliament Buildings, Mungo Martin sponsored a potlatch to mark the opening of his community house in Thunderbird Park. Although the documentation is vague, it appears that Martin insisted on giving this potlatch as a condition for building his house in the park, and Wilson Duff agreed. Just as the house was a "real" (named) house, so was the potlatch a "real" potlatch in which names were given and property distributed. Duff and Martin were united on the importance of the event; as Duff reported, "Mungo is convinced: (a) that this will be the last 'house-warming' potlatch and (b) that nobody else but him knows how to do the whole thing properly. So he is determined that his will be authentic, so that I can record it all and have it right."[34] At the time, this view was widely popularized by Harry Hawthorn and Wilson Duff, that the Kwakwaka'wakw tradition was on the verge of collapse and that Mungo Martin was the single thread on which it depended. Martin proved to be wrong on both counts—it was not the last house opening, and he was not the only knowledgeable man left, but the strength of his feeling helps explain the nature of this performance and the careful efforts to record it. Whether future house openings occurred despite Martin's beliefs or because of it is a difficult question to answer.

The "potlatch" performance actually consisted of roughly similar events repeated over three days. The first, on December 14, was for a Natives-only audience, although

a number of anthropologists and students from UBC and the University of Washington were allowed in as "honorary Indians."[35] On the following night various high-ranking white dignitaries—provincial and local government officials, corporate sponsors, and the like—were invited, while the final night was thrown open to the general public. These three days were preceded by three evenings of rehearsals and followed the day after by some unspecified ceremonial activity at Martin's house, and on February 3, 1954, by a ceremony for taking down the dance screen.

The character of each evening changed to fit the audience. Naturally, the first night was closest to Native custom, though it was not therefore more "polished." Audrey Hawthorn reported that "for the white invitation evening, the ceremony was even more careful, the 'stage managing' went along a little quicker, and no long pauses in it." She added that "the audience clapped at each item, which increased the feeling of a stage production. It was very much shorter."[36] As there are no extensive notes on the two evenings for the white audiences, the details of these performances are unclear. From the printed program (reproduced in Nuytten 1982:90, 94), it appears that they were more of a "show," that is, with speeches and dances but no ritual events or property distribution. The final night, for the general public, attracted

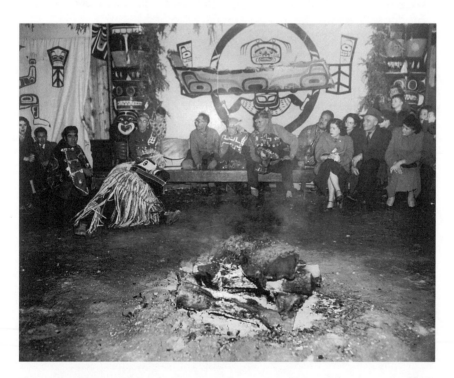

Figure 4.12. Guests watching a hamatsa raven dancer, Mungo Martin's house opening, Thunderbird Park, Victoria, 1953. CMC neg. no. 71–6900.

a great deal of press attention. The fact that hundreds had to be turned away at the door suggests the publicity value of Martin's presence in Victoria.

This potlatch is surely one of the best-recorded Kwakwaka'wakw performances ever given. The three nights of rehearsal and the first afternoon and evening were taped and later transcribed by Duff with Kwak'wala to English translation by Helen Hunt. The B.C. Government Photographic Service took still and motion pictures, and some of the anthropologists (such as Duff, Audrey Hawthorn, and Richard Conn) took notes.[37] Although Martin was certainly pleased to be able to build the house in the first place, and even more gratified to offer the potlatch, there can be no doubt that a major motivation was to put these customs on record.

Following custom, the various roles were taken on by Mungo Martin's family and friends. Tom Omhid, from Fort Rupert and renowned for his knowledge of songs and ritual, was Martin's speaker. Daniel Cranmer translated from Kwak'wala into English and also offered commentary for those not familiar with the proceedings. David Martin danced as his father's hamatsa, as he had done several times before. Henry Hunt, his wife Helen, and son Tony took roles in several dances. Charles Nowell was one of the older men versed in ritual affairs who helped direct the proceedings. Wilson Duff acted as usher, and perhaps in partial recognition of his services was given a name by Martin.[38]

The money for the potlatch came from the Martin family as well as the provincial government. The latter was responsible for those aspects related to a white audience: invitations, programs, and the seating. It also paid for dinner on the first night, and for the services of the dancers and singers for the two performances for whites, and to defray the expenses of Natives for traveling down from distant villages. On the third night, donations were accepted from the general public. Mungo and Abayah Martin were responsible for paying the participants on the first night, as well as giving out cash and token gifts to the audience for witnessing the event, amounting to $600, a considerable sum in those days. Thus the allocation of funding neatly symbolizes which parts of this performance complex were a Native ritual and which parts were non-Native shows.

The Native audience was largely, though not exclusively, Kwakwaka'wakw. Martin made a particular point of inviting and addressing the Kwakwaka'wakw from Cape Mudge, for although he had validated his position to those from around Fort Rupert at a potlatch a few years earlier, he had not yet done so for these "people from the south." Reportedly, several Natives invited to the ceremony refused to come, remembering the official prosecutions and attempts to eradicate the potlatch. The fact that this was to occur in the heart of the provincial capital must have made some uneasy.[39]

Martin's ceremony followed the general format of the winter dances, but all the action was condensed into an afternoon and evening. As speaker Omhid explained this compression, "We have taken only a little bit out of what we do. . . . It would take all day if we went into all the different parts of the great chief's *gi'gagit* (chiefly accomplishments). . . . You would never want me to stop, all you tribes, . . . if you un-

derstood every little part of my speech."[40] As Holm (1977:12, 21) has pointed out, this trend toward condensation, accelerated after the war, has been going on at least since the turn of the century.

After the traditional opening of mourning songs for recently departed relatives, there was a cradle ceremony in which Martin gave a name to a granddaughter. Then David Martin as the hamatsa rushed in, followed by the announcement that he would dance later in the evening. The afternoon session was completed with the distribution of money. After dinner came the winter dances. Speeches about the house were made, and Martin gave names to the children of Ellen Neel. Next came a series of dances: one by the hamatsa and his attendants, including those with cannibal bird masks, a bee dance, a women's dance, a tuxw'id dance, and the grand conclusion— a presentation of one of Martin's special privileges, the dance of the animals (also known as the Animal Kingdom). The evening portion had lasted from 7:15 to after midnight.

For the most part, Mungo Martin used masks and paraphernalia already in his possession, but wanting this occasion to be special and as complete as possible, he made several new pieces, most notably, four cannibal bird masks: a huxwhukw, raven, and two multiple birds (crooked beak of heaven and ravens). Costumes followed "traditional" style: button and Chilkat blankets, cedar bark head, neck, and leg rings. A range of props was also present: screens, the large cradle, rattles, drums, a frog puppet for the tuxw'id. Tradition would have mandated that Martin commission another carver to produce the required masks, but most likely he was in a hurry. Possibly he believed that he was the only one left who could do such work, although many artists—including Willie Seaweed, who had earlier made several pieces for Martin's potlatches—were still actively carving.

Speakers stressed several themes, as indicated by the transcript. An especially valuable source is the record of the rehearsals, when elders felt called upon to make explicit the rules of conduct and the reasons behind them. This traditional practice (Holm pers. comm. 1998) was undoubtedly heightened by Martin's desire for a full record and by the small, but important, white audience. The ceremonial rhetoric is virtually unchanged from that recorded by Boas and Hunt in 1894 (Boas 1897b). Throughout, the speakers refer to continuity—that this potlatch unifies the past (ancestors) with the future (descendants). Intertwined with this is the claim that nothing is made up, that the participants follow exactly what their grandparents had done:

> Why should we try to put on a different dance from what we are supposed to do? We have to follow the rules of our dances, just as we talk our language, so that we will all understand one another. Because it has been told by our old people that we must never forget. All these dances we would never have seen if our children had been weak. That is why you teach them to keep their courage. . . . We can't just walk over certain parts of the ceremonies, in our gathering here today. We are following this step by step, following what we have seen from our forefathers. We don't just think up each part of these ceremonies. . . . My children, you must follow these exactly as I have told you.[41]

A constant refrain is the necessity of following the rules so that one will not be shamed in the eyes of Natives and whites, so that one will be proud:

> We don't want to shame ourselves. We want to remember that we respect what we are going to do, that we have been brought up that way, and we mustn't throw it away. It wouldn't be him [Mungo Martin] that we would shame, we'd be shaming ourselves, and what we honour. We are to put on our best when the night comes, and remember what we have been taught, and not make a mistake. Because this potlatch business is not just a game, it is something very sacred to us, and we have to remember that.[42]

Although the potlatch proper was an event by and for Natives, they were acutely conscious of the white world. It had only been a few years since the ban on the potlatch had been lifted, and the speakers reiterated the importance of maintaining their traditions in the face of white opposition. In his final speech, talking of his rights to various privileges, Martin stressed the ancient roots that Indian people had in the province.

> I am saying all this because of what has been said to us Indians, "You just came to this country. You are a Chinaman, you are a Japnee." That is what all us tribes are called. . . . Take a look at what you see of what our people used to eat in the olden days. Clamshells as deep as this. . . . That is what your people used to eat. Today you will find great big trees growing over them, so big that these trees are old themselves. . . . The reason I am saying all this is because of what the white people say about us. Haven't they done enough now. . . . My family story really tells that they are not what they call us. My family story (nu'yem) tells. It has not just been made up recently.[43]

Nowhere were the basic themes of Mungo Martin's potlatch made clearer than in Tom Omhid's closing oration. Linking the concepts of continuity and ethnic pride to that of the name, he said: "We can never change and be different, all you tribes. 'No more potlatch' say the young men of today. What tribe are we going to be when we stop potlatching (ba'sab). We are Indians. You yourself try to forget the fact that you are an Indian. Your yourself leave your name. You will have people call you chief for nothing, leaving your real name behind."

The continuity of this potlatch with past practice was expressed bodily and physically when Martin gave a name to a now old woman who had danced as a girl in the old chief Nakap'ankam's house in Fort Rupert. The name she was given was the same one she had been given then, the song that was sung was the same, her dance was the same, and, in a real sense, the house was the same.

TOTEM POLE REPLICATION AT THUNDERBIRD PARK

Almost from the beginning of his tenure at the Provincial Museum, Wilson Duff had intended to renovate Thunderbird Park, undoubtedly with the model of UBC's program in mind. So when Mungo Martin finished his preservation work at the university, it was only natural to bring him over to Victoria to carry out a similar treatment

of these poles. However, it was decided that instead of repairing poles that would remain outside, Martin would carve replica poles, with the originals to be stored indoors. Duff probably took this idea from the earlier Alaskan program, as he wrote in 1951 to his former teacher, Viola Garfield, for her suggestions on totem preservation based on her own experience in the northern state.[44]

Before commissioning Martin, however, Duff did consider other alternatives. In addition to wooden copies, hand-carved by Natives, Duff thought of concrete copies, but there were numerous technical problems—the difficulty of making accurate casts with the extensive undercuts and checking of the poles, and the necessity of casting in many separate parts. Even if these problems could have been overcome, as they now can be with plastics, such a scheme would have done nothing for the stimulation of tradition and the handing-down of skills, nor could it replace the enormous publicity value of Native carvers at work in the park.[45]

In his work, Mungo Martin was guided by the current understanding of older Kwakwa̱ka̱'wakw styles. Like Harlan Smith, who had tried for subdued paint, and Harry Hawthorn, who had suggested that Martin leave his new poles partly painted (see chapter 7), Duff advocated restrained repainting of the replicas. In 1960 he offered advice on the repainting of old poles to Polly Sargent of the Skeena Restoration Society:

> An old totem pole cannot be restored to the point where it looks new, and no attempt should be made to do so. To cover the figures completely with paint, as has been done at Kitwanga and one or two other restorations in the area, is a mistake. It obliterates much of the remaining fine detail of the sculpture; clashes with and destroys the aged and weathered texture of the pole. Furthermore, it is usually not in any real sense "authentic" since the finest old poles, when they were new, were not painted in such a way. The over all painting of old poles can no longer be justified on the grounds that it helps in their preservation. Effective, colorless preservatives are now available. The Provincial Museum's policy is not to paint its old poles. When new copies are made in our carving workshops, we paint them only to the extent and in the manner that the old poles were painted when they were new.[46]

Duff added that if it were necessary to paint, the painting should be of small areas only, to outline facial features, for example.

This anthropological "reaction" against the all-over enamel painting of recent decades was also expressed in an acceptance of natural decay and weathering. Duff wrote to an official concerned about the "checking" (cracking in the wood) of newly carved poles: "In general we accept it as a natural phenomenon common to all cedar totem poles and do nothing about it."[47] When, in the spring of 1960, most of the poles in the park were treated with preservatives and repainted, some were left unpainted, at least in part, "as it was felt that their appearance would be improved by further weathering" (BCPM Annual Report for 1960:B23).

In most cases, evidently, Mungo Martin and his assistants were left to their own best judgments in copying and painting the replicas, and just as he had imposed his contemporary style on his old pieces at UBC, so in Victoria Martin usually gave the

decoration of the replicas his own personal stamp. These changes are readily apparent in a comparison of photographs of Martin's versions with field photographs of the original poles in situ. None of Martin's replicas were identical to the originals, though some, especially the Kwakwaka'wakw examples, were very close. Take, for example, the famous pole from Dzawadi, one of the first tall poles carved by the Kwakwaka'wakw, originally erected about 1870. By the time Martin got to it, its original paint was probably long gone; the copper on the bottom figure's chest is smaller than on the original; but, most important, the final figure (a bear?) is gone, probably because it had rotted away (figures 4.13, 4.14).

As some have argued, when the Kwakwaka'wakw carvers copied Haida poles, they did it with a Kwakwaka'wakw accent: "They are very prone, when working in the style of another tribe or in collaboration with a carver from another tribe, to impose their own irrepressible personality on either the work or the man."[48] In many cases the old Haida poles Martin was copying had lost their paint by the time they were collected, and rarely did in situ photographs record this information. The Haida memorial carving from Tanu is a good example (figures 4.15, 4.16). The thunderbird and whale were copied during the first year of the program, 1952. While the whale figure is generally close, one can find differences in the whale's eye, the eyebrow, and the eye motif on the whale's shoulder. However, the thunderbird figure on top is in a radically different style. The museum's Annual Report (1952:B21) states that "the old whale as it stood in the park was copied, and the Thunderbird was added, based on an old photograph of the figure taken in its original village." If this is so, one must conclude that only the general idea of a thunderbird was taken from the photo, for the forms are quite distinct. The Haida original has outstretched upright wings carved from separate panels, while Martin's version has wings folded into the body, carved from a single piece of wood. The painting and especially the head reveal two different tribal styles. The Haida example has a distinct northern feel, resembling Tlingit clan hats, while Martin's is thoroughly Kwakwaka'wakw, looking like an eagle welcome figure (e.g., Holm 1972a:64–65 or 1983:46–47). Perhaps the museum recognized the incongruity of these two styles, for some time later it replaced his thunderbird with one more in keeping with the original.[49]

The year 1954 was largely devoted to finishing the replications, and the following summer thirteen poles and other exhibits were erected in a newly landscaped Thunderbird Park. In 1956 totem pole replicas were erected for the first time outside of Thunderbird Park. Both were copies of Haida poles collected in 1954 by the cooperative B.C. Totem Pole Preservation Committee: a Tanu frontal pole was placed outside the B.C. building on the grounds of the Pacific National Exhibition in Vancouver, and at Peace Arch Park at Blaine, on the U.S.-Canadian border, a frontal pole from Skedans was erected. As Duff wrote:

> In doing so our main aim is to place them in appropriate places where they will be seen by the greatest number of people. . . . Title to the poles is being retained by us to en-

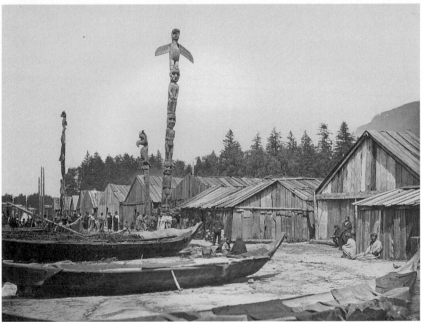

Figure 4.13. Mungo Martin's copy of a Kwakw<u>a</u>ka'wakw pole (center), Thunderbird Park, Victoria, 1952; Photo probably 30 April 1969. RBCM pn 12988–5. **Figure 4.14.** Kwakw<u>a</u>ka'wakw totem pole, Dzawadi, collected by Charles F. Newcombe in 1914 (RBCM cat. no. 1859), cf. 4.13. Photo by Edward Dossetter, 1881. AMNH neg. no. 42259.

Figure 4.15. Mungo Martin's copy of a Haida thunderbird and whale memorial carving, surrounded by other Haida poles, Thunderbird Park, Victoria. Photo by Wilson Duff, 1955. RBCM pn 13002.

sure their proper display and maintenance. We hope this programme of putting excellent poles on display in various parts of the Province will increase the public appreciation of Native art and counteract the effects of atrocious totems so frequently seen. (BCPM Annual Report for 1956:D21)

With the completion of the Thunderbird Park renovation in 1955, the carving program turned mostly to the production of new poles on commission, while strictly preservation activity lay dormant. In addition to replicas of the poles already erected in the park, versions of Haida poles, collected in 1954, were produced. The major preservation-by-replication effort in these later years (1958–1965) was the series of Kitwancool poles, in which one set of replicas was returned to the Native village and another placed in the park. After the completion of the museum's new building in 1968, many of the original poles were exhibited in a special "Glass House" addition, under climate control.

MUNGO MARTIN'S ORIGINAL TOTEM POLES

After Mungo Martin had spent a year and a half at UBC tediously restoring old totem poles, someone—perhaps Harry Hawthorn—decided that he should carve two new and original poles.[50] According to Audrey Hawthorn (1993:12), the commission grew out of conversations with Martin, who was finding the restoration work frustrating. The new poles came "perhaps at his suggestion" but also from a "growing . . . possibility within our minds." Whoever the instigator, the intent was clear: "Because of

Figure 4.16. Haida thunderbird and whale memorial carving, Tanu, Queen Charlotte Islands, cf. 4.15. Photo by Charles F. Newcombe, September 1902. RBCM pn 299, cat. no. 1393.

the slowness and expense of that process [restoration], which at best resulted in a rather perishable article, we then tried carving new ones."[51] The existing documentation suggests that the primary motivation for commissioning new poles was practicality, but undoubtedly Hawthorn and the Totem Pole Committee hoped to contribute to the growth of Native culture.[52] When he was given the task in 1951, it is probable that Mungo Martin had not carved a full-sized pole for several decades, but he launched into the work with enthusiasm in the spring and by the end of the year had completed two 50-foot poles (figure 4.6). Martin had some occasional help with these poles, probably his son David, and for each was paid about $2,500 in wages (Hawthorn 1961:66).

Figure 4.17. Haida original pole (left), collected by Charles F. Newcombe in Tanu, 1911, and copy by Mungo Martin and David Martin (right), close-up view, 31 May 1954. RBCM pn 12893.

Although Wilson Duff's primary purpose in hiring Mungo Martin was to have the totem poles in Thunderbird Park replicated, he quickly agreed to let Martin create a replica house and a completely original pole. With the completion of the replication project in 1955, Duff searched around for projects to keep Martin and his assistants employed. Frequently during this decade, the Provincial Museum found all its allotted funds depleted and was forced to lay off its carvers for the remainder of the fiscal year, in some cases up to four months. The first time this happened, at the end of 1955, the museum succeeded in gaining an outside commission for the carvers. With sponsorship by the Victoria *Daily Times,* they spent three and a half months carving (what was then, at 127 feet) the world's tallest totem pole, erected in Victoria's Beacon Park the following July (Nuytten 1982:102).[53]

Mungo Martin and Henry Hunt continued to take outside commissions. For almost a year, over 1957 and 1958, the carvers worked on a pair of poles sponsored by the Vancouver commission set up to celebrate the province's centennial. Two 100-foot poles were produced, the original to be presented to Queen Elizabeth, erected in Windsor Great Park outside of London, with a replica to be placed on a site near the Vancouver Maritime Museum. Over these years, until Martin's death, there were

many other outside commissions of poles, masks, and smaller items, allowing the carvers to continue working in the carving shed at Thunderbird Park.

Almost all these original poles differed radically in iconography, as well as form, from previous Kwakwaka'wakw examples. Mungo Martin seems to have had complete freedom in the selection of the crests for his two poles at UBC (Hawthorn 1993:12), and thus he chose crests from his own patrimony. One pole was associated with Chief Kalilix, "commemorating the head of his family line, who obtained the privilege of being served first at potlatch feasts," while the other was for Chief Kwekwelis, "honoring his father's maternal grandfather, who was noted for having given the longest potlatch of his time, at Fort Rupert" (Hawthorn 1979:73–74). So from this perspective, the poles were like traditional poles, commemorating a specific family. But there were some important changes. According to previous custom, an artist desiring objects for his own use commissioned them from other carvers. Here Mungo Martin was making his own poles. Of course, it was not actually Martin who was commissioning the poles, but the museum. Here we see the merging of family and institution as patron. From another perspective, the two poles were not really familial poles, for in the context of the UBC totem pole park, they were intended as examples of Kwakwaka'wakw tribal style.

Again in 1953 Mungo Martin was allowed to select the crests when carving his original pole for Thunderbird Park. Perhaps sensing the corporate nature of the site, with diverse tribal groups, in the shadow of the Parliament Building, Martin depicted crests from four Kwakwaka'wakw tribes—the thunderbird for the A'wa'etḻala of Knight Inlet, the grizzly bear and man for the Kwagu'ł, the beaver for the 'Nakwaxda'xw of Blunden Harbour, and the dzunukwa for the 'Namgis (Nimpkish). For the pair of centennial poles Martin again selected diverse crests, this time representing ten Kwakwaka'wakw tribes. As he said, "This will be a real totem. I designed this to show the family stories of my tribe, the Kwakiutl. This is the way we show our history" (Nuytten 1982:104). However, another outside commission of the period, the Beacon Park pole, was somewhat of a mixture. For this tallest totem pole in the world, Martin used crests from one of his own family legends (Nuytten 1982:103, 86–87), but finding himself short, he added two humans, "first men," who originated other Kwakwaka'wakw clans.

Original poles from the early 1960s combine personal and regional themes. A pole for Mexico City, carved in 1961, consists of crests of four Kwakwaka'wakw tribes to which Martin traced his ancestry: thunderbird ('Namgis), sea otter (Gwawa'enuxw), sisiyutł ("Tlitlekit," Kwagu'ł), and cedar man (Kwikwasutinuxw). Yet a newspaper account noted (probably citing museum anthropologists) that the thunderbird and sisiyutł had parallels in Mexican culture, and the sea otter represented the common Spanish exploration in Mexico and British Columbia.[54] This invention of regional associations for crests was extended in another pole of the same period. In 1961 Henry Hunt carved an original pole for British Columbia House of San Francisco. An anonymous note in museum files characterizes the thunderbird, sea otter, and man

as "appropriate Indian crests, and in addition, the sea otter will symbolize the common historical background of the whole Pacific Coast area."[55]

Certainly, the creatures depicted on these new poles were the same as those on Native ground—thunderbird, beaver, dzunukwa. What changed, in many cases, was the association of the ensemble of crests on a pole with the entire Kwakwaka'wakw people or an abstract historical theme, instead of the single individual or family of former times. This was a shift that Mungo Martin worked out over his last decade as he was repeatedly called upon to produce works that would stand in great public places. While he first used crests from his own family, he carved the poles himself; later he added other Kwakwaka'wakw figures; until finally he combined creatures from multiple Kwakwaka'wakw tribes. Even when he used his own crests, as in Mexico City, they were interpreted as representing an entire region. Thus the change in crests reflected the change in patronage from the family to a non-Native institution. At the same time, Martin seems to have been conservative, employing his own designs whenever possible.

Along with their iconographic changes, most of the original poles carved under museum auspices represented a formal shift. For the UBC poles, his first in decades, Mungo Martin adopted a style quite unlike the one he had formerly used. While the actual carving is somewhat shallow and stiff, reflecting perhaps a lack of time or Martin's advanced age, it is not far removed from his earlier poles. The painting, however, is quite different. All his life Martin had used a full covering of enamel paint, often over a white base (Howatt-Krahn 1988:161). His stepfather and teacher, Charlie James, had also employed commercial paints (although for the black he used a Native pigment). The two UBC poles were painted sparingly, only accenting certain features such as eyes, mouths, and noses. The rest of the wood was left bare. This was the direct result of museum wishes: "The outcome of many deliberations was to direct the carvers to return to the style of the first phase of contact, using steel tools but painting sparingly" (Hawthorn 1961:70).

There can be little doubt that in making this suggestion Harry Hawthorn was acting on the basis of an aesthetic preference. Hawthorn characterized three phases in postcontact Kwakwaka'wakw carving. In the first, after the introduction of steel tools, "the potential expressive range was widened; some carving became stronger in relief, some more delicate in detail. Probably originality and innovations increased" (Hawthorn 1961:69). In the second phase, associated with Fort Rupert, "intensive use of commercial paint began to supplant the sculptural quality of the poles" (ibid.). The final phase was a decline: "It can be labelled nothing other than that." Speaking at the end of the 1950s, Hawthorn acknowledged that "a few carvers work capably, even imaginatively," but he attributed this to museum support. More common were the carvers who "work crudely and repetitively, their work separated from the values of their communities and selling on a completely uninformed, external market" (ibid.).

In discussing his choice for the first phase of contact, Hawthorn (1961:70) explained why a precontact style was rejected: "A return to pre-contact style and technique would have been interesting but much more difficult on many counts: slow

Figure 4.18. Memorial post for David Martin, by Mungo Martin and Henry Hunt, erected 1959. Photo 24 October 1969. RBCM pn 2856.

manufacture, few models, and long separation from the surviving traditions." The first two postcontact phases "were creative and readily distinguishable from the recent period when the remnant of the art has been copyist but inaccurate and unschooled" (ibid.). Yet because he gives no compelling reason for choosing the earlier, more sculptural period over the later, more painterly period, one is forced to conclude that it simply did not seem to represent the best in Kwakwa̱ka̱'wakw art. A decade into the revival, Hawthorn said that the artists agreed: "These directions [to paint sparingly] grew acceptable to the carvers, and the phase of the art used as the standard for the museum revival has come to appeal to them as the peak of its achievement" (ibid.). Indeed, this more restrained style, begun by Mungo Martin and carried on by Henry and Tony Hunt, became the standard for Kwakwa̱ka̱'wakw art for more than three decades.

The museum's role in fostering this archaic style has been decisive, but it was one of which Hawthorn was fully aware. In characterizing the work of museums in such programs, he saw two paths: "conservative where standards are judged to have been maintained at a high level to the present, and returning to the past where an earlier style is rated more highly than the existing one" (Hawthorn 1961:70). Clearly, the Kwakwaka'wakw case was the latter. While such policies were influential, thought Hawthorn, they were not determinative: "Presumably such a policy will fix the nature of the art until and unless the creative innovations of new craftsmen and artists make it progressive once more" (ibid.).

Duff and his successors at the Provincial Museum reinforced this trend toward an earlier Kwakwaka'wakw style of bare wood and matte paint. Although Mungo Martin had used restrained painting for his new poles at UBC, after coming over to Victoria he reverted to his former style of all-over enamel painting. While it is impossible now to precisely ascertain responsibility in the matter, apparently it was Wilson Duff who suggested using a matte finish. After reviewing the museum's collections with Martin, Duff contacted the British American Paint Company (BAPCO) and had it make up a standard set of colors, dubbed "totem pole" paints. After many samples, they finally got a paint that resembled the old pigments mixed with salmon egg binder, which resulted in a matte finish. The Thunderbird Park carvers used the "totem pole" paints on most of their work, but especially on their replicas of Haida and Tsimshian poles.[56]

The anthropologists' desire for totem pole preservation and a surface of matte paint when preserving those poles is not surprising, as it reflected a persistence of the salvage approach of the classical era. These values of focusing on the past were then expressed aesthetically in the anthropological appreciation, even preference, for an aged patina. Wanting to return the art to the classical period, their replicas were made to look old (although not aged), and new objects (poles and house) were made in olden styles. This ideology has remained consistent, from Boas and Hunt, to Harlan Smith, to Hawthorn and Duff. Native peoples, on the other hand, have tended to take the opposite approach, as Haida carver Bill Reid once commented in a well-known passage: "It is easy to become entranced by the soft curtain of age, seeing this instead of what it obscures. An ugly building can make a beautiful ruin, and a beautiful mask in the dark of many years, softened by wear, becomes a symbol which tells us that the cycle of life, death, decay and rebirth is a natural and beautiful one" (Duff et al. 1967:n.p.). Yet, as Reid continued, "this is not what their creators intended. These were objects of bright pride, to be admired in the newness of their crisply carved lines, the powerful flow of sure elegant curves and recesses—yes, and in the brightness of fresh paint." So strong was this impulse that it was quite common for Kwakwaka'wakw owners to repaint masks before displaying them in a potlatch (Holm 1987:102–103). Thus the patinated efforts of Mungo Martin and Henry Hunt represent an accommodation to anthropological instigation.

FROM REPLICATION TO CREATION

Following Mungo Martin's death on August 16, 1962, his funeral, as mentioned earlier, was held in his big house at Thunderbird Park. Given the preservationist nature of his work during the last decade of his life, his death was appropriately marked by the playing of a tape of his own voice, recorded by Bill Holm.[57] He was honored by many—a naval ship escorted his casket to the Alert Bay cemetery, and the *American Anthropologist* published an obituary (de Laguna 1963). The last thirteen years of Martin's life, which he spent in Vancouver and Victoria, substantially changed the course of Kwakwaka'wakw art.[58]

Mungo Martin's late career (1949–1962), when he worked for the anthropology museums in Vancouver and Victoria, was critical to the evolving relationship between anthropologists and Kwakwaka'wakw art. He played a transitional role that was perceived as such even at the time. Martin's work during this period can best be seen as the creation of Kwakwaka'wakw artifacts in and for a museum context. Although this had begun as early as the classical collecting commissions, Martin's creation for the museum "storage box" was on a vastly greater and more important scale.

Although anthropologists and Natives may have been coming from different places, they moved in the same direction. The museum programs predicated on preservation were based on the common anthropological belief that Kwakwaka'wakw traditions were moribund and thus in need of salvage. These views were congruent

Figure 4.19. Mungo Martin. Photo by Jim Ryan, 1950s. RBCM pn 13492.

with Mungo Martin's own insistence on the importance of preservation and documentation (as seen in his work with anthropologists, and his help in the acquisition of the UBC collection; see chapter 8). His intense desire to maintain continuity with a threatened past was expressed repeatedly at his house-opening potlatch. Martin himself as well as the anthropologists seem to have felt that he was a thin thread of tradition, perhaps the last of a line.

Nevertheless, although garbed in the rhetoric of preservation, almost all of Martin's late work was profoundly creative, even innovative. At first glance, it may seem that his early efforts at UBC were no different from preservation treatments performed by Native artists since the turn of the century. Yet Martin expressed his creativity even in the seemingly unoriginal activity of restorations, as in the many changes he made in "repairing" his Sea-Raven Pole. Two projects began to move these efforts from preservation to creation: the creation of entirely new objects in old form (copies) and then the creation of completely original objects (though in archaic styles). His "copies," such as the "replica" of Nakap'ankam's house and the poles at Thunderbird Park, strayed rather far from the putative originals. Martin's original poles were unprecedented in Kwakwaka'wakw tradition, with their combination of a conservative, if not archaic, form and mixed iconography. Many of these objects were then presented in a museum environment as representations of Kwakwaka'wakw culture. Of course they were, but not in the neutral way the curators imagined. Instead they documented the interaction of anthropologist and Kwakwaka'wakw artists (as in the classical period of Boas and Hunt).

Over the span of these thirteen years, the essential movement of Mungo Martin's work was along the continuum from restoration to replication to creation. Viewed from another perspective, however, this was actually a move back to the past, back to Martin's period as a creative artist working for Native patrons. As he worked, his anthropological patrons began to recognize this creativity and found themselves acting, like a Kwakwaka'wakw chief in the old days, as patrons for the production of new masks and totem poles. As the carving program at the Provincial Museum continued after Martin's death, this progression toward creation became even more marked. While anthropologists never fully yielded in their archaic and salvage motives, as discussed in chapter 7, there was a new recognition of continuity and vitality of Native artistic traditions, which led to the growth of a Native clientele for their programs.

5

THE CONTEMPORARY ART WORLD

Ethnic Fine Art

I n 1967, to mark the centennial of Canadian Confederation, the Vancouver Art Gallery devoted its entire gallery space to *Arts of the Raven: Masterpieces by the Northwest Coast Indian*. The team organizing the show, selecting the works and writing the catalog were Wilson Duff, who had moved from the Provincial Museum to the University of British Columbia, Bill Holm, an artist-scholar teaching high school art in Seattle, and Bill Reid, a Vancouver artist of mixed Haida and American heritage. Like many of the temporary exhibits of the 1960s, the works were borrowed from many public and private owners across North America. The size and scope were rather large—546 objects.[1] Doris Shadbolt, the acting director of the Gallery, made bold claims in the catalog foreword for these artifacts as art: "This is an exhibition of art, high art, not ethnology. It proposes to bring together many of the masterworks of this art, to show the range and aesthetic excellence of its forms, and to explicate and establish its claim to greatness" (Duff et al. 1967:n.p.).

This aesthetic orientation was expressed by several features beyond the venue of an art museum. The works were grouped into nine sections: (1) Faces, (2) Small Sculptures in Wood, (3) Interpretation, (4) Slate, Ivory, Horn, Bone, Silver, (5) Flat Design, (6) Charles Edenshaw, Master Artist, (7) Masterpieces of Northwest Coast Indian Art, (8) Arts of the Kwakiutl, and (9) The Art Today. Unlike the cultural arrangements favored by Erna Gunther and many other exhibitors, Duff, Holm, and Reid followed formal or artistic criteria. The Edenshaw section, for example, was probably the first

Figure 5.1. Display of Kwakwa̱ka'wakw masks and ceremonial art, *Arts of the Raven*, Vancouver Art Gallery, 1967. VAG.

one-man show of a historical Northwest Coast artist, one who was then—and still is—recognized as among the finest practitioners of his craft. Similarly, the masterpieces unit singled out superlative examples, according to what the organizers hoped were the aesthetic standards of the artists. The interpretation section was arranged by Bill Holm to explain the principles of graphic design that he had codified in his recent book (1965).

Following the common distinction between northern graphic styles and the more sculptural southern style, the Kwakwa̱ka'wakw were given a room of their own, arranged and installed by Bill Holm (pers. comm. 1998). It was filled mostly with masks, but also held feast dishes, ladles, houseposts, figures, and screens. In contrast to the negative views of Kwakwa̱ka'wakw art held by George Dawson or Marius Barbeau, by the 1960s, after the work of Mungo Martin in Victoria and Vancouver, it was viewed much more positively. Duff called the Kwakwa̱ka'wakw bold, assertive, and creative: "The result is a highly distinctive, strong and flamboyant style of their own" (Duff et al. 1967:n.p.). In his appreciative catalog essay, Reid, too, had praise for Kwakwa̱ka'wakw art, as different as it was from his own Haida styles. Like Duff, stressing its theatricality, Reid wrote: "It seems that the only limitations to Kwakiutl expressiveness were those of material and techniques, and the eventual bounds of wildly untrammelled imaginations."

With two practicing artists—Holm and Reid—as organizers, it is not surprising that a room was devoted to contemporary works. Duff acknowledged that Kwa-

kwaka'wakw art had not suffered a full eclipse and was "continuing as always to find new expression." "But," he added, "now these are arts in a different sense. Though truly enough of Indian descent, they are now Canadian art, modern art, fine art." Artists represented were the Kwakwaka'wakw Douglas Cranmer, Henry Hunt, and Tony Hunt, along with a few works by the Haida Robert Davidson and many by Bill Reid. Others included the whites Bill Holm, Michael Johnson, and the Cherokee Don Lelooska Smith. Missing, however, were many of the active Blunden Harbour-Smith Inlet masters, such as Charlie George Jr., or Charlie G. Walkus (Macnair pers. comm. 1999).

The display techniques, while dramatic, were not far removed from d'Harnon-court's Museum of Modern Art installations. Like many displays since, the foyer was lined with photomurals of Native villages, portraits, and landscapes. Darkness split by dramatic lighting, suggesting a flickering fire, was effectively used. And as d'Harnon-court had done (cf. an Adena pipe, Schrader 1983:232), the gallery presented a small, intricate object, in this case a painted box, surrounded on all sides by a photomural blow-up of its surface (Reid 1981b:300–303; also in Boas 1927:276, fig. 287b; and Ward-well 1978:100). In the Kwakwaka'wakw gallery, tapes of Native music played contin-uously. The masks in this room were hung from wires or placed on thin wire pedestals over a bed of gravel.

The exhibition was a popular success, visited by over 50,000 people during its three-month run. Again, the critics were surprised at the quality of the art. John Canaday of the *New York Times* called the show "an eye-opener." According to Canaday, the In-dian found in the face, as on rattles, masks, and totems, was "the revelation of per-sonality and character. The subtlety of the Indian sculptor . . . goes beyond the for-mal sensitivities of the greatest African tribal artists to enter the area of psychological exploration typical of the great periods of European painting. And for sheer wit, the natural balance to such perceptions, the animal masks of the Kwakiutl people have never been surpassed."[2] Whether or not Canaday was accurately interpreting Native art, the point was that he was taking it very seriously.

Canaday, observing that the appreciation for this art (as measured by the sources of the loans) seemed to be restricted to the region, remarked: "The Vancouver show would be a revelation in New York or Paris." But the critic of the *Vancouver Province* was similarly impressed: "The average person brought up at [sic] the coast, who has perhaps grown blasé about Indian art, will be struck as by a revelation. The range of the work is extraordinary, from a horn spoon with an intricately carved handle to the monumental totem pole."[3] As Duffek (1983c:313) notes, the *Arts of the Raven* show has been widely regarded as a turning point for the appreciation of Northwest Coast art, leading directly to its current state of high acclaim.

By the mid-1960s, the state of Northwest Coast Indian art had changed drastically from the time of its display at the Museum of Modern Art in 1941. Around 1967 a point of transition occurred as several trends—in personnel, institutions, publication,

display, and marketing—started to thicken and entangle. Unlike the temporary exhibitions and artistic enthusiasms, they began to be institutionalized. The most critical development was the burgeoning creativity of a new generation of Native artists. After the deaths of Mungo Martin in 1962, Ellen Neel in 1966, and Willie Seaweed in 1967, the best-known Kwakwaka'wakw artists became the students of Mungo Martin: Henry and Tony Hunt and Douglas Cranmer, eclipsing those in Blunden Harbour-Smith Inlet. Also active were the Haida artist Bill Reid and his protégé Robert Davidson. For the first time in decades, the production of Coast art vastly increased. More important, there was a critical shift in audience and context for this art, from Native ritual use to primarily white aesthetic purchase. The works of contemporary artists were featured for the first time in the *Arts of the Raven* show, and this was about the same time that Tony Hunt and others began to produce silkscreen prints. Accordingly, dealers in Vancouver and Victoria opened galleries with a distinctive "fine arts" approach. The coming to terms with this basic structural shift formed the contemporary worlds of art and anthropology for Kwakwaka'wakw artifacts.

THE DEVELOPMENT OF THE ART MARKET

The structure of the Indian art market parallels ethnographic collecting. Both are systems of distribution in which artifacts move from Native makers/users to white owners, usually with the exchange of money. In a sense, collecting is a subset of the broader market, distinguished by location (in the Native village), personnel (an anthropologist or someone working for one), and final destination (the museum). Nowadays, museum anthropologists still collect, though on a much reduced scale. Yet this collecting must be radically different because of the great changes in the Native art market. In this section I cover the rise of a specialized art market and the role anthropologists have played in its development.

THE EARLY MARKET (1880–1930)

During the late nineteenth century, just as systematic ethnological collectors began to comb the region, several retailers of coastal artifacts set up shop in Victoria. Many were German Jews whose trade included Native "curios" along with cigars (Henry Stadthagen) or diamonds, precious stones, watches, chains, and the like (A. A. Aaronson). One of the first was Frederick L. Landsberg, who opened for business around 1884. But by 1910, most had given up their curio concerns, in many cases selling their remaining stock to museums. The earliest merchants in Vancouver to include Native crafts along with other merchandise were N. L. Lando, with furs, and William Webber, with stationery, who opened in 1918 and 1923, respectively. As a rule, these dealers acquired their stock from Natives visiting their shops in the city, and while, especially in the earlier years, there were objects that had been used by Natives, for the

most part these shops dealt in "decorator items," such as baskets, blankets, and model totem poles. Also popular around the turn of the century were Western objects such as letter openers or napkin rings, ornamented with Native motifs.

Despite his belief that much of Native culture was doomed, Franz Boas felt that some aspects could and should be encouraged, thereby enriching the lives of both Natives and whites. In 1899 he wrote in defense of potlatch ceremonials: "They are so intimately connected with all that is sacred to the Indian that their forced discontinuance will tend to destroy what moral steadiness is left to him" (BAAS report, in Stocking 1974:106). In his sixties Boas tried to better the condition of the Native artist. During a general lecture to the Natural History Society of British Columbia in 1922, he urged his audience to pay more attention to the "preservation of native art." Realizing that the quality and quantity of Native crafts would decline when confronted with the mass introduction of manufactured goods, Boas felt that something of value could be saved: "It would seem to me that if the people here were to pay more attention to the preservation and development of native art of such a peculiar type of artistic expression, the development of such an undertaking would be of very great value. It is a great pity to see this art disappearing and simply substituting for it the ordinary forms we find everywhere."[4]

A few years later, as a result of his final trip to the Kwakwaka'wakw in 1930–1931, Boas tried to take direct action, writing to the lieutenant governor about the poor

Figure 5.2. Frederick L. Landsberg's curio shop, Victoria, c. 1900. RBCM pn 9748.

sanitary conditions in Alert Bay and about "the possibility of disposing of Indian art work to better advantage to the Indians than can be done at the present time." Upon his return, he had investigated several stores in New York and found one that "will pay to the Indians nearly five times the amount that they receive at the present time from local traders."[5] But, considering the fact that these items would be subject to duty, transportation costs, and higher operating expenses, Boas suggested that such local emporia as the Hudson's Bay Company and David Spencer might take on these goods, "paying the Indians the highest possible price, deducting no more than the actual over-head expenses." Although eventually these stores did sell Native crafts, Boas's efforts appear to have had no direct results.

ALICE RAVENHILL AND THE B.C. INDIAN ARTS AND WELFARE SOCIETY (1940–1960)

The decade of the 1930s was an important period of reconsideration for the arts of so-called folk and primitive peoples (Vlach 1985). To some extent an expression of Depression populism, this interest focused as much—if not more so—on economic welfare as on aesthetic appreciation. For instance, in 1935 the Board of Indian Arts and Crafts was established as part of the U.S. Department of the Interior (Schrader 1983). Its first chairman was René d'Harnoncourt, who, when director of the Museum of Modern Art, organized many influential exhibits of "primitive art." The board's task was "to promote the economic welfare of the Indian tribes and the Indian wards of the government through the development of Indian arts and crafts and the expansion of the market for the products of Indian art and craftsmanship" (quoted in Schrader 1983:106).

In Canada, similar efforts were made to stimulate the development of Native art (Nicks 1982:40–45, 1990). Since 1900 the Women's Art Association of Montreal (later, the Canadian Handicraft Guild) had actively tried to commercialize Indian art by organizing exhibitions, sponsoring competitions, and lobbying the federal government to establish craft programs. In 1937 the Indian Affairs Branch of Canada responded by including the arts as one program of its Welfare and Training Division. As the name indicates, the emphasis was on the marketing of Indian handicraft. In fact, "the preservation of arts and crafts for their cultural or historical [let alone aesthetic] significance was not even a consideration" (Nicks 1990:15).

Despite their national ambitions, neither the guild (located in Montreal), nor the Welfare and Training Division (in Ottawa) did much for the Indians of British Columbia. Instead another, parallel organization arose. A small group of whites, active mostly in the social welfare arenas of church and school, realized that artifact production could revitalize Native societies by giving them simultaneously a source of income and a source of pride. Although this movement often used the term "art," their prime gloss for Native artifacts was "handicraft," and their major efforts were directed not at the few remaining masters, but at children and beginners. While their attempts at stimulating art production were largely ineffectual, their true legacy lies

in their determined activities in publicizing the arts and developing a local marketing structure.[6]

The leader of this movement was Alice Ravenhill (1859–1954), an English immigrant to British Columbia.[7] Coming from a background in health care and home economics, Ravenhill first encountered Indian art in 1926 when she was asked by the Women's Institutes of B.C. for advice on how to adapt Native designs to hooked rugs. Finding she knew little about the subject, Ravenhill consulted her neighbor, William Newcombe. By the time she felt qualified, in 1929, the Women's Institutes were no longer interested, yet Ravenhill continued to learn about Native arts. Starting in the fall of 1936 she began fourteen months of work on a basic guide to British Columbia's Indians, to be used by grade-school teachers. The Provincial Museum published the guide in 1938, and from then on Ravenhill worked closely with the museum.

In 1939, at the age of eighty, Alice Ravenhill founded the Society for the Furtherance of Indian Arts and Crafts (renamed the B.C. Indian Arts and Welfare Society in 1946). Her cofounder was Anthony Walsh, a teacher of Native children on the Inkameep Reserve near Oliver, B.C. Other founders came from various provincial departments—the schools, the Archives, and museum. The guiding assumptions of the society are readily apparent from its three founding aims:

(1) To arouse more interest in the Arts and Crafts formerly brought to a great perfection by the Indian Tribes of British Columbia, which constitute a valuable background to Canadian Culture.

(2) The utilisation of these noteworthy designs for Commercial purposes, and to promote their use for Tourist "Souvenirs" in place of the inaccurate articles now offered.

(3) The encouragement in Indian Schools and among certain Tribal experts in the revival of their latent gifts of Art, Crafts and Drama, with a view of improving their economic position, of restoring their self-respect and inducing more sympathetic relations between them and their fellow Canadians. Some encouragement in advancing these objects has been gained.[8]

Sharing the position of Marius Barbeau and others, the society viewed Native culture, no matter how great, as a *background* to contemporary Canadian culture. There was a tendency to regard Native artifacts as crafts and souvenirs, rather than fine art, and thus support for artistic activity was phrased in terms of social and economic welfare.

Although the society survived until the 1980s (as the "B.C. Indian Arts Society"), its heyday was the 1940s and 1950s, when its major programs consisted of publications, exhibitions, scholarships, merchandising, and conferences. Ravenhill published three general accounts of Native culture (1938, 1944, 1953), which were intended to popularize anthropological research for interested laymen such as teachers, as well as for Native artists searching for models. The most visible program of the society was the annual series of exhibitions held at the Provincial Museum from 1942 to 1953. The displays, consisting mostly of children's art, were meant to encourage Native be-

ginners to continue with their art, and this heavy emphasis on children's art was no doubt due to the influence of the teacher Walsh. The educational mandate was continued in the several scholarships granted to adults, such as the one awarded to promising Native artists to study the collections at the Provincial Museum. The merchandising efforts of the society were largely devoted to finding sales outlets for basketry, setting up the Goldstream Indian Co-operative Store, and arranging for a system of labels certifying authentic Indian workmanship. Finally, the society sponsored two province-wide conferences, in 1948 and 1958. Both were held at UBC and involved Harry and Audrey Hawthorn and the Kwakwaka'wakw artist Ellen Neel. These were important forums for Natives and those interested in Native affairs to come together and exchange views.

Despite these accomplishments, the society's achievements were circumscribed. Throughout its statements one finds a condescending tone. No Natives were present at the founding, and when they were allowed in as members several years later, their status was honorary and advisory only. In spite of its aims, the society was directed toward white culture, not Native. Things would have been different if its members had located and supported the elderly Native masters (their "certain Tribal experts"), producing for Native ritual contexts. Yet this was a time when the potlatch was still banned. Most whites, and many Natives, believed that the future lay not in traditional ritual, but in adapting Native crafts for a white audience. The "serious" adult artists the society did sponsor, the Nuu-chah-nulth George Clutesi and the Tsimshian

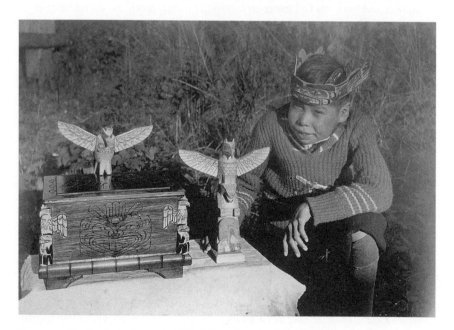

Figure 5.3. Kwakwaka'wakw artist Alfred Shaughnessy, about age fifteen, with his carvings. RBCM pn 11535.

Judith Morgan, both worked in the nontraditional medium of easel painting, a medium the white world recognized as "art." While it is easy to criticize the Arts and Welfare Society from present perspectives, in its time it represented an important positive reevaluation of Native potential.

"THE ECONOMIC ROLE OF ARTS AND CRAFTS" (1958)

Until the mid-1960s the view of Native arts in predominantly economic terms continued. In 1948 Audrey and Harry Hawthorn were asked to survey the Native arts of the province for a commission examining the state of Canadian arts (Massey 1951: 239–43). Their findings were revised and included in the report of UBC's Indian Research Project of the mid-1950s (Hawthorn et al. 1958). While admitting the existence of their "aesthetic value," they addressed themselves only to those Native arts that were sold to whites and couched the entire discussion in terms of "arts and crafts," not fine art.

Following a review of the state of the various crafts, the Hawthorns outlined a series of proposals. First came public instruction, as "a programme which aims at developing Indian artistic resources must depend ultimately upon public interest and understanding" (Hawthorn et al. 1958:265). Among the media mentioned were books and leaflets, films, and museum displays. Of the last, they wrote: "Not only through displays of the past cultures, but also through support of contemporary design by Indian artists, by seeking out local craftsmen, and by offering them opportunities for exhibition, the museum can foster an interest in Indian products and techniques. In fostering research projects in local areas, and in explaining and presenting those projects to the museum public, a new understanding will be built up" (ibid.:265–266). This could be the charter for the program of the UBC Museum of Anthropology, especially since the opening of its new building in 1976. Of all their proposals, it was perhaps public instruction that had the greatest impact on the Native arts.

The other suggestions were marketing, instruction programs, and the rationalization of production. Formal and systematic marketing programs have long been recommended, though they rarely have had much impact. The Hawthorns' approval of a combination of museum, workshop, and sale outlet did in fact prove effective, the best example being the 'Ksan complex at Hazelton, along the Skeena River. Though they were not many, training programs—such as those at the Provincial Museum and 'Ksan—were critical in the development of the Native art market. Finally, the authors were cautious about the institution of "factories." Individual artists, especially those younger and less experienced, do turn out objects in a mechanical, "rationalized" fashion, but nothing more organized has been attempted.

THE FINE ART MARKET (1965–1981)

For over a century there have been shops in Victoria and Vancouver selling tourist-oriented crafts, though their number and popularity have waxed and waned over the decades. During the Depression and war years, following the general white percep-

tion that Native culture was moribund, these shops experienced relatively little busi-
ness, but they revived as the aesthetic appreciation of coastal crafts gradually grew,
until in the mid-1960s the first explicitly "art"-oriented galleries opened.[9] The "ma-
turing" of the market for Northwest Coast artifacts has not seen a replacement of
"art" for "curio" so much as a diversification. There are still shops catering to the
tourist and those looking for decorative crafts. Only now there are in addition art gal-
leries and dealers, selling works for great prices to discriminating collectors. This
upper end has two profound divisions—the historic and the contemporary—neither
of which has much to do with the other.

The historic market is centered in New York. Here are the displays of the Ameri-
can Museum of Natural History, the Brooklyn Museum of Art, and the National
Museum of the American Indian (former Heye Foundation), presenting the art at its
turn-of-the-century glory. The city is also home to the American art establishment—
the auction houses, art press, and galleries. This is where the Surrealists and Expres-
sionists championed Northwest Coast art. By definition, the historic art, that pro-
duced before the end of "classical" collecting in 1920, is a limited resource and thus
claims the highest prices. As Alsop (1982:21–22) notes, "It is a truism of the art mar-
ket that the works of a dead but still-admired master are more valued than the works
of a master still alive and currently productive. Death limits the supply."

The effective beginning of the historic market for all American Indian art is cus-
tomarily dated with the 1971 auction of the Green Collection at Parke-Bernet (Meyer
1973:8–10). Though weak in Northwest Coast pieces, the auction raised prices that,
for the time, were very high. The following years saw the first specialized auctions
for American Indian art (Johnson 1975). A series of large review shows of Indian art
fanned the market, but Sotheby's (which acquired Parke-Bernet) did little until 1976
(McKillop 1983). Its entrance into the market further inflated the prices, and North-
west Coast pieces were soon garnering some of the highest prices of any American
Indian art. Most of the dealers, and many of the collectors, involved in this material
are based in New York.[10] In recent years, however, the market has diversified, with
Santa Fe, the "capital" of Indian art, also including historic Northwest Coast objects.

The strong contemporary market is firmly located in the Northwest, specifically
Vancouver. In the late 1960s galleries began to open that clearly presented work by
living Northwest Coast Natives as art (Duffek 1983a). The timing of this new approach
seems not accidental. Holm's book on the traditional graphic system appeared in
1965, and 1967 saw Audrey Hawthorn's book on Kwakiutl art and the *Arts of the Raven*
show. There were also changes in the museum world as new buildings opened in
Seattle and Victoria, and Wilson Duff began teaching at UBC.

Two basic forms—masks and silkscreen prints—reveal differing accommodations
to the contemporary art market. The carving of masks for sale on the Northwest
Coast goes back at least to some Haida examples from the 1820s (Macnair et al.
1998:56–60). While Kwakwa̲ka'wakw masks have long been a part of this trade, es-
pecially for museum collectors, their abundant production came only in the early

1950s. While employed at the Provincial Museum's Thunderbird Park, Mungo Martin made some masks specifically for sale. These he carved during the winters and in off-hours in order to supplement the museum's low wages. Although created according to traditional forms and subjects, they were not intended for a specific patron or ritual use. Henry Hunt soon took up the craft, followed by his son Tony, as well as Douglas Cranmer. By the early 1970s contemporary masks were a popular item in the few shops selling Indian art in British Columbia. Around 1980 several young artists began to carve rattles for sale as well as Native use. Both cases represent the aestheticization of a ritual form.

Silkscreen prints, on the other hand, are an almost purely aesthetic form, though based on traditional graphic styles (Hall et al. 1981). Although Northwest Coast Indians have created silkscreen prints since the late 1940s, they were not common until the mid-1960s. Their greatest popularity came in the late 1970s and early 1980s, when they were the staple of the Native art market. Kwakwa̱ka'wakw artists such as Ellen Neel, Tony Hunt, and Douglas Cranmer were among the pioneers of the medium, and Kwakwa̱ka'wakw are the still the most active tribe of Coast printmakers; there are more of them and they release more prints. They fall into three major circles: the Hunt family of Victoria (the most active), the Henderson family of Campbell River, and the students of Douglas Cranmer in Alert Bay. And since the early 1980s, more diverse and individual artists have come to the fore. While some artists view the medium purely as a source of income, others take great pains with their work. Artists of an older generation such as Douglas Cranmer (and before his death, Henry Hunt), who regard themselves primarily as carvers, have released relatively few prints. In contrast to masks, which shifted from ceremony to gallery, silkscreens have recently made the opposite move, toward ritualization. Silkscreened designs have been used at potlatches as invitations and as gifts (and they are a popular item as decorations in Native homes).

Markets for Native art may be characterized by a number of variables that, though independent, usually cluster together. The first concerns the kind of object: old versus new, art versus craft. Then there is a rough continuum of spaces: tourist shop, museum shop, art gallery, auction house, and private dealer. Regions (East versus West) and owners (white versus Native) form other axes. As suggested, the old is usually sold as fine art by private dealers or in the art galleries of the East, while contemporary objects may be sold as art or craft in the shops or galleries of the West. With a few exceptions, there is virtually no contemporary art for sale in the East, though several dealers and galleries in the West offer historic pieces. Very recently, a sprinkling of smaller outlets between the two coasts has begun to carry both historic and contemporary art of the Northwest Coast.

As in ethnographic collecting, chains of purchasers can be shorter or longer. In the contemporary market, private collectors usually start with sales from dealers but then often commission directly from the artist. Although tourists may buy from the artist, as a rule they purchase their articles from mass merchandisers. Dealers, of

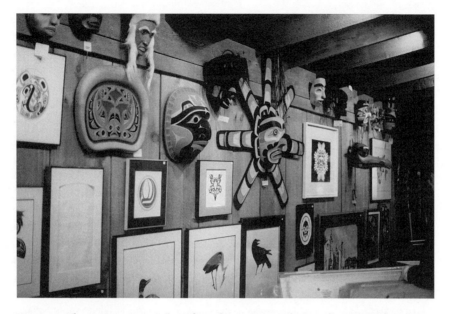

Figure 5.4. The *Leona Lattimer Gallery* of Northwest Coast Indian art, Vancouver. Photo by Ira Jacknis, June 1988.

course, always buy for resale, most often from the artist, but occasionally from other dealers or collectors. As noted in chapter 4, museums may fit anywhere into such a field, buying directly from the Native or secondarily acquiring objects from dealers or collectors.

MUSEUMS AS MARKETING AGENTS

Anthropologists and museums have had a decisive influence on the Northwest Coast Indian art market (see the discussion of patronage in chapter 7). Museums play at least three roles in the market—as retail outlets in their own right (museum shops), as purchasers of Native artwork, and as tastemakers. The first two are relatively minor. Often run by volunteers and usually quite small, most museum shops in the Northwest carry a wide mixture of objects, appealing to all parts of the collecting spectrum. Naturally, most of their sales are at the lower end—cards and prints that appeal to tourists and casual collectors. Most serious collectors prefer to purchase expensive items in the serenity of a gallery, but the museum shops often carry a small selection of these more expensive goods. As tastemakers, museums have been more important. For instance, the shop at the Vancouver Museum was very important in educating the market in the early 1970s. The shop, and not the museum itself, gave Robert Davidson his first one-man show.

For its area, the shop at the Campbell River Museum has been important in developing the market for local Kwakwaka'wakw artists. Since the 1960s the museum has been buying from artists, encouraging them to raise their aesthetic standards. In

the early 1980s, its policy was to support the art by buying what was offered to them from any artist it had not dealt with before. However, as the museum would make clear, it would not purchase anything further from the artist until the piece sold.[11] In its relative success, the Campbell River Museum differs from most museum shops. Many are not big enough to have a large impact, and even the major urban shops have to cater to large tourist markets, on the one hand, or compete with well-funded art galleries, on the other. The Campbell River shop seemed to be in the right place at the right time.

Most museums have very little money for the purchase of collections, relying more on gifts of money or objects from private patrons. This is true even for the large urban museums in Vancouver and Victoria. The B.C. Provincial Museum gets some acquisition money apportioned from the provincial coffers, but it, too, is limited. As most museums acquire the bulk of their new accessions from donations, rather than purchases, they cannot play a very strong role in the market. More important, however, is the role of museum as patron—through a few, important commissions and through the unique and long-lasting carving program at the Provincial Museum (chapter 6).

While the direct role of museums in the market is relatively weak, their indirect influence as tastemakers has been particularly important. According to one survey, 55 percent of the collectors of Northwest Coast Indian art first encountered the art in museums (Duffek 1983a:251). On the Northwest Coast, curators' common stress on the historic styles fostered a conservatism among collectors, and thus among artists. As chapter 7, on the museum as patron, explains, when museums deal in the work of living artists they wield an enormous influence on the course of the art, and of the market. The various contemporary shows, as in *The Legacy* or the several one-man exhibits at UBC, have served to legitimize certain artists. Collectors tend to follow the artists who are featured in museum exhibits, and not take seriously artists who lack such pedigrees. Similarly, artists have reported difficulty in selling rare types of objects that have not been widely illustrated and displayed. Any work always sells better, they say, if it comes with a story. As Becker (1982) suggests, critics and scholars play a crucial role in the construction of any art world.[12]

DISPLAY

TEMPORARY ART EXHIBITIONS (1950–1981)

The 1950s and 1960s were the time of consolidation for the appreciation of Northwest Coast artifacts as art. Nowhere is this better seen than in the series of temporary exhibits. After the two "precursor" shows of the 1920s, devoted only to that region, and the several exhibits of the 1930s and 1940s covering the entire continent, there was a serious return to moderate-sized exhibits dealing only with the Northwest Coast, a

sign that this art was achieving a distinct profile, apart from the then better-known arts of the Southwest.

The clear leader in this effort was Erna Gunther, of the University of Washington. After organizing the Northwest Coast section at the San Francisco exposition, she went on to curate shows at Mills College (Oakland) in 1945, the Taylor Museum (Colorado Springs) and Seattle Art Museum in 1951, the La Jolla Art Center in 1962, her work culminating in the Seattle World's Fair in 1962. Moreover, her knowledge and advice were influential in the forming of the *Yakutat South* exhibit, organized by Allen Wardwell at the Chicago Art Institute in 1964.

The presentation at the Seattle Fair was typical of Gunther's approach. Although it was housed in the Fine Arts Pavilion, Gunther espoused a cultural approach to the art. The introductory section, "The Anatomy of the Art," outlined the basic materials and motifs. The historical research that Gunther had launched in the early 1950s was expressed in "Historical Perspective," containing some of the earliest pieces collected by explorers and traders. Needless to say, Gunther was a pioneer in advocating a temporal perspective on these tribal arts. The bulk of the exhibit was arranged by functional complexes: ritual and dance drama, potlatch and feast, household crafts, shamanism. In exception to this cultural context she admitted, "Many pieces, large and small, are displayed as sculpture and thus are removed from their original purpose, but perhaps are adjusted better to our aesthetic enjoyment" (Gunther 1962:101).

From slow beginnings in the 1950s, at the Montreal Museum of Fine Arts (1951), the Vancouver Art Gallery (1956), and Gunther's shows, temporary exhibits of Northwest Coast objects came every year or so in the 1960s: at the Chicago Art Institute (1964), Lowie Museum (UC-Berkeley, 1965), Montreal Expo (1967), Vancouver Art Gallery (1967), Princeton University (1969), and the Musée de l'Homme (Paris, 1969). Many were at art museums, and those in anthropology museums had a strong aesthetic approach. Still, in virtually every one of these shows the focus was on objects from the "classical period."

The pace of temporary exhibits greatly accelerated in the 1970s. These were of two kinds. On the one hand, for the first time since the Museum of Modern Art show in 1941 there were comprehensive reviews of all of American Indian art: at the Whitney Museum (1971), the Walker Art Center / Minneapolis Institute of Arts (1972), the Nelson-Atkins Museum (1977), and the Chicago Art Institute (1977). However, in these shows fewer concessions were made to the cultural context of the artifacts, which were displayed more as fine art in the Western tradition.

On the other hand, there were many smaller exhibits on specialized aspects of Northwest Coast art: functional types (boxes and bowls, prehistoric stone art), individual retrospectives (Bill Reid, Robert Davidson, Willie Seaweed), historical perspectives (contemporary Native art of British Columbia, Haida argillite, the fur trade), institutional and regional collections (American Museum of Natural History, the Seattle area), and tribal styles ('Ksan, Coast Salish, Kwakwa̲ka̲'wakw ceremonial art).

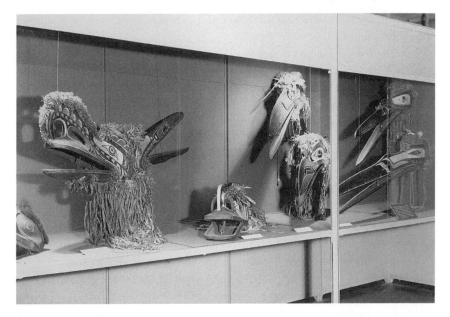

Figure 5.5. Kwakw<u>aka</u>'wakw hamatsa masks, *Art of the Northwest Coast,* Lowie (now Phoebe Hearst) Museum, University of California at Berkeley. Photo by Eugene Prince, 1965. HMA.

By far the majority of these have been presented in museums and galleries in British Columbia (Ames 1981a:10–11).

PERMANENT COLLECTIONS IN ART MUSEUMS

The aesthetic shifts marked by these temporary displays were slowly institutionalized in museums. Most of the great American art museums were devoted originally to the art of Europe (and to a lesser extent, America), and only gradually came to include the arts of other civilizations. Among the earliest with large samples of American Indian art were the museums in Cincinnati, Brooklyn, and Denver.

Apparently Indian artifacts first appeared in the permanent collections of an art museum around 1890. Founded in 1881 with a strong interest in the decorative arts, especially ceramics, the Cincinnati Art Museum in 1885 obtained some Pueblo pottery from the U.S. National Museum. Two years later it was given a collection of American Indian archaeology, followed soon by a large collection of African objects. Its Northwest Coast collection is early and respectable; the first pieces arrived in 1888, and several more donations came soon thereafter. Most were given by local residents who had obtained them on their travels in Alaska, but in 1889 the museum again benefited from an exchange with the National Museum. Most, if not all, of the American Indian collections were on exhibit by the first decade of the century, cared for by an unpaid curator.[13] The Native American holdings continued to swell over the years,

and they are currently included in the Department of Costume, Textiles, and Tribal Arts (Shine and Meyer 1976).

When Stewart Culin took charge of a newly created Department of Ethnology in 1903, the Brooklyn Museum (founded in 1890) was a general museum, including natural history as well as art.[14] From 1903 to 1911, Culin actively built up the American Indian collection, with most of the Northwest Coast holdings acquired from Charles F. Newcombe in 1905, 1908, and 1911. The Kwakwaka'wakw, Haida, and Coast Salish are the major tribes represented. In the last half of his career, Culin turned increasingly to the world of art, presenting in 1923 an exhibition of art from the Congo, widely perceived as one of the first displays of primitive artifacts as art in an American museum. These trends continued after Culin's death in 1929, and in the early 1930s the institution was redefined as an art museum. Thus what had been collected as ethnology became art. Under a series of shifting labels (now Arts of Africa, the Pacific, and the Americas), the department continues to this day (Fane et al. 1991).

Thirty-two years after it was nominally founded, the Denver Art Museum initiated a Department of Indian Art in 1925. Frederic H. Douglas, curator from 1929 to 1956, raised the collection to national prominence, until it now comprises over half of the museum's holdings of 30,000 objects. Early strengths were in the Southwest; the museum acquired its first Northwest Coast object in 1925 (a Haida wooden rattle). Partly as a result of U.S. territorial ties, the arts of the Tlingit and Kaigani Haida are better represented than Kwakwaka'wakw works, but the museum has been particularly successful at acquiring other personal and institutional collections. The largest coastal accession came in 1952 with the collection of Walter Waters of Wrangell, Alaska (Feder 1962; Conn 1979; Ritchie 1981).[15]

As in Denver, though on a smaller scale, the Native art collection at the Portland Art Museum forms a major portion of the total holdings of a regional Western museum. In a rather unusual move for an art museum at the time, in 1948 Portland purchased the Rasmussen collection of Northwest Coast art (Davis 1949; Gunther 1966). Its director, Robert Tyler Davis, had been encouraged in his interest in the region's Native art by Erna Gunther. Axel Rasmussen, an educator in Alaska, sold the museum roughly 400 pieces gathered between 1926 and 1945. Most of it was Tlingit, acquired directly from Native owners, though some came from dealers such as G. T. Emmons and W. Waters. The collection also included a number of Kwakwaka'wakw objects, and the museum continued to add to it other art from the region. As Gunther (1966:273) points out, the Rasmussen collection is unique for an art museum, as it came to the museum as a whole and includes many items of domestic craft. However, when it was first displayed in two galleries, only the "choicest of the artifacts" were shown "as works of art" (Davis 1949:xii).

In general, the interest of art museums in "primitive art" has been a postwar phenomenon, growing out of new interests in foreign countries, and encouraged by the changing social climate of the 1960s. These interests were spurred on by the 1954 establishment of the Museum of Primitive Art in New York (opened in 1957). Formed

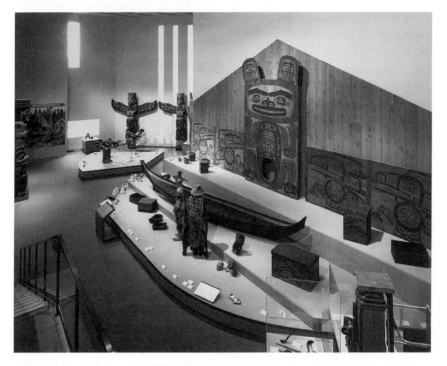

Figure 5.6. Northwest Coast Indian gallery, Denver Art Museum, 1988.

out of the private collection of Nelson Rockefeller, the works were gathered with the assistance of René d'Harnoncourt, then director of the Museum of Modern Art. In 1956 the Art Institute of Chicago became one of the first major museums to have a department of primitive art (Maxon 1970:19). New departments soon sprang up, often coinciding with a new building or director. Among those museums establishing departments of primitive art (often referred to with the more neutral phrase, "African, Oceanic, and New World Cultures") in the 1970s were the de Young Museum of San Francisco in 1970 (Seligman and Berrin 1982), the Minneapolis Institute of Arts in 1974 (Lincoln 1986), and the Detroit Institute of Arts in 1976 (Kan and Wierzbowski 1979).

The 1983 opening of the Michael C. Rockefeller Wing in the Metropolitan Museum of Art was widely regarded as the final attainment of "fine art" status by primitive art, now comparable to the art of Europe, Egypt, or China (Newton et al. 1975). For years, a common riddle defined primitive art as "the stuff that isn't in the Metropolitan" (ibid.:182). Actually the museum had acquired a small collection of prehistoric American Indian pottery as early as 1879, followed by a group of ancient Peruvian pieces in 1882, but in 1913 it decided that these would be more appropriate on long-term loan to the American Museum of Natural History (Glueck 1982:40). By 1970 attitudes had changed, and the museum's department was formed out of the transfer

of the Museum of Primitive Art. The American Indian collections are marginal; though the Northwest Coast is represented by several fine pieces, the group is small. Unlike the Sepik River objects, collected by Michael Rockefeller in New Guinea, they were acquired singly in the 1950s and 1960s from the New York art market.

There seem to be three primary modes for the institutionalization of primitive art collections. In one, such as at Brooklyn, the museum redefines its ethnology as art. In a second, as at Chicago, the museum starts from scratch, and in the more common, third mode, as in Cincinnati or Detroit, the museum newly recognizes, after a period of neglect, such material that it had collected from early in its history. Today it is the norm for major encyclopedic art museums to include primitive collections; among the others are Seattle, Houston, Dallas, St. Louis, Cleveland, and Baltimore. Because of their small size and recent establishment, the relative strengths of each collection vary widely. American Indian pieces often came, unsolicited, as donations from local patrons.

Beyond the question of whether a particular museum had Native American or other primitive art, though this simple fact is important, is the issue of what was done with it. Was there a separate department and curator, and when was it begun? What was the size and relative importance of Native art to the total holdings of the museum? In most of these cases, the museums had for some time been accumulating isolated pieces of Native design, shunted around from department to department (most often decorative arts). For instance, although the Detroit Institute of Arts was "one of the first American art museums to have a gallery devoted to ethnographic art" (Kan and Wierzbowski 1979:57) when it opened in 1927, the gallery was given over to other arts following the Second World War, and it was not until 1976 that a separate curator and department were established. Thus while many of these museums did occasionally exhibit single objects and temporary displays, permanent galleries generally had to await the establishment of separate departments.

One important factor behind the history of these collections is the local museum "ecology." These art museums must be related to their town's other institutions, often to a major natural history collection. In New York, for example, the Metropolitan (and its antecedent Museum of Primitive Art) has avoided American Indian art because of the major collections of the American Museum of Natural History and the Museum of the American Indian. Similar relationships characterized the Museum of Art and University Museum in Philadelphia, the Art Institute and Field Museum in Chicago, and the de Young Museum and Hearst Museum in San Francisco/Berkeley. Since the 1970s, however, most major art museums have felt they had to include some primitive art if they were to be encyclopedic.

More generally, these art collections must also be related to anthropological expertise. Brooklyn and Denver, the museums with the largest and finest collections of American Indian (and more specifically, of Northwest Coast) art, not accidentally also had important early ties to ethnology. At Brooklyn, the first two curators—

Stewart Culin and Herbert J. Spinden, were anthropologists, while at Denver, Frederic H. Douglas, trained as an artist, was something of a self-taught anthropologist, and Richard Conn had a master's degree in the subject.

Another ecological issue is the museum's place in its region. Native American art is often well represented in regional collections, of which Denver is merely the largest and finest example. Others are the Philbrook Art Center in Tulsa, the Joslyn Museum in Omaha, or the Taylor Museum in Colorado Springs (most of whose Northwest Coast collection was acquired by Eugene and Clare Thaw for the New York State Historical Association; see Vincent et al. 2000). The Heard Museum in Phoenix is a special case, as it is a museum of both anthropology and art. As important as these regional collections of Native art are, especially to aficionados, they do not have the same status as the departments within the major encyclopedic art museums in the larger cities.

As with the claim of priority for the first exhibit of American Indian artifacts as art, this brief history reveals that the wheel keeps getting reinvented. In this case, at least, an aesthetic appreciation did not explode unheralded, but grew cumulatively. "Primitive art" (especially pre-Columbian) was often in art museums from very early on but was only gradually recognized and re-recognized. For instance, the received wisdom has it that in 1925 the Denver Art Museum was the first museum to exhibit American Indian artifacts as art (Feest 1980:13; Ritchie 1981:65). Why was Cincinnati's priority not acknowledged? There are probably several reasons. There is Cincinnati's relatively small population and minor importance as an art center, as seen from New York. Denver, in a region of significant Indian populations, has, since 1925, continually emphasized its Indian collections: its Indian collections form a large portion of the museum's total holdings, and its curators—Douglas, Feder, and Conn—have been prominent in the field. What counts, in the end, are the people, institutions, and programs that resonate with larger trends. What had little impact in 1890 had an effect in 1931 and 1941, and even more in the 1960s and 1970s.

What happened to the Native American collections at Brooklyn, though somewhat unusual, is significant because it reveals in a single museum a more general process. Instead of exhibiting the entire collection, complete with tools and materials, Spinden and his successors chose only selected pieces, which could be construed as sculpture or painting. Extensive labels were done away with. The original collection had been a more of less coherent ethnographic sample, of the kind that ethnologists such as Newcombe and Boas were accustomed to making.[16] This integrity was broken up, according to criteria of aesthetic excellence, with the final result resembling those collections in art museums that had been accumulated piece by piece, usually with scant documentation. In sharp contrast to ethnographic collections, the Museum of Primitive Art, by set policy, acquired objects on a piece-by-piece basis; no collections were purchased and no field expeditions were sponsored (Newton et al. 1975:184). In this way was created the image of the timeless Indian, creator of exquisite forms.

ARTISTS AND THE HOBBYIST TRADITION

Paradoxically, while "primitivism" commonly refers to the movement of Western artists who appreciated and were influenced by Native arts, most surveys of the movement (e.g., Rubin 1984) do not include the work of those white artists who were most affected by Native styles—the so-called Indian hobbyists (Powers 1988; Deloria 1998). These are people, often starting as Boy Scouts (Mechling 1989), who create objects in Indian forms, dress up in Indian costumes, and put on Indian dances, feasts, and ceremonies. Although this tradition continues to this day in such contemporary forms as the "New Age" movement, its hobbyist incarnation is more a movement of the first half of the twentieth century.

BILL HOLM

The scholar who has had the biggest influence on Northwest Coast art started as an Indian hobbyist.[17] Bill Holm was first attracted to Indians as a boy of nine, living in central Montana. Moving with his family to Seattle in 1937, when he was twelve, he soon discovered the Washington State Museum, where he spent all his free time. It was not long before he met the director, Erna Gunther. Gunther, who became a close personal friend, encouraged Holm's research into Indians and his attempts to duplicate their crafts. Though still a Plains hobbyist, Holm began to study Northwest Coast artifacts and read books by Boas and Curtis. One event that impressed him very much was his trip with Gunther to nearby La Conner to see the Coast Salish Spirit Dances, his first glimpse of a Northwest Coast ceremonial.

Another of Holm's mentors was Roger Ernesti, a graduate student at the university during the time Holm was in high school. Though the two performed Indian dances before the war, Holm and Ernesti did more of it when Holm returned to Seattle from army service. They danced with the Yakima Indians at Toppenish in eastern Washington, as well as for white audiences. In the late 1940s and early 1950s, Holm and his friends often appeared on programs with Erna Gunther, who would lecture and show Indian "fashions" from the museum collections.

After the war, Holm enrolled in the art program at the university, earning his B.A. in 1949 and an M.F.A. in 1951. After earning a teaching certificate in 1953, Holm returned to his former high school to teach art. During this time he was seriously attempting to recreate traditional styles of Northwest Coast art. Although he rarely copied specific pieces, Holm used museum collections and the scholarly literature as his models. There were some old Kwakwaka'wakw artists around with whom Holm could have studied, but until Mungo Martin moved down to Vancouver in 1950, they were remote, and by that time there were few, if any, northern artists who commanded the traditional formal system.

Bill Holm was not alone in his interests. The 1950s were a time of great activity for the Indian hobbyist movement. Like Holm, these people were deep enthusiasts, meticulously trying to duplicate old-time crafts and putting on dances. Among Holm's

friends at the university were several who went on to careers in the Indian art field (McEachern 1959). Richard Conn, who earned an M.A. in anthropology and worked at the museum, later became the curator of Native art at the Denver Art Museum. Michael Johnson's interests in Indians were intensified by his meeting with Holm, and he later became a dealer in Indian art. Another colleague was Donn Charnley, who, like Holm, was a counselor at the Henderson Camps on San Juan Island.[18]

A turning point in Holm's life came when he met Mungo Martin. After witnessing his first Kwakwaka'wakw dances at the dedication of Martin's house in Victoria in 1953, Holm's efforts were increasingly devoted to their culture. For some years, he and his wife Marty had been giving Indian dances at the Henderson Camps, later moved to Lopez Island, but this event seems to have spurred him into building his own community house. The couple first proposed its construction in 1954 and spent part of that summer traveling through Kwakwaka'wakw country. After a winter of carving four 12-foot houseposts, they erected the cedar building in the summer of 1955. Surrounded by woods, the house sits facing the beach, like traditional Native houses. Decorating the front is a circular Kwakwaka'wakw design, surmounted by an eagle carving, with a totem pole to the side (both added in later years). Because they were wary of using for the houseposts any design that was held as an ancestral privilege, the Holms "made up some which looked right but weren't anybody's personal crests" (Downey 1986:53). At the entrance to the camp stands another Holm pole, this one in Haida style.

Although the house was finished in 1955, Martin was not able to come down, and so the Holms held their first "potlatch" the following summer. For the next twenty-five years or so, groups of Kwakwaka'wakw came down to Lopez for these dances. That first summer, Martin arrived with seven or eight members of his family. The night before the dance, he walked into the house, looked around, and was silent. Helen Hunt, who acted as his interpreter, said to Holm: "Do you know what you're doing to the old man?" Holm wondered, "What?" "He can't believe his eyes, that this is actually here. And that what people are letting go at Fort Rupert and Alert Bay is happening down here." When they had their dances the next night, Martin got up and made a big speech, reiterating his sentiments about what was being preserved by these hobbyists. In a large, elaborate potlatch on Turnour Island in 1959, Martin gave Bill and Marty Holm Native names, along with the rights to use certain dances and crests. From then on Holm was an active participant in Kwakwaka'wakw potlatching and was commissioned by a number of Natives to create objects for ceremonial use (Downey 1986:51).

After Mungo Martin's death in 1962, the Holms thought that perhaps that would be the end of their Kwakwaka'wakw guests, but instead their numbers grew, to groups of forty or fifty, coming from all over Kwakwaka'wakw country. Holm remembers it as being a lot of fun and thinks that the Natives enjoyed it so much because they were free of responsibilities. Still, there was always some ritual "business"

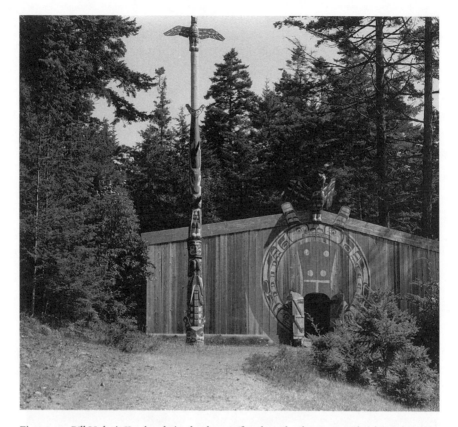

Figure 5.7. Bill Holm's Kwakwa̱ka'wakw house (facade and pole), Lopez Island, Washington. RBCM pn 7832–16.

transacted, giving names to children and grandchildren, with some distribution of property. Physically, the place reminded them of Fort Rupert.

But the Lopez dances were especially appreciated because "they could do things that they didn't do at home a lot. . . . Things that they hadn't done for a long time, they'd begin to do at Lopez." The hobbyists, their minds full from reading old ethnographies and talking to elders, wanted to recreate former practices. "We wanted to do those things. People'd suggest that we'd do it; they'd say, why don't you do this or that; that's the way we used to do it in the old days." According to Wilson Duff, basing his comments on what Martin and others had told him, these Lopez dances had an important influence on the contemporary revival of Kwakwa̱ka'wakw ceremonialism. People would go back and try out some of the customs they had revived in the south. However, these intercultural performances were not universally approved of. There were always some Natives who feared that the white man might be taking over their dances as he had taken over their artifacts.

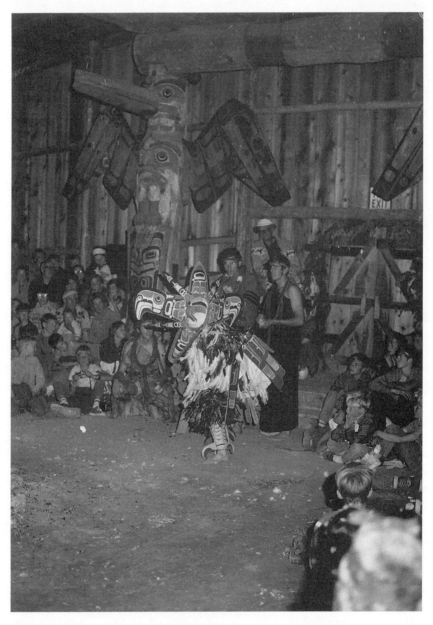

Figure 5.8. Bill Holm dancing in his sea-eagle transformation mask and costume, Lopez Island, Washington. RBCM pn 7827–9.

In the late 1950s, while taking a research course with Erna Gunther, Holm decided to try to put into writing his years of study of the Northwest Coast graphic system. Eventually this course paper grew into his path-breaking book: *Northwest Coast Indian Art: An Analysis of Form* (1965) (see chapter 6). Another pivotal point was his co-curation of the *Arts of the Raven* exhibition. With his scholarly reputation growing, in 1968 Holm accepted a joint position at the University of Washington, teaching in the art history department and curating the Northwest Coast collection at the Burke Museum. Holm has continued to dance at potlatches in Kwakwa̲ka'wakw territory, "participating as masked dancer, singer, dancer's attendant, speaker and potlatch bookkeeper."[19] Since he began teaching, however, he has curtailed his independent dancing for white audiences. After a very influential career of teaching and scholarship, in 1985 Bill Holm retired, to return to his artwork (especially painting; see Brown and Averill 2000) and special writing projects.

LELOOSKA

Not all the hobbyists are white. In 1960 a Cherokee Indian named Don Smith moved to Ariel, a small logging town in southern Washington (Smith 1958; Falk 1976). Smith (1933–1996), who went by his Nez Perce name of Lelooska ("He who cuts against wood with a knife"), grew up in a world of crafts and performance. Lelooska's grandfather performed with Buffalo Bill, and his early dancing seems to have been typical of the pan-Indian powwow and rodeo circuit. Years before their fame as Northwest Coast artists, Lelooska and his family were old hands at putting on formal programs for whites. Gradually, Northwest Coast dances began to supplant the Plains and Plateau repertoire, especially after their move to Ariel.

Like Holm, Lelooska saw his career change significantly after witnessing a Kwakwa̲ka'wakw potlatch. At an Alert Bay ceremony in the mid-1960s, he and his family met James Sewid, who commissioned a mask from Smith. The two soon became so friendly that in 1968 the Sewid family adopted the Smiths, giving each a Kwakwa̲ka'wakw name. In 1971 they were given the rights to use the Sewid crests in song, dance, and masks, for by now Lelooska was beginning to dedicate himself to re-creating the Kwakwa̲ka'wakw aesthetic world.

Lelooska and his family were soon making a living from their craftswork, becoming among the most successful of Northwest Coast artists. Lelooska, too, built a community house, but unlike other hobbyists, he also used the site as a home (Falk 1976:12, 66, 68). On the wooded property in Ariel are five buildings: a large A-frame exhibit hall, a pair of Native-style community houses, and apart from these, two homes. The two big houses, clustered to suggest a village, are constructed in Kwakwa̲ka'wakw style, from adzed cedar planks. The older house, now used as a workshop, is entered through a frontal pole. The larger, more recent one, used as a theater, is decorated with a set of four carved houseposts, a large raven screen, and a speaker figure. There are benches for the audience, and the floor is dirt. In the exhibit hall the Lelooska family displays its personal collection of Indian artifacts, including Plains,

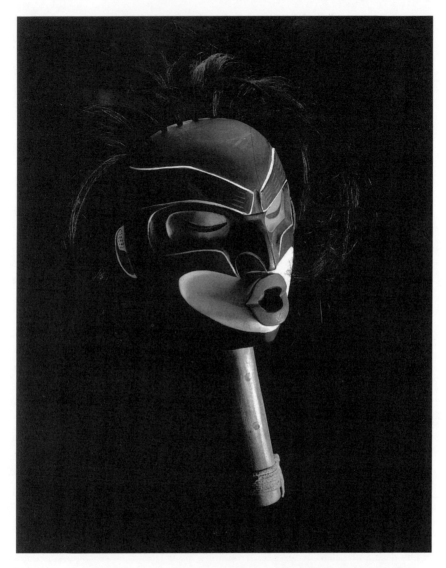

Figure 5.9. Dzunukwa rattle by Lelooska, acquired 1978, Royal British Columbia Museum. RBCM cat. no. 16458.

Plateau, and Southwestern items, in addition to the Northwest Coast pieces. Like other Natives, the family avoids the use of the word "museum" for this exhibit space (Falk 1976:68).

In the winter of 1971, about forty members of the James Sewid family visited the Lelooska family compound to help dedicate the exhibit hall. Wearing masks carved by Lelooska, they potlatched and presented the Animal Kingdom dances. The hall was given the name "Nawalagwatsi" (literally, "Receptacle of Magic," also referred

to as the "Cave of the Supernatural Treasures," and the source of the Animal King-dom crests).[20] Sporadically at first, but soon as a regular event, the Lelooskas began to put on elaborate performances, mostly for white audiences (Falk 1976:66–89). Their hour-and-a-half program, "The Salmon and Cedar People," presented almost daily during the spring and fall, plays to an average audience of 200–250, for an esti-mated yearly total of 25,000. Stressing the performance context, Lelooska told his au-dience that the masks they would be seeing would not be "behind the cold glass of museum showcases, but alive in the environment for which they were intended" (Falk 1976:66). Accordingly, the dances take place in the darkened plank house, lit by a central fire.

The Lelooska performance, accompanied by explanatory narration, is not a co-herent ritual but picks and chooses among the Kwakwaka'wakw ceremonials. In-cluded are masked dances of the hamatsa series, an echo mask, an elaborate trans-formation version of dzunukwa (cannibal woman), and the comical duel of the full and half moons. As with the Sewid family Ah'nus Dancers, the emphasis is on the more secular components. The action moves quickly, full of drama, and is at all times comprehensible by a general audience. Members of the family also visit museums and schools to demonstrate their craft techniques. Like Holm, the Lelooska family supplements its performances for non-Native audiences with participation in pot-latches, in its case, particularly for the ceremonies of James Sewid (Falk 1976:96–103). Performances at museums, schools, and the family's own compound have been es-pecially popular, and the family has a regular relationship with the Oregon Museum of Science and Industry in Portland, which sponsors some of the Lelooskas' pro-grams. Interestingly enough, like many white hobbyists, Don Smith and his younger brother also became students of the fur trade period (Anderson 1984:157–165). Dressed in meticulously researched costumes, they presented educational workshops. With the death of Chief Lelooska, his family has carried on his educational and artistic efforts.

RECENT NORTHWESTERN ARTISTS

The artistic appreciation of Northwest Coast art has changed since the days of the Abstract Expressionists. Among those non-Native artists who admire the art, there are relatively few who make formal allusions to it. Instead, most create more or less directly in Indian styles. In the last three decades a substantial community of white artists working in Northwest Coast Indian styles has grown up in Seattle and the sur-rounding region, among them James Bender, Steven Brown, Jay Haavik, Barry Herem, Duane Pasco, and Tom Speer (Averill and Morris 1995:149–168; Brown 1998:163–164).[21] While not all those adopting Native styles have actually studied with Bill Holm, al-most all were inspired by his example. Some are professional artists, while others teach or support themselves through other means. Some work in conservative tribal styles, while others freely combine them, even extending them into Western styles, such as realistic perspective. Although Northwest Native artists have recently begun

working in new media such as cast paper, plastic, glass, and bronze, many of the Seattle artists had preceded them.

Perhaps the most important of this group is Duane Pasco (b. 1932). Raised in the Northwest, Pasco began to carve in his spare time while supporting himself as a carpenter and iron worker. The publication of Holm's 1965 monograph turned him into a serious student, with consultation of texts and museum collections. Since 1967 Pasco has been creating art in Native styles full-time and has had many public commissions. Like many of these recent Seattle artists, Pasco has leaned toward the eclectic: "His earlier work was heavily Tsimshian in character, especially during his tenure at 'Ksan, where he emphasized Gitksan characteristics. In more recent years, much of his work has been influenced by Bella Coola style, although he is not at all tied to it" (Bill Holm pers. comm. 1998). Washington has long had a stronger connection with Alaska than with its neighboring Canadian province, and Holm's codification of the northern graphic style emphasized this tie. However, Pasco, Herem, and others have created objects in Kwakwa̲ka'wakw style.

While the work of the "Seattle Tribe"—as it was called, somewhat facetiously, by Haida artist Bill Reid—is exhibited and sold widely in the city, few merchants in British Columbia are willing to take them on, partly because so many of the Indian artists object and partly because most of the collectors feel Native art by whites to be inauthentic.[22] An interesting exception is John Livingston (b. 1951), who, though white, has long been a close associate of and collaborator with Tony Hunt in Victoria. As a youth, Livingston was informally adopted by Henry Hunt and has been

Figure 5.10. "Kwa-giulth Bullhead Design," silkscreen print by John Livingston, 1979, Hearst Museum of Anthropology. Photo by Lee Fatherree. HMA cat. no. 2–71689.

carving in Kwakwaka'wakw style since his teenage years. Though he has released some silkscreen prints, most of Livingston's work has gone into commissions shared with Hunt, into ceremonial works, and into his teaching at the Arts of the Raven workshop (1970–1990). He has also freely worked in more northern styles. The work of Livingston and other non-Native artists forces us to confront our basic definitions of Kwakwaka'wakw and other Northwest Coast Indian arts.

AUTHENTICITY AND ETHNICITY IN THE NORTHWEST COAST INDIAN ART WORLD

The second period of aesthetic appropriation for Northwest Coast Indian artifacts differed significantly from the first. Earlier, between 1920 and 1950, the basic question was whether these objects were art. By the mid-1960s their fundamental aesthetic status had been accepted, but the question now was what kind of art was it? More to the point, how did the creative work of a new generation—Henry Hunt, Tony Hunt, and Douglas Cranmer, among the Kwakwaka'wakw—relate to classic art?

The creation and distribution of Northwest Coast Indian art have changed profoundly over the past century. In 1880 the vast majority of Kwakwaka'wakw art was created for a Native audience with only a small amount going to whites, whereas by 1980, the proportions were reversed. At the same time, a hundred years ago, most artists supported themselves by specific commissions, whereas today they spend most of their time producing work for an assumed audience, to which they must then try to sell after they are finished. This situation clearly results from the severe acculturative changes wrought by white society, not the least of which was the massive depopulation through disease coupled with a ban on the potlatch.

Over the decades there has been a progressive aestheticization of Northwest Coast culture. In the late nineteenth century Native people gave up most forms of their aboriginal domestic artifacts—clothing, tools and utensils, houses and canoes, and the like—to be replaced by Euro-Canadian trade goods. Virtually the only items of their former material culture that they retained were ceremonial objects, the only kind of artifact they could not obtain from the whites. Accordingly, masks and totem poles became the major tangible symbols of their ethnic identity, both to themselves and to whites. Independently, but at the same time, whites gradually grew to appreciate Native artifacts, granting them the high status of "fine art."

The revival of Northwest Coast art since the Second World War has been, in part, the development of a mascot culture, in Wilson Duff's words.[23] In this process Native culture is appropriated by whites as emblems of regional identification. As a report on the UBC Totem Pole Preservation Committee stated: "Totem poles . . . are important as a colorful and distinctive Indian contribution to the developing regional culture of this part of Canada."[24] This appropriation has been most direct and significant as a source of artistic inspiration. Nationally, Marius Barbeau proposed

that Native art serve as the first chapter to a distinctive Canadian art. Similar senti-
ments are found in the notes for the dedication of the Haida village at UBC in 1962
(which, while anonymous, were probably prepared by Harry Hawthorn):

> [These totem poles] have been carved as part of our attempts to study and to match
> the highest achievements of a vanishing past. They may serve as inspiration for other
> sculptors and artists, perhaps some of them Indian, others not. And from these carv-
> ings, students can learn principles of design and representation which may lead to still
> new arts as yet undeveloped, arts which will be as truly Native to the British Columbia
> of the future as these are to that of the past.[25]

Mascot culture can be seen most especially in the prevalence of totem poles
throughout British Columbia: in the province's erection of poles at the ferry land-
ings, their commissioning gifts to foreign governments, their reproduction on tourist
literature, and their erection outside corporate offices, such as the Canadian Broad-
casting Company in Vancouver (Francis 1992:182–188; Jonaitis 1999a).

Mascot cultures are found in many regions of the world simultaneously distant
from metropolitan capitals and close to Native groups, such as the American South-
west and New Zealand, with its Maori.[26] The current appreciation of Native art and
culture in the regions such as the Northwest takes place in a particular political situ-
ation, with definite boundaries. Many whites view Natives favorably as producers of
great art, not as the usurped owners of the province (almost none of the land in
British Columbia was ever ceded by signed treaty). Regarding the Indians as artists
rather than as a political and economic problem is very convenient for the dominant
society, especially the provincial and federal governments.

Moreover, as a shift in Western consciousness and action, it is not surprising that
the construction of the Indian art world has had little room for Native initiative. Un-
like other aspects of the anthropological encounter, until recently (essentially after
1980), a Native perspective has been virtually absent from art display and art circles,
and present in marketing only to a limited degree. Even when it is positive, primi-
tivism is something done to Indians. As I discuss in chapters 8 and 9, for most of the
past century Native people have had to assert their autonomy in other venues.

Such cultural borrowing inevitably raises the issue of ethnicity and race, and some
of the most vexing questions are provoked by the hobbyists, a group truly betwixt
and between. Like some of the Surrealists or Expressionists, they were Western artists
who formally incorporated Native styles into their own work. Yet, unlike these other
groups, who adapted Native motifs into basically Western art styles, the hobbyists at-
tempted to create directly in Native media and genres. Where many of the former
tended to work basically out of ignorance, the hobbyists were motivated by a search
for authenticity.[27] These two groups played very distinct roles in the modern West-
ern art world. The former assumed the role of Artist, with gallery shows, dealers,
and so on, while the latter group, as the name implies, were motivated by personal

recreation and did not sell their work. Hobbyists fit more into the model of crafts-men and were not trying to "express" themselves.

The recent rise of Northwestern artists who grew out of the hobbyist movement has blurred these older groupings. While most still work in very conservative styles, there are some who extend these styles into personal innovations.[28] Though some have recently taken on an artist role, with gallery shows and sales, their work is still generally not regarded as fine art by the Western art world. Perhaps as a sign of its regional identification, this movement is firmly localized. Although there are many hobbyist artists working in the Midwest, East, and Europe, few have worked so closely in Northwestern Native styles.

As Karen Duffek (1983b:101–105) has noted, ethnic identity is perhaps the single most important criterion of authenticity in Indian art. Many Natives view white cre-ations in Indian styles as cultural and economic exploitation, while many white col-lectors see such work as less attractive and "real." With their mission of the cultural preservation and description of the Other, anthropology museums also encourage such perceptions by their common refusal to acquire works in Native styles by non-Indians.

The Lelooska family has been criticized by some Kwakwaka'wakw for crossing ethnic boundaries. In response Lelooska replied:

> For many years the white man has gone to Florence, Venice, Rome and the Orient to study the arts of many different races, and has enriched himself in doing so. Therefore, I see no validity in criticizing an Indian for simply reaching across from one American Indian culture to another. I've come to the Florence of North America. I've come to the Northwest Coast to study and work. . . . Those who are concerned, especially today, that Northwest Coast art be created exclusively by artists of Northwest Coast tribes are unrealistic in their thinking. What is so important is that the art survive, and I feel that anyone who can contribute—anyone who can help put back some of what has already been lost—should be more than welcome to do so. (Falk 1976:126)

Lelooska stressed that he was invited by James Sewid and that he intended to devote the rest of his life to the task. Similarly, Bill Reid, with a white father and a Haida mother, who learned his craft from museum collections, said: "I don't think you can have it both ways; either you had a universal art form develop here on the coast or you didn't. If it is universal, as everyone would like to believe, if it has that status, the concept implies that it transcends geographical barriers and that it belongs to every-body" (Reid 1981a:n.p.). Yet Kwakwaka'wakw seem to save their sharpest barbs for the white hobbyists and artists. As one asked, "They've taken so much, couldn't they leave us our art?"

Yet art is not a genetic trait. Many of the more accomplished artists working in Kwakwaka'wakw styles are non-Kwakwaka'wakw. Some are whites (John Livingston and Bill Holm); some are Natives from other tribes (Lelooska, Cherokee), and even

more are of mixed parentage (Gene Brabant, Métis Cree; and Larry Rosso, Carrier Indian/Italian). In fact, many of the most respected "Kwakiutl" artists—Charlie James, Mungo Martin, and Ellen Neel—had substantial white ancestry.

Moreover, Native artists themselves have blurred cultural boundaries. For over a century they have used introduced materials such as silver and gold or wool cloth and pearl buttons. Bill Reid and Robert Davidson have worked in Western forms, and Marvin Oliver (Quinault/Isleta Pueblo) freely creates in Tlingit styles. Many Native artists—although relatively fewer Kwakwaka'wakw—are among those influenced by Bill Holm's books and teaching. Some Natives have asked non-Natives for help in teaching; Holm and Pasco taught at the 'Ksan school in Hazelton, and Steven Brown has worked with Tlingit and Makah. Natives, such as Bill Reid, have often invited non-Natives to help them with large projects, and they have commissioned them, no-tably Holm, to produce objects for use in potlatches (Averill and Morris 1995:150). In fact, ethnic distinctions between artists tend to be of much greater importance to buyers and supporters of Native art than to artists themselves.

Recently, there has been some crumbling of the traditional view that anthropol-ogy museums document the complete range of a culture's objects, while art muse-ums deal with the best, the unique, and the exceptional. Museums are coming to a more flexible stance, realizing that in the ideological content of their collections and arrangements it does not have to be a question of either/or. For instance, the Smith-sonian Institution has a Museum of African Art as well as a curator of African eth-nology in its Natural History Museum. Closer to the present story, UBC's Museum of Anthropology is an important exception as a museum that blurs the borders be-tween art and anthropology. After a series of one-person shows and exhibitions cu-rated by artists, in 1991 it appointed Rosa Ho as curator of art and public programs. The disciplinary perspectives have become increasingly complementary (Roberts and Vogel 1994; Berlo and Phillips 1995), and some have made the converse argument that all art is ethnic art (Ames 1992; Phillips 1994).

Despite its newly won acclaim, however, Native art continues to be segregated. In all aspects of the art world—marketing, exhibition, or publication—Native art is not generally treated in the same venues, or with the same seriousness, as the fine art of Western culture (Ostrowitz 1999:132). Though contemporary Native art is reviewed in the local press in Vancouver and Victoria, until recently its coverage has been more journalism than criticism. In Canada contemporary Native art is actively collected by the Museum of Civilization and the Federal Department of Indian Affairs, but—until 1986—not by the National Gallery.[29] Only in the past few years have the art museums of Seattle and Vancouver begun to acquire Northwest Coast Indian art; for the entire century covered in this volume, these works, even works of "art," had been collected by the respective anthropology museums.[30] Native art is part of the Western art world, but it has not been fully integrated into the core of that world.

The art world of Kwakwaka'wakw artifacts, expressed in museums and the mar-ket, is bifurcated into separate spheres for historical and contemporary objects. The

paradox is that the historic artifacts—largely created for Native use and collected by anthropologists as cultural documentation—have now been accepted as high art, especially in American art museums such as the Metropolitan. Contemporary Northwest Coast artifacts, on the other hand, most of which are now explicitly created for sale as "works of art," are generally acquired by anthropology museums, rather than art museums. Despite the accommodations between art and anthropology, these kinds of objects are treated differently in the contemporary art world. Karen Duffek (1983b) has noted this irony in her exploration of "authenticity" in the Northwest Coast Indian art market. In order for objects to be accorded this status, many consumers prefer that they be created by an ethnic Indian, by "traditional" techniques, in "traditional" forms, and made for ritual use (or appear as such). Thus consumers are not fully comfortable with classifying Native artifacts as fine art, in the sense of art for art's sake.

Paradoxically, in this approach there is a striking resonance to a common formal and social conservatism in Kwakwaka'wakw art. As Nelson Graburn points out, for many Northwest Coast Indian artists, especially Kwakwaka'wakw, "there is a . . . strong feeling that the art, including the commercial productions, must serve or be connected to the continuity-giving spiritual, ceremonial, and genealogical heritage of the culture. Anything else is considered 'selling out' Having been 'given back' the art they had lost, the artists strongly believe that they should never again depart from the ancestral style (which coincides with white demand) and that spiritual continuity is the way to keep on this path" (Graburn 1993:186–187; see also Ostrowitz 1999). On the other hand, there are the "post-modernist" Native artists, who do not want to be tied to a specific tribal identity. What many recent critics of Northwest Coast Indian art (DeMott and Milburn 1989; Duffek 1993) are finding is that the diversity of Native art cannot be restricted to the Western dichotomies of art and anthropology, tradition and innovation. Native artists come to the table with a different perspective, one that they have not given up, merely adapted to the dominant society in which they find themselves.

Despite this massive creation of a Western art world, Northwest Coast Natives still create objects for ceremonial use; reserving some of their best work for the Native context (Blackman 1985). While such uses continue, over the past century there has been a profound change in the professional production of such ceremonial art. No carver can now support him- or herself solely by this means. In fact, the influence goes the other way. The robust white market has allowed Native artists to become full-time professional specialists, who can then turn their attention to the much fewer, less lucrative, but more meaningful ritual commissions. Without this essentially foreign market, one wonders if the current ceremonial revival would have been quite so vital.

After having seen their productions accepted as "art," many Northwest Coast carvers now resist this seeming honorific. As Richard Hunt maintains, "I don't think of what I do as art but as cultural property. In this way we may be able to keep and

hold onto our cultures" (Wyatt 1999:40). Cultural property means that it is inherited and that one must have the rights to create and reproduce it: "I think that if you call it art, you give everyone a chance to do what belongs to us."[31] Given their intimate participation in the Western art market, one can safely say that some of what Kwakwaka'wakw carvers create will be considered art, and some will not. The object worlds of their creations will continue to be, as they have for the past century, multiple and contested.

6

CONTEMPORARY ANTHROPOLOGY

The Kwakwa̱ka̱'wakw Object in History

In 1971 British Columbia celebrated another centennial, this time marking the province's entry into the Canadian Confederation. The year before Peter Macnair, curator of ethnology at the B.C. Provincial Museum, had been approached for ideas by a celebration committee.[1] Recognizing that there were by then a fair number of competent contemporary artists, Macnair proposed an exhibit of their work. He felt that the museum was a particularly appropriate place because, since the time of Duff and Martin, it had been directly involved in promoting contemporary art. Macnair wrote a proposal, to buy or commission a contemporary collection but was turned down by the committee. Instead, he eventually received funding from the province's First Citizens Fund, and then asked Wilson Duff and Gloria Cranmer Webster to join him. At that time Duff was a professor at the University of British Columbia, while Webster was a curator at the university's museum. The three traveled up the coast, locating and interviewing artists, but Duff dropped out at Alert Bay, and Webster and Macnair continued north. When they returned home they had a roster of artists and a list of commissioned pieces.

The Legacy opened in Victoria in August 1971, for a run of over a year. The show consisted almost entirely of commissioned pieces, though a few things had been previously acquired. As it was restricted to the Native arts of the province, there was no representation from the Tlingit of Alaska. This version had eighty-eight objects, thirty-

eight of them by thirteen Kwakwaka'wakw artists. Their work included paintings, masks, jewelry, model poles, a chief's seat, a plaque, and a feast dish. Although a catalog was planned, there was neither time nor money to prepare one, but, despite its limited budget, the show received a favorable response.

The popularity of the exhibition demanded further travel; in 1975–1977 the show toured across Canada. For this incarnation, the National Museum of Canada contributed money to add to the collection, but the show was still limited to contemporary pieces. As some items were added, others were deleted. In this second version 12 Kwakwaka'wakw artists contributed 20 pieces out of a total of 85. After a redesign, *The Legacy* toured British Columbia until the spring of 1980. The exhibit received its final version as the result of an invitation from the Edinburgh Festival. The festival persuaded the provincial government to contribute substantial funding. For this version historic pieces from the collection were added, thus better demonstrating the continuity between past and present. Out of the total of 100 works, 70 were by named artists. The 14 known Kwakwaka'wakw contributed 28 works, in addition to 3 by their anonymous predecessors. Unlike the previous versions, this show no longer included Coast Salish basketry and textiles. After its presentation during the summer of 1980,

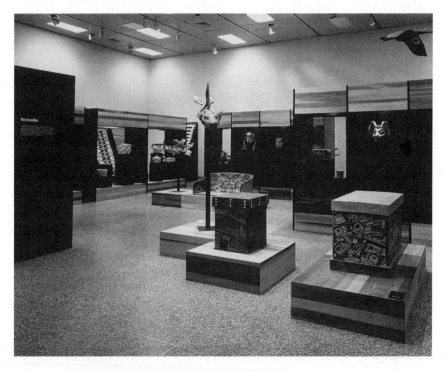

Figure 6.1. *The Legacy* exhibit at the Provincial Museum of Alberta, Edmonton, April 1975. RBCM pn 12782.

it opened again in Vancouver and Victoria, and this time there was a catalog (Macnair et al. 1980).

The Legacy was significant for its documentation of the revival in Northwest Coast Native art. Whereas the Kwakwaka'wakw had earlier been disparaged for their flamboyant styles, here they were acclaimed for maintaining the continuity of their artistic traditions. Yet even for the groups that were experiencing a rebirth after a period of decline, for the first time since the period of classical collecting, attention was drawn to the great work of living Northwest Coast artists. Throughout the decade, the Native art scene on the coast continued to develop. As new artists came to the fore and others dropped out, the curators continued to shift and judge; for every version of the show there were commissioned pieces that were not included for aesthetic reasons. The exhibition continued to travel and evolve over a decade because of the change and vitality in contemporary Northwest Coast Indian art.

The 1971 *Legacy* exhibition thus marked the shift in anthropological appreciation of Northwest Coast Indian traditions from that of a completed, "classical" state to that of a living art. In Fabian's (1983) terms, there was now a recognition of coevalness, that anthropologist and Kwakwaka'wakw were experiencing the same time. Since the mid-1960s, both the art world and anthropologists have shared an interest in the history and change of Kwakwaka'wakw and other Northwest Coast artistic traditions, a view stimulated by the need to account for contemporary creation. The conceptual shifts represented in the exhibit were also a reflection of larger movements in the discipline of anthropology. After decades of neglect, the field of museum anthropology was revitalized in the mid-1960s; marked by the founding in 1964 of the Committee on Anthropological Research in Museums, a special interest/advocacy group organized under the American Anthropological Association (Freed et al. 1977).[2] A generation of graduate students went into museum storerooms to look again, with new eyes, at the vast collections that had accumulated over a century. This increased activity was partly an outgrowth of new interests in linguistics and symbolic systems as well as fundamental disciplinary changes. A sense of crisis encouraged a reflexive interest in history, which was fed further by increasing problems in conducting fieldwork (Hymes 1972). All this gave museums a relevance they had not had for decades.

COLLECTING

On the Northwest Coast, these scholarly trends coincided with physical and social developments in the region's major anthropology museums. New buildings came with new names, and often new curators. In 1962 the Washington State Museum moved into its new building, changing its name to the Thomas Burke Memorial Museum, with new exhibits opening two years later. In 1968 George Quimby and Bill

Holm accepted permanent positions at the Burke Museum, as director and curator of Northwest Coast art, respectively, positions they held through the early 1980s. In 1968 the Vancouver City Museum occupied its new building under its new name as the Vancouver Centennial Museum (renamed yet again in 1981 as the Vancouver Museum). The B.C. Provincial Museum erected a new building in 1968 as well, though its curator of ethnology, Peter Macnair (b. 1940), had assumed his post the year before. At the University of British Columbia, Wilson Duff began teaching anthropology in 1965, and Michael Ames (b. 1933) became director of its museum with the opening of its new building in 1976. (Both Ames and Macnair retired in 1997.)

With these new activities came new approaches to all aspects of museum anthropology: collecting, conservation, display, and scholarship. As always, collection led the way. Since the end of the "classical period" in the 1920s, there has been a general shift in the relative importance of institutional collecting to private collecting, much of which eventually finds it way to museums. At the same time, the collecting of historic pieces has been greatly reduced, especially for institutions. As a corollary of the fact that there is a limited supply of old objects, contemporary pieces are cheaper and more available. For this reason as well as more theoretical ones, both the B.C. Provincial Museum and the UBC Museum have made an effort to document contemporary Northwest Coast styles.

UNIVERSITY MUSEUMS IN VANCOUVER AND SEATTLE

In making their collections of new material, local museums had to first locate financial support. Like most museums, but especially those run by universities (Nason 1987), the museums at UBC and the University of Washington have depended largely on wealthy patrons for the development of their collections. The two principal benefactors of the UBC Museum of Anthropology, H. R. MacMillan and Walter Koerner, both came to their love of Northwest Coast art through years of experience in the province's hinterlands; both parlayed careers as foresters into great business empires (Ames 1975a, 1975b). Although MacMillan was more important in developing the museum's basic collections, he collected little, if any, himself. Instead, his yearly contributions, from 1948 to 1964, allowed the museum to acquire existing collections or to buy individual pieces.

Kwakwaka'wakw pieces comprise the single largest component of the MacMillan collections. As the museum points out, "It is the only major collection assembled during the 1950s and thus represents an important recent phase in the evolution of Kwagiutl art and technology" (Ames 1975a:38). The converse of this is that because of the museum's late founding, there is very little old (pre-1900) material. The collection was not gathered systematically; the Hawthorns stress that the objects were sent down to them, unsolicited, by Kwakwaka'wakw who had decided to give up the potlatch or who felt that the museum would be safer place for preservation (Hawthorn 1979:viii).[3] "Crates of masks, rattles, whistles and headdresses arrived weekly, fol-

lowed or accompanied by a letter enumerating the contents and naming prices. . . . Our donor friends supported the purchases without hesitation and with generosity. We could pay what was stipulated by the owner and still feel that we were acting properly in relation to the donors and with a fair relation to the value of the pieces we were buying" (Hawthorn 1993:15). Mungo Martin played an critical and active role as a liaison, alerting the Natives to the existence of the museum and encouraging his people to deposit their regalia there. Because of the lack of field collecting, the documentation of the UBC Kwakwaka'wakw collection has always been spotty and uncertain. From the time the pieces first arrived, the museum has constantly sought out Native expertise to help amplify and correct the data.

MacMillan was also the principal patron of the B.C. Totem Pole Preservation Committee. As noted in chapter 4, this grew out of an earlier committee concerned with the display of totem poles on the UBC campus. By the beginning of 1953 a new committee was formed (with representatives from the university, the Provincial Museum, and the provincial Indian Affairs Branch) to coordinate all totem pole preservation in the province. After an initial survey of all surviving poles, plans were made to salvage the best of them. The Native owners were paid for their poles, which were then split between the Provincial and UBC Museum collections. All were preserved indoors, though replicas of some were displayed in outdoor parks. The Kwakwa-

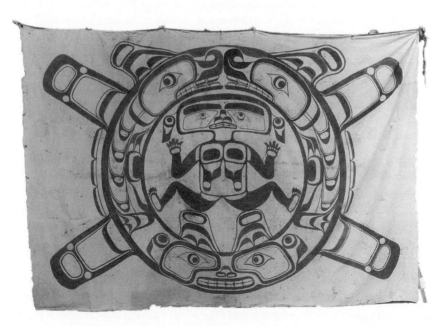

Figure 6.2. Kwakwaka'wakw ceremonial curtain, painted muslin, H. R. MacMillan purchase, Museum of Anthropology, University of British Columbia. Photo by William McLennan. UBC cat. no. A4363.

ka'wakw poles were surveyed in May 1955 and collected the following year, with most going to the UBC Museum. With few exceptions, this marked the end of the collection of extant Kwakwaka'wakw totem poles. Henceforth, if a museum desired a totem pole, it commissioned one.

Like his colleague, Koerner supported the construction of the Haida village on campus, but he differed from MacMillan in that he himself liked to collect Indian art, much of it purchased from dealers. Accordingly, the Koerner collection is smaller (there are seventy-eight Kwakwaka'wakw pieces), but marked by works of great aesthetic quality. The promise of his collection in 1971 helped persuade the federal government to contribute to the new museum building. Like many museums, the UBC Museum of Anthropology has little designated funds for acquisition, depending mostly on private and corporate generosity. Although material from the rest of the world is often collected as part of student and faculty fieldwork, its contemporary Northwest Coast pieces tend to come from commissions, dealers, or private collectors (see Hawthorn 1993; Webb 1999).

The Burke Museum in Seattle has also benefited from the patronage of wealthy local businessmen. From the 1940s until his death in 1965, Sidney Gerber of Seattle collected Northwest Coast art, most of it purchased from Natives in the field. Many fine pieces were exhibited at the 1967 *Arts of the Raven* show, and the following year Ann Gerber donated the 124 objects (about half of them Kwakwaka'wakw) to the Burke Museum. Bill Holm (1972a:9) has noted: "It was at the time of its transfer to the Burke Museum perhaps the largest and most significant private collection of Northwest Coast Indian art in the Pacific Northwest and ranked with the finest in the world." Unlike earlier collectors who regarded their purchases as curios, Gerber treated his purchases as fine art, which he kept with his contemporary Western art collection (see Holm 1987).

B.C. PROVINCIAL MUSEUM

In recent times, the B.C. Provincial Museum has been the most active institutional collector in the Northwest. The classical holdings in the museum were due primarily to Charles Newcombe, from his prewar expeditions and the purchase of the remaining Newcombe collection in 1960. Little collecting was supported between 1915 and 1950, when Wilson Duff became curator, and Duff's purchases were mostly of older pieces (particularly the Mungo Martin collection in 1959). Contemporary artifacts have been a concern only since the appointment of Peter Macnair in 1965.

The commissions for *The Legacy* exhibit of 1971 were the museum's first opportunity to acquire a contemporary collection, for until then it had to rely upon its own employees to produce contemporary art. The initial showing stimulated Macnair to build a representative contemporary collection. His hope was to have enough money so that every year he could acquire at least one piece from the original Legacy artists, and to add the work of other artists. In 1973 the museum set up an acquisition fund, largely reserved for the Ethnology Division, which allowed such collecting for a

while, but prices became so high that Macnair was forced to become selective.[4] Macnair had a similarly systematic plan to acquire a copy of each silkscreen print produced, but in this case, it was not price that checked him so much as the vast increase in the production of such prints.

Despite an interest in and encouragement of recently made artifacts, a bias for age has long characterized the collecting of the Provincial Museum. As part of a museum-wide mandate, Macnair's 1981 "Collecting Policy" for the Ethnology Division was "committed to preserving as much of British Columbia's Indian history as possible."[5] This retrospective and conservative thrust was further spelled out in the policy: "The number of ethnographic specimens relating to British Columbia Indian culture is finite, and . . . these are obviously rare." Obviously, it is the historic pieces that are finite; Natives can and will continue to make further "ethnographic specimens." Although most of the museum's acquisitions were, and are, probably of contemporary pieces, given their availability and lower prices, its statements evinced a preference, within limited resources, for older, pre-1950 artifacts.

Aesthetics continues to be an important consideration for ethnographic collecting, though it has now been transformed by the art world's appropriation of these artifacts as art. Today much of what the Provincial Museum's Ethnology Division collects—be it classic or contemporary—could be acquired in an art gallery. According to the 1981 policy, "The Ethnology Division, BCPM, collects objects of ethnography or ethnographic art made by, reworked by or adapted for use by persons known as Indians of the territory that is now British Columbia." Although no definition of "ethnography" was given, it is notable that a distinction was made between "objects of ethnography" and "ethnographic art."

While aesthetic or technical excellence was one of the museum's prime criteria for acquisition, it was seldom the first, according to the collecting policy. However, if an item was also well documented and filled a gap in the collection, it was an especially likely candidate for purchase. But, as the statement continued: "The ethnographic (cultural) information is almost always seen as most important and should over-ride aesthetic consideration if a choice must be made."

While curator, Peter Macnair maintained a double, almost ambivalent, attitude toward "ethnography as art." On the one hand, he collected "art," as it is defined in contemporary society, simply because that is the kind of artifact created by Natives today. Here he revealed a basic documentary interest. For instance, when silkscreen prints first became an important medium of livelihood and expression, he set out to purchase two copies of every Native print released and only limited himself in the face of rising production and fixed means. Qualitative choices were avoided. Similarly, he once expressed a fantasy to one day have enough money to station collectors all around the province's galleries and shops. On a set day they would walk in and make a representative sample of the Native art available commercially—along the complete range of quality from masterpiece to tourist trinket.[6]

On the other hand, Macnair acknowledged that he brought his own evaluative

sense of Native aesthetics to bear on purchase decisions. When all other criteria were equal, the museum would decide to put its limited funds toward "aesthetic achievement." Although it was nowhere made explicit, naturally it was the curator's tastes that applied. Macnair recognized a category of "production pieces," the simpler, cruder works that carvers turn out in bulk in order to earn money. These were distinguished from outstanding or special pieces, which showed an advanced control over materials and techniques. Although the museum in principle might have liked to document production pieces, when their prices begin to match the special pieces, Macnair just as soon was inclined to purchase the finer object. To take another example, some of the works commissioned for the Legacy collection were never used because Macnair felt they were "not good enough" aesthetically.

Documentation has continued to be a defining desideratum for ethnological museums. According to the 1981 collection policy of the B.C. Provincial Museum: "An object or collection is considered to be of utmost significance if it is fully documented. That is, if facts such as date and place of manufacture, record of Native owner and details of use accompany the object." Even if the vendor does not have this information, the museum may still consider the purchase, if it believes that such data could be obtained later.

During the Macnair years the Provincial Museum developed an innovative approach to collecting. With the rise in Native autonomy and changing evaluations of Native tradition, collecting has become more difficult. In response, the museum offered an exchange as part of its collecting transaction. Although this program only began in the late 1960s, it was rehearsed by another innovative one of the previous decade. In 1952, after returning from a study trip to the Skeena River, Wilson Duff was determined to preserve Tsimshian (Gitksan) totem poles, particularly in the village of Kitwancool. Yet, paradoxically, Duff felt that complicating his efforts at preservation was the vibrant culture of the people at Kitwancool. They would not part with their poles, and thus Duff began to think of preserving them in situ. However, as the totem pole replication program got under way at Thunderbird Park, Duff came up with the idea of copies. As he first explained it in a 1954 report: "One need, then, is to obtain at least six for our collections, by offering the Indians compensation that will be adequate to them; for example, trade them an exact copy for the original."[7] The plan was adopted; three poles were collected in 1958, and were replicated between 1958 and 1965 (along with copies for Thunderbird Park and of another pole collected in 1962). Copies of each pole were then erected, with appropriate ceremony, in Kitwancool.

Of course, this was not the first time that Northwest Coast artifacts had been replicated as part of a purchase transaction. In 1881 J. Adrian Jacobsen had commissioned a copy of the Heiltsuk chief's seat that he was not able to secure. But an important change had occurred by the 1950s. Whereas Jacobsen left the original in the village and had the copy sent on to Berlin, Duff kept the original at the museum and sent a copy to the village. The significance of this inversion is ambiguous. While it might be argued that in the 1880s Native culture was so strong that they would not part with

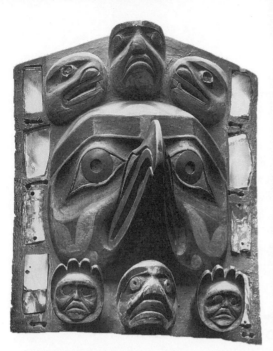
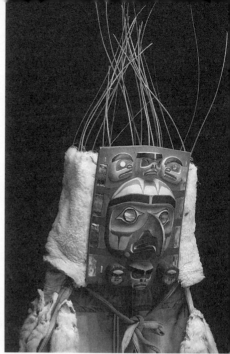

Figure 6.3. Collecting by exchange: original frontlet of Alice Glendale Smith, purchased in August 1973, Royal British Columbia Museum. RBCM cat. no. 15050. **Figure 6.4.** Collecting by exchange: replica version of Smith frontlet, by Richard Hunt, given to Alice Smith in March or April 1974; purchased from Smith estate in 1977, Royal British Columbia Museum. RBCM cat. no. 15598.

the object, and thus was correspondingly weaker in the 1950s when they would, the opposite case might equally be made. Duff himself felt Kitwancool culture to be active and tenacious when he visited. What had changed was the Native attitude toward museums, as well as the anthropological attitude toward Native culture. Natives now had an understanding of the archival function of museums, that they might be the best places to preserve fragile, old artifacts. At the same time, anthropologists no longer believed, like Boas, that Native culture was doomed to inevitable extinction. Most turn of the century collectors thought it enough to preserve the object in the museum. Now there was a feeling that the museum had some obligation toward fostering Native traditions in general. There was also the pragmatic realization that programs such as these were the only way to make contemporary collections.

The Kitwancool case would seem to have been a clear model for the Provincial Museum's later exchange program, but, in fact, the curator denied it.[8] The precedent Peter Macnair cited was the similar exchanges devised by art dealers in the late 1960s.[9] At this time there was much Native resistance to the selling of old objects, but there were also a number of young carvers around willing and able to make replicas. As it was becoming something of a practice to offer a copy along with the purchase price, Macnair began to commission copies from his carvers in order to compete on the market (figures 6.3, 6.4).

By the early 1980s, the museum's exchange program worked in the following manner. Depending on the circumstances and the Native's relationship with the museum, a copy might be negotiated at the time of purchase, but if not requested, a copy was not necessarily offered. (While exchanges are still possible, without staff carvers they would be difficult to implement.) Owners always had the option of temporarily borrowing back their pieces, as long as the object was not too fragile.[10] The museum's decision to produce a copy was made on a case by case basis. Among the deciding factors were the physical condition of the object, its ethnological value and importance in the collections, and the Native's own wishes. There have been times when objects, copies or otherwise, were given to Natives as gifts, usually in recognition of previous service and kindness to the museum. As a governmental body the museum has to be somewhat bureaucratic, to avoid charges of favoritism. This program of exchange is only one of several in which contemporary museums may balance their own needs against Native desires and demands.

TEMPORAL SAMPLING: THE RELATION OF COLLECTING TO ARTISTIC GENERATIONS

In considering the temporal sampling in Kwakwaka'wakw collecting, one soon notices a striking situation. Except at the beginning and in the present day, collectors rarely acquired current artworks, contemporary to their times. Instead, driven by a salvage search for the "traditional," they invariably purchased the oldest objects they could find. This resulted in a kind of "cropping," as in the harvesting of timber. An inspection of museum collections confirms that Jacobsen and Boas principally acquired artifacts made between 1850 and 1900, while Newcombe, coming almost twenty years after, bought objects made between 1870 and 1920. The large UBC Museum collection, made in the 1950s, is full of items made in the preceding four decades. Bear in mind that these are only broad trends; each collection was mixed, with some very old pieces and some created only months before. Although all were driven by the same preservationist desire to collect the oldest pieces they could find, because of their repeated activity, museums served to successively remove the current production of Kwakwaka'wakw artists. While a Willie Seaweed mask may have been scorned as too new in 1915, by 1950 it was a classic.

In his acclaimed travelogue, *Tristes Tropiques*, Lévi-Strauss (1974:43) noted this irony of changing perceptions: "While I complain of being able to glimpse no more than the shadow of the past, I may be insensitive to reality as it is taking shape at this very moment, since I have not reached the stage of development at which I would be capable of perceiving it. A few hundred years hence, in this same place, another traveller, as despairing as myself, will mourn the disappearance of what I might have seen, but failed to see."

The exceptions prove the rule, as both periods were structurally unlike the great period of classical collecting. At the time of first contact, by Cook and Vancouver, collectors knew so little about Native styles and their interests were so casual, that

objects were picked up more or less at random. In the present, since 1950, and espe-cially since 1965, museums have revised their attitudes toward the viability of Native tradition and now are trying to document a current, vibrant artistic scene. Modern museums have not given up their interest in the old, but now there is very little of this in Native hands, and what is present is only given up under special circumstances. The historic market, such as it is, is largely one of recirculation from previous white owners.

While all the generations of Kwakwaka'wakw artists of the past century are rep-resented in museums, there is no one museum with a complete series. Typically, the large East Coast museums are filled with old pieces (old even when they were col-lected), while the West Coast museums have mostly new objects. (While this com-parison was never absolute and is continually breaking down, especially in the West, the relative balances still apply.) This creates problems for exhibition, with the visitor inevitably getting a skewed picture of the tradition. Because of the uneven represen-tation, moreover, most museums have trouble adequately conveying a sense of sty-listic change.

Contemporary collecting tends to work under very different rules from those in the classical period. First, many museums (particularly the large natural history mu-seums) do not collect at all, except to accept worthy objects donated to them. Money is a problem, and these museums are struggling to care for the massive collections they have already. Second, artifacts are rarely purchased today from Native owners; the political situation has changed. If the artifact is old the Native tends to value it very highly (though dealers never give up the chase), and if the object has been newly carved, the owner is still actively using it for ceremonies. Most anthropology cura-tors prefer to acquire artifacts that have been used by Natives, but this is practically impossible today, especially for contemporary pieces. As noted in chapter 7, the Provincial Museum has a program of commissioning masks that are then lent out for potlatch use. This clever plan is about the only way a museum can own a contem-porary artifact that has seen ritual use. Because of this, most works of contemporary Kwakwaka'wakw art are purchased directly from the artist, or secondarily from a dealer or private collector, but not from a Native patron/user. This does not neces-sarily make these collections less authentic. Most contemporary artifacts are made to be collected; the context has changed.

CONSERVATION

The physical manipulation that anthropologists had applied to objects in their care during the "classical" period has continued to the present. While the technology may have changed, then, as now, this treatment follows from a conception of authenticity—what a Native artifact is and how and why the museum is preserving it. These atti-tudes underlie what is collected and how these objects may be displayed. Perhaps

nowhere is the "biography of things" (Kopytoff 1986) more critical than in conservation treatment.

Shortly after Duff's departure, the Provincial Museum in 1966 hired Philip R. Ward, a trained conservator from the British Museum. Ward, the first full-time, professional conservator west of Toronto, brought to Northwest Coast artifacts the new scientific attitudes of conservation as they had developed in the postwar period. Preventive conservation through the establishment of a stable environment was preferred over treatment, and all treatment was now restrained. Preservation had replaced restoration. As little as possible was done, and the goal was to have a reversible treatment, so that anything that had been done could be undone. Careful documentation was to accompany all treatment. These principles continued after Ward's departure in 1977 and spread to the UBC Museum of Anthropology, which hired a trained conservator, Miriam Clavir, in 1980. These professionals try to share their expertise with the smaller, local museums in the province, which often lack such trained staffs (Ward 1978).

All the exhibits in Thunderbird Park were repainted around 1980, the first time in two decades.[11] This action was largely in response to constant public criticism over the park's "shabby" appearance. The curator, Peter Macnair, had preferred to have the poles weather naturally, as they would have done traditionally, and he "agonized" over repainting the facade of the Mungo Martin house and the pole. Unlike the replica poles, these were "original artifacts," as the artist had left them. But he had them treated as well, to avoid the contrast with the newly painted poles and because of the Native precedent of repainting facades. The work was done by staff carver Tim Paul, using mostly the original kinds of paints.

As most older totem poles were copied and stored indoors, conservation efforts in the region began to shift to smaller, portable artifacts. So, for example, a major task for Ward and his colleagues was to prepare the specimens for exhibition in new displays (opening in 1976 in Vancouver and in the following January in Victoria). Like all conservation, however, such treatment did not take place in a curatorial vacuum. All manipulations of an object must be based on decisions of "authenticity," on what is deemed to be the "true" state of the artifact.

An interesting case in point is the treatment given a Kwakwaka'wakw mask by the Provincial Museum (Hillman 1982).[12] It is a common Kwakwaka'wakw practice to repaint masks to "freshen them up" for ceremonial use, but for several decades the museum has been stripping recent painting, in selected cases, in order to reveal the original layer of paint. In 1981 the museum acquired a Kwakwaka'wakw sea monster mask, evidently carved in the nineteenth century, which had been purchased from Mungo Martin by its last owner. Before selling it to him, Martin said that he would "fix it up" by adding a missing lower jaw and "horns," as well as probably repainting the entire mask. Peter Macnair decided to strip off the recent repainting "in order that we might return the mask to its original state" (Hillman 1982:16).

Several factors led to the decision to remove the top layer of paint. First, the paint was clumsily applied, with spills and drips and uneven edges. Second, some of the

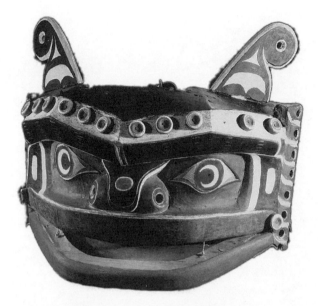

Figure 6.5. Sea monster mask, after conservation treatment,
Royal British Columbia Museum. RBCM cat. no.
16805.

colors used were "uncharacteristic of the traditional Kwakiutl art style," according
to the curator. As the conservator outlined the basic motivations for the treatment:

> It should be noted that paint stripping is not a normal procedure in the conservation
> of ethnographic artifacts. There are several masks in the collection which show evi-
> dence of repainting; however, they were repainted while still in use within their native
> context. It was not uncommon for a mask changing ownership within the native com-
> munity to be modified in some ways by the new owner, and these modifications are
> always preserved as a record of the object's history. However, in the present case, the
> mask had been removed from the original cultural setting and the modifications were
> no more than cosmetic treatments to "freshen up" the mask for its new non-Indian
> owner. (Hillman 1982:17)

But more important, according to Macnair, stylistically the mask could be dated to the
late nineteenth century and the museum had very few masks from that period. Given
the choice of the two versions, the museum decided that it wanted an old mask.

In addition to having some parts of the mask removed, the museum decided to
add others. "All the missing 'suckers' which went across the brow will probably be re-
placed by newly carved ones. This approach of 'adding' to the mask is acceptable be-
cause we have one-half of one of the originals to use as a model and because their
absence is visually disruptive to the full appreciation of this artifact" (Hillman 1982:19).
This concern for the full visual effect may indicate that the museum wished to ex-
hibit the piece, for scholars are usually content with the object as they find it.

Figure 6.6. Sea monster mask, detail of eye area, after conservation treatment. Royal British Columbia Museum. RBCM cat. no. 16805.

Contrary to the conservator's statement, repaintings are not "always preserved." For instance, in the 1960s or early 1970s, Macnair collected a thunderbird headdress carved by Willie Seaweed. Unlike the previous example, this object had been repainted by a Native carver at the request of the Native owner. But, according to Macnair, the new painting was rather sloppy and denied the subtleties of the original decoration. The curator "felt the piece was more meaningful in its earlier version" and thus had it recorded and photographed as it was and the paint stripped. The motive was in part aesthetic, but also research-oriented.

Macnair has done the same with a number of other masks. There are no hard and fast rules for such treatments; each case must be decided on its own merits, and much depends on the object's place in the museum's total collection. The curators work closely with the Conservation Division, following a cautious policy, and only alter an object when they have clear and direct evidence of an earlier state. Usually the curator orders such treatment only if he or she knows the history of the piece, or conversely, if there is no history at all. As Macnair argued, such repainting was often done by people with no real knowledge of the form. That is "an ethnographic statement, but it's not as important as the original, in most cases." As he added with a grin, no doubt thinking of his staff carvers, "The thing is, we can always paint it again."

Figure 6.7. Sea monster mask, detail of eye area, before conservation treatment. Royal British Columbia Museum. RBCM cat. no. 16805.

Within the museum's actions one can discern several assumptions: one, that museological interest focuses on actions within the Native community, not between the Native and white communities; two, that usually an earlier state of Native culture is of greater curatorial interest than a later state; and three, that the work of important and well-known artists takes precedence over lesser artists. While there is much support for such views, they are choices, not self-evident truths.

DISPLAY

Starting in the 1960s, after many years of stasis, exhibits of Northwest Coast Indian artifacts in anthropology museums began to change. A response to the opportunities of new buildings and new personnel, they also demonstrated new concerns. These exhibits gradually expressed again an engagement with anthropological theory, moving beyond simple arrangements of culture area and cultural domain.

MILWAUKEE PUBLIC MUSEUM (1962)

In October 1962 the Milwaukee Public Museum opened what came to be a very influential display of Northwest Coast culture. Anthropology had long been a special focus at the Milwaukee Museum, particularly during the tenure of Samuel Barrett as director, from 1920 to 1940. And ever since it created the first habitat group in

Figure 6.8. Entrance, *The Salmon and Cedar People* display, Milwaukee Public Museum, 1962. MPM no. 4X272A.

an American museum (Carl Akeley's muskrat diorama of 1890), the museum had been noted for its advanced exhibit techniques. In 1903 it became perhaps the first American museum to portray Native people as part of dioramas with painted backgrounds (the Eskimo Fishing Girl, see Lurie 1983:46–47), techniques that were not widely adopted until the teens.

In effect, *The Salmon and Cedar People* institutionalized in the form of a permanent museum hall the display techniques introduced by René d'Harnoncourt in his temporary shows of 1939 and 1941. According to Lee Parsons, assistant curator and part of the design team with artists Edward Green and Lee Tischler, "It was the designers' intention to recreate both the environmental and cultural atmosphere of the Salmon and Cedar People" (Parsons 1962:66). The Milwaukee approach was yet a further step in the direction of environmental display suggested by the post-Boasian hall at the American Museum.

The hall took its general character from architectural imagery: evidently for the first time, a (loose) reconstruction of a cedar plank house was used as a setting for the display of objects. Instead of a full-sized, fully enclosed structure, the museum

used a smaller framework (with a facade 16 by 9 feet), open on one and a half sides, which functioned as an entrance to the exhibit. On one half of the front, museum artists had painted a none-too-accurate Northwest Coast design.

As d'Harnoncourt had done, Parsons and his designers took a cue from the Native performance setting and exhibited their masks in a large, open, darkened space, illuminated by spotlights. After a period of spare, isolated installations with few objects, Milwaukee reintroduced a sense of plenitude. About thirty masks were displayed in a space 10 feet deep, 15 feet wide, and 15 feet high. Hung at varying heights and depths, the masks seemed to float mysteriously. The performance context was made even more vivid by the use of a mechanism to open and close a Kwakwa̱ka'wakw transformation mask. As the thunderbird opened to reveal a human face, the color of the lighting changed suddenly. This transformation was set on a continually operating one-minute cycle. Motion was present in other parts of the hall, in the form of "a mountain stream complete with salmon models and running water" (Parsons 1962:65). The atmosphere was reinforced by the general use of spots in all exhibits, many of them colored, with an overall color scheme of "very deep tones of blue, red, and green (taken from the specimens themselves)" (ibid.:66). In another innovation now frequently used, scattered around the hall were quotations taken from Kwakwa̱ka'wakw texts gathered by Boas and Hunt.

The Salmon and Cedar People opened just as the museum was planning a new building (Lurie 1983:114–117). As the new building began to open its halls in the mid-1960s, this and several other exhibits were installed essentially intact, where they remain more or less the same to this day. However, the Northwest Coast display changed its meaning as its surroundings changed. The new exhibits were all arranged according to a systematically geographical and ecological plan. Expanding the culture area concept to the entire world, each display of regional culture was juxtaposed to exhibits of natural history: the local flora, fauna, and landscapes. Consequently, the displays emphasized the adaptation of human cultures to their environments.

This philosophy of conceptual juxtaposition was also spatially implemented in the new museum's open plan. Distinctions between exhibits and backgrounds tended to be blurred as glass cases were avoided in favor of open areas simulating "natural habitats" such as village markets and several house interiors. According to its planners, "through its exhibit enclosures and display techniques each exhibit area will take on a character in keeping with the subject interpreted" (Parsons and de Borhegyi 1964:24). A generalized "precontact" phase was chosen as the basic time period, with occasional cases devoted to the archaeological past or contemporary acculturation (ibid.:21, 24).

Whether intentional or not, the 1967 *Arts of the Raven* exhibition at the Vancouver Art Gallery used many of the same devices: cedar planks and gravel, darkened areas with spots, and open walls of masks. More firmly documented is the tie between Milwaukee and the current installation at the B.C. Provincial Museum. The designer, Jean André, had been quite a fan of what became known as the "Milwaukee style,"

and adopted its general approach of walk-in environmental exhibit spaces. In turn, many of the Provincial Museum's techniques were adopted by the Field Museum's new installation.

B.C. PROVINCIAL MUSEUM (1977)

Between the mid-1960s and the mid-1970s, the four major museums in the Northwest with anthropological collections constructed new buildings: the Burke Museum (1964), the Vancouver Centennial Museum (1968), the B.C. Provincial Museum (1968), and the UBC Museum of Anthropology (1976). Yet only the latter opened with complete exhibits; the others spent years in finishing their new displays. After decades of neglect, they now leaped ahead of the large Eastern museums in the sophistication of their displays.

The Provincial Museum's *First Peoples: Indian Cultures in British Columbia* went through a long period of gestation before it opened, finally and officially, on January 17, 1977 (Corley-Smith 1985:27–46).[13] Archaeologist Donald Abbott began to plan the exhibit in 1965 as he took over Wilson Duff's position. Hired later that year, Peter Macnair assumed greater responsibility after he became curator of ethnology in 1967. The first part of the display to open was a single gallery of Northwest Coast Indian art, designed by Bill Holm. There were problems with the general concept, however, and after discussion the administration decided to start over. De Borhegyi was called in as a consultant, and soon thereafter André was hired. Because the institution was essentially a natural history museum, the administration decided that the basic thrust would be environmental. In the fall of 1973, the museum hired a cultural ecologist, John Pritchard, who devised the exhibit's basic plan, with the help of staff members to select and research artifacts.

The ethnology displays were a central component of the museum's master exhibit plan. As a member of the committee, Abbott proposed ordering all the human history displays into one chronological circle, "The Ring of Time." Starting in the present, the visitor would move backward in time, through the period of white colonization, then to a section on Native prehistory, until one came to the ethnology section. *First Peoples,* carrying out the temporal theme, is itself divided into two parts, each on a different spatial level: "The first describes the cultures as they existed before the arrival of the White Man; the second deals with the effects of European culture on the native way of life" (introductory label, as quoted in Halpin 1978b:43).

Like the Boasian Northwest Coast Hall at the American Museum, this display includes the cultures of the Plateau region, here designated Interior (of British Columbia). Although one reason for their inclusion was political—they are within the province's borders—given the exhibit's basic theme of environmental adaptation—this regional comparison helps clarify these accommodations to differing settings. As in that earlier New York exhibit, the Coast vastly outnumbers the Interior materials.

A series of categories further defines the contents. Displays within each half of the hall (pre- and postcontact) are grouped into units on technology, transportation and

Figure 6.9. Plant Gathering and Intertidal Gathering, *First Peoples* display, Royal British Columbia Museum. RBCM pn 13204–4.

demography, society, and cosmology. Each of these is further subdivided into separate sections. For example, the "Technology—Food Quest" unit for the coastal cultures covers fishing, processing, sea mammal hunting, intertidal gathering, and plant gathering.

Display techniques are sophisticated and contemporary. Objects are interpreted by means of lighting, models, mannequins, and illustrative media. The ambient lighting is dark, with spotlights focusing attention on particular objects. In the cosmology section, for instance, partial highlighting, now a standard treatment, is used to simulate the inconstant firelight in which the masks were originally meant to be seen. The lighting in the house replica is appropriately dramatic—dark, with the embers of a simulated fire on the floor, beneath a smoke hole that appears to open out to the sky.

A range of models is used effectively to induce a sense of functional context. Most spectacular was the long case depicting methods of coastal fishing, as viewed from underwater (since removed). Here the visitor could see how fish were caught by the various traps and hooks, amidst a realistic setting of seaweed, rocks, and rippling water. Its impact was heightened by its placement directly opposite the entrance. At several points one finds "how-to" models of stages in a technological process: dressing hides, Coast Salish weaving, constructing birch-bark containers, and making a Kwakwa̱ka̱'wakw kerfed or bent-corner box. These are demonstrated by a series of raw materials, tools, and partly completed artifacts.[14]

Figure 6.10. Woodworking: figure of carver and box construction, *First Peoples* display, Royal British Columbia Museum. RBCM pn 13494–21a.

Dwellings are presented on two scales, the nearly full-size and the miniature. The former consist of a Kwakwa̱ka̱'wakw plank house in the great open space where the totem poles are displayed, and a Thompson pit house, at the entrance to the ethnology halls. One may walk into the plank house, arranged for ceremonial use, and the covering of the pit house is cut away to show its construction and layout. Both houses are reconstructions. The miniatures are two detailed models of Native villages: an Upper Kootenay encampment, and the Haida village of Skedans, c. 1875.

A variety of media are used to supplement the artifacts. Photomurals—mostly enlargements of Curtis images—cover many of the walls, and the audiovisual devices include a continuous filmloop of the wedding scene from Curtis's 1914 Kwakwa̱ka̱'wakw film, a taped commentary on the ravages of culture contact read by Haida artist Bill Reid, and, in the totem area, tapes of Mungo Martin and the Hunt family singing, interspersed with raven calls and forest sounds. In the 1980s, there was also a small theater for slide/tape presentations near the argillite display.

Descending the stairs, one comes to the section devoted to "A New Environment: The Coming of the White Man." An attempt is made to compare this adaptation to a new social context with the earlier adaptation to the natural environment, but the linkage is weak. Although the same cultural complexes, including technology, are considered in both sections, questions of subsistence are slighted in favor of issues of art, religion, and politics.

This new world is visually introduced with sculptural representations of the white man and large murals of drawings made on the first explorers' voyages. Postcontact technology is vividly illustrated in "before-and-after" comparisons, showing Native artifacts, such as fishhooks, with traditional materials (horn, wood) next to similar items using introduced materials (iron). Throughout this section are numerous cases depicting Native uses for white trade goods, such as iron caldrons, glass beads, flannel blankets, guns, and silver. The creative side of culture contact is expressed in cases titled "Art Made for Sale," containing argillite (which had a small gallery), baskets, silverwork, curio carvings, canes, and the like.

The oppressive impact of the dominant culture is dealt with in two sections: on the great population decline through disease, and the loss of sovereignty and land claims. These themes are illustrated primarily in words—in taped commentary and mural-sized newspaper articles, official reports, and statutes. Both sections are supplemented with historic photographs. Yet in one case, at least, an artifact is used with great dramatic effect. A partly burned Tsimshian mask is juxtaposed to a mural photograph of the missionary church at Metlakatla, with a quotation from a Kitamaat (Haisla) woman relating that her grandfather burned his masks and regalia upon conversion to Christianity.[15]

In addition to the new exhibit theme of history, there is an explicit focus on aesthetics. A series of cases, titled "Northwest Coast Indian Art: Form and Meaning," circles a display of totem poles. The emphasis, however, is almost entirely on the various tribal styles. Unlike their treatment as sociocultural "tools" elsewhere in the hall, the artifacts here are presented as "art," in the Western sense. Their appreciation is heightened by the "mystery" of their surroundings. The large and impressive space, filled with a shadowy, blue-gray light and broken with raven calls, suggests a forest.

Given the museum's long involvement with the Kwakwaka'wakw, it is not surprising to find their culture prominently featured. Their winter ceremonials, part of the cosmology section, are illustrated with three of the large cannibal bird masks, two by Mungo Martin. The potlatch section, placed next under society, does not avoid the influence of white culture, first explaining the attempts made to ban the ceremony, and then in a large, crowded case representing an array of potlatch gifts: silver bracelets, frontlets, a copper, potlatch sculptures, and mounds of trade goods (plates, blankets, sewing machines).

The Kwakwaka'wakw are further represented by displays of Martin and Hunt family material. Nearby is the reconstruction of the Jonathan Hunt house, with Tony Hunt's frontal painting, and to the left is a cavelike space intended to represent Nawalagwatsi ("Cave of Supernatural Power"), the cave on Gilford Island that was the source of the dance complex "The Dance of the Animals." Inside stand eight masks from this Kwakwaka'wakw crest privilege, some originally owned by Mungo Martin, others carved by Richard Hunt. A label explains Martin's right to the privilege and its current ownership by the Kwikwasutinexw band.

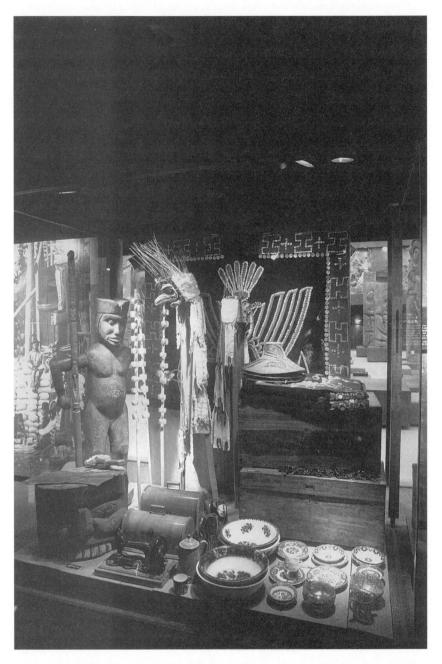

Figure 6.11. Kwakwa̱ka̱'wakw potlatch, *First Peoples* display, Royal British Columbia Museum. RBCM pn 13930–8.

The Provincial Museum displays have proved to be among the more popular on the continent, and their combination of conservative and innovative techniques has influenced several more recent installations. Even at the time of its opening, however, local curators were proposing radical alternatives.[16]

UBC MUSEUM OF ANTHROPOLOGY (1976)

The University of British Columbia's grand museum building, opened in May 1976, was a vast advancement over its earlier facilities. Despite the fact that for over twenty years its exhibits had been restricted to one room in the library basement, the UBC Museum of Anthropology was able to carry on an active exhibition schedule. All the exhibits were temporary, and most were arranged with assistance from student volunteers. Their subjects ranged widely, from technology (basketry, 1953) and iconography (the killer whale in Northwest Coast art, 1966) to intercultural themes (tourist art, 1956) and one-man shows (Bill Reid, 1954) (for a complete list see Hawthorn 1974:1–3).

In order to make the collections more accessible, in 1967 Audrey Hawthorn published *Art of the Kwakiutl Indians* . . . , depicting virtually the entire ceremonial collection from the region. This led to an invitation to show the collection at the Man and His World exposition at Montreal in 1969 and 1970, which in turn encouraged the federal government to donate funds for the construction of a new museum building. The exhibits in the new museum proved to be innovative and influential because of the radical decision to display the entire collection of 12,000 specimens. Although this was justified largely on the grounds that the setting was a university museum, other aspects of the display countered this emphasis on study.

Ironically, for a museum dedicated to scholarship over aesthetics, the museum building was a self-conscious work of art (Vastokas 1976), unlike other recent museum buildings in the region. The architect, Arthur Erickson, known for his interest in non-Western architecture, here conceived of the project as a kind of Haida village. The museum was spectacularly sited, on a sloping cliff overlooking the Straits of Georgia. Like coastal villages, the site paralleled the shore, facing water (real water in the Straits and metaphorical water consisting of pebbles that replaced a proposed pond outside the building). Surrounding the structure was the relocated totem pole park, with its Haida houses. Though constructed from concrete and glass, the building's primary structural motif is the post and lintel, the same basic form of Northwest Coast architecture. This symbolic link is visually confirmed inside, where two such post-and-beams from Kwakwa̲ka̲'wakw houses are on display.

Three major spaces act as settings for the presentation of the collection as *art*. The Great Hall, though rectangular in shape, is functionally a rotunda. A monumental space, it contains 40-foot totem poles, standing next to an immense glass wall that draws in the outdoor totems and the sea, sky, and mountains beyond. This space leads off to a much smaller corridor, still bathed in light. Here museum-proclaimed "masterpieces" from the Koerner collection have been displayed (since 1998 the

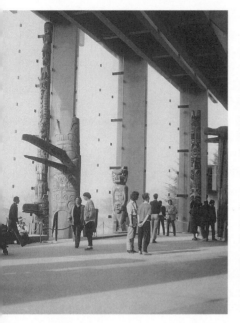

Figure 6.12. Great Hall, with Kwakwaka'wakw and Oowekeeno totem poles, Museum of Anthropology, University of British Columbia. Photo by William McLennan. UBC.
Figure 6.13. Visible storage galleries, Museum of Anthropology, University of British Columbia. Photo by William McLennan. UBC.

space has been used for other small exhibits). Most are small and intricate; many are actually jewelry. The Plexiglas cases allow one to view the object from all sides. Finally, under a nearby skylight, is Bill Reid's monumental sculpture, *The Raven and the First Men.* Given its own space, under diffuse light, the object has an aura of a religious shrine. All of these spaces present the unmistakable message that here is fine art.

In contrast, the bulk of the collection is stored in a simple, open area with a low ceiling, level floor, and no distracting windows. The cases are similarly nondescript: of modular sizes, with functional shelves and plain fluorescent lighting. The objects are grouped by region, and then by an etic, cross-cultural (and admittedly, arbitrary) system, intended merely as a retrieval device, as in a library classification. All the catalog information possessed by the museum is available in books of computer print-outs, located conveniently around the exhibition area. The visitor may look up the specimen in the catalog to discover what the museum knows about it. The museum's display areas are completed with several temporary / experimental galleries, for traveling, temporary, and student shows.[17]

This form of display, called "visible storage," grew out of the conception of the museum as a place for teaching and research. As the museum's director explained it, "This rethinking included our desire to make all the artifacts in the museum available

to university students, and it therefore meant we decided to invite all the visitors to the museum to participate with us as students of the world's cultures" (Ames 1977:77; see also 1981b). It is easy to see this visible storage, combining the museum functions of storage and display, as a result of the museum's previous condition of "invisible storage."[18] Before, virtually nothing was visible; it was essentially dead storage. While the teaching mandate was no doubt formative, perhaps this scheme of total exposure would not have been adopted if there had been a separate museum building, with a historical commitment to explanatory displays, as in the university (and state) museum in Seattle. This flexible, open system complements the didactic public exhibits nearby in Victoria, which fully opened several months later. Certainly the University would have been aware of the thrust of the Provincial Museum's plans, and thus could work for complementary rather than competitive exhibits.

In addition to the audiences of students and the general public, the UBC displays are directed at Natives, especially Native artists. Just as the two editions of the Hawthorn book are used as visual sources by artists, so, too, are the exhibits. There are no statistics kept of such informal use by artists, but the museum director felt that it has been substantial. Natives are often intimidated by the locked storeroom mentality of many museums. Here they can study whatever they wish for as long as they wish without troubling anyone.[19]

"The accessibility of these collections makes it easier to justify having them at all." So wrote Eleanor Wachtel (1977:11) in a general article on the museum. Wachtel had a good point here. Although the museum claims that all its pieces were acquired legally, with free donations or fair (then-current) prices given for the objects, the UBC museum, like many museums, has had to deal with Natives' demands for repatriation of their heritage. One response is to support Native carving through commissions. Another is to make available all the collections for Native visitors. A common perception among museum visitors is that if artifacts are not being used in a display they are being neglected and wasted. Visible storage allows the viewer-student to have ready access to as much of the collection as he or she desires. Visible storage thus acts as a kind of outreach comparable to the Provincial Museum's loan program, increasing the accessibility of museum collections to the Native community.

FIELD MUSEUM OF NATURAL HISTORY (1982)
In April 1982, after seven years of preparation, a new Northwest Coast display opened at Chicago's Field Museum, installed in one of the largest halls in the museum.[20] As one of the more recent permanent installations of Northwest Coast culture, *Maritime Peoples of the Arctic and Northwest Coast* combines a number of features employed in the exhibits of the previous decade.[21]

Unlike the old hall, which had covered the culture of each tribe as a separate unit, the reinstallation groups together all the Coast tribes, in contrast to Eskimo culture, although material from the former vastly outnumbers that of the latter. In each section, Eskimo and Coast artifacts are placed on opposite sides of the hall, and the con-

trast is emphasized by differences in cases and lighting: Northwest Coast cases are cedar-lined, with white print on black, while Eskimo cases are white, with labels in reverse colors. The hall is then divided into five functional complexes: introduction; fishing, hunting, and gathering; village and society; spiritual world; and art. Each unit can be entered separately from adjacent halls, or sequentially, one after the other. This flexible system of exhibit entrances, allowing the visitor freedom in determining the order of viewing, contrasts sharply with the rigid, linear path set out in the Provincial Museum.

As at the Provincial Museum, environmental adaptation is used as a general theme, but after the sections on subsistence and technology, it tends to fade as an explanatory device. The environmental theme also accounts for the union of the maritime Eskimo and the Northwest Coast cultures, but again, while the similarities are apparent in subsistence, in later sections the comparison has no more point than a comparison between Coast and Plateau or Coast and Plains might have been. And as Rathburn and Lupton (1983:63) point out in their review, because of the division into separate cultural domains, there is little feeling for the functional integration of cultures.

Like the Provincial Museum, Chicago stresses history. But where the Victoria Museum uses nineteenth-century artifacts to represent precontact culture, the Field Museum has decided to use all of its artifacts to represent the period 1850 to 1890 (also given as 1900 and 1920), when most of its collections were made. A historical context is established in an introductory section with displays on the history of culture contact and of the formation of the collection. Like the second half of the Provincial Museum hall, the Field Museum has exhibits that depict the impact of white culture, most notably in a life-sized diorama of the interior of a Kwakwaka'wakw house, c. 1890. A woman in a calico dress tends a fire, surrounded by cedar baskets and iron pots (figure 6.14).

From the UBC Museum, Chicago has taken the idea of visible storage, although here it is integrated into didactic displays. The Chicago curators have arranged their cases according to a hierarchy of importance. A casual viewer could glance only at the several large dioramas and still receive the basic message of each of the five main units. Most of the cases are built on the second level, offering basic explanations, in combinations of objects, photographs, and labels, of subcomplexes of each thematic unit. Finally, scattered throughout are "study areas" that display a great many similar artifacts: halibut hooks, trap sticks, clubs, masks, boxes and bowls, spoons, baskets, mats, and blankets. Anyone who desires to examine at close hand variations within a type can resort to these study areas.

Maritime Peoples uses the now common lighting mode of darkness, cut by dramatic spots, introduced by d'Harnoncourt, popularized by de Borhegyi at Milwaukee, and used prominently in Victoria. A new wrinkle here is the use of a variable system in which the light brightens as the visitor moves up to a case, thus protecting the artifacts from the deteriorating effects of light (and also saving energy). A telling, and ironic, use of this dramatic lighting can be seen in the current reuse of the Dorsey

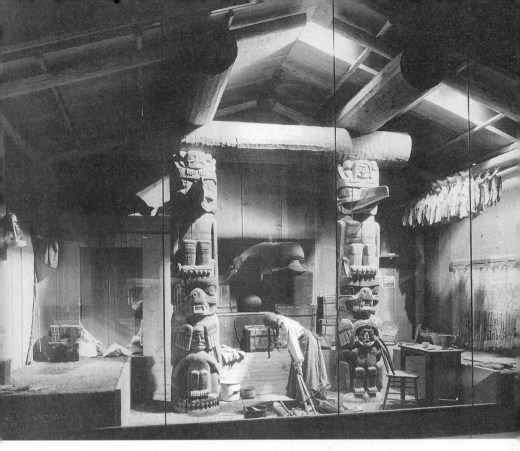

Figure 6.14. Cutaway replica of Kwakwa̱ka̱'wakw house, with daily-life furnishings, *Maritime Peoples of the Arctic and Northwest Coast*, Field Museum of Natural History. Photo by Ron Testa. FMNH neg. no. A109290.

version of the hamatsa initiate diorama. The curators decided to reinstall this same life group, but instead of the even and brightly lit figures of 1904, the mannequins are illuminated by dramatic spots, imitating the firelight of a plank house.

The Field Museum has carried the use of audiovisual units to a higher level than in Victoria. Ethnohistorical photographs tend to be used more for the contextualization of specific artifacts, within cases, rather than as in the mood-setting murals of the Provincial Museum. In place of the one filmloop in Victoria, there are five video units, one in each section of the hall, each with two programs—one for the Eskimo and another for the Coast.

Again, like the Provincial Museum, the Field Museum now gives "art" a clearly acknowledged place in an anthropology museum. Although the section does have cases on strictly aesthetic problems, such as iconography, visual play, contemporary media of serigraphy, argillite, and jewelry, and the work of an individual artist (Charles Edenshaw), many objects in this section could have just as easily, and sometimes are, displayed in other, "functional" sections. For instance, baskets and boxes are exhib-

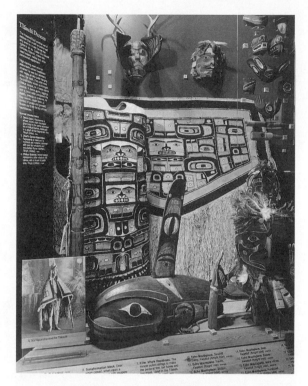

Figure 6.15. Accoutrements of Kwakwaka'wakw winter cere-
mony, *Maritime Peoples of the Arctic and Northwest
Coast,* Field Museum of Natural History. Photo
by Ron Testa. FMNH neg. no. A108628.

ited in a somewhat formal/technical context, when they could have gone into the
sections on subsistence or village life. Totem poles are massed under "art," when
they could have been included next to the cases on the potlatch, under "Village and
Society."

A sense of change is also evident in the inclusion of the work of several contem-
porary Native artists, such as Douglas Cranmer, Joe David, Robert Davidson, and Bill
Reid. These works are part of an exhibit titled "The Artist as an Individual," along with
pieces by Edenshaw, John Robson, Bob Harris, and others, thus expressing in a mu-
seum format the current interest in the role of the individual in Northwest Coast art.

The opening of the hall was marked by lavish ceremonies, including dances by
the Hunt family and the raising of a Tsimshian (Nisga'a) totem pole outside the
museum. Natives—including Kwakwaka'wakw artist Douglas Cranmer—served as
consultants, and many Northwest Coast museums presented the museum with con-
temporary works of art for the collection (Grumet and Weber 1982:68). With this
opening, the Field Museum now has one of the largest and most impressive exhibits
of Northwest Coast material culture on the continent.

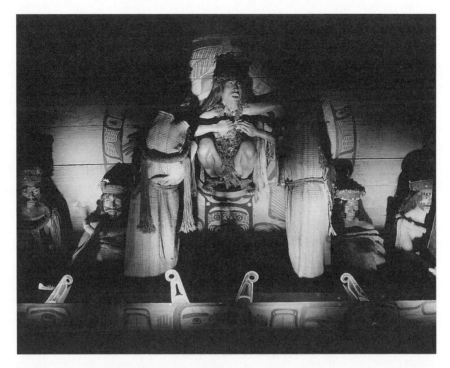

Figure 6.16. Kwakwaka'wakw hamatsa exhibit, revised version, *Maritime Peoples of the Arctic and Northwest Coast,* Field Museum of Natural History. Photo by Ron Testa. FMNH neg. no. A108625.1.

CANADIAN MUSEUM OF CIVILIZATION (1989)

Although it opened after the period under consideration, the new Northwest Coast hall at the Canadian Museum of Civilization is important for my story and merits some discussion. As in many museums considered here, this large, comprehensive display made up for many decades of inadequate presentations. The National Museum of Canada renovated its exhibits during the 1960s; in 1968 the anthropological material became the responsibility of the renamed National Museum of Man. Between 1969 and 1974 the Victoria Memorial Museum was closed for renovation, with the Northwest Coast exhibit, *Children of the Raven,* opening in 1975 (Rogers 1976). Owing to conservation problems, it was replaced in 1981 by another version, *Raven's World,* but because the environmental restrictions precluded virtually all the ceremonial material, this exhibit was clearly temporary. It, too, was closed in 1982—along with the rest of the building—for environmental reasons. In 1986 the name was again changed—to the Canadian Museum of Civilization—and in June 1989 a new building opened in Hull, Quebec (MacDonald and Alsford 1989:78–88).

One of the museum's first priorities was to open a new Northwest Coast exhibit, which was completed in stages over the following years (Laforet 1992, 1993). Planning

for the hall began in late 1983, with significant Native advice and participation. The guiding force behind the exhibit was the museum's director, George MacDonald, an archaeologist specializing in the northern Northwest Coast. Gloria Cranmer Webster, then director of the U'mista Cultural Centre, played a leading role in the curatorial team for the Kwakwaka'wakw house, while her brother Douglas Cranmer was the principal artist and project supervisor for the house, constructed in Alert Bay.[22] This emphasis on the Native voice grew out of the national reevaluation of the relationship between museums and Native peoples in Canada (now called First Nations), which was stimulated by the controversy over the exhibit *The Spirit Sings: Artistic Traditions of Canada's First Peoples* at the Glenbow Museum in 1988 (Hill 1988).

The Northwest Coast display fills the Grand Hall, an immense space measuring about 300 by 50 feet with a 50-foot ceiling—similar to the Great Hall of the UBC museum. As an indication of the symbolic and aesthetic importance it holds, Northwest Coast culture was chosen for the Grand Hall to serve as an introductory exhibit for the entire museum. The hall's main feature is a row of six full-size coastal housefronts, canoes, and other monumental pieces. Although from different cultures, the line of houses is intended to suggest the appearance of a coastal village arranged along the beach. Inside the houses are didactic displays; the Kwakwaka'wakw house (opened in March 1990) presents the potlatch in three time periods: the turn of the century, when much of its collection was acquired; the 1930s, featuring a Charlie James housepost (carved in 1925) in a simulated Alert Bay room; and the present (Laforet 1993:56–57). Like the Provincial Museum's approach to the potlatch, intercultural influence is present in all sections, especially in the range of trade goods given as gifts. In addition to several old houseposts, the other major Kwakwaka'wakw artifact in the hall is a 27-foot dzunukwa feast dish set carved by Calvin Hunt. Before taking a closer look at the Kwakwaka'wakw house, it is helpful to review the recent displays of Northwest Coast Indian houses.

HOUSES IN MUSEUM INTERIORS

In the late 1960s two museums tried to present an innovative display of Northwest Coast architecture within the museum building. Because of the great size of Northwest Coast houses, it was thought impractical at the turn of the century to install complete structures inside museum halls. Instead, scale models were used. In the 1890s the Field Museum set up a miniature Skidegate village, composed of models constructed by Haida carvers especially for display at the Chicago World's Fair. This museum was also able to exhibit a Haida mortuary house that resembled a normal dwelling in miniature.[23] Although museums had displayed Native habitations like tipis for years, it was not until fairly recently that full-size versions of Northwest Coast plank houses were attempted.

In 1966 Seattle lumberman and collector John Hauberg purchased one of the last standing Kwakwaka'wakw houses in the old style (Abbott et al. 1995:242–245). The John Scow house from Gilford Island was missing its roof, front, and sides, but its

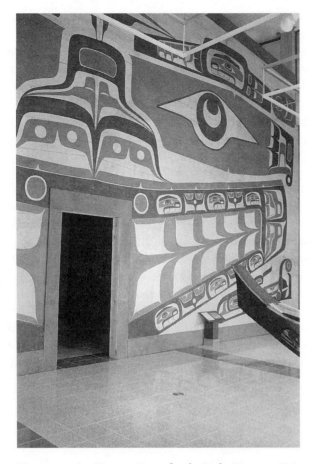

Figure 6.17. Sea-Monster House facade, Burke Museum, University of Washington, Seattle. Photo by John Putnam. BM no. 1993-39/2.

carved houseposts were still in reasonable shape. Hauberg bought it with the intention of re-erecting it inside a museum, and in 1968 plans were announced for its refurbishment within the Pacific Science Center in Seattle, where it was to be used as a combination display area and classroom.[24]

The renovation, directed by Bill Holm, was a synthetic effort. Only the main frame and interior houseposts were original; the rest was reconstructed. Like the Mungo Martin house in Victoria, the decoration of the house combined elements of two houses, both owned by John Scow. The frontal pole and painting were copied from photographs of Scow's first house (the Sea Monster House) at Gwa'yasd̲ams, built in 1902, while the original posts were from the Raven House, constructed in 1916. The frontal pole for the Sea Monster House was by Mungo Martin, one of the first of his commissions, in 1908. The interior posts were carved in 1907 by Arthur Shaughnessy.

Perhaps the pole and the painting of the earlier house were combined with the posts from the latter because the frontal painting of the Raven House (with a beak extension, but no pole) was deemed inferior to that of the Sea Monster House. Holm assembled a group of young carvers, mostly white students of his, but also including the Kwakwaka'wakw brothers Russell and Jerry Smith, to hand-adz the cedar planks and duplicate the missing designs. In October 1971, after three years of effort, the 50-by-60-foot house opened. William Scow, the son of the original owner, came with over forty Kwakwaka'wakw to the ceremonies, marked by singing and dancing. Around the inside walls artifacts were displayed in cases.

A renovation of this display opened in May 1985. As the exhibits in the house had been stripped for the installation of Holm's Willie Seaweed exhibition in 1983, this was a chance to offer a new perspective. Planned by his student Patricia Cosgrove, the Sea Monster house was set up to resemble a Kwakwaka'wakw interior from the time of its erection, around the turn of the century. Therefore the five basic themes—fishing and transportation, food gathering and preparation, woodworking, fiber arts, and ceremonialism—were illustrated with a combination of aboriginal and introduced artifacts. Crosses and Salvation Army uniforms were displayed alongside masks and rattles. Unlike so many museum houses, presented as empty aestheticized shells, the Sea Monster House was arranged as a living space. The series of bedroom alcoves around the perimeter were discretely adapted as exhibit spaces, with Native artifacts, didactic labels, drawings, photographs, models, and participatory displays (Cosgrove 1985). When Hauberg decided to give the original posts, along with the rest of his Northwest Coast collection, to the Seattle Art Museum in 1991, the reconstructed parts of the Sea Monster house were transferred to the Burke Museum, where they have been displayed (Averill and Morris 1995:87–88).[25]

Almost from the beginning of plans for the Indian exhibits in the new Provincial Museum, there was to be a replica of a plank house.[26] This would be a companion to the Interior Salish pit house at the entrance to the ethnology exhibits. Given the long and intimate involvement between the museum and the Martin-Hunt family, it is not surprising that the house chosen for display belonged to Jonathan Hunt, the son of George and father of Henry. The house, constructed wholly of new materials, was built with traditional tools and techniques by Henry Hunt and his sons Tony and Richard between 1967 and 1974. Actually, it had two incarnations. Under the first exhibit plan, it was only a partial structure, with two-thirds of a facade, the four interior posts, and styrofoam beams. Realizing the problems with the structure, the museum never fully opened the house to the public, and it was later moved to a new area of the display and finished as a complete house model.

The Provincial Museum house is not a literal copy of the Jonathan Hunt house in Fort Rupert, but it does have the same name and Hunt's crest designs. In fact, the house is something of a composite (as was Martin's Thunderbird Park house); the prerogatives employed there were never all together in a single house. Tony Hunt's

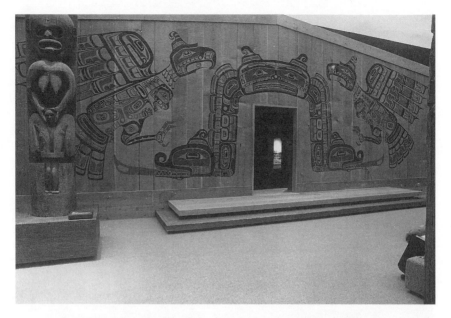

Figure 6.18. Jonathan Hunt house facade, *First Peoples* display, Royal British Columbia Museum. RBCM pn 13498–20.

frontal painting, of two flanking thunderbirds and a sisiyutł, was an entirely original design, which he considered at the time (1970–1971) to be the summation of his career. Inside, the Hunts executed the four interior posts, a welcome or speaker's figure, two chief's seats, a screen, drum, and two hamatsa raven masks attached to stands in the floors. While the exhibit did not open to the public until January 1977, the house was dedicated with a potlatch on the site in May 1969, and with another potlatch in Alert Bay soon thereafter. The museum paid the Hunts a modest sum in order to use the specific rights to the crests and to the songs that are played from tapes within the house, but the Hunts still retain family privileges to it. Unlike Martin's house, the Hunt house has been "used" only once, in the dedication potlatch.[27]

The Field Museum, following the success of its 1977 Pawnee earth-lodge, wanted to represent architecture in its new Northwest Coast Hall, opened in 1982 (Joyce 1982; Blackmon and Weber 1982). But instead of a complete structure, they erected two ends of a Kwakwaka'wakw house, side by side against a wall. Each is meant to represent an end of the same house during one of the two seasons, domestic and ceremonial. Like most museum versions of plank houses, they are slightly smaller than full-size: 15 feet high, 22 feet wide, and 11 1/2 feet deep. The domestic half, fronted with glass, contains several costumed figures, along with the mixture of Native and trade goods to be found in a Kwakwaka'wakw house of the 1890s. The ceremonial version beside it is quite different: the visitor can walk into it and peer behind the painted

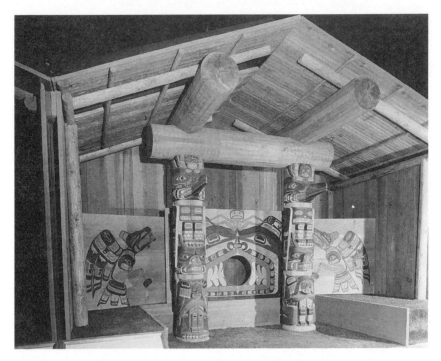

Figure 6.19. Kwakwaka'wakw ceremonial (winter) house, *Maritime Peoples of the Arctic and Northwest Coast,* Field Museum of Natural History. Photo by Ron Testa. FMNH neg. no. A108627.

dance screen to see two masks (one by Douglas Cranmer, the other by Richard Hunt). Each house contains a pair of houseposts carved by Tony Hunt, with the assistance of his second cousin Calvin Hunt and his partner John Livingston. Although the display was not modeled after any specific house, the posts are carved with ravens, a major crest of the Hunt family, as well as with grizzlies. The masks and Tony Hunt's tripartite screen, though meant as depictions of 1890s artifacts, are clearly in the contemporary—albeit conservative—styles of their makers.

Although the new Northwest Coast hall at the Museum of Civilization includes other kinds of objects and displays, the six houses are its central feature; because of the hall's great size, one can speak here of a re-created village rather than just a house (see Ostrowitz 1999:47–82). George MacDonald had been originally motivated to present the painted facades only, but as plans proceeded, the decision was made to expand them into houses where possible (the shallowness of the space limited the structures to a range of 30 to 40 feet wide and 20 to 36 foot deep). In a recognition of the legacy of the collecting and study of the salvage period, all the housefronts are modeled after a specific structure from the late nineteenth century. The sources for the houses were diverse: "The final design draws on ethnographic records, historical photographs, the analysis of structural engineers, and the considerable help afforded

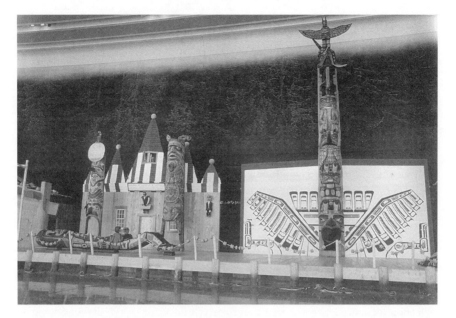

Figure 6.20. Grand Hall (Northwest Coast display), Canadian Museum of Civilization (Kwakwa̲ka̲'wakw house, right; Nuxalk house, left). Photo by Steven Darby. CMC neg. no. S92–6123.

to the teams by older Native people from the coast who shared their traditional knowledge generously" (Laforet 1992:15). The facade chosen for the Kwakwa̲-ka̲'wakw house was that of Chief Wakas as it stood in 1900 with its great entrance pole. While the house was made of new materials, the frontal pole is the actual pole (with a new Raven's beak and Thunderbird), which had stood in Vancouver's Stanley Park between 1924 and 1987. This combination of old and new was also present inside, with a contemporary dance screen protecting a set of nineteenth-century masks. Given the historical model, the museum's original intention was to simulate a patina of age on the surface of the houses. Yet as work progressed all felt uncomfortable with this approach. Like the masks and dance screen, housefront paintings are inherited crest privileges. They are regarded as enduring conceptual entities, and contemporary expressions of them are acceptable, even preferred.

As seen in all these houses—in the Pacific Science Center, the Provincial Museum (within its entire exhibit), the Field Museum, and the Museum of Civilization—museums have adopted two approaches to the display of cultural time in Northwest Coast societies: a simultaneous recognition of change, in a specific Western sense, as well as a kind of eternal ritual space, flowing from a Native worldview. In these approaches, museums have responded to their Native consultants. As Gloria Webster put it (Laforet 1993:27): "The new comes from the old and there's not necessarily a place where the old stops and the new begins. They all flow together. If there are

drastic changes in the old and people consider that what was old was worth hanging onto, they'll find a way to do it."

PERMANENCE AND CHANGE IN ANTHROPOLOGICAL DISPLAY

Like many aspects of the anthropological encounter of the Kwakwaka'wakw, museum display falls into three clearly defined periods: 1880–1920, a competitive time marked by stylistic innovations; 1920–1965, a quiescent time when innovations were restricted to temporary art exhibitions; and 1965–1980, another period of great activity and new approaches, continuing to the present.[28]

Conservatism in museum display manifests itself on several levels. Over the decades a particular specimen may be on continual view, either in its original installation or as part of a revised exhibit. More generally, we often find that the basic task of representation as well as the approaches to it will remain the same. Recently some museums have tried to expand their coverage of Native culture, by depicting change or the work of recent artists, but virtually everyone has accepted as its mission the presentation of the early contact period of Kwakwaka'wakw culture. Once a particular collection is amassed, particularly when there is little chance (or desire) of adding to it, its character, its strengths and weaknesses, will of necessity limit what the museum can do with it. With the cession of substantial collecting around the first decade of the century, these then became the objects to be interpreted in all succeeding displays. If the collection is important enough, parts of it will always be on display. As institutions devoted to conservation, museums tend to be conservative in their displays (Fitzhugh 1997).

The Northwest Coast Hall at the American Museum of Natural History is now an enduring artifact in its own right (Jacknis 2001). Like a literary palimpsest or a painterly pentimento, the hall carries with it elements that go back a century. The cedar bark life group and the Kwakwaka'wakw village model have moved only a few feet from where Boas put them in 1896. At the Field Museum the hamatsa life group of 1901 was retained in the 1982 renovation. Since the turn of the century, both museums have had a Northwest Coast hall, and some of their specimens have been continuously exhibited.

Although these conservative forces restrained museum exhibits for decades, there were periods of innovation. Again, as in other aspects, one trend from the first to the third periods was the westward movement in the focus of activity; from Washington and New York to Chicago to Seattle, Victoria, and Vancouver. Although the causes for these two periods of relatively rapid change are moot, they undoubtedly result from more general transformations in anthropology. Moreover, they are not restricted to display, for these periods of activity cut across all museum media and functions. Invariably new exhibits coincided with new museum buildings and additions. The first and third periods were also times for great growth of museums in general, not just those for anthropology.

242

When museums reinstall their collections, they often radically recontextualize their specimens. Although the particular artifact and the basic task—the representation of Kwakw<u>aka</u>'wakw culture—may remain the same, the specific message about Kwakw<u>aka</u>'wakw culture communicated by this object can be different. Where a iron-tipped fishhook may have previously illustrated fishing technology, in a timeless ethnographic present, it now may show the effects of acculturation. Before the fishhook may have been juxtaposed to nets and floats, and thus carried one kind of meaning, while now, next to a bone-tipped fishhook, it suggests quite another. Any display can only focus on one or a few of an artifact's many possible meanings.

Distinctive architecture may be part of a museum's message. The various totem pole parks, with their reconstruction of plank houses suggested a regional alternative for the Northwest Coast. While most of the recent museum buildings in the area are undistinguished, the UBC Museum decided to invoke the form and setting of Northwest Coast architecture. Such an approach could only work for a museum dedicated to a single culture or region (UBC's non-Northwest collections are relatively small). The two Kwakw<u>aka</u>'wakw museums have followed this kind of architectural symbolism.

As a primarily visual medium, the museum display is affected greatly by changes in visual styles and commercial media (graphics and interior design). Consider the changing formal resources used to suggest the cultural context of the artifacts. In the early years of this century, murals (at the American Museum, Brooklyn Museum, and Milwaukee Public Museum) depicted the environment and daily scenes, anticipating the use of photos and films. Foreshadowed by the forest motif at the American Museum, René d'Harnoncourt introduced symbolic form to exhibit design. That is, the shape, layout, decoration, and lighting of the hall was mimetic of the region in which the art therein originated (Bateson 1946). The Northwest Coast was dark and tall, while the Plains was open and light. This style has now come to dominate most anthropological halls, and many installations of ethnic art in art museums.

Beyond mere style, the appearance of exhibits is always an expression of what is technologically possible. For instance, earlier cases needed more wooden frameworks to support the glass, whereas one can now have larger expanses of glass or Plexiglas (Eri 1985). New fixtures can now allow lighting to be placed within the case. The cumulative effect of these innovations is to stress the object over its setting. To a great extent the differences between temporary art exhibits and permanent anthropology examples are attributable more to technology than discipline. Beyond the fact that permanent displays will be, almost by definition, more conservative, there is the technical point that one can be physically more adventurous in a temporary show—for example, it is much easier to have uncased objects if they will not have to be exposed to decades of visitor attention.

Although the visible storage of UBC may seen innovative, it is actually a return to earlier exhibition styles; late nineteenth-century museums customarily displayed all their collections. The trend in this century has been the steady reduction in the den-

sity of items exhibited; the American Museum is an excellent case in point. Several times in the decades following Boas's tenure, the number of objects was reduced. The same shift occurred at the B.C. Provincial Museum in the 1940s.

There were two grounds for such trends: educational and stylistic. Collections were divided into the great bulk of the "study series," containing multiple variants for the specialist, and the "exhibit series," consisting of a few, carefully chosen items, for the general visitor. It was felt that such concentration would help the viewer grasp the essential point of the exhibit. However, a reinforcing trend was the changing aesthetic temperament from Victorian plenitude to *art moderne* spareness, the latter seen most strongly in the displays of René d'Harnoncourt. After several decades of this reduced style, the exhibition of the entire collection did seem quite radical. (Yet even here, UBC had its gallery of selected treasures, apart from mere "artifacts.") Now the open-storage style has started to seem attractive to other museums, like the Field Museum, which, if they do not exhibit their entire collection in this fashion, devote large sections to it.

The most important trends of recent years have been the presentation of Northwest Coast artifacts as art and as parts of thriving, changing cultures. The aesthetic shift came first, introduced in temporary art exhibitions and only taken up in permanent anthropology display in the 1970s. Labels now give the name of the artist and the date of creation, if known, in place of the earlier anonymous tribal artisan. Visually, the Western notion of the individuality of the art object was marked by focused, dramatic lighting, instead of even, bright illumination, with more space surrounding each object, so that it was more clearly perceptible.

The new historical interests were first suggested in the *Arts of the Raven* show and demonstrated in *The Legacy* exhibit, before being institutionalized in the new Provincial Museum halls. For the first time, anthropology museums acknowledged that these Native traditions were not dead. This new interest came in two guises, depending on whether the stress was on art or material culture. The first dealt with the creation of new art objects, while the latter was a retrospective application of a sense of change to classical period artifacts.

Many of the more advanced trends in exhibition—both conceptual as well as technological—have been adopted by West Coast museums, for so long the conservative backwaters in museology. Until the 1980s, few museums in the East exhibited contemporary Northwest Coast artifacts. The Northwest Coast halls of these museums are devoted to the quantities of classical artifacts accumulated early in their history. (The new halls in Chicago and Ottawa were important changes; some other Eastern museums may show contemporary Coast art in temporary shows.) The West Coast museums, on the other hand, were founded too late or were uninterested or too poor to acquire extensive collections of classical period artifacts. Instead, they acquired pieces from the more recent history, and were ideally situated to obtain the contemporary objects created during the recent revival.

Though the Provincial Museum's innovative attempt to treat postcontact culture is an important statement, the entire display is constructed upon a fiction—the use of postcontact artifacts to depict precontact culture. In the first section, despite the fact that all the artifacts were collected (and in many cases made) in postcontact times, all obvious signs of white culture contact are avoided. No doubt, the primary reason for this was a shortage of precontact objects in the museum's collections. Thus, like salvage ethnographies, this display is a reconstruction (Halpin 1978b:43) and not a direct presentation of the culture it purports to describe.

Partly in reaction to anthropological fictions such as this, the UBC Museum was led to adopt its open-storage display mode. According to curator Marjorie Halpin (1983), displays are symbolic, even ideological, constructions of artifacts, forming a kind of anthropological myth. Halpin and her colleagues regard the museum visitor as a student, actively encountering and making sense of exotic artifacts, with a minimum of curatorial "narrative." Such views were a part of the general questioning of anthropological authority in the 1970s.

Commissioning for display has continued; witness the latest exhibits in Victoria and Chicago and Ottawa.[29] The literal anthropological creation of exhibits is often found in the fabrication of models based on the accumulated anthropological literature. For instance, the fishing and box-making displays at the Provincial Museum were based primarily on Boas's monographs. Thus the specific representation of an early ethnographer is replicated again and again, from museum to museum, confirming a particular image of the Kwakwaka'wakw.

Finally, what of the role of Native initiative in displays? As a museum function that perforce takes place on museum grounds, often many miles and years away from the point of collection, exhibition has rarely involved Natives. Yet the anthropological encounter of the Kwakwaka'wakw has included a persistent place for Native consultants who visit museums to advise and document the collections and exhibits. In 1903 Franz Boas brought George Hunt to the American Museum for several months of such review, and the following year Charles Nowell and Bob Harris did much the same at the Field Museum, although they also constructed pieces for the collection. In 1915 Samuel Barrett checked his diorama model with elders (Ritzenthaler and Parsons 1966:18–19). When Boas made a brief visit to British Columbia in 1922, he arranged for Hunt to review the collections at the Provincial Museum.[30]

This "classical" tradition was revived in the 1950s when Mungo Martin, Douglas Cranmer, and others visited the UBC Museum to document the Kwakwaka'wakw collections, and Martin did the same for the Provincial Museum. In the 1960s and 1970s Gloria Webster was employed by the UBC Museum to document the Kwakwaka'wakw collection in the field. Since then, the state of interethnic relations has changed. Today, when major exhibits of American Indian material are planned, they usually involve some form of Native consultation, as, for example, in the planning of the new Northwest Coast hall at the Field Museum. More recently, as in the Cana-

dian Museum of Civilization, this has meant full partnership and co-curation.[31] Until very recently, though, Kwakwaka'wakw did not get the chance to act as curators designing an exhibit. As chapter 9 notes, when they did, they did it with a Kwakwaka'wakw accent.

PERFORMANCE: THE "MUSEUM INDIAN"

As a form of display, in the extended sense, performance has played a persistent and critical role in the case of Northwest Coast Indian art. The context of song and dance has been quite important to many Native carvers; the best carvers, such as Mungo Martin and Willie Seaweed, are often the best performers. Reportedly, Mungo Martin often thought of the associated song and dance as he carved a mask (Hawthorn 1961:62, 66). This performative context for carving was attenuated when many artists began to learn their craft in the cities. Whereas Tony Hunt learned carving along with Kwak'wala and performance, his brother Richard did not and had to gain this experience later. More recently, however, the revival in the visual arts has encouraged a ceremonial revival. Performance has been a stimulus even for Indian hobbyists. Incorporating costumes, props, and settings, it has often served as the goal of their efforts.

Despite their focus on artifacts, museums in Western culture have their own kinds of performances, such as gallery openings, lectures, and educational programs.[32] Natives have long participated in these performances, and on the Northwest Coast, at least, these have recently become an important genre of Native performance (see Blackman 1985:37; Ostrowitz 1999:83–104). As in any bicultural situation, there has been an overlap and accommodation between traditions. For instance, both Kwakwaka'wakw and Western cultures have ceremonies for the dedication of a building or monument. Although each culture may have its unique understandings regarding the event, their surface congruence allows for ready interaction.

These performances can be grouped according to different variables. First, some events are displays of work and some are displays of music and dance. In the one, the action is almost secondary to the resultant artifact, whereas in the other, action is primary. A second typology differentiates performances by their frequency. Most important, because they are the rarest, are the dedications of museums, and following that, of galleries and of special exhibits such as totem poles. Most museums have galleries for temporary exhibitions allowing for more frequent events. Next in rank, because they do not involve changes in the exhibits, are the periodic lectures and concerts. Finally, there are the more or less daily events, such as the carving in the shed at the B.C. Provincial Museum.

Occasionally, a museum will maintain a permanent staff of Native performers. Much as they institutionalized the displays at the world's fairs, so also museums have made more or less permanent the demonstrations of craft or dance. Since the turn of the century, Natives have been invited to museums to review the collections. On one of

these trips in 1904, Charles Nowell became part of the exhibits in the Field Museum: "The next day they got me to stand inside the case—a big glass room—and explain the thing to the people that come, and to answer their questions" (Ford 1941:191).

There are at least two precursors to Mungo Martin's role of "artist in residence" at the B.C. Provincial Museum. During the last years of his life, 1911–1916, the Yahi Indian Ishi lived in San Francisco at the University of California Museum of Anthropology. Ishi, the last of his tribe, served as an informant and often spent his days constructing Yahi artifacts for the museum's collections. Performances were also part of Ishi's routine; he was present at the museum's opening and sang Yahi songs at Sunday lectures. These "ethnological" services were actually donated by Ishi, for he was supported by his modest salary as the museum's assistant janitor (Kroeber 1961). The Tlingit Louis Shotridge made the move from informant to ethnographer. Shotridge and his wife were demonstrating crafts at the 1905 Portland exposition when they were discovered by George B. Gordon of the University of Pennsylvania museum. From 1911 to 1932 Shotridge worked for the museum, first in Philadelphia and after 1915 as a field collector in Alaska. During his museum residency, which served as a kind of apprenticeship, he helped set up their Northwest Coast exhibit and even studied for a time with Boas in New York (Cole 1985:254–267; Milburn 1986).

The role of the carvers at the Provincial Museum combined elements of Ishi's and Shotridge's experiences. Like Shotridge, they were paid a salary and lived off the premises. But like Ishi, they served less as curators and more as technicians, even somewhat as displays. Moreover, in evaluating this role one must bear in mind the place of the museum work in the respective life histories of these Native individuals. Ishi, as the last of his people and a middle-aged man, was isolated. Though he could have lived with other Indian groups, he preferred to stay at the museum, where he found some kind of support from the anthropologists. Louis Shotridge, young and acculturated, was able to take on greater responsibilities.

The experience of the Provincial Museum carvers has varied. When advanced in years, Mungo Martin was given a chance to return to the large-scale commissions of his youth. Although separated from his ancestral home, he was able to bring a small, but growing, group of relatives with him to Victoria. Henry Hunt was middle-aged, but learned his craft from Martin at the museum. For his sons Tony and Richard, museum support was even more important in their artistic development. But with their access to a growing tourist and art market, which Martin and Ishi had never had, the Hunts were not as dependent on the museum.

One might be tempted to regard this Victoria "colony" of Kwakwaka'wakw as a kind of permanent "exposition" setting, of art out of context, and at first it was just that. But after more than thirty years, many Kwakwaka'wakw have made Victoria their home. Some of the younger Hunt children have lived most of their lives here, although they return constantly to Fort Rupert for visits and family occasions. However, the world of museums and galleries is one that was not native to Martin.

A large part of Mungo Martin's experiences in Vancouver and Victoria consisted

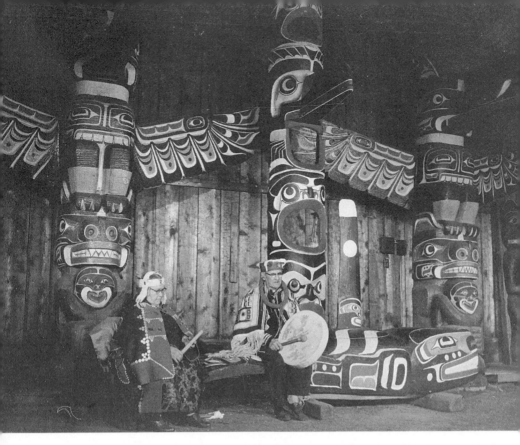

Figure 6.21. Mungo and Abayah Martin, singing in the Mungo Martin house, Thunderbird Park, Victoria. Photo by William Heick, October 1961, courtesy of the photographer.

of public performance. Because of the massive scale of totem poles, there is strong pressure to make their carving into a public event. So it was with Martin's work at UBC; he and his family were great tourist attractions. While Martin carved, his wife Abayah wove blankets and baskets. As Harry Hawthorn noted, "While Mungo has been here, the University has received continual and excellent publicity from his work."[33] In Victoria he was even more popular: "Thunderbird Park is familiar with cameras. But for every one camera previously, at least 10 buzzed and clicked as Mungo worked on his personal totem pole. The carpenter counted 147 movie cameras and 1,400 people in one sunny four-hour session."[34] In 1956 Duff reported that "the carving of the world's tallest totem goes on apace. The chips are flying as never before and public interest is at a new high."[35]

From all reports, Mungo Martin thrived on this attention. "Mungo was no stranger to public performances," writes Nuytten (1982:100). "Veteran Victoria photographer, Jim Ryan, remarked several times on Mungo's ability to strike just the pose called for, without 'hamming it up,' or causing the pose to appear contrived." While carving, Martin dressed in plain work clothes, not in any kind of Native costume. Although

his English was rudimentary, he was evidently eager to explain his work to passers-by and especially to sing them songs associated with the object he was working on (Nuytten 1982:80).[36] Perhaps Martin was unusual, for Henry Hunt and the others were not as eager to accommodate tourists.

A new form of public event generated by the museums was the "first cut" on a totem pole. In Native villages the carver did his work in private, with the ceremony reserved for the dedication. In Victoria, Mungo Martin often posed with white dignitaries as they made the initial swings with the adz, much like the laying of a building's cornerstone. At the 1957 ceremony for the B.C. Centennial poles, Martin addressed the crowd in Kwak'wala, translated by his foster daughter, Helen Hunt (Nuytten 1982:104). He spoke of his sense of honor and pride at being allowed to carve a pole for the queen. As at the house dedications, the ranking white person present, the lieutenant-governor, was given a Kwak'wala name.

In some museum performances the goal is to demonstrate technological processes for an audience, and the objects produced are by-products. For the carving program at UBC and the Provincial Museum, the production of new objects was the focus and the performance incidental. There was always a good reason for the production of each totem pole or mask; work was never done merely for the sake of swinging an adz. Sometimes, as when Henry and Tony Hunt carved at the Montreal exposition, demonstration was quite important, but it was never the primary motivation. In fact, at the museum the carvers did much of their work out of public sight. Unlike music or dance, these work performances did not exist for the sake of an audience and would have been carried on in much the same way if no audience had been present.

While all Native performance in museums can be classed under the museological function of interpretation, some of it is conducted as part of a formal education program. Invariably this is defined as general education for children and lay adults. During the early 1970s, the B.C. Provincial Museum used members of the Hunt family in several of its programs. In 1970 and 1971, curator Peter Macnair lectured on the myths and winter dances of the Kwakwaka'wakw, illustrated with masked dances from the family. For years, Helen Hunt, wife of Henry, had served as the interpreter for Mungo Martin, and during 1971, she ran Indian programs for children. Two years later, Emma Hunt, wife of Thomas (a grandson of George), directed a traveling dramatic show, "Son of Raven, Son of Deer," based on a story by the Nuu-chah-nulth artist George Clutesi. All the costumes, masks, and paraphernalia were commissioned from contemporary carvers.

Museum dedications are not genres of Native culture, but a form of Western cultural performance (at which Native performance may be included), and just as Kwakwaka'wakw have constructed their own museums so have they sponsored opening ceremonies for them (see chapter 9). One example of a permanent exhibit opening is the dedication of the new Northwest Coast Hall at the Field Museum on April 24, 1982. The major feature was the erection of a 55-foot totem pole commissioned by

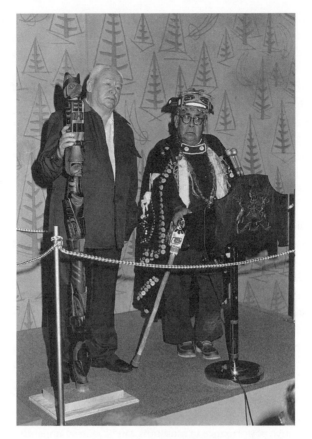

Figure 6.22. Opening of *First Peoples* display, Royal British Co-
lumbia Museum, chiefs Thomas Hunt (left) and
James King (right), 17 January 1977. RBCM pn
13199–13a.

the museum from Nisga'a Norman Tait. Speeches and dances—open to the general
public with the mayor present—celebrated the opening and the raising. On the fol-
lowing day in the museum's grand lobby, there were crafts demonstrations and fur-
ther dancing by the Tait family and the Hunts (excerpts from the winter ceremoni-
als). Throughout, there was celebration of family prerogatives; Rufus Watts, Tait's
grandfather, narrated the story of the pole in Nisga'a. In an inversion from former
collecting relations, Natives brought artifacts as gifts for the museum, and a special
gallery was set up as a shop for the sale of contemporary Coast artwork. A variety of
educational public programs included several lecture series, a symposium of artists,
courses, and further performances (FMNH 1982).

Totem poles are a kind of permanent exhibit, though they are not restricted to mu-
seum premises. Totem pole dedications, while a Native form, are readily assimilated

to monument dedications in white culture. Perhaps the most elaborate of these was one of the earliest—the three-day opening and dedication of Mungo Martin's house and totem pole at Thunderbird Park. Many of the elements that later became essential were present at the opening of UBC's totem park on May 16, 1951, held after graduation exercises. Mungo Martin gave a two- to three-minute talk on the meaning of one of the poles, followed by an explanation by Hunter Lewis and remarks by President N. A. M. MacKenzie. The event closed with a reception at the faculty club. The invited audience was inclusive, with representatives from the university, artists and art galleries, the fishing and lumber industry, and Indians.[37]

Exhibit openings, especially in anthropology and natural history museums, have recently grown in elaboration and importance, with the burgeoning of museums in the 1960s, the extension of audiences beyond a traditional elite, and the search for new funds. As a performance genre, the exhibition opening varies with the kind of material displayed. If it is a single-artist show, as is common at the UBC Museum of Anthropology, then it more closely resembles the "gallery opening," an occasion unique to contemporary Western culture.

A typical exhibition opening was held at the UBC Museum on May 26, 1981, for the Hunt Family Heritage show. The event took place in the "rotunda" area of the museum—its Great Hall—with a large crowd standing or sitting on the floor. First there were speeches by the provost, Kevin Neary of the Provincial Museum, and one of the participating artists, Tony Hunt. Then members of the Hunt family danced for about an hour. In a format quite similar to other Hunt performances for white audiences, dances were chosen from both the winter dances and the more "secular genres," and the singing was provided by a small group of family elders. At one point, people were called out of the audience to share in the dancing, and prominent among them were the provost and the museum's director (who donned a Chilkat blanket). After the conclusion of the formal program, the guests moved to refreshments of smoked salmon and seaweed with drinks. This time was used for socializing, where Native artists could mingle with friends and collectors. The museum's extension curator at the time (who was responsible for arranging the openings), claimed that the institution always strove to make openings into a "special" kind of event, with some kind of Native performance, if possible (see Michael Ames in Webb 1999:12).[38]

Nelson Graburn (1977:16) has called attention to the festive, party atmosphere of the museum opening. It is well known in museum circles that openings are the worst time to actually *see* a new exhibit: "The crowds are indeed part of the show, more than the exhibits themselves. Information is exchanged which may or may not relate to the show, the museum program or particular artistic and intellectual themes." Openings, necessary for museums to generate patron and member support, are a chance for the public to meet the artists and curators, to glimpse a bit of the museum's back region.

At such events two cultures intermingle in a gesture of friendship and equality, yet, as in this example, with the emphasis on the white's celebration of Kwakwaka'wakw,

and in particular Hunt, culture. The refreshments often served at openings here take the form of symbolic Native foods—salmon and seaweed. The audience, overwhelmingly white, is composed of museum members and the "regulars" of the art world of Northwest Coast Indian art in Vancouver—journalists, curators, dealers, and collectors. Such occasions are a time for exchange and negotiation, with boundary marking and transgression, as the fiction is created and sustained that whites participate in the Natives' world and vice versa.

In the fashion of a pidgin or creole, such dedicatory performances typically combine elements of white and Native culture. Native performance genres, such as song and dance (secularized ritual), are combined with white forms, in this case the basic occasion of a museum or gallery dedication.[39] Some elements are shared by both cultures, such as oratory, which invariably comment on the significance of the object or space being dedicated. Commonly, the artist says a few words, often in his Native language. Other speakers usually include officials, such as a curator or mayor, and sponsors, typically the forestry company that has donated the logs. The dedication/opening is an occasion for basic metastatements about the structure of the event, who is responsible and what their goals are, and the work's relation to tradition.

SCHOLARSHIP

These museum activities of collecting, conservation, display, and performance have taken place within a larger setting of the academic study of Kwakwa̱ka'wakw objects. For at the same time that the production and reception of these objects has shifted to a largely aesthetic context, the research and publication on them has also moved—into universities (although still with strong ties to museums). Boas, the most important scholar of the classical period, played a dual role, as both curator and professor, and this model has remained dominant. What has changed is the comparatively substantial growth of scholars holding only a teaching position.

TEACHING

The Boasian tradition was handed down to the present generation of scholars principally by Erna Gunther, who taught the two who were probably the most important teachers of Northwest Coast art in the period since 1965: Wilson Duff and Bill Holm. Since her retirement in 1966, the Department of Anthropology at the University of Washington has maintained an interest in Northwest Coast studies, some of it conducted in the related museology and Native American Studies programs. Although Gunther had given informal museum training, courses in the subject did not begin until 1966, under George Quimby, who had come the previous year as director of the Burke Museum. He was joined in 1970 by James Nason, a graduate of the department. The two started a master's program in museology in 1972. Naturally, a number of these museology students have worked on Northwest Coast topics. With Holm's

appointment in 1968, however, the principal teaching of Coast material culture shifted to the Art History Department. Bill Holm's courses soon attracted a large audience, including a steady stream of auditors. While his teaching has influenced many, relatively few have gone on to scholarly careers; by the time of his retirement in 1985, he had directed four master's and four doctoral students, and of those none has specialized in Kwakwaka'wakw art.

In 1963 UBC became the second university in Canada to grant the doctorate in anthropology and sociology. The department has generated almost all the anthropologists in the province specializing in museums and material culture, especially since 1965, when Wilson Duff joined the faculty (Anderson 1996). Duff had been one of Harry Hawthorn's first students, with a bachelor's from UBC in 1949, before going over to Seattle for his master's (1951), under Gunther and Garfield. Duff's tenure at the Provincial Museum (1950–1965) was only the beginning of close ties between the university and the museum. Mungo Martin's restoration work at the museum was seen as a direct continuation of the program he had started at the university, and the B.C. Totem Pole Preservation Committee, of the mid-1950s, was a joint effort of the two institutions. At the university in the early years, Audrey Hawthorn was responsible for training in primitive art and museology. From 1948 on, she offered regular, systematic, but noncredit courses, and in 1963 instituted the university's first formal credit course in "primitive art," with a similar course in "museum principles and practice," begun two years later (Hawthorn 1993:31–32).

Peter L. Macnair, a student in these courses, was hired by the Provincial Museum in late 1965, and in 1967, following the departure of Duff, was promoted to curator of ethnology, a position he held until his retirement in 1997. Macnair's work is very much like the detailed description of the Hawthorns and the early Duff, and is quite distinct from the more symbolic and interpretive anthropology of Duff's UBC students. But Duff and Macnair were only two of the many curators trained at UBC.[40] Most of these students gained museum experience as volunteers—in cataloging, arranging exhibits, and showing artifacts to the public.

As discussed in the next section, Duff brought a new perspective to his teaching during his decade or so at UBC. Two of his early students, Trisha Glatthaar Gessler and Susan Thomas Davidson, wrote essentially art history master's theses, attempting to delineate the individual styles of the Haida artists Tom Price (1969) and Charles Edenshaw (1967), respectively. Jennifer Gould (M.A., 1969) employed concepts from Panofsky's iconographical methodology. One of the first of Duff's students to elaborate his symbolic and structuralist analyses was Marjorie Halpin, whose 1973 doctoral dissertation on the Tsimshian crest system was based on the museum collections and field notes of Marius Barbeau and William Beynon. Because Duff was never able to fully publish the interpretive analyses of his later years (he died in 1976), his students took the place of publications as a scholarly expression (Abbott 1981).

Museum method and theory have long been an important strain of teaching at UBC. Supplementing Audrey Hawthorn's more practical instruction, Michael Ames

Figure 6.23. Harry Hawthorn, Bill Reid, and Wilson Duff (left/right), field trip to collect totem poles, Ninstints, Queen Charlotte Islands. Photo by B. Atkins, 1957. RBCM pn 9050.

focused on more critical issues during his directorship (1976–1997). Joined by Halpin, Ames stressed the questioning of museum practices common at the time (e.g., Ames 1992). Karen Duffek (1983a, 1983b), for one, investigated the market for contemporary Northwest Coast Indian art, while other UBC students explored these concerns in small provocative exhibits. In 1997 the concentration in museum studies was formalized in a certificate program, followed three years later by an M.A. in critical curatorial studies, offered jointly by the respective museums and academic departments of Fine Arts and Anthropology.

While scholarly exchange between Seattle and Vancouver was important in the early postwar years, it has become less so of late. With his mixed national education, Wilson Duff was an important pivot in transferring the Boasian tradition to Western Canada, as in fact were the Hawthorns (Hawthorn 1993:53) and Wayne Suttles (who earned his doctorate at the University of Washington and taught at UBC from 1951 to 1963).[41] With the maturing of Canadian scholarship and the rise of Canadian nationalism in the late 1960s, this interchange has diminished (at least in personnel;

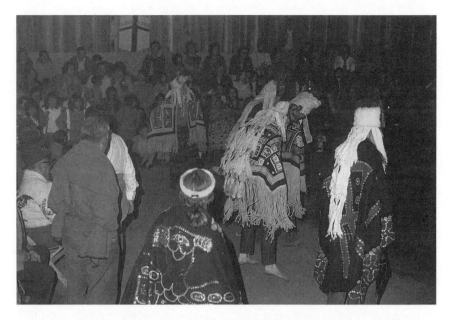

Figure 6.24. Peter L. Macnair (in center) dancing at Helen Knox potlatch, Alert Bay, 1972 (see 6.3). RBCM pn 11532–13.

ideas and, especially, publications do circulate, of course). Although other Northwest Coast scholars are scattered throughout both the United States and Canada, their concentrations come nowhere near these two Northwestern cities.

As scholarly centers, Vancouver and Seattle present an interesting contrast. Both their universities have active master's programs and both have museum anthropology curricula, but as far as Northwest Coast art is concerned, UBC focuses on the anthropology department, whereas Washington is more interested in art history. Among other differences, there is more activity in British Columbia. Here the contemporary market is most active. The Puget Sound area was never a center for traditional artwork, and Washington State has long had a relationship with the Tlingit of Alaska (though this is muted; Alaska now has its own centers of scholarship). Through the work of Bill Holm as a hobbyist-teacher, Seattle has become important as a center for non-Native artists working in Native styles.

The teaching of Northwest Coast art and material culture can be readily seen as a process of institutionalization, as a group of personnel and institutions become linked and divided in time and space. This review, along with the following review of publication, suggests the interplay of internal and external forces in the formation of scholarly traditions. On the one hand, one can trace the conservatism in approaches through the chain of teaching to Boas, or the linkage of many of the local museum curators through their university training. On the other hand, the density of scholarly activity follows white perceptions of the vitality of the Native artistic traditions—

active at the turn of the century, then moribund during the interwar years, and then revived in the mid-1960s. The question could be asked, Which came first, the revival in the art or the scholarship? A careful look at timing reveals that the revival came first in art, which then attracted a vast increase in students.

Regionalization is another key trend in the history of teaching. Over the years, the center for scholarship and teaching has shifted from New York to the Northwest, thus paralleling a similar shift in the scholarship of Southwestern Indian art from Boston, New York, and Washington, D.C., to the region. Yet even within the region, there is a kind of local specialization: anthropology at UBC and art history at the University of Washington. However, the scholarly tradition begun by Boas has remained the core of Northwest Coast studies in North America.

RESEARCH AND PUBLICATION

The beginning of the contemporary period of scholarship in Northwest Coast Indian art can be marked by the 1965 publication of Bill Holm's *Northwest Coast Indian Art: An Analysis of Form,* which has become the foundation for all subsequent study. While research in this period addressed older topics such as techniques, formal analysis, iconography, and social context, new kinds of problems were treated for the first time. Of the older questions, the most important to be reconsidered was that of meaning and symbolism. All of the newer approaches can be related in some way to change, to the recognition that Northwest Coast cultures were not static and dying traditions. As this perspective grew, scholars began to apply it to the works from earlier times. Three of these new interests, all interrelated, were in the historical development of styles, the works of living artists, and monographic studies of specific artists, living and dead. In addition to Holm's codification of the formal principles of graphic style, the other pivotal studies of the contemporary period were his study of the oeuvre of the Kwakwaka'wakw master Willie Seaweed (1974, 1983), Lévi-Strauss's (1975 [1982]) interpretation of Kwakwaka'wakw and Coast Salish masks and Macnair's (Macnair et al. 1980) summary of contemporary Northwest Coast art.

Recent original research on Kwakwaka'wakw material culture can be divided into two principal kinds. In the earlier period, roughly 1950 to 1960, it was conducted mostly in Vancouver and Victoria, as the Hawthorns, Duff, and Holm worked with Mungo Martin and his family. In this decade Wilson Duff was able to compile a good bit of mostly ethnohistorical data on the Kwakwaka'wakw, though he published little of it.[42] Beginning in the late 1950s, Bill Holm began to spend time in the field, first with Mungo Martin and then other Kwakwaka'wakw, as a ceremonial participant. Since 1967, Provincial Museum curator Peter Macnair has done the same, though his official position (until 1997) led him to act more as an observer than a participant. This recent participant-based research is quite a change from earlier work, which was largely a by-product of collecting. The reason is clear—collecting in the field has virtually ceased. The political situation has changed to the extent that Natives are re-

luctant to give up their ceremonial artifacts. After a feeling of trust is built up, research into art and ceremonialism is possible.

Another outcome of these changing ethnic relations was the Provincial Museum's program of documenting potlatches in the form of sound tapes and still photographs. After making the first tapes in 1967, at the request of Native potlatchers, Macnair soon realized that this was a valued service by which the museum could maintain friendly relations.[43] Unlike most other documentation, these records were explicitly created *not* for publication; the museum produced them as a service for the Native community. One copy was given to the Native patron and another copy was stored in the archives of the Ethnology Department, to be consulted only with the permission of the Native patron. Although these records are thus for Native use rather than scholarship, contemporary potlatching was being documented, and the intention was probably to produce a record that in time could be more widely analyzed and distributed. With changes in institutional funding, staffing, and priorities, this program gradually diminished.

However, as in many other museum programs, the efforts of anthropologists have been replaced by those of Natives. Macnair had pointed to an additional benefit of the program: "It has also been a vehicle through which the museum has been able to train young Kwakwa̱ ka'wakw in the techniques of recording and analyzing cultural events" (Macnair 1986:517).[44] Indeed, partly with this stimulus, the local Native population in Alert Bay have become avid videographers of potlatches and oral history (Webster 1990b:137). 'Na̱mgis Barb Cranmer is a notable independent filmmaker. With her Nimpkish Wind Productions, formed in 1994, she has made films on Mungo Martin, salmon fishing, eulachan fishing and rendering, the revival of oceangoing canoes, and the new Big House at Alert Bay.

Scholarly literature on Northwest Coast, specifically Kwakwa̱ka'wakw, art and artifacts treats a variety of subjects: materials and techniques, form, iconography, social context, historical development, museum collections, individual artists, and contemporary art. The years since Boas have seen very few publications on materials and techniques, but this does not mean that there has been no research on the subject. It is true that materials have changed and the range of techniques has diminished. Thus classical descriptions cannot now be supplemented or superseded. Furthermore, other kinds of questions now seem of greater intellectual interest. But with the revival of art production, by Natives and whites working in Native styles, this is becoming a period of great technical experimentation. Many of these artists learned their craft from accounts in books and from physical inspection of old artifacts. In so doing, they often found that the old texts had not supplied all the details and were thus forced to seek out the few elders who still knew the old ways, or to use trial and error. Indian hobbyists were particularly active in these efforts, and Bill Holm has tried his hand at almost every material and technique employed by Northwest Coast artists: woodworking, painting and drawing, jewelry in stone, bone, shell, and metal,

weaving and basketry. But like almost all the current research into materials and techniques, very little results in publication. Instead, knowledge is shared, as in the old days, orally and by imitation. Exceptions are the Arima and Hunt (1975) study of Kwakwa̲ka̲'wakw tourist masks, Susan Davidson's (1980) review of bent-box craft, and Hilary Stewart's (1984) book on cedar technology.

Of all the scholarly genres on Kwakwa̲ka̲'wakw art, perhaps the least studied is form. The influence of Bill Holm's 1965 study of Northwest Coast northern graphic style—built on a Boasian base—cannot be overemphasized. Even though it contains no examples from the quite different Kwakwa̲ka̲'wakw style, it has supplied the scholarly vocabulary for all formal studies of Northwest Coast graphic art. Though more superficial, his 1972 (1972b) essay has done much the same for sculptural styles, forming the basis for Macnair's (1980:43–62) analysis in *The Legacy* catalog. The most in-depth analysis of Kwakwa̲ka̲'wakw form can be found in Bill Holm's (1974, 1983) research on Willie Seaweed.

At least since his days with the Surrealists, Claude Lévi-Strauss has been attracted to Northwest Coast Indian art. His 1945 essay on the problem of split representation (1963), inspired by Boasian analysis, combines formal and semantic problems. According to this structuralist program, formal problems are ultimately related to social structure. In his 1975 book on Kwakwa̲ka̲'wakw and Coast Salish masks, Lévi-Strauss elaborated his structural analysis of art, in this case attempting to link formal properties of the masks with the semantic content as revealed in mythology. Extending his myth tetralogy, Lévi-Strauss tackles the fundamentally Boasian problem of cultural diffusion, but approaches it with an emphasis on the structural transformations of visual form and mythic meaning.

The problem of meaning in the visual arts exists on many levels. After Boas there were virtually no analyses of meaning in Northwest Coast art until the mid-1960s (an anticipation was Deborah Waite's 1966 essay on transformation masks, based on the Boasian literature). The leaders in this change in focus were Lévi-Strauss and Wilson Duff. Although his early training had been in a conservative Boasian tradition, when Duff began teaching at UBC in 1965 he turned increasingly to the previously neglected problem of meaning. Synthesizing influences from Bateson, Turner, and early Lévi-Strauss, Duff (1981) was preoccupied with logical structures and paradoxes, and especially sexual symbolism. However, with his focus on the Haida, Duff rarely discussed Kwakwa̲ka̲'wakw forms.

A student of Lévi-Strauss who came to study with Wilson Duff, Martine Reid (née de Widerspach-Thor) has effectively combined the detailed Boasian tradition of Duff's early work with the structural interests of her French mentor. While her dissertation on the Kwakwa̲ka̲'wakw hamatsa ceremonial (M. Reid 1981a) is based primarily on mythic and ritual aspects, it is also relevant to issues of material culture and art (Reid 1986). In an essay on the copper (M. Reid 1981b)—not restricted to the Kwakwa̲ka̲'wakw, though taking her prime evidence from the tribe—she is primarily occupied with seeking structural parallels within the culture. These studies are distinct

from but related to the more recent symbolic analyses of Kwakwaka'wakw culture by Goldman (1975) and Walens (1981), both of whom frequently discuss material culture. Both use general theory to extrapolate from the Boas and Hunt texts, Walens primarily in a psychoanalytic perspective on orality (see Suttles 1979).

The social context of these artifacts has been addressed principally in terms of ritual use. The gap for the middle years is filled somewhat by Drucker's brief review of Kwakiutl dancing societies (1940). Since the mid-1960s there have been several reviews of the social context of Kwakwaka'wakw art. Though that tribe comprises only a small part of the Rasmussen collection, Gunther's (1966) annotation, based on the literature, is devoted mostly to a discussion of social use. One of the major contributions to Kwakwaka'wakw art studies, Audrey Hawthorn's 1967 volume (and its revised version, 1979), was organized around functional, especially ceremonial, complexes. Going beyond the literature, Bill Holm (1972a, 1977) was able to contribute his field investigations to knowledge of the uses of Kwakwaka'wakw ceremonial artifacts.

An interesting comparison can be made between Boas (1897a), Drucker (1940), and Holm (1977), representing three generations with changing perceptions of the viability of tradition. Boas is taken as the classic account, and Drucker and Holm both refer to this baseline. Boas recorded massively, assuming that the tradition was doomed. Working during the Depression when the potlatch was illegal and seemed moribund, Drucker spent very little time in the field. Holm for the first time documented the basic continuity in ceremonialism, while recording its changes. Of these studies, however, only Boas deals extensively with the use of artifacts.

While change and historical development had been considered in Northwest Coast art studies before the 1960s, it was treated on the level of macrohistory, spanning centuries, not decades. Basic Boasian reconstructions of styles continued, addressed primarily to conjectures as to how the northern formline system had developed and spread (Wingert 1949; Duff et al. 1967). Even Lévi-Strauss's analysis of masks was of this speculative sort of history. This formulation of time by tracing distribution of objects in space was essentially a form of diffusionism. One variety especially popular in Northwest Coast art studies was the positing of trans-Pacific contact (Fraser 1968; Coe 1972; cf. Jonaitis 1995:314–320). These analyses were gradually replaced by the more empirical approach of archaeology (Carlson 1983). With an increase in excavation, scholars began to find dated objects extending over some time depth, from which a stylistic development could be reconstructed.

Change on a more particular level, however, was not considered until the artistic revival in the 1960s. Until white scholars had observed Native art long enough to perceive stylistic changes, they did not look for them in the art of the past (except when noting what they thought was artistic degeneration due to white contact). One of the earliest scholars to conduct historical research on the subject was Erna Gunther. She had begun her work in the early 1950s, though it was not until 1972 that her historical ethnography was published. This was not a study of change so much as one addressed to the reconstruction of material cultures at contact. Expanding and refining

the approaches of Carlson's authors as well as Gunther, Steven Brown (1998) has offered a stylistic reconstruction of the development of Northwest Coast art, based now, not on speculation, but on well-dated archaeological specimens and museum specimens.

Also growing out of Gunther's historical studies is a related genre devoted to museum collections. Until the present study, there has been no book-length account focused solely on the Kwakwaka'wakw, but an important foundation is Douglas Cole's (1985) general review, and Kwakwaka'wakw objects were included in Jonaitis's (1988) book on the Northwest Coast collections at the American Museum of Natural History as well as her 1991 exhibit catalog on the Kwakiutl potlatch. Although not directed to historical concerns, catalogs of museum collections have offered an opportunity for the publication of important insights into Northwest Coast art: for example, Holm (1987) on the Burke Museum, and Abbott (1995) on the Hauberg collection at the Seattle Art Museum, which featured essays by Native authors.

Throughout this recent scholarship, a concern for artistic change has been combined with the study of individual artists. In 1961 Harry Hawthorn published an important essay on the role of the artist in Northwest Coast society, focusing on Mungo Martin, who died the following year. In the 1950s and 1960s Wilson Duff and Audrey Hawthorn published several journalistic essays on Martin, who became the most famous Kwakwaka'wakw artist, past or present. Audrey Hawthorn adopted this new approach in her 1967 volume on the UBC Kwakwaka'wakw collection, which included attributions whenever possible and a brief biographical appendix. The same year also saw the pivotal publication of the *Arts of the Raven* catalog (Duff et al. 1967). This work simultaneously considered an outstanding artist of the classical period— Charles Edenshaw—and the work of contemporary artists.

By far the most critical study of this kind, at least for the Kwakwaka'wakw, has been Bill Holm's work on Willie Seaweed (1974, 1983). This stylistic analysis was significant on several accounts. Most important was the continuity in Kwakwaka'wakw artistic creation that Holm demonstrated. As he firmly documented, Seaweed was at the peak of his career, creating new objects for ceremonial use, throughout the 1920s, 1930s, and 1940s, a period during which whites had thought such work had ceased. The work is also valuable for its delineation of the Blunden Harbour style, as a corrective to the earlier focus on Mungo Martin and the Fort Rupert/Alert Bay style.

Publication on individual artists culminated in *The Legacy* catalog (Macnair et al. 1980), an overview covering past masters and well as contemporary artists. For the Kwakwaka'wakw, Nuytten's (1982) biographical study deals with a group of related artists, the more recently deceased carvers Mungo Martin and Ellen Neel, as well as the early master Charlie James. However, beyond *The Legacy* catalog and the occasional work of journalism (Falk 1976 on the Lelooska family), there have been relatively few treatments of living Kwakwaka'wakw masters, such as Douglas Cranmer and Tony Hunt, to name only the senior artists (but see Neary 2000 on Richard Hunt).

In this the Kwakwaka'wakw case differs from the Haida, with the many studies of Bill Reid and his protégé Robert Davidson (e.g., Shadbolt 1986; Thom 1993).[45]

Related to questions of change is the issue of intercultural arts, first treated for the Kwakwaka'wakw in a study of tourist masks (Arima and Hunt 1975), and then in an introductory study of Coast (including Kwakwaka'wakw) silkscreen prints (Hall et al. 1981). Such analyses were similar to the many recent studies of another art of acculturation, the purely Haida medium of argillite sculpture (e.g., Macnair and Hoover 1984). Scholars from the University of British Columbia, such as Michael Ames (1981a, 1992) and his student Karen Duffek (1983a), have begun to address the contemporary intercultural context for Native arts—the galleries and museums. These concerns were refined in Judith Ostrowitz's (1999) discussion of the uses of the past in contemporary Northwest Coast art.

These trends are indicative of the growing interrelation between anthropology and art history. While anthropology has continued to supply the data and much of the basic approach for the study of these artifacts, as they have been considered more and more as art, the categories and approaches of art history have come to influence scholarly discourse. For example, Duff often cited Panofsky in his work, and as a trained artist and professor of art history, Bill Holm has been a major proponent of such perspectives. Yet even today, the number of art historians who work on the region is small and with the exception of Holm and Jonaitis, few art historians have addressed themselves to Kwakwaka'wakw themes.

From the standpoint of scholarship, one finds that the role of the Kwakwaka'wakw in Northwest Coast art studies has been important but circumscribed. Between c. 1920 and 1960, with the general decline in original research on the art of the region, the Kwakwaka'wakw were usually considered along with the other tribes in general surveys. Students of Boas, such as Gunther and Garfield, chose not to work with the Kwakwaka'wakw. The revival in Kwakwaka'wakw art studies may be directly attributed to the relocation of Mungo Martin in Vancouver and Victoria during the 1950s. Martin was strongly committed to having his knowledge recorded, and Audrey Hawthorn and Bill Holm, two of the leading recent writers on Kwakwaka'wakw art, were first drawn to the subject by Martin. Both produced surveys of Kwakwaka'wakw ceremonial art (Hawthorn 1967, 1979; Holm 1972a), and Holm (1983) later outlined an art history for twentieth-century Kwakwaka'wakw art in his monograph on Willie Seaweed.

Yet, as mentioned earlier, there has been an enduring Euro-American bias for northern, especially Haida, styles in several arenas: exhibition, the art market, and scholarship. Dawson and Barbeau were only two of the early prominent proponents of this view. As Suttles (1990:11–12) puts it, "There has been a persisting popular image of a culturally superior 'real' Northwest Coast in the north and an imitation one in the south." Even beyond these personal aesthetic preferences, Kwakwaka'wakw art has suffered from its relative avoidance by leading scholars, even by its most com-

mitted students such as Boas and Holm. In part, this is due to the more personal and idiosyncratic nature of Kwakwaka'wakw styles, which are less susceptible to the kind of codification Holm (1965:ix) gave the northern styles. Because of the great influence of these works among collectors, according to one dealer, people think that "if it isn't Haida, it isn't right" (Duffek 1983a:131)—an unintended example of anthropological influence.

All of these studies, since the time of Boas, have formed a more of less coherent discussion, a discourse, one may say. These scholarly traditions, however, can easily become reified and "ossified." Such was the outcome of the construction of the "ethnographic present." One implication of the production of any ethnography is the freezing of a fluid social field. Of the Boas-Hunt list of potlatch "seats" in rank order, Rosman and Rubel (1971:137) have commented:

> In our opinion, this list rather represents an ideal conceptualization in the minds of informants of positions, potential seats as well as those actualized and validated by potlatching. The rank order, if gathered from several informants, would probably vary and be subject to dispute. Further, it is apparent from the Hunt-Boas correspondence that the recording of the Mamaleleqala rank order of seats (Boas 1897[a]:339–40) gave permanence in the act of recording to something which had been flexible when it existed as a set of cognitive concepts. Hunt notes that the recorded rank list was used in disputes by the Mamaleleqala themselves (Hunt-Boas correspondence).

Boas was primarily interested in past practices. Tending to ignore present behavior, observable during his period in the field, he recorded "traditional" Kwakwaka'wakw culture, mostly in the form of texts, and to a large extent, vicariously from Hunt (Jacknis 1984:45–48; cf. Berman 1996).

Through 1980, most post-Boasian scholars—art historians as well as anthropologists—addressed themselves to art of the classical period. They tended to repeat the information contained in the classic ethnographies or in museum collections, and when they did come up with new data, their sources were documents or artifacts—all objects—not the behavior and intentions of living people. Examples here were the symbolic analyses of meaning and iconography (topics largely ignored by Boas) in the work of Duff, Lévi-Strauss, or Walens. Consequently, with no firsthand experience, it was all too easy for scholars to create and perpetuate mistakes—by combining accounts, ignoring local variation, mistranslating, repeating cataloging errors.[46] As these were repeated from citation to citation, the errors became "real," forming a tradition of knowledge, albeit garbled.

There are at least two ways to supplement the classical record: objective (artifact collections, field notes, and photos) and behavioral (informants and experimentation). It is possible to exploit a wider range of classical objects to discover aspects not considered and questions not asked by the ethnographers who produced them. Then there is the approach of Bill Holm and his fellow artist/hobbyists. As a practitioner himself, Holm has had access to contemporary behavior (Mungo Martin and other

Kwakw<u>aka</u>'wakw), and when he has not (the northern formal system or techniques of copper-work, for example) he has attempted to re-create older forms by actual experimentation based on museum collections and literature. (The hobbyists' efforts have been paralleled by recent approaches in experimental archaeology.) From both these sources, Holm and his colleagues have injected something new into the record of the classic literature, even in those cases where they are guided by it.

The scholarly literature can be used in the same manner as photographs and museum exhibits. These cultural representations become objectified, detached from their context of generation in the field (i.e., in the Native culture and its encounter by an ethnographer) and set free to live a secondary life, "out of time." Because of this, they are all the more susceptible to becoming an anthropological fiction.

Just as in the art world in general, certain Native artifacts are selected to form a "canon." The same classic pieces, supposedly the masterpieces, are chosen again and again for exhibition in temporary loan shows and illustrated in the permanent catalogs. Perhaps the most often cited Kwakw<u>aka</u>'wakw artifact has been a potlatch figure originally collected by Captain D. F. Tozier. The piece was then purchased by George Heye, who, in turn, sold it to Wolfgang Paalen. In 1951 the Taylor Museum of Col-

Figure 6.25. Potlatch figure (center) once owned by Wolfgang Paalen, as displayed at *Art of the Northwest Coast,* Lowie Museum, University of California at Berkeley. Photo by Eugene Prince, 1965. HMA.

orado Springs acquired it, and about 1992 Eugene and Clare Thaw bought the figure for their collection at the New York State Historical Association (Vincent et al. 2000:326). Perhaps these travels helped to publicize it, for it was exhibited or illustrated at least a dozen times from 1943 to 1995.[47] Although one is only speculating, it is likely that its shift from an anthropology museum to the collection of a Surrealist artist (who, in turn, showed it to colleagues such as Miguel Covarrubias) brought it to the attention of a wider audience. The Thaw collection is particularly rich in objects with such pedigrees. Another especially popular Kwakwaka'wakw piece was the so-called hawk-spirit mask. Representing a bak'was, or Wild Man of the Woods, this mask was part of the potlatch collection that was confiscated from the Kwakwaka'wakw in 1922 (see chapter 9). It was included in several of the temporary shows during the 1960s: the Chicago Art Institute in 1964, the Lowie (Hearst) Museum in 1965 (figure 6.25), the Arts of the Raven show in 1967, and the Musée de l'Homme in 1969.[48] Although few pieces are given such notoriety, the number of objects that are ever exhibited or illustrated is quite small. Thus there must be strong selection pressures acting to choose just these to represent all of Kwakwaka'wakw (classical) culture. On a broader level, certain collections and museums have played the role of "type" or reference collection. According to Holm (1979:77), "The greatest collection of Northwest Coast Indian art in the world is in the American Museum of Natural History." The classic status of the American Museum collection was established when Boas studied and illustrated it in his influential 1897 and 1927 essays, and it has been studied by generations of scholars and aficionados ever since. Collections that vary substantially from such types seem "wrong" or misformed in some way; yet there is rarely reflection on the representativeness of the collecting process.

While much of the past century of Kwakwaka'wakw art scholarship has been profoundly conservative, there have been revisionist trends, a search for new problems and interpretations. Since 1965 or so, the hobbyist/artists have been searching for new data, and, more important, attention has gradually shifted to issues of continuity and change, and the role of the individual artist. The anthropology of the Kwakwaka'wakw and other Northwest Coast Indian cultures has, of course, changed as the discipline at large has changed, and by the end of the 1990s, scholarly writings on the region were expressing the fundamental readjustment in interethnic relations. In their complex interweaving of formal, contextual, and historical aspects, two of the best exemplars of these trends were the exhibition catalogs *Chiefly Feasts,* on Kwakwaka'wakw potlatch arts (Jonaitis 1991) and *Down from the Shimmering Sky* (Macnair et al. 1998), on Northwest Coast masks, including a strong Kwakwaka'wakw concentration. Certainly the most critical feature of both projects was the collaborative participation of Native scholars and artists. In order to understand how such approaches came to be considered desirable and even necessary, one must turn to the long history of museum programs addressed to a Native constituency.

PART THREE

REPATRIATION: "GIVING THE ART BACK TO THE INDIANS" (1950–1980)

7

THE MUSEUM AS PATRON

B ecause museum programs are predicated upon the preservation and presenta-
tion of discrete collections, they are naturally focused in single locations. Yet, for
at least the past century museums have tried to extend their influence through a va-
riety of outreach programs (Alexander 1979:221–229). Around the turn of the cen-
tury museums introduced extension services, in which specimens were loaned to
schools; later, John Cotton Dana, founder and director of the Newark Museum from
1909 to 1929, pioneered the museum's role of community service (Alexander 1983:
377–411). After several decades of inactivity, outreach has recently become a major
museum function, as these institutions respond to public demands (greatly stimu-
lated by the social unrest of the 1960s), and as they attempt to justify their existence
to the source of their funds: governments and foundations. Outreach, defined as in-
terpretation, is usually regarded as a task for the education department. Among their
several audiences are elementary and secondary school students, university students,
and the general adult public. Extension or outreach may be defined more broadly,
however.

A special audience for museums in the Northwest is the Native community, from
whom come the bulk of the objects in their collections. Ever since 1950 and Mungo
Martin's work in Vancouver and Victoria, Natives have played increasingly active
roles in museums. Although commissions and forms of outreach were old museum
functions, they took on a new cast as these local institutions began to work directly

and intimately with Indian artists. Over the course of these decades, in fact, there has been an inversion. Where once the museums were patrons to Native artists, "museum anthropologists have become the clients and the Indians the patrons" (Ames 1992:67). It is thus more accurate to say that museums have played increasingly active roles in Native culture.

COMMISSIONS

Commissions for specific objects are nothing new to the Kwakwa̲ka̲'wakw, for this was their standard mode of artistic creation. Carvers were paid in valuables, materials, and support to make particular objects to which the patron held an ancestral privilege. Unlike contemporary Western artists, carvers never created generally, without knowing in advance who was to acquire their work.

Since the turn of the century, museums have been commissioning works from Kwakwa̲ka̲'wakw artists (chapter 1). After this initial, classical period (c. 1880–1920), when it was an adjunct to and grew out of collecting in the field, commissioning entered a period (c. 1950–1981) when it was a part of local programs on museum premises. During the interim, both collecting and museum patronage were practically nonexistent, as a result of the anthropological perception that Native aesthetic traditions were virtually dead.

In the contemporary period patronage has undergone a fundamental change. "Commissions" are a special type within the general category of patronage. While patronage can refer to support for specific pieces or for artistic activity in general, commissions are always orders, in advance of creation, for a particular object or group of objects. One of the trends in this history is a shift to general patronage, supplementing specific commissions.

B.C. PROVINCIAL MUSEUM CARVING PROGRAM

The four-decade history of the carving program at the Provincial Museum can be divided into roughly three overlapping phases. The first, from 1952 to about 1965, was dedicated to the production of replica totem poles. The second, from 1956 to 1970, was largely spent making original totem poles. In the final phase, 1970 to 1992, the production of smaller objects, mostly original masks, predominated. That these are not absolute periods can be seen from the fact that totem poles have been carved throughout, and all three modes—replica poles, original poles, and masks—were present in the first two years, when Martin started work in the park, the culmination of which was the erection of his house with its potlatch. Rather than a linear sequence, the carving program has been more of an organic growth from germs present from the beginning. During each phase one or the other activity has been dominant.

Each of these three phases has been composed of groups of major projects. Replication was first carried out with the poles of Thunderbird Park, completed in 1955.

The next big replica project was the carving of several copies of the poles collected at the Tsimshian (Gitksan) village of Kitwancool, which lasted from 1958 through 1965. Projects during the second phase, of original poles, were more individual. This was largely a reflection of the fact that during these years funding for the program was uncertain. Most of the original poles were made not for the museum, but for outside clients; thus each original pole was produced on demand as the occasion presented itself. During the most recent phase, projects again can be grouped. Much effort during the first years (1966–1975) was devoted to preparing for the new exhibits, isolated objects as needed, but especially the Jonathan Hunt house with its contents. Since the early 1970s, two programs, the set of objects for loan at potlatches and the exchange of newly made items as part of the collecting of old ones, have taken up most of the carvers' time. Both concentrate on masks and other kinds of portable ceremonial paraphernalia.

The shape of the program's history has been determined by the interaction of curatorial intentions and contexts of Native art as they changed outside the museum. The shift into the second phase of original poles came somewhat fortuitously, as the museum struggled to find some way to keep the program going in the face of Provincial budgetary limits. The transition into the present period was more intentional.[1] When Peter Macnair was put in charge of the carving program in 1966, he tried to move the program away from what he perceived as problems in earlier periods. He had been unhappy with the program's dependency on outside commissions, in which a great deal of effort was expended on copies or on poles that often went to minor and obscure patrons. This new direction was marked in the Henry and Tony Hunt pole for the 1967 Expo at Montreal, an original pole that he feels was their finest up to that time. Subsequently, Macnair developed the carving program to meet Native demands and a changed political and aesthetic situation.

Throughout its history, the personnel of the carving program was overwhelmingly Kwakwa̲ka'wakw, and the role of the chief carver remained within one family until its final six years. The size and specific composition of the staff fluctuated according to the vagaries of governmental funding and the availability of interested, talented apprentices. The program was originally built around Mungo Martin, who remained with it until his death in 1962.

Reports for the first years talk of the difficulty of finding suitable apprentices (BCPM Annual Report for 1952:21). During these years Martin's son David was the principal assistant. Although "an accomplished carver," in Duff's words (ibid.), David Martin found it hard to support his family on the museum's wages. In the first year he spent the summer in commercial fishing, the occupation to which he returned when he finally left the program in mid-1957. A grant from a local businessman allowed the museum to hire Henry Hunt for two months in 1954. Hunt, the husband of Martin's adoptive daughter Helen, began work full-time the following year. After David Martin's departure, Henry Hunt became the assistant carver.

During the decade of Mungo Martin's employment, a few other apprentices

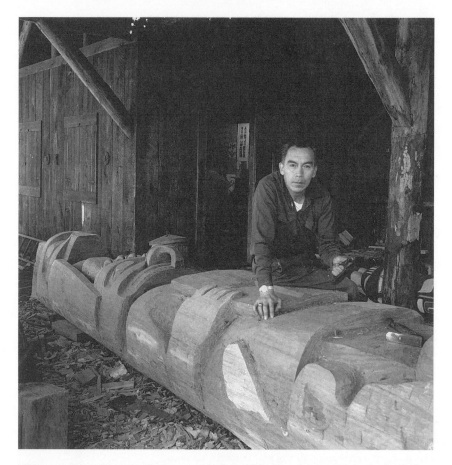

Figure 7.1. Henry Hunt, carving totem pole for J. Alsford Lumber Company, England. Photo by Clifford Carl, 1969. RBCM pn 3089.

worked for short periods. The first year Martin's granddaughter Mildred Hunt helped while David was off fishing. The following year David and Mungo Martin received assistance from R. J. Wallace, the museum's carpenter, in building the house. In 1956 the Haida carver Bill Reid worked briefly at Thunderbird Park, more for the purpose of gaining experience in large-scale wood carving than in helping with the museum's own projects. Another relative, Godfrey Hunt, worked the summer of 1957, and the Nuu-chah-nulth artist George Clutesi carved for a short period in the spring of 1959.

Within two weeks of Martin's death on August 16, 1962, Henry Hunt was promoted to chief carver, and his son Tony was appointed assistant carver. The team worked continuously until Tony resigned on February 15, 1972, to devote more time to his own carving and especially to his recently opened shop, Arts of the Raven, and

Henry resigned on July 4, 1974, also to do his own carving. Among Tony Hunt's more important works in this period were the pole for the Montreal Expo in 1967 and the Mungo Martin memorial pole for Alert Bay, 1970. He also created a small but important group of masks commissioned by the museum for ceremonial use.

Until 1970 the father and son team worked alone. The one exception was the Cowichan Salish Simon Charlie who was an assistant carver from September 1966 to the end of May the following year. Between 1970 and 1974 there were often several apprentices assisting the two principal carvers. The one who spent the most time at the museum was the Nuu-chah-nulth Ron Hamilton, starting in 1971 and leaving in 1973, with his last year as assistant carver. Several Haida and non-Hunt Kwakwaka'wakw passed through the program for brief periods.[2]

Just as Tony Hunt had assisted his father on museum projects before his official hire, so his brother Richard worked with Henry Hunt for two months in 1973 finishing the Jonathan Hunt house. Though born in Alert Bay, Tony's younger brother Richard Hunt (b. 1951) has lived most of his life in Victoria. Throughout his childhood and youth his father was carving for the Provincial Museum, and at the age of thirteen Richard began learning from him. After working with his brother for a year, in 1973 Richard Hunt became apprentice carver at the Provincial Museum, where he was chief carver from 1975 to early 1986. During these years most of Hunt's output took the form of masks and ceremonial paraphernalia, commissioned as part of the museum's programs. Joining him in 1977 as assistant carver, was Nuu-chah-nulth

Figure 7.2. Tony Hunt, putting finishing touches on the pole carved with his father for the 1967 Montreal Expo. RBCM pn 12758.

Figure 7.3. Richard Hunt, painting, 1974. RBCM pn 12613.

Tim Paul, who held the position of chief carver from the time of Hunt's retirement until 1992 (Macnair 2000). With his departure, the program officially ended.[3]

Thus for the first thirty-three years of its history, the chief carver was a member of the Martin-Hunt family, and until 1973 so was the assistant carver. The tribe with the most sustained participation after the Kwakwa̲ka'wakw are their neighbors, the Nuu-chah-nulth. While there have been a good number of Haida, they each spent relatively brief periods at the museum.

THE UBC MUSEUM AND OTHER CONTEMPORARY COMMISSIONS

The UBC Museum of Anthropology has had a special relationship with several carvers—Mungo Martin, Bill Reid, Robert Davidson, Douglas Cranmer, Norman Tait, and, more recently, Lyle Wilson. Except for the group of small objects produced by

Martin and his wife, most of the museum's commissions have been of monumental sculpture. After Martin's two poles of 1951, the next major project was the production of the Haida village by Reid and Cranmer, 1959–1962. Reid followed this up with several free-standing figures, a wasgo or sea wolf in 1962 and a bear the year after. In the late 1960s and early 1970s Davidson and Cranmer carved at the museum, although most of their production went elsewhere.

For its new building the museum sponsored works that could only be called "art": a set of carved wooden doors by the 'Ksan carvers of the Skeena River (1976) and the Bill Reid monumental sculpture of *The Raven and the First Men* (1980). In an effort to complete its tribal representation in the totem park, the museum obtained a Nisga'a pole from Tait in 1978 and a Gitksan one from 'Ksan in 1980; several Haida and Coast Salish poles have been erected since. While some, such as parts of the village, are replicas, most of these works are original creations, and the result of the UBC commissions has been to further the aesthetic approach to Native artifacts. Unlike much of recent Provincial Museum production, none of these objects were meant to be used in Native society; instead all were created specifically for a museum setting.

In addition to commissions for its own collection, the UBC museum acts as a general patron, offering Native artists the use of its facilities. Unlike the Provincial Museum, UBC has not operated a formal carving program. Instead, carvers come to the museum with their own, outside funding, and make arrangements to use the Haida house as a carving shed, with the understanding that at least some of their work will be open to the public as a demonstration. The program is ad hoc; the museum does not recruit artists, and they can stay as long as their project lasts.[4]

Museums are only one of the many patrons of contemporary Northwest Coast Indian art. Others include governments, corporations, collectors, tourists, ad hoc groups, as well as Natives. The Province of British Columbia, beyond its support of the Provincial Museum, has been an important patron. To commemorate the centennial of its founding, the province commissioned a series of nineteen poles, erected in 1966 as the "route of the totems" at various ferry landings, and in 1971 another thirteen were commissioned and given as gifts to other provinces, to mark British Columbia's entrance into Confederation. Although these competitions were open to all Natives in the province, Kwakw<u>a</u>ka'wakw were the majority of carvers in both.[5]

Corporations have a long history of commissioning Native art, particularly totem poles, a trend that has become even more important in the past two decades. B.C. Packers, the owners of the local cannery in Alert Bay, had a pair of houseposts in front of its store from the early 1940s until the early 1960s. Although little is known about their origins (whether they were specifically commissioned by the company or purchased later), they were quite accomplished.[6] As fishing declined in Kwakw<u>a</u>ka'wakw territory, it was replaced by mining and forestry, and these companies have taken up the role of corporate sponsors. For example, in 1981 the Finning Tractor Company commissioned a post and lintel arch for its facility outside Fort Rupert. Constructed in the form of a sisiyutł by Douglas Cranmer and his apprentices, the

arch was dedicated with an impressive ceremony. Other Kwakwaka'wakw totem poles have been erected by shops in Victoria (Tony Hunt in the early 1970s) and the Canadian Broadcasting Company in Vancouver (Richard Hunt in 1982).

Quite a number of poles, house frames, and the like were sponsored by ad hoc, local white groups, often for special purposes or events. Several of Mungo Martin's Provincial Museum poles fall into this category, such as the "world's tallest totem pole" for Beacon Hill Park and the two Centennial poles. In 1971 another ad hoc commission deposed that Victoria pole as the world's tallest. The Alert Bay Board of Trade (with a provincial grant and a donated log) sponsored such a superlative pole that was finally erected two years later.

The commissions of private collectors are now the major source of income for the leading artists. Usually arranged through dealers, these commissions are often quite specific, as collectors request copies of works they have seen in books or museums or ask for decorative items to fit a special place in their homes. Generally, these are smaller pieces, masks and jewelry. Tourists are in the area for such a short time that they are generally not a source of commissions, though the more committed of them may fall into the category of private collectors. A final source of commissions—important, if not plentiful—is Native patrons (Blackman 1985).

INSTRUCTIONS

Of the objects commissioned by museums, many differ from those made for other patrons in their form and meaning, which are determined by the instructions given to the artists and by the various uses and motivations for the artifact. Like collecting, museum patronage tends to involve a direct social relationship between anthropologist and Native. Accordingly, patronage is a system of mutual understandings and assumptions, and the artist's creation will be determined in part by his or her understanding of the audience for the completed work, and, more specifically, by any instructions he or she may have been given (Becker 1982:99–107).

On what basis did the classical collectors instruct Native artists? Although they could not acquire it, the collectors had in mind a prior model. Either they could still see it in Native hands (but could not buy it, as in Jacobsen's case), or they had some evidence of its prior existence, from other museum collections, from drawings or photographs, from previous observation, or from testimony. How were these models transmitted to the artist? Was the instruction specific or open-ended? Instructions are apt to be most limited when the object is destined for display, and only slightly less rigid when the piece is intended to fill gaps in the collection. Although Martin was given freedom to choose the iconography of his original UBC poles, the form resulted from strong suggestion on the curator's part. Similarly, though he was allowed to choose the forms for his Thunderbird Park house and pole, when it came to the replication work, his freedom was, naturally, circumscribed.

Unfortunately, in most cases there is not enough information to answer such questions. For the original poles at the Provincial Museum, it is no longer possible in many

instances to ascertain who chose the crests—the carvers or the museum anthropologists. Usually, though, the artists were apparently given the freedom to select the features they desired.[7] Perhaps some of the regional associations (e.g., of the sea otter) were a product of joint discussion, or even, post facto interpretations. Competitions are usually more straightforward; for the two centennial commissions, in 1966 the province insisted that each pole incorporate a grizzly bear, as "the only symbol common to all British Columbia Indian tribes," whereas in 1971 the prime requirement was that the pole relate to British Columbia legend. In both cases a height limit was specified.[8]

The nature and degree of constraint in the production of many of the objects made for exchange and potlatch use is complex. The basic form and iconography are limited by the need to make a particular type of object (mask or rattle) and by a particular kind (fool or cannibal bird mask). While a curator may wish to encourage the carver toward artistic freedom within these limits, carvers often feel bound by the conservatism of their Native patrons.

FORM AND MEANING

Perhaps the most decisive aspect of anthropological patronage of Kwakwaka'wakw carving has been the fostering of archaic forms. Although Mungo Martin adopted matte paint, he still tended to cover his poles with paint. Henry Hunt was responsible for popularizing a bare wood finish.[9] The pivotal work in this transition was the Grizzly Bear post for Swartz Bay, the ferry terminus on Vancouver Island (figure 7.4). Hunt had entered this 1966 piece in a Centennial competition. As Macnair remembered it, Hunt was the one who decided to leave the post unpainted:

> Henry's original intention was to paint the thing over entirely as he had been taught by Mungo. As the carving began to develop, Henry began to develop more and more the aspects of the carving. At one point I talked to him about it, and he agreed that he would be restrained in his use of paint—use the black, the red, and the green. But he even went a step further; in the end he didn't paint it at all.[10]

Macnair felt that Hunt had made up his own mind but perhaps was prodded a bit by Macnair's suggestion. Another contributing factor was the fact that this Grizzly post was the third that Hunt had entered in the competition and, consequently, he had less time to work on it. The next pole that Henry and Tony Hunt completed, destined for the Indian Pavilion at the 1967 Montreal Expo, was painted in the new restrained style, and it became the precursor for their 1970 Mungo Martin memorial pole, which was the paradigm for their later style.

The decision by Martin and the Hunts to adopt this more archaic style was a personal, aesthetic one. Yet while Duff and Macnair were more encouraging, Hawthorn seems to have been more directive. It is unlikely that this stylistic revival would have occurred outside of the museum setting, which contained records of older artifacts and historic photographs that were necessary to reach back beyond the memories of

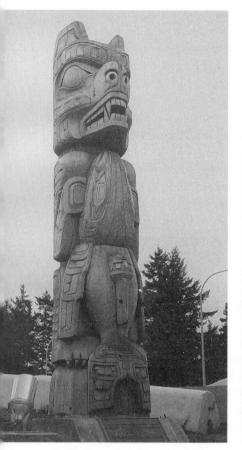 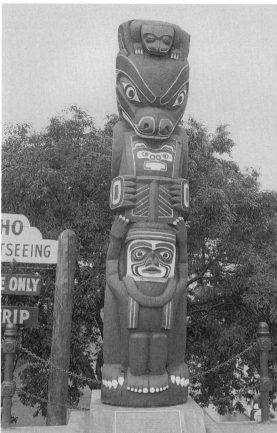

Figure 7.4. Unpainted grizzly bear of the sea housepost, by Henry Hunt, Swartz Bay, Vancouver Island. RBCM pn 6174–5. **Figure 7.5.** Painted grizzly housepost by Henry Hunt, Victoria harbor, 1966. RBCM pn 2331.

the oldest carvers, such as Martin and Seaweed, who had been using the all-over enamel style. Beyond this temporal influence from older Kwakwaka'wakw pieces, there was also a geographic influence from the carvers' experiences in replicating Haida and Tsimshian poles.

Museum curators also played a role in funding, if not selecting, the iconography of totem poles. In the years since Martin's death, the Provincial Museum has commissioned poles to commemorate its intimate involvement with the Martin and Hunt family. The Mungo Martin memorial pole in Alert Bay, carved by Henry and Tony Hunt in 1970, contains two crests that Martin traced through his father (thunderbird and cedar man), one transferred to David Martin by marriage (raven), and one acquired by Martin through his wife Abayah (dzunukwa) (Carter 1971:45). A decade later,

Richard Hunt's pole for the Hunt family, formerly erected in front of the museum, was similarly composed of family crests.

In summary, a range of social groups is represented by the crests on these original museum poles. Some were explicitly intended as institutionally sponsored memorials to specific families (the Martin Memorial and the Hunt pole). Others, meant as examples of Kwakwa̱ka̱'wakw or Indian art, were exemplified by specific crests (the UBC and Beacon Hill Park poles). Others, composed of diverse crests, stood for the entire Kwakwa̱ka̱'wakw nation (the Thunderbird Park pole and the pair for the provincial Centennial). Finally, some (Mexico City and San Francisco) were linked with general regional history.

Two themes (somewhat opposing) run through these choices of museum-sponsored original poles. On the one hand, there is a strong commitment to a single

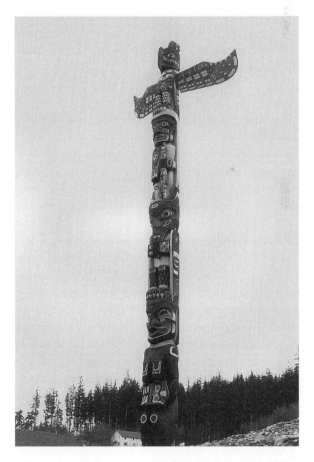

Figure 7.6. Mungo Martin memorial pole by Henry and Tony Hunt, Alert Bay, at raising. Photo by Peter L. Macnair, 1970. RBCM pn 7807–18.

family, the Martin-Hunts. The creation of new poles composed of crests belonging to a specific individual or family was a direct continuation of traditional practice. On the other hand, there is innovation, though it is circumscribed. Rather than depict foreign elements, such as white men, chickens, or steamships (motifs found on Haida argillite, for example), all crest figures on these museum poles are traditional. However, their social associations have been changed. This change has been relative and overlapping. Some family poles were later interpreted in general terms; some poles combined familial and tribal crests.

The principle of merging more local differences in favor of a pan-tribal statement was not unique to these museum poles. Common, shared crests were also chosen by James Sewid for the interior posts in the community house at Alert Bay, just as he had earlier presented family dances as simply "Kwakiutl" (chapter 8).[11] Significantly, many of these were presentations of Native culture for a predominantly white audience, for whom the expression of local distinctions would carry little meaning. Another motive was a Native desire to avoid factionalism. This was undoubtedly the case for the Alert Bay houseposts and was also likely a factor in Martin's choice for his Thunderbird Park pole.[12]

USES AND MOTIVES

The uses of museum commissions parallel the several museum functions, primarily collection, display, preservation, and outreach. Another, more general aim, especially important in the 1950s, was to support tradition. A major goal in earlier commissions was to have a comprehensive representation of the Native material culture inventory. Such was Dorsey's rationale when putting Nowell and Harris to work in 1904. During the first decade of the carving program at the Provincial Museum, preservation was the justification for most of the totem poles produced. These new poles were to serve as outdoor exhibits while the originals were stored inside.

Display, in the form of photography and museum exhibition, has always been a powerful motive for commissions. Both have strong fictive and imaginative bases. In order to represent an exotic culture for a general audience, it is not good enough to describe things in words or drawings, or even in second-rate artifacts. Only the most typical, beautiful objects will suffice, and if the particular museum has none of the proper pieces, commissions are deemed appropriate. Museum commissions for display purposes have been consistently archaic. Commissions for photography, though serving a display function, tend to result in special kinds of objects. Boas's commissions of cedar crafts in 1894 were primarily for a permanent exhibit and were only secondarily photographed as a means toward this. The objects produced for Curtis's book and film, on the other hand, were only intended to make a good impression before the camera. Thus costumes could be roughly constructed from raffia and houses and totems made of false fronts. For the real objects involved, Curtis had little care, and they were collected or not as fate would have it. On the other hand, after Samuel Barrett filmed Mungo Martin making a bentwood box in 1961, he collected the box

for the Lowie (now Hearst) Museum (see chapter 10). Still other artifacts, such as Bill Reid's totem for Skidegate, were commissioned for their own sakes and only secondarily filmed.

One kind of object has been especially popular for recent museum commissions—monumental works such as totem poles and houses. Because the latter are rarely collected, when they became popular as exhibit spaces, they had to be specially commissioned. For the sponsorship of totem poles, museums have been particularly important. Because of their great size, and the consequent expense and time needed to produce them, they are almost never produced on speculation, in the hope that they will later find a buyer. As in Kwakwa̱ka̱'wakw society, each is specifically commissioned, and public institutions like museums and governments, as well as corporations, are just the kind of patron that would desire such a public monument.

In recent decades outreach has become more important as a motivation for patronage. Many of the totem poles produced in the late 1950s and early 1960s were given as gifts by the Province of British Columbia to cities and countries. Smaller objects such as masks, staffs, and plaques were often given to government officials. Obviously, this was not a traditional museum function, and the scholarly or educational justification was minimal. Although their aims were never made explicit, these presents were intended as gestures of propaganda, ensuring that the recipient would be kindly disposed to the province, and by extension the museum. In many cases the smaller items were by-products of the carving program, made so that the carvers would have something to do in off-times and inclement weather. Another common motive for many contemporary commissions is to produce replicas that may be used in demonstrations and other educational programs. The principal recipient of museum commissions, at least from the Provincial Museum, has now changed from governmental bodies to the Native community. Most of the Victoria museum's replicas are for exchange in acquiring specimens and for loan in potlatch use (see the later section on loan programs).

Finally, many commissions combine motives. For the Legacy commissions, Peter Macnair was thinking primarily of an exhibition, but it was to be a general presentation of contemporary art, not a specific ethnographic representation. Thus his instructions were entirely open-ended. Yet he also started the collection with the intention of building up a comprehensive documentation of contemporary art, with periodic purchases from the original artists. This program, if fully carried out, would also have served to support the artists, as well as to build the permanent collection. Some of the pieces were later used in the Potlatch Collection, supporting the Native culture in yet another way.

INVENTING THE SUBJECT

Patronage has always been a controversial role for museums. Especially as they have evolved in the past century, the great public museums have been seen as places of *record*, documenting the best or most representative of what has existed in the past.

As Gertrude Stein is reported to have said, "A museum can either be a museum or it can be modern, but it cannot be both" (Lynes 1973:287). Thus for some the very title of the Museum of Modern Art is a contradiction. According to this view, a museum runs great risks in readily accepting the work of contemporaries. Curators may be misled by current fads, instead of allowing time and opinion to shift and select.

The step from merely acquiring contemporary works to actively arranging for their creation is one that many museums, even of modern art, wish not to take. For an art museum, its active participation in the market may be quite influential, but for a "science" museum such as one devoted to ethnology, the institution runs the risk of creating what it collects and thus losing its "objective" status. Its collections would then document the museum and its relation to the Native community, rather than Native culture.[13]

The nature of anthropologists' commissions has changed over the decades in response to their changing views of the strength and continuity of Native artistic traditions. During the period of classical collecting, commissions were a last resort. Although they rarely discussed their motives, collectors apparently regarded such commissions as less authentic. Given their belief that these would be the last documentations of "traditional" cultures, a newly made object, even in old style, would not have been as desirable as their constant quarry—the old, precontact artifact. Because of this "salvage" focus, these commissions were minor and did little to encourage contemporary art styles or production. Collectors were motivated primarily by a desire for displays that would represent Native cultures accurately, completely, and attractively. More generally, they wanted study collections that were as comprehensive as possible.

During the years when Mungo Martin worked in Vancouver and Victoria, c. 1950–1965, anthropologists felt that the traditions were still alive, but just barely. Convinced that the potlatch was moribund, Hawthorn (1961:70) spoke of his desire to "replace [the art's] ceremonial base with a commercial one." Thus the focus of anthropologists shifted from the commission of specific pieces to broader support of carving, hoping that apprentices would be trained. These programs proved to be crucial. At the turn of the century the primary support for Native arts was the Native community; anthropologists were a minor factor. By the early 1950s there was very little new production of Kwakwaka'wakw artifacts; the potlatching that still continued for the most part employed older pieces still in Native hands. Thus the museums were probably the most active patrons at the time.

Partly as a result of the very success of their programs, museums now play a much more limited role in patronage. Today the Native community is still not the primary patron of Native artists; instead it is the white collectors market. (In fact, most of the UBC Museum's commissions are objects that could just as easily be produced without museum support.) Museums now serve the important role of educating the market, of legitimizing current art production, and of relating it to the masterworks of classical traditions. Whereas museums were once reluctant to commission, they now

feel a need to, when they do not actually desire it. Instead of, or in addition to, their focus on the past, they are now concerned with contemporary Native culture.

Despite this openness to innovation, archaism has been and still is a persistent trait of museum patronage. Though museums, like private collectors, ask for pieces in contemporary styles, only museums ask for replicas of obsolete technology, such as halibut hooks or utilitarian food boxes. Display is the main motivation here. From whatever source—other collections or Native testimony—early collectors had learned about particular objects that they wished to exhibit but could not collect. Boas commissioned his cedar crafts exhibit and Dorsey his hamatsa screen. Partly because of their accumulated collections, contemporary museums still accept as their mission the representation of the classical period of Native culture. They may wish, however, to make didactic points for which they lack the proper artifacts. Giving careful instructions to the artists, they commission archaic objects.

A case in point is the Provincial Museum's display on bent-box construction, produced in 1976 (figures 6.10, 10.3). Although the museum had many such boxes, it had no unfinished examples showing the process of construction. Because this was to be Richard Hunt's first box, he consulted a variety of sources: his father, Henry; the film of Mungo Martin making a box (in which Henry Hunt had assisted); the boxes in the collection; and Boas's ethnographies.

The Provincial Museum's display needs have also encouraged a ceremonial revival. Although there were a few old examples in the village, no rattles had been carved in Alert Bay for years before Peter Macnair commissioned one from Bruce Alfred in 1979 for the Legacy collection (Macnair et al. 1980:124, 170). Alfred had inherited the right to this particular rattle type—for the hamatsa cradle dance—but it was Macnair who had the initial idea. Since then Alfred, and others, have gone on to carve many rattles and whistles, for sale as well as ceremonial use. Although perhaps not as decisive, a similar case is the use of ceremonial puppets. Their popularity had declined in the early twentieth century, but Bill Holm recalls their common appearance during the 1950s and 1960s: Mungo Martin used a tuxw'id frog at his house opening at Thunderbird Park in 1953, James Sewid owned and used a baby rising out of a cradle. Also seen at potlatches were a canoe full of paddlers and birds on sticks that flew over the singers, among others (pers. comm. 1998; see also Holm 1977:9, 19). In early 1970 the Provincial Museum commissioned Tony Hunt to make a puppet for the tuxw'id dance (Macnair 1973a:104–105). Used for the March performance by the Hunt family, the piece was then accessioned into the collection (figure 7.7). Though intended originally for didactic purposes, the puppet was used twice in potlatches at Alert Bay, in 1974 and 1977. Thus, as in the museum's loan program, an item made originally in the museum and for the museum was later reintegrated into Native ceremonials. Moreover, despite the continuous Kwakwaka'wakw use of puppets, it can be argued that Holm himself played a stimulating role: "I made and used in 1954 a flying sisiuɬ that split in two, and many others since, including the frog that the Kwakiutl group used at the raising of the Big Beaver Pole at the Field Museum [in 1982]. At least four of

my puppets have been used in tux'wid dances at various Kwakiutl potlatches" (pers. comm. 1998).

One important role for museum patronage is to supply materials, for as Becker (1982:71–76) notes in his discussion of "mobilizing resources," the acquisition of materials must be a necessary preoccupation for all artists. The administration of the 1893 Chicago World's Fair supplied material for button blankets—red and blue flannel, pearl buttons—for the visiting Kwakwaka'wakw,[14] but the most important service has been the supplying of timber for totem poles. Invariably, these are donated by local lumber companies, whose board members are often personal supporters of the carving programs. It is not a simple matter for carvers to obtain such timbers, and few artists will undertake a totem pole without such institutional support. Perhaps the most influential action of this kind was the Provincial Museum's role in developing the "Totem Pole Paints" with the British American Paint Com-

Figure 7.7. Tuxw'id puppet in a box, by Tony Hunt, Royal British Columbia Museum; made for use in a performance of the Hunt family dancers, with Peter L. Macnair, 9 March 1970; first used at a potlatch in 1974. RBCM cat. no. 16491.

pany (BAPCO). While this brand is no longer produced, essentially identical shades became the preferred kind of paint through the 1970s, regardless of context, patron, or use.[15] (Since 1980, the turn-of-the-century enamels have again become popular.)

Authenticity is another criterion for museum patronage. Over the past few decades, there has been a growing sense of specificity. As Duff explained the choice of design for Martin's Centennial poles: "In the interest of authenticity, it was decided that the pole should be an original creation rather than a copy of one or more other poles, and that it should be carved in a single tribal art style rather than in some combination or mixture of the several good styles found on the coast" (BCPM Annual Report for 1957:C23). In the initial planning for the renewal of Thunderbird Park, Duff wrote of "replacing the present poles with exact replicas and rebuilding two massive Indian houses in authentic tribal styles."[16] As mentioned earlier, Martin's house may have been "authentic," but it was not an exact replica; neither were the totem poles replicas. In 1960 a new thunderbird figure was placed on the arch in the park to replace one that was judged "not very authentic in style" (BCPM Annual Report for 1960:B23).

These changing kinds of commissions reveal different attitudes in the relationship between whites and Indians. During "classical" times, the commissions resulted in objects, produced at the request of whites, that left the Native community. In the next phase, while the museum retained the objects, the hope was that Native skills would be passed on. More recently, with the Provincial Museum's loan and exchange programs, the artifacts result from Native request and (even if still owned by the museum) return to the Native community.

TRAINING PROGRAMS

Though not perhaps one of their defining functions, artistic education is a service that museums have long performed. Of the great public museums founded in the last century, many began as educational institutions, and it was not uncommon for them to be associated with art schools. A natural justification was the proximity of the great masterpieces, which could serve as models and inspiration to young artists. When concerned whites in British Columbia realized that young Natives were not being taught the old skills, they turned to local museums as sources of expertise and for the reference value of their collections.

EARLY VIEWS (1880–1950)

White attempts to encourage the training of Native artists were rooted in a slowly developing belief that the best way to improve the lot of Indians lay not in forcing them to become imitation whites, but in exploiting and developing their traditional talents. Early missionary efforts to make farmers out of the Northwest Coast Natives soon foundered owing to the unsuitability of the land as well as the hold of traditional lifestyles. But, according to Boas (1887c:232),

Their own industries and occupations suggest that an introduction of trades would be more successful. Carpentry and basketry would require little encouragement and instruction to give good results, and the original character of the Indian art-products would secure a great market. It seems to me that the development of methods of fishing and of trades would prove the most satisfactory method of civilizing these Indians.

For those concerned with the training of Native youth and their assumption of civilization, it was a natural step to place their attention and faith in the schools. The primary form proposed was the residential or industrial school. Native children would be sent to centrally located institutions to live apart from their parents and the supposedly degrading mores of their traditional culture. As George M. Dawson (1887:88) wrote, here "the younger people will be separated from their old associates and instructed in various callings appropriate to their condition and surroundings." And in keeping with late-nineteenth-century views of the proper methods of advancement for the lesser races, the best form of training was manual labor.

The residential school was introduced to the Kwakwaka'wakw in 1880, the year the missionary Alfred J. Hall moved to Alert Bay, and in 1892 the church established the Industrial School for Boys. Here students could learn job skills, as in the local sawmill. The school was so important to government plans that a large part of the reserve was set aside as the Alert Bay Industrial Reserve for Kwakwaka'wakw from all other reserves who were willing to become Christians and give up potlatching. In addition to classes for the residential students, there was a school for local day students. Over the years, the schools grew, until in 1929 the residential school achieved grand proportions. St. Michael's School, a large brick building, opened with a farm, cattle, a garden, and an electrical plant. Until its doors closed in 1974, the school continued to be run by the Anglican Church, though it received increasing government funding.

Although most of the students' time was devoted to church service, farming, fishing and boat-building, tending machinery, household chores, and the like, a small program in Native art was allowed. Not surprisingly, perhaps, this program is very poorly documented. The authorities forbade the speaking of Native languages, but apparently felt that the creation of "crafts," such as model totem poles or chests decorated with Native crests, would not unduly disturb the students' cultural advancement. For while the children were introduced to the rudiments of Native styles, they were not encouraged to create objects such as masks or rattles that could be used in the still-outlawed ceremonials. Instead, there was a desire to adapt these forms to decorative objects that could be sold to whites.

Concern about the loss of Native craft skills goes back to 1911, but again, it is significant that utilitarian, not ceremonial, objects were discussed. In that year a member of the Natural History Society of Victoria spoke of the loss to posterity of the knowledge of "primitive arts such as blanket and basket making. . . . Something should be done to get schools to preserve and teach this primitive art and perpetuate

Figure 7.8. Display of student work from St. Michael's Residential School, Alert Bay, at the Pacific National Exposition, Vancouver. Photo by Dorothea Lucas, c. 1940. BCA cat. no. 83585, neg. no. E-4685.

the knowledge."[17] Other members brought up the comparable case of the Navajo, whose blankets had proved so profitable.

It is not known when instruction in Native art began in the residential school, but by the 1920s famed carver Charlie James was teaching the craft (Nuytten 1982:37). Although James continued to serve the ceremonial community, for instance, with his totem poles for the cemetery in Alert Bay, during these last years of his life most of his output consisted of model totem poles for tourists. After James's death in 1938, instruction in Native art was offered by Arthur Shaughnessy. Periodically during these years, there would be exhibitions of student work, as at the 1934 anniversary of the residential school.[18] Although detailed information is scarce, it may be that the early training some artists received at St. Michael's laid a foundation for their later artistic efforts.

The B.C. Arts and Welfare Society, founded in 1941, had no formal educational programs, but it did support the artistic explorations of Native children. Despite its ef-

forts to address the problem, the society was ineffectual because there was no white market for the students' work. Though the potlatch was outlawed, the older artists could supply this market. Youngsters turned out crafts, knickknacks, for which there was little demand in either Native or white society. Such work fell between categories; it was not seen as fine art by the whites, nor as ceremonial art by the Natives. Another problem must have been the availability of competent teachers. Under such circumstances, even if the Native children had learned something and were encouraged in their classes, they had no place to take their skills.

CARVING PROGRAMS AT THE UBC
AND PROVINCIAL MUSEUMS

As in Alaska a decade earlier, the shift at UBC from the preservation of old poles to the carving of new works coincided with the initiation of a training program for Native artists. The relative success of the latter effort resulted from the greater retention of traditional skills and the indefinite continuation of the program.

As Mungo Martin began to carve his new, original poles in 1951, it became obvious that a man of his advanced age would need some help in handling the large logs. Although the university staff came to his aid, relatives such as David Martin and Douglas Cranmer became informal apprentices. Harry Hawthorn soon wondered if it might "be better to restore the craft itself rather than the old carvings," though he realized that "both sorts of work should go ahead together."[19] Hunter Lewis, in his 1951 annual report of the President's Committee on Totem Poles, reviewed the prospects for a "School of Totem Pole Carving":

> The Committee discussed and decided to explore the possibility of establishing a school in which young Indians would be trained to carve totem poles. Such a scheme would involve bringing two or three accomplished older carvers to the University; employing them to carve poles that would be for our own collection, for a provincial restoration scheme; or for sale to other institutions; and employing younger apprentice-assistants who would work with and under them. Such workers could be used either on original poles or in duplicating old ones. The Committee feels that if this plan proves possible it will be invaluable to the province in preserving a skill which is rapidly disappearing, which is otherwise doomed to extinction, and which, even now, displays itself only sporadically.[20]

Such a statement could have been a charter for the program as it was formulated by Henry Hawthorn and Wilson Duff and implemented when Mungo Martin moved over to the Provincial Museum in 1952. In his many reports on the Carving Workshop at Thunderbird Park, Duff always listed a "school for carving," which would perpetuate the craft, as one of three main aims for the program (along with the replication of poles, and the supporting of an educational and tourist attraction).[21]

The training program at the Provincial Museum always remained small. Annual Reports continually complained of the lack of money. Those in charge were aware

of the problem (Hawthorn et al. 1958:267) and suggested federal aid, but nothing was forthcoming. David Martin decided to return to commercial fishing, and even Mungo Martin and Henry Hunt were repeatedly laid off. Henry and Tony Hunt, and Douglas Cranmer were the only serious artists trained by Mungo Martin (with the exception of David Martin), but through them his skills were widely distributed.

Because the core of the program has always been the Martin-Hunt family, much of the real instruction that went on occurred not at the museum but at home. For instance, as a teenager in the 1950s, Tony Hunt learned more from hanging around Martin and his father than he did while on the payroll in the 1960s. Similarly, most of Richard Hunt's training from his father came at home, not at the museum, where their tenures overlapped only slightly. But because of this familial connection, the museum has been the locus of a fairly continuous transmission of skills.

Since the departure of Martin for Victoria, training at the UBC Museum has tended to be more informal. Going back at least to the late 1950s, the museum had a special relationship with Bill Reid, who has trained a number of students over the decades. Kwakwaka'wakw Douglas Cranmer and Nisga'a Norman Tait are among the other artists who have used the museum more recently for training. Cranmer has been both a student and a teacher at the university. Although he gained a great deal of experience while working with Reid on the Haida village, 1958 to 1962, Cranmer could not expect much guidance in carving techniques, since most of Reid's own experience with large-scale wood carving had come from spending two weeks with Mungo Martin in 1957 (Nuytten 1982:104). What he did learn from the Haida artist was northern graphic styles, which later influenced his own work (Macnair 1978). In turn, Cranmer demonstrated and taught carving at the museum in the early 1970s. His principal students were the Kwakwaka'wakw Roy Hanuse, who worked with him over 1971 and 1972, and Larry Rosso (Carrier/Italian, married to a Kwakwaka'wakw), who had a private training session around the same time.[22]

All the training supported by museums has been in traditional skills, but in their mid-1950s survey of Native crafts, the Hawthorns also recommended more innovative education: "There must be space and materials for shop work and a wide range of graphics arts. In this way, the individual will be able to experiment and discover new interests, and possibly new talents" (Hawthorn et al. 1958:267). Perhaps they were thinking here of silkscreening, a medium with which Ellen Neel had been experimenting. Haida, such as Bill Reid and Robert Davidson, have generally been more inclined than the Kwakwaka'wakw to enroll in formal training in Western art techniques. Relatively few Kwakwaka'wakw have had such experience, though some of the younger artists are now turning to such sources. Beau Dick and Cecil Dawson, cousins from Kingcome, have both created drawings and paintings of Kwakwaka'wakw scenes and ceremonialism in a fundamentally Western realistic mode. Through 1980, to the extent that Kwakwaka'wakw adopted these innovative techniques, they generally learned them on their own. Since then, however, more Kwakwaka'wakw artists with art school training have come to the fore; among the more prominent are

the photography/multimedia artists David Neel (b. 1960), Mary Anne Barkhouse (b. 1961), and Marianne Nicolson (b. 1969) (Neel 1992; Hill 1995).

The Provincial Museum was also important in the development of the museum and school at 'Ksan. Founded in the Skeena River town of Hazelton in 1967, the Kitanmax School of Northwest Coast Indian Art provides formal classroom instruction. In its early years it relied on many non-Tsimshian teachers: Haida Robert Davidson, Kwakwaka'wakw Tony Hunt and Douglas Cranmer, and whites Bill Holm and Duane Pasco. Most of its students have been Tsimshian.

COASTAL INDIAN HERITAGE SOCIETY

In the early 1970s the Vancouver Museum sponsored an important cultural program—the Coastal Indian Heritage Society.[23] It was never an official museum service or program, but an independently financed and run society that merely used museum facilities, much as a community naturalists' club might. Thus in terms of control, of whites telling Natives what to do, as in Martin's museum experiences, this museum-Native program moved quite a bit toward Native autonomy, with whites playing only supporting roles.

The program was first conceived in the fall of 1970 by Joy Inglis, adult education officer at the museum. Hoping to make museum resources available to the Native community, she first thought of a series of general lectures on Native culture. After consultation with Susan Thomas Davidson (then wife of the carver Robert), Gloria Cranmer Webster and Della Charles Kew (Natives who had been trained at UBC), it was decided to make the course more of a "hands-on," experiential one. As the initial prospectus put it, "The purpose of the 'Indian Heritage Project' is to carry out an educational program for the Indian men and women here in the Centennial Museum with the purpose of imparting a truer understanding of this rich heritage, part of the material aspects of which are on display in the Northwest Coast galleries of the museum."

In addition to this goal, directed to a Native constituency, a secondary aim was to improve the understanding that white visitors had of Native cultures: "We hope that the presence of Indian people here will form a link in the minds of the general public between the rich and beautiful cultural materials on display, and the living Indian people in the community today."[24] Although there were some public shows and ample publicity, as the program developed, Native interests won out over any interpretive functions that may have been envisioned.

Inglis was quite supportive of the program's Native autonomy. In a grant proposal of the museum's role, she wrote of "the present urgency to bring Native people into a direct working relationship with the collections of materials from the Northwest Coast that are on display in our galleries. . . . The people feel alienated from [these] rich and impressive cultural materials. . . . There is an increasing demand on their part . . . that they be the ones to represent their own people in all matters relating to

their cultural heritage."[25] This was an important sign of the new relationship between Natives and museums that would increasingly characterize the decade.

The primary audience was the Native community of Vancouver, although Natives visiting from other areas were also accepted. Whites were denied admission. As the program was grant-supported with no fees, membership was restricted at first. Membership waxed and waned over the years, usually with about fifteen to twenty at a time, and at least fifty-seven individuals passed through the program at one time or another. As desired, both men and women joined, but while some local Coast Salish did participate, most of the members were Kwakwaka'wakw. Several of the founders had been Kwakwaka'wakw, and they continued to dominate the leadership positions. At the time there was a fairly large Kwakwaka'wakw community in the city, and the membership was probably drawn naturally through family connections and word-of-mouth.

The first half of 1971 was spent in planning—applying for grants, preparing general statements, and drawing up a constitution. With funding from the Koerner Foundation and the Provincial First Citizens Fund, the group was registered in the fall as the Coastal Indian Heritage Society, a chartered society with officers, a constitution, and assets. Weekly meetings, lasting three hours, were held on Wednesday evenings in the Junior Museum area of the Vancouver Museum. The carvers met again on Saturdays and worked on their own time as well. The program was run on a vaguely academic year, September through June.

Not all the proposed programs came to fruition. One early hope was for the construction of a Coast Salish dance house next to the museum. "This building would in itself become a major craft project and would ultimately house the craft workshops during the summer time, and be a display area for blankets, baskets, canoes and carvings. We would hope that in time it might also be used for ceremonials such as dancing, canoe-racing and salmon barbecues."[26] Such a house could thus subsume all proposed cultural activity, as the dancing would, in turn, require artifacts.

Although the dance house was never more than an idea, performance was a continual motivation to the program. Hoping that the project would become self-sustaining, the organizers wrote: "The dancing group itself might become effective enough to eventually raise money for the "Indian Heritage Project" by offering to explain and demonstrate the world view of the people through the dance."[27] Yet nothing ever came of the plans for dancing either, most likely because it did not appeal to the Native members.

The programs that were implemented included the making of button blankets and cedar bark robes, drawing and wood carving, language classes in Halkomelem Salish, and a class in photography. In August 1972 the program began with the button blanket course. Taught by Susan Davidson, the course was an excellent first choice, as according to tradition, it involved both men (to make the flat design) and women (to sew the garment). The costume was needed for dancing, and its construction was

not too taxing for either group of beginners. The Natives already had some famil-
iarity with the process, nor did it require expensive or elaborate materials or tools.
This led to plans in the following spring for the construction of cedar bark mats,
capes, and baskets, and in June the group took a trip to the UBC forests to gather the
materials. The cedar crafts, which continued at least through the fall of 1973, were
supplemented in the spring of 1973 with preparations for a Salish weaving course.

Probably the most important of the society's programs was the course in carving.
Taught by Kwakwaka'wakw Douglas Cranmer, who was then carving at the UBC
Museum of Anthropology, it attracted a group of young but committed students.
Despite inadequate facilities at the museum, the carvers persisted, working with
Cranmer at UBC during the summers. As in traditional practice, the class began with
two-dimensional design before beginning low relief and then full carving. The train-
ing was quite informal; the students generally working at their own pace. By the fall
of 1974 they were tackling model masks, bent boxes, and the like. The photography
course was an important adjunct to this work: "It is intended that the carvers will use
it to record the works and techniques of other carvers, and build up a library of pho-
tos and slides. A photo record is also being kept of the activities of the Society."[28] For
example, Kwakwaka'wakw carver Beau Dick made a duplicate set of the slides Bill
Reid had brought back from his trip to European collections.

The program made use of the following museum resources: collections, exhibits,
library, shop, classroom and meeting spaces, auditorium, publicity, and curatorial ex-
pertise. Ironically, despite the noble intentions of the planners, the society made rel-
atively little use of the resources unique to museums. The carvers made the most use
of the collections, particularly Norman Tait who needed to consult examples from
his own Nisga'a people. Cranmer and Rosso examined boxes to help them in their at-
tempts to re-create traditional techniques, but collections were only one of their
sources. Books were consulted in the button and cedar bark blanket classes. Cedar
bark clothing had not been made for decades, but button blankets were still an active
craft, and here the Natives relied largely upon their own knowledge and skills. Per-
haps it is not coincidental that those programs that involved heavy re-creation, such
as cedar bark crafts and weaving, never developed very far. The major demand on
museum resources was the use of work space, but this turned out to be a serious
problem. The carvers complained especially about a lack of space for the storage of
their work-in-progress. Museum assistance was important in the initial organization
and in securing the grants, but by and large, much of the program could have been
carried on outside a museum. The primary resource was, as perhaps intended, Native
expertise.

Like many programs, the Society started with a fairly big bang and then slowly pe-
tered out. The first two years, 1971–1972 and 1972–1973, seem to have been the best.
A climax for these years was the late March 1973 reception and exhibit of the society's
work. There was less activity in the second two years, 1973–1975, but the carving
classes remained strong as the backbone of the program. Little happened in the fall of

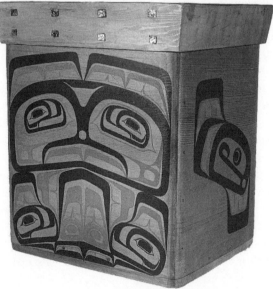

Figure 7.9. Douglas Cranmer. Photo by Vickie Jensen, c. 1980, courtesy of UCC.
Figure 7.10. Kerfed box (painted in northern style), by Douglas Cranmer, c. 1970, Vancouver Museum, acquired in 1975. VM cat. no. AA 2560.

1975 and nothing after 1977, when Webster and Cranmer returned to Alert Bay to work for the U'mista Cultural Society. By 1978 there were efforts to terminate the society, and the remaining assets (mostly artifacts) were transferred to the U'mista Society.

Several factors probably account for the fate of the Coastal Indian Heritage Society. Money was undoubtedly a problem. They got a good bit for the first year, though half of what they wanted. While generous, the foundations could not keep up their support year after year, and the city, which ran the museum, had little to spare. Leadership was also a problem. In Native fashion, the program worked by consensus. The elected officers were more for purposes of formal incorporation and getting grants. Thus if there was a minority conflict, action was stymied. Again, as in many Native organizations, there were tribal and familial rivalries. The real reason for the decline in the program was not its failure, but its success. Because it was Native-run and responded to members' desires, the program ended when its members got what they wanted out of it and decided to move on to other projects.

The society had an important legacy. Its members came away with valuable experience. Officers such as Gloria Webster and Della Kew went on to other positions in Native cultural societies, while carvers Norman Tait, Beau Dick, Larry Rosso, and Jerry and Russell Smith all received basic instruction in their craft.

CONCLUSIONS

Throughout the world there has been a growing movement for the conservation of the intangible elements of culture. One of the oldest of these has been the Japanese program of Living National Treasures. Since 1950 the government has recognized "intangible cultural properties," including performance traditions and crafts skills. The program, run by the Ministry of Education, consists of a system of registration, annual grants for expenses and the training of apprentices, visual documentation, purchases of selected works, and sponsorship of exhibitions (Fontein 1982:14–15). Such approaches have also been advocated in the United States. Recent trends in folklore have broadened the focus of cultural conservation beyond craft skills to entire lifestyles (Feintuch 1988; Hufford 1994). While these movements parallel the situation in British Columbia, as in the case of folklife museums, there is no evidence that people in the province were aware of these trends. Rather, they seem to have been creating these programs out of their own needs and situations.

The most significant trend in training, paralleling that in other domains, has been the shift from white-dominated, paternalistic activities to Native-led programs. The museum programs at Vancouver and Victoria did fulfill their stated goals of training, though not as they had intended. Because of chronic underfunding, their paid staff was kept to a minimum. Yet several committed young Kwakwaka'wakw were attracted enough to Martin to learn from him on their own, and they in turn taught others in programs they have developed and controlled.

Moreover, these formal programs represent the institutionalization of the traditional master-apprenticeship relationship. The traditional Native way of learning is

by observation and experience, not verbal instruction, and this mode has largely been retained in the new programs. Though formal school methods have made some inroads, they have not been widely adopted. As in many art styles, the rudiments of Northwest Coast art that can be taught formally are much less important than the simple process of gaining experience.

The level of instruction—child versus young-adult/adult—is an important variable. While the former level may be important in fostering an early interest, it is only the latter that can impart the advanced instruction necessary for a competent artist. Several of the carvers, among them Henry Hunt and Douglas Cranmer, had informal carving experience as children, often making model totems for tourists, but they did not obtain serious instruction until they were in their early thirties, after an early career in fishing and lumbering, when they worked with Mungo Martin. Since then artists have more often undertaken professional training in their teens. Though the various museum programs may have included some fairly inexperienced students, they have been directed at those who intended to make a career as carvers.

As just noted, much of the real training took place outside formal museum programs. Yet museums were correct in their belief that training could benefit from its juxtaposition to great collections of past achievements. These collections, directly or through books, stimulated artistic creativity.

LOAN PROGRAMS

Although the heart of the museum idea may be the gathering in of objects, for at least a century museums have also habitually lent out parts of their collections. In the nineteenth century, this was called an "extension" program. Typically, items of lesser value such as duplicates or replicas were lent out to school groups. In this way teachers could integrate objects into their lessons without the trouble of a trip to the museum. While many museums today still have extension programs, their importance has waned, and most contemporary museum loans consist of rare and valued objects desired for temporary exhibitions.

Anthropology museums in the Northwest reflected this shift in priorities. Extension has been important at the Burke Museum since the 1930s, first under Erna Gunther and after 1968 under Bill Holm. The Burke also lent its expertise and many of its objects for the construction and furnishing of the Scow House display at the Pacific Science Center, heavily used by school groups. The UBC Museum of Anthropology had a large extension program, but it became so demanding that the museum transferred the service to the Vancouver Museum in 1968 (Hawthorn 1974:8–9). Until about 1982, the Provincial Museum maintained a modest collection for school use and demonstrations.[29] The Campbell River Museum also had an extension collection, consisting largely of replicas.

Between the early 1970s and the late 1980s the Provincial Museum developed a dif-

ferent kind of loan program. Although never formally terminated, the program gradually became moribund as the need for it diminished.[30] Informally dubbed "the Potlatch Collection," it consisted of a group of cataloged objects that the museum loaned out for Native ceremonial use. Over its active life, the collection achieved a certain character and procedure, little of which was consciously intended at the start. Curator Peter Macnair cited a specific event for its inception. In March 1970 he gave a public lecture at the museum, dealing with Kwakwaka'wakw myth and ceremony. The presentation included masked dances by the Hunt family, with most of the artifacts coming from the museum's Mungo Martin collection. Finding that several masks were missing from the complete set, Macnair had Henry Hunt carve them. But in repeating the program, Macnair realized that many of the pieces were too fragile and valuable, so he encouraged the carvers to create new masks. While these first components of the Potlatch Collection were made by Natives for Native use, they remained within the museum, intended for demonstration purposes.

At the time, Tony Hunt, who had not yet made any pieces for ceremonial use, thought that it was strange for a museum to commission artifacts to be used, but such acts were not unprecedented. For his house opening in 1953, Mungo Martin reportedly borrowed a few pieces from museum storerooms and carved four cannibal bird masks and related paraphernalia. These new works remained his personal property until his entire collection was sold to the museum in 1959. The year before, Martin had made three copies of fragile old Kwakwaka'wakw masks in the museum collection, with the new copies intended for use in demonstrations and for loan to other institutions (Annual Report for 1958:C26). This set was a direct precursor to the original Macnair commission, even if it was not a conscious model.

From these early efforts it was not a large step to the lending out of the collection for use at Native ceremonials. Such a program blended several motives. Macnair's predecessor, Wilson Duff, had established good rapport between the museum and the Native community, a trust that Macnair wanted to deepen and extend. There was a Native demand and need for such service. As potlatching revived and grew in the late 1960s and early 1970s, there was a shortage of many pieces, especially the large spectacular cannibal bird masks. Lending such objects would encourage the revival of ceremonialism and the development of art styles as a range of artists fulfilled commissions. Finally, the carving program was at a point of transition. Totem pole replication was long done, and production for the new exhibits was nearing completion. By 1974 Henry and Tony Hunt had resigned, and Henry's son Richard had joined the program. Yet despite his talent, Richard Hunt had little experience carving major pieces and had made nothing for Native use. Macnair felt that by commissioning new objects for use Richard could develop his skill and possibly become an active participant in Kwakwaka'wakw dancing.

Some specimens that may have been loaned were not part of the Potlatch Collection, strictly speaking. When old pieces were sold to the museum, there was the understanding that they could be borrowed back temporarily for ceremonial use by the

owner or his or her descendants. As the 1981 "Collecting Policy" of the Ethnology Division stated,

> The Division is prepared to lend those objects to the original owner for legitimate use at some future date, providing the objects are robust enough to stand the use and providing a member of the Ethnology Division is present to assume responsibility for the objects. Where the object(s) is considered to be too fragile for use, the Ethnology Division is prepared to make a replica, or preferably a new version, of the object so that it can be loaned for use.[31]

Operationally, the Potlatch Collection can be defined as all those pieces that had been lent out at least once.[32] There was thus no definite set of objects. Although conceivably any specimen might have been lent out, in practice virtually all the objects used were carved since 1970, most by staff carvers. Since there tended to be a group of pieces that were suitable for use and filled Native needs, this set of about forty objects, mostly masks, was stored in an easily accessible area. Nearby was a binder with documentation: a sheet for each, listing catalog number, type of artifact, and for each use, the place, date, and giver of the potlatch. There was also a space for comments such as the maker, how the object was rigged for use, what objects it was used with, and so on. Although the two programs were separate, many of these potlatches were also recorded in still photographs or sound tapes, further adding to the documentation. If a Native request was approved, an ethnologist from the museum brought the piece to the village, made notes on its basic use, and carried it back to the museum when the ceremony was over.

The collection fell into definite tribal and artifactual clusters. The vast majority of the artifacts were made by Kwakwaka'wakw in Kwakwaka'wakw styles and types, for use by Kwakwaka'wakw. The only other tribal representation was about five masks and a drum carved by Tim Paul and Ben David, Nuu-chah-nulth artists. While these were used mostly at a Nuu-chah-nulth potlatch, some were also used at Kwakwaka'wakw events. The collection included a few old objects, notably Chilkat and other blankets, from the Tlingit or unidentified Northwest Coast tribes.

This Kwakwaka'wakw predominance was not intentional but resulted from the fact that the Kwakwaka'wakw have been the most numerous and active potlatchers in the province, and that Richard Hunt, the chief carver during the period when most of the collection was created, is from this group. Hunt carved the bulk of the collection, as he was paid a regular salary to provide such a service. Some were carved by his father and other staff carvers. The museum acquired a number of items in the collection as works of art (e.g., from dealers or the Legacy commission), again mostly by Kwakwaka'wakw, which were subsequently lent out for use. Macnair tried to encourage assistant carver Tim Paul to carve ceremonial pieces in his Native Nuu-chah-nulth style, but there was generally more of a call for Kwakwaka'wakw examples.

As of the end of 1981, a total of 107 items had been used since the first recorded use in 1973. Of this total, the great bulk were masks (56 pieces). Other types included

musical instruments, such as rattles, whistles, horns, and drums (15); blankets and aprons (12); headdresses and frontlets (11); cedar bark rings (6); staffs (2); screens (2); coppers (2); and one puppet. While the collection was fairly representative of pot-latch paraphernalia, no definite scheme was followed in building it. Rather, it grew ad hoc as specific pieces were requested. If the museum lacked such a piece that could be lent out, it was made. If the object was apt to be used more than once, if it filled a gap in the museum collection, and if there was enough time, it was more likely to be carved. For instance, a Native asked for a set of Gyitakhanis masks. Not only did the museum lack a set of these masks, which come in groups of eight, but there were none in Native hands. If the museum were ever to acquire a set, it would most likely have to commission it. Now the museum possesses a set that has been used in a Native context and thus has a more representative Kwakwaka'wakw collection (figure 7.11). The vast preponderance of masks can be explained by the fact that masks are the most important and costly item of paraphernalia. While they are more likely to be sold, they are also the most vital for the ceremonials.

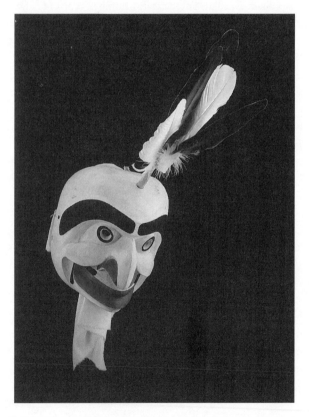

Figure 7.11. Gyitakhanis mask, from a set of eight, by Richard Hunt, 1978, Royal British Columbia Museum. RBCM cat. no. 15997 (v. 1).

The bulk of the collection was newly made from original designs; there were few copies or replicas of older pieces. For instance, when the museum could not loan out a fragile sun mask, instead of copying the old mask, Richard Hunt carved a new one in his own, current style (Macnair et al. 1980:99–100). Here, as in the creation of new pieces to be traded in exchange for older ones, Macnair preferred to encourage the growth of new styles and interpretations. On the other hand, in deference to what he perceived as the conservatism of Native patrons, Hunt restrained himself: "You don't want to offend people and have them say, 'Oh, he's trying to branch off in his own style.' I may have my own style [but] I don't want to bring it to the potlatch" (Blackman 1985:27). Among the oldest artifacts lent out were some carved by Henry Hunt in the 1960s. They themselves gradually became "heirlooms," until they were retired to the storerooms in 1985 as "historically and culturally significant objects in their own right," upon Henry Hunt's death (Henrikson 1995:72).

These artifacts were not loaned out indiscriminately to anyone who asked for them. Following traditional custom, the borrower had to possess the inherited right to use the object, even if he or she may have lacked the particular material manifestation of the privilege. These rights, well known in the Native community, are validated and publicized at potlatches where the history of the family and its crests is recounted. It was the curator who had to decide if the person requesting a piece had the right to use it, basing his decision on his knowledge of the object and local tradition. Thus, for this system to work properly, it required an anthropologist with a detailed sense of local family history.[33] If there was some uncertainty as to the legitimacy of the request, it was refused, and the potential borrower was steered to other, more suitable pieces. Such cases, however, were rare. Certain objects were asked for frequently because they were seen at one potlatch and then requested for another. If these secondary borrowers were entitled to the item, it was brought to their potlatch as well.

As already mentioned, some artifacts were originally created as "works of art," to be appreciated aesthetically, and later were turned into Native "artifacts" used in ceremonials. An example was a huxwhukw mask by Douglas Cranmer (figure 7.12). It had been commissioned for the first version of *The Legacy* exhibit but had come in too late for the exhibit. When the Dan Cranmer memorial pole was being raised in Alert Bay, the museum received a request for such a mask, and Macnair suggested using the Cranmer mask, which up until that point had been only a "museum piece." When this and similar pieces were used, they often had to be "rigged" or modified with a harness and cedar bark fringe, in order to be worn by a dancer. In some cases, this meant that the museum had to "tamper with" an artifact. Sometimes the mask was too heavy to be danced with and needed to be thinned out; usually holes had to be drilled into painted wood to accept the rigging or bark fringe. Although museum specimens are modified during conservation treatment, it is rarely so severe, and the action adopted is usually intended to bring the object back to the state in which the artist left it. In this case, the rigging may be a violation of the artist's intentions. Yet

this is a decision the curator made, expressing his belief that such pieces were more "authentic" when so modified and used.[34] And one must add that most artists are happy to see their masks used in ceremonies.

In the past, extension specimens were the less valued objects of a collection and thus could be lent out without fear. In a sense, the items in the Potlatch Collection were also of less value; they were almost all relatively new and sturdy, in order to withstand ceremonial use. But just as with Tlingit clan symbols, each potlatch increased their value; only this time it was an "ethnological value," not one of familial prestige. This value was in addition to the aesthetic associations that accrued as the object aged and its artist gained in reputation.

Although the Provincial Museum had the largest potlatch loan collection, it was not the only museum in the province with such a program. The Campbell River Museum serves the local Kwakwaka'wakw community and cooperates with the Victoria museum.[35] Usually people went first to the Provincial Museum, and if it did not have what was required or if the piece was otherwise unavailable, they came to the Campbell River Museum. Being closer to Kwakwaka'wakw communities, Campbell River is also more convenient. To some extent, each museum "specialized" in different items; the Provincial Museum in masks, and Campbell River in costumes—blankets, cedar bark, and aprons. When a large display was desired, the costume items, especially, were used to supplement those supplied by the hosts and guests. The Campbell River Museum's policy was to lend when the artist was still alive; that way, the object was not totally irreplaceable.

In the early 1980s, the Museum of Anthropology at UBC also instituted a program of loans for Native ceremonial use. Generally, such pieces—masks, rattles, and dance costumes—are contemporary works by living artists. They are acquired directly from Native artists or indirectly from dealers and are rarely commissioned explicitly for use, as in the Provincial Museum's Potlatch Collection. Moreover, as the program operates, they are lent directly to the artist, thus avoiding the problem of the ancestral right to use the piece. Such objects thus have no prior history of Native ceremonial use, which they can then acquire through this program. (New pieces are sturdier than old ones and also not worth as much monetarily.) Modifications of the objects are allowed, but they must be requested in writing and approved by the museum. Unlike the Provincial Museum, the UBC Museum does not send a staff member with the object. Objects must be returned as they were sent out, with a report on their use. As part of its support for Native traditions, the museum also has accepted Native loans; that is, Native-owned artifacts have been stored in the Vancouver facility (Clavir et al. 1988).

While the idea of lending back artifacts for Native ceremonial use would undoubtedly have been anathema to the classical collectors, it has gradually become an accepted part of museum practice on the Northwest Coast. During the 1930s and 1940s, Axel Rasmussen let his collection be used this way, before it came to the Portland Art Museum (Davis 1949:28). With the Provincial Museum as the leader, many

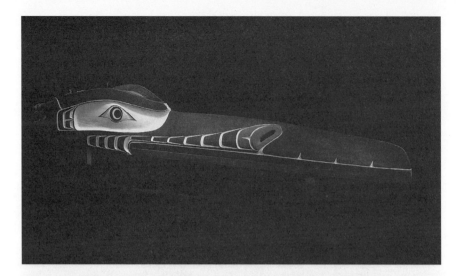

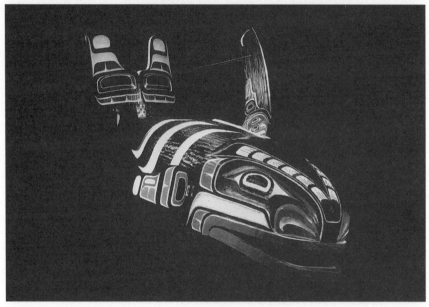

Figure 7.12. Huxwhukw mask by Douglas Cranmer, Royal British Columbia Museum. According to the museum's catalog, "This mask was modified by Richard Hunt for use in the potlatch. Cedarbark was added, as was a wooden bar and the rigging. Holes were also drilled at this time." Notes suggest that this was at a potlatch on 9 September 1978, but the mask was first used in 1974. RBCM cat. no. 13948. **Figure 7.13.** Whale mask by Richard Hunt, 1978, Royal British Columbia Museum. Made for a potlatch given by Tommy Hunt. Catalog notes: "First mask of this type which Richard made and it took 8 days to complete. However when used it was too heavy and didn't articulate well, so during the following months he re-made it, i.e., re-carved it, re-rigged it, and then painted it with glossy paint rather than the flat paint he'd used earlier. The glossy paint he considered more suitable for a creature from the water. It is larger than old masks because he found they do not fit him." RBCM cat. no. 16460 (v. 1).

regional museums now lend back objects, especially when they are used by their former or present owners. For example, beginning in 1982, the Alaska State Museum has had agreements with the Tlingit Kiks.adi. clan of Sitka to lend several objects in its permanent collection: a crest hat, Chilkat robe, beaded shirt, and song leader's paddle (Jones 1986:257; Henrikson 1994). Ceremonial loans, in fact, are a program of most Native-run museums, although in most cases, they are only lending back artifacts that still belong to their original owners (chapter 9). In all cases the anthropological curators have shifted to a new position—that their goals of preservation apply not just to the artifact but also to the cultural traditions that surround its construction and use. This may even take precedence over the physical integrity of the object, as when it might be rigged to support a dance harness or suffer some wear and tear in a dance. In accepting such a position, these curators have come to adopt, even if only in part, Native views of objects.

MUSEUMS AS REFERENCE

In addition to the active influence of specific commissions, the relationship can be inverted, with museums the passive partner and Native artists the active agents. Natives themselves visit the exhibits and collections to seek inspiration from the older objects preserved therein. In this, Native artists are no different from Western artists, who have used museums in this fashion for centuries (McShine 1999). Also like white artists, Natives have supplemented the "real thing" with the texts and photographs of books. In fact, the ease with which books may be consulted has made them the dominant medium for museum-artist contact and influence.

Although most late-nineteenth-century museums did not count Natives as part of their constituencies, one exception was the Sheldon Jackson Museum in Sitka, Alaska (Cole 1985:92–95). Reverend Jackson, a missionary, founded the institution in 1887, partly to keep Native artifacts in the territory, and partly "to show the coming generation of natives how their fathers lived" (quoted in Cole 1985:93). Associated with an industrial school, the collection was to "have on hand for study of the students the best Specimens of the old work of their Ancestors" (ibid.). Yet, despite its noble goals, the museum had little impact on Native arts.

Until mid-century, Native artists continued to have little contact with museum collections. At the conclusion of the Second World War, the B.C. Indian Arts and Crafts Society tried to bring the two together. In searching for a suitable memorial to those Natives who had given their lives for their country, the society proposed

> the gathering together of a collection of first class Indian handicrafts, so as to recall ancient legends and stimulate pride in the traditions of their race. Such a collection would inspire the higher standards of craftsmanship, and when articles were sold, would help bring about better prices for good work. The collection would be held in trust for the

Society . . . and would be used solely for demonstration and exhibition purposes. It would be loaned to government departments and private agencies interested in building up an industry of native handicrafts, for which there is so great a demand. The granting of a research scholarship in the Indian arts to promising young Indians would complete the memorial to those young Indians who made the supreme sacrifice for Canada.[36]

The society's orientation toward crafts and economic development is evident from this passage. In any event, while they did establish the scholarship for Native artists to study in the Provincial Museum, this separate study collection was never assembled.

The growing number of publications around 1950 coincided with the beginnings of the artistic revival. One of the earliest and most important resources for artists was Robert B. Inverarity's *Art of the Northwest Coast Indians* (1950), consisting mostly of photographs of prime artifacts from major museum collections. As Inverarity wrote to one curator, "It is wonderful how a photograph will isolate an object and a person will see it for the first time."[37] Marius Barbeau's 1953 study of Haida argillite was in great demand on the Queen Charlottes. Writing to Wilson Duff of the carvers' interest, Bill Reid asked for assistance in getting them copies: "I don't see any particular reason why they should have to pay to buy their own stories and art works back again."[38] Duff did what he could to facilitate their dissemination (Blackman and Hall 1982:32).

In the early 1950s, both the UBC Museum and the Provincial Museum collections were drawn upon by Mungo Martin and his family. When Abayah Martin was weaving her Chilkat blankets at the UBC Museum of Anthropology, she adapted her designs from older Kwakwa̲ka'wakw Chilkats in the collections (Hawthorn 1979:159). Tony Hunt has acknowledged the support he got from Wilson Duff at the Provincial Museum while he was working with Mungo Martin: "Wilson also encouraged me in studying the old pieces in storage at the museum. He gave me the freedom to relax and study the old pieces, doing sketches and taking photographs of them" (cited in Abbott 1981:294).

The UBC Museum of Anthropology has been an especially important source, first with its publication of the Northwest Coast collection (Hawthorn 1967) and since 1976 with its open storage system of display. The Hawthorn book is perhaps the single most used reference by Kwakwa̲ka'wakw carvers. Beyond its use as a source of ideas, many employ it as a "catalog," as a listing of what is available for dealers and other prospective buyers. According to Michael Ames, the museum's former director, carvers have praised the open-storage system, which allows them to study a piece without having a curator breathing down their necks. The museum grants them special privileges with passes and getting items out of the cases so they can be examined and photographed.[39] The Campbell River Museum has also encouraged artists to use the collection for reference. In the late 1960s curator Rose MacKay gave free run of the place to the Henderson sons, who often came in after school in order to get ideas. They and many other Natives soon came to regard the museum as "theirs."[40]

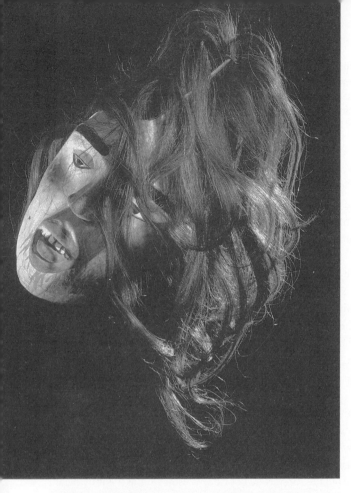

Figure 7.14. Wood carving of a woman's severed head, tuxw'id prop by Beau Dick, 1980, Royal British Columbia Museum. Dick based his carving on the illustration in Boas's *Primitive Art*. RBCM cat. no. 16616. **Figure 7.15.** Wood carving of a woman's severed head, tuxw'id prop, illustration from Franz Boas, *Primitive Art* (1927, fig. 156).

As for present practice, there are two main issues to consider: the use of photographs as sources and the role of copying. Of the two sources through which artists experience past artifacts—museum collections and visual documents—the latter have been much more important. Blackman and Hall (1982) define visual documents as paintings and silkscreen prints, photographs (of artifacts and of events), and reproductions in books. Northwest Coast artists have exploited such sources for over a century, especially since about 1950. Most of the early examples are Haida, as the Kwakwaka'wakw seem to have made little use of visual documents until very recently.

Of course, the most common source of photographs is books. Museums can also be counted on to supply images, and both the UBC and Provincial Museums freely make their collections available to artists in the form of object photographs.[41] A special resource at the latter is also its large ethnohistoric photograph collection, de-

picting people, village sites, totems, and ceremonials from all over the province. One of the more important visual archives of Northwest Coast art is Bill Holm's slide library at the University of Washington. During a sabbatical in 1976–1977, Holm traveled to major museums in the United States, Canada, and Europe, photographing the art of the region, "thus acquiring the largest known collection of slides on the subject" (Wright 1985:n.p.). These he has lent generously to all, including Native artists, and with his retirement, the collection has been transferred to videodisk.

Apart from museums and anthropologists, many contemporary artists maintain photo albums of their own work and the work of their colleagues. Kwakwaka'wakw artists who have at some point in time maintained such collections include Bruce Alfred, Richard Hunt, and Beau Dick. Artists often share their work with colleagues (Blackman and Hall 1982); for instance, Bruce Alfred has photographed works of Beau Dick. Like many galleries, Victoria's Arts of the Raven kept a photo album to give potential customers an idea of what was available.

One might imagine that artists would prefer the actual object over its image, but for their purposes the latter will often do as well. Practically, it is too difficult to study museum collections, given the issues of access and security, and few artists like to work apart from their studio. Generally, it is too much effort to take photos and notes, though some do.[42] Moreover, few artists seem motivated to make detailed copies of previous works, desiring, instead, a general inspiration.

In their use of publications, artists tend to stress the pictures, preferring volumes with many good, color pictures. Many do not consult the text at all, and if they do the symbolic analyses of Lévi-Strauss, Duff, or Goldman are perceived to be irrelevant to their tasks as creators of form. One exception that may be cited was those artists who tried in the 1960s and early 1970s to reconstruct the methods of bent-box making, which they could not learn from living masters. In this they were assisted by curators, as when the Hunts fabricated the box for display at the Provincial Museum.

The Northwest Coast case is almost a textbook illustration of Malraux's (1967) "museum without walls." What are the consequences of this reliance on a secondary world of reproduced images? Paradoxically, while encouraging a general formal conservatism, inevitably the deficiencies of the photographic image stimulate creativity: motifs from diverse objects (often from diverse tribes) are combined, and the artist must rely on his or her own resources to compensate for missing or obscured parts, the flattening of perspective, and the frequent lack of color. Blackman and Hall (1982:36–37) note other effects. Photographs stress the surface qualities of objects, leaving out indications of a mask's thickness, its rigging for ceremonial use, or the rest of the dance costume. Consequently, emphasis is placed on the object as art, rather than ritual paraphernalia. Like printing, the mechanical reproduction of photography increases the rate of stylistic development. Learning from objects rather than teachers allows one to be both more and less "authentic." On the one hand, one can be hypertraditional. The older artists worked from memory and personal experience and when creating an object in a current or former style were likely to intro-

duce slight innovations. With access to a museum collection, one can combine the best features from a wide range of examples. On the other hand, one is more apt to combine old forms with new forms and approaches.

Artists have several motivations for copying.[43] One of the most important is teaching. In the traditional teaching mode, the student would attempt to copy the half of a mask or totem pole made by his teacher or might attempt to replicate a piece being worked on by a master. Now many beginning artists practice by copying masterworks from books, which make available to them a much greater visual archive. Commissions, both commercial and museum, are another stimulus for copying. Patrons will commonly commission a replica of a specific object illustrated in a book. The artist will then make an exact or free copy, depending on the patron's desires. The motives of museum commissions have already been considered.

The most common motivation for copying, however, is to gain artistic inspiration. Much copying, as in the old days, grows out of family tradition. For instance, the Hunts have turned repeatedly in the past several decades to the motif of a supine sea otter with a sea urchin on its abdomen. In 1950 Mungo Martin painted a water color version (in the UBC collection), which inspired several works by his artistic descendants—silkscreens by John Livingston 1973 and by Tony Hunt in 1975 (see Blackman and Hall 1982:37), and a 1980 bowl by Henry Hunt (BCPM; see Macnair et al. 1980:116). Another example is the Tony Hunt Jr. version of a whale mask by his "great-grandfather" Mungo Martin (in the McMichael collection, see Haberland 1979:82).

Museum collections (directly or through photographs) expose artists to a wider array of forms, in space and time, than they were exposed to in their initial training. Thus museums foster stylistic borrowings, within Kwakwaka'wakw forms, for example, the adoption of Willie Seaweed's distinctive eye motif by members of the Hunt family, as well as across tribes. Tony Hunt, who has worked in Tlingit styles, claims a Tlingit connection through George Hunt's mother, Mary Ebbetts, and Douglas Cranmer has acquired a Haida influence from working with Bill Reid on the Haida village at UBC. Yet the only Northern art either of these artists had seen when they were growing up and learning their craft was in museum collections. Two specific examples of "stylistic fantasies," in the words of Blackman and Hall (1982:32–34), are a version of a Haida puppet in Kwakwaka'wakw style carved by Gene Brabant, a Cree artist trained by Tony Hunt, and a Kwakwaka'wakw nuḷamaɬ or fool mask in Nuxalk style carved by Beau Dick (Macnair et al. 1980:126, 169). One is a non-Kwakwaka'wakw type created in Kwakwaka'wakw style; the other is the opposite.

Anthropological media also foster temporal borrowings. Some artists prefer archaic styles that are invariably derived from collections and books. Beau Dick is one of the leading artists to work in archaic styles, especially in his masks from other tribes, like the Nuxalk, and, as previously mentioned, his appreciation for a sense of past time often leads him to abrade the surfaces of his masks. Important aspects of the recent revival of Kwakwaka'wakw stagecraft (as opposed to ceremonialism per se) were stimulated by Bill Holm's play potlatches and assisted by support from the

Provincial Museum. Its visual manifestations have been derived largely from collections and photographs. For instance, Calvin Hunt has made several complete dance costumes that are essentially replicas of museum specimens, as recorded in photographs (figure 7.16, cf. Macnair et al. 1980:125–126; see also Haberland 1979:2, 266–267).

The increasing reliance upon books, supplementing or even supplanting living teachers, has greatly affected contemporary Northwest Coast art. When one learns an art from objects, be they artifacts or photographs or records, one can experience

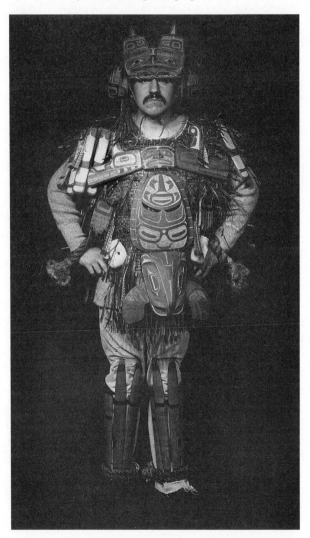

Figure 7.16. Hamatsa dance costume by Calvin Hunt, 1979, Royal British Columbia Museum; modeled on original in Field Museum by Xexa'niyus ("Bob Harris") (fig. 1.8). RBCM cat. no. 16617.

the item repeatedly. With a restriction to *form* only, however, one does not necessarily learn to produce the culturally patterned motions that produce the object. Thus many of the kerfed boxes made today follow traditional practice, though some artists have devised novel techniques that can result in the same form as found in museum specimens. The final product may be identical, even if the means or intention differ (as in the difference between a copy and a fake, between a blink and a wink). More important, one cannot produce the object according to the traditional meanings and associations that cluster around it, be they aesthetic or social.

Many of the contemporary artists who are self-taught through the use of illustrated books tend to excel at formal skills while lacking the traditional knowledge of iconography and ceremonial use. Although the Hunts have been trained by masters, their residence in Victoria initially distanced them from such contexts. For example, Tony Hunt was one of the last major artists to be trained in Kwak'wala and though he attended numerous potlatches as a child, he did not learn by producing objects for use; his younger brother, Richard, had even less ceremonial experience when he was growing up. Both Hunts gained this knowledge after they were already accomplished carvers. Others, with less sense of the Native context, are encouraged to follow the dictates of the white collectors' market. Countering this "estrangement" from ceremonial traditions, however, has been the revival of ritual fostered by the growing experience and commercial success of some artists (Blackman 1985:37). Moreover, as Blackman (1990:37) points out, "Despite the obvious reliance on this visual literature, these non-visual sources [songs, dreams, visions, personal memories, and oral history] are given primacy in Native culture in the creation of works of art." That is, while purely formal influences from non-Native sources are present, Native artists regard them as subordinate, if for no other reason than because of the stress on inherited ancestral crest privileges in Northwest Coast art (Ostrowitz 1999:105–138).

Finally, paralleling the rise in Native initiative in so many elements of the anthropological encounter is a Native kind of art scholarship, undertaken by practicing artists. "Northwest Coast Indian artists, in accumulating their own libraries of richly illustrated books on Northwest Coast art and sets of 35 mm slides of old masterworks housed in museums, are becoming art historians in their own right, curators and chroniclers of the native traditions they are reviving and reinventing" (Blackman and Hall 1982:38).

THE USES OF MUSEUMS: TRADITION AND CREATIVITY

Despite the praise of Native artists for the preservationist function of museums, there has also been a profound unease. At the 1948 Conference on Native Indian Affairs, held at UBC, Ellen Neel gave a stirring speech. Addressing herself to the then widespread view that Indian art was dead, and that "efforts should be confined to

preservation of the old work," she said: "For if our art is dead, then it is fit only to be mummified, packed into mortuary boxes and tucked away into museums. Whereas to me it is a living symbol of the gaiety, the laughter and the love of color of my people. . . . And our art must *continue* to live, for not only is it part and parcel of us, but it can be a powerful factor in combining the best part of the Indian culture into the fabric of a truly Canadian art form" (Neel 1948:12; see also Nuytten 1982:50). Pointing to the introduction of steel tools and new paints, Neel maintained that Native artists should have the right to continue to enrich their art with new tools, materials, and techniques.[44]

More recently, contemporary Northwest Coast artists have continued to distance themselves from what they perceive as the museum's deadening influence. According to Holm, Bill Reid had "found the bones of a great art and—shamanlike—shook off the layers of museum dust and brought it back to life" (Shadbolt 1974:n.p.). Reid himself had remarked somewhat ironically of his monumental wood sculpture at the UBC museum: "They were actually museum pieces before they were even made" (contrasting them to his 1978 pole for Skidegate).[45] While Robert Davidson has praised the role of museums in preserving Northwest Coast culture, he feels that they must now move on: "Things that have not been collected—like some of the totem poles in abandoned villages like Ninstints—should be left to die. Museums should not stop collecting, but they should collect new pieces—say, at intervals—to document the progression of the art form" (Davidson 1978:11). Ambivalence or outright hatred of museums is common among artists (Nochlin 1972), much like the antipathy of contemporary composers toward the conservative opera houses and symphony orchestras, which are seen as custodians of a long-dead (classical) tradition. But the museum influence has been especially noted in the revival of Northwest Coast art.

Museums have been largely responsible for the common perception that Indians are extinct, or that if alive, they must follow their "traditional" culture or cease being Indian (Wade 1981). Change is rarely attributed to Indians because—until recently, at least—people never got to see evidence of it in museum displays. For the reasons considered here (the great rush to build up collections around the turn of the century, followed by its curtailment), Native cultures have been reified in a classic phase. As Malraux (1967) once observed—now a commonplace in museum criticism—museums create their own context. Objects are displayed as icons, as representations of Native culture, in a situation where the viewer is in no position to compare the accuracy of the portrait to the model. In a museum display the signified is suppressed in favor of the signifier.

UBC anthropologist Marjorie Halpin has noted that one of the outcomes of the visible storage at the university museum has been to expose the record of "cultural loss and disintegration" so often relegated to museum storerooms (Halpin 1983:269). As an answer she advocates acknowledging this fact and going on to present "human creativity and vitality, rather than cultural death" (ibid.: 273). "By shifting from the

cultural achievements of the past to those of the present, presenting most notably the revival of Native art traditions and their occasional achievement of formal excellence to rival their grandfathers, we can share with Canadians a profound cultural principle: that artists create culture and in turn are created by it. The role museums can play in this process is that of midwife rather than undertaker" (ibid.). Here Halpin refers to Michael Ames's (1981a) observations of the role anthropologists have played in fostering contemporary Northwest Coast Indian art. Particular examples are the supportive potlatch programs of the Provincial Museum, UBC's exhibitions of the works of contemporary artists, or the patronage of both museums. Anthropology museums in the region, perhaps because they count Natives as a major constituency, have been at the forefront in developing the advocacy role of museums.

The ultimate form of outreach is the satellite and neighborhood museum, yet in British Columbia, as elsewhere, various kinds of intermuseum relations have taken the place of branch museums. A general professional organization, the B.C. Museums Association, was founded in 1958, and from 1967 through the mid-1990s the provincial government sponsored a museums adviser (subsequently transferred to the Museums Association). The large urban museums have supplied central services, especially conservation, and curators have been trained both formally and informally at the UBC Museum of Anthropology. Since at least 1972 the federal government of Canada has offered assistance to local museums. Instead of branch museums, associated with large urban museums, British Columbia has seen the recent establishment a multitude of small local institutions, and chief among them have been Native-run museums.

While some of the various forms of outreach (patronage, training, museums as reference, loans) go back to the first anthropological encounter with Kwakwaka'wakw art, the rapid explosion of such programs in the past forty years, particularly in the past two decades, is a sign of the changing cultural and political relationship between the Indian and white communities. At the vanguard have been the various programs of the Provincial Museum—the exchange mode of collection, the photographic and sound documentation of potlatches, and the potlatch loan program. All are forms of "giving the art back to the Indians" (Wilson and Dickman 1964), the most radical form of which is the establishment of Native museums.

8

NATIVE CULTURAL PROGRAMS

I n May 1951 a group of Kwakwaka'wakw in Alert Bay presented their dances in a program that they themselves had organized for a largely non-Native audience and for which they charged admission. This radical and dramatic shift in Kwakwaka'wakw modes of cultural presentation was a part of a larger context of changing interethnic relations. That same year the clause banning such Native dances and potlatches was quietly dropped from the Indian Act.[1] Along with this revision came the institution of a new system of local government for the reserves—the election of tribal councils. At the same time, Mungo Martin was working with anthropologists in Vancouver and Victoria in programs that included his original totem poles, house at Thunderbird Park, and house-opening potlatch.

Beginning in these years, the Kwakwaka'wakw expressed greater initiative in taking over from whites the exclusive control over their image in the white world. Significantly, this effort was centered not in the cities of southern British Columbia, but in Alert Bay, the largest Kwakwaka'wakw community. One program led to another, as the local Kwakwaka'wakw put on dances, renovated their totem poles, built community houses for potlatches, and established marketing and training programs for their art work. Ultimately, these endeavors would culminate in the founding of the two Kwakwaka'wakw museums. This chapter thus tells a story of institutionalization and objectification, as Kwakwaka'wakw begin to present their culture in concrete form in an interethnic setting.

ON HOME GROUND: DANCES,
TOTEM POLES, AND HOUSES

The Kwakwaka'wakw dances of the early 1950s represented a revival of intercultural performance after the burst of activity at the worlds' fairs. Since the turn of the century, the Kwakwaka'wakw had very few opportunities to display their culture for white audiences. After 1915 foreign fairs were fewer and stressed the world of futurist technology, while at home the Kwakwaka'wakw suffered through a time when the anti-potlatching laws were most emphatically enforced. Although potlatching did decline during the interwar years, it was due more to the worldwide economic depression than to governmental edict. Kwakwaka'wakw continued to potlatch, however, escaping governmental view by doing so in isolated villages or disguising them as innocuous Christmas or wedding exchanges (Cole and Chaikin 1990:138–152, 161–169). At the time, many anthropologists believed that Native culture was moribund if not dead, while other whites promoted rapid assimilation. Repeatedly during the first decades of exposition performances, local Canadians had tried to prevent these displays, and with the decline in anthropological support, there was little white interest in arranging such events.[2]

Yet on several occasions during these decades Kwakwaka'wakw themselves used sanctioned events to put their heritage on display. Typically, these were celebrations of royalty. When the Duke of Connaught, then the governor-general of Canada, stopped in Alert Bay in 1912, he was greeted by a party of Natives who, having danced for him, presented him with a speaker's staff. Dance paraphernalia—button blankets, cedar bark rings, frontlets, and speaker's staffs—was taken out for the 1934 visit of the lieutenant governor, but there was an even bigger celebration for the coronation of

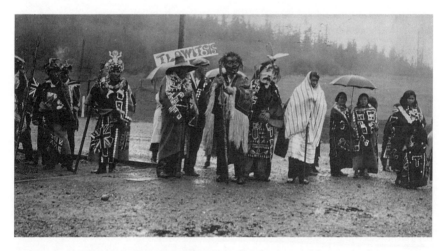

Figure 8.1. Kwakwaka'wakw celebration of the coronation of King George VI, Alert Bay, 12 May 1937. RBCM pn 1866.

King George VI in 1937 (figure 8.1). As the Kwakwaka'wakw paraded in their ceremonial costumes, some wore masks and old-style spruce-root hats. A huge cradle in the form of a whale was wheeled out on a dolly, as people massed behind signs identifying their tribal affiliation.[3] The previous spring, a memorial pole had been raised in the village of Gwa'yi, in Kingcome Inlet. A memorial for King George V, this newly carved pole was designed by Willie Seaweed and executed by several carvers, including Seaweed, Herbert Johnson, and Tom Patch Wamiss (Holm 1983:44). In this way the Kwakwaka'wakw continued to carve and raise memorials for high-ranking nobles, albeit of an exotic lineage.

JAMES SEWID AND THE HOSPITAL DANCES (1951)

The 1951 dances in Alert Bay were given as part of a fund-raising effort for a new hospital wing that had been built two years earlier. And because it was used by both Natives and whites, there was a joint effort to raise money for it. This program was combined with the period of spring celebrations marking Empire Day (originally held on the birthday of Queen Victoria, May 24, and thus known also as Victoria Day). The earliest recorded observance of Victoria Day in Alert Bay was in 1888, when the Indian agent, R. H. Pidcock, and the missionary, Reverend Alfred J. Hall, arranged modest celebrations, including a twenty-one gun salute. The day seems to have been celebrated continuously since the early 1940s, when the first May Queens were crowned.[4]

In 1951 James Sewid (1913–1988), who had just been elected the first chief councilor of the Nimpkish Band, was also chosen general chairman of the Annual Hospital Week Celebration Committee, the first Native to serve in this position. Among the activities planned for the week were a parade with costumes and floats, the crowning of a May Queen, folk dancing, and children's and adult sports, with prizes going to the best "Indian costume." But this year James Sewid, working with Agnes Cranmer, had also arranged for two nights of Native dances, to be held in the recently completed Community Hall. All admissions, a dollar for adults and a quarter for children, were to be donated to the hospital. The Indian Dances were a great success.[5] An estimated crowd of almost 700 came on the first night, the twenty-fifth, and almost as many the next night, with receipts of over $900.

The roster of those who participated in some form or another reads like a who's who of the contemporary Kwakwaka'wakw ceremonial/artistic elite: Mungo Martin and Tom Johnson (Fort Rupert); Harry Mountain (Village Island); James Sewid, Daniel Cranmer, and Ed Whonnock (Alert Bay); Henry Speck and Bill Matilpi (Turnour Island); William Scow and Herbert Johnson (Gilford Island); Bob Harris (New Vancouver); Tom Dawson (Kingcome); Willie Seaweed and Charlie George (Blunden Harbour). Along with these elders, a group of young people had volunteered to make up for a shortage of experienced dancers, an indication of the state of ceremonialism at the time.

These intercultural dances, with roots in exposition performance, were a complex mixture of tradition and innovation. All the dances were performed according to cus-

tom, but the format and presentation were novel adaptations from white culture. The biggest difference, and the one that at first caused the most opposition, was the performers' acceptance of money from the audience. This system, familiar to Euro-Canadians from commercial theater and dance, was a intentional model for the Kwakwaka'wakw. Dances in traditional potlatches were the exact inverse—in exchange for the guests' witnessing of the display of privileges, the hosts paid them in food, gifts, and money.

When Sewid first presented his plan, many felt they would lose prestige by putting on their dances without the distribution of property. This initial opposition spurred him on to "bring out" his own masks and dances, for although he had the rights to these privileges, he had not as yet publicly validated them. Sewid's relatives were the first to agree to the new plan, saying that they had given away enough in the past to feel secure in doing it this time "for nothing," especially for a good cause. What must have motivated them was the fact that they were not putting on these dances for each other, as part of status validation, but as a "show" for non-Natives.[6]

Along with this inversion came a shift in scale for the patron. In place of a single individual, representing a family and kin-group, performing for a comparable unit, dances belonging to eight Kwakwaka'wakw tribes were placed on the program. Thus the cultural "message" was that this was "Kwakwaka'wakw" heritage, not Kwagu'ł, 'Namgis, or 'Nakwaxda'xw. Custom was obeyed in that each presenter was displaying a dance to which he or she had the inherited rights, and the various tribes insisted on performing their dances in the order of the traditional ranking system, thus emphasizing tribal distinctions. Kwakwaka'wakw have continued to follow these ritual imperatives, even when the non-Native audience is oblivious to them (Ostrowitz 1999:104).

The program as a whole was a carefully rehearsed and stage-managed affair. Each group was given a set amount of time and was cut off when it went over. Some groups were not even allowed to perform, as their "acts" were not considered polished enough. Each group was introduced by a master of ceremonies, a position roughly analogous to that of the "speaker" or orator in the potlatch. All the songs and speeches were given in Kwak'wala, so the master of ceremonies, William Scow, also served as an interpreter. As far as one can tell, although translations were *added,* the language was not appreciably modified for a white audience. A closing speech from Daniel Cranmer ended a program that, reportedly, went on for "over five hours" (Spradley 1969:162).

The performance was well covered in the local paper: "Friday night's shorter program was of a serious nature and the dances mainly solemn."[7] From the list of dances given, apparently most were part of the Animal Kingdom complex from Gilford Island, along with a tuxw'id display—a model war canoe paddling above the heads of the audience. The following night also consisted of mostly animal dances but was filled with comic routines, many arranged by Willie Seaweed. Although a few cannibal bird masks were present, dances from the "sacred" hamatsa complex were

missing. Evidently for this non-Native audience the Kwakwaka'wakw chose to emphasize the more secular tła'sala repertoire. From the available photographic documentation, one can see that many spectacular masks were still in Native hands.[8]

The Natives tried to explain their customs to the whites. In his introduction, William Scow reported that "this was the Indian culture the way they entertained themselves and forgot their cares in the long winter evenings before the white man came." Daniel Cranmer in his closing speech said that they were "just playing" and that in former times the dances went into the morning and continued night after night for weeks.

These Hospital Week dances were a turning point in Kwakwaka'wakw performance. On the one hand, with the ameliorating climate of Indian-white relations, symbolized by the joint fund-raising for the hospital, they marked the beginning of Native control of their own image in white culture. Along with this went basic structural innovations in performance style: sponsorship by groups larger than families, rehearsals and set performances, an emphasis on the more secular tła'sala dances, commentary, and paying guests. While some of these features had been anticipated in world's fair performances, they were now undertaken by Kwakwaka'wakw themselves and became the norm for such intercultural events.[9] At the same time, along with the new Indian Act, these dances must have encouraged Native potlatching for Native audiences. Despite a ceremonial continuity, potlatches were still more or less clandestine, and few, if any, were given in Alert Bay. James Sewid dates his interest in public potlatching from this event (Spradley 1969:160, 162), and perhaps others as well now felt comfortable about displaying their heritage.

INDIAN DANCES AND JUNE SPORTS (1952–1981)

The Indian Dances started by James Sewid in 1951 proved so popular that they continued as a part of the Victoria Day celebrations in Alert Bay until they were fundamentally transformed in 1958. Their impressiveness and popularity waxed and waned over the years: 1951, 1952, 1953, and 1956 were the big years. Since most of the associated events were held outdoors, weather was a factor in their success from year to year. Again serving as chairman of the Indian Dance Committee, Agnes Cranmer was still able to get distinguished artists and ceremonial experts to participate. Willie Seaweed organized dances for several years, and among those who joined the first year's roster were George Walkus (Smith Inlet), James Dick, Tom Patch Wamiss and Dick Hawkins (Kingcome), and Thomas Hunt and Herbert Martin (Fort Rupert). Although Gilford and Village Island were also important, during these years there seems to have been a preponderance of people from Blunden Harbour/Smith Inlet and Kingcome, both areas known for their conservatism. Fort Rupert and Alert Bay did not send representatives equal to their populations, indicating, perhaps, that there were fewer carvers and dancers with suitable paraphernalia in these villages (Mungo Martin was in Victoria).

Journalistic accounts indicate that in later years more dances and masks from the

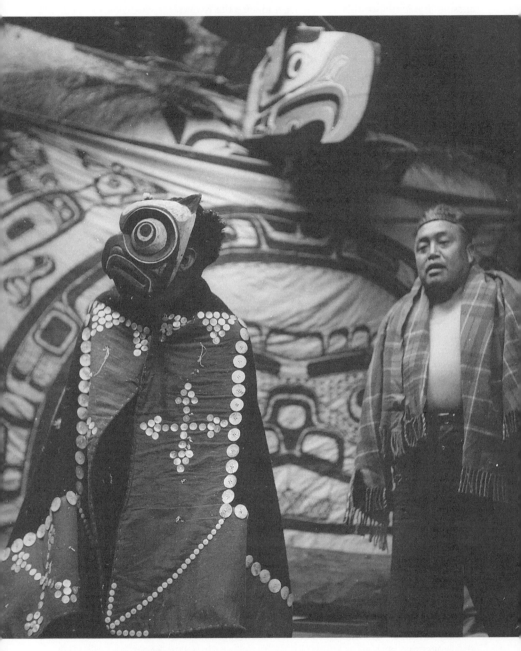

Figure 8.2. Owl mask by George Walkus (c. 1920), dance at Blunden Harbour. The mask was collected from Willie Seaweed by Sidney Gerber in 1952 and donated to the Burke Museum in 1969. Photo by William Heick, June 1951, courtesy of the photographer.

hamatsa complex were used, though the Dance of the Animals (or atlak̲im, Wonders of the Woods), with its colorful cast of characters, was a favorite presentation. Spectacular stagecraft, for which the Kwakwaka'wakw were known, was offered: a female tuxw'id dancer was pierced in the head with a spear, only to be revived unharmed.[10] Reportedly, for these dances masks were refurbished with fresh cedar bark and new coats of paint. In 1953 a boat parade was added for the first time. While costumed Natives danced on their decks, fishing boats circled the island, with prizes going to the best decorated boat. The best adult and children's Indian costumes were also honored. But their Native heritage was not the only festive concern of the Kwakwaka'wakw. The Indian Dances for 1954 were more modest, perhaps because of the great Native participation in the Jubilee Celebration, held the month before, of the local Anglican mission, Christ Church.

Plans to celebrate in 1958 the joint centennials of the British discovery of Alert Bay and the founding of the Crown Colony of British Columbia were discussed throughout the preceding year. Many of the events used to mark Victoria Day were incorporated into a vastly expanded array of programs, but this year, for the first time, separate celebrations were organized by Natives and whites. As before, the whites continued to mark Victoria Day with a parade, a May Queen, a band concert, fireworks, a dance, and children's and adult sports. The white community also presented a historical pageant, "From Wilderness to Wonderland," depicting the story of British Columbia. The pageant included an entire section dedicated to Native culture, but it was presented more as a first act, with the white conquest to follow.

The Indian Centennial Celebrations were held on June 21.[11] For this effort, the Nimpkish, the local band in Alert Bay, organized contributions from all the other Kwakwaka'wakw villages. Separate committees were set up for ceremonial dances, a salmon barbecue, the cemetery renewal, the renovation of the band council hall, and refreshments. For many years a popular event had been the spring soccer playoffs of competing Kwakwaka'wakw villages, and so the Nimpkish organized the Cormorant Island Athletic Club "to promote athletics on a more permanent basis and specifically for this year's sports' day."[12]

The aims of the Native celebrations were "to recall the old days in celebration of the centennial and in honour of the Native people of pioneer days."[13] The local paper presents an excellent review of the planned activities:

> Every effort is being made by the large local committee assisted by representatives from other villages to stage this celebration as close to the customs of 25 to 50 years ago as possible. Indian Ceremonial Dances by dancers from all over the district, featuring a variety of Indian masks and costumes, around an open council fire will be the grand finale on the Saturday evening. All day long members of the Native Brotherhood of B.C. will serve barbecued salmon using the famous Nimpkish River sockeye. The celebrations will actually begin on the Friday night when Chiefs and councilors from the 16 tribes will choose their Indian Princess from candidates representing all the tribes. Then

will follow the playing of the ancient, exciting, competitive game of La Halle. This will all take place in the Nimpkish Council Hall which has just been enlarged and renovated. A full and colorful program of sports has been drawn up for the Saturday, following the grand parade at 9 am. led by the chosen Indian Princess. Included in this programme are: singing, tug-of-war, canoe races, net lacing contest, push tug-of-war, high and broad jumps, relay and flat races, children's sports, soccer and softball cup finals with nine teams competing.[14]

The scale of such a Native, pan-Kwakwaka'wakw celebration was unprecedented, and many new events were introduced. Native ethnicity was emphasized repeatedly, in the Indian Dances and their location, the salmon barbecue, the playing of the La Halle (lehal) games, the crowning of the Indian Princess, and the parade. While costumed dances did go back to the 1951 Hospital Week, this time they were part of an explicit Native context. Dances were traditionally held indoors, but one could argue that these outdoor performances, held on the reserve, around a fire, were more "authentic" than the earlier dances given under the full, unvarying light of the Community Hall over on the white side of town.

The communal salmon barbecue, held apparently for the first time, served several functions: partly as a fund-raiser, partly as a supply of food, and partly as an expression of Native ethnicity. Over 200 sockeye, split and roasted, were all gone by early afternoon. To this day, the salmon barbecue is a popular method of raising funds for local museums and at Native events.[15]

The playing of lehal, or slehal as it is more commonly known, must have been a part of the conscious effort to return to "the customs of 25 to 50 years ago." The "hand game," popular in traditional times, had become almost extinct by the mid-twentieth-century among the Kwakwaka'wakw. This exciting game is played by two teams sitting across from each other. The opposing team has to determine which hand holds the marked bone, as each team sings fiercely in an attempt to confuse its rivals.[16]

Parades had also been part of Victoria Day celebrations, but this one, too, was made thoroughly Native. Leading the parade and officially opening the ceremonies was the Indian Princess. She was chosen by the Natives to supplement the May Queen, now elected by the whites. Instead of starting from the white half of the island, the entire parade traveled over reserve ground, from the Council Hall to the newly christened Thunderbird Park playing field. Behind the princess were leaders from various Kwakwaka'wakw villages, and following them were members of the sixteen Kwakwaka'wakw tribes taking part.[17] Many were garbed in ceremonial costume—some with masks, most with button blankets and cedar bark rings.

At the end of the festivities, the Indian Princess presented the prizes. Interestingly, most of the awards were donated by businesses in the white town, possibly in the interests of Native patronage, and all of the judges for best costumes, sports events, and other activities were white, most likely to avoid charges of favoritism.

The theme of the celebrations as a Native statement of pride and autonomy was made explicit in the opening speeches. As the local paper reported, William Scow al-

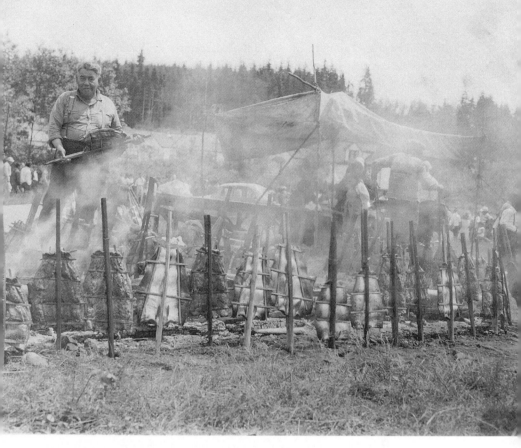

Figure 8.3. Oley Shaughnessy cooking salmon, June Sports, Alert Bay, 1959. Alert Bay Museum and Library neg. no. Ind 041.

luded to a senator's remark that "the darkest page in our history was our treatment of the Natives." He went on,

> We are making it up. We are progressing under this democratic system. We must get over the impact of the coming of the white man. It has been proven in two world wars that the Indian people are an asset to the country. Given a chance they will continue to prove themselves. Give our people the tools and they will take care of themselves. Today our people have modified some of their customs. The Indian Princess has made it possible for all these different tribes to celebrate this great occasion in our Centennial year.[18]

These remarks were amplified by Chief Tom Johnson of Fort Rupert, who said in Kwak'wala that he was pleased with the response from all the bands. They had "opened up their lockers" to present costumes and masks that have not been seen for many years. Then, seconding Scow, he said, "We respect the white people and wish to co-operate with you but the Indian must also be treated with respect." As have many Native leaders since, he used the occasion of a cultural celebration to insist on

Native land claims: "The chief advocated the enlargement of the Indian reserve to accommodate the rapid increase in Indian population."[19]

The tone of these remarks is indicative of the state of intercultural relations in Canada at the time. For the most part, the Natives still adopted an assimilationist model, accepting the basic institutions of the dominant society. At the same time, they demanded respect, insisting on attention to their claims, and appealed for unity among their own people. This union of assertive and accommodating elements of Native pride was echoed in the speeches at the June Celebrations the following year. Three Kwakwaka'wakw chiefs, Tom Dawson and Tom Wamiss of Kingcome and Bill Matilpi of Turnour Island, spoke of an imminent journey to Ottawa by B.C. Natives Robert Clifton and Peter Kelly. There they would present a brief to the Committee on Indian Affairs, "laying out the rights and privileges that they expected from the government." Yet they went on to speak of the great honor of being allowed to dance for the queen on her visit to Vancouver Island later that summer.[20]

Although these celebrations of 1958 were originally meant as a one-time event to mark a centennial, festivities closely following their model were held the next year and every year since (the 'Namgis First Nation Annual June Sports is now held on Canada's National Aboriginal Day). For the first several years, though, the same events were variously described: in 1959 they were called Kwakwala Indian Celebrations, in 1960 the Annual Indian Celebrations, in 1961 the Annual June Celebrations, in 1962 the June Celebrations, and in 1963 the Native Celebrations, or June Sports. Despite their athletic reference and the intense Native enthusiasm for the games, the June Sports, as they are now called, have become a major and complex cultural performance.

In any given year, the format and components of events may vary, but the basic structure is repeated each year. All activities are usually spread over a three-day weekend in mid-June. By 1962 cars decorated with people in costume, masks and screens, and the ritual hemlock boughs became important components of the annual parade, and like the costumes, they were awarded prizes. In addition to the parade, the selection of the princess, barbecue, and sports were all continued from earlier June celebrations. New elements added in the mid-1970s were carnival games for the children and cabarets for adults.

Several important changes occurred after 1966, when the community house (or Big House) at Alert Bay was officially opened. The Indian Dances that had been a featured part of the various spring celebrations were now held in this traditional-style structure. However, they soon moved from playing once a year, primarily to local white audiences, to presentations for tourists, given repeatedly over the summer. At the same time, the building of the Big House coincided with, and perhaps fostered, the recent potlatch revival among the Kwakwaka'wakw. From the first ceremony in 1965, it became the practice to schedule potlatches for the days or week preceding June Sports.

June became a "full" time for Kwakwaka'wakw, in which people from scattered

villages congregated in Alert Bay for potlatches, the June Sports celebrations, and the beginning of the fishing season. From at least 1960 the June Sports included the blessing of the fleet by the local Anglican minister, for after the games the massed Kwakwa̲ka'wakw fleet would disperse to the fishing grounds. As the fishermen tended to gather together anyway, in order to match crews with fishing boats, the Sports became a useful way of accomplishing this with a flourish. With its salmon barbecues and blessing of the fleet, the Sports were thus, in part, a celebration of subsistence. And since these modes of subsistence were direct, albeit modified, continuations of aboriginal practices, they were at the same time celebrations of ethnicity.

In recent years, however, as their context has changed, the June Sports have become less important in Kwakwa̲ka'wakw life. The fishing stocks have declined, pushing the opening of the fishing season later and later into the summer. Thus the Sports can no longer mark the beginning of the season, and consequently, perhaps, the boat parade has not been held for several years. Although the soccer playoffs are still a central event, their consuming interest for Natives has declined somewhat with the competition of satellite television and other electronic entertainment, coupled with the growing ease of travel to the big cities "down south." Finally, potlatching has now grown to the extent that all cannot be conveniently fit into the days immediately preceding the Sports. Now people tend to schedule their ceremonies for more meaningful times.

TOTEM POLES IN THE ALERT BAY CEMETERY

Although they had long created interior houseposts, the Kwakwa̲ka'wakw began erecting large, free-standing totem poles only in the final quarter of the nineteenth century, as they adopted a northern custom. These included housefront poles, as well as memorial poles in graveyards. It had not been a Northwest Coast custom to repair totem poles, especially memorial poles. Unlike inherited crest objects such as masks—which, because they had an enduring conceptual existence independent of material expression, could be repaired and replicated—memorials were dedicated to specific individuals and were intended to physically decay along with the memory of the deceased (Laforet 1993:30). Nevertheless, the cemetery at Alert Bay has been renovated several times in its history. The Kwakwa̲ka'wakw community on the island goes back only to the founding of the cannery by white entrepreneurs in the 1870s, and apparently most of the early burials were in trees. Photographic documentation suggests that the earliest memorials were small and simple, and that the small forest of totems dates primarily from the 1920s. By 1940 there was extensive discussion in the local Board of Trade about the cemetery needing to be "renovated," largely as a tourist asset, and in June of the following year there was a white-instigated cleanup. With joint funding from B.C. Packers (owners of the local cannery), the Union Steamship Company, the Board of Trade, and the Department of Indian Affairs, the cemetery was cleared of underbrush and the fences and at least some of the poles painted. The

failure to mention Native involvement is notable, for only a few months before the Kwakwa̱ka̱'wakw had erected a new pole in the cemetery. When the Natives did clean up the site a decade later, they apparently left the poles unpainted.[21]

While touring the province in the 1950s, searching for totem poles that needed to be preserved, Wilson Duff naturally singled out the cemetery at Alert Bay: "Alert Bay is the best known totem pole village on the B.C. coast, and the only one which tourists see on the regular steamship lines." In addition to five poles in the village, he found nine poles and six other totem carvings in the graveyard, situated on a sloping hill facing the beach. Pointing to "this . . . admirable situation for a park-like display," Duff listed the following steps "to make this place an attractive and fairly permanent totem pole display": "The brush should be cleared and kept down. The fence should be rebuilt and repainted. The totem pole bases should be remade to prevent decay

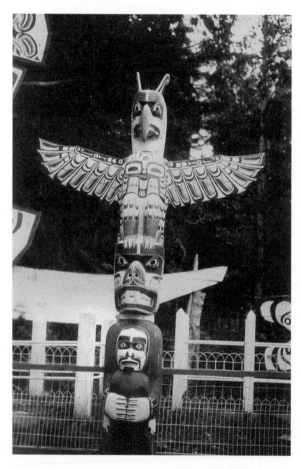

Figure 8.4. Totem pole with thunderbird and bear, by Charlie James, Alert Bay cemetery. Photo by Barney Williams, c. 1940. RBCM pn 1936-a.

and leaning over the years. Each pole should be wire-brushed, soaked with preservative and repainted after missing parts have been replaced. Provision should be made for continuing care over the years. It might prove desirable to erect explanatory signs and to print an illustrated folder or booklet on the totem poles, for sale in the village."[22] Because this was an active graveyard on reserve land, Duff noted, the restoration would have to be done with the cooperation of the Kwakwaka'wakw and without disturbing the graves. Possible contributors to the expenses were the Indian Affairs Branch (funds), the Union Steamship Company (funds, freight of materials), B.C. Packers (funds or materials), the Provincial Museum (supervisory personnel), and the Nimpkish Band (labor). Apparently Duff was unaware of the earlier renovations, though his own plans were quite reminiscent of them.

It is interesting that Alert Bay was the only site surveyed for which Duff recommended in situ restoration rather than collection and replication. In part, this was because the Alert Bay poles were fairly recent, but it must have also been due to the active state of Kwakwaka'wakw culture. Like the earlier Skeena project, upon which this plan seems to have been modeled, tourism and transportation access were crucial issues. Although the joint Provincial Museum–UBC totem pole project collected some poles and posts from Kwakwaka'wakw territory in 1956, Duff's proposed restoration work at Alert Bay was never attempted.

The Native community did restore the cemetery poles in 1958, however, but in their own way. In Alert Bay, there were both Native and white projects to celebrate the joint centennial of the establishment of British Columbia as a crown colony and the British discovery of Alert Bay. As part of their contribution, the Natives decided to clean and refurbish the cemetery.[23] Although it was on Nimpkish land, the cemetery was open to all Kwakwaka'wakw, and thus contributions of money and labor were accepted from all bands. The Indian Affairs Branch also bore some of the costs. Under the direction of James Sewid, the chief councilor of the Nimpkish Band, the work began in January and was by and large completed by March. The brush was cleared, all the totems were taken down, repainted, and re-erected in new locations, and a fence and cement wall were added along the perimeter. At the height of work there were fifty to seventy people participating, and Sewid reports a festive, committed mood (Spradley 1969:202–203).

Though such a restoration program was unprecedented in traditional times, it was also quite different from similar schemes in the Skeena Valley. This time there were no antiquarian whites around to tell the Natives to paint the poles in subdued colors. In fact, little effort seems to have been made to follow the original designs. Like the repainting of a mask when it is to be brought out again, this opportunity was used to bring the totems up to date, according to the personal styles of the supervising artists. In the absence of local talent, the artists chosen were Henry Speck of Turnour Island and James Dick of Kingcome. When many of the poles and carvings were first erected in the late teens and 1920s, the dominant styles were those of Charlie James, and to a lesser extent, Arthur Shaughnessy, who together created most of the poles.

The final results varied widely; while some poles were quite close to the original, others bore little resemblance to them. The very different styles of Dick and Speck so completely effaced the earlier decoration of many poles that without recourse to personal memory or the photographic record, there was no way one could know that this was not the way the poles had always looked (see figures 8.5, 8.6). In addition to being given the personal styles of Dick and Speck, the poles were painted in the manner of most Kwakwaka'wakw artists of the time. That is, all the poles were generally covered with a coat of white enamel and then painted in bright colors. This was not the archaic style then being fostered in the museums in Victoria and Vancouver.

Since then the local band has continued to care for the poles and grounds. In 1960 the brush was cleared again and many simple white crosses were erected. Over the summers of 1971 and 1972 there was yet another repainting, roughly following the designs laid out by Speck and Dick. The work was executed by young Natives under the direction of Beau Dick, the grandson of James Dick, and himself only sixteen at the time. This federally funded project also included oral history on the poles and their owners and carvers.

Today many of the poles, even the several new ones erected in the 1970s, again need treatment. The beginning of a new attitude may be seen in a recent repair and

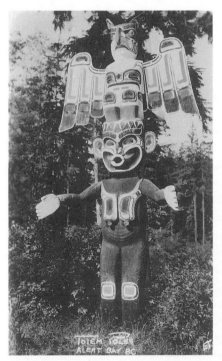 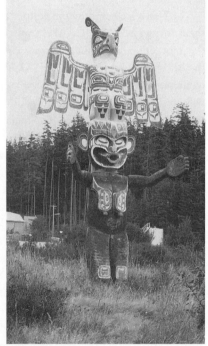

Figure 8.5. Dzunukwa pole by Willie Seaweed, Alert Bay cemetery. From a postcard in author's possession. **Figure 8.6.** Dzunukwa pole, by Willie Seaweed, after repainting, Alert Bay cemetery, September 1965. From a postcard in author's possession.

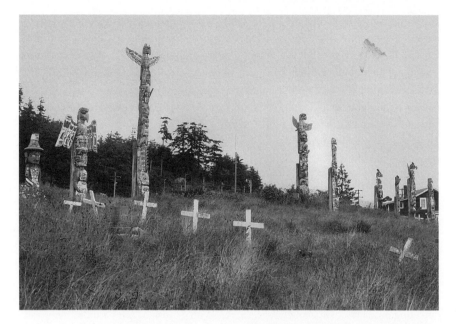

Figure 8.7. General view of cemetery, 1970, Alert Bay; notice the change in the Charlie James thunderbird and bear post (at left). Photo by Peter L. Macnair. RBCM pn 3177.

in plans for the future. In 1982 local carver Richard Sumner replaced a damaged memorial arch with a replica. Originally created by Henry Speck in 1958, the arch's painted panels depict flanking whales and a humanoid sun. Although he modified a few motifs, Sumner kept very close to the original. Such a close replica was a new thing for Kwakw̲a̲ka̲'wakw territory. For the renovation of the other poles in the cemetery, some Native carvers suggested at the time that perhaps they should go back to the original styles, as documented in photographs. Some poles would be restored, while very damaged ones might be replicated. If this plan were adopted, it would be quite unlike the 1958 renovation and would perhaps point to the historicist influence of anthropologists.

COMMUNITY HOUSES

With all this revival activity, it was not long before Natives themselves began to erect contemporary community houses. But unlike their earlier houses, these were not dwellings. While the houses erected by whites were more often used for display, performance tended to be the prime motivation for Native people.

The first of these Native houses was the Skeena Treasure House, completed in 1958 in Hazelton, B.C. The Gitksan of the area, familiar with the totem pole restoration in their territory during the late 1920s, had occasionally discussed the idea of a local museum. Around 1950 the trustees of the public library, searching for more spacious quarters, started to plan a combined library and museum, but it was not until

celebrations of one of the province's many centennials, in 1958, that funding was secured. With support from the province and approval from the local bands, the building was finished in 1958, but the opening of the museum portion was delayed until June 1960, after further funds had been obtained for display cases and so on. The Treasure House followed traditional Coast styles. Built by Native craftsmen of cedar planks, it measured 27 by 30 feet, with two carved and painted houseposts in the front corners. The structure was designed by a white, Bill Birmingham, and art historian Leslie Dawn speculates that he may have copied some of the poles from the 1940s house at Thunderbird Park (Dawn 1981:102–103). The frontal painting was by a Native, but it revealed a somewhat clumsy command of design principles.

During the 1960s, the Native and white communities of Hazelton developed plans for a model village, incorporating the Treasure House.[24] Serious plans surfaced in 1966 and went rapidly forward. With funding from the federal, provincial, and town governments, as well as the local Indian bands, the complex, dubbed 'Ksan, was by and large completed by mid-1969 and was formally opened in August 1970. On a site on the Hazelton Reserve, the "village" consisted of six Native-style buildings, arranged in a row facing the Skeena River: (1) the Frog House of the Distant Past, with exhibits depicting precontact Gitksan culture; (2) the Wolf House of the Grandfathers, containing early postcontact displays, and also used for performances; (3) the Fireweed House of Treasures, the old Treasure House, now used for display of old artifacts in cases; (4) the Today House of the Arts, the sales shop; (5) the Carving House of All Times, the workshop used by the associated Kitanmax School of Northwest Coast Indian Art; and (6) an unnamed house, used as an administrative and storage building. In the mid-1970s a seventh building, also in Native style, was built to house traveling museum exhibitions (also to serve administration and storage purposes). The houses, named after the traditional clans of the Gitksan, are all smaller than traditional community houses and have been modified to contain exhibits. All the decoration—carving and painting—was executed by the local carvers trained at the school. The village setting was completed by five totem poles, two canoes, a grave house, and associated displays (Weeks 1972).

Today there are six traditional-style community houses (gukwdzi in Kwak'wala) on Kwakwaka'wakw reserves. Two are surviving dwellings (Kingcome and Gilford Island), while the other four are modern versions (Fort Rupert, Alert Bay, Comox, and Campbell River). Still within Kwakwaka'wakw territory, though not on the reserve, is a seventh structure, essentially a house frame, at Campbell River.

Architecture did not escape the great changes in Kwakwaka'wakw material culture brought by intensive white settlement, but the villages were variously affected. For the first two decades or so after Alert Bay was founded in the early 1870s, the houses were constructed in traditional styles. But after the sawmill was built in 1887, milled lumber was increasingly used as a siding over a framework of carved house posts. Gradually, community houses were replaced by smaller, Western-style houses.

According to photographic evidence, this trend accelerated in the 1920s and 1930s and was basically complete by the 1940s.[25] The same process occurred in more remote villages such as Blunden Harbour, but there the last big house did not come down until the late 1950s (Holm and Quimby 1980:39).

The community house at Kingcome is the oldest surviving example of Kwakwa̲ka̲'wakw architecture; Wilson Duff dates it to about 1895. In 1955 he reported that a former owner was ha'mdzid, although he added that the claims on the house were disputed. He also observed that "the house isn't very large or ornate as such houses go, but is complete and essentially sound."[26] While the framework is original, the cedar shake covering is recent. For a long time, the Kingcome house was little used— opened up for visiting dignitaries and used for slehal games—but recently potlatches have been given in it.

A former dwelling, the house at Gilford Island was once owned by Herbert John-son, who was also responsible for the two posts outside the door.[27] Actually, the structure is something of a composite, incorporating carved beams from older nearby houses. The Gilford Island house was restored as a project for the 1967 Canadian Centennial, with partial funding from the federal and provincial governments, in addition to the local community. More recently, it has been named Nawalagwatsi (after the nearby cave that was the traditional origin site for the Dance of the Animals privilege) and decorated with paintings by Allen James showing scenes from the Dance. The Gilford house is much the same size as the one at Alert Bay: 70 feet long, 45 feet wide, 20 feet high. Inside are a set of four houseposts, carved and heavily painted in enamels. Planks cover the floor, shakes the roof. Although this is the only functional community house in the village, nearby are the ruins of a comparable dwelling.

The first of the new houses to be built was the one at Comox, constructed in 1958. Actually, the house was originally located just outside Courtenay, in Centennial Park. David Martin carved three of the interior houseposts. To commemorate the death of his son the previous year, Mungo Martin carved a memorial pole that was erected in front of the house on May 28, 1960 (see figure 4.18). In 1974 the house and pole were moved to the Comox Reserve, out of a sense of renewed ethnic pride and respect for the wishes of Chief Andy Frank, who was largely responsible for its erection. Today Frank's family assumes some responsibility for it, and it has been used by the Hunt family and others for potlatches (Nuytten 1982:109; Stewart 1990:126).[28] In the 1990s, Calvin Hunt played an active role in the enlargement and refurbishing of the structure.

In Alert Bay, the largest Kwakwa̲ka̲'wakw community, the gradual changes in domestic architecture were coupled with a shift in communal and ceremonial spaces. In 1949 the Natives and whites jointly built a community hall, which the Natives used to present traditional-style dances and performances, as well as some potlatches. On the reserve, following the new system of local government instituted in 1951, the band council renovated two mission schools, the old day school in 1958 and the residential school in 1974. However, there had not been a traditional-style community house in

Alert Bay for several decades, when, in the early 1960s, James Sewid began to plan one. In his initial proposals Sewid stressed tourism and crafts over performances as motivations:

> It would be a good place for the tourists to go and look around when they visited our village. It would be nice for the people who could do a little carving to have a place and for the women who had been making rugs and baskets with Indian designs on them because they could sell them to the people who came. We could have a workshop in the back and provide tools for those who didn't have any, and the people could go there to work and it would be a little income for them. (Spradley 1969:236)

Though the project was initiated, directed, executed, and funded in large part by the Natives, other agencies assisted. Chief among them was the federal Department of Indian Affairs, which paid some of the workers through its Winter Works Fund. The Alert Bay Board of Trade donated several hundred dollars, and a local forest company supplied some of the materials.

As James Sewid remembers it, he thought about building such a house soon after his move to Alert Bay in 1945 (Spradley 1969:236). His partner in these discussions was his village-mate from Village Island, Simon Beans. But it was not until the artist Henry Speck moved to Alert Bay about 1963 that final plans were formulated. That year Sewid presented his idea to the Nimpkish band council, and a building committee formed. Sewid was made responsible for architecture and engineering, Henry Speck was given over-all direction of the artistic plan, and Charlie George directed the actual carving of the houseposts and cross-beams. No particular houses were used as models; Sewid planned a generalized building as he remembered it from his youth. Thus the sources in this case were personal knowledge and oral history, not photographs or books.

Physical preparations began in late 1963, and the carving of the four houseposts started soon after.[29] By April 1964 two of the houseposts were carved and painted, but work stopped for the summer fishing season. After an autumn of work, the posts were finished and installed in early 1965. Another push was made to complete the structure by the beginning of the 1965 fishing season, and the house was essentially finished by the first week in June.

The Alert Bay community house was an interesting combination of old and new features (figures 8.8, 8.9). Measuring 70 by 50 feet, it had two main beams running the full length, supported by houseposts 17 feet high and 3 feet in diameter, and thus compared favorably with old-style houses. Yet it was set in a concrete foundation and clad with milled lumber. Other modern touches were electric lights and a sound system. Like older houses, it had a dirt floor.

Unlike traditional Kwakwaka'wakw houses, this one did not have a name. This and the decoration chosen indicate that the Alert Bay house was a "communal" house. Instead of selecting crests from an individual family or just the 'Namgis tribe, the committee decided to use crests from several Kwakwaka'wakw tribes: grizzly bear

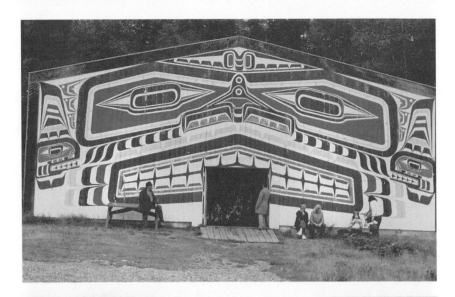

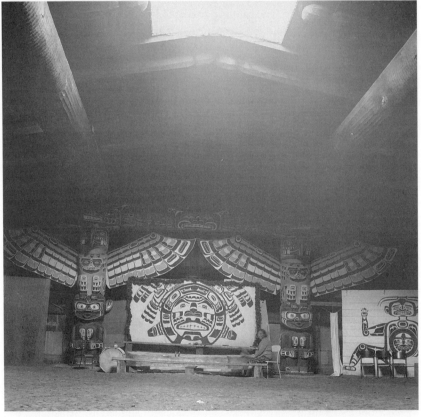

Figure 8.8. Facade of the big house at Alert Bay, 1966. Original painting by Benjamin Dick. RBCM pn 2955. **Figure 8.9.** Interior of the big house at Alert Bay. Photo by Jean André, 1972. RBCM pn 12922.

and kolus (a supernatural bird) on the front posts, and dzunukwa (wild woman) and thunderbird on the back. The cross-beams were carved as sisiyutł, although, as Sewid remembers, the beams in most houses of his youth were uncarved (Spradley 1969:237).[30] The front was painted with a whale design, created by Benjamin Dick (Gunn 1966). Not only is the iconography mixed, but the style is diverse. The three principal artists were each from different places—Speck from Turnour Island, George from Blunden Harbour, and Dick from Kingcome—and each brought to the project his own tribal and personal styles.

The house was also a social conglomerate. The location was neutral; centrally located Alert Bay was also the most populous Kwakwaka'wakw community, and the site was formerly controlled by the residential school. The building was constructed and run by a pan-Kwakwaka'wakw society, and white organizations contributed to the funding. A major impetus for its construction was to have a performance and sales space for tourists.

When the house at Alert Bay was expanded about 20 feet in 1986, Douglas Cranmer designed a new facade. The painting, executed by Bruce Alfred and his brother David, was completed in 1990 (Jonaitis 1991:226). This painting, based on Cranmer's Spirit Lodge facade at the 1986 Vancouver Expo, represented a sea monster. While independent in form and iconography and rendered in Cranmer's own simpler and more angular style, it did bear a general visual resemblance to Dick's painting. In April 1995 another addition was completed. Unfortunately, the house was burned in an arson fire on August 29, 1997. The community was devastated, but many generously contributed building materials, services, or money; Canadian Forest Products donated the lumber. The reconstructed house opened on May 28, 1999. Named I'tusto (To Rise Again), it measures 90 feet on the facade, 80 feet on the side, with a 36 foot extension at the rear for food services, dance preparation, and so on. Douglas Cranmer was again the master artist, assisted by Bruce Alfred, Wayne Alfred, Stephen Bruce, Beau Dick, Patrick Hunt, Vincent Shaughnessy, and Don Svanvik. Because of its many memories, and as a tribute to the original artists, the community decided to maintain the design and style: grizzly bear and kolus on the front interior posts, and dzunukwa and thunderbird on the back pair, with sisiyutł cross-beams. The facade was a version of Cranmer's earlier design.

Until recently the community at Campbell River used community halls for their potlatches. There was a related structure in town that was neither a complete house nor was on the reserve. The Heritage Park Pavilion was dedicated July 1972, built largely as a federally funded local works project. Open at the sides, the structure consists only of a set of four carved houseposts, cross-beams, and a roof and is set in a park on the shore, not far from the local museum and ferry landing. The Native carvers responsible for the posts were Sam Henderson and family, Benjamin Dick, Robert Neel, Eugene Alfred, and Dora Cook. Though primarily a piece of monumental sculpture, the space is also used for dance performances for white audiences.

On May 24, 1997, a traditional-style big house was dedicated on the reserve of the

Campbell River Indian Band. Called Kwanwatsi (House of Thunder), it is located next to the band-operated Community Hall. It measures 88 by 100 feet, with an attached 60- by 24-foot space for a preschool, as well as for storage of potlatch goods and ceremonial gear during potlatches. Sam Henderson's sons were active in the project: Bill Henderson was the master carver, assisted by Greg Henderson, Patrick Hunt, and Junior Henderson; and his brother Mark was the senior designer (painter). Opening a few years earlier, in June 1992, was the big house at Fort Rupert. Designed by Tony Hunt and executed for the most part by the Hunt family, it was completed after many years of planning and construction and has since been the site of many potlatches.

COMMUNITY HOUSE OPENINGS: ALERT BAY (1966) AND GILFORD ISLAND (1967)

The first performance in the Alert Bay community house was not its official opening, and this fact is significant. Just as the building was being finished in early June 1965, James Knox of Fort Rupert came to James Sewid with a request to hold a potlatch there (Spradley 1969:245–248). Knox wanted his guests to witness his adoptive son Peter (son of David Martin and thus Mungo's grandson) become a hamatsa. As soon became the practice in Alert Bay, the potlatch was held the night before the start of June Sports. The event generally followed the format of contemporary potlatches, with some twists. Lasting an entire evening with an audience of over 500, the potlatch was announced by a master of ceremonies using a microphone. Sewid explains that this was because "there were a number of white people visiting us" (Spradley 1969:246). Following the dances and speeches, cash and presents were handed out to the guests. What is important about this event is not its form, but that it happened at all. By its construction, Sewid had hoped that the house would foster a revival of Kwakwaka'wakw culture, but even before it could be formally inaugurated, it played host to a Native desire for a ceremonial space. While Sewid had been thinking of touristic uses, the community house quickly became the primary locus for Kwakwaka'wakw potlatching (Webster 1991, 1995).

Although the house had been essentially completed by 1965, James Sewid wanted to wait a year until British Columbia's Centennial. The inaugural ceremonies, held on June 18, were a clear bicultural performance.[31] Prominent white officials were invited as guests in order to validate and celebrate Native identity in a plural society. Nowhere was this theme sounded more emphatically than in the other event of the day—the province's return of the foreshore (Spradley 1969:248–253). Through a bureaucratic oversight, when a road had been built along the shore of the Nimpkish Reserve in the 1930s, the province claimed the land between the road and the waterline. After intensive lobbying, the province had agreed to return the land, thereby acknowledging, at least in part, Native claims on it, and by extension, Native autonomy. By deciding to hold the ceremony during the community house opening, Sewid was uniting the themes of Native political and cultural survival.

The opening ceremonies consisted of speeches and token gifts in the afternoon, followed by a salmon barbecue dinner, with Native dances in the evening. The white guests of honor were the lieutenant governor of British Columbia, George R. Pearkes and his wife, and the provincial minister of municipal affairs, Dan Campbell and his wife. After their arrival and a brief visit to the Canadian Legion Hall, the guests had lunch with the Nimpkish Council at the Council Hall, thus touching base at major buildings of the Native and the white communities in Alert Bay. Then, on the field before the community house, the first order of business was the return of the fore-shore, after which everybody took their seats inside.

The house was symbolically inaugurated by the lieutenant governor, who was made an honorary Kwakwaka'wakw. Given a blanket and cedar bark regalia, he entered the house with Sewid, preceded by the tribal chiefs. With a long torch, Pearkes lit the central fire, declaring the house officially opened. As Sewid said, "We wanted to make it different and authentic" (Spradley 1969:254). The committee had considered a ribbon-cutting, but had rejected it in favor of the traditional Kwakwaka'wakw custom. There was song and dance, a speech by Sewid with the confirmation of Pearkes' Kwak'wala name (he had been given one two years before at Gilford Island), the presentation of carved paddles to the men and bracelets to the women, and the conferring of the Loyal Order of the Whale's Tooth on Pearkes and Sewid by Campbell. In the spirit of the potlatch, these reciprocal gifts bound the donors and the donées into a single moral community, or at least everyone hoped so.

The remainder of the day, the barbecue and Indian dances followed the format of the June Sports, which were to begin the next morning. The Indian dances, for example, were not rituals, but fund-raising events on behalf of the Kwakwala Arts and Crafts Society. Within days, however, the house was again being used for potlatches; over 400 people gathered for two potlatches given by Peter Smith and George Scow.[32]

The basic structure of the dedication of the Gilford Island house was much the same, though simpler.[33] Held on May 28, 1967, this time the white guests were L. J. Wallace, chairman of the Canadian Confederation Centennial Commission, and his assistant, Robert Gillespie.[34] After a song and dance greeting at the wharf, they were led to the house by Chief William Scow and Chief Councilor Peter Smith. Instead of lighting a fire, Wallace cut a ribbon over the door. In his remarks Wallace commented on the role the Native people were playing in the centennial celebrations, "It recalls the great achievements of your people in the past and promises to bring enjoyment to a great many in the future." As in the June celebrations in 1958, it was now becoming important to have Native participation in the various Canadian centennials. After dancing and speeches, the guests received button blankets and were given Kwak'wala names. They, in turn, gave centennial books to Scow, Smith, and the school library. The food this time was a large centennial cake. Compared with the Alert Bay opening, the Gilford one seems more modest, without the great symbolic significance of the former.

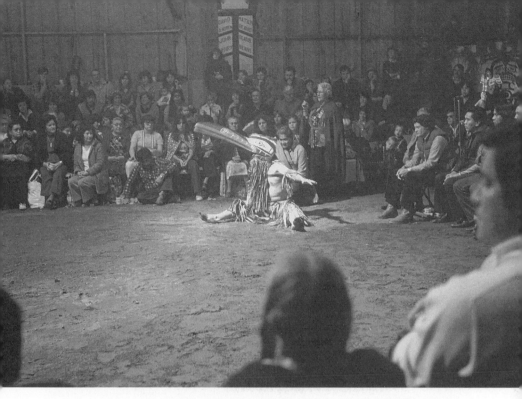

Figure 8.10. Hamatsa masked dances (haṃsaṃł) at a potlatch in the Alert Bay big house. Potlatch sponsored by 'Naṃgis chief Roy Cranmer as part of the opening ceremonies for the U'mista Cultural Centre, Alert Bay. Photo by Vickie Jensen, November 1980, courtesy of UCC.

SOCIETY AND FAMILY DANCE TROUPES

Performances for tourists were very much in the mind of James Sewid when he formed the Kwakwala Arts and Crafts Society in the mid-1960s.[35] Although he talked of "revival" and the "preservation" of the arts (Spradley 1969:240–241), it is clear that he felt that the means to these goals would be the tourist: "We thought we could sell our arts and crafts and perform our dances for the tourists, because that was the reason why we built that Kwakiutl house." If nothing else, such efforts would be a source of income: "I felt that a lot of my people, especially the older people, had no jobs that they could do, but they could make something to sell to the tourists" (Spradley 1969:256). Since the late nineteenth century, cruise ships headed north along the Inside Passage had been stopping for a few hours in Alert Bay, and Sewid hoped to reach this more or less captive audience.

The society was proposed in February 1964, the first general meeting was held in June 1965, as the Big House was being completed, and the first season of dances was the summer of 1966. While Natives conceived and ran the group, there was much cooperation with the white community of Alert Bay, and the structure of the dances

indicates that, as with the Hospital Indian Dances, the Kwakwaka'wakw were adopting Western modes of performance. Because Sewid and so many others would be away fishing during the summer, they arranged for the Alert Bay Board of Trade to run the shows. Sewid also hoped that the local merchants' greater business acumen would help put the society on a firm financial foundation. Realizing their own self-interest in the deal, the Board of Trade had brochures printed up, with the Alert Bay killer-whale logo (designed by Henry Speck) on the front and the program of dances on the inside. Through arrangements with the steamship lines, tickets and programs were distributed to the passengers as part of their fare.

During that first summer the Kwakwala dancers played to over three thousand people from fourteen cruise ships. The tourists were brought up to the Big House by taxi, and as they waited for the performance to begin, they were invited to snap pictures and purchase souvenirs such as model totem poles, straw mats, pottery, and bracelets. Each dance on the program, which altogether lasted about half an hour, was introduced and explained by a master of ceremonies, Sewid himself at the beginning. Costumes were traditional regalia, and, all in all, the performance seemed similar to the earlier Indian Dances (Ostrowitz 1999:93). Each dancer was paid according to how long he or she danced, and whatever was left over went into the society's coffers (Spradley 1969:257). The tourist dances were met with great success. The following year there were twenty-five cruise ship visits, and an audience of 3,200 left over $10,000 in Alert Bay, with half of that going to the society. As the Board of Trade noted in its report, the number of visitors was equal to five times the local population.[36] After two seasons, in 1968 management of the dances was assumed by the Natives themselves, the first manager being James Sewid's daughter, Daisy Neel.

While the Kwakwala Arts and Crafts Society performed mostly in Alert Bay, from time to time it did visit other locales. For instance, in 1968 thirty-three singers and dancers appeared at the Vancouver Sea Festival. Audience reaction was not always enlightened. When performing at Woss Lake, a small logging community nearby, a spokesman offered the following comments:

> No other entertainment group could possibly be more welcome than the Kwakwala people. They are unique, colorful, and what is more, they represent one of the strongest fibres in the cultural development of our province. These people have donated their time and talents and will do a great deal, not only in promoting the northern [Vancouver] Island area, but in helping to make the loggers' sports day a success. Since this performance will be held on the outdoor stage, we have been assured the group will not perform a "rain dance."[37]

Though clearly well-intentioned, this patronizing attitude was common in the 1950s and 1960s, when white society was beginning to adopt a more positive attitude toward the Native.

Throughout the 1970s, the Kwakwala Society remained active, but as tourism declined in importance and the Kwakwaka'wakw cultural revival burgeoned, its role

became more circumscribed. Now under the aegis of the U'mista Cultural Society, the Kwakwala Dancers still perform occasionally for tourists and other interested parties in the Big House at Alert Bay.

With the stimulation of the new community house and the Kwakwala Society, other groups formed to present dances to non-Native audiences. One outgrowth of the society was the Ah'nus Dancers of James Sewid and family, which began about 1971. Unlike their parent group, they tended to present most of their performances outside of Alert Bay. They have always featured the Animal Kingdom dances, which was a privilege claimed by Sewid. For these dances, the chief commissioned Lelooska to create a diverse set of vivid masks. Performances, lasting several hours, were narrated, and sometimes included as many as forty dancers. Often the Ah'nus Dancers performed to raise funds, which they did for the Cape Mudge museum in 1977 and the Campbell River United Church in 1978.[38]

Most of the Native dance troupes on the coast are loosely organized family groups, arranged around leading artists. In Campbell River there is the Henderson family and in Fort Rupert and Victoria there are the Hunts. When not taking part in actual ritual potlatches, both groups tend to dance most often at museums, and there are similar groups among other tribes: the Davidsons (Haida), Taits (Nisga'a Tsimshian), and the 'Ksan group (Gitksan Tsimshian). In these northern tribes, especially, artists have been largely responsible for the revival of ceremonialism. Since 1984, one of the more important venues for these intercultural performances has been the First

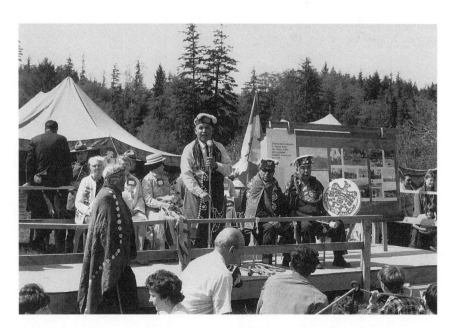

Figure 8.11. James Sewid making an announcement at the dedication of Cheslakees Campsite, near Beaver Cove. Photo by Peter L. Macnair, 17 May 1970. RBCM pn 7803–25a.

Peoples Festival in Victoria, sponsored by the Victoria Native Friendship Centre and (since 1987) by the Royal British Columbia Museum. Over three days in August, Kwakwaka'wakw, Coast Salish, Nuu-chah-nulth, and other Native groups participate in canoe races, dance competitions, sports, an artists market, and food booths. Like many of the intercultural performances over the decades, the First Peoples Festival is a joint production of Native and non-Native and speaks to a mixed audience.

MARKETING

Northwest Coast Native peoples have played an active role in the merchandising of their art since contact, but for the Kwakwaka'wakw this activity increased substantially during the twentieth century. Around the turn of the century, they sold crafts, mostly model totem poles, to tourists who stopped in Alert Bay on their cruises up the Inside Passage. Unfortunately, little is known about these exchanges; some items may have been handled by local merchants, but most seem to have been sold directly by the artists to the visitors. From these first artist-to-collector sales, Natives have gradually increased the sophistication and complexity of their marketing.

Almost all the local artists did some of this production, but one of the most active was Charlie James, who turned to it after a career producing works for ceremonial use (Nuytten 1982:13–41). Unlike his ceremonial pieces, his model totem poles were painted with poster paints and signed. In the 1920s James created a series of watercolors of mythical creatures, which were forerunners of Mungo Martin's later works in this medium and of the subsequent silkscreen prints. Charlie James was the effective beginning of direct Kwakwaka'wakw production for a white market. Among other forms produced for trade were silver jewelry (also used ceremonially) and smaller amounts of basketry and curio carvings. However, the Kwakwaka'wakw did much less of this than did the Haida and Nuu-chah-nulth.

James's granddaughter, Ellen Neel (1916–1966), played a decisive role in developing the white market for Kwakwaka'wakw art (Nuytten 1982:42–73). While still a youth in Alert Bay, Neel began selling model poles to tourists. After moving to Vancouver in the late 1940s, she began to work full-time in order to support her family following her husband's stroke. The couple worked as a business; she would design, carve, and paint the pieces, while he would buy materials, keep the books, sell the production, and generally promote his wife's work. Most of it consisted of simpler and smaller items for sale to souvenir shops, curio dealers, and department stores. Among these were small and large totem poles, paddles, carved ashtrays, bookends, rattles, masks, carved Indian seats, chief's staffs, lamps, model house frames, and carved table legs (Nuytten 1982:56–57). But from time to time Neel received commissions for large-scale, finely detailed masks and totem poles. The couple used their home as a combination workshop/studio/store, and in the late 1940s she began to carve in Vancouver's Stanley Park, where they also sold to visitors.

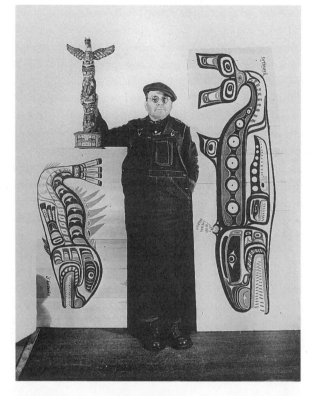

Figure 8.12. Charlie James, holding a model pole, flanked by
painted panels of a whale and "codfish," Vancouver,
c. 1928. VM cat./neg. no. 445.

Ellen Neel was an important transitional figure. Unlike her grandfather, who spent many years creating for Native patrons before turning to tourist crafts, Ellen Neel never created objects for ceremonial use. Her urban setting and marriage to a white man with business experience made her quite different from many of her Kwakwa̱-ka̱'wakw contemporaries. To some extent she had to struggle in the Native art market. Since most of her work was sold wholesale, she had little control over how it was displayed or sold, and though she took more time with her pieces, she was competing mainly with cheap tourist souvenirs. But in many ways her work forged new paths. Always on the lookout for new approaches, she "produced a number of commercially successful silk screened designs on cloth beginning in 1949" (Hall et al. 1981:50); it was not until the late 1960s that silkscreens would again be taken up by B.C. Natives.[39] Ellen Neel twice participated in conferences on Native affairs held at UBC (1948 and 1958), frequently demonstrated carving (e.g., at the Stratford Summer Festival in 1960), and fulfilled many commissions (e.g., five full-size totems for a mall in Edmonton in 1955). Neel's tireless efforts in publicizing her people and her art were crucial in developing the market that later artists exploited.

The first Native-run retail art shops opened in the 1960s, though their time had not yet arrived and none lasted very long. In June 1960 the Nuu-chah-nulth painter George Clutesi opened a shop in Victoria, selling B.C. Native crafts such as carvings, model totem poles, masks, basketry, mats, beadwork, and knitted sweaters. In writing to the Provincial Museum asking if he could relocate to the house in Thunderbird Park, Clutesi said, "My ultimate goal is to create a central outlet for all Native craftsmen for their work at a reasonable price to encourage continued production, thus foster and reawaken the desire to create with good returns for labour involved."[40] But Clutesi's request was not granted, and he soon closed up.

The "Talking Stick" has been called "probably the first serious attempt by British Columbia Indians to market quality art through a retail outlet controlled and run by them" (Macnair 1978). The Vancouver shop, run by Douglas Cranmer and Peter Scow, lasted from 1963 to 1965. Like most Native artist-retailers, Cranmer's standards were high, but as he later admitted, "We learned too late it was the junk that paid the rent" (ibid.).

The next time a Native opened a shop, the market had matured enough so that it met with success. In 1969 Tony Hunt (in partnership with John Livingston) began his "Arts of the Raven" gallery in Victoria. Hunt had been producing pieces for sale throughout the 1960s, and this experience was put to good use in his shop. The gallery was combined with the Raven Arts Workshop, in which Hunt trained young artists,

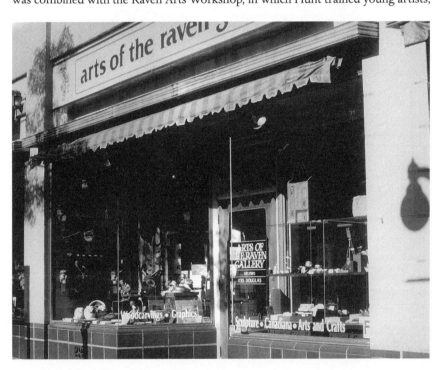

Figure 8.13. Tony Hunt's Arts of the Raven gallery, Victoria. Photo by Ira Jacknis, June 1988.

and many of its offerings came from this source. Without a doubt, this was the most successful Native-run gallery in British Columbia until it closed in 1990.

Several Kwakwaka'wakw have had retail art galleries in towns closer to Native settlements. For a brief period in the early 1980s, Tony Hunt's sister Dorothy ran "Legends in Cedar" in Port Hardy, and Bill Assu owned the Killerwhale Gallery in Campbell River.[41] Calvin Hunt, Tony's cousin, currently operates the Copper-Maker Carving Studio and Gallery in Fort Rupert. In 1982 Calvin Hunt moved back to his home village from Victoria and built a studio, which he opened to the public as a gallery in 1989. In towns such as Alert Bay, Native-run shops, catering mostly to the tourist trade, appear periodically, often with seasonal or irregular hours. Though on a comparatively small scale, the gift shops in the Native-run Kwakwaka'wakw museums in Cape Mudge and Alert Bay are important local markets and important sources of income to their owners. Members of other B.C. Native groups have also opened art galleries, some of which sell Kwakwaka'wakw objects.

In virtually every one of these Native-run shops the owners have been artists and so have naturally featured their own work. Of all these shops, Tony Hunt's was the most successful, for several reasons. Hunt's work sells for some of the highest prices of any Northwest Coast artist, and his shop was supported by its double function as a carving workshop and school. Still, none of these Native-run shops have been as financially successful as some white-owned galleries in Vancouver. Though Natives have shown a growing initiative, they have not been as successful in controlling marketing as they have other aspects of their image.

TRAINING PROGRAMS

Until the early 1970s all the formal training programs (as opposed to the traditional master-apprentice system) were organized and run by whites. One early effort was included in the Alert Bay cemetery restoration in 1958, where, reportedly, there was some training (Spradley 1969:203). The Coastal Indian Heritage Society was an important transition in that it was wholly run by Natives, though started in a white institution. Beginning in the early 1970s, Native-run programs became the dominant mode of artists' training, despite the fact that many have white (usually governmental) financial support. In these Native training programs the fundamental approach, at least for Kwakwaka'wakw, remains the master-apprenticeship system, though this now takes place in a more formal setting.

In the workshop associated with the Arts of the Raven gallery, Tony Hunt trained over fifty Kwakwaka'wakw artists. In many ways Hunt's shop was the implementation of the full-scale carving school the Provincial Museum had always planned but never had the funds to implement. After years of working formally and informally at the museum, Tony Hunt left in 1972. After his father, Henry, left in 1974, his brother Richard joined the staff, becoming chief carver the following year. Though talented,

Richard Hunt was too inexperienced at the time to lead an ambitious program of instruction. Thus Tony Hunt's workshop came to serve this function for the Kwakwaka'wakw. Much of the instruction was carried out by John Livingston, Tony Hunt's associate. The impact of Hunt's workshop has been immense. In the period through 1980, most of the younger Kwakwaka'wakw artists probably spent some time with the program, if not as beginners, then later in a kind of postgraduate study. Since the early 1990s much of the teaching function of Tony Hunt's gallery has been taken up by Calvin Hunt's Copper-Maker gallery in Fort Rupert.

An alternate setting for carving instruction began in April 1977 when Douglas Cranmer returned to Alert Bay to lead a carving program for the U'mista Cultural Society. After his Vancouver shop closed in the mid-1960s, Cranmer carved on independent commissions. He has also devoted much of his time to teaching; before he returned to Alert Bay, he had taught at 'Ksan in 1970 and at the Vancouver Museum in the early 1970s. Although originally planned for three years, with funding from Canadian federal labor sources, the U'mista program ran formally for only one year. Cranmer and his group of apprentices—such as Bruce Alfred (b. 1950), Fah Ambers (b. 1955), and later, Richard Sumner (b. 1956)—continued to work informally. Starting slowly in the traditional manner, they concentrated on graphic design before tackling work in three dimensions. Cranmer and his group were soon given the task of constructing parts of the new museum and cultural center building. After preparing the logs and siding, they painted the facade. This group of carvers around Cranmer has continued to work together and on their own. In the 1980s Beau Dick became one of the more important teachers of Native art in Alert Bay. Dick had taught in the Alert Bay schools, sponsored by the Band Council, as early as 1973, while he was still a teenager. Since then he has offered occasional instruction in the public school and worked with several of the Cranmer students.

Artistic training is now part of a general program of cultural instruction in the Alert Bay public schools, including language, dancing, oral literature, as well as the visual arts. The teachers work closely with the U'mista Cultural Society, which also collaborates with the local tribal school. However, neither system offers rigorous instruction in visual art; youths who desire this training end up working informally with one of the local carvers. There are similar cultural programs in the Campbell River school system, though with less instruction in Native visual arts.

One of the most important sources of funds for training in the late 1970s and early 1980s was the B.C. Indian Arts and Crafts Society, established in mid-1977.[42] The society grew out of the Indian Arts and Crafts Development Board, an advisory group to the federal Department of Indian Affairs. Though federally funded, the society was run by an elected board of Native directors. Most were experienced artists, and the plan was that each would at some time supervise a training program. Tony Hunt, one of the directors, ran some of these training sessions. While the society was an important source of financial aid for schooling and the purchase of tools, its thrust was toward group training programs.

The Kwakwaka'wakw artistic tradition has been conservative when compared with the Haida and, even more so, to many Eastern Native groups. One reason for this, as Nelson Graburn (1993:187) has noted, has been their revival of a traditional apprentice system and the creation of Native-run schools. While art school and university training are open to Kwakwaka'wakw, and some have taken advantage of it, most have been trained by direct practice under a master's supervision. This style of learning has fostered the development of a fairly close-knit community of peers. As Gitksan artist Doreen Jensen observed, other Indians are "the toughest and most important critics" (ibid.). Many, if not most, Kwakwaka'wakw artists thus adhere fairly closely to "traditional" models of the artist's role, a role that in Western culture is closer to "craftsperson" than "fine artist." Along with this role comes a formal conservatism and the use of iconography to which they are entitled—either through family inheritance or permission. Certainly there are exceptions to these generalizations, but there are marked tendencies to contemporary Kwakwaka'wakw art (Ostrowitz 1999).

SCHOLARSHIP

As a discipline coming to maturity in a colonial context, anthropology cannot escape its Eurocentric base; it has mostly been the study of darker-skinned peoples by white Europeans and North Americans. Natives have typically been seen as "informants," passively supplying information to the outside observer. Whatever its more general applicability, such a model for the Kwakwaka'wakw case is seriously misleading. Like the Iroquois, Navajo, and Hopi, the Kwakwaka'wakw have had a long and continuous relationship with anthropologists, and as in these other societies, certain individuals and families soon began to move from prime informant to gathering data on their own. Over the century they have developed what one may call a Kwakwaka'wakw tradition of anthropology.[43]

The ethnographic tradition begun by George Hunt (and Charles Nowell) was continued by Daniel Cranmer (1888–1959). A 'Namgis (Nimpkish) chief, Cranmer married one of Hunt's granddaughters; his second wife, Agnes, was the daughter of George Hunt's eldest son, David, and Sarah Smith. After Hunt's death in 1933, Cranmer became Boas's principal Kwakwaka'wakw informant. In 1938 and 1941 he visited Boas in New York, helping especially with linguistics and recording songs. Making his living as a fisherman and small businessman, Cranmer was active in the Native Brotherhood of B.C. and during the 1950s served as chief councilor for the Nimpkish band. Daniel Cranmer's relations with anthropologists were revived in the early 1950s when he served as informant for Helen Codere, and later in the decade when he traveled down to the UBC Museum to help identify artifacts. Daniel Cranmer did investigate matters for which he had no personal knowledge, but ethnography was never the virtually full-time preoccupation it was for Hunt.[44]

Mungo Martin, though primarily an artist, also acted as an informant and consult-

ant. Related by marriage to the Hunt and Cranmer families, Martin's second wife was
Sarah Smith, also known as Abayah, the same Sarah Smith who was David Hunt's
widow.[45] Mungo Martin was an informant for many anthropologists, especially Gun-
ther and Holm, and during his decade in Victoria he worked seriously and systemati-
cally with Wilson Duff to record Kwakwaka'wakw culture.[46] With much the same
spirit as Hunt, Martin viewed himself as perhaps the last Kwakwaka'wakw knowl-
edgeable about traditional lore. Martin often visited Duff's office, unsolicited, to
have him record information, and sometimes he brought over notes, written in one
of the several Kwak'wala orthographies with which he was familiar (Reverend Hall's
and Boas's). When he was unsure about a particular point Martin would go back
home to check with the old people, returning with the supplemental information.[47]

As the Kwakwaka'wakw collection came down to the UBC Museum in the 1950s,
Martin would help identify the pieces. "He gave both the Kwakiutl name and a trans-
lation. . . . He was concerned that his words should not be wasted. 'Write that down,
now,' he often said, and then, 'Say it back,' until he was satisfied that the transcription
was reasonably correct" (Hawthorn 1979:viii). Like Hunt, Martin was an active con-
sultant, counseling against the purchase of particular items if he thought the owner
was selling someone else's property, or if it lacked a legitimate ancestral myth.

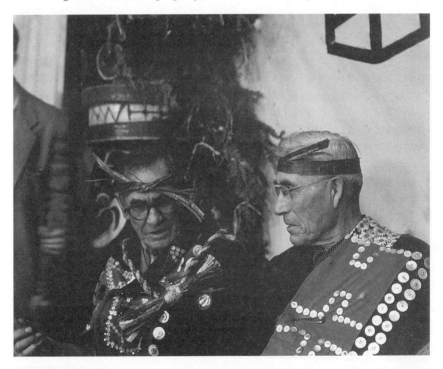

Figure 8.14. Mungo Martin (left) and Daniel Cranmer (right) (with Wilson Duff in the left
edge, cut off), at the opening of the Mungo Martin house, Thunderbird Park, Vic-
toria. Photo by Clifford G. Carl, 14 December 1953. RBCM pn 12887.

"Should 'people see it here, they would laugh' and say that the museum had bought a mask that was not genuine" (Hawthorn 1979:ix). In addition to his work with material culture, Martin played an important role in the recording of Kwakwaka'wakw songs, especially for UBC ethnomusicologist Ida Halpern (Cole and Mullins 1993; Chen 1995),[48] but also for Wilson Duff at the Provincial Museum, and informally for Bill Holm.

The family that grew around Mungo Martin in Victoria was the nucleus for what has become a substantial Kwakwaka'wakw community, much of it dedicated to work in art and museums. Among the others were Thomas Hunt (1906–1983) and his wife Emma, and Helen Hunt (1923–1972) and her husband Henry. At Martin's death, Thomas Hunt (son of David Hunt and Sarah Smith) was chosen to carry on his work in preserving the cultural heritage of his family and tribe. Helen Hunt (Martin's foster daughter) was especially active as a translator. Serving continually as Mungo Martin's interpreter, particularly at openings, she supplied the English for Duff's transcriptions of the tapes from Martin's potlatch, and toward the end of her life taught at the Provincial Museum.

Gloria Cranmer Webster (b. 1931) has continued and extended her family's anthropological tradition. The daughter of Daniel Cranmer and Agnes Hunt, she was born in Alert Bay and attended Victoria High School, graduating in 1949. In 1956 she became one of the first Kwakwaka'wakw to earn a bachelor's degree. At UBC she studied anthropology with the Hawthorns, Helen Codere, and Wayne Suttles, turning to an early career in social work and education. During the 1950s she was encouraged by Mungo Martin, working with him to record his knowledge of Kwakwaka'wakw culture. In 1971 Webster returned to the UBC Museum of Anthropology as a curator, also serving as instructor and director of Indian Extension Activities. Two of Webster's principal periods of research came in the mid-1960s and in 1974–75, when she spent time in the field helping to document the museum's Kwakwaka'wakw collection (Hawthorn 1979:ix). Built up in the 1950s, most of these accessions had not been collected in the field but sent down to Vancouver by their Native owners. In the early 1970s, Gloria Webster helped establish the Coastal Indian Heritage Society at the Vancouver Museum. Between 1977 and 1990, she served as founding director of the U'mista Cultural Centre, curating its collection and supervising its various programs of research, films and publications, and language instruction (chapter 9). During these years she was also active as an author (e.g., 1988, 1991, 1992a) and as a consulting curator for *The Legacy* (Provincial Museum, 1971), *The Copper That Came from Heaven* (UBC Museum, 1983), the Grand Hall (Canadian Museum of Civilization, 1989), and *Chiefly Feasts* (American Museum, 1991), among others. Cranmer Webster has clearly moved to a professional position that was denied to her predecessors: Hunt, Martin, and her father.

Since their participation at the world's fairs at the turn of the century, Kwakwaka'wakw have demonstrated an interest in cultural documentation and presentation. Among the most active in this have been the descendants of George Hunt, so much

Figure 8.15. Gloria Cranmer Webster (left), with Andrea Laforet, of the Canadian Museum of Civilization. Unpacking a dant'sikw (commonly called a "power board"), given on permanent loan to the U'mista Culture Centre by the Canadian Museum of Civilization. Photo by Vickie Jensen, 1980, courtesy of UCC.

so that one may speak of an institutionalization of the ethnographic tradition.[49] This long history was marked by a reunion of many members of the Boas and Hunt families in 1986, commemorating the century since their ancestors had first met (Webster 1990b:137, 140). While not unexpected, a problem with this is that the ethnographic sources for the Kwakwaka'wakw have been limited to a small region—Fort Rupert and Alert Bay—and to a relatively small social group within it. Although Hunt and his descendants did make efforts to document a wide range of knowledge and opinion, their work is situated in the way any other ethnographer's might be.

The anthropologist plays several roles: primarily, that of cultural researcher and intercultural mediator. A related, yet alternative, role in many tribal societies was that of "cultural specialist," performed by elders and others who have undergone special

training. Particularly in a stratified society like the Kwakwaka'wakw, knowledge is not evenly distributed but is held by a range of ceremonial experts, artists, song-makers, orators, and chiefs. Because many cultural traditions were, and still are, in-herited by ancestral privilege and were often expressed in ceremonial "secret soci-eties," only certain experts had access to this knowledge. Kwakwaka'wakw social roles were thus preadapted for the activity of Native anthropologists.

Other cultural specialists, such as Tom Omhid or Willie Seaweed, served as inform-ants, but they spoke only from personal experience. Unlike Mungo Martin, they did not go out of their way to research what they did not know; unlike Hunt, they did not make an effort to document and present their knowledge for others, espe-cially those in another culture. To be an ethnographer implies active investigation into the social practices of others, and, even more important, the commitment to record-ing it in a permanent medium.

In fact, anthropology was not the most important intercultural enterprise among the Kwakwaka'wakw. Among the others were the Anglican Church, the Native Broth-erhood, and the band councils, alternate forums in which Kwakwaka'wakw people could present their culture to whites. Initially a missionary endeavor, the church in Alert Bay gradually found a place for Natives in its services. Many leading Natives became lay readers, as did the Cook family, Nowell, as well as James Sewid. Also important was the women's auxiliary.[50] The Kwakwaka'wakw branch of the Native Brotherhood of B.C. was founded in 1936 as a fishermen's union in order to represent Natives to the white business world, but it also furthered nonbusiness goals. Com-pletely Native-controlled, the Brotherhood gave Natives important political experi-ence before the establishment of the band councils. Since the introduction of the band councils in 1951, Natives have participated in growing forms of self-government. Kwakwaka'wakw such as Robert Joseph have served as officials in the Indian Affairs bureaucracy; Joseph was also cultural affairs liaison for the Kwakiutl Museum at Cape Mudge (Joseph and Mann 1980; Joseph 1998). All of these governmental officers be-came experienced in representing their culture to whites, skills they drew upon when they turned to cultural presentations such as a Native museum.

Questioning the usefulness of the term "native anthropologist," Narayan (1993:672) reminds us that all anthropologists are hybrid and bicultural, simultaneously engaged in scholarship and the world of everyday life. Simple labels such as "Native" and "Kwakwaka'wakw" actually obscure a bundle of complex and shifting identities. As Cohodas (1997) demonstrated in his study of the intercultural community in Cali-fornia's Klamath River Valley at the turn of the century, individuals actively construct their identities from multiple ethnic strands. Some of the Kwakwaka'wakw ethnog-raphers (George Hunt and Mungo Martin, as well as artists Charlie James and Ellen Neel) had mixed parentage; others (Charles Nowell and Daniel Cranmer) were fully of Kwakwaka'wakw ancestry. But all moved constantly between Native and white cultural worlds; just as, from a different position, did Franz Boas. Anthropology is always situated and positional.

As a distinctive Kwakwaka'wakw anthropological tradition evolved, it took on several characteristics. It was devoted to historical concerns and the documentation of oral traditions, expressed in particularistic and descriptive accounts, rooted in its community, and expressed in socially useful products. During a time of great culture change, Kwakwaka'wakw certainly felt the many differences between their culture and white culture, and between their present and their past. Such feelings of disjunction spurred some of them to take up the roles of preservationists and collectors. Their fundamental motivation seems to have been to document cultural information that they felt to be threatened by the dominant society.

As they compiled their studies, these Kwakwaka'wakw ethnographers rarely resorted to cross-cultural theory, and only implicitly to the categories of other cultures. Anthropologists would once have questioned whether such work belongs to their discipline, but recent authors such as Abu-Lughod and Narayan have argued that generalization and cross-cultural analysis is not necessarily better anthropology, just different (Abu-Lughod 1991:154; Narayan 1993:680). In fact, in their ethnographic bias, these Kwakwaka'wakw are not much different from most non-Native anthropologists who have worked with their culture. Almost all white scholars who have deep, firsthand experience with the Kwakwaka'wakw, from Boas and Newcombe to Holm and Macnair, have rarely used Kwakwaka'wakw materials for explicit cross-cultural comparison or analysis. It is ironic, but perhaps not surprising, that those anthropologists who have achieved the greatest fame for doing so, for relating Kwakwaka'wakw data to etic theory, such as Benedict, Lévi-Strauss, Goldman, and Walens, have no field experience with the Kwakwaka'wakw. The reasons for this strong descriptive tradition are moot; perhaps it is the impress of the Boasian model, or perhaps it is due to the feelings of the Kwakwaka'wakw themselves and the nature of their relationship with those ethnographers closest to them. In any case, it is no wonder that Kwakwaka'wakw have not been attracted to a comparativist study of humankind.[51] This particularism is just one of the traits that a Kwakwaka'wakw ethnographic tradition shares with the Americanist tradition fostered, but not limited to, the Boasians, as delineated by Darnell (1999:45–47). Among the others that are germane here are a focus on language and texts, the need to preserve the knowledge encoded in oral traditions as a permanent record, a historical view of cultures, and ethnography that is produced by means of cultural dialogue over the long term. That there is a Boas-Hunt tradition of Kwakwaka'wakw anthropology, jointly produced by Native and non-Native, is what one might expect from such a dense anthropological encounter.

Living in a period of fundamental culture change and fearing that the world he had known as a child would be swept away, George Hunt dedicated his life to documenting it. The texts he collected have been used by his great granddaughter to teach children in the U'mista Cultural Centre, linking the familial and the cultural. A Native, Kwakwaka'wakw anthropology is also a practical, socially useful anthropology.

9

NATIVE MUSEUMS

N ative museums are always reflexive institutions. Like museums of history in Western culture, but unlike anthropology museums, they are on *home ground*. Instead of presenting one culture's view of another, they give one culture's view of itself to itself, and only secondarily to others. In this sense, their collections are a homecoming, an end to alienation, as the Kwakwa̱ka̱'wakw say, of *u'mista*. Although the represented culture remains the same as the culture of the viewers, the time is invariably different, thus giving museums their special power in Native communities.

FOUNDING PROCESS: REPATRIATION AS SOCIAL DRAMA

The opening of two Kwakwa̱ka̱'wakw-run museums around 1980 was the outcome of a long period of intercultural conflict set in motion a century earlier. In 1884 the Canadian Parliament amended the 1880 Indian Act by proclaiming that "every Indian or other person who engages in or assists in celebrating the Indian festival known as the 'Potlatch' or in the Indian dance known as the 'Tamanawas' is guilty of a misdemenour, and shall be liable to imprisonment" (La Violette 1973:43; see also Cole and Chaikin 1990; Bracken 1997). The government adopted this moral legislation under the pressure of missionaries, in the interest of "civilizing" the Indians and preventing them from what they believed to be "degrading" practices.

Partly because of the ambiguous wording of the law, it was difficult to obtain convictions, but after a potlatch held on Village Island in December 1921, the local Indian Agent, William May Halliday, decided to try for a successful prosecution. This potlatch, one of the largest ever given up to that time, had been sponsored by 'Namgis chief Daniel Cranmer in order to repay his wife's family as part of the marriage settlement (Codere 1961:468–471). On this occasion, Halliday was able to obtain forty-five convictions. With three on appeal, twenty individuals (including ranking chiefs and women) went to prison. However, twenty-two received suspended sentences in return for agreeing to hand over their potlatch regalia.[1] Three tribes were represented: the 'Namgis of Alert Bay (in the north), the Mamalilikala of Village Island (in the central area), and the Ligwiłda'xw of Cape Mudge (in the south). A total of 750 objects were turned in, for which the government gave the Natives collectively $1,495. Many of them denied receiving any compensation, and the government never paid for the twenty coppers handed over (Cole 1985:252–253). From the Native point of view, these shields—abstract counters of wealth—were an even greater monetary loss than the artifacts, as they represented massive amounts of property exchanged in potlatches. One Native estimate put their worth at $35,000 (U'mista 1980).

After he had gathered together the regalia, Halliday displayed it in the parish hall at Alert Bay, where it was inventoried by the local school teacher. As Saunders (1997:99) notes, "This display and its inventory in effect transmuted the Regalia into a 'collection,' Halliday charging an entrance fee to view it." Whereas before these objects had been part of disparate personal sets of items, they now achieved a coherent status that has continued to characterize them—even when contested—until the present. As Halliday was amassing the collection, George G. Heye, the ever acquisitive founder of the Museum of the American Indian, happened to visit Alert Bay. Acting against instructions, the Indian agent sold 35 of the finest items to Heye and shipped the rest to Ottawa. From the Victoria Memorial Museum (now the Canadian Museum of Civilization), part of the collection (about 100 pieces) was transferred the next year to the Royal Ontario Museum, and 11 items were retained for his personal collection by Duncan Campbell Scott, Superintendent of Indian Affairs.[2]

The Kwakwaka'wakw never forgot the 1922 "confiscation," but until the anti-potlatch law was dropped in 1951 there was little they could do. That year Canadian Natives began to govern themselves under a system of local band councils. Now that potlaching was no longer illegal, it increased in frequency and elaboration. Throughout the 1950s the Kwakwaka'wakw created contexts for the presentation of their culture, activities that prepared the way for their museum/cultural societies of the late 1970s. One strand was the series of intercultural performances: the Hospital Dances (1951–1957), leading to the Centennial Celebrations of 1958, in turn becoming the June Sports (1959–present). Another strand was the physical transformations of Alert Bay: the restoration of the cemetery (1958) and the building of the Alert Bay Museum-Library (1959) and the community house (1965). Finally, there were the cultural societies: the Kwakwala Arts and Crafts Society, begun in 1965, and the Coastal Indian

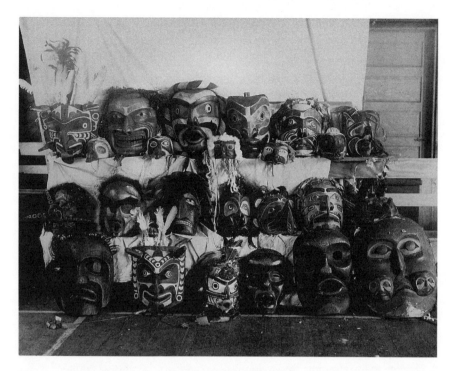

Figure 9.1. Confiscated masks in the Anglican church hall, Alert Bay. Photo by Rev. V. S. Lord, 1922. RBCM pn 12189.

Heritage Society at the Vancouver Museum (1971–1975). In all these endeavors Natives were the prime organizers and officers, and thus in all the Kwakwaka'wakw were working to present their image of their own culture, for themselves and others.

Of these cultural institutions, two were particularly important in preparing the way for the Kwakwaka'wakw museums: the Alert Bay Museum-Library, opened in February 1959, and the Kwakwala Arts and Crafts Society, organized over 1964–1965. Commemorative of the provincial centennial the previous year, the museum-library was a project of the municipality of Alert Bay.[3] While support came from both Native and white communities, the Native sentiment was stronger, and largely as a result, it was constructed next to the 'Namgis cemetery, then undergoing renovation. A strong backer was James Sewid, who "thought it was necessary to have a place for the masks and Indian stuff. Most of the people were just putting all their things in their basement and people were breaking it. I put my big raven mask and the mask I wore when I was a hamatsa in there" (Spradley 1969:204). Sewid felt that if there had been a museum in Alert Bay earlier, perhaps Natives would not have sold their paraphernalia.[4] House fires were another concern. While the museum exhibited pioneer heirlooms as well as Native pieces, evidently most of the display was Native, and most of these were on loan.

The Kwakwala Arts and Culture Society was the most important precursor of the

two Kwakw<u>a</u>ka'wakw cultural societies, and thus of their museums. As already mentioned, this group, under the direction of James Sewid, was responsible for the building of the Alert Bay community house and for organizing the tourist dances. But viewed more generally, it was a general association dedicated to the preservation of Kwakw<u>a</u>ka'wakw culture. Sewid was motivated by what he felt was a loss of tradition: "Like any other nation, I would like to preserve the arts and crafts of the Indian people because I think they are beautiful. Those old people who really knew how to sing and dance and carve were dying off and I felt that something should be done to preserve those good things from the old way" (Spradley 1969:236). As Sewid was quick to point out, this cultural loss was due not only to Native lack of interest; the government's policy of outlawing potlatches was largely to blame (ibid.:240).

In Sewid's organizational letter, of February 1964, two motives for the society are given: ethnic pride and economic development. Pointing to the worldwide demand for Native arts, Sewid alluded to the growing ranks of Indian hobbyists.

> If we do not take a firm stand now, we shall lose our dances, carvings, etc. to the non-Indians as well as to the other Nations. These people know the great demand and value of our Arts for they have already begun to learn and produce them. These are ours and our people should be the people to benefit from them. Let us not lose our Arts like we did our lands, for if we do we shall regret it. (Ibid.:242)

As in so many attempts to develop Native carving programs, economics was a stimulus: "Unemployment is getting worse each year. Let us help one another and start an industry of Arts and Crafts for our people" (ibid.:242). Sewid hoped that craft sales to tourists would bring in much-needed income, but in addition, he was concerned about "the exploitation of those who have tried to sell their articles to dealers themselves and have not received the full value of their work" (ibid.:241). The society, open to all of Kwakw<u>a</u>ka'wakw descent, was run by an elected board of directors, and there was an initial membership fee of one dollar. The group met for the first time in June 1965, upon the completion of the community house. As the program developed, dancing came to supplant any artifact activity. While some items were sold to tourists in the early seasons, there was no training program. Nor was there, as hoped, an expansion of the complex with a smaller building, about 20 feet square, for the storage of paraphernalia (ibid.:258). However, the idea of a museum building was not distant.

The first recorded efforts to have the so-called Potlatch Collection returned date from 1958. At the request of Andrew Frank (a Coast Salish married to a granddaughter of George Hunt), his local member of Parliament, Tom Barnett, located the collection in storage at the National Museum. Barnett, the member from Campbell River and the Kwakw<u>a</u>ka'wakw lands of northern Vancouver Island, continued to be of assistance throughout the two decades it took to bring the collection home. One plan called for its display on permanent loan in the Native community house then being planned for Courtenay. Museum officials were quoted as supporting the idea

of a Native museum on the coast for the display of such material, providing there were proper facilities.[5]

When visiting the capital on business in 1963, James Sewid demanded to see the collection but was given a poor reception.[6] After finally getting to see the collection, most of which was in storage, Sewid requested that the objects be returned, as they were stolen goods. When told that the government had paid $1,400 for them, Sewid pulled out his checkbook and offered to pay for them but was refused (Sewid-Smith 1979:2–3). Sewid persisted, returning to Ottawa several times over the next few years. This encounter of 1963 marked the beginning of the period of effective "redressive action" to secure the return of the collection.

In the mid-1960s the general idea of Native museums began to gain currency. Considering plans for the celebration of the 1967 centennial, the local paper in Alert Bay suggested "the construction of a Community House maintained as a museum." Possible support could come from the combined efforts of the local 'Namgis band, the white town, and the Department of Indian Affairs.[7] And Philip Ward, conservator at the Provincial Museum, was quite sensitive to Native desires for local control. In a comprehensive review of the "conservation of antiquities," Ward proposed "that the Indian material should be in their hands." Totem poles, he thought, should be re-erected on reserves, in local centers of Native population such as Alert Bay.[8]

By 1967 the federal government was moving to return the confiscated objects. That year, archaeologist William E. Taylor became director of the newly reorganized National Museum of Man, and there was talk in both Alert Bay and Campbell River of housing the collection in their municipal museums.[9] Taylor, with support of the museum's trustees, began negotiations, with former board member Michael C. D. Hobbs meeting with representatives of the Kwakiutl District Council. The council appointed a cultural committee consisting of James Sewid, William Scow, and Dave Dawson to pursue the matter.

One can only speculate as to the motivations of the federal museum for considering this action at this time. Undoubtedly, it resulted from many conjoined factors. Issues of Native sovereignty were more salient in a period of the U.S. civil rights movement and the upheaval over the war in Vietnam. In Canada, the new Liberal Party government of Pierre Trudeau was advocating "participatory democracy," which it began to apply to many aspects of national life (Tennant 1990:147). For instance, the Department of Indian Affairs moved to transfer much of its administrative burden to the provincial level (ibid.:142).[10] In the cultural arena, the act of repatriation may have grown out of the National Museum's policy of "democratization and decentralization," adopted in 1968 and reaffirmed in 1972. The museum attempted to make its resources more readily available to Canadians across the country, living far beyond the capital region. Under this program, twenty-five institutions were declared associate museums, entitled to special funding and assistance. As part of its generally increased services to the nation's museums, the National Museum established its Museums Assistance Program, which funded half the construction costs for the Kwakwaka'wakw museums.

Regionally, the talk of repatriation came at a time of intense awareness and acclaim for Northwest Coast Indian art, both historic and contemporary. Although probably a coincidence, the Potlatch collection began to be exhibited at the same time that the Kwakwaka'wakw intensified their efforts. Evidently the entire collection had never been exhibited, but during the 1960s a number of the pieces were displayed at several of the decade's temporary art shows.[11] Exhibitions such as *Arts of the Raven* (1967) included work by living Northwest Coast artists, among them Kwakwaka'wakw Henry and Tony Hunt and Douglas Cranmer. This period also saw the beginning of a market for the sale of contemporary Northwest Coast objects as fine art. Whether dealing in revival or continuity—the issue varied for different peoples and groups— these displays made the point that Native Northwest Coast cultures had not totally vanished as Boas and Newcombe had feared. And if they were still here, alive and vibrant, perhaps their claims on the Potlatch Collection, acquired under a different set of assumptions, needed to be listened to.

With assurances of provincial support, in mid-1972 the Kwakiutl Council voted to build a museum for the collection at Cape Mudge.[12] Among the reasons given for its location was its accessibility to large populations. Immediately, however, there was dissension, with people from the north maintaining that the museum should be placed in Alert Bay, citing its central location for the Kwakwaka'wakw and arguing that most of the artifacts had come from the area. Matters were in limbo until December 1973, when the Kwakiutl District Council accepted a motion by the Nimpkish Band Council for the establishment of two cultural societies, each to run a museum housing one half of the collection. Accordingly, in Alert Bay the U'mista Cultural Society was founded in March 1974, and in January 1975 the Nuyumbalees Society was established in Cape Mudge.

In May 1978 the two societies met with representatives of the National Museum to work out the procedures for dividing the collection. At this meeting, there was also discussion about the disposition of the confiscated objects that had come from the people of Village Island. Village Island had been abandoned by this time, so its inhabitants, living in both of the other towns, were to decide which museum was to receive their objects. That November the objects left the National Museum for temporary residence at the B.C. Provincial Museum.[13] Before they could be inspected by the families, they had to be fumigated and their condition recorded. Photographs of the collection had been sent to each family to help them make their identifications. This allowed all but 15 percent to be attributed. The process was difficult as the items were not adequately identified when they were picked up, and many of the family members originally present had since died.[14] Early in the year the families were able to inspect the collection and make the final claims; the people from Village Island had their review in late January. As the split worked out, about half the collection went to each society. On February 10, 1979, the two societies agreed to the division, and seven days later the Nuyumbalees Society and the National Museum agreed on the final terms of transfer. The U'mista Society reached an agreement some months later.

The collection remained at the Provincial Museum until each museum was completed and ready to accept its respective objects.

Construction of the Kwagiulth Museum, as the facility at Cape Mudge was called, began in November 1978 and was completed the following May, shortly before the opening on June 29, 1979.[15] In Alert Bay the construction began in August 1979, with completion about a year later. After several months of installation, the U'mista Cultural Centre was dedicated on November 1, 1980.

The process of repatriation did not end with the opening of the two museums, and, as might be expected, the issues were rather different for the Royal Ontario Museum (ROM). When intensive negotiations began with the ROM in late 1984, the museum felt "it had some legitimate claim to the collection" and wanted something in return for the years of curatorial care (Webster 1988:43). As has occurred to several museums considering repatriation, the Royal Ontario Museum hoped that some kind of cooperative arrangement could be worked out, by which the collection could be shared or replaced with replicas. The Kwakwaka'wakw refused, feeling that they had a legal and unconditional right to the objects.[16] With help from the federal Department of Indian Affairs, the Kwakwaka'wakw finally got their way, and the ROM returned its part of the collection in 1987. On January 30, 1988, the objects were apportioned between the two Kwakwaka'wakw museums (Lohse and Sundt 1990:92).

Negotiations with the Museum of the American Indian had intensified in 1984, but there was little headway until the institution became a branch of the Smithsonian Institution in late 1989. One of the principal problems at this institution was that many of the objects that Heye had acquired from Halliday could not be distinguished from other Kwakwaka'wakw items that Heye had collected around the same time and place. Undoubtedly, the influential factor here was the appointment of a Native American, W. Richard West Jr. (Cheyenne-Arapaho), as director in May 1990. In 1993 the museum agreed to return the nine objects that could be effectively identified. Subsequently, another twenty objects were isolated and negotiations are continuing (U'mista 1999:6). Even with these transfers from the three museums in Ottawa, Toronto, and New York, there still remain other objects taken from the Kwakwaka'wakw in 1922. Over the years, some of the Potlatch Collection has been deaccessioned to other repositories, such as the British Museum, and thus the repatriation efforts are continuing, although on a much reduced level.

In recent years the repatriation of Native objects has become an important fact of life for many museums, especially since the passage in the United States of the Native American Graves Protection and Repatriation Act in 1990.[17] While it is now commonplace to consider how ethnographies function as narratives (Bruner 1986), a narrative approach in general and a dramatic model in particular are especially suited to an analysis of repatriation, as they encompass ways of thinking about social action over time—with a plot, characters, and (often opposing) motivations. One may usefully speak of a poetics of repatriation.

The Kwakwaka'wakw case examined here may be profitably analyzed in terms of

the "social drama," a model of conflict resolution proposed by anthropologist Victor Turner (1957:91–93). Turner defined four phases in a social drama: breach, crisis, redressive action, and reintegration. In this case, the "breach" phase corresponds to the programs of enforced acculturation impressed upon the Kwakwaka'wakw, marked by the legal prohibition against potlatches and ceremonials. The pivotal point, the moment of "crisis," was the 1922 "confiscation" of dance regalia by the Canadian government. Following this was a half century of "redressive action," in which the Natives worked with greater or lesser effect at securing the return of the "Potlatch Collection." The return of the collection and the opening of the two museums mark the beginning of "reintegration." For Turner, the model of a drama was a metaphoric form that both actors and analysts could use to understand fundamental social and cultural oppositions and accommodations.

For the Kwakwaka'wakw, the events of 1922 have become a central point of reference in their definition of themselves and their relation to the dominant society. They are a prime example of what Michael Harkin, following Raymond Fogelson, calls "epitomizing events" (Harkin 1997:43). These are "condensing, symbolic actions," which come to stand for larger social movements, in the way that the 1929 stock market crash ushered in the Great Depression. The confiscation marks a time of oppression and forced culture change, and the outcome of the drama, the return of the artifacts, symbolizes their new relationship to white society. Now they have more autonomy, and there is more respect for their art and culture.

The Kwakwaka'wakw case was a relatively early instance of Native American repatriation, especially in Canada. Because of this, negotiations proceeded slowly, with the museums worried about setting precedents. Structurally, of course, repatriation is the inverse of collecting—as artifacts go from Western museums back to the Natives, from centralized, metropolitan repositories to localized, remote villages. Just as the original movement reflected the existing power relationships, so repatriation comes about with a readjustment in those relations. While the museums were cautious, the ultimate repatriation was undoubtedly helped along by the circumstances of the original acquisition. An important question to examine is, Why was it considered appropriate to acquire the objects in 1922 and to return them in 1978? This case involved the rather unusual circumstance that the National Museum acquired the collection as part of a legal proceeding, obtaining the objects under duress (although with some compensation) and not as part of scientific research. The legal argument that the Kwakwaka'wakw raised in their negotiations was that the alienation of ceremonial objects in exchange for dropping criminal charges is contrary to principles of Anglo-American justice. Once the anti-potlatch law was dropped in 1951, the reasons for keeping the collection must have seemed less compelling to the National Museum, whatever their earlier validity. The situation might have been different if the Kwakwaka'wakw had claimed artifacts, collected by Franz Boas, for which they had been fairly paid. In that case, contemporary curators would be inclined to uphold the original motives and methods of the collector/museum.

While Natives and anthropologists may both currently accept a narrative of cultural continuity and resistance, there are likely to be significant cultural differences in the way they cast the narrative. That the events of 1921–1922 constitute an important story at all is due primarily to Native concerns; one sees few references to the question in Canadian writings until the Kwakwaka'wakw pressed the issue in the late 1960s.

The fourth phase in Turner's social drama model included the "recognition of schism" as well as reintegration. With the Potlatch Collection, the two sides continued to talk while recognizing basic differences. Although the Canadian government has returned the confiscated regalia, its status remains ambiguous. These objects were essentially returned on the government's terms (Inglis 1979:29). From the beginning of negotiations, the National Museum insisted that they would not be returned until the Natives could supply a museum building with proper climate and security controls. And the government would return them not to the individuals from whom they were taken or their descendants, but only to the Kwakwaka'wakw people as a whole, evidently from the concern that they could later be sold out of the country (see Sewid-Smith 1979:3).

Although the Kwakwaka'wakw and the government were able to reach an agreement, the Natives did not see the situation quite the way the officials did. The repatriation was a compromise; the Natives did get the return of their heritage, while the government was able to keep the objects in a museum environment (built largely with government funds). But, as explained in the following section, the Natives redefined the object-centered museum as a broader cultural center and refused to consider the artifacts as communal possessions. Sewid maintained that they "belonged to individual Chiefs, not the tribe" (Sewid-Smith 1979:3), and other Kwakwaka'wakw regard them as a family donation to the museum.[18] (In fact, at Cape Mudge they were initially displayed in cases devoted to specific families.) The National Museum may have been able to accept both of these positions; what is of interest is the fundamentally different priorities of Native and white. As in other cases of repatriation, this is a tension that both parties have chosen not to resolve.[19] Narratives of repatriation are by definition intercultural. Each side has its version, often many versions, which may not coincide with those of the other(s). Like a pidgin or creole in linguistics, a shared code is developed that allows speakers of two languages to communicate, without necessarily reaching full agreement or even full comprehension.

THE MUSEUM AND THE CULTURAL CENTER

Many Native people have been quite sensitive to the word "museum," associating it with false images of their culture. With good reason, they complain of the common museum focus on only the old objects. With few, if any, contemporary pieces, the impression left is that Kwakwaka'wakw culture is extinct.[20] As one of the original board members of the U'mista Cultural Society said, "Indians don't go to museums" (Web-

ster 1990b:135). Thus when searching for names for their own museum-like institutions, they chose the phrase "cultural center." This they felt would be a "living place," for teaching and activity, not a collection of dead objects. Yet despite their best efforts, the incorporating group at Alert Bay despaired of finding a Kwak'wala equivalent for "culture center," thus referring to the building itself as *humu'wilas,* or a "place in which you look at things."

The associations of "museum" were avoided elsewhere in the region. When a Kitwancool chief was asked in 1960 to name the group's project, he proclaimed, "It shall not be called a museum, for we are not a dead people; let it be called the Skeena Treasure House" (Weeks 1972:12). Later its name was changed to the Fireweed House of Treasures, as it was incorporated in the 'Ksan village. The naming of the Makah project at Neah Bay, as noted later in the chapter, was determined partly by its funding source, the Economic Development Association. Finding it hard to justify a museum as a money-making institution, as intended by the agency, "it was decided that the building would be called the Makah Cultural and Research Center, as this would have a more positive impact on the community. This was due to the potential service it could provide as a cultural center and as a research center for scholars from both inside and outside the community" (Hughes 1978:19).

Turning to a synchronic perspective, I next examine the basic structural components of the two Kwakwaka'wakw museums at their founding and in their first years: names, charter and goals, governance, staff, and funding. Semantic associations were carefully considered in the naming of the two Kwakwaka'wakw cultural societies. The people of Cape Mudge selected Nuyumbalees, whose meaning is given as "the beginning of all legends" (Joseph and Mann 1980:7). Composed of the roots, *nuyem* (legend or myth), *bal* (denoting movement), and *is* (on the river bank), the term refers to the creation story of the localized kin-group or *numaym,* when its founding ancestor came down to the beach (Mauzé 1984:313–314). By using this name, the society associates itself with the originating principles of Kwakwaka'wakw culture and history. The Cape Mudge institution opened as the Kwakiutl Museum, but soon changed the spelling to Kwagiulth, to better reflect the pronunciation of the Kwak'wala word. As Harry Assu explained, "We chose the name Kwagiulth Museum because we wanted it to be for all our people not just our Letwiltok tribe" (Assu and Inglis 1989:106). More recently, it has become known as the Kwagiulth Museum and Cultural Centre.

When searching for a name, members of the U'mista Society consulted their elders, who said getting back the Potlatch Collection was like *u'mista* in former times. As explained in the guide leaflet: "In earlier days, people were sometimes taken captive by raiding parties. When they returned home, either through payment of ransom or by a retaliatory raid, they were said to have "u'mista." The aims of the Society are the u'mista of our history, our language and our culture" (U'mista 1980:n.p.). As founding director Gloria Webster (1992a:37) explained, it is the closest Kwak'wala term for "repatriation," but that "it also means the return of something important."

Both societies explicitly set out their goals in written charters. For the U'mista Cultural Society, they were

1. To collect, preserve and exhibit native artifacts of cultural, artistic and historic value to the Kwagu'l people.
2. To promote and foster carving, dancing, ceremonials and other cultural and artistic activities engaged in by the Kwagu'l people.
3. To collect, record and make available information and records relating to the language and history of the Kwagu'l people for the use of the Kwagu'l people.
4. To promote, build and maintain facilities for carrying out the above aims and objects.
5. To recover from other institutions and individuals artifacts and records of cultural, artistic and historical value to the Kwagu'l people. (U'mista 1980:n.p.)

The Nuyumbalees Society recognized the same combination of broad cultural goals for the running of a museum.[21] As their cultural liaison officer, Robert Joseph, expressed their mandate:

1. To secure funds, construct an appropriate building and re-patriate artifacts.
2. To operate and maintain the Kwakiutl Museum and provide services for the general public.
3. To broaden our on-going responsibilities and role as a museum for general public purposes, as well as to include a strong emphasis on becoming a cultural learning centre for Kwakiutl Indians to develop their heritage and culture to a meaningful level.[22]

While recognizing that the first two goals were well on their way to fulfillment, Joseph felt that more effort needed to be applied toward the final aim. Repeatedly, he has spoken out against what he regards as the material bias of governmental officials: "The Kwakiutl are not interested in building a monument."[23] They want to develop their cultural programs, but there is a lack of funds. The National Museum's primary financial contribution was the construction of the building, with meager funds for operating expenses.

Each society is governed by a board of ten directors. While neither is restricted to the dominant tribe of the respective towns—the 'Namgis in Alert Bay and the Ligwiłda'xw in Cape Mudge—according to the by-laws each is wholly Kwakwaka'wakw. One reason for this provision was that the museums had been established to receive artifacts confiscated from Native people, and thus there was strong sentiment that Natives should always maintain control. The membership is open to all, however, and both groups try to attract as many dues-paying members as possible. As in most corporate bodies, the boards formulate general policy and hire the staff to carry it out.

The staff in Alert Bay has been more stable than in Cape Mudge. After several years as assistant curator at the Museum of Anthropology at UBC, in 1977 Gloria Cranmer Webster joined the U'mista Society as curator, a post she held until about 1990. In mid-1978 the Kwagiulth Museum appointed George Mann director and Ruby Wilson curator. Mann, a white, had experience in Native education at UBC. Wilson, in charge

of the day-to-ay running of the place, was a Native from Cape Mudge, and her grand-father was one of those who gave up his regalia. As neither had any museum experi-ence at the time of their appointment, they received training at UBC and the Provin-cial and Campbell River museums. After Mann's resignation at the end of 1980, the society chose Gillian Delamer, another non-Native and anthropology graduate of UBC. Delamer served for one year. Perhaps because both directors were white, there was friction with the Native board, which led to this relatively rapid turnover.[24]

A problem for both museums has been a shortage of staff, directly attributable to a shortage of funds; given the multiplicity of tasks set out for the cultural societies, this is a severe strain. Both institutions have hired temporary consultants as needed and as funding has allowed. For many years Joy Inglis, trained at UBC and formerly at the Vancouver Museum, has been a consultant for the Nuyumbalees Society, active especially in their public programs.

Funding for the museums' construction and operation was overwhelmingly gov-ernmental. Each museum cost roughly half a million dollars to build, with about half coming from the National Museum's Museum Assistance Program. Other funds came from the province's First Citizen and Community Recreational Facilities Funds, and the federal Department of Indian Affairs.[25] In addition, logs for the big house sec-tion at Alert Bay were donated by local forest companies. Each museum received a three-year grant of $20,000 a year from the Museum Assistance Programme, with provisions for a seven-year extension. Operating costs are covered by receipts from the gift shop, admissions, memberships, small grants, and fund-raising events in the local community.

Clearly, such funding leaves these museums at the whim of bureaucratic fashions and priorities. To thrive, the Native museums must be successful lobbyists. Like all nonprofit institutions, these museums must orient their programs to their funding sources. The Kwakwaka'wakw cultural centers might wish to stress oral-performative programs over the display of artifacts, but the governmental perception of them as "museums" limits their activity. Still, by seeking a range of sources the cultural soci-eties have managed to accomplish much.

MUSEUM FORMS AND FUNCTIONS

Although a museum opening is not a traditional form of Kwakwaka'wakw perform-ance, the parallels between the openings of the two museums are striking. At this in-tensely meaningful time, it seems that the Kwakwaka'wakw had no problem decid-ing how to mark the occasion.

OPENING CEREMONIES

The syncretism of culture in Cape Mudge is evident from the first two events of the museum's dedication.[26] On June 28, 1979, the night before the opening, a potlatch was given. The first celebrated in the village in over fifty years, the event was spon-

sored by James Sewid and Harry Assu of Cape Mudge and Jimmy Wilson of King-come and was meant to dedicate the new 29-foot totem pole installed in the museum's central stairwell. The pole was carved by Sam Henderson and sons in memory of Chief Bill Assu, father of Harry. The next day's program began with the celebration of the 101st anniversary of the Walker Memorial United Church, a short walk from the new museum. The service was conducted in Kwak'wala as well as English, an expression of the church's mixed congregation from both the white and Native communities.

After lunch the group gathered at the shore for a symbolic welcome of visitors from other Kwakwaka'wakw tribes arriving on seine boats. Both hosts and guests, arrayed in ceremonial costume, sang and danced in greeting. Most of the guests arrived by ferry. Then all moved to the nearby community hall for more dancing, concluding with the Animal Kingdom dances from Gilford Island. The building was dedicated with the cutting of a square of cedar bark. Permission for this ceremony was given by the family that possessed it as a privilege. Held by four chiefs and dramatically split with a knife, the bark was then cut into pieces and distributed to guests. In former times, this cedar bark would have been worn as a head band; here it served as a memento of the occasion. The speeches, in Kwak'wala with some English interpretation, followed, and at one point a bald eagle dramatically flew over the assembly. As the museum was declared open, the first visitors were the Native elders. As the director said, "This is their museum and it's their stuff from the old days."[27] The rest of the crowd followed them into the building to view the exhibits, and the day ended with a lavish salmon barbecue.

With construction completed by late summer of 1980, the U'mista Cultural Centre began to plan for its November 1 dedication.[28] Opening day began with the formal greeting of the guests. As members of the 'Namgis band danced before the museum facade, guests from other tribes in ceremonial costume arrived on seine boats. Despite the contemporary replacement for earlier canoes, this was the traditional manner for the arrival of guests at a potlatch. Next, all assembled at the entrance to the center, where the chiefs, in traditional rank order, offered speeches. Mostly in Kwak'wala, the chiefs spoke of the originating events with sadness and of the return of the collection with joy. William Cranmer, chairman of the society, read the following statement:

> We dedicate the U'mista Cultural Centre to our forefathers, whose struggles and suffering during the years of potlatch prohibition have left us a legacy in which we can take pride. We recognize their greatness and value the rich history they bequeath us. The U'mista Cultural Centre is not a memorial to a dead past. It is a symbol of our survival and, in it, we strengthen the culture we might have lost, had not our forefathers been strong for us. As the speakers at potlatches say, "we do not invent anything, we just follow the path they laid for us." (U'mista 1980)

The honor of officially opening the building was given to elderly Agnes Alfred, one of the few survivors of those originally charged in 1922. Mrs. Alfred cut a strip of

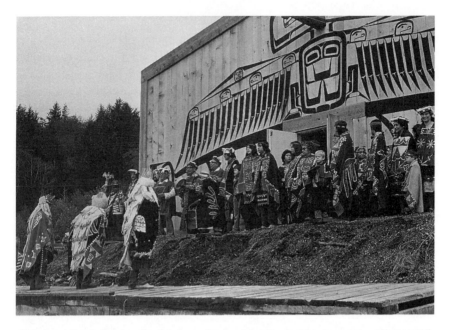

Figure 9.2. Chiefs dancing the tła'sạla or "peace dance," opening ceremonies, U'mista Cultural Centre, Alert Bay. Photo by Vickie Jensen, November 1980, courtesy of UCC.

dyed cedar bark stretched across the doors. After a brief tour of the exhibits, all proceeded to lunch. The final event of the day was a potlatch held in the community house. This was a closing of the circle: "As our treasures had been taken away as the result of a potlatch, it was fitting that a potlatch should mark the occasion of their return" (Webster 1981:12). And as the original potlatch had been given by the Cranmer family, so, too, was this one. Roy Cranmer sponsored the ceremonial in honor of his father and brother (see figure 8.10). At this time, the museum was presented with gifts for the collection.

Both openings shared a number of common features. As both museums are on islands, it was natural for the guests to make a formal arrival by boat—a traditional arrival for potlatch guests—followed by a ceremonial greeting. Throughout the program, traditional tribal divisions and rank-ordering were respected. The primary language was Kwak'wala, with English used only for commentary. There was a ritual cutting of cedar bark, similar to the ceremonial lighting of the first fire in the Alert Bay big house. Potlatches, not merely general tribal dances, were given by leading families of the respective villages, the Cranmers and Assus. Family privileges such as the cedar bark cutting were also recognized. The emphasis throughout was on the role of the elders, particularly those who had suffered personally under the 1922 proceedings. In general, these elements added up to a pronounced stress on ethnic heritage, particularly traditional social organization.

ARCHITECTURE

The form and siting of both museums hark back to traditional custom. Both are clad in cedar and placed on beach plots of reserve land. Before each stand totemic figures. And, following dictates of the National Museum, both structures follow modern principles of museum design, with spaces for display, storage, and processing under proper climate and security conditions. Yet in other aspects they present radically different approaches to the problem of the symbolic clothing of a Native museum (see Krinsky 1996:204–220). Henry Hawthorn, the son of Harry and Audrey, was the architect for the Alert Bay building, while the Cape Mudge museum was designed by Campbell River architect Alan Murnaghan.

Despite traditional elements, the Kwagiulth Museum at Cape Mudge marks a break with the past (figure 9.3). The entrance is vertical with a post-and-lintel doorway, as in earlier Kwakwaka'wakw buildings, and the materials are customary: rough-peeled fir poles support sawn beams, while cedar board-and-batten siding and roof shakes cover the exterior. But the design is unprecedented—the main gallery is round, with a central spiral staircase and a conical roof. This shape has a double justification. Practically, the progressively diminishing interior spaces house a range of objects from large totem poles (erected in the center) to small fishbone needles. But symbolically, the cyclic motion of the interior indicates "the forward motion and constant change in the Kwakiutl life style" (Joseph and Mann 1980:10). The shape was inspired by a sea snail, and though not of great importance in traditional Kwakwaka'wakw culture, the creature underscores the maritime culture of the Kwakwaka'wakw. But as two of its officers maintain, "One of the primary functions of the museum is to form a link between the past, the present and the future" (ibid.). Recognizing that a museum was not a Native institution, the directors of the Kwagiulth Museum felt its architecture should synthesize Kwakwaka'wakw and Western styles, marking its Western function and Native content. Its location in Cape Mudge is appropriate, as the reserve has long supported material and social innovations.

The U'mista Cultural Centre also makes a symbolic statement. In addition to its site on the beach, it stands before 'Namgis House, the central building for the 'Namgis Band. Built in 1929 as St. Michael's Residential School, it was turned over to the band in 1974. As Gloria Webster, the museum's curator, commented, "Our museum is new and symbolic of the new attitude of Indian people towards their own identity and the former residential school is a symbol of the old attitudes and approaches towards Indians" (Webster 1980:14). Although Webster maintained that the building "combines effectively traditional and contemporary aspects of the communities it represents" (ibid.), when contrasted with the Cape Mudge museum, what is striking is its traditional image. The focus of the building is a 40-by-50-foot section, modeled after a traditional plank house, holding the Alert Bay portion of the Potlatch Collection. There are four huge plain houseposts, a wooden platform running around the perimeter, and on the front, a door (normally kept closed) that opens out onto the beach. Naturally, there is no smokehole. The link with the past is made em-

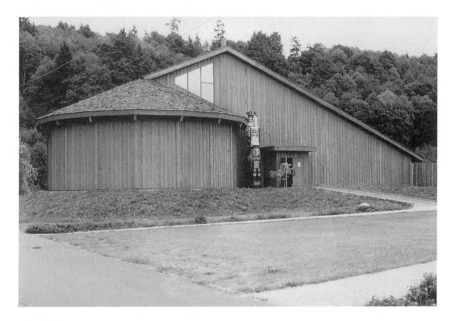

Figure 9.3. Facade, Kwagiulth Museum, Cape Mudge. Photo by Ira Jacknis, 1982.

phatically with the frontal painting. This is a nearly identical version of a famous and widely reproduced frontal painting from the house of chief Tla-glo-glass. Standing not far from the museum's present site in Alert Bay, the original was the first facade to be painted in the village, around 1874 (figures 9.4, 9.5).

The rest of the building forms a trapezoid sloping down to the big house section. In addition to the three galleries, there are three back rooms: one for receiving and storage, one for collection storage, and one for general use, particularly as a class-room. The space is completed by a curator's office and a reception area, including a gift shop. The sense of Native culture is underscored by the signs on the bathroom doors. In addition to the international graphic images for the sexes, the only other identification are the Kwak'wala words for male and female.

Both museums have thought of expanding by building adjacent big houses as a space for public programs. Alert Bay wanted to build two—one as a carving school and gift shop, the other as a classroom (Webster 1980:15). Cape Mudge hoped to use such an extension for potlatches and museum classes.[29] But given the severe funding constraints on these institutions, it will take time to bring such plans to fruition.

Compared with modern Western museums, both buildings evoke a strong Native symbolism in their use of cedar planking and the post and lintel. As building types, however, both structures are also fully modern instances of the "museum." Of the two, Alert Bay seems the more conservative, complete with a close version of an ear-lier Alert Bay housefront, while Cape Mudge is more abstract and idiosyncratic.

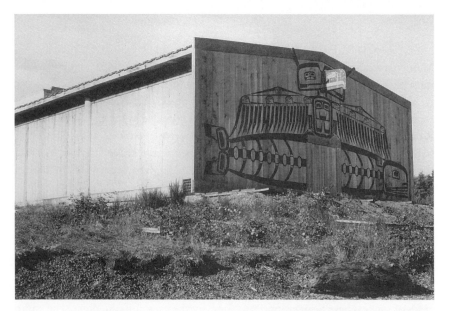

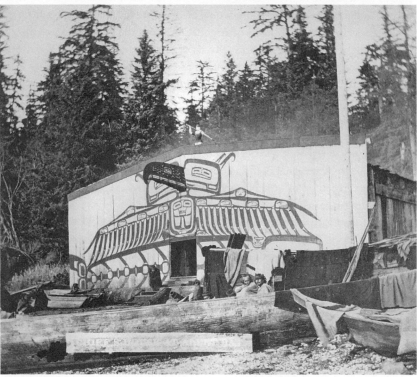

Figure 9.4. Facade, U'mista Cultural Centre, Alert Bay. Photo by Ira Jacknis, 1982.
Figure 9.5. Facade, house of Tla-glo-glass, Alert Bay. Photo by Richard Maynard, 1874. RBCM pn 2709.

COLLECTIONS AND COLLECTION POLICY

Museums acquire their collections by several modes: purchase, gifts, and loans. Like most museums, the Kwakwaka'wakw museums have little money to acquire objects, relying mostly on a combination of gift and loan. The U'mista Centre, like other museums in the country, was eligible to receive funds provided by the Canadian Cultural Properties Export Act, and in this way obtained a mask collected in the 1930s. The bulk of its collection, however, comes from the special case of repatriation. As noted earlier, from the white perspective this is viewed as a long-term loan, while the Natives regard it as a return of property.

Naturally, the core of both museums' holdings is the Potlatch Collection. Of the 750 objects confiscated, 313 items were turned over to the two institutions, divided about equally. Each museum expands its collections as opportunities arise, and both are continuing their efforts to secure the remainder of the collection, from European museums and private collectors. One suggested means, used by the Provincial Museum for acquisition, is to have replicas carved for exchange with the originals. Other kinds of replicas have been proposed to augment the museums' holdings. The entire Potlatch Collection in two museums would be duplicated, so that each could have a complete set. In their final stages of negotiations with the National Museum, the U'mista Society was holding out for such a set of replicas, funded by the Department of Indian Affairs, but such plans have not yet been implemented.

The Potlatch Collection is not the only group of objects given to the Kwakwaka'wakw museums. Several museums have donated pieces deemed more appropriate for them. Shortly before the Cape Mudge museum opened, two welcome figures returned to the village after spending two decades across the Strait in the Campbell River Museum, where they had been brought for safekeeping. They now stand outside the museum, several hundred feet from their original location.[30] In two instances of voluntary "repatriation," the National Museum of Canada gave the U'mista Centre a ceremonial board collected in Alert Bay by Franz Boas in 1889, and the Queen Charlotte Islands Museum "returned" a cedar bark ring originally from Kwakwaka'wakw territory. The Provincial Museum donated to each museum Native art that the province had commissioned and displayed at the Osaka World's Fair in 1970. The U'mista Centre received a set of four panels, carved and painted with mythic scenes, while the Kwagiulth Museum got a totem pole.[31] Both had been created by leading artists of their respective areas—Douglas Cranmer at the former and Sam Henderson at the latter—and both, by coincidence, were dedicated in November 1980. Both museums received presents, old and new, at their openings. In addition to transfers from museums, many contemporary artists also offered gifts: Tony Hunt gave the U'mista Centre a set of four hamatsa masks, and Bill Reid presented a print design that had been influenced by Kwakwaka'wakw graphic styles (Webster 1981:12). James Sewid gave the Kwagiulth Museum a set of old masks.

As the museum has evolved in the twentieth century, curators have come to see it primarily as an institution for the preservation of fragile objects. Although museums

are often forced to allow donors special and continuing privileges over their objects (such as how they are displayed), they prefer to have complete discretion over their disposition. Given the century-long alienation of Native artifacts from their owners, it is not surprising that for a Native museum to exist at all there would have to be some changes in "standard" museological practice. Accordingly, the collection policy of most Native museums has shifted from one based primarily on ownership to one based on loan. The Skeena Treasure House adopted this policy upon its inception. As Wilson Duff explained at the opening, these "heirlooms and treasures still belong to [the owners] and their families forever. Lending them to the Treasure House is a mode of safekeeping."[32] At the opening ceremony, each owner was given a certificate giving them the right to reclaim their objects at any time. During the first years of the Skeena museum, about half of the collection was on loan, from whites as well as Natives (Dawn 1981:105).

Because of the extent of collecting, when Native museums were being created in the 1960s and 1970s, they had few sources of old objects. Most Native museum collections do not come from pieces held continuously in Native hands. The 'Ksan Treasure House did have a small collection of old heirlooms, but most of the display consists of replicas, produced by the associated art school. The objects in the Makah Center, recovered from an archaeological site, had been in the community for centuries, but with their protective coat of mud, had lain unknown. The Kwakwaka'wakw collections had been removed to museum care as part of the potlatch proceedings, and thus their return was an act of repatriation.

Both museums store and exhibit family collections in current potlatch use. As Webster (1980:14) notes, "We feel this is a service we owe our people." Although the mode of ownership and donation differ from the practices of the Provincial Museum loan program, from a museological viewpoint, the net result is the same: parts of the collection are removed from the building to be used in Native ceremonials. These "extension" programs, by yielding somewhat on earlier museum imperatives of acquisition, allow a balance to be struck between the desires of individual owners and museums to maintain the objects.

DISPLAY

The inaugural exhibits in both Kwakwaka'wakw museums followed a Native logic, with the potlatch as the organizing principle for both displays of the Potlatch Collection, though interpreted in different ways.[33] The introductory section in both museums is a presentation of traditional tribal difference and distinction. In each, a series of historic images depicts villages of the twenty-three Kwak'wala-speaking "tribes." The photographs are mostly from c. 1880–1900, but some are from the 1950s, by which time the villages had been abandoned. Unlike Cape Mudge, Alert Bay has them mounted in rank-order, with an origin myth given under each group. As the curator explained, "Because the museum is for all the people in our cultural area and because each tribe in the area is different from all the others, we decided to focus on these dif-

ferences. Our older people feel that it is important that these tribal distinctions be remembered" (Webster 1980:14). Interestingly, the rank-order chosen was the late-nineteenth-century tribal order as recorded in Boas and Hunt. Thus there is an image of Fort Rupert, but not Alert Bay (the village at the mouth of the Nimpkish River is used for the 'Namgis). As this fact suggests, and as is known from ethnohistory, this order was in flux, at least until 1900 (Codere 1990:359).

At Cape Mudge, the exhibits begin outside. Near the entrance are several boulders, engraved with petroglyphs, moved from a nearby beach. To the side are three recently carved welcome figures and a large totem pole by Sam Henderson (dedicated to the memory of Chief Billy Assu). Upon entering the building, one passes two more welcome figures, which formerly stood in the village. On the ground level of the Kwagiulth Museum are the cases for the Potlatch Collection, laid out in gentle arcs because of the circular building. Near the entrance is a circular staircase leading down to an area for temporary exhibits and up to a small, partial balcony. Running the height of the stairwell is the 29-foot Henderson totem pole (Assu and Inglis 1989:107–108).

The exhibits at Cape Mudge are grouped according to the sixteen families who originally gave up material. Smaller collections share a case, while larger holdings occupy several. A few large objects—large masks, a sisiyut panel—are left uncased. Labels are not abundant. Each case bears a label for the respective owner and a numbered list of items, with basic identifications such as "echo mask" or "intruder mask." Scattered around are several general labels on the nature of the potlatch, types of potlatches, the order of events in the potlatch today, family groups, masks, coppers, and whistles. Befitting their professional design (by Bill McLennan of UBC's Museum of Anthropology, with additional help for the Provincial Museum), the displays in the Kwagiulth Museum are stylistically indistinguishable from those in urban museums. Labels are silkscreened and objects are lit with dramatic spots.

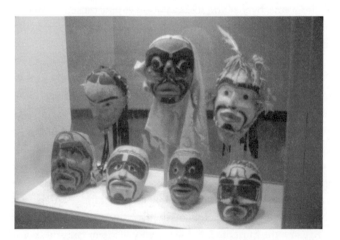

Figure 9.6. Exhibits at the Kwagiulth Museum, Cape Mudge. Photo by Ira Jacknis, 1982.

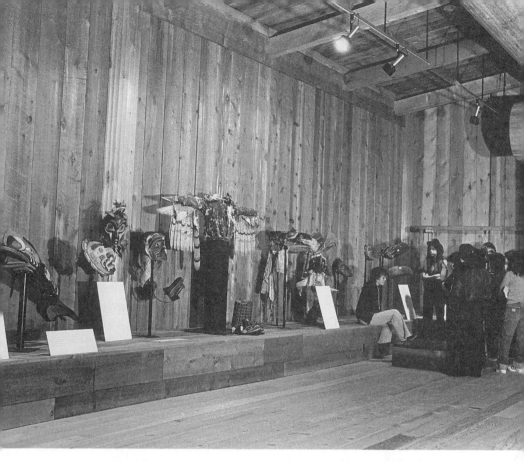

Figure 9.7. Exhibits at the U'mista Cultural Centre, Alert Bay. Photo by Vickie Jensen, c. 1981, courtesy of UCC.

Alert Bay has five exhibit spaces: a ramp and four galleries. Going down the ramp, after the tribal display, one comes to the first ramp case. Dedicated to the times and places of seasonal activities, it is based on oral history, the Boas/Hunt texts, and an archaeological survey of 'Namgis territory. The next two cases display some of the ceremonial objects on loan to the museum. One of the remaining galleries holds works made by earlier masters such as Willie Seaweed and Mungo Martin, while contemporary pieces are shown in two smaller galleries. Included here are several matted silkscreen prints made as potlatch gifts. All these spaces are for temporary displays. As the U'mista Centre was unable to obtain the designer it wanted, the installation was executed by its own staff, with the help of friends in the local museum community, and carried out with a limited budget (Webster 1980:14).

The Potlatch Collection, the only permanent exhibit, occupies the largest room, in the wooden big house section. As the U'mista Centre interprets the potlatch, the objects are placed, by type, as they would appear in the ceremony: first coppers, then masks of the three hamatsa birds, bears, eagles, wolves, dzunukwa, and xwixwi. Fol-

lowing are masks from the tla'sala, a series of dances involving supernatural gifts and family crests. The guide leaflet suggests that the visitors "enter the exhibit from the right, as a dancer does at potlatch ceremonies." Here the performance context is the basis for the logic of display. However, most of the labels concern not the ceremony, but the government's attempt to ban the potlatch, as described in letters, petitions, and reports, countered by Native testimony. In contrast to Cape Mudge's familial approach, here "on the advice of our older people, the objects have not been designated as having belonged to particular individuals, since identification labels given at the time the objects were taken did not always correctly indicate ownership" (U'mista 1980).

Unlike Cape Mudge, Alert Bay does not have any displays enclosed in glass cases, except in the ramp area. The Potlatch Collection is mounted on metal stands placed on cedar platforms. As the curator explained, when the artifacts were taken away they were locked up in storage. This was wrong, and it did not seem right to lock them up again upon their return.[34] Not all pieces in the Potlatch Collection are on display, however. Of their roughly eighty whistles in storage, U'mista's curator explained, they "were never seen anyhow. In Boas's literature, early informants said whistles were the voices of the birds and were not meant to be seen."[35]

Both museums have a space for temporary shows, usually staying for a month or two, and most of which come from other museums.[36] For instance, in the fall of 1981 the U'mista Centre displayed the "Hunt Family Heritage," which had opened at the UBC Museum of Anthropology. In addition to the traveling shows, in early 1981 the Cape Mudge museum opened an important exhibit produced by the museum itself: "Masks to Show our Powers: Woodcarvings from Campbell River, Cape Mudge, and Area." The show sought to draw attention to these seven artists.[37] Both museums have small gift shop areas, offering books, postcards, posters, and works of Native art—carvings, jewelry, and prints. None of the artwork is especially expensive, probably to attract tourist dollars.

Both museums have adopted, each in a different way, a Native style of exhibition. Logically, for both, the potlatch supplies the order for the display of the Potlatch Collection: by performance context in Alert Bay, by family context in Cape Mudge.[38] For the Potlatch Collection in Alert Bay, the display technology of Western museums is avoided—there are no cases and no labels for individual objects (although there are labels for contemporary pieces and cases for objects on loan). A Native logic is also followed in the nondisplay of whistles, similar to the absence of sacred masks in museums of the Pueblos or Iroquois.

Though there are extensive labels for the Potlatch Collection in Alert Bay, they are tied to the general, Native-defined context, not to specific objects. White visitors, especially tourists, often complain about the lack of labels directed toward them, toward their interest in the objects, explaining form, iconography, and use. The intended audience in the U'mista Centre is signaled by the use of Kwak'wala: for place and animal names in the case on subsistence, for place names under each village photograph in the introductory ramp, even for the restrooms.

Two early displays in Alert Bay stressed the maintenance of tradition. A case on subsistence showed traditional Native uses of land that is now leased by the province to timber companies. The point was made another way by the juxtaposition of works of the modern masters (Seaweed, Martin, and Price) with those created by young artists more recently. As explained by the accompanying leaflet: "One of the strengths of the Kwakwaka'wakw is that our artistic traditions did not disappear, as happened in other areas. There is a continuity between the early masters and our artists and craftsmen of today" (U'mista 1980). Of the galleries for contemporary artists, they say, "Not only do these contributions honour those who have gone before, but they also demonstrate the strong link between the past and present."

The style and content of these displays are a visual expression of the social process that gave rise to the creation of the Kwakwaka'wakw museums in the first place—the government's confiscation and the Native attempts to resist it.

PUBLIC PROGRAMS

It is in their nonartifactual programs that these Native institutions reach beyond the museum to the cultural center. While such programs might be called "outreach" in other museums, in Alert Bay and Cape Mudge they are central to self-definition, as can be seen in their audience, education (school/public programs), research, publications and media, and relations with artists and other museums.

Like all museums, the Kwakwaka'wakw centers have several audiences. Both welcome a large summer audience of tourists. During its first summer, the Cape Mudge museum had an average of fifty-five visitors a day in July and August, and half that number in September and October.[39] In addition to these tourists (many of whom come to Alert Bay on cruise ships), there are smaller numbers of non-Natives—local whites, visitors from the province and further afield in Canada and the United States—who are especially interested in Native art and culture. Even for the latter, their primary experience of the institutions is viewing the objects on display. In Alert Bay, all visitors are given a pamphlet with an general introduction to the potlatch and the history of the museum, the basic organization of the displays, and the society's goals. The resident Natives, however, are better able to take part in the range of nonartifactual programs. These patrons usually come in the winter months, which also coincides with the school year. It is in these programs that the societies distinguish themselves as cultural centers as opposed to mere museums.

Native-controlled education is important to the Kwakwaka'wakw, and in the mid-1970s the 'Namgis Band organized a program of instruction separate from yet parallel to the public school system. The new museum and cultural center has become the local resource for classes in Kwakwaka'wakw cultural heritage. For instance, the display on traditional subsistence in the Nimpkish Valley is labeled, "for our children." At the heart of this activity has been the center's Kwak'wala Language Curriculum Project. Between 1979 and 1981, UBC linguist Jay Powell helped prepare a series of thirteen books for use in the schools. Powell devised a practical orthography, allow-

ing the language to be easily written and typed. These books are used in both the Native and the public school systems.[40] The society has also offered adult language courses. During 1982, for instance, classes open to whites as well as Natives were held at the beginning and advanced levels. In the latter, texts included the publications of Boas and Hunt from the turn of the century.

Cape Mudge has run several public programs. One program that filled a need was a course in button blanketmaking. With the revival of ceremonialism in the area, there was a shortage of proper accoutrements, which this course helped alleviate. Two daughters of James Sewid, Dora Sewid Cook and Louisa Sewid Assu, taught two classes of twenty-four students over the winter months of 1982–1983 and 1983–1984. Two weeks after the blankets were completed, some of the women were taught dancing by Lucy Olney, another Sewid daughter (Jensen and Sargent 1986:28). Other programs directed primarily at Natives were short courses in carving and Kwak'wala. In the spring and fall of 1978, Joy Inglis taught a basketry class, and in the summer of 1982, the museum conducted tours of the adjacent petroglyph sites.

Both institutions have sponsored cultural research that they feel is being neglected by white scholars. In Cape Mudge, Peter Lando, a UBC anthropology student, was hired for two years of research on the split of the Potlatch Collection and, in prepara-

Figure 9.8. Pauline Alfred teaching the Kwak'wala language to school children, Alert Bay. Photo by Vickie Jensen, c. 1980, courtesy of UCC.

tion for an exhibition, on local carvers. During the summer of 1980, the U'mista Society sponsored an archaeological survey of the traditional territories of the 'Namgis, information from which was incorporated into its display on subsistence, and plans were made for expanding this survey to other tribal areas. In addition to their collections of artifacts, both museums are accumulating various kinds of archival and especially photographic documentation. Along with oral history audio- and video-tapes, these sources will serve as a kind of cultural memory for their people.[41]

Publications and other media are an important form of expression for both organizations. Both societies publish a newsletter for their members and interested outsiders. In keeping with the centrality of the 1922 confiscations to the establishment of both societies, each group has produced a document explaining its side of the events. In 1979 the Nuyumbalees Society published *Prosecution or Persecution,* a history of the anti-potlatch campaign and of the 1922 trials in particular, written by James Sewid's daughter Daisy Sewid-Smith. Based heavily on original documentation in the so-called Potlatch File of the Department of Indian Affairs, the book is supplemented with oral history and family photographs.

Even before the opening of the museum, the U'mista Society had produced the film *Potlatch . . . A Strict Law Bids Us Dance* (1975). Employing an innovative mix of documentary footage, still photographs, and dramatic recreation, the film tried to explain the potlatch and narrate the events surrounding the 1922 trials and confiscations. This was contrasted with a 1974 potlatch and the Native attempts to bring the artifacts home. Financed by a provincial grant, the film marked a new approach to Native cultural production. The society paid the filmmakers and receives the bulk of the royalties. As the director commented, "*Potlatch* is a film made *with* the Kwagiutl, not about them."[42] The U'mista Society uses this film, made to explain its mission and history, as a basic introduction for tour groups, especially for the large boatloads of tourists. The natural sequel of the *Potlatch* film was *Box of Treasures,* dealing principally with the museum's opening ceremonies. Also produced by the society, it has been widely shown at museums and film festivals in the United States since its release in 1983 (Morris 1994:123–136). Work on this film led in 1985 to a training course on videography so that the local Native community could record oral history, potlatches, and other important events (Webster 1990b:137).

An important constituency for both museums is local Native artists. One of the first programs of the U'mista Society was the sponsoring of a training program, funded for the first year by the Canadian federal government. Between 1977 and 1980 a group of young carvers, under the direction of Douglas Cranmer, helped build the Alert Bay museum by "milling the required planks, adzing the posts and beams for the big house, as well as painting the housefront design" (U'mista 1980). Since then they have worked informally, using the basement of the nearby band council building as a workshop. The original plans for the center called for an attached workshop, and there is still some sentiment for such a scheme, provided that the artists maintain their independence. Among the benefits of any plan to replicate the remainder of the

Potlatch Collection would be the creation of jobs for local carvers, as well as the opportunity for training. As in the other museums, these Native museums have served as artistic reference. Since their return to Alert Bay, at least two masks in the Potlatch Collection have inspired new works (Wyatt 1994:48, 118).

The Cape Mudge museum has worked in a similar fashion with local artists. The Henderson family of carvers has been especially active, one of its products being the museum's centerpiece, the totem pole in the stairwell. One important service was the exhibit of the work of seven local artists, for until this show the region's artists had not been the subject of exclusive scholarly research and exhibition. Both museums sell the works, mostly those less expensive, of local artists in their gift shops.

As for intermuseum relations, all museums are part of a kind of "museum ecology," a set of relationships with other institutions, near and far, large and small. These connections tend to be especially acute for the small and isolated Native museums. There is a structural parallel between Native and white museums in the two regions—Campbell River and the reserve on Cape Mudge and the village and reserve of Alert Bay. In both cases the white museums were founded around the time of one of British Columbia's centennials (1958), both are devoted to white as well as Native culture, and both shared quarters with libraries. (With a larger community, Campbell River's museum naturally has a larger budget and thus more active programs.)[43] The two Native museums, founded at the same time as a result of the repatriation effort, opened in 1979 (Cape Mudge) and 1980 (Alert Bay).

The museums at Campbell River and Cape Mudge actively cooperate. First, there is a complementarity of focus. The former includes white history and an archives, and its Native collections draw from the local Coast Salish and Nuu-chah-nulth, in addition to the Kwakwaka'wakw. Now that Cape Mudge has such a repository, whenever the Campbell River Museum is offered an object from the village it will try to send it across the strait, as, for example, the set of welcome figures taken from the village in the late 1950s and recently returned to the new museum. Campbell River has also assisted the Native museum at Alert Bay, for example, with its installation.

There seems to have been less interaction between the two local museums at Alert Bay. One reason may be that in Alert Bay the Native museum is the more advanced one. Its curator works full-time and can draw upon a bigger budget (because of support from federal and provincial governments). The Alert Bay Museum, on the other hand, is not separately incorporated but part of the library, and owing to limited facilities and staff, it maintains only a small and representative collection. Though there has been some thought of giving the Indian material to the U'mista Centre, much of it is on loan and is still controlled by the owners.[44]

In addition to these local relations, both Native museums have ties to provincial and federal institutions. As noted, the Provincial Museum and UBC Museum of Anthropology have offered help in the training of curators, the design of exhibits, conservation, and in many continuing services and favors. Because of the special circum-

stances of founding by repatriation, the National Museum of Canada was particularly obligated toward them, giving the bulk of the funding for initial construction and for operating costs. These Native museums, in turn, play an active role in professional organizations such as the B.C. Museums Association.

NATIVE MUSEUMS ON THE NORTHWEST COAST

While Native museums are a fairly recent phenomenon, they have respectable roots on the Northwest Coast. The earliest known precursor comes from the Tlingit village of Kluckwan, Alaska, around the turn of the century. The treasures in the Whale House were stored in a cabin, where they were sometimes shown to visitors for a fee (Cole 1985:260). Although it was not a Native-run museum, in the early 1930s the educator and collector Axel Rasmussen bought Chief Shakes's house in Wrangell, Alaska, which he used as a museum to house his collection. The site was frequently visited by Tlingit, who offered comments on the pieces (Gunther 1966:175–177).

The earliest Native museums in British Columbia were in the Skeena River Valley. Perhaps influenced by the totem pole preservation efforts, John Laknitz, from Kitwanga, opened his house in 1925 as a museum, displaying his regalia. As Harlan Smith reported:

> His little museum was visited by many tourists, but was closed a year later on the death of its owner. Soon afterwards, however, his father Jim Laknitz opened his own house, a much more suitable place. Its large size, its fire-place, smoke-hole, and two large ridge-poles with four carved house posts . . . are typically Indian features, although the pitch of the roof, the shakes, [etc.] . . . are modern in character. Inside are a large number of excellent old Gitksan specimens.[45]

Evidence from old photographs leads Dawn (1981:28) to believe that by the 1930s this house was no longer used as a museum, as "native cooperation waned."

Perhaps these early efforts led to the development of the first Native-run museum in British Columbia. The Gitksan of Hazelton, with local white cooperation, built the Skeena Treasure House, a combined museum and library, which opened in June 1960. During the 1960s, plans were made to expand this single building into an outdoor "village," and in August 1970, 'Ksan, a six-structure complex, was formally opened. The success of this museum and its associated art school did much to stimulate Native museums in the province (Dawn 1981).

Another model for Native museums in the region, especially in the United States, was the cultural center and museum of the Makah, a Nootkan-speaking group living at the northwest tip of Washington State. In 1966 Richard Daugherty of Washington State University began extensive archaeological excavations at Ozette, a former village site that had been covered by a mudslide over 400 years ago. The Natives insisted that all recovered remains—including a range of perishable wood and basketry materials—stay on the reservation, and so, beginning in 1973, plans were made

for a museum. In 1979 the Makah Cultural Research Center opened to the public in Neah Bay, the principal Makah village (Hughes 1978; Kirk 1980).[46]

There has also been museum activity among the Nuu-chah-nulth, a group neighboring the Kwakwaka'wakw. In the early 1970s the Provincial Museum ran a multidisciplinary program on the reserve of the Hesquiat band, a Nuu-chah-nulth group on Vancouver Island. Both the linguistic and the archaeological programs had important components of Native advice and control. As in the Makah dig at Ozette, all archaeological specimens remained in Native hands, leading to plans, as yet unfulfilled, for a museum on Nuu-chah-nulth territory. Although there is strong sentiment for such a project, the major problem seems to be the site, and one suggested solution is to have a decentralized institution.

In the early 1970s the Provincial Museum noted that, "predictably, the success of the pioneering Hesquiat Project has aroused the interest of several other Indian Bands in the province, at least six of whom have communicated with us regarding comparable programmes of their own" (Annual Report for 1972:91). Many of these projects never came to fruition; others took years to complete. Among the few Native museums established in that decade were a Haida museum on the Masset Reserve, no longer operating, and the one-room museum in Waglisla run by the Heiltsuk, a northern Wakashan group.

Since the opening of the two Kwakwaka'wakw museums, several more Native museums have opened in British Columbia. Two of the largest are the Cowichan Nation's Native Heritage Centre in Duncan and the Secwepemc Native Heritage Park on the Kamloops Indian Reserve. The former has four longhouses, with an introductory gallery, a display featuring the local Cowichan sweaters, a sales gallery, and a large carving shed. The Secwepemc Native Heritage Park sits on the site of an ancient village, on the banks of the South Thompson River. Here the Secwepemc (Shuswap) have constructed two summer lodges and four winter kekuli (pithouses), a salmon-fishing station by the river, a traditional food plant garden, and a museum and gift shop housed in the former residential school.[47]

The establishment of Native American museums has recently become a major museological trend (Horse Capture 1981; West 1999). Although the Cherokees of North Carolina had a museum collection as early as 1828 (Hanson 1980:45), most date from the 1960s and 1970s, spurred by the civil rights movement and growing Indian pride.[48] There was another spurt of growth in the 1990s, this time aided by gaming revenues. By the early 1980s there were over 100 museums in North America operated by Native Americans, and in 1994 a Smithsonian Institution museum program listed over 200 (Simpson 2001:137). Whether combined with repatriation or not, their formation reflects the postcolonial crises in anthropology and the rise in feelings of Native autonomy and sovereignty. Their founding has also been related to the increase in community development projects on economically depressed reservations, funded often by federal money. Invariably defined broadly as cultural centers, these small tribal fa-

cilities have served as forces in cultural preservation. On the Makah reservation, for example, there has been a revival in carving and basketry (Kirk 1980:8). More important, these museums present Native culture as the Native people wish it to be seen. Far from being a special case, the two Kwakwaka'wakw museums are central examples of an important movement.

CULTURE AND HISTORY IN THE KWAKWAKA'WAKW MUSEUMS

The museum has been good for the Kwagiulth people. Our people who want to learn about native customs come to the museum. When the Ainu or Hawaiians or other people come to visit, we bring them here. Many of our young people have been trained to teach school classes and the public in the museum. They are learning the Kwak'wala language, and there is carving, dancing, button-blanket-making, and work with cedar bark. They learn about the potlatch and how everything was used. The elders teach it to the kids. One of the museum programs won first prize for a program in the schools. . . . I think that getting our potlatch goods back has done a lot to teach our youth who we really are. It will help us to hold on to our history. (Chief Harry Assu, in Assu and Inglis 1989:108)

Museums are uniquely Western institutions, particularly of the modern West. Yet notions of preservation and display are not foreign to many Native cultures. When defined as the "storing of objects of value, of exhibiting them to persons other than their producers and of being a structure that is itself valued because of how it is used and what is in it" (Mead 1983:98), then there are many indigenous parallels. Sidney Mead has discussed the Oceanic examples of the Maori meeting house and the Melanesian men's or custom house. Northwest Coast cultures, of course, carefully preserved ancestral objects of great aesthetic power, to be displayed at important public occasions. In this, as in so many areas, the Kwakwaka'wakw were "preadapted" for adopting exotic modes of cultural expression (in a kind of reverse primitivism). Another kind of intermuseum relation exists between the two Kwakwaka'wakw museums, however, especially in their relation to the past.[49]

The two Kwakwaka'wakw museums get along well, on both a professional and personal level. Each helped the other prepare for its respective opening, and at the event itself each cultural society presented the other with a gift for its collection. Yet, considering their history, it is not surprising that the two museums share a sense of distance as well as solidarity. The split of the Potlatch Collection into two was just the latest expression of traditional rivalries between the northern and southern Kwakwaka'wakw. In the traditional rank-ordering of potlatching positions, the 'Namgis (at the mouth of the river bearing their name and later at Alert Bay) were ranked near the top, while the Ligwiłda'xw of Cape Mudge were near the bottom. These communities are also home to the distinct dialects of Kwak'wala and Lik'wala, respec-

tively (Anonby 1997). These groups led the two factions that demanded the collection be split.[50]

Alert Bay and Cape Mudge-Campbell River also differ in the size and makeup of their Native populations—the primary audience for the respective museums. When the museums opened, there were about 330 Kwakwaka'wakw in Cape Mudge, with another 800 living in Campbell River (both on and off the reserve). In Alert Bay alone, there was a Native population of about 800 living on the largest Kwakwaka'wakw reserve, and there are other neighboring Kwakwaka'wakw communities, especially at Port Hardy (not far from the village of Fort Rupert). Both Alert Bay and Cape Mudge-Campbell River are home to Kwakwaka'wakw people from diverse tribes, resulting from heavy intramigration since World War II (Pineo 1955). Predictably, Alert Bay and nearby Port Hardy have received more from the northerly groups, and the Cape Mudge-Campbell River area has accepted more from the south.

Both Native museums have played a key role in the recent cultural revival, although to different degrees. Confronted with a colonial situation, the people at Cape Mudge decided they could thrive by following the ways of the white man; they gave up many of their traditional customs, particularly ceremonialism (Inglis 1964). Reportedly, before the opening of Kwagiulth Museum, no potlatches had been held in Cape Mudge for over fifty years.[51] Now that they have established a museum dedicated to their traditional culture, many in the community may rely more on objective sources—museum collections and ethnographies—to supplement their knowledge of these old ways. The Kwagiulth Museum, along with the neighboring Campbell River Museum, has been their principal source.

The museum at Cape Mudge represents the culture of the community's grandfathers, of their ancestors (see Mauzé 1983). Except in a special way, it does not represent the culture of today; art and ceremony are not the village's daily concerns. Rather, it has one of the biggest Kwakwaka'wakw fishing fleets. This "progressive" attitude helps explain its Western-style museum. By contrast, the U'mista museum has had less of an impact on the Alert Bay area because of the greater retention of traditional ways. While Native ceremonialism had declined in Alert Bay, with its strong mission influence, the reserve always had ties to more outlying communities, many of whose populations have since settled there. Still, much was being lost, and programs like the language project are keeping parts of the culture alive.

Both museums now represent a restricted sector of Kwakwaka'wakw culture, akin to the ritualization of the salmon barbecue or big house. Potlatches, with their associated dancing and artifact-creation, continue. These museums represent a new kind of cultural expression for the Kwakwaka'wakw, though one that has been in preparation for over a century. They must be understood against the confrontation with white culture, responding first to the combination of white cultural oppression and scholarly curiosity, and second to Native attempts to portray their culture to this still-dominant ethnic group. Now they fulfill real needs, given the continuing threats to their traditions from Western culture.

The biggest difference between a Native museum and those of whites dealing with the same culture is, clearly, its reflexivity. While some media are addressed primarily to whites, as in the two films, others are aimed mainly at Natives, such as the language booklets. Forms such as the exhibits speak equally, though differently, to both audiences. Yet Native curators are adamant that their primary audience is their own people, particularly the children. While they are also concerned that whites learn from their presentation, this is secondary. In this intracultural rather than cross-cultural goal, Native museums are much more like Western museums dedicated to history rather than to anthropology.

The importance to the Kwakwaka'wakw of the historical narrative embodied in the Potlatch Collection is evident from the representations produced by the two cultural societies—exhibit labels, books, and films. During the 1970s, the societies produced accounts of the repatriation story, which they hoped would educate the world about their culture and their claims, thereby bringing about the return of the Potlatch Collection. A key feature of the *Potlatch* film was the footage of a contemporary potlatch given by the Cranmer family, thereby making a claim for the continuity and legitimacy of the Kwakwaka'wakw potlatch in general and the Cranmer family in particular. Both this film and the *Box of Treasures* sequel included much oral testimony from elders concerning the events of 1921–1922. In all these representations, the witnesses served as a physical and moral link between past and present, demonstrating the continuity of Kwakwaka'wakw culture during the enforced absence of the Potlatch Collection.

The label copy at the U'mista Cultural Centre also focuses on this story. In both museums, the potlatch is taken as the organizing principle—the sequence of mask presentations at Alert Bay and family ownership at Cape Mudge. In Alert Bay, to the surprise of many white visitors, the text panels do not speak primarily of the artifacts themselves or of the potlatch ceremony but instead trace the story of the Potlatch Collection confiscation. Exhibit labels and films are different means by which the Kwakwaka'wakw tell their version of the repatriation narrative in an otherwise static museum setting.

Almost by definition, repatriation cases invoke a sense of history, as they encompass ethnic relations in the past and in the present and the changes in these groups over time. As Bruner (1986) has pointed out, for contemporary Native Americans and anthropologists the story of intercultural encounter over the past century has a specific plot. As in the Kwakwaka'wakw repatriation case, there has been a shift from a belief in culture loss and the necessity for salvage to a perception of continuity and resistance. Both of these sides seem now to be working within this paradigm, but it is essential to remember that this is a story, a way of making sense, a reading of history, and not "history" itself. As such, there are apt to be divergences among each group and surface commonalties that mask underlying differences.

One would expect narratives to be conceived in terms of a Native style, logic, and preoccupations. As the Kwakwaka'wakw are a society founded on rank and ancestral

privilege, it should not be surprising that they possess an extensive body of oral literature that narrates family histories. *Nuyem* ("myth" or "history") are largely concerned with ownership of objects, resources, and privileges. An important subgenre, the house story, focuses on continuity: "The importance of the chiefly crests and privileges acquired in the stories is that they *did* exist at the beginning of time, and have been handed down to the present unchanged" (Berman 1992:148). These themes of continuity are the substance of much of the oratory at potlatches (Boas 1966:212, 216–217).[52] Transposed to another level, the idea of a *nuyem* family history has been secularized and shifted into postcontact times. Where it had once accounted for the genealogical relation of a privilege-holder to an ancestor active in mythic times, a narrative was now traced between the present-day descendant and the Kwakwaka'wakw person who had given up his or her regalia in 1922. Although at some points in the repatriation negotiations there was a sentiment for making an even and arbitrary split in the collection, the Nuyembalees Society insisted on tracing, as far as it was possible, the actual history of each piece and determining specific descendants (Saunders 1995:43–44). It was these histories and relationships that were then demonstrated in the family groupings of the inaugural exhibit.

Significantly, repatriated objects rarely return to the original owners but to their descendants. The facts of individual cases may differ, but questions of legitimacy and continuity inevitably arise. For the Kwakwaka'wakw, claims of cultural continuity are now central to statements about their history. As Gloria Webster proclaims at the end of *Box of Treasures*: "We are still here, and will always be" (U'mista 1983). The issue has been made relevant by the very denial of their cultural autonomy and history by nineteenth-century whites—by both missionaries and anthropologists, though in different ways. As well, the Kwakwaka'wakw are very aware of the substantial loss of culture and discontinuity in potlatching by their Native neighbors such as the Nuu-chah-nulth and Haida (Webster 1991, 1995).[53]

The Kwakwaka'wakw are also aware of the fragility of their cultural traditions and of the struggle to hand them down to succeeding generations.[54] Recognizing "the significant loss of knowledge" during the period the period 1921–1951, Kwakwaka'wakw refer to it as Luł paḏax'idan's 'nalax, "when our world became dark" (Webster 1995:193). As Chief Harry Assu wrote, "I think that getting our potlatch goods back has done a lot to teach our youth who we really are. It will help us to hold on to our history" (Assu and Inglis 1989:108). Gloria Webster spoke in similar tones in *Box of Treasures*: It is important for the children "to know who they are." Speaking at the opening of the U'mista museum, her brother, Chief William Cranmer, said, "It's important to know your past if you are going to fight for your future." Cranmer was referring not just to art or language, but to all the group's contemporary grievances, such as land claims and fishing rights.

While it may be tempting to see their founding as an influence of anthropologists on Kwakwaka'wakw culture, all the evidence suggests that these institutions are almost wholly the result of Native initiative. There was no strong anthropological sen-

timent for the founding of the museums; in fact, there was resistance to it for quite a while. Although Webster had museum training and later assistance came from Vancouver and Victoria, the existence of these museums really flows from a long independent history of Kwakwaka'wakw cultural activities. While the idea of a museum and its implementation were originally foreign, the Kwakwaka'wakw have made it their own, giving it a shape and function that can influence their sister institutions in the West. These Native museums are thus perfect examples of the complex blending of Western and Kwakwaka'wakw traditions in the anthropological encounter.

EPILOGUE

Continuity and Influence

B y the early 1970s, many people—anthropologists, art critics and historians, deal-ers, and perhaps even some Native artists—believed that Northwest Coast In-dian art was undergoing a renaissance (Cocking 1971; Vastokas 1975). Based on the model of European history, this renaissance was seen as a revival of an earlier classi-cal period following a "Dark Age." Despite some recent questioning of this model (Reid 1993; Jonaitis 1993), at the time a renaissance was strongly perceived. I want to evaluate both the perception and reality here.[1]

As already discussed, anthropologists have been slow to acknowledge the viability and continuity of Kwakwaka'wakw artistic traditions. Convinced that "what little there is left of native culture is disappearing rapidly," Boas reported in 1899 that "it is rather difficult nowadays to obtain good works of art of these Indians [Kwakiutl]. During my last few trips I have hardly seen any thing that can compare with the good old carvings."[2] These sentiments persisted; around 1930 Harlan Smith reiterated, "I guess the days for getting specimens are drawing to a close rapidly. . . . Most seems [sic] to be gone now."[3] As late as the 1950s Erna Gunther was writing: "Northwest Coast Indian art is today as much a matter of the past as the art of the Renaissance," and "The culture which [the Indian] had is gone. We can't bring it back. We've taken the heart out of it, and once that has happened it is almost impossible to restore it to its own old form." Rooting her approach so deeply in the social context, Gunther be-lieved that acculturation had irrevocably destroyed the art as a living force.[4]

Yet the anthropologists of the 1950s had to admit that the Kwakwa̱ka̱'wakw artistic tradition had survived, even if just barely. Many viewed Mungo Martin as the last of his kind. According to Harry Hawthorn, he seemed "an awfully frail old thread for this terrific tradition to depend on." Haida carver Bill Reid wrote that "after he's gone, it's unlikely that anyone will be qualified to carry on his work. . . . Neither the inspiration nor the skill remains, and any results must be only inferior copies."[5] While aware of the incipient revival, Gunther (1961:218) felt that the works of Mungo Martin, Bill Reid, and Bill Holm were "a new art." They were "more creative on the basis of Northwest Coast art, rather than a continuation of the tradition."[6]

By 1967 and the *Arts of the Raven* exhibition, this view had been challenged: "The Kwakiutl style never did suffer a full eclipse, but was kept alive by such artists as Charlie James, Mungo Martin and Ellen Neel. Today in the hands of Henry Hunt and Tony Hunt of Victoria, Doug Cranmer of Vancouver, and Henry Speck and many others in the Kwakiutl villages, it is continuing as always to find new expressions" (Duff et al. 1967:n.p.). Wilson Duff and his colleagues added, however, that "the old Indian cultures of the coast are dead, but the art styles continue on in new and modern contexts." By 1973 Peter Macnair was much more positive, claiming that "of all the tribal artistic traditions found on the Northwest Coast, that of the Kwakiutl alone has remained uninterrupted" (Macnair 1973b:184), a position he amplified and documented in *The Legacy* catalog (Macnair et al. 1980:71).[7]

How can we account for this striking change in anthropological viewpoint? The current burst of artistic activity since the mid-1960s is undeniable, but there are two possible explanations. Was this a true renaissance after a break in tradition, or was it merely a fluorescence, a rapid growth in a continuous tradition (a renascence, in Panofsky's [1960] terms). In other words, was the Kwakwa̱ka̱'wakw tradition viable and continuous and merely misperceived by earlier anthropologists? Or was it virtually dead at some point in the past and brought gradually back to life?

As early as 1977, Philip Drucker was calling attention to the anthropological support of Mungo Martin and other Northwest Coast artists (Drucker 1977:91). He wondered what part museums and anthropologists had played in the putative continuity (or "revival") of Kwakwa̱ka̱'wakw ceremonialism. Lacking any hard data, Drucker could only raise the question. More recently, Michael Ames (1981a) has offered an initial overview of the impact of anthropologists and museums on the arts of the Northwest Coast, and the present study attempts to document this problem in greater detail.[8]

Though related, continuity and influence are two separate questions. In order to answer the latter, one must first examine the former. Evidence for the continuity of Kwakwa̱ka̱'wakw artistic traditions comes from several sources: the history of carving (most forcefully in Willie Seaweed's work), but also in the erection of totem poles, the Native retention of old artifacts, and records of ceremonialism.

Questions of continuity and influence seem inevitable when one considers that so many of the current artists trace their training back to Mungo Martin (Macnair et al. 1980:73–74), and that in the last decade and a half of his life Martin was sup-

ported thoroughly by the museums in Victoria and Vancouver. If Kwakwaka'wakw art did undergo a revival, it is natural to think that, as the source of "classical" artifacts, museums would have played a crucial role. Perhaps anthropologists were right—Kwakwaka'wakw art was in danger of extinction and their museum programs brought it back to life. A separate but related question is whether there is any connection between the current "revival" and the founding of the two Kwakwaka'wakw museums.

In the early 1950s when Mungo Martin began to work in Vancouver and Victoria, the anthropological estimation of his talents was unbounded. Harry Hawthorn believed that Mungo Martin had "done magnificent work, probably the best work in Southern Kwakiutl tradition that has ever been done." Of Martin's two new poles, he wrote: "These are perhaps the finest examples of Kwakiutl carving ever made." Some broadened Martin's expertise to the entire region. Speaking for the UBC Totem Pole Committee, Hunter Lewis claimed that "there is no carver at present . . . whose skill is known to equal that of Mungo Martin," while Wilson Duff stated flatly that Martin was "without doubt the finest carver still alive on the coast." And one could go on.[9] By 1980, however, estimates had become more considered. As Peter Macnair wrote: "Martin . . . was almost singularly responsible for the revival of Northwest Coast art, for he brought it to wide public attention during the last two decades of his life" (Macnair et al. 1980:73). Macnair's statement is very interesting, for the first clause seems to attribute to Mungo Martin the culture hero role, while the second stresses not so much the carving itself but his publicity of it, an undoubtedly fairer estimation of his role.

Building on earlier traditions, Charlie James seems to have created a modern artistic style associated with the two centers of Kwakwaka'wakw innovation and acculturation: Fort Rupert and Alert Bay. This carving style was carried on by his stepson, Mungo Martin (who was only about eleven years younger than James). Martin began carving around 1900, and his first major commissioned totem poles were created about a decade later. After another decade of ceremonial productions, Martin's career changed radically. While all biographies agree that Martin became a full-time commercial fisherman, from the early 1920s to the late 1940s, there is some uncertainty about the place of carving in his life. Duff (1959:37) claims that Martin was a carver for "most of his life," while Hoover and Neary state that "he had been a practicing artist all his life" (Macnair et al. 1980:185). His student Tony Hunt is adamant that Martin "carved all his life" (and that "there was no revival. Perhaps there was a bit more involvement with the public. . . . It was very important that the history or tribal style of the Kwakiutl never died") (Hunt 1983:266).[10] Although detailed evidence on Martin's work in this period has not yet been brought together, Nuytten's (1982:77) estimate, that Martin did "the small amount of carving for which there was still a demand," is perhaps fairer. After all, carving was never a full-time profession, and commercial fishing only occupied part of the year (Holm 1983:33).[11] For example, a number of ceremonial works have been attributed to Martin around 1940.[12]

For the most part, Mungo Martin's three principal students—Henry Hunt, Tony Hunt, and Douglas Cranmer—all learned independently from each other. (Ages and artistic generations on the Northwest Coast are often skewed. While Henry was the father of Tony [nineteen years older], Martin taught both at about the same time.) Henry Hunt, in turn, taught his son Richard, and Tony Hunt instructed many others in the Arts of the Raven studio. Douglas Cranmer taught Roy Hanuse, Larry Rosso, and the "U'mista" carvers in Alert Bay: Bruce Alfred, Fah Ambers, Richard Sumner. Beau Dick, an eclectic artist, studied with several teachers, including Cranmer and Henry Hunt. Though these artists differ somewhat in style, clearly they represent a continuous line of transmission.

The best evidence for the continuity of the Kwakwaka'wakw carving tradition comes from Bill Holm's (1983) careful research on Willie Seaweed. Holm has shown that Seaweed was only the leading figure of a community of artists in the isolated Blunden Harbour and Smith Inlet area, and Macnair (Macnair et al. 1980:96) has stressed the importance of artists of the George and Walkus families. Willie Seaweed continued to create masks, totem poles, rattles, screens, and other ceremonial art throughout the "Dark Ages" of the 1920s, 1930s, and 1940s, with his last hamatsa mask dating from 1954. Like Martin and the Hunts, Willie Seaweed and his local colleagues handed down their skills to their sons.

Continuity is thus a matter of training as well as activity. While many carvers—such as Charlie James (c. 1867–1938), Dick Price (1880–1936), or Arthur Shaughnessy (1880–1946)—were active between 1920 and 1940, this period was late in their lives. Mungo Martin (c. 1885–1962) and Willie Seaweed (c. 1873–1967) were roughly of the same generation as these men, yet their special role came from the circumstances of survival and contact. One also needs to look at those in this period who were still in their youth or middle age—James Dick (1900–1979) and Henry Speck (c. 1909–1971)—and then were able to carry over their skills to a younger generation in the 1950s—Henry Hunt (1923–1985) and Douglas Cranmer (b. 1927).

Totem poles, as public displays, supply some of the most decisive data on Kwa-kwaka'wakw continuity. Poles were erected almost continually throughout the "Dark Ages": the Seaweed pole at Kingcome in 1936, a Tom Patch Wamiss pole in the Alert Bay cemetery in 1941, and possibly the B.C. Packers pole in Alert Bay in the early 1940s. Slightly later poles were the 16-foot pole carved by Ellen Neel for UBC in 1948, Mungo Martin's UBC poles of 1952 and his Victoria house and pole of 1953. No poles were erected in the Alert Bay cemetery between 1941 and 1970, when Tony and Henry Hunt carved the Mungo Martin memorial pole.[13] If one looks only at Alert Bay, there was a gap of three decades, but when all Kwakwaka'wakw totems are considered, the gap was a matter of about a decade. Either way, it was not an excessively long period, in both cases well within an individual's memory and life span.[14]

Continuity is an issue that can apply to knowledge as well as behavior. Although the documentation may not be as detailed as one would like, it is clear that Willie Seaweed and other Blunden Harbour artists continued to create throughout the first

half of the twentieth century. Others, like Mungo Martin (and possibly Sam Henderson and James Dick), carved relatively little, but retained the knowledge, which was drawn upon when invoked in the 1950s. Although Charlie James carved several totems during the 1920s for the Alert Bay cemetery, he seems to have gradually given up ceremonial carving in the 1920s and 1930s for the production of tourist poles. And some gave it up entirely.

Cultural and artistic continuity, however, concerns more than the creation of new objects. Even with a break in new production, continuity could occur through the retention and use of old objects. To what extent was this done by the Kwakwaka'wakw during the Depression? Evidence such as Native testimony, the dates of museum collection, and photographic documentation (see chapter 1) reveals that Natives still retained significant amounts of paraphernalia until the late 1950s. The case for ceremonial continuity is much the same as for artifacts; in fact, indications are that it thrived to a greater degree than the production of new objects. Writing before her fieldwork, Helen Codere (1950:117) concluded that the winter ceremonials had effectively ceased around the turn of the century, but Bill Holm's (1977) extensive research has shown that aside from structural changes of simplification and condensation, the ceremonial tradition has been unbroken. In fact, recently there has been a resurgence in activity and an increase in ceremonial complexity.

These anthropological misperceptions contained an element of truth; remember that Martin himself thought that his 1953 house-opening potlatch would probably be the last one given. It is clear, however, that the Kwakwaka'wakw artistic tradition was continuous. Some of its strands may have been broken, and others weakened (particularly the Fort Rupert-Alert Bay substyle, its best known variant), but when looked at as a whole, it was continuous. Strong documentation of its viability exists up to the mid-1920s and after 1950, so even if it had been broken, it would have only been a matter of a few decades, well within a generation (the life span of a single carver).

The irony is that the artist who supplies the best evidence for continuity, Willie Seaweed, is also one of those who was least involved with anthropologists. Similarly, James Sewid's efforts to stimulate cultural presentations in dances, the June Sports, the cemetery restoration, the Big House, and the founding of the Kwakwaka'wakw museums had virtually nothing to do with anthropologists (beyond telling his life story to Spradley). The implications of this situation are significant.

What, then, were some of the influences of anthropologists on Kwakwaka'wakw art? The fundamental question of their influence on continuity has been answered. Did they revive it by hiring Mungo Martin? No, even apart from Martin, the Kwakwaka'wakw artistic tradition has been uninterrupted, though anthropologists greatly encouraged it. Yet there were a host of secondary influences implicated in their "invention" of Kwakwaka'wakw culture.

The anthropological encouragement of archaism is pervasive and well documented, the most definite and significant example of anthropological influence. Harry Hawthorn's active support was vital in redirecting Kwakwaka'wakw art away from its

then-current all-over enamel style to a restrained matte finish. Wilson Duff continued the effort with his help in developing a distinct totem pole paint. Though not as decisive, Peter Macnair continued the trend in his encouragement of Henry Hunt's experiments with bare wood. Though all these developments took place in a museum setting, the anthropologists were rarely directive in a heavy-handed manner. Rather, the outcome was a mutual product of Native initiative and anthropological stimulation. A perfect illustration of this, not from a museum context, was the archaic ceremonial revival stimulated by Bill Holm's play potlatches.

Archaism is also a matter of personal artistic preference, such as Beau Dick's appreciation of patina (paint rubbed off masks to simulate wear). In fact, artists refuse to be tied down, and recently there has arisen a kind of revisionist or "reverse archaism." Richard Hunt, who learned the Hunt family style in the early 1970s, exclusively used a matte paint in his early work. By the late 1970s, however, he had begun to produce pieces with shiny enamel (e.g., Macnair et al. 1980:120, 168), which was Hawthorn's middle-period style adopted by Martin and Seaweed and had replaced an earlier use of natural pigments. Other Kwakwaka'wakw artists now feel free to use enamels when they choose (e.g., Bruce Alfred; see Coe 1986:258–259). Issues of artistic influence are the same for Natives as they are for Europeans—it is a creative reaction, not a passive impression (Baxandall 1985:58–62). Artists always have a choice in what they accept or reject.

Conservation and commissions are a special problem of influence because anthropologists literally create or re-create the object of their study. Though it may be an influence subsequent to the creation of the work, conservation is a process that often starts in the field. Anthropologists are usually not the immediate actors here, those offering the treatment being either Natives or conservators, though both may act under the instructions of anthropologists. While one can speak of a clear and definite anthropological influence on particular works, conservation is more significant for the creation of the image of the Kwakwaka'wakw in anthropology than for an influence on Kwakwaka'wakw art or artists.

Anthropologists have actually had relatively little active influence on the creation of Kwakwaka'wakw art. Much more pervasive has been a passive influence, in the uses made by nonanthropologists of the objects produced or controlled by anthropologists—collectors in the contemporary art market, or white and Native artists. Native artists have turned to these visual documents as sources of inspiration, resulting in several features: archaism, the combination of personal and tribal styles, a stress on surface effects, and the like. When they have not played form-creating roles, museums have been important facilitators. For example, the potlatch loan program of the Provincial Museum was not responsible for a ceremonial revival per se, but it has undoubtedly been important in making more and often better-carved objects available, especially at a time when elaborate masks were not common. Objects originally created in a museum context—a tuxw'id puppet or the hamatsa cradle rattle—have later been taken up in ceremonialism.

Anthropology undoubtedly also encouraged a stylistic syncretism. Malraux's museum without walls includes Kwakwaka'wakw exhibits; Native artists have been stimulated by access to a wide range of examples preserved in illustrated books and museum collections. They have combined Kwakwaka'wakw subtraditions as well as those from other Coast tribes. For example, Tony Hunt has adopted the distinctive Willie Seaweed eye as well as a Tlingit influence. (Though Hunt saw these masks as a child in potlatches, he did not adopt the style until his maturity). The strong northern influence in Cranmer's work is derived most likely from his work on the Haida village at UBC, and Beau Dick, an eclectic artist, has been an attentive student of visual sources.

Perhaps even more important than an influence on artists has been anthropologists' education of the buying public, through their products—exhibits, books, lectures—and their own purchases for museum collections (Duffek 1983b). Their display of the classical canon during the century ending in 1980 has fostered a conservative archaism in the marketplace, as well. Though museums have done so unintentionally, they have encouraged the dominance of one particular style (that of Martin and the Hunts) through study, publicity, and commissions. A literal example of their conservative influence is the widespread use of Audrey Hawthorn's compendium as a catalog, before the fact by carvers and after by dealers and purchasers. It is precisely indirect influences such as these that are at the heart of the anthropological encounter.

One of the more interesting questions in the history of Kwakwaka'wakw art in the twentieth century is the role of the Blunden Harbour–Smith Inlet style. It seems to have been quite strong, even stronger than Fort Rupert and Alert Bay, because these northern villages were more isolated, more conservative. The differences may be marked symbolically, at least, in the life histories of their leading artists—Mungo Martin gave up active carving, while Willie Seaweed continued his ceremonial production. But until Holm's recent research, anthropologists gave no indication that they knew about Seaweed. Around 1950, while Martin was being lavished with superlative praise, no one cited his colleague, and it is quite some time in the anthropological record before Seaweed makes his appearance. Regardless of the truth in the case, this perception is a historical fact that must be explained.

Though both were old men by 1950, Willie Seaweed was only slightly older than Mungo Martin, and his last pieces date from the 1950s. Thus he could have been chosen for the UBC-BCPM carving programs. At this point it is difficult to reconstruct the reasons for the choice of Martin over Seaweed. The Blunden Harbour master may have been essentially retired at the time, but then so was Martin; or he may have been too old or sick. The real reason was probably circumstantial; Martin had better connections. Related to Ellen Neel, who was already in contact with the Hawthorns, Martin was more available in Fort Rupert (Henry Hawthorn may have visited him on an early survey of the province) than in Blunden Harbour.[15] Bill Holm notes another important factor: "Mungo Martin was more comfortable around Whites and spoke

English. Seaweed spoke very little English" (pers. comm. 1998). When the Blunden Harbour style finally did get mentioned in the anthropological literature, and when it did come to influence the Fort Rupert style, it seems to have been a result of museum influence and exposure.

Of course, it is ultimately pointless to play "what if" in history; one cannot know what might have been, only what did happen. Who knows what would have happened if Martin had not come south. Would there have been a revival; would Seaweed's work ever have been noticed in the white world? Boas and the other turn-of-the-century collectors were trying to anticipate the future, but they could not know it. The fact is that Seaweed went on carving and teaching his son but had little direct influence on future carvers outside his own community, whereas Martin had given up active carving, was invited by anthropologists to museums, and taught Henry and Tony Hunt and Douglas Cranmer, who taught most of the contemporary Kwakwa̱ka̱'wakw carvers.

There is a paradox in the relative success of the various Kwakwa̱ka̱'wakw substyles. While carving became moribund in Fort Rupert and Alert Bay, sites of the most pervasive acculturation, it continued in outlying areas. However, between 1950 and 1980, the Fort Rupert–Alert Bay style became the most popular Kwakwa̱ka̱'wakw variant, its success spread by the various training programs—at the Provincial Museum, Tony Hunt's Arts of the Raven shop, and among the U'mista carvers. To some extent, the distinctive Campbell River/Cape Mudge style of the Henderson family can still be distinguished. Though comparatively few now work in a "pure" Blunden Harbour style—or any other, for that matter—it has been fully assimilated by those working in the Fort Rupert style. Artistic communication, whether directly or mediated by books and exhibits, has now led to a pan-Kwakwa̱ka̱'wakw style, blurring if not erasing former tribal accents. Or, put more precisely, artists now create in more personal idioms.

Loaded questions about concepts such as tradition, continuity, and authenticity are always matters of perception and perspective. The view changes dramatically depending on where one stands—whether anthropologist or Native, earlier or later. Natives have experienced some confusion and bitterness at changing white attitudes toward their culture, as earlier cultural opposition was replaced by cultural support. It was only in the 1920s that the Native community began to feel the effects of preservationist efforts. When the American Museum of Natural History wanted a set of houseposts in 1922, the carver, Arthur Shaughnessy, was one of those Kwakwa̱ka̱'wakw in jail as a result of the Cranmer potlatch, and George Hunt noted that the Indians were afraid to carve: "Yet the government [was] Buying their totem Poles." The curator had to ask permission from the Indian Agent.[16] As Harlan Smith reported Native reaction to the Skeena preservation project: "A few years ago [the government] had prohibited the erection of totem poles; why did they wish now to preserve them?" (Cole 1985:275).

The stress on continuity is ultimately a retrogressive way of looking at Kwakwa̱-ka̱'wakw tradition. While it is a valid enough exercise, it slights the progressive aspects of cultural creation. The issue of continuity naturally arises when one considers the creation and aftermath of the "classic," but this is due less to analytic decision than to the definitions of the actors—anthropologists and artists. There is, and always has been, a great deal of creativity and novelty in Kwakwa̱ka̱'wakw visual art. Today there are innovations like Cranmer's abstract paintings. Any cultural tradition is composed of old and new elements (Handler and Linnekin 1984), and to focus exclusively on the old, as has been the common anthropological habit, is a polemical decision. To a great extent, the contemporary Kwakwa̱ka̱'wakw emphasis on continuity has been necessitated by the calling into question of that continuity by non-Natives for over a century. Like all statements about the past, theirs are rooted in and affected by present concerns (Fienup-Riordan 1990:221–231).

In his analysis of a related case of Native American identity, James Clifford (1988:341) suggests alternatives to the "narrative continuity of history and identity." In a 1977 trial in Boston, the Mashpee Wampanoag of Cape Cod argued that they had existed as a people continuously since contact. All acknowledged cultural loss and gains, as well as continuities, but the adversarial nature of the trial demanded the application of an either/or logic. Even resistance and continuity, which both the Kwakwa̱-ka̱'wakw and anthropologists now acknowledge, are, in the end, too restrictive. As Clifford (1988:342–343) argues,

> No one in Boston Federal Court, expert or layperson, stood at the end point of this historical series, even though the stories of continuity and change they told implied that they did. These stories and the trial itself were episodes, turns in the ongoing engagement. Seen from a standpoint not of finality (survival or assimilation) but of emergence, Indian life in Mashpee would not flow in a single current. . . . Interpreting the direction or meaning of the historical "record" always depends on present possibilities. When the future is open, so is the meaning of the past.

Therefore, even the narrative that I have constructed here—moving from a view of cultural loss and the necessity for salvage to one of continuity and the recognition of Native resistance (as suggested by Bruner 1986)—is only one possible story, told from one viewpoint. Actors in the past, such as Franz Boas or Harry Hawthorn, were not "wrong" so much as living in another time. It has now become convenient and expected for many, anthropologists as well as Natives, to stress the role of Native autonomy. Those who come after them will undoubtedly see things differently.

These perspectives call into question the usefulness of the "renaissance" (the classical and the revival) and authenticity as analytic models. One problem with the concept of renaissance is that it is built on an organismic model of birth, death, and rebirth, and on a view that precontact cultures were coherent and were undermined with contact from the outside. Such models really do not apply to the flux of culture

(see Handler 1988; Jonaitis 1993). As Clifford suggests, it does not have to be a case of either/or (maintenance or change) when speaking of cultural tradition, and works such as Cohodas's (1997) study of Klamath River basketry have demonstrated the hybridity of colonial cultures. On the other hand, invoking a renaissance is appealing because it does apply to some extent. As Blundell and Phillips (1983:124) point out:

> As is the case with all stereotypical views, the problem with the revivalistic perspective on contemporary Indian art is not that it is totally false, but that it distorts the nature of this art. It is true that many Indian artists link their artistic activities to goals of cultural preservation, but this does not mean that they are advocating a return to some nearly-forgotten way of life. . . . This mining of tradition, however, has been highly selective and innovative.

Authenticity has its own seductions. The problem is not so much how to reject it as to find out how it has been created and then changed by various actors. From the classical period to the present, there has been a shift in the application of the authentic for every group—anthropologists and artists, Kwakwaka'wakw and non-Native—and in almost every category. As the past century of Kwakwaka'wakw art history has evolved, the accepted understanding of that tradition has been doubly transformed. Among non-Native anthropologists, the salvage model of decline and extinction has been replaced by an emphasis on continuity, but, paradoxically, there has also been an acceptance of change and creativity by individual, named artists. In both cases, this has followed the adoption of a more historicized conception of tradition. At the same time, the authentic still tends to be conceived in terms of the past and of a Native ritual context. This may be seen in the encouragement of archaic styles, in the conservation treatment of museum objects (removing later additions), and in the management of loan collections (withdrawing masks as they get older). Guided by the conservative objectifications of anthropologists (exhibits and books), the art market tends to be even more restrictive and conservative.

Throughout the century, Kwakwaka'wakw have also maintained a conservative view of authenticity, although it is quite at odds with that of non-Natives. As Ostrowitz (1999) and others have maintained, "privileging the past" is embedded in Northwest Coast cultural idioms. Consistently the focus has been on the priority of inherited prerogative over physical substantiation. By stressing a conceptual kind of permanence, the Kwakwaka'wakw allow change on a material level and are not troubled by it. This encouraged turn-of-the-century owners to easily sell objects to collectors and have new versions carved, and for artists to freely present new versions of old objects—Mungo Martin's sea-raven pole and Victoria house facade, the Alert Bay cemetery poles, and the housefronts at the Canadian Museum of Civilization. In each case, widely diverse physical expressions were regarded as fundamentally the same thing. More recently, however, there has been some change in this view, too, with the insistence on having the 1922 Potlatch Collection returned, the desire of

some to repair totem poles to an earlier state, and the depiction of specific historic periods in exhibitions and publications.

Both anthropology and Kwakwaka'wakw art are traditions that have changed dramatically over the course of the century, with a reciprocal influence and accommodation between them. Each of the four terms of the anthropological encounter around which this study has been composed have been transformed: *anthropology* (from tendencies of conservatism to forces for innovation, and recognition of coevalness), *museums* (from programs of preservation to outreach), *art* (from racist curiosity or hostility to aesthetic praise and appropriation), *Kwakwaka'wakw* (from a role of cultural specimen or performer to one of cultural director and entrepreneur). In a mutual invention of culture, anthropology and Kwakwaka'wakw culture have become part of each other. As James Boon (1982:ix) puts it, "A 'culture' can materialize only in counterdistinction to another culture." In similar tones, James Clifford (1988:14) argues: "'Cultural' difference is no longer a stable, exotic otherness; self-other relations are matters of power and rhetoric rather than of essence. A whole structure of expectations about authenticity in culture and in art is thrown in doubt." In the same vein, Masco (1996:847) suggests that the Kwakwaka'wakw potlatch may be usefully regarded "as a native/white collaboration, a mutually generated myth, filled with asymmetrical power relations and appropriations—a fiction increasingly legitimized by time and repetition."

Figure 10.1. Storage box by Mungo Martin, October 1961, collected by Samuel Barrett. Hearst Museum of Anthropology. Photo by Eugene Prince. HMA cat. no. 2–30858a.

Figure 10.2. Mungo Martin steaming a cedar plank for a storage box, Thunderbird Park, Victoria. Photo by William Heick, October 1961, courtesy of the photographer.

The revival of the kerfed box is emblematic of the themes of this study. In a culture built upon the storage of food and the accumulation of wealth, it is not surprising to find that the box is a key metaphor for the Kwakwa̱ka'wakw (Walens 1981:46–58; see also Sturtevant 1974). Ceremonially, boxes are central in the transference of cultural patrimony. A father-in-law gives his son-in-law a box of "treasures" containing privileges to the winter ceremonials. While the chest may contain tangible objects—masks and rattles—it also comes with the intangible—songs, dances, and names. Boxes were of two principal kinds: the common utility boxes for everyday use, and the painted and carved boxes for the storage of valuables. For most of the twentieth century neither kind had been made. Today the decorated box is regarded as a work of art, produced mainly for sale to whites, and not generally used by natives. The common storage boxes are made as replicas for museum displays, as in the permanent exhibit at the Provincial Museum.

Although initially prompted by museum requests for replicas, the rediscovery of box construction by contemporary Kwakwa̱ka'wakw has basically been a trial-and-error process. In 1951 the UBC Museum asked Mungo Martin to produce a series of storage boxes showing the stages of construction (Hawthorn 1979:14–15). Despite this experience, a decade later when Samuel Barrett asked Martin to make a bent box

so that the process could be filmed (Barrett 1962; see also Jacknis 2000:119–125), Martin reportedly encountered some difficulty.[17] When Martin was learning his craft at the turn of the century, the making of bent boxes was rapidly going out of style, and by the 1950s he had probably not produced one in years, if ever (figures 10.1, 10.2).[18]

The current revival in bent-box construction has sprung from Mungo Martin's efforts, though experimentation has continued. The leader in this revival has been Douglas Cranmer, who seems to have taken the idea of making boxes, rather than any actual techniques, from Martin. Cranmer made many of his first boxes while working at the Vancouver Museum, which he used as a resource. Among his students were Larry Rosso in the early 1970s and since 1977 Alert Bay students such as Richard Sumner and Bruce Alfred, who have been especially prolific and skilled box-makers. Perhaps also inspired by Martin's efforts, Tony Hunt learned box-making through trial and error.[19] For all, box-making was a technological problem to be experimented

Figure 10.3. Storage box by Richard Hunt, September 1976, Royal British Columbia Museum. According to the museum's catalogue, "This is the first box made by Richard Hunt. It was made in September 1976, with instruction from Henry Hunt. Both Henry and Richard had viewed the film 'Mungo Makes a Box,' as well as boxes in the Ethnology collection, and Boas's 'The Kwakiutl of Vancouver Island,' (1909) and 'The Ethnology of the Kwakiutl' (1913–14). After Richard had made the box, it was decided that it would hold the dried salmon tails . . . in the First Peoples exhibit." RBCM cat. no. 14788.

with and solved (Davidson 1980), and just as Richard Hunt did (figure 10.3), all these artists carefully studied museum collections and the literature (principally the account in Boas 1921:60–81).

In the case of the revival of the bent box, one can see the slippage from what is first a commissioned reproduction to what is a free version, and then to what is finally a creative production. The revival also seems to be a good example of the Kroeberian (1940) notion of stimulus diffusion. For many of these artists, the anthropological influence came not so much in the direction to make such an item or in instructions on its construction, as in the suggestion that such objects might be made by contemporary artists, despite the fact that Kwakwa̲ka̲'wakw no longer require them for storage. Thus the revival of the kerfed box was the result of a complex interchange. While museums and anthropologists were not directly responsible, they served as

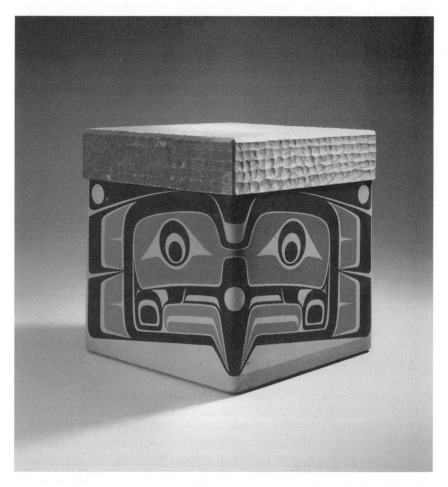

Figure 10.4. Storage box, by Richard Sumner, 1981. Private collection. Photograph by Lee Fatherree.

vital stimulants and as resources for the creative activity of Kwakwaka'wakw artists. It may make for a complicated and qualified story, but such seems to be the manner of cultural exchange in the anthropological encounter of the Kwakwaka'wakw.

For the past century the museum has served as a storage box for Kwakwaka'wakw tradition. In a letter of introduction to the Kwakwaka'wakw that Franz Boas wrote for George Hunt to read before his arrival for the 1894 field season, he stressed the distinctiveness of Kwakwaka'wakw culture, noting that the young people were not taking up the traditions. The books produced by Boas and Hunt would ensure that the Kwakwaka'wakw of future generations would be able to consult and learn from these traditions: "Then we shall place your laws in a book your children can read. Your laws will not be forgotten. Your children and the white man will understand that the old ways of the Indians were good."[20] In 1900, only a few years later, Boas was writing that before he could publish his monograph on Kwakwaka'wakw material culture he would have to go to European museums to "hunt up some old things that have gone out of use."[21] Although he feared the worst (and there has been cultural loss), Boas profoundly hoped that Kwakwaka'wakw culture would endure and that his work with George Hunt would help ensure that endurance. Today, a century later, museums are lending and returning artifacts to the Kwakwaka'wakw, and Kwakwaka'wakw are curating their own exhibitions. There are now museums conceived, planned, and run by the Kwakwaka'wakw. Together, anthropologists and Kwakwaka'wakw have created these storage boxes. As Agnes Alfred, an elder who had been tried for potlatching in 1922, remarked at the opening of the U'mista Cultural Centre: "It is like a storage box, a box of treasures."[22]

NOTES

INTRODUCTION

1. Among the recent book-length studies of the interplay between anthropological and Native constructions of culture, see Borofsky (1987) on the Pukapuka of Polynesia, Handler (1988) on the Québécois of Canada, Gordon (1992) on the "Bushmen" of Namibia, Ivy (1995) on the Japanese, and Adams (1996) on the Sherpas of the Himalayas. For Native Americans, related works are Faris (1990) on the Navajo and Dilworth (1996) and Fowler (2000) on the Southwest.

2. In addition to the studies listed in note 1, for other important anthropological studies of tradition, see Shils (1981), Hobsbawm and Ranger (1983), Handler and Linnekin (1984), Hanson (1989), and Mauzé (1997).

3. "Classical Kwakwaka'wakw artifacts" are defined here operationally as all those collected during the great age of systematic collecting, c. 1880–1920, and thus made c. 1850–1920.

4. For example, one can trace ownership from Kwakwaka'wakw chief to anthropological collector to artist and perhaps back to museum, as in the dzunukwa house post sold to Charles F. Newcombe, then to the Brooklyn Museum of Art when it had an ethnology department, then to Surrealist artist Max Ernst when the museum had been redefined as an art museum, and finally to the Musée de l'Homme in Paris, an anthropology museum (see Stokes 1987:91, 93).

5. While I have noted some comparisons with other regions (especially the Haida in the Northwest and the Southwest) and with other disciplines (especially folklore and art history) in passing, because of limited space I have made no systematic attempt to discuss the many similarities and differences between these and the case of anthropology and the Kwakwaka'wakw.

6. The situation of "anthropological" objects is related to that of tourist arts, the so-called arts of acculturation (Graburn 1976), which are also artifacts that move between cultures. See also Phillips (1998) and Phillips and Steiner (1999).

7. For a general review of the concept of authenticity in anthropology, see Handler (1986). Benjamin's essay (1936) was an important classic discussion of authenticity and objects. Some of the best recent discussions of authenticity in art (and its corollary, fakes) have been in the context

of African art, where a fairly narrow conception has driven the market; see Povey et al. (1976), Kasfir (1992), and Steiner (1994). Especially useful is Bendix's (1997) review of the concept in folklore studies. My discussion of authenticity has been informed by my participation in a series of sessions on the subject organized by Barbara Kirshenblatt-Gimblett at the 1985 meetings of the American Folklore Society.

8. Kwakw̲a̲ka̲'wakw is rendered according to the orthography adopted by the U'mista Cultural Centre, Alert Bay. A general, nontechnical pronunciation is: Kwak-wak-you-wok. For spellings of Kwak'wala terms not used in direct quotations, I have used the U'mista orthography. For a consideration of Kwak'wala orthographies, including the U'mista system, see Suttles (1991a) and Powell (1994). As Berman (1991:111–14) points out in her excellent review of these various ethnonyms, like the terms Kwagu'ł or Kwakiutl, Kwakw̲a̲ka̲'wakw has also changed its meaning over the past century. Early in the nineteenth century, it referred to speakers of only the central Kwak'wala dialect, not those of the north, west, or south; the scope of its reference has broadened over time until now it means all speakers of Kwak'wala.

9. In the same spirit, many other Native groups in British Columbia have proposed new terms for their common names. The peoples referred to in the anthropological literature as the Bella Coola, Bella Bella, and Nootka now wish to be known as the Nuxalk, Heiltsuk, and Nuu-chah-nulth, respectively, the terms adopted here. The original inhabitants of the continent have been known by many names. In this study I generally employ the term "Native"; original sources may use American Indian or Native American. Current Canadian usage is First Nations or First Peoples. As noted in the preface, for reasons of historical consistency in a study devoted primarily to the period before 1981, I use the name British Columbia Provincial Museum in place of its new name, Royal British Columbia Museum, adopted in 1987. For similar reasons, I employ the earlier anthropological term "informant" instead of more contemporary usages such as "consultant."

10. This incipient integration of Native and western economies on the Northwest Coast has been discussed by Knight (1978) and for the Tsimshian in particular by McDonald (1984). For an incisive analysis of the interplay between economic and cosmological factors in the history of the Kwakw̲a̲ka̲'wakw potlatch, 1849 to 1922, see Masco (1995).

11. While I have tried to assume no previous knowledge of Kwakw̲a̲ka̲'wakw art, some readers may desire further elaboration on Kwakw̲a̲ka̲'wakw artistic culture. Two comprehensive reviews are Hawthorn (1979) and Jonaitis (1991). Macnair et al. (1980) contains an excellent outline of the principles of Northwest Coast (including Kwakw̲a̲ka̲'wakw) graphic and plastic design, in addition to its summary of the art's history during the past century.

12. Listings of some of the Kwakw̲a̲ka̲'wakw artists active in the first half of the twentieth century may be found in Hawthorn (1967:377–83, 1979:256–66), Macnair et al. (1980:179–88), and Holm (1983:29).

13. There has been a great deal of confusion over the year of Mungo Martin's birth. Most sources acknowledge the lack of a definite date and use c. 1881. Nuytten (1982:75) gives "around 1880 or 1881," noting that "Mungo used an 'official' date of April, 1884, although he believed himself to be several years older." Discussing Martin's own dating of his birth from his witnessing of the Seattle fire of 1889, "which he saw as a boy or nine or ten," de Laguna (1963:895) estimates his natal year to be 1879. However, Martin told Bill Holm (pers. comm. 1998) that "he was nine when Boas visited [Fort Rupert] in 1894, and the Hastings photos seem to confirm that; that would make his birthday about 1885." Oregon C. Hastings, a professional Victoria photographer, took at least two photos of Martin on that trip, and in them he does look more like a boy than a teenager (see Nuytten 1982:76; Jacknis 1984:12).

14. The literature on Mungo Martin is extensive. See Hawthorn (1952, 1964, 1993:11–19); Duff (1959); B.C. Indian Arts Society (1982); Nuytten (1982:75–126); Glass (1999).

15. In addition to Willie Seaweed, other important Blunden Harbour artists were the brothers Chief George and Charley George Sr. and George Walkus of Smith Inlet. In turn, their sons—Joe Seaweed, Charley George Jr., and Charlie G. Walkus—carried on the distinctive regional style (Macnair et al. 1980).

16. Peter L. Macnair (pers. comm. 1999).

17. Other notable Kwakwa̲ka̲'wakw artists born in the 1950s include Russell Smith (b. 1950), Simon Dick (b. 1951), and Wayne Alfred (b. 1958).

1. COLLECTING

1. Although there is a fairly extensive literature on art collecting (see Alsop 1982), there have been fewer comprehensive studies, either analytic or historical, of ethnographic collection (see Sturtevant 1977). Recently, however, scholars have begun to address the topic, but often the emphasis is on the collector or the collection (Wade and McChesney 1980; Fitzhugh and Kaplan 1982), rarely on the process itself, seen as an intersocial and intercultural exchange (Fane et al. 1991). On comparative regions, see Thomas (1991) on Oceania, Price and Price (1992) on French Guiana, Boone (1993) on Pre-Columbian Mesoamerica, Steiner (1994) on Africa, and Taylor (1994) on Indonesia. Taking examples from the rest of Native America, in the Southwest generally there are Wade (1976) and Parezo (1987), and Frisbie (1987) and Faris (1990) on the transmission and exchange of Navajo ceremonial artifacts. Collecting among Californian Natives, especially of baskets, has recently drawn attention: Bernstein (1979), Bates and Lee (1990), Jacknis and Schevill (1993), and especially Cohodas (1997). John Ewers (e.g., 1982, 1983) produced the most comprehensive research on the collectors of Plains artifacts. Phillips (1998) is an important work on the souvenir in the Northeast. For the Arctic and Subarctic, see Fitzhugh and Kaplan (1982), Krech and Hail (1991), and a series of studies by VanStone (e.g., 1972, 1980). This volume deals only with the collecting of Kwakwa̲ka̲'wakw objects, and, while coherent in its own terms, this is only a part of the larger collection of Northwest Coast artifacts. Edmund Carpenter (1975) was one of the first to seriously consider the subject, and since then there have been more detailed studies of particular museum collections: Wardwell (1978) and Jonaitis (1988, 1991, 1999b) on the American Museum of Natural History, and collectors; Low (1977, 1982) on George T. Emmons and Charles F. Newcombe, respectively; and Black (1997) on the Richard W. Large Heiltsuk collection at the Royal Ontario Museum. Historian Douglas Cole (1985, also 1982a, 1991) has summarized collecting on the Northwest Coast in an excellent volume that should be consulted for this broader picture.

2. Gunther (1972:26) speculated that several of the carved wooden heads collected in Nootka Sound in 1778 were of Kwakwa̲ka̲'wakw origin, suggesting that they may have been used in the tuxw'id dances. Kaeppler (1978:258), however, noted that "apparently there is no documentary evidence for this attribution." While Kaeppler accepts the Capetown head as a Cook piece, to her (and to the present author) it looks Nuu-chah-nulth in style (cf. King 1981:77–80, 1999:138–41). In a recent exhibition, Martha Black attributed the South African mask to the Mowachaht, the Nuu-chah-nulth inhabitants of Nootka Sound (Black 1999:23).

3. Haberland (1980) gives a figure of 1,000, but it is unclear whether he is referring here to the total number collected or the number surviving the war.

4. George M. Dawson, 29 September 1878, Field Journal; and George M. Dawson to Anna Dawson Harrington, 6 September 1885. Both in Rare Books Room, McGill University (transcripts kindly shared with me by Douglas Cole).

5. As Galois (1994:277) notes, the collective name of Nahwitti "is probably the most confusing in the lexicon of the Kwakwa̲ka̲'wakw peoples." It has been applied, with various spellings, to a site at Cape Sutil and to a local chief. "By the last quarter of the nineteenth century [during the collecting of Boas and Newcombe] it was used as a collective name for the Nakomgilisala, the Yutlinuk, and the Tlatlasikwala [three of the Kwakwa̲ka̲'wakw tribes living at the north end of Vancouver Island] and as the name of their village, now on Hope Island."

6. Franz Boas to Edward B. Tylor (draft), 17 August 1888, FBP.

7. Franz Boas to Edward B. Tylor (draft), 15 August 1888, FBP.

8. George M. Dawson to Franz Boas, 29 May 1889, FBP.

9. For the American Museum diorama, Boas acquired many unfinished objects of cedar bark in order to show the processes of construction: a mat, weaving stick, cedar bark being shredded, cradle stick, blanket, rope. He also secured two old houseposts and a grave monument. For the Smithsonian, he found three masks and thirteen cedar bark rings.

10. Acc. 30,192; forty items, see correspondence in the Registrar's Office, National Museum of Natural History, Smithsonian Institution.

11. As Boas (1969:262–263) wrote to his mother, "What museum pieces I shall get I don't yet know myself. I leave this to my man here, to whom I gave a whole list of what I want."

12. Franz Boas to George Hunt, 14 April 1897, Acc. 1897–43, AMNH.

13. Franz Boas to George Hunt, 30 April 1897, FBP; Franz Boas to George Hunt, 13 January and 13 September 1899, Acc. 1899–50, AMNH.

14. Objects collected by Edward S. Curtis are also in the Smithsonian's National Museum of the American Indian, University of Pennsylvania Museum of Anthropology, Denver Art Museum, Southwest Museum, Los Angeles County Museum of Natural History, and British Museum (Gidley 1998:82, 298).

15. Sources for Newcombe's 1899 trip: catalog (box 40, folder 1), and notebook (box 35, folder 4, and box 58, folder 28), CFNP.

16. Charles F. Newcombe to George A. Dorsey, 14 November 1899, FMNH.

17. See the lists in Newcombe's notebooks: box 36, folders 10, 16, 17, 19, and box 37, folders 3, 6, 7, CFNP.

18. Charles F. Newcombe to Charles C. Willoughby, 22 May 1917, Acc. 17–17, PM.

19. Charles F. Newcombe to George A. Dorsey, 5 November 1906, FMNH.

20. Charles Nowell to Charles F. Newcombe, 7 June 1912, CFNP. Spelling and grammatical irregularities in the correspondence of Charles Nowell and George Hunt have been quoted verbatim.

21. Charles F. Newcombe to Charles C. Willoughby, 20 September 1917, Acc. 17–17, PM.

22. George Hunt to Franz Boas, 26 September 1899, FBP.

23. Charles F. Newcombe to George A. Dorsey, 12 March 1901, FMNH.

24. Sources: (1) Ritzenthaler and Parsons (1966); (2) the original transcript of the interview with Barrett (9 August 1962); (3) Henry L. Ward, Report to the Board of Trustees, 1914–1915, Milwaukee Public Museum; (4) Shipping List for the accession, April 1915, Milwaukee Public Museum. All except the first were shared with me by Douglas Cole.

25. Samuel A. Barrett to Edward Sapir, 21 March 1914, Sapir Papers, Canadian Ethnology Service, National Museum of Man. This letter was kindly shared with me by Douglas Cole.

26. Samuel Barrett, late in his life, reported that he had consulted Boas "as to the best locality for a study of Northwest Coast culture" (Ritzenthaler and Parsons 1967:17), but in the extant Barrett-Boas correspondence there is no such discussion. Either their exchange was oral, Barrett was misremembering, or the letter simply did not survive.

27. Samuel A. Barrett to Charles F. Newcombe, 3 February 1915, CFNP.

28. Samuel A. Barrett to Charles F. Newcombe, 6 March 1915, CFNP.

29. *Vancouver Province*, 16 October 1932.

30. Franz Boas to George Hunt, 30 April 1897, and Franz Boas to George G. Heye, 5 June 1906, FBP.

31. Charles F. Newcombe to George Dorsey, 12 March 1901, FMNH.

32. Charles Nowell to Charles F. Newcombe, 24 February 1904, box 54, file 9, CFNP.

33. Charles F. Newcombe to George Dorsey, 8 February 1901, FMNH. See also Nowell to Newcombe, 26 January 1901, CFNP.

34. George Hunt to Franz Boas, 26 September 1899, FBP.

35. George Hunt to Franz Boas, 23 October 1905; cf. Franz Boas to George Hunt, 31 October 1905, Departmental Correspondence, AMNH.

36. See note 25, and Samuel A. Barrett to Charles F. Newcombe, 27 August 1914, box 1, CFNP.

37. Samuel A. Barrett to Charles F. Newcombe, 11 December 1914, box 1; Charles F. Newcombe to Samuel A. Barrett, 26 September 1922, box 42, folder 51, CFNP.

38. Charles F. Newcombe to Franz Boas, 25 January 1902, Acc. 1901–31, AMNH; Charles F. Newcombe to Pliny E. Goddard, 17 May 1922, box 3, CFNP.

39. Franz Boas to John R. Swanton, 5 November 1900, Acc. 1901–31, AMNH.

40. Respectively: (1) George M. Dawson to Charles F. Newcombe, 4 December 1899, box 53, file 2, CFNP; (2) George A. Dorsey to Charles F. Newcombe, 10 October 1901, FMNH; (3) Franz Boas to George Hunt, 30 April 1897, Acc. 1897–43, AMNH.

41. Franz Boas to George Hunt, 13 September 1899, Acc. 1899–50, and 30 April 1897, Acc. 1897–43, AMNH. Both letters also survive in the Boas Papers.

42. George G. Heye to Franz Boas, 7 June 1906, and Franz Boas to George Hunt, 8 June 1906, FBP; George Dawson to Charles F. Newcombe, 19 December 1899, box 53, file 2, CFNP.

43. Franz Boas [1887], Catalog Notes to the Heber R. Bishop Collection, Acc. 1869–90–94, AMNH.

44. Franz Boas to George Hunt, 30 April 1897, FBP.

45. Franz Boas to Frederic W. Putnam, 12 September 1896, FWPP.

46. Franz Boas to George Hunt, 13 January 1899, Acc. 1899–50, AMNH.

47. Charles F. Newcombe, catalog for 1899 collecting trip, box 40, file 1, CFNP.

48. Charles F. Newcombe to George A. Dorsey, 2 January 1900, FMNH.

49. George Dawson to Charles F. Newcombe, 4 December 1899, box 53, file 2, CFNP.

50. Franz Boas to George Hunt, 30 April 1897, and 14 April 1897, Acc. 1897–43, AMNH.

51. Franz Boas to Morris K. Jesup, 25 March 1899, Central Archives, AMNH.

52. George M. Dawson to Charles F. Newcombe, 24 March 1897, box 2, CFNP.

53. When revising this passage for his book *Primitive Art*, Boas (1927:183) deleted the phrases, "decorative art" and "purely works of art," perhaps now realizing their ethnocentric connotations. However, he does later oppose "realistic truth" to "decorative art" (Boas 1927:185).

54. George M. Dawson to Charles F. Newcombe, 11 May 1897, box 2, CFNP.

55. Charles F. Newcombe to George A. Dorsey, 6 March 1900, FMNH.

56. Charles F. Newcombe, 1899 Kwakiutl collection, notebook (box 58, file 28) and catalog (box 40, file 1), CFNP.

57. Charles F. Newcombe to Charles Nowell, 5 December 1905, CFNP.

58. Douglas Cole kindly shared with me a photocopy of Boas's Berlin catalog.

59. Franz Boas to George Hunt, 14 April 1897, Acc. 1897–43, AMNH.

60. See especially the labels for Acc. 1902–46, AMNH.

61. Franz Boas to George Hunt, 14 April 1897, Acc. 1897–43, AMNH.

62. George Hunt to Franz Boas, 23 April 1895, Acc. 1895–4, AMNH; 24 May 1897 and 18 February 1899, FBP.

63. George Hunt to Franz Boas, 24 April 1899 and 12 April 1901, FBP.

64. Franz Boas to George Hunt, 21 March 1901, and Franz Boas to George Hunt, 24 February 1900, FBP.

65. Charles F. Newcombe to Samuel A. Barrett, 18 August 1914, box 1, CFNP.

66. Charles F. Newcombe to Charles Nowell, 10 February 1906, CFNP.

67. Charles F. Newcombe to Samuel A. Barrett, 18 August 1914, box 1; Charles Nowell to Charles F. Newcombe, 15 June 1914, box 40, file 9, CFNP.

68. Charles F. Newcombe to Samuel A. Barrett, 3 September 1914, CFNP.

69. Charles Nowell to Charles F. Newcombe, 29 November 1910, CFNP.

70. Charles F. Newcombe to George A. Dorsey, 2 January 1900, FMNH.

71. Newcombe often noted that he paid Natives extra to repair and repaint artifacts before they were sent to the museum. See notebooks, box 37, folders 3 and 6, CFNP.

72. Charles F. Newcombe to Stewart Culin, 9 June 1914, box 2; Charles Nowell to Charles F. Newcombe, 16 June 1911, CFNP.

73. George Hunt to Pliny E. Goddard, 20 June 1924, Acc. 1924–78, AMNH.

74. George T. Emmons to Charles F. Newcombe, 15 April 1908, 17 September 1910, 30 September 1913, 1 February 1914; George T. Emmons to William A. Newcombe, 16 March 1926, box 3, CFNP. Also, Low (1977:9–10).

75. Alfred L. Kroeber to Charles F. Newcombe, 26 August 1911, box 41, folder 19; Charles C. Willoughby to Charles F. Newcombe, 10 September 1913, box 5, 31 December 1917, box 41, folder 16, CFNP.

76. Both Heiltsuk settees have been attributed to the carver Captain Richard Carpenter, also known as Du'klwayella (1841–1931) (Black 1997:110–112). After 1900 he was keeper of the Dryad Point lighthouse just north of Bella Bella. When the Provincial Museum's chief's seat was seen at the Bella Bella lighthouse in 1900, Captain Carpenter's name was written on it (Black 1997:112). However, both settees differ somewhat from some of Carpenter's other known work and exhibit numerous stylistic differences. Bill Holm (pers. comm. 1998) has noted, "The two settees *might* be by the same carver, but they are very different," a point seconded by Martha Black (pers. comm.), who is less sure of the Carpenter attribution for the Berlin settee.

77. Charles C. Willoughby to Charles F. Newcombe, 17 March 1917, Acc. 17–17, PM.

78. Acc. 1900–73, AMNH.

79. George Hunt to Franz Boas, 15 January 1895, Acc. 1895–4, AMNH.

80. Franz Boas to George Hunt, 18 May 1899, Acc. 1899–50, AMNH, and FBP.

81. Franz Boas to George Hunt, 3 January 1900, FBP.

82. George Hunt to Franz Boas, 22 June 1904, Acc. 1904–38, AMNH.

83. George Hunt to Pliny E. Goddard, 29 March 1923, Acc. 1924–78, AMNH. However, as Peter Macnair (pers. comm. 1999) points out, these poles were painted in enamels.

84. George A. Dorsey to Frederick J. V. Skiff, 5 October 1904, Acc. 883, FMNH.

85. Charles Nowell to Charles F. Newcombe, 26 January 1901 and 10 April 1901, CFNP.

86. See Wyatt (1984:46–52); and Charles F. Newcombe to Charles Nowell, 11 November 1905, CFNP.

87. According to Peter Macnair (pers. comm. 1999), "Many chiefs objected to real pieces, especially hamsaml masks, being used in the film and/or in still photos, thus necessitating new examples produced as props."

88. Charles F. Newcombe to George A. Dorsey, 14 November 1903, FMNH. Although, as Bill Holm (pers. comm. 1998) notes, "Tozier got some *very good* poles."

89. George Hunt to Franz Boas, 4 July 1902, Acc. 1902–46, AMNH.

90. Documentation for the Cadwallader collections at the Vancouver Museum, the UBC Museum of Anthropology, and the B.C. Provincial Museum.

91. As late as 1942 museums were still considering confiscation as a possible source of specimens. The director of the B.C. Provincial Museum wrote to the Indian Commissioner of B.C. upon hearing of a possible confiscation from "medicine men" at Kispiox: "If the action is carried out by your Dept. would it be possible to arrange for the costumes and accessories to be deposited in this Museum?" The commissioner replied that the items should remain the property of the court until the case was disposed of, and went on to express a more enlightened attitude: "Apart from this the confiscation of treasured articles of this character and their removal from Reserves is frequently responsible for the development of a hostile attitude among the Indians toward the Department and the Police so, naturally, we are very anxious to avoid this if at all possible." Clifford Carl to Major D. M. MacKay, 5 June 1942, and D. M. MacKay to Clifford Carl, 9 June 1942, BCPM Correspondence, GR 111, box 11, file 1, BCA.

92. Charles F. Newcombe to Charles Nowell, 5 December 1905, CFNP.

93. George Hunt to Franz Boas, 10 October 1900 and 22 February 1901, FBP.

94. Harlan I. Smith to Franz Boas, 13 June 1898, Acc. 1898–41, AMNH.

95. George Hunt to Franz Boas, 12 August 1901 and 6 September 1901, FBP.

96. George Hunt to Franz Boas, 14 February 1897, FBP.

97. George Hunt to Franz Boas, 10 October 1900, FBP.

98. George Hunt to Pliny E. Goddard, 22 February 1923, Acc. 1924–78, AMNH.

99. George Hunt to Franz Boas, 17 September 1897, Acc. 1897–30, AMNH.

100. George Hunt to Franz Boas, 20 March 1895, Acc. 1895–4, AMNH.

101. George Hunt to Franz Boas, 4 January 1898, Acc. 1897–43, AMNH.

102. Franz Boas to Charles F. Newcombe, 11 December 1897, box 1, CFNP.

103. Franz Boas to George Hunt, 7 March 1901, FBP.

104. Franz Boas to George Hunt, and Franz Boas to the Kwakiutl, 14 April 1897, Acc. 1897–43, AMNH, see epigraph.

105. Franz Boas to George Hunt, 3 February 1899 (reprinted in Stocking 1974:125–127).

106. George Hunt to Franz Boas, 14 March 1898, FBP.

107. George Hunt to Franz Boas, 9 June 1904, Acc. 1904–38, AMNH. Cf. Jonaitis (1999b).

108. George Hunt to Franz Boas, 26 September 1899, FBP.

109. George Hunt to Franz Boas, 4 March 1898 and 6 September 1901, FBP.

110. Franz Boas to Edward B. Tylor, 17 August 1888, FBP; Franz Boas to Edward B. Tylor, 6 February 1899, Departmental Correspondence, AMNH; Franz Boas to Morris K. Jesup, 1 October 1900, Acc. 1900–73, AMNH.

111. Charles F. Newcombe to Charles L. Owen, 5 January 1918, FMNH.

112. Harlan I. Smith to William A. Newcombe, 31 October 1928 and 24 July 1934, box 14; Philip Drucker to William A. Newcombe, 8 April 1937, box 12, CFNP.

113. Franz Boas to Edward B. Tylor, 17 August 1888, FBP; Harlan I. Smith to Frederic W. Putnam, 18 June 1898, Acc. 1898–41, AMNH.

114. Charles F. Newcombe to George A. Dorsey, 6 March 1900; 15 January 1901, FMNH; Samuel A. Barrett to Charles F. Newcombe, 3 February 1915, box 1, CFNP.

115. Samuel A. Barrett to Charles F. Newcombe, 6 March 1915, CFNP; Samuel A. Barrett, "Kwakiutl Indian Collection at Milwaukee Public Museum," p. 6, Barrett Papers, Bancroft Library, University of California at Berkeley.

116. Charles F. Newcombe to Charles C. Willoughby, 7 March and 12 April 1917, Acc. 17–17, PM.

117. Charles F. Newcombe to Charles C. Willoughby, 22 May 1917, Acc. 17–17, PM.

118. Charles Nowell to William A. Newcombe, 3 March 1928, box 4; Philip Drucker to William A. Newcombe, 8 April 1937, box 12; Stewart Culin to Charles F. Newcombe, 10 April 1908, box 1; CFNP.

119. The primary evidence for this is various: two sets of photographs in the Alert Bay Museum (Ronald Shuker's prints and the Richard Pattinson collection of slides [copies at RBCM]), written accounts of the Indian Dances in Alert Bay (Shuker's articles in the *Pioneer Journal*), and Native testimony (interviews with Douglas Cranmer, 18 January 1982; Robert Joseph, 5 July 1982).

120. These masks, frontlets, screens, staffs, and other items are now in the collections of the B.C. Provincial Museum, the UBC Museum of Anthropology, the Gerber collection at the Burke Museum, and the Glenbow Museum, among others. While the Pattinson slide collection is perhaps the best in situ documentation of these, one example is Willie Seaweed's 1942 hamatsa raven mask, photographed in use at a potlatch in 1963 and now in the Glenbow Museum (Holm 1983:106–108).

121. Franz Boas to Daniel G. Gilman, 5 February 1902, Departmental Correspondence, AMNH.10

122. Thomas F. McIlwraith to Louis C. G. Clarke, 16 January 1924, Cambridge University Museum of Archaeology and Ethnology. This letter was kindly shared with me by Douglas Cole.

123. Franz Boas to Daniel G. Gilman, 5 February 1902, Departmental Correspondence, AMNH.

124. The removal of artistic models through massive collecting was a common phenomenon among American Indians. Before the collecting expeditions of the U.S. National Museum (1879–1884), Zuni pottery styles evolved gradually. "However, when Stevenson removed more than 5,000 ceramics from the pueblo in a five-year period, the Zuni ceramic tradition collapsed within twenty years. A few popular styles continued; but whereas the pottery of 1880 was not much different from the pottery of 1860, the pottery of 1900 was radically different from that of 1880, and not much was made" (Batkin 1987:82; cf. Parezo 1987:31–32).

125. I owe the observation on master carvers and model poles to Bill Holm (pers. comm. 1998).

126. Subsequently, the Provincial Museum added to its collections the second version of the Seaweed mask, in addition to the original; the UBC Museum owns the Seaweed version of the Mungo Martin mask.

127. Other Kwakwaka'wakw objects may have also been suited to being collected. According to Hawthorn (1979:29), masks made for the Atlakim ritual were meant to be destroyed after use; to the Kwakwaka'wakw selling them to whites was just as good as burning them. Only recently has there been a desire to save them. Macnair (pers. comm. 1999), however, doubts that this was the custom.

128. Gillean Douglas, "A Link with Our Past," *Vancouver Sun Magazine Supplement*, 7 April 1951, p. 5.

129. Charles F. Newcombe, Collection Notes, box 40, folder 1; notebook, box 36, folders 6 and 8. For similar purchases from Nowell and family, see notebook for 1913, box 37, folder 3, and for 1914, box 37, folder 6, CFNP.

130. However, as Macnair points out, there were probably other equally conservative villages (pers. comm. 1999).

131. George Hunt, for instance, began his collecting in Fort Rupert and Nahwitti, and his early trips included nearby Quatsino (Koskimo) and Alert Bay. It was only during his later collecting for Heye that he visited northern and southern Kwakwaka'wakw villages (Jacknis 1991b:204–205).

2. ANTHROPOLOGICAL REPRESENTATIONS

1. An exception was William Dall's brief work of 1884, based on the Smithsonian collections.
2. One of the rare instances when Boas does discuss recent change is his statement that formline art was a late introduction to the Kwakwaka'wakw, citing elderly informants who claim that before 1860 houses and their decorations resembled those of the Coast Salish (Boas 1927:289).
3. This material is now preserved in the Newcombe Papers, BCA.
4. The following discussion is only a summary statement. For further information on Hunt's career, see Cannizzo (1983), Jacknis (1991b, 1992b), Berman (1994, 1996), and Briggs and Bauman (1999).
5. George Hunt to Franz Boas, 12 August 1901, FBP.
6. George Hunt to Franz Boas, 15 March 1930, FBP.
7. Obituary in PJ, 19 June 1957.
8. The documentation differs for each period of exhibition. For the earlier years we have access to correspondence allowing us to re-create some of the contexts of the creation of the halls, while for the contemporary period, the mid-1960s to the present, the halls in question (B.C. Provincial Museum, UBC Museum of Anthropology, and Field Museum) still exist, allowing us to make a more detailed formal analysis of their content and design.
9. See MacDonald (1984:115) for an illustration. Although he offers no evidence, MacDonald thinks that the housefront was probably not exhibited at the fair, while Miner (1972:211) and Cole (1985:30) suggest that it was.
10. While the Nuxalk were in Berlin in early 1886, Carl Günther photographed them in their borrowed masks and costumes. See Holm (1977:6), Cole (1982b:112), and especially Haberland (1987).
11. Parts of the following section are drawn from Jacknis (1991a), which should be consulted for further detail on non-Kwakwaka'wakw Northwest Coast Indian participation at the fair.
12. Frederic W. Putnam to George R. Davis, Monthly Report for October 1891, p. 13, WCE Correspondence, FWPP.
13. The former name given in the *Chicago Record*, 14 April 1893, and the latter in the *Chicago Tribune*, 6 May 1893, and the *Chicago Times*, 7 May 1893; all found in the World's Columbian Exposition Scrapbooks, vol. 2, FWPP. Raibmon (2000:177) speculates that the house may have belonged to John Drabble or one of the other troupe members from Nahwitti. The fate of this house is uncertain, as it does not seem to have been accessioned by the Field Columbian Museum along with the rest of the fair's collections. As Malin suggests (1999:96–97, fig. 41), this house is the same one that Boas had earlier sketched in Nahwitti (Boas 1897a:376). Although Malin concludes that the Chicago housefront was actually a reproduction, the fact that Hunt collected a housefront in Nahwitti leads me to think that he obtained the original, acc. 61, FMNH.
14. *Chicago Record*, 14 April 1893, World's Columbian Exposition Scrapbooks, vol. 2, FWPP.
15. *Chicago Times*, 16 April 1893, World's Columbian Exposition Scrapbooks, vol. 2, FWPP.
16. *Chicago Times*, 7 May 1893, World's Columbian Exposition Scrapbooks, vol. 2, FWPP.
17. *Baltimore American*, 27 August 1893, World's Columbian Exposition Scrapbooks, vol. 3, FWPP.
18. *Chicago Tribune*, 2 July 1893, Newspaper Clipping Scrapbook, 1887–1894, Stewart Culin Papers, Brooklyn Museum.
19. Among the Kwakwaka'wakw subgroups represented were the Kwaguł and Gwetela (from Fort Rupert), the 'Namgis (from Alert Bay), the Gusgimaxw (Koskimo), and Tłatłasikwala and Nakomgilisila (Nahwitti), all tribes at or close to Hunt's home in Fort Rupert. For a discussion of the identities of the Chicago troupe, see Raibmon (2000:175).
20. Frederic W. Putnam to George R. Davis, 27 March 1893, World's Columbian Exposition, Correspondence, FWPP. The following quotations are also taken from this letter.
21. Contract between Frederic W. Putnam and George Hunt, 29 September 1892, World's Columbian Exposition, Miscellaneous Papers, FWPP.
22. Wilson Duff, 1955, Notebook no. 10, "Kwakiutl Totem Survey," miscellaneous notes at back, KWA-W-007, Ethnology Division, RBCM.
23. *Chicago Tribune*, 6 May 1893, World's Columbian Exposition Scrapbooks, vol. 2, FWPP.
24. *Chicago Herald*, 13 May 1893, FWPP.
25. *Chicago Times*, 13 June 1893, FWPP.
26. Lawrence Vankoughnet to Reverend Alfred J. Hall, [September?] 1893, "Request to put together

an Indian exhibit at the Columbian World's Fair, 1892–1894," Canadian Department of Indian Affairs, Canadian National Archives, RG 10, vol. 3865, file 85,529. See also Cole (1985:129–130).

27. Emma Sickles had long been a thorn in the side of Professor Putnam (Dexter 1966:326–328). Through political connections she was given an appointment in the Ethnology Department, over Putnam's objections. After several spats, she was dismissed but returned in the guise of the chairman of the Indian Committee of the Universal Peace Union.

28. *New York Times,* 8 October 1893, World's Columbian Exposition Scrapbooks, vol. 2, FWPP.

29. Putnam's statement was widely reproduced in contemporary papers; see, for example, *San Francisco Chronicle,* 7 October 1893, FWPP.

30. Despite this identification in almost all the literature, including Nowell's memoirs (Ford 1941:186), in the 1950s Mungo Martin and other elderly Kwakwa̱ka'wakw identified the man who went to St. Louis with Nowell as Bob Harris's older brother, X̱ix̱anius. See Wilson Duff, [no date], [Miscellaneous Notes from Mungo Martin], KWA-T-011; Duff, 1955, Notebook no. 10, "Kwakiutl Totem Survey," KWA-W-007, Ethnology Division, RBCM; Bill Holm (pers. comm., 21 January 1982; see also Holm 1983:29). As Holm noted, "Mungo, who knew both well, was very definite in his identification" (pers. comm. 1998). As a partial explanation for the problem, Peter Macnair notes, "In trying to identify 'Bob Harris,' it appears there were three half brothers, all with different surnames, but that two of them were sometimes referred to, in English, as Bob Harris" (pers. comm. 1999).

31. Charles F. Newcombe to George A. Dorsey, 13 April 1904, box 54, file 9, CFNP.

32. For a while there was another group of Northwest Coast Natives at the St. Louis fair. Several Haida and Tlingit had come from Alaska, but they served only as workers to erect the house and totems brought down by Governor Brady (Wyatt 1986:20). Because they arrived during the preceding winter and left the week the fair opened, their work could not be part of the "show."

33. Charles F. Newcombe to George A. Dorsey, 13 April 1904, box 54, file 9, CFNP.

34. Henry E. Krehbiel, 6 August 1893, "Folk-Music in Chicago, II: Cannibal Songs of the Indians," *New York Tribune,* WCE Scrapbooks, vol. 2, FWPP.

35. Henry E. Krehbiel, 6 August 1893, "Folk-Music in Chicago, II: Cannibal Songs of the Indians," *New York Tribune,* WCE Scrapbooks, vol. 2, FWPP.

36. In more recent times, Kwakwa̱ka'wakw winter ceremonials have been given in the summer, especially around June.

37. However, citing Boas, Holm (1990b:378) notes that it was possible to hold these ceremonies "at any time, given the proper circumstances," although it was "formerly very unusual."

38. George A. Dorsey recorded seven wax cylinders in 1899, probably in Victoria; Charles F. Newcombe recorded some in Nahwitti, c. 1899; and Edward S. Curtis made several in July 1910. Boas later made a series of 156 cylinders in January 1931 on his last field trip to Fort Rupert, and another series on aluminum disks in 1938 and 1941 when Daniel Cranmer visited New York. All except Newcombe's (now in RBCM) are in the Archives of Traditional Music, Indiana University. Major collections of Kwakwa̱ka'wakw recordings since the late 1940s include those of Ida Halpern (BCA), Wilson Duff (RBCM), and Bill Holm (personal collection).

39. However, it should be noted that this argument may have been less an indication of his true feelings and more an attempt to save money.

40. For museum anthropology and its history, see Sturtevant (1969), Osgood (1979), Lurie (1981), Stocking (1985), Ames (1992), and Jones (1993). For two excellent recent studies of anthropological museums and their communities, see McLoughlin (1999), on the situation in Canada, and Simpson (2001), with a more international perspective.

41. The relative value of these plans for ethnological displays had been debated in the 1840s by the Dutchman Philipp von Siebold, advocating the former position, and the Frenchman Edmé-François Jomard, favoring the latter (Frese 1960:38–42).

42. The source of this screen is a mystery; the Smithsonian has no record of accessioning such a screen. As Hinsley and Holm (1976:306) point out, while the Chicago screen was painted on milled lumber, the Washington screen was constructed of wide, hand-adzed wood. The painting in the latter is much simpler (e.g., missing the flanking thunderbirds) and a little shakier, and could possibly have been done (or at least painted) at the museum, as the wooden-plank drum

was (cat. no. 239,096; acc. 46,518). Furthermore, pushing the series of replicas back another level, the circular painting of these hamatsa screens resembles that of the Chicago housefront; they may depict the same sun crest.

43. Frederic W. Putnam to Franz Boas, 18 February 1895, FBP.

44. George A. Dorsey to Charles F. Newcombe, 7 December 1900, FMNH.

45. Unfortunately, Newcombe never published this material, and it remains in his notes: notebook (box 35, file 10) and notes on the Field Museum display (box 58, files 5 and 10), CFNP.

46. Charles F. Newcombe to George A. Dorsey, 11 March 1913, and George A. Dorsey to Charles F. Newcombe, 18 March 1913, FMNH.

47. Seizing upon the metonymic connection of part-whole, ethnologists made sure that dwellings would be present at virtually every exposition where Natives were represented. This interest was perhaps a result (or at least a parallel development) of Lewis H. Morgan's 1881 study, *Houses and House-Life of the American Aborigines*.

48. Franz Boas to Frederic W. Putnam, 7 November 1896, FWPP.

49. For discussions of contemporary attitudes toward the ritual cannibalism of the Kwakwa̱ka̱'wakw hamatsa, see Bracken (1997), McDowell (1997), and Raibmon (2000). A similar example of the depiction of ritual violence in ethnographic displays was the Hopi Snake Dance (Dilworth 1996:44–54).

3. AESTHETIC APPROPRIATION

1. Herman Haeberlin's early formulation of the relation between the individual and tribal styles was later followed up by Ruth Bunzel (1929) on the pueblo potter, Lila O'Neale (1932) on Yurok-Karok basket weavers, and Gladys Reichard (1936) on Navajo weavers.

2. Viola Garfield's field notes and manuscripts on the subject are preserved in the University of Washington Archives.

3. Among the topics Erna Gunther treated during the 1950s in her television series were primitive art, Northwest Coast cultures, and her ethnohistorical research on the region.

4. In 1989–1991 the seventeen mannequins in the canoe were completely refurbished (Coffee 1991).

5. For a basic history of the Washington State Museum, see Krohn (1985), Holm (1987), and Ziontz (1988); for the B.C. Provincial Museum, see Corley-Smith (1985, 1989); for the Vancouver Museum, see Mayer et al. (1982).

6. For a critical review of the New York art world's appreciation of Native American art in this period, 1910–1950, see Rushing's comprehensive volume (1995), which goes into much more detail on the story recounted here.

7. Sources: NGC (1927), Leechman (1928), Tippett (1979:139–41, 147–49), Morrison (1991).

8. Leechman (1928:331), Tippett (1979:149), Cole (1985:284), Nemiroff et al. (1992:21–25).

9. Walter Pach, 22 November 1931, "The Indian Tribal Arts," New York Times, sec. 8, p. 13, cited in Schrader (1983:50).

10. For a photograph of part of the San Francisco display, see Schrader (1983:65; for a floor plan, see p. 187).

11. Augustus Pollock [curator in the Division of Pacific Cultures] to Erna Gunther, 5 April 1938, Burke Museum Miscellaneous Papers, Acc. box 70–17, University of Washington Archives.

12. Among the major sources on the 1941 Museum of Modern Art show are: d'Harnoncourt (1941), Douglas and d'Harnoncourt (1941), Lynes (1973:268–69), Schrader (1983:223–41), and Staniszewski (1998:84–98).

13. The most comprehensive source for the Surrealists and Native art is Cowling (1978), which, unless otherwise cited, is the source for the remarks below. Also relevant are Carpenter (1975), Jonaitis (1981), Clifford (1981), and Maurer (1984).

14. Lévi-Strauss and Eribon (1991:33), Mauzé (1990:52). For a Haida rattle thus obtained by Lévi-Strauss, see Wardwell (1964:65). For financial reasons, in 1951 Lévi-Strauss was forced to sell at auction his predominately Northwest Coast collection; the pieces were subsequently acquired by the Musée de l'Homme and the ethnology museum of Leiden, among others.

15. In his otherwise exhaustive review of primitivism in modern art, Goldwater (1967:222) mentions the Surrealists' appreciation of Northwest Coast art in a phrase. However, with the recent exhibit

on primitivism in twentieth-century art, historiographic research on the topic has become much more comprehensive and detailed (see Rubin 1984 and the chapters by Maurer and Varnedoe).

16. Of the twenty-six Emily Carr paintings on display, ten were of Kwakwaka'wakw subjects (Gilford Island, Alert Bay, Cape Mudge, Campbell River, and Village Island).

17. Tippett (1979:74–75, 107–13, 118–19, 134–36, 139–49); Stewart and Macnair (1999). Macnair clarifies Carr's use of ethnological sources: "Carr made very little use of the collections at the Provincial Museum and the Provincial Library. Nearly all of her work in this regard was conducted in Vancouver at the Vancouver Museum and the Art, Historical, and Scientific Association there. She virtually abandoned Northwest Coast subject matter (except for her pottery) after her failed attempt to sell her 1912 collection (exhibited in Vancouver) to the Provincial government. She only returned to a study of museum specimens and anthropological texts after her 1927 success in Ottawa, and most of her inspiration came from the National Museum collection and Boas's Primitive Art. Swanton's Haida ethnology was a post-1912 inspiration which she probably came to use through Newcombe, rather than the Provincial Library" (pers. comm. 1999).

18. The literature on primitivism in modern art and the relations between the art world and anthropology have recently grown quite large. In addition to the central texts by Goldwater (1967), Newton (1978), and Rubin (1984), the more important studies include Clifford (1988), Vogel et al. (1988), Faris (1988), Price (1989), Steiner (1994), Marcus and Myers (1995), Barkan and Bush (1995), Errington (1998), Phillips and Steiner (1999), and on American Indian art specifically, Gordon and Herzog (1988), Rushing (1995, 1999), and Dubin (2001).

19. Of the three kinds of primitivism—the influence of the "primitive" on modern art—considered in William Rubin's exhibition and publication (1984), I am concerned here with only two: (1) where the influence is historically documented and visible, and (2) where it is historically documented but invisible (i.e., conceptual). Not considered here is Rubin's more dubious relation of affinity, a similarity where there is no possible connection.

20. As Gertrude Stein put it in her patented manner, "People do not change from generation to generation. . . . Nothing changes from generation to generation except the things seen and the things seen make that generation, that is to say nothing changes in people from one generation to another except the way of seeing" (Alsop 1982:4).

4. MUNGO MARTIN AND THE RENAISSANCE OF KWAKWA̱KA̱'WAKW ART

1. Proclaimed the Sitka National Monument in 1910, since 1916 it has been part of the National Park System (Knapp 1980).

2. The principal source for the following discussion of the Stanley Park poles is the minute books of the AHSA, vols. 2 and 3, AHSA Papers, Vancouver City Archives, add. ms. 336. Also, the several guides to the poles: Campbell-Johnston (1924), Goodfellow (1924), Raley (1937), and Gunn (1965), as well as articles by Goodfellow (1926) and the AHSA (1926).

3. Vancouver *Daily News Advertiser,* 1 July 1915, p. 4, as cited in Dawn (1981:19–20).

4. As there is some uncertainty in the literature over the source of the Stanley Park houseposts, it should be noted that Campbell-Johnson reported to the AHSA at its meeting on July 6, 1920 that for $50 he had purchased the pair from Deer Island, the little island in Beaver Harbour (next to Fort Rupert), where Curtis did most of his filming. Minutebook no. 3 (1920–1944), AHSA Papers.

5. Minutes of the AHSA, 25 January 1923.

6. H. E. C. Carry, 6 April 1924, "The Indian Village in Stanley Park," manuscript report, copy sent to Frederic W. Howay, "Stanley Park Totems and Village," Vertical File, BCA.

7. In 1985 the Wakas pole "was transferred to the Vancouver Museum. The Vancouver Museum, the Vancouver Board of Parks and Recreation, and the Canadian Museum of Civilization agreed in 1987 that the Canadian Museum of Civilization would borrow the pole for a period of thirty years. A 'new generation' Wakas pole, commissioned by the Canadian Museum of Civilization and carved by Doug Cranmer, with the assistance of Fah Ambers and [Richard] Summer, was erected in Stanley Park in May 1987. The original pole was restored for the Grand Hall exhibit [at the CMC] by Doug Cranmer and Bruce Alfred in 1988" (Laforet 1992:34–35; see also 1988). Charlie James's Sisaxo'las pole was taken down in 1986. Lent by the Vancouver Mu-

seum to the Vancouver Trade and Convention Centre, it was erected in its Canada Place lobby. Around the same time, the pair of Kwakw<u>a</u>ʼwakw house posts was restored by Tony Hunt, and original poles by Beau Dick and assistants (Kwakw<u>a</u>ka̲ʼwakw), Art Thompson and Tim Paul (Nuu-chah-nulth), and Norman Tait (Nisgaʼa) were raised.

8. Harlan I. Smith report, in *Annual Report of the National Museum of Canada for 1926* (1928:81), Bulletin 50, cited in Darling and Cole (1980:39).

9. Later that decade, in 1926, James L. Kraft, famous for his cheese, purchased (through intermediaries) two totem poles from Alert Bay, one of which he donated to the City of Chicago. Erected in 1929 in Lincoln Park, the pole has undergone more than a dozen modifications since that date; wings and arms were mixed up with its mate and large portions recarved, but the biggest problem has been the radical changes in painting, as each repainting got further and further away from the artist's conception. By the 1960s the pole bore such a faint resemblance to the original that it was mislabeled as Haida (Leslie 1982). In 1986 a replica carved by Tony Hunt was erected in its place and the original returned to British Columbia, initially to the UBC Museum.

10. Harlan I. Smith to William A. Newcombe, 6 December 1929, box 14, CFNP.

11. Harlan I. Smith, Report on Totem Pole Preservation, 6 December 1934, CFNP.

12. In the late 1960s local residents restored the Skeena poles for a third time (Ward 1978:6).

13. Brown (1998:144) also notes that among the Tlingit, "the traditional styles that distinguish classic period art survived more completely in terms of sculpture than in the two-dimensional tradition." This may account for the apparent decline in painting noted by Garfield. In the opinion of Bill Holm, the CCC Alaskan poles "are actually very much better than we have any right to expect!" (pers. comm. 1998).

14. In the late 1960s the State of Alaska conducted a survey of all remaining totem poles and initiated another preservation program (Demmert and Demmert 1972).

15. Alice Ravenhill to Clifford Carl, 26 August 1949, BCPM Correspondence, GR 111, box 16, file 28, BCA.

16. Or so says the guidebook. The design shows no understanding of traditional stylistic rules but could have been executed by a Kwakw<u>a</u>ka̲ʼwakw. The guide states that the "painted design" was "modern work" ("Thunderbird Park," B.C. Government Travel Bureau [no date, early 1940s], p. 19).

17. Although anthropology had been taught earlier in other departments, the first Canadian faculty position in the discipline came in 1925, when Thomas McIlwraith took a joint appointment at the University of Toronto and the Royal Ontario Museum. The department Harry Hawthorn joined in 1947 combined the social sciences; since 1959 it has been a separate department of anthropology and sociology.

18. Report for 1950, President's Committee on Totem Poles, Totem Pole file, UBC.

19. Hunter Lewis, draft for article in *Vancouver Sun*, 12 October 1948, Hunter Lewis Papers, Special Collections, UBC Library.

20. There has been a great deal of confusion in the literature as to when Neel and Martin came to UBC. For instance, A. Hawthorn (1979:vii, also in 1974:7) claims that Neel started in 1949 and Martin the following year. Duff (1959:37) wrote that Martin started in 1947, a date that Macnair et al. (1980:73) repeat. My dates (Neel in 1948 and Martin in 1949) are based on a range of diverse evidence. The Neel date is best documented in a letter from Harry Hawthorn to Ellen Neel (30 April 1948, Harry Hawthorn Papers, Special Collections, UBC Library), cf. Nuytten (1982:52). And the Martin date is fixed by an article in the *Native Voice*, 1 September 1949, p. 1. According to Audrey Hawthorn (1993:9–10), UBC learned of Mungo Martin from Marius Barbeau at about the same time as they were in touch with Neel.

21. According to the UBC Museum of Anthropology, Martin's sea-raven pole was carved around 1902 (Hawthorn 1979:73 or Halpin 1981:40–41). A date of 1911 is more likely since securely dated contemporary photographs of the house (e.g., by Harlan Smith in 1909 at the American Museum, copies in the Provincial Museum; or the 1909 painting and photograph of Alert Bay by Frederick Marlett Bell-Smith; Stewart and Macnair 1999:20) do not show the pole before August 1911–April 1913. They do show the separate raven sculpture, placed on the roof of the house around 1901. Around 1912 the raven was placed on top of the pole in front of the house. It is pos-

sible that Martin carved the pole earlier and that it was only erected in front of the house c. 1912, but the museum's sources were most likely thinking of the bird sculpture when giving the earlier date.

22. Hunter Lewis, Annual Report of the President's Totem Pole Committee, 27 October 1951, UBC.

23. Hunter Lewis, 25 October 1949, Minutes of the President's Committee on Totem Poles, Totem Pole file, UBC.

24. Report for 1951 [October], President's Committee on Totem Poles, Totem Pole file, UBC.

25. Report for 1951–1952, President's Committee on Totem Poles, Totem Pole file, UBC. The idea of a Northwest Coast ethnobotanical display goes back at least to Harlan Smith in the 1920s. In the 1970s the Provincial Museum created such a garden, and in 1985 the Burke Museum dedicated one to the memory of Erna Gunther's pioneering research in the field.

26. Harry Hawthorn to Norman A. M. MacKenzie, 9 August 1951, Memo re: Mungo Martin, Totem Pole file, UBC.

27. Wilson Duff, [1954], Proposals on Totem Pole Preservation, Totem Pole file, UBC.

28. The following discussion is drawn from Jacknis (1990).

29. Tom Omhid, during the rehearsal. Omhid used nearly identical words during the actual potlatch. 13 December 1953, Transcript, KWA-W-009, Ethnology Division, RBCM.

30. Although at some point in the past such a sculpin design may have been painted on Kwaksistala's Ḵalugwis house, in Newcombe's 1900 photographs of the village no such painting is visible anywhere. In 1904 Newcombe showed a photograph of the village to Bob Harris and Charles Nowell, and there is no painting on the house that they identified as belonging to Quaxsixstali (RBCM Ethnology Division, photo no. 251). In his 1900 photograph of Tsadzis'nukwame' Newcombe identifies the relevant painting as a sun crest (Sentle) over a tsekish, or sculpin, and links this house to KwaxshistE (notes to RBCM photos no. 242 and 949, derived from Misc. Ethnology File no. 7, CFNP).

31. Peter L. Macnair, interview, 8 September 1982. Although Audrey Hawthorn (1979:257) claims that Martin painted one of the Scow houses at Gilford, Macnair, citing members of the Hunt family, believes this to be false. According to Bill Holm, "Mungo carved the front figures for the Sea Monster House (a baleen whale with a man on the back) and the Raven House (a big raven head supported on the head of a man, a functional necessity, since the raven was too heavy). The frontal painting was copied from a model sent down from Bella Bella (through marriage) and now in the Glenbow Museum" (pers. comm. 1998).

32. Duff also noted: "The house being copied had no frontal painting so this one is being 'borrowed' by Mungo." Whether this facade-less house is Naka'penkim's house or Kwaksistala's is unclear. Wilson Duff (n.d.), "Notes on Mungo Martin's House," File on Totem Pole Projects: Thunderbird Park, Ethnology Division, RBCM.

33. *Victoria Times,* 17 and 21 December 1953; *Victoria Daily Colonist,* 16 and 21 January 1954.

34. Wilson Duff to Richard Conn, 4 December 1953, BCPM Correspondence, GR 111, box 8, file 39, BCA.

35. Wilson Duff to Erna Gunther, 30 November 1953, BCPM Correspondence, box 4, file 14, BCA. Among those who accepted invitations were Erna Gunther, Viola Garfield, Catherine McClellan, Richard Waterman, Richard Conn, Bill and Marty Holm, from Seattle; and Audrey Hawthorn, Charles Borden, Cyril Belshaw, Gordon Marsh, and Della Charles (later Kew), from Vancouver. These were most of the local anthropological population interested in Native Northwest Coast culture.

36. Audrey Hawthorn [probable author], [1953], "Kwakiutl Ceremony: Dedication of the New House in Thunderbird Park, Victoria," Contemporary Northwest Coast Carvers file, UBC. There is also a copy in the Ethnology Division, RBCM. Nuytten (1982:94–99) has published an edited version. Nuytten suggests that it was written by someone at the Provincial Museum, but internal evidence suggests that Audrey Hawthorn was the author.

37. Tapes, KWA-T-027 A-F; Transcript, KWA-W-009; Film, KWA-F-006; and Photographs, all in the Ethnology Division, RBCM. It is unclear which night was photographed, but from the presence of whites in the audience, it would appear that they were taken on either the second or third night.

38. Mungo Martin said, "I am going to give a name, as I don't consider us to be two men" (rather, as one or related). Transcript, see notes in Nuytten (1982:99).

39. Peter L. Macnair (pers. comm.).

40. Tom Omhid, at the conclusion of the mourning section, first potlatch night, 14 December 1953, Transcript.

41. Respectively, George Scow at the rehearsal, 11 December 1953; Tom Omhid at the rehearsal, same day; and Tom Omhid on the first night, 14 December 1953; Transcript.

42. Helen Hunt's explanation of Tom Omhid's advice to the performers, at the rehearsal, 12 December 1953, Transcript, p. 5.

43. Mungo Martin, 14 December 1953, Transcript.

44. Wilson Duff to Viola Garfield, 26 November 1951, Ethnology Division, Correspondence, RBCM.

45. On concrete casting, see Wilson Duff to W. T. Straith, 16 August 1951, Thunderbird Park file, Ethnology Division, RBCM; and Wilson Duff to Stanley Rough, 3 June 1963, RBCM Correspondence, box 18, file 9, BCA.

46. Wilson Duff to Polly Sargent, 9 May 1960, BCPM Correspondence, box 18, file 19, BCA.

47. Wilson Duff to Neil Dresen [City Engineer of Courtenay], 9 December 1959, Thunderbird Park file, Ethnology Division, RBCM.

48. Philip R. Ward, 1967, "Some Notes on the Preservation of Totem Poles in British Columbia." Unpublished manuscript, 18 pp., delivered to the Second Conference on Southeast Alaska Artifacts and Monuments, Alaska State Council on the Arts, Anchorage, Alaska, 17 November 1967. Thunderbird Park file, Ethnology Division, RBCM, p. 15.

49. Against this interpretation, Bill Holm finds "very little 'Kwakiutl accent' in Mungo's Haida copies. In the case of the whale and eagle monument, the picture of the original eagle was not available to Mungo, so rather than 'make up' a Haida eagle, he did one he felt comfortable with. When he had a Haida or Gitksan piece beside him, he made quite a faithful copy, without 'Kwakiutl accent.'" While this is certainly true, replica poles often differed from their originals as documented in historic photographs.

50. But in a letter to President Norman A. M. MacKenzie, Hawthorn wrote: "Following your suggestion I have gone into the question of getting new totem poles carved for the University Park." March 1951, Totem Pole file, UBC.

51. Henry Hawthorn to H. R. MacMillan, 16 January 1952, Totem Pole file, UBC.

52. Newly made totem poles were not a foreign item on the UBC campus, for in the fall of 1948 Ellen Neel had presented a 16-foot thunderbird post to the university, where it was erected outside Brock Hall for the Alma Mater Society. The pole was handed over to the university in a public ceremony by Chief William Scow of Alert Bay, then president of the Native Brotherhood of B.C. Scow thereby gave the university the right to use the name and image of the Thunderbird (Nuytten 1982:51–52).

53. Not surprisingly, the honor of having "the world's tallest totem pole" has been sought by many communities. The 127.5-foot pole at Victoria's Beacon Hill Park was eclipsed by a 173-foot pole erected in Alert Bay in 1974. It, in turn, was topped in 1994 by a 180-foot pole at Songhees Point in the Victoria harbor, but it was taken down not long after (Macnair, pers. comm. 1999). Undoubtedly, others will attempt to take the prize.

54. Newspaper article [source not noted], 1961, "Thunderbird Park," vertical file, BCA.

55. Anonymous [Wilson Duff, probably], [1961], Thunderbird Park file, Ethnology Division, RBCM.

56. This discussion on the development of a restrained Kwakwaka'wakw painting style is based on two interviews with Peter L. Macnair: (1) Tony Hunt and Peter L. Macnair, interview with Imbert Orchard, Canadian Broadcasting Company, (1969), Acc. 1024–1, Aural History Division, BCA; (2) Peter L. Macnair, interview with author, 4 December 1981.

57. Because this incident has been previously cited (e.g., de Laguna 1963:896; Nuytten 1982:114–115), it is useful to offer Bill Holm's clarification: "At the funeral the song leader came to me and asked if I had my tapes, since the singers were uncertain of their ability to sing the mourning songs correctly. I went out to the car and got my tape recorder and a tape I had recorded at a potlatch at Kalogwis (not at the museum) of Mungo *leading* the singing of mourning songs. It did include 'his own voice,' but also the voices of a large chorus" (pers. comm. 1998).

58. The career of Mungo Martin raises multiple issues. Those of performance, his subsequent commissions and training programs, and Native scholarship are considered in chapters 6, 7, and 8, respectively.

5. THE CONTEMPORARY ART WORLD: ETHNIC FINE ART

1. Compare this total to the 226 of *Yakutat South* at the Art Institute of Chicago (Wardwell 1964) or the 334 pieces selected for the Seattle World's Fair (Gunther 1962).

2. John Canaday, 3 September 1967, *New York Times*.

3. Joan Lowndes, 16 June 1967, *Vancouver Province*.

4. Franz Boas, 28 August 1922, "The Indians of British Columbia," unpublished lecture before the Natural History Society of British Columbia, copy in vol. 1, p. 11, CFNP.

5. Franz Boas to the Lt. Governor of British Columbia, 5 March 1931, FBP.

6. A forerunner of this movement was the Reverend George H. Raley, a missionary with wide experience on the British Columbia coast (see Ames et al. 1975a:32). In 1935 he contributed an article to the *Journal of the Royal Society of Arts* (London) advocating governmental support for a revival of Indian arts and crafts.

7. For summary sources on Alice Ravenhill and the Society, see Ravenhill (1951:209–31), and Agnes Carne Tate, "Up-Hill Battle for 25 Years," *Victoria Daily Colonist*, 22 March 1964, pp. 2–3.

8. [Founding Statement], Society for the Furtherance of Indian Arts and Crafts, January 1940, Alice Ravenhill file, BCPM Correspondence, GR 111, box 16, file 36, BCA.

9. A full description and analysis of the contemporary Indian art market in the Northwest is beyond the scope of this study, but a solid introduction to it has been prepared by Karen Duffek (1983a).

10. Of course, the historic market has not been restricted to New York. About 1949 the Los Angeles dealer Ralph Altman began an influential career as a purveyor of Northwest Coast art (UCLA 1968), and the McKillop family has been selling Indian art in Seattle since 1933.

11. Jay Stewart, interview, 7 July 1982.

12. Museums have played an especially active and decisive role in the marketing of Native arts in the Southwest; for a good review see Bernstein (1994).

13. Stewart Culin, 1911, Report on a Collecting Expedition among the Indians of Oklahoma, New Mexico, California, and Vancouver Island, May-August, 1911; Stewart Culin Archival Collection, Brooklyn Museum of Art, pp. 2–5.

14. Like almost all the dates given in this study for the founding of museums, it is a matter of choice of when one dates the beginning of the Brooklyn Museum. With roots going back to 1823, the Brooklyn Institute of Arts and Sciences was reorganized in 1890, with the first museum building opening in 1897. For most of the museums discussed here, an art association preceded the erection of a building.

15. Some of this information came by correspondence from Richard Conn, 24 February 1986.

16. Bear in mind that this issue of "coherence" is a relative matter; Fane exposes the gaps and fictions in Culin's collecting (Fane et al. 1991:25–27).

17. The primary source for this section is an interview with Holm, 8 October 1981. Unless otherwise noted, all quotations are from this interview. See also M. Holm (1958), B. Holm (1985), Wright (1985), Downey (1986), Jonaitis (1988:243–44), and Brown and Averill (2000).

18. In the late 1950s, Bill Holm served as an adviser to another Indian hobbyist in the Northwest: Carl Heinmiller, a businessman-scoutmaster in Port Chilkoot, Alaska. Heinmiller's group, which included Tlingit youth and elders, built a community house in 1962 and formed a dance troupe. They "inspired other dancers, notably of Yakutat [another Tlingit group], to revive their tribal dances and to put on exhibitions at various gatherings throughout the state" (Keithahn 1963:122).

19. Patricia Cosgrove-Smith, 1984, "Kwakiutl Indian Daily Life in 1900," National Endowment for the Humanities Grant Proposal, Pacific Science Center, Seattle, p. 4.

20. According to Falk (1976:7), the Sewids named and dedicated the *exhibit hall*, but it seems more likely that it was the first, smaller community house that received the name.

21. For extensive documentation of public displays of many of these Seattle artists, see Averill and Morris (1995).

22. In the few galleries in British Columbia that carry such work, a common code phrase for non-Native artists is the suffix "-style," as in Haida-style. Formally, the work may be identical to creations labeled simply as Haida, but it seems to comfort potential clients and critics.

23. In letters and unpublished writings, UBC and RBCM.

24. Report of the Committee for the Preservation of Totem Poles, February 1953, Totem Pole file, UBC.

25. [Harry Hawthorn?], "Notes for Totem Park Ceremony [for a talk by Chancellor P. Ross], June 1962, Totem Pole file, UBC.

26. The relevant literature on the American Southwest is especially rich; see Wade (1985), Dilworth (1996), Mullin (2001). On the Maori, see Mead (1976). For a general review of cultural appropriation, see Ziff and Rao (1997)

27. With his support for his Seattle artistic colleagues, Bill Holm is an exception to the impression that there seems to be less interchange between contemporary anthropologists and artists than in former times.

28. On the other hand, several Native artists—such as Bill Reid and Lyle Wilson—have been among the most creative in their combination of Native and Western motifs (Wade and Strickland 1981: 30–31, 34).

29. "In the late 1970s the National Museum Corporation assigned the federal mandate to collect and exhibit Native art to the Canadian Museum of Civilization" (McMaster and Martin 1990:52). Although the National Gallery of Canada was free to cooperate, not until 1985 did the National Gallery revise its Collections Policy to include Native art. In January of that year they hired a curator of Inuit art but decided that Indian work would be acquired and exhibited by the curators of contemporary art, with the advice of the Museum of Civilization (Nemiroff 1987). The National Gallery acquired its first work by a Native Canadian in 1986, a painting by Ojibwa Carl Beam. *Land, Spirit, Power: First Nationals at the National Gallery of Canada* in 1992 (Nemiroff et al. 1992) was its first international exhibit of Native American art. When the Museum of Civilization opened in June 1989, it included a gallery of Indian and Inuit art. It also had a 1992 art exhibit, organized by Native curators—*Indigena: Contemporary Native Perspectives in Canadian Art* (McMaster and Martin 1992).

30. A sense of this belated chronology is evident when one considers the history of Native art exhibits at the Vancouver Art Gallery. After *People of the Potlatch* (1956), came *Arts of the Raven* (1967), *Bill Reid* (1974), and *Images: Stone: BC* (1975), most of which were devoted to historic art. There was not another show of Northwest Native art for almost twenty years. However, *Beyond History* (1989) featured Native artists from eastern Canada, and *Lost Illusions* (1991) included the coastal imagery of Lawrence Paul Yuxweluptun's oil paintings. As Doreen Jensen, Gitksan artist and curator, notes, "It was not until 1994 that the gallery hosted a show by a traditional contemporary Northwest Coast artist—Haida artist Robert Davidson" (Jensen 1996:102).

31. Richard Hunt, 1998, "Dialogue: Art versus Cultural Property." Richard Hunt web site, http://www.richardhunt.com.

6. CONTEMPORARY ANTHROPOLOGY: THE KWAKWA̱KA̱'WAKW OBJECT IN HISTORY

1. The following account is based on an interview with Peter L. Macnair, 8 September 1982, and files in the Ethnology Division, RBCM.

2. In 1974 the committee became the Council for Museum Anthropology, which continues to the present, now as a unit of the American Anthropological Association.

3. Confirmed in an interview with Harry Hawthorn, 21 October 1981.

4. Today, purchase funds come from a variety of sources. While some are appropriated from the provincial government, and some from the federal government as part of its repatriation program (Canadian Cultural Property Export and Import Act of 1977, Ministry of Canadian Heritage), the division relies mostly on private support in the form of the Friends of the Royal British Columbia Museum.

5. Peter L. Macnair, "Collecting Policy, Ethnology Division, British Columbia Provincial Museum," [1981], typescript, 4 pp. All citations in the following discussion are taken from this doc-

ument. It was a supplement to the "Collections Policy, British Columbia Provincial Museum," prepared by Bill Barkley, Don Abbott, and Bob Ogilvie, January 1980. The current museum-wide collection policy was approved by the director in 1997, and is accompanied by an "Aboriginal Material Operating Policy." Its basic character is evident from the following policy goal: "The Museum is committed to the involvement of Aboriginal peoples in the interpretation of their cultures as represented in exhibits, education programs, and public programming developed by the Museum. The Museum is committed to a continuous dialogue with Aboriginal communities in British Columbia in relation to its collections, repatriation policies, and co-operative management efforts."

6. Peter L. Macnair, interview, 4 December 1981.

7. Wilson Duff, "Proposals on Totem Pole Preservation," 1954, file on B.C. Totem Pole Preservation Committee, UBC.

8. The following discussion of the Provincial Museum's exchange program is based on an interview with Peter L. Macnair, 4 December 1981.

9. Apparently the first to use replicas as part of a purchase was the Victoria dealer Howard Roloff, around 1969. Most of his early copies were made by John Livingston, the white carver and partner of Tony Hunt. Unlike Macnair, who encouraged free copies, Roloff insisted on exact duplicates, even to the extent of aging materials. Howard Roloff, interview, 8 December 1981.

10. Since 1987 the Campbell River Museum has carried out a similar project: the creation of a large set of masks (eventually numbering about thirty) devoted to the Dance of the Undersea Kingdom. Peter Macnair has been commissioning versions of the masks in the set from leading Kwakwa̱ka'wakw artists. Normally on display, they may be borrowed back for use in potlatches by Chief Tom Willie of Hopetown, owner of the rights to this privilege (Jonaitis 1991:251, 265).

11. The following discussion is based on an interview with Peter L. Macnair, 8 September 1982.

12. The following discussion is also based on comments by Peter L. Macnair in an interview, 8 September 1982.

13. This description refers to the First Peoples exhibit as it was originally installed and as it appeared c. 1980. Since then minor modifications have been made; most notably, the large underwater display of salmon traps and the mannequin of a Coast Salish weaver have been removed. The film and tapeloops were taken out, as was the small argillite gallery. The exhibition's subtitle has now been changed to "Aboriginal Culture in British Columbia."

14. Scattered throughout the first, precontact half are several mannequins. Although the fact is nowhere acknowledged (no doubt considered to be of merely anecdotal interest) that the models for two of these were prominent Coast artists: Douglas Cranmer posed for the Kwakwa̱ka'wakw woodworker adzing a plank and Norman Tait stood in for the Tsimshian chief in full ceremonial regalia.

15. This mask was not a "real" Tsimshian mask, but a replica carved by staff artist Richard Hunt.

16. Outside the Provincial Museum, the appearance of Thunderbird Park has changed little since Mungo Martin's time. In 1960 the exhibits were repainted and treated with preservatives. In 1972 a general development of the park was planned, with a new carving shed, a regrouping of the totems for freer access and better photography, and a relandscaping of the site. Because the original, nondescript shed was too small and inconvenient for the use it was getting, the museum decided to build a house in another tribal style that could be used as an exhibit in its own right. A distinctive feature is the removable side panels, which allow the room to be opened up for public viewing. The new Haida-style carving shed did not open until the fall of 1975, only to burn in an accidental fire in July 1980. In 1982 it was replaced with a duplicate, carved under the supervision of Haida Gerry Marks and dedicated by a Haida chief. At this time, the poles and housefront were repainted again. In October 1999 a new Kwakwa̱ka'wakw pole was erected (see chapter 7, note 3). The totem park at UBC has changed less since the completion of the Haida houses—mainly, several more poles and monumental sculptures have been added in an attempt to fill out the tribal representation and documentation of major contemporary artists.

17. In 1990 the UBC Museum of Anthropology was expanded with a new wing for the Koerner ceramics collection, a laboratory, library, curatorial offices, and extra lobby space. By the end of the decade, however, the visible storage area had reached its capacity, and plans were being made

for another expansion. For reasons of space, as well as preservation and cultural relations, items not on public display were culturally sensitive objects, textiles, and two-dimensional objects. The museum was also planning to replace the documentation books with computer terminals.

18. The first mention of the notion of visible storage at UBC goes back to the early 1960s. In a statement on accessions for the year 1961 (October 16): "All the Northwest Coast materials for which we can find room have been put on display in the Museum, in cases which are converted to "Visible Storage" so that the students of anthropology, art, and other fields can see, compare, and contrast the larger tribal differences in masks, costumes, feast dishes, magic techniques, etc." History Box 2, UBC.

19. Michael M. Ames, interview, 26 May 1981.

20. A measure of the scale of the hall comes from its exhibition of about 2,500 objects in an area roughly 15,000 square feet. The Provincial Museum in a space as large, if not larger, exhibited only about 800 objects. The difference comes from the Field Museum's use of the visible storage scheme. While they characterize their level-three displays as visible storage, even their secondary level is more densely packed with artifacts than is the style in most contemporary museums. For comparison, the UBC Museum devoted about 10,000 square feet for almost all of its 12,000 piece collection.

21. Sources for this discussion: Blackmon and Weber (1982), Weber (1982), Weber and Crane (1982), Grumet and Weber (1982), and Rathburn and Lupton (1983).

22. The assistants for the Kwakwaka'wakw house were Bruce Alfred, Al West, Gus Matilipi, Donna Ambers, and Hup.

23. FMNH, photograph no. 16246A.

24. Pacific Science Center (PSC 1981), Annual Reports of the Burke Museum for 1968 through 1972, and NIG, 16 November 1966.

25. The frontal pole, at 35 feet, was too tall for the Burke, so it was installed in the Washington State Convention and Trade Center in Seattle (Averill and Morris 1995:62–63).

26. Corley-Smith (1985:27–28); BCPM Annual Reports from 1967 through 1976; interview with Peter L. Macnair, 8 September 1982. On the Tony Hunt frontal painting, see Abbott (1981:294, 296–297).

27. Since these two projects, both begun in the late 1960s, several other museums have resorted to large-scale Native houses as a contextual display for artifacts. The Makah tribal museum at Neah Bay, Washington (see chapter 9), used such a replica in its 1979 building. This structure "was built outdoors and allowed to weather before being installed in the museum. For added authenticity the young carvers hung salmon in the house rafters to cure and . . . then hosted a community dinner at which the new-old house was dedicated with traditional songs and dances" (Kirk 1980:8).

28. The subject of the exhibition of ethnic artifacts has recently generated a large literature. For further discussion and references, see Karp and Lavine (1991); Karp et al. (1992); Roberts and Vogel (1994); Simpson 2001.

29. For a discussion of the creation of artifacts for display at the B.C. Provincial Museum, see the section on patronage in chapter 7.

30. George Hunt, "Notes on the Anthropological Collection in the Provincial Museum," 22 September 1922, box 40, folder 16, CFNP; also BCPM Annual Report for 1922.

31. Since 1980, there have been two important temporary exhibits of Kwakwaka'wakw art in museums of anthropology: *The Copper That Came from Heaven: Dance Dramas of the Kwakwaka'wakw,* at the UBC Museum of Anthropology, July 1983-April 1984 (Kendon and Perkins 1983); and *Chiefly Feasts: The Enduring Kwakiutl Potlatch,* which opened at the American Museum of Natural History in 1991 (Jonaitis 1991:21–69, 1992a; Berlo and Phillips 1992; Webster 1992b; McDonald 1992; Ostrowitz 1993; Masco 1996). The two are related in subject and approach and involved some of the same personnel (such as Gloria Cranmer Webster and Peter L. Macnair, both of whom had worked on the original *Legacy* exhibit). *Copper* was developed by both Kwakwaka'wakw Native museums as well as the Provincial and UBC museums. Accordingly, it sought to present objects from a Native perspective, with labels in Kwak'wala and English. *Chiefly Feasts,* which featured the Boas-Hunt Kwakwaka'wakw collections, was organized by art historian Aldona Jonaitis with the intimate involvement of the Kwakwaka'wakw community.

32. Issues of intercultural performance have been treated most thoroughly in the recent literature on folk festivals (Baron and Spitzer 1992; Bauman et al. 1992; Cantwell 1993; Price and Price 1995) and on living history museums (Anderson 1984; Snow 1993), as well as in the comprehensive review of Kirshenblatt-Gimblett (1998).

33. Harry Hawthorn to Norman A. M. MacKenzie, 9 August 1951, Totem Pole File, UBC.

34. Lyn Harrington, "Totem Carver Plans Potlatch," unattributed newspaper clipping, [January–September] 1953, Northwest Coast Contemporary Artists file, UBC.

35. Wilson Duff to Harry Hawthorn, 20 January 1956, Ethnology Division, RBCM.

36. This was confirmed in interviews with Donald Abbott (22 April 1982), Tony Hunt (9 September 1982), and Michael Kew (22 September 1982).

37. Totem Pole file, UBC, 5 April 1951.

38. Hindy Ratner, interview, 25 May 1981.

39. Twentieth-century Kwakwaka'wakw ceremonialism is particularly well suited for such museum display. As Bill Holm notes, "I don't know of any Kwakiutl dances that are not 'secular.' None today, even at the greatest Winter Ceremonials, are sacred or religious. They are considered prerogatives, and even at 'museum openings' they are usually performed by those entitled to them, and often there is even a token payment, at least to the biggest 'chiefs' of the event" (pers. comm. 1998; also Holm 1977).

40. Other UBC graduates up through 1980 include Marjorie Halpin (UBC Museum of Anthropology), Lynn Maranda (Vancouver Museum), Joy Inglis (Vancouver Museum, Cape Mudge Kwagiulth Museum), Andrea Laforet (Provincial Museum and Canadian National Museum), Margaret Stott (Redpath Museum, National Museum, UBC), Marilyn Chechik (Provincial Museum), Gillian Delamer (Cape Mudge Kwagiulth Museum), and notably, two Native scholars, Della Charles Kew (Vancouver Museum, Musqueam Band), and Gloria Cranmer Webster (UBC, U'mista Cultural Centre) (Hawthorn 1974:14–16). Note: the institutions listed are for the 1970s and 1980s.

41. Although Wayne Suttles is known primarily for his work with the Coast Salish, he has done research and writing on the Kwakwaka'wakw (Suttles 1979, 1991a, b).

42. Duff's manuscripts are held in the Royal British Columbia Museum (Library), the British Columbia Archives (microfilm copies), the UBC Museum of Anthropology, and by his daughter, Marnie (see Anderson 1996).

43. It is important to note that Macnair's sound recording of potlatches was preceded by Bill Holm's taping of his first complete Kwakwaka'wakw potlatch at Kalugwis in 1959, as well as three or four more before Macnair began in 1967 (Holm pers. comm. 1998). Holm's work, however, was not part of any institutional program.

44. Source: Peter L. Macnair, interview, 4 December 1981. Natives' motives in requesting such records are unclear. Ames (1981a:12) claims that "they use [them] to plan future potlatches or for their own entertainment," but Macnair was not sure about the latter.

45. Ironically, the biographical approach, focusing on individual artists creating unique artworks, was applied to Native art as it was being rejected by postmodernist art historians (Preziosi 1989:32–33).

46. Taking a Haida example, discussions of argillite sculpture invariably mention that it is soft when quarried and hardens with age. As Bill Holm (1972a:86) has pointed out, this is a misperception. For a Kwakwaka'wakw example, in his review of Wardwell's *Objects of Bright Pride*, Holm calls our attention to an inaccurate account of a bear mask (Wardwell 1978:fig. 40), which, he notes, "follows very closely a similarly erroneous statement in a standard Kwakiutl art reference" [apparently Hawthorn 1967:254] (Holm 1979:78).

47. See Wardwell (1964:49, no. 103) for its first seven references; also Feder (1971:xvi, no. 31), WAC (1972:124, no. 213), Coe (1977:145, no. 321), Leuzinger (1978:261, no. 336), and Vincent et al. (2000:326), which also has a comprehensive summary of ownership and scholarly citations.

48. See Wardwell (1964:35), Harner and Elsasser (1965:99), Duff et al. (1967:n.p), and Duff (1969: sno.63). The mask, attributed to Bob Harris by Peter L. Macnair, is now in the collection of the U'mista Cultural Centre, Alert Bay.

7. THE MUSEUM AS PATRON

1. Peter L. Macnair, interview, 8 September 1982.
2. Haida: Ron Wilson (June 1970–December 1971 [?]), Lawrence Bell (June–December 1970), David Gladstone (six weeks in 1972), and Francis Williams (last half of 1974). Kwakwaka'wakw: Oscar Matilpi (July–August 1970, a month in 1972) and Frank Puglas (July–August 1973, December 1974–March 1975).
3. Since the ending of the formal museum carving program, the Royal Museum has collaborated with the Victoria Native Friendship Centre to produce the Echoes of Ancestry emerging artists program. The two organizations had already worked together in the production of the annual First Peoples festival. The coordinator of Echoes of Ancestry is Leslie McGarry, culture and recreation director at the centre, who is a great-granddaughter of Mungo Martin. Beginning with a one-month pilot program in the summer of 1995, it was held every summer through 1999. A shifting group of young carvers used the facilities of the carving shed in Thunderbird Park while they practiced their craft. In October 1999, their efforts culminated in the erection of a new totem pole in the park, the first to be raised on the site in forty years. This thunderbird and whale pole was carved by Kwakwaka'wakw Johnathan Henderson and Sean Whonnock (McGarry 1996; museum press release, 1999).
4. Hindy Ratner, interview, 25 May 1981; Michael M. Ames, interview, 26 May 1981.
5. Sources: NIG, 28 September 1966, and 24 June 1971.
6. Bill Holm believes that the B.C. Packers posts were not commissioned but were originally houseposts at Kalugwis on Turnour Island (pers. comm. 1998).
7. Michael Kew, Duff's assistant during 1956–1959, confirms that Duff allowed the carvers a great deal of freedom in carrying out their appointed tasks (interview, 22 September 1982).
8. NIG, 28 September 1966, and 24 June 1971.
9. As early as 1964, though, Douglas Cranmer and his apprentice Peter Scow were leaving unpainted pieces (masks, feast bowls, rattles, paddles, and wall plaques) that they were selling in their Vancouver gallery. As Scow remarked, "Colors were always used sparingly in the old days, but we've also found that unpainted carvings are easier to sell. Probably they go better with modern furniture" (Wilson and Dickman 1964:17).
10. Peter L. Macnair, interview with Imbert Orchard, Canadian Broadcasting Company (1969), Acc. 1024–1, Aural History Division, BCA.
11. Such a shift from familial to tribal identity—and the alternate Native attitudes toward it—is also present in the recent dispute over the ownership of the art treasures in the Whale House in the Tlingit community of Klukwan, Alaska (Herem 1991).
12. With a decline in the marking of traditional social categories, brought on by population loss and acculturation, artists from other tribes have also begun to raise poles that represent the entire tribe. In two of his major projects—his first pole of 1969 and his Edenshaw Memorial houseposts of 1978—Robert Davidson has combined crests from both Haida moieties. For his pole, "The artist deliberately chose three Grizzly Bears and three Watchmen, crests which did not belong exclusively to either Eagle or Raven clans, in order to make it clear that the pole was for all of the people" (Thom 1993:71, see also 88). However, as Thom notes, "In fact, Davidson made an error. The Bear is a Raven clan crest, and as an Eagle he did not have rights to it. That Davidson could make such an error is further indication of the lack of knowledge then in Massett about traditional culture" (ibid.:165).
13. Recently, folklorists have addressed themselves to the ethical obligation of the folklorist and his or her role in the marketing of the crafts created by their informant-craftsmen (Jones 1970; Briggs 1986; and Joyce 1986). Such essays reflect the changing political situation and the erosion of the ethnographer's position of detachment, seen also in the various kinds of action and applied anthropology.
14. Frederic W. Putnam to George R. Davis, 29 April 1893, FWPP.
15. A fascinating Maori parallel has been reported by Barton (1984). Around 1890 it became the practice for curators in New Zealand to paint their monumental Maori artifacts with red paint, in the mistaken belief that this was a widespread precontact custom. In actual fact, such styles were restricted to particular regions at particular times. Working under false assumptions, the cura-

tors had introduced a kind of "hyperarchaism" into the ethnographic record, literally inventing a tradition. As in the British Columbia case, Native artists soon adopted the red paint for their new works, enough so that a local paint company made up a formula for Native use.

16. Wilson Duff to Heaney Cartage and Storage, 26 May 1952, Thunderbird Park file, Ethnology Division, RBCM.

17. W. B. Anderson, 7 August 1911, Natural History Society of Victoria, Minute Books, BCA. This reference was kindly shared with me by Douglas Cole.

18. *Vancouver Province*, 19 May 1934.

19. Harry Hawthorn to H. R. MacMillan, 16 January 1952, Totem Pole file, UBC.

20. Hunter Lewis, 27 October 1951, Annual Report, President's Committee on Totem Poles, Totem Pole file, UBC.

21. Wilson Duff, [1954], "Proposals on Totem Pole Preservation," Totem Pole file, UBC.

22. Hanuse, see Hawthorn (1979:250); Rosso, interview, 7 April 1982.

23. This section was drawn principally from the two files on the Coastal Indian Heritage Society (CIHS) in (1) the records of the Vancouver Art, Historical, and Scientific Association, add. mss. 336, vol. 32, files 417–418, 419, 422, Vancouver City Archives; and (2) the Education Department of the Vancouver Museum. The former source is stronger on the initial planning for the organization, while the latter is mostly concerned with the actual activities of the group. These were supplemented with two interviews: with Joy Inglis, 6 July 1982; and Larry Rosso, 7 April 1982.

24. "Indian Heritage Project of the Coastal Indian Heritage Society," CIHS files, no. 418, Vancouver City Archives.

25. Joy Inglis to Judy Roberts [Donner Foundation, Toronto], 21 July 1971, CIHS files, no. 418, Vancouver City Archives.

26. Joy Inglis to the director, [early 1971], Draft proposal, CIHS files, Education Department, Vancouver Museum.

27. "Indian Heritage Project of the Coastal Indian Heritage Society," CIHS files, no. 418, Vancouver City Archives.

28. Susan Davidson, First Annual Report of the CIHS, 1971–1972, CIHS files, Education Department, Vancouver Museum.

29. Around 1982 the Provincial Museum's collection of demonstration artifacts was transferred from the Education to the Ethnology Department.

30. In explaining the "phasing out" of the potlatch loan collection, Peter Macnair wrote: "A new generation of carvers has arisen and individual Kwakwa̱ka̱'wakw are increasingly commissioning them to carve the newly necessary ceremonial regalia" (1986:517).

31. Peter L. Macnair, Collecting Policy, 1981, Ethnology Division, RBCM.

32. The following describes the Potlatch Collection as it worked at the end of the period under discussion—the early 1980s.

33. Sometimes the local patrons may reinterpret what the museum does. Richard Hunt remembers one occasion when he carved what he thought was an owl mask for use in an "Animal Dance" at a 1976 Alert Bay potlatch. When it was delivered, however, the chiefs interpreted it as a hawk. "Now we just take the masks up to the potlatch and let them call them what they want" (Blackman 1985:25).

34. Adjustments to masks for performance are made not only to museum pieces. As Bill Holm (pers. comm. 1998) points out, he and other artists are "frequently called upon in the back room of a Kwakiutl bighouse to make a last-minute modification of a mask (make the inside bigger, repair a broken part, etc.)." In fact, this has been a traditional practice.

35. Jay Stewart, interview, 5 July 1982.

36. Mrs. A. J. Tullis to Lawren Harris, 10 November 1945, BCPM Correspondence, box 5, file 7, BCA.

37. Robert B. Inverarity to Clifford Carl, 17 April 1944, BCPM Correspondence, box 6, file 24, BCA.

38. Bill Reid to Wilson Duff, February 1954, BCPM Correspondence, box 17, file 46, BCA.

39. Michael M. Ames, interview, 26 May 1981. Artists who have made frequent use of the UBC collection up to the early 1980s include Kwakwa̱ka̱'wakw Roy Hanuse and Russell Smith, as well as Joe David, Ron Hamilton, Roy Vickers, James Hart, Norman Tait, and Lyle Wilson. Hindy Ratner, interview, 25 May 1981.

40. Jay Stewart, interview, 7 July 1982.
41. The UBC Museum supplies photographs at cost to Native artists; the Provincial Museum used to give them away gratis, but it now offers them at cost.
42. Peter Lando, interview, 10 November 1981.
43. For a general reference on reproductions and fakes in Native American art, see Horse Capture and Tyler (1992).
44. Erna Gunther, who saw few signs of life in the contemporary Native art of the 1950s, agreed with this progressive view of tradition: "If the creative spirit is ever revived among these Indians, one can only hope that it will lead them into newer fields to develop, not binding them to their older traditions, but using their heritage as a basis for new formulations." Erna Gunther, 1954, "Design Areas: The Northwest Coast of America," lecture no. 5 of a televised course, "Primitive Art," copy in Audio-Visual Center, University of Washington.
45. Quoted in the film *Bill Reid* (1979); Jack Long, director, National Film Board of Canada.

8. NATIVE CULTURAL PROGRAMS

1. It is not clear whether the Natives were consciously reacting to the lifting of the ban or whether their efforts were independent developments. There is reason to think that it was more of a coincidence, though one ultimately responding to a basic shift in the nature of Indian-white relations, marked by this revision of the Indian Act.
2. One curious exception was their participation in the Curtis film, *In the Land of Head Hunters*, 1914 (Holm and Quimby 1980). In his attempt to portray their precontact culture, Curtis combined some quasi-documentary footage with a melodramatic story. The Kwakwa̱ka'wakw were paid for their appearances, and most reportedly enjoyed the experience. However, despite Curtis's great hopes, the film met with little commercial success and has only been widely seen and appreciated with the new sound version of 1974.
3. The principal documentation of these events consists of the photographs in the Ethnology Division, RBCM, no. 1872 and 1877 (Duke of Connaught, cf. Healey 1958:62), no. 1865-b (Lt. Governor), and no. 1866, 1866-b, 1867 (King George VI).
4. PJ, 15 May 1939; 13 May 1953; 24 May 1963.
5. Sources for the following account are PJ, 30 May 1951, also 18 April, 2 May, 16 May, 23 May, 30 May; and Spradley (1969:158–162).
6. According to Drucker and Heizer (1967:49), Charlie Nowell was trying to persuade a young relative of his to exhibit his masks and privileges at this Hospital Dance and then give a "private (house to house) potlatch, formally stating his claims to the privileges publicly displayed." This scheme was abandoned when the anti-potlatch law was lifted. The dating of this event is a little uncertain, as Drucker and Heizer suggest the dances had started in the late 1940s, but it must have been sometime in 1951. This combination of "free" show for non-Natives and payment to Natives has continued in Kwakwa̱ka'wakw intercultural performances, however, even if the payments are small and symbolic (Ostrowitz 1999:101–102).
7. PJ, 30 May 1951, p. 1.
8. Richard Pattinson's color slides (Alert Bay Library and Museum, and copies in the Ethnology Division, RBCM), and Ronald Shuker's black-and-white photographs (in the PJ and the Alert Bay Library and Museum).
9. Most of these performance features characterized Mungo Martin's 1953 house-opening ceremony in Thunderbird Park.
10. PJ, 21 May 1952, pp. 4, 5.
11. Sources for the following discussion of the Centennial Celebrations are PJ, 26 March, 30 April, 4 June, 25 June (the main coverage), 2 July 1958.
12. PJ, 26 March 1958.
13. PJ, 30 April 1958.
14. PJ, 4 June 1958.
15. There is some confusion as to whether this was the first such event. The *Pioneer Journal* indicates that it was, but James Sewid suggests in his memoirs, without using dates, that the first one was held about 1955 or 1956 (see Spradley 1969:190).

16. The Kwak'wala name for the hand game is alax̱wa. Though no longer much played among the Kwakwa̱ka̱'wakw, "it is *very* popular among the Coast Salish, the Sahaptians, and many Plains tribes" (Bill Holm pers. comm. 1998).

17. The leaders at the head of the line were James Sewid from Alert Bay, Henry Bell from Village Island, Tom Johnson from Fort Rupert, and William Scow from Alert Bay, formerly from Gilford Island. The villages represented were Fort Rupert, Smith Inlet, Blunden Harbour, Nahwitti, Quatsino, 'Na̱mg̱is of Alert Bay, Village Island, New Vancouver, Turnour Island, Gilford Island, Kingcome, Hope Town, Cape Mudge, and Campbell River.

18. PJ, 25 June 1958, p. 1.

19. PJ, 25 June 1958, p. 2.

20. PJ, 24 June / 1 July 1959.

21. For the 1941 renovation, see PJ, 17 June 1941, also 15 March, 15 May, 15 September, 15 October, 1940, and 1 February, 3 June 1941. For the erection of the new pole, see PJ, 19 April 1941. For the 1951 cleanup, see PJ, 16 May 1951.

22. Wilson Duff, [1954], "Proposals for Totem Pole Preservation," Totem Pole file, UBC.

23. Sources are Spradley (1969:202–203); PJ, January–June 1958; and photographs in the Alert Bay Museum-Library and the Ethnology Division, RBCM.

24. Between the construction of the Treasure House and the plans for an expanded village, an open-air museum opened that was cited as an explicit model by the planners for 'Ksan. The restoration of Barkerville—a town made famous in British Columbia's 1860 gold rush—began in 1958 and continues to this day.

25. Best seen in the files of the Ethnology Division, RBCM.

26. Sources are Wilson Duff's 1955 field notebook (no. 10) of his survey of Kwakiutl Totem Poles (RBCM, Ethnology Division, KWA-W-007); and Nicole Strickland, "The Winds of Change," *Vancouver Province*, 5 October 1974, p. 39.

27. The following account is based on three sources: Duff's 1955 notebook (see note 26); Rohner (1967: 18, 152–156); Rohner and Rohner (1970:84–85); and articles in NIG, 23 February 1966, 31 May 1967.

28. Information on the houses at Kingcome, Gilford, as well as Comox was offered in an interview with Peter L. Macnair, 8 September 1982. Of the Comox house, Macnair notes that it was originally located on the agricultural fair grounds. Objecting to its use as an animal shelter, Andy Frank had it moved to the reserve. Macnair and Jay Steward also supplied information on the new house at Campbell River and the rebuilding of the house at Alert Bay (pers. comm. 1999).

29. This account of the construction of the Alert Bay community house is based on Sewid's memoirs, which should be consulted for further details (Spradley 1969:236–245), and reports in PJ (11 December 1963; 1 and 22 January, 11 February, 8 April 1964) and Campbell River *Upper Islander* (21 July 1965).

30. Bill Holm notes that while most old beams were not carved, some were, including those in the surviving houses at Kingcome and Gilford, and the Sea Lion House at Quatsino (pers. comm. 1998).

31. The following account is based on Spradley (1969:252–256) and NIG, 8 June, 22 June 1966).

32. See unattributed notes [Philip Ward?], "Alert Bay Big House Opening," KWA-W-010, Ethnology Division, RBCM.

33. NIG, 24 May and 31 May 1967.

34. Wallace is identified as such in the report of 24 May, but in the 31 May report his position is given as general chairman of the British Columbia Centennial Commission.

35. The Kwakwala Arts and Crafts Society is also referred to as an "organization" and an "association."

36. NIG, 6 December 1967, p. 7.

37. On the Woss Lake Loggers Sports Day, 14 June 1969, see NIG, 11 June 1969.

38. Campbell River *Upper Islander*, 22 May 1971; Comox District *Free Press*, 9 June 1978, 26 August 1977.

39. One might note here the silkscreen prints that dealer Gyula Mayer made from original paintings of Kwakwa̱ka̱'wakw Henry Speck in the early 1960s (Hall et al. 1981:50). Although Speck did not have a long career of designing silkscreens, they were an important link between Neel and later, more active, artists such as Tony Hunt and Robert Davidson. Between 1958 and 1964, Mayer patronized the production of more than 700 watercolors from thirty-three Kwakwa̱ka̱'wakw artists (Duffek 1986).

40. George Clutesi to Clifford Carl, 20 September 1960, Correspondence, Ethnology Division, RBCM.

41. For Hunt, cf. NIG, 26 August 1981.

42. Sources: Larry Rosso, interview, 7 April 1982; and Campbell River *Upper Islander*, 29 December 1978.

43. Recent trends in anthropology have privileged the role of so-called "Native" anthropologists (Abu-Lughod 1991; Narayan 1993). While the concept has been discussed, particularly in regard to "third-world" countries (Fahim and Helmer 1980), it also applies to Native groups in Western countries. Recent research has demonstrated the role played by American Indians as scholars and intellectuals (Liberty 1978; Mark 1982). For broader discussion of Indians as culture brokers, see Clifton (1989), Karttuten (1994), Szasz (1994). Among comparable non-Kwakwa̱ka̱'wakw cases on the Northwest Coast were Louis Shotridge (Milburn 1986) and William Beynon (Halpin 1978a). A related issue is Native (sometimes scholarly) responses to published ethnographies (Brettell 1993). For a Kwakwa̱ka̱'wakw example, see Ignace et al. (1993).

44. Obituaries in PJ, 10 June 1959; *Native Voice*, July 1959. There is some uncertainty about the date of Daniel Cranmer's birth, which the *Native Voice* gives as 1872.

45. In a genealogical twist that continues to cause confusion, Martin's first wife was Bessie Hunt, the daughter of Sarah Smith and David Hunt. By marrying his mother-in-law, he made it possible—and even necessary—for his descendants to resort to multiple kinship relations.

46. Mungo Martin had several encounters with Franz Boas. While still a boy, Martin had his picture taken by Boas and his photographer when they were in Fort Rupert in 1894 (Nuytten 1982:76), and he also participated in Boas's 1930 Kwakwa̱ka̱'wakw films (Holm 1973). Later, when Daniel Cranmer was negotiating with Boas his 1941 trip to New York, Martin volunteered to accompany him and serve as an informant. Unfortunately, Boas could not afford to fund both Cranmer and Martin (Daniel Cranmer to Franz Boas, 21 September 1940, Franz Boas to Daniel Cranmer, 14 October 1940, FBP).

47. Donald N. Abbott, interview, 22 April 1982; Michael Kew, interview, 22 September 1982; also Harry Hawthorn, interview, 21 October 1981.

48. See two record-sets recorded and annotated by Ida Halpern, both on [Smithsonian] Ethnic Folkways: *Indian Music of the Pacific Northwest Coast* (FE 4523, released in 1967), *Kwakiutl Indian Music of the Pacific Northwest* (FE 4122, released in 1981).

49. A similar case from another Native American culture is Ely S. Parker, Lewis H. Morgan's Iroquois informant/assistant, whose grandnephew Arthur became an anthropologist and museum curator.

50. The Native community in Alert Bay was not homogeneous in spiritual matters. Never a traditional village site, the reserve was originally set up as a missionary community for those Kwakwa̱ka̱'wakw who espoused Christianity and swore off potlatching. Kwakwa̱ka̱'wakw who followed more traditional practices tended to live in outlying villages. Many Natives, such as Charles Nowell, found no problem in following both, and gradually this split came to mean less and less as traditional practices waned or were integrated with Western ones.

51. Such descriptive tendencies also characterized other Native American ethnographers. According to historian Joan Mark, Francis La Flesche, the Omaha Indian who worked with Alice Fletcher, "was not particularly interested in cross-cultural understanding. His life's work indicates that he wanted to collect every available bit of vanishing information, in order to make as complete as possible the historical record of his own and related peoples" (Mark 1982:507).

9. NATIVE MUSEUMS

1. For reviews of the confiscation, see Sewid-Smith (1979), Cole (1985:249–254), Assu and Inglis (1989:103–104), Cole and Chaikin (1990:118–124), Loo (1992), and Saunders (1995, 1997). In this accumulating literature, many of the numerical details concerning the episode have been given variously. Saunders (1995:57, nn. 30, 36) offers a particularly full accounting of these discrepancies. My text follows the U'mista Cultural Society (1980; see also Webster 1990b:133), but Cole and Chaikin (1990:123) give a total of 58 individuals tried, with 9 dismissed, 23 suspended sentences, and 23 jailed, and about 450 objects confiscated.

2. All but two of the eleven items kept by Duncan Campbell Scott came to the National Museum

of Canada by 1932. In 1928, however, a mask and a sculpture were exchanged with George T. Emmons (Cole 1985:254).

3. Similar centennial-associated museums were established in Campbell River on Vancouver Island and in Hazelton, a town near a Gitksan Reserve.

4. PJ, 25 February 1959; see also issues of 22 and 29 January 1958.

5. "Seized Indian Regalia May Be Returned to B.C.," *Native Voice,* March 1958, p. 5.

6. Although Sewid gives the year as 1963 (Sewid-Smith 1979:2; cf. *Vancouver Sun,* 30 June 1979, p. A8), 1964 may be more accurate. He remembers traveling to Ottawa with fellow Native Guy Williams for a meeting on fishing rights, which he gives as 1963 in Sewid-Smith and 1964 in his memoirs (Spradley 1969:221–224). In July 1964 the *Native Voice* (p. 1) reported Williams's examination of the part of the collection at the Royal Ontario Museum.

7. PJ, 1 February 1963.

8. Philip Ward to Clifford Carl, 20 March 1967, Ethnology Division, RBCM.

9. In 1966 a member of the Campbell River board suggested housing the collection in the new museum building (John Kyte to Dave Moon, 14 November 1966, Kwagiulth Museum file, Campbell River Museum). The following year, George Moore, provincial museums adviser, on a visit to the town discussed the possibility of expanding the Alert Bay Museum (NIG, 7 June 1967).

10. For an excellent account of the ironies and complexities in the ultimate battle for repatriation in British Columbia—the fight over land and sovereignty—see Tennant (1990).

11. The Seattle World's Fair (Gunther 1962:77–78), the Chicago Art Institute (Wardwell 1964:35), the Lowie Museum (Harner and Elsasser 1965:99), the Vancouver Art Gallery (Duff et al. 1967:n.p.), and the Musée de l'Homme (Duff 1969:no. 63).

12. Sources for the decision to split the collection: Ron Rose, "The Crime of Indian-Giving," *Vancouver Sun,* 10 June 1972, p. 6; Gloria Cranmer Webster, 20 June 1972, letter to the editors, *Vancouver Sun,* in response to Rose article; NIG, 6 and 20 July 1972. Saunders (1995:42–45, 1997:104–108) gives further details on the disagreements between the two societies.

13. Sources for the final apportioning of the artifacts: *Campbell River Courier,* 6 October and 24 November 1978; *Upper Islander,* 22 November and 29 December 1978, 28 February 1979.

14. According to Bill Holm, "Many of the confiscated objects had the owner's name penciled on the inside or back" (pers. comm. 1998).

15. For an account of the founding of the Cape Mudge museum, see Assu and Inglis (1989:104–106).

16. At least one of the masks, however, has been replicated, the frequently published Wild Man of the Woods. The U'mista Cultural Centre has the original and the Canadian Museum of Civilization made a very close copy for its collection.

17. For two useful summaries of the rapidly burgeoning literature on repatriation, see Greenfield (1996) and Messenger (1999). For four well-documented Native American case studies, see Fenton (1989) on the Iroquois wampum belts; Merrill et al. (1993) on the Zuni war gods; Bray and Killion (1994) on the human reburials from Larsen Bay, Kodiak, Alaska; and Ridington and Hastings (1997) on the Omaha sacred pole. See also Mihesuah (2000).

18. Nuyumbalees board member Rod Naknakin, quoted in Campbell River *Upper Islander,* 22 November 1978. This stress on ritual patrimony is a striking exception to the earlier generalization that almost all contemporary Kwakwaka'wakw objects are seen as art. Like the Zuni war gods considered by Clifford (1988:247), they "are certainly not ethnographic artifacts, and they are certainly not 'art'. . . . The encounter is too specific, too enmeshed in family history and ethnic memory. Some aspects of 'cultural' and 'aesthetic' appropriation are certainly at work, but they occur within a *current tribal history."* Like contemporary works created for potlatches, these works are not commoditized; they are inalienable and not for circulation in the general art market.

19. Relevant here is the perspective of Richard Handler (1985, 1991), who argues that collecting and repatriation operate within a logic of nationalism. According to Handler, the modern nation is conceptualized as a corporate entity, a thing, that is embodied in things. Although the Kwakwaka'wakw were working together to secure the return of the collection from a nation-state, they—unlike the modern nation-state—were operating more on the level of families and groups of related individuals.

20. These points were made by Gloria Cranmer Webster in the film "Box of Treasures," U'mista 1983.

21. The Nuyumbalees Society's first annual meeting, at which its constitution was formally adopted, was held in November 1978.
22. Robert Joseph, Minutes of the Third Annual Meeting, Nuyumbalees Society, 13 December 1980.
23. Robert Joseph, interview, Campbell River, 5 July 1982.
24. By 1992 the Cape Mudge museum had hired five white directors (Mauzé 1992:30). For Mann, Wilson, and Inglis, see *Campbell River Courier,* 5 May 1978. For Delamer, see Campbell River *Upper Islander,* 24 December 1980.
25. For the Cape Mudge building, the amounts were $250,000 (National Museum), $155,000 (Department of Indian Affairs), and $75,000 (First Citizens Fund), for a total of $480,000. For Alert Bay, the figures were $250,000 (National Museum), $191,000 (Community Recreational Facilities), and $84,000 (First Citizens), for a total cost of $525,000 (in Canadian funds). Sources: Joseph and Mann (1980:10); and NIG, 9 April 1980, p. 6.
26. Sources for this account, all 1979: Campbell River *Upper Islander,* 4 July; *Campbell River Courier,* 1 June; *Vancouver Sun,* 30 June; *Victoria Times,* 9 July; *Native Voice,* July, pp. 6–7; the program for the opening; Assu and Inglis (1989:106–7).
27. George Mann, quoted in *Campbell River Courier,* 1 June 1979.
28. Principal sources are Webster (1981); U'mista (1983); NIG, 5 November 1980, p. 2; Campbell River *Upper Islander,* 5 and 12 November 1980.
29. *Campbell River Courier,* 2 January 1981, p. 2.
30. *Comox Free Press,* 6 July 1979.
31. For the Henderson pole, see Campbell River *Upper Islander,* 5 December 1979; the *Courier,* 11 July 1980; and Assu and Inglis (1989:107–108). For the Cranmer panels, see Webster (1981:12).
32. Wilson Duff, quoted in an article in Prince Rupert *Daily News,* 7 June 1960, p. 1 (cited in Dawn 1981:101). This principle was also embodied in the by-laws.
33. The following section describes the inaugural displays at the museums, as they were in 1981, the end of the century with which I am dealing. The exhibits at Cape Mudge are now arranged by object type, not family. In 1995 several descendants of the original owners decided that they wanted their objects to go instead to the U'mista Centre, where these forty-plus pieces were stored until display space could be found (Saunders 1997:122, n. 36).
34. Gloria Cranmer Webster, in U'mista (1983).
35. Gloria Cranmer Webster, quoted in NIG, 5 November 1980, p. 2.
36. During the early years, temporary shows at the U'mista Centre included the argillite of Haida carver Tom Price (early fall 1981, from the Queen Charlottes Museum), and one on B.C. Native languages (from BCPM). Those at the Kwagiulth Museum were devoted to two print shows from UBC: Bill Reid's beaver print (May 1980) and Robert Davidson's retrospective (July 1980), ethnohistorical photographs (November 1980), James Sewid's set of masks from the Dance of the Animals (October 1981), the Legacy exhibit (November 1981), and local petroglyphs (summer of 1982).
37. *Campbell River Courier,* 23 January 1981, p. 5.
38. Interestingly, a precedent for the display of crest objects by family was an exhibit arranged by the Tlingit Louis Shotridge at the University of Pennsylvania Museum in the late 1920s. Shotridge (1928:352) placed the most important specimens, "as nearly as space permits, in the order of their rank." Moreover, the artifacts from the Raven moiety faced those of the ritually opposing Eagle moiety.
39. Minutes of the Second Annual Meeting, Nuyumbalees Society, 14 November 1979.
40. There is a similar program of Kwak'wala instruction in the Campbell River public school system, devised independently at about the same time as the one at Alert Bay.
41. The Kwagiulth Museum once had plans for building a comprehensive research library of all publications dealing with the Kwakwaka'wakw, in the hope that this would become a center for Kwakwaka'wakw studies. Campbell River *Upper Islander,* 29 December 1978. While this plan was never realized, since 1993 the U'mista Society has been accumulating such materials for a similar Information and Resource Centre.
42. Joan Lowndes, "The Potlatch in Perspective," *Vancouver Sun,* 20 February 1976, p. 9A.
43. The museum at Alert Bay did not open until 1959, and the Campbell River and District Histori-

cal Society was not incorporated until 1961, although it was first formed in 1958. Though the museum at Alert Bay is run by the local municipality and the one at Campbell River by a society, the latter works closely with the town. In 1994 the Campbell River Museum moved into a new building, separate from the library. Its major permanent exhibit is devoted to "The Treasures of Siwidi," a light/sound presentation with a commissioned set of masks. In the late 1990s, the Alert Bay Library moved to the former fire hall/municipal office on the waterfront.

44. Joyce Wilby, interview, 15 July 1982.

45. Harlan I. Smith, "Restoration of Totem Poles in British Columbia," in *National Museum of Canada Annual Report for 1926*, p. 81 (cited in Dawn 1981:28).

46. An important recent Native American museum in the extended Northwest is the Museum at Warm Springs, Oregon, which opened in March 1993 (Patt 1994). It includes the cultures of the three tribes resident on the reservation: the Warm Springs Sahaptin, the Wasco Chinook, and the Paiute.

47. Among the other recent Native museums in British Columbia are the Coqualeetza Longhouse Interpretive Centre in Sardis, run by the Stó:lo, at the site of the old residential school, and Tems swiya ("our world"), a museum of the Sechelt, a Coast Salish group, in the tribal center at Sechelt.

48. In 1978 the North American Indian Museums Association (now disbanded) was founded from a constituency of over 125 museums in the United States and Canada. In 1998 the American Indian Museums Association was established under the auspices of the American Association for State and Local History. It was hoped that this new organization would overcome its predecessor's "lack of structure, support, and funding" (Karen Kramer in Nason 1999:25).

49. For a comprehensive review of Northwest Coast Native museums (especially two in Washington State—the Makah Cultural and Research Center in Neah Bay and the Suquamish Museum in Suquamish), see Broyles (1989); for a comparison of the two Kwakwa̱ka̱'wakw museums with museums in Vancouver and Victoria, see Clifford (1991).

50. Another reason for the shift of museum activity to Cape Mudge was James Sewid's move in the early 1970s to Campbell River (where he lived part of the year). In 1958 Sewid's daughter Louisa had married Don Assu, from a leading family in Cape Mudge, and Sewid soon began to work with these southern Kwakwa̱ka̱'wakw communities.

51. Jay Stewart, interview, 5 July 1982.

52. These same sentiments were expressed at the Mungo Martin potlatch at Thunderbird Park, which in turn echoed the potlatch oratory of the 1890s (as recorded by Boas and Hunt). Though the vehemence of these statements may have been stimulated by an interethnic audience, the fact that they have been reiterated for a century testifies to the strength with which they are held.

53. The theme of continuity is marked spatially at the U'mista Centre with galleries for new as well as old art. "Not only do these contributions [from artists, given at the opening] honour those who have gone before, but they also demonstrate the strong link between the past and the present" (U'mista 1980).

54. Toward the end of his life, George Hunt noted with regret that most Kwakiutl used "one word for every thing instead of using the different word for the different way of answer." George Hunt to Franz Boas, 15 March 1930, FBP. In 1959, toward the end of his life, Daniel Cranmer spoke "in the same vein" (Bill Holm pers. comm. 1998). Whatever the degree of linguistic loss over these three decades, the persistent decline in Kwak'wala-speaking over the twentieth century is unmistakable.

EPILOGUE: CONTINUITY AND INFLUENCE

1. Martine Reid (1993:71) calls the "renaissance" of Northwest Coast Indian art a "misnomer." She argues that unlike the European case, "the Northwest Coast 'Renaissance' . . . was encouraged not by an indigenous impulse or an inner innovation but by a few members of the white community, whose interest began to bloom thirty years ago. It involved only a few artisans, not a whole culture. And the rebirth it contemplated was not meant to serve some social or religious need, but to satisfy a commercial market ranging from 'fine art' to 'airport art.'"

2. Franz Boas to Edward B. Tylor, 17 August 1888, FBP; Franz Boas to Edward B. Tylor, 6 February 1899, Departmental Correspondence, AMNH.

3. Harlan I. Smith to William A. Newcombe, 31 October 1928 and 24 July 1934, box 14, CFNP.

4. Erna Gunther, "Northwest Coast," lecture no. 6 of a televised course, "Primitive Art," [no date, c. 1954]; "The Indian Today," lecture no. 13 of a televised course, "Indian Cultures of the Pacific Northwest, 1954;" copies at University of Washington Audio-Visual Center.

5. Harry Hawthorn to Wilson Duff, 17 March 1953; Bill Reid to Norman A. M. MacKenzie, 25 September 1955; Totem Pole File, UBC. The metaphor of a thin thread was echoed in the title of an exhibit presented by the U'mista Cultural Centre on the tenth anniversary of its opening: *Mungo Martin: A Slender Thread*. After opening in Alert Bay in November 1990, the show traveled to museums in Canada and the United States (Webster 1990b:142).

6. Erna Gunther, "Northwest Coast," lecture no. 6 of a televised course, "Primitive Art, [no date, c. 1954]"

7. It must be emphasized that the following discussion of continuity applies only to the Kwakwa̱ka̱'wakw. Until quite recently there was little disagreement that for the Haida, Tsimshian, and Coast Salish, "the classic forms either disappeared altogether or were replaced by substitute styles" (Macnair 1993:51). During the 1980s scholars slowly came to the understanding that artistic traditions for some groups, particularly the Kwakwa̱ka̱'wakw and Gitksan, were unbroken during the past century. Recently, however, some have argued that the Kwakwa̱ka̱'wakw do not deserve a special status and that, in fact, traditions of groups like the Haida and Nuu-chah-nulth were also intact (as suggested by many of the speakers at the conference "The Legacy of Bill Reid" held at UBC in November 1999). Unfortunately, this is not the place for an exploration of these complex issues, but these views do point to the continual change in conceptions of Native cultural traditions in response to changing interethnic relations.

8. Other references on non-Native influences on Native American art include Frisbie (1973), Washburn (1984), Dockstader (1985), Feder (1986), and Cohodas (1997).

9. Harry Hawthorn to Ralph Altman, 11 October 1951, Totem Pole Preservation file, UBC; H. Hawthorn to H. R. MacMillan, 16 January 1952, TPPC file; Hunter Lewis, 27 October 1951, Annual Report, President's Committee on Totem Poles, UBC; Wilson Duff to W. T. Straith, 16 August 1951, Thunderbird Park file, BCPM.

10. In contrast to Hunt's view (reiterated in an interview, 9 September 1982) that Martin never gave up carving, Douglas Cranmer remembers him primarily as a fisherman, claiming that he gave up active carving from his early adulthood until he came down to the southern museums (interview, 8 February 1982).

11. Mungo Martin's style, unlike Willie Seaweed's, did not change appreciably over his lifetime. The totem poles and cannibal birds that Martin made in the teens are quite similar to those he carved in the 1950s. One might expect such a pattern from an artist who resumed work after a gap of several decades.

12. The Hauberg collection in the Seattle Art Museum contains a rattle and four masks by Martin dated to c. 1940 (Abbott 1995:210, 212, 224, 230, 232). The Vancouver Museum has a pair of thunderbird canoe panels by him, attributed to c. 1939 (AA 2267a,b).

13. This was soon followed by another Tony Hunt pole in 1976 for his grandfather, Jonathan Hunt, a Douglas Cranmer pole in 1978, and two memorial plaques carved by Richard Hunt in 1978. According to Holm (1990c:630), "From the mid-1930s until the late 1950s, no memorial poles were erected" among the Kwakiutl.

14. In 1947 Daniel Cranmer gave Marius Barbeau a list of ten important totem pole carvers, most of whom were still active carvers: Charlie James, Arthur Shaughnessy, Yurhwayu, Willie Seaweed, Mungo Martin, Tom Patch, Albert Johnson, [George?] Nelson, Awalaskyinis, and Herbert Johnson (Barbeau 1950, pt. 2:798, 800).

15. According to Donald N. Abbott, Wilson Duff's former assistant, at least by the late 1950s Duff knew of Willie Seaweed and was aware that Mungo Martin was not the only suitable Kwakwa̱ka̱'wakw artist for the carving program. But Martin had been more than willing to come down to Victoria to teach and have his knowledge committed to the anthropological record (interview, 22 April 1982).

16. George Hunt to Pliny E. Goddard, 23 June 1923, acc. 1924-78, AMNH.

17. Although Martin makes the task look effortless in the film, Douglas Cranmer reports that the

scene had to be repeated several times until Martin got it right (interview, 2 September 1981). However, the cinematographer, William Heick, reported that Martin "seemed to know what he was doing" (interview, 25 September, 1996). The surviving footage in the Hearst Museum, University of California at Berkeley, does not contain multiple takes, although Martin may have had to repeat some actions before they were filmed (camera rolls 429–449). The box that Martin created in October 1961 was accessioned by the Lowie (now Hearst) Museum (cat. no. 2-30858, acc. 1476). Listed in the catalog as an "unfinished cedar wood box," it is certainly a little rough.

18. Interviews with Douglas Cranmer, 2 September 1981, and Bruce Alfred, 15 August 1982. Tony Hunt claims that Charlie James and others taught Mungo Martin to make boxes, which were still being actively made and used c. 1900; interview, 9 September 1982. Mungo Martin's lack of expertise in such turn-of-the-century craft technology is also attested by an earlier experience at the UBC Museum. Expressing a desire to make a spoon from the horn of a mountain goat by the old technique of steaming and bending, Martin spent several days at the task, until admitting in frustration that, although he had seen them made in his youth, he had never done it himself. According to Audrey Hawthorn (1979:5), he "found himself defeated by this new medium." Martin also made rattles and whistles for UBC in the 1950s (ibid.:16–17), items not commonly made at the time, but this did not lead to an immediate revival, which came only in the 1980s.

19. Tony Hunt, interview, 9 September 1982.

20. Franz Boas to the Kwakiutl, 14 April 1897, Acc. 1897–43, AMNH.

21. Franz Boas to Charles F. Newcombe, 9 September 1900, box 1, CFNP.

22. The box metaphor for the U'mista Cultural Centre is made even more resonant when we consider that the model for its frontal painting—the whale and thunderbird design on the Tla-glo-glass house façade—was reportedly inspired by a northern-style box (Peter Macnair in Jonaitis 1991:figs. 2, 3).

REFERENCES

Abbott, Donald N., ed. 1981. *The World Is as Sharp as a Knife: An Anthology in Honour of Wilson Duff.* Victoria: British Columbia Provincial Museum.

Abbott, Helen, et al., ed. 1995. *The Spirit Within: Northwest Coast Native Art from the John H. Hauberg Collection.* New York: Rizzoli.

Abu-Lughod, Lila. 1991. Writing against Culture. In *Recapturing Anthropology: Working in the Present,* ed. Richard G. Fox, 137–162. Santa Fe: School of American Research Press.

Adams, Vincanne. 1996. *Tigers of the Snow and Other Virtual Sherpas: An Ethnography of Himalayan Encounters.* Princeton, N.J.: Princeton University Press.

Alexander, Edward P. 1979. *Museums in Motion: An Introduction to the History and Functions of Museums.* Nashville, Tenn.: American Association for State and Local History.

———. 1983. *Museum Masters: Their Museums and Their Influence.* Nashville: American Association for State and Local History.

Alsop, Joseph. 1982. *The Rare Art Traditions: The History of Art Collecting and Its Linked Phenomena Wherever These Have Appeared.* Princeton, N.J.: Princeton University Press.

Altick, Richard D. 1978. *The Shows of London: A Panoramic History of Exhibitions, 1600–1862.* Cambridge, Mass.: Harvard University Press.

Ames, Michael M. 1977. Visible Storage and Public Documentation. *Curator* 20 (1): 65–79.

———. 1981a. Museum Anthropologists and the Arts of Acculturation on the Northwest Coast. *BC Studies,* no. 49:3–14.

———. 1981b. Preservation and Access: A Report on an Experiment in Visible Storage. *Gazette* [Canadian Museums Association], no. 3–4:22–33.

———. 1992. *Cannibal Tours and Glass Boxes: The Anthropology of Museums.* Vancouver: University of British Columbia Press.

Ames, Michael M., et al. 1975a. *Northwest Coast Indian Artifacts from the H. R. MacMillan Collections, in the Museum of Anthropology, The University of British Columbia.* Vancouver: University of British Columbia Press.

————. 1975b. *Indian Masterpieces from the Walter and Marianne Koerner Collection, in the Museum of Anthropology, The University of British Columbia.* Vancouver: University of British Columbia Press.

Anderson, Eugene N., ed. 1996. *Bird of Paradox: The Unpublished Writings of Wilson Duff.* Surrey, B.C./Blaine, Wash.: Hancock House.

Anderson, Jay. 1984. *Time Machines: The World of Living History.* Nashville, Tenn.: American Association for State and Local History.

Anonby, Stan J. 1997. Reversing Language Shift: Can Kwak'wala Be Revived? Master's thesis, Linguistics, University of North Dakota.

Appadurai, Arjun. 1986. Introduction: Commodities and the Politics of Value. In *The Social Life of Things: Commodities in Cultural Perspective,* ed. Arjun Appadurai, 3–63. Cambridge, England: Cambridge University Press.

Arima, E. Y., and E. C. [Tony] Hunt. 1975. Making Masks: Notes on Kwakiutl "Tourist Mask" Carving. In *Contributions to Canadian Ethnology, 1975,* ed. David Brez Carlisle, 67–128. National Museum of Man Mercury Series, Canadian Ethnology Service, paper no. 31.

Art, Historical, and Scientific Association (AHSA). 1926. The Indian Village. *Museum Notes,* 1st. ser., 1 (2): 13–15. Vancouver.

Ashwell, Reg. 1975. The Master Touch. *Westworld* 1 (1): 27–30.

Assu, Harry, with Joy Inglis. 1989. *Assu of Cape Mudge: Recollections of a Coastal Indian Chief.* Vancouver: University of British Columbia Press.

Averill, Lloyd J., and Daphne K. Morris. 1995. *Northwest Coast Native and Native-Style Art: A Guidebook for Western Washington.* Seattle: University of Washington Press.

Barbeau, Marius. 1950. *Totem Poles.* National Museum of Canada Bulletin no. 119, Anthropological Series no. 30, 2 vols.

Barkan, Elazar, and Ronald Bush, eds. 1995. *Prehistories of the Future: The Primitivist Project and the Culture of Modernism.* Stanford: Stanford University Press.

Baron, Robert, and Nicholas R. Spitzer, eds. 1992. *Public Folklore.* Washington, D.C.: Smithsonian Institution Press.

Barrett, Samuel A. 1962. *Wooden Box: Made by Steaming and Bending.* Film, 16 mm., color, sound, 33 minutes. Berkeley: University of California Extension Media Center.

Barton, Gerry. 1984. Conservation Considerations on Four Maori Carvings at Auckland Museum, New Zealand. *Studies in Conservation* 29:181–186.

Bastian, Adolf. [1884]. *The North-West Coast of America, Being Results of Recent Ethnological Research from the Collections of the Royal Museums of Berlin, Published by the Directors of the Ethnological Department.* Translation from the German edition, 1883. New York: Dodd, Mead and Co.

Bates, Craig D., and Martha J. Lee. 1990. *Tradition and Innovation: A Basket History of the Indians of the Yosemite-Mono Lake Area.* Yosemite: Yosemite Association.

Bateson, Gregory. 1946. Arts of the South Seas. *Art Bulletin* 28:119–123.

Batkin, Jonathan. 1987. Pottery: The Ceramic Tradition. In *Harmony by Hand: Art of the Southwest Indians,* by Patrick Houlihan et al., 77–103. San Francisco: Chronicle Books.

Bauman, Richard, Patricia Sawin, and Inta Gale Carpenter. 1992. *Reflections on the Folklife Festival: An Ethnography of Participant Experience.* Folklore Institute, Special Publications, no. 2. Bloomington: Indiana University Press.

Baxandall, Michael. 1985. *Patterns of Intention: On the Historical Explanation of Pictures.* New Haven: Yale University Press.

Becker, Howard S. 1982. *Art Worlds.* Berkeley: University of California Press.

Bendix, Regina. 1997. *In Search of Authenticity: The Formation of Folklore Studies.* Madison: University of Wisconsin Press.

Benedict, Burton. 1983. The Anthropology of World's Fairs. In *The Anthropology of World's Fairs: San Francisco's Panama Pacific International Exposition of 1915,* by Burton Benedict et al., 1–65. Berkeley: Lowie Museum of Anthropology.

Benedict, Ruth. 1934. *Patterns of Culture.* Boston: Houghton Mifflin.

Benjamin, Walter. 1936 [1969]. The Work of Art in the Age of Mechanical Reproduction. In *Illuminations,* ed. Hannah Arendt, 217–251. New York: Schocken Books.

Bennitt, Mark, and Frank Parker Stockbridge, eds. 1905. *History of the Louisiana Purchase Exposition.* St. Louis: Universal Exposition.

Berkhofer, Robert F. Jr. 1978. *The White Man's Indian: Images of the American Indian from Columbus to the Present.* New York: Alfred A. Knopf.

Berlo, Janet Catherine, and Ruth B. Phillips. 1992. "Vitalizing the Things of the Past": Museum Representations of Native North American Art in the 1990's. *Museum Anthropology* 16 (2): 29–43.

———. 1995. Our (Museum) World Turned Upside-Down: Re-Presenting Native American Arts. *Art Bulletin* 77 (1): 6–10.

Berman, Judith. 1991. The Seal's Sleeping Cave: The Interpretation of Boas' Kwakw'ala Texts. Ph.D. diss., Anthropology, University of Pennsylvania.

———. 1992. Oolachan-Woman's Robe: Fish, Blankets, Masks, and Meaning in Boas's Kwakwala Texts. In *On the Translation of Native American Literatures,* ed. Brian Swann, 125–162. Washington, D.C.: Smithsonian Institution Press.

———. 1994. George Hunt and the Kwak'wala Texts. *Anthropological Linguistics* 36 (4): 483–514.

———. 1996. "The Culture As It Appears to the Indian Himself": Boas, George Hunt, and the Methods of Ethnography. In *Volksgeist as Method and Ethic: Essays on Boasian Ethnography and the German Anthropological Tradition,* ed. George W. Stocking Jr., 215–256. Madison: University of Wisconsin Press.

Bernstein, Bruce. 1979. A Native Heritage Returns: The Wilcomb-Hall-Sheedy Collection. In *Natives and Settlers: Indian and Yankee Culture in Early California,* ed. Melinda Young Frye, 69–87. Oakland: Oakland Museum.

———, ed. 1984. Native Fairs and Markets of the Southwest. Special issue. *Expedition* 36 (1). Philadelphia: University of Pennsylvania Museum of Archaeology and Anthropology.

Black, Martha. 1997. *Bella Bella: A Season of Heiltsuk Art.* Vancouver: Douglas and McIntyre.

———. 1999. *HuupuKwanum Tupaat: Out of the Mist, Treasures of the Nuu-Chah-Nulth Chiefs.* Vancouver: University of British Columbia Press.

Blackman, Margaret B. 1976. Creativity in Acculturation: Art, Architecture, and Ceremony from the Northwest Coast. *Ethnohistory* 23 (4): 387–413.

———. 1985. Contemporary Northwest Coast Art for Ceremonial Use. *American Indian Art Magazine* 10 (3): 24–37.

———. 1990. Facing the Future, Envisioning the Past: Visual Literature and Contemporary Northwest Coast Masks. *Arctic Anthropology* 27 (2): 27–39.

Blackman, Margaret B., and Edwin S. Hall Jr. 1982. The Afterimage and the Image After: Visual Documents and the Renaissance in Northwest Coast Art. *American Indian Art Magazine* 7 (2): 30–39.

Blackmon, Carolyn, and Ronald Weber. 1982. Maritime Peoples of the Arctic and Northwest Coast: A New Permanent Exhibit in Hall 10. *Field Museum of Natural History Bulletin* 53 (4): 20–25.

Blundell, Valda, and Ruth Phillips. 1983. If It's Not Shamanic, Is It Sham? An Examination of Media Responses to Woodland School Art. *Anthropologica,* n.s. 25 (1): 117–132.

Boas, Franz. 1887a. The Occurrence of Similar Inventions in Areas Widely Apart. *Science* o.s. 9:485–486.

———. 1887b. Museums of Ethnology and Their Classification. *Science* o.s. 9:587–589.

———. 1887c. Census and Reservations of the Kwakiutl Nation. *Bulletin of the American Geographical Society* 19:225–232.

———. 1888. The Development of the Culture of Northwest America. *Science* o.s. 12:194–196.

———. 1890. The Use of Masks and Head-Ornaments of the Northwest Coast of America. *Internationales Archiv für Ethnographie* 3:7–15.

———. 1897a. The Social Organization and the Secret Societies of the Kwakiutl Indians. *Report of the U.S. National Museum for 1895:*311–738.

———. 1897b. The Decorative Art of the Indians of the North Pacific Coast. *American Museum of Natural History Bulletin* 9:123–176.

———. 1900. *Ethnological Collections from the North Pacific Coast of America: Being a Guide to Hall 105 in the American Museum of Natural History.* New York: American Museum of Natural History.

———. 1907a. Some Principles of Museum Administration. *Science* 25:921–933.

———. 1907b. Notes on the Blanket Designs of the Chilkat Indians. In *The Chilkat Blanket,* by

George T. Emmons. Memoirs of the American Museum of Natural History 3:351–400.

———. 1909. *The Kwakiutl of Vancouver Island.* Publications of the Jesup North Pacific Expedition. American Museum of Natural History. 5 (2): 301–522.

———. 1921. *Ethnology of the Kwakiutl.* Bureau of American Ethnology Annual Report for 1913–14, no. 35 (pts. 1 and 2).

———. 1927. *Primitive Art.* Oslo: Instituttat for Sammenlignende Kulturforsking, ser. B, vol. 8. Reprint. New York: Dover Publications, 1955.

———. 1966. *Kwakiutl Ethnography,* ed. Helen Codere. Chicago: University of Chicago Press.

———. 1969. *The Ethnography of Franz Boas: Letters and Diaries of Franz Boas Written on the Northwest Coast from 1886 to 1931,* ed. Ronald P. Rohner. Chicago: University of Chicago Press.

Bolz, Peter, and Hans-Ulrich Sanner. 1999. *Native American Art: The Collections of the Ethnological Museum Berlin.* Seattle: University of Washington Press.

Boon, James A. 1982. *Other Tribes, Other Scribes: Symbolic Anthropology in the Comparative Study of Cultures, Histories, Religions, and Texts.* Cambridge, England: Cambridge University Press.

Boone, Elizabeth Hill, ed. 1993. *Collecting the Pre-Columbian Past.* Washington, D.C.: Dumbarton Oaks Research Library and Collections.

Borofsky, Robert. 1987. *Making History: Pukapukan and Anthropological Constructions of Knowledge.* Cambridge, England: Cambridge University Press.

Bracken, Christopher. 1997. *The Potlatch Papers: A Colonial Case History.* Chicago: University of Chicago Press.

Brawne, Michael. 1982. *The Museum Interior: Temporary and Permanent Display Techniques.* New York: Architectural Book Publishing.

Bray, Tamara L., and Thomas W. Killion, eds. 1994. *Reckoning with the Dead: The Larsen Bay Repatriation and the Smithsonian Institution.* Washington, D.C.: Smithsonian Institution Press.

Brettell, Caroline B., ed. 1993. *When They Read What We Write: The Politics of Ethnography.* Westport, Conn.: Bergin and Garvey.

Briggs, Charles L. 1986. The Role of *Mexicano* Artists and the Anglo Elite in the Emergence of a Contemporary Folk Art. In *Folk Art and Art Worlds,* ed. John Michael Vlach and Simon J. Bronner, 195–224. Ann Arbor: UMI Research Press.

Briggs, Charles L., and Richard Bauman 1999. "The Foundation of All Future Researches": Franz Boas, George Hunt, Native American Texts, and the Construction of Modernity. *American Quarterly* 51 (3): 479–528.

British Columbia Indian Arts Society. 1982. *Mungo Martin: Man of Two Cultures.* Sidney, B.C.: Gray's.

Brown, Steven C. 1998. *Native Visions: Evolution in Northwest Coast Art from the Eighteenth through the Twentieth Century.* Seattle: University of Washington Press.

Brown, Steven C., and Lloyd J. Averill. 2000. *Sun Dogs and Eagle Down: The Indian Paintings of Bill Holm.* Seattle: University of Washington Press.

Broyles, Julie Anne. 1989. The Politics of Heritage: Native American Museums and the Maintenance of Ethnic Boundaries on the Contemporary Northwest Coast. Ph.D. diss., Anthropology, University of Washington.

Bruner, Edward M. 1986. Ethnography as Narrative. In *The Anthropology of Experience,* ed. Victor W. Turner and Edward M. Bruner, 139–155. Urbana: University of Illinois Press.

Bunzel, Ruth L. 1929. *The Pueblo Potter: A Study of Creative Imagination in Primitive Art.* New York: Columbia University Press.

Burlington Fine Arts Club (BFAC). 1920. *Catalogue of an Exhibition of Objects of Indigenous American Art.* London.

Campbell-Johnston, Ronald C. [1924]. *The Story of the Totem.* Vancouver: J. T. Pyott.

Cannizzo, Jeanne. 1983. George Hunt and the Invention of Kwakiutl Culture. *Canadian Review of Sociology and Anthropology* 20 (1): 44–58.

Cantwell, Robert. 1993. *Ethnomimesis: Folklife and the Representation of Culture.* Chapel Hill: University of North Carolina Press.

Carlson, Roy, ed. 1983. *Indian Art Traditions of the Northwest Coast.* Burnaby, B.C.: Department of Archaeology, Simon Fraser University.

Carpenter, Edmund. 1975. Collecting Northwest Coast Art. In *Form and Freedom,* by Bill Holm and Bill Reid, 9–27. Houston: Institute of the Arts, Rice University.

Carry, H. E. 1926. The Indian Village. *Museum Notes* [Art, Historical, and Scientific Association, Vancouver], 1st ser., 1 (2): 13–15.

Carter, Anthony. 1971. In Memory of Mungo Martin. *Beaver,* Outfit 301 (spring): 44–45.

Chen, Kenneth. 1995. Ida Halpern: A Post-Colonial Portrait of a Canadian Pioneer Ethnomusicologist. *Canadian University Music Review* 16 (1): 41–59.

Clavir, Miriam, Elizabeth Johnson, and Audrey Shane. 1988. A Discussion on the Use of Museum Artifacts by Their Original Owners. In *Symposium 86, Proceedings: The Care and Preservation of Ethnological Materials,* ed. R. Barclay, M. Gilberg, J. C. McCawley, and T. Stone, 80–89. Ottawa: Canadian Conservation Institute.

Clifford, James. 1981. On Ethnographic Surrealism. *Comparative Studies in Society and History* 23 (4): 539–564.

———. 1985. Histories of the Tribal and Modern. *Art in America* 73 (4): 164–177, 215.

———. 1988. *The Predicament of Culture: Twentieth-Century Ethnography, Literature, and Art.* Cambridge, Mass.: Harvard University Press.

———. 1991. Four Northwest Coast Museums: Travel Reflections. In *Exhibiting Cultures: The Poetics and Politics of Museum Display,* ed. Ivan Karp and Steven Lavine, 212–254. Washington, D.C.: Smithsonian Institution Press.

Clifton, James A., ed. 1989. *Being and Becoming Indian: Biographical Studies of North American Frontiers.* Chicago: Dorsey Press.

Cocking, Clive. 1971. Indian Renaissance: New Life for a Traditional Art. *University of British Columbia Alumni Chronicle* 25 (4): 16–19.

Codere, Helen. 1950. *Fighting with Property: A Study of Kwakiutl Potlatching and Warfare, 1792–1930.* American Ethnological Society Monograph, no. 18.

———. 1961. Kwakiutl. In *Perspectives in American Indian Culture Change,* ed. Edward H. Spicer, 431–516. Chicago: University of Chicago Press.

———. 1990. Kwakiutl: Traditional Culture. In *Northwest Coast,* ed. Wayne Suttles, 359–377. Vol. 7, *Handbook of North American Indians,* ed. William C. Sturtevant. Washington, D.C.: Smithsonian Institution.

Coe, Ralph T. 1972. Asiatic Sources of Northwest Coast Art. In *American Indian Art: Form and Tradition,* 85–92. Walker Art Center, Indian Art Association, Minneapolis Institute of Arts. New York: E. P. Dutton.

———. 1977. *Sacred Circles: Two Thousand Years of North American Indian Art.* Kansas City, Missouri: Nelson-Atkins Museum.

———. 1986. *Lost and Found Traditions: Native American Art 1965–1985.* New York: American Federation of Arts.

Coffee, Kevin. 1991. The Restoration of the Haida Canoe Life Group. *Curator* 34 (1): 31–43.

Cohodas, Marvin. 1997. *Basket Weavers for the California Curio Trade: Elizabeth and Louise Hickox.* Tucson: University of Arizona Press.

Cole, Douglas. 1982a. Tricks of the Trade: Northwest Coast Artifact Collecting, 1875–1925. *Canadian Historical Review* 63 (4): 439–460.

———. 1982b. Franz Boas and the Bella Coola in Berlin. *Northwest Anthropological Research Notes* 16 (2): 115–124.

———. 1985. *Captured Heritage: The Scramble for Northwest Coast Artifacts.* Seattle: University of Washington Press.

———. 1991. Tricks of the Trade: Some Reflections on Anthropological Collecting. *Arctic Anthropology* 28 (1): 48–52.

Cole, Douglas, and Ira Chaikin. 1990. *An Iron Hand upon the People: The Law against the Potlatch on the Northwest Coast.* Seattle: University of Washington Press.

Cole, Douglas, and David Darling. 1990. History of the Early Period. In *Northwest Coast,* ed. Wayne Suttles, 119–134. Vol. 7, *Handbook of North American Indians,* ed. William C. Sturtevant. Washington, D.C.: Smithsonian Institution.

Cole, Douglas, and Christine Mullins. 1993. "Haida Ida": The Musical World of Ida Halpern. *BC Studies*, no. 97:3–37.

Collier, Donald, and Harry Tschopik, Jr. 1954. The Role of Museums in American Anthropology. *American Anthropologist* 56 (16): 768–779.

Conkelton, Sheryl, Martha Kingsbury, and Laura Landau. 2000. *What It Meant to Be Modern: Seattle Art at Mid-Century*. Seattle: University of Washington.

Conn, Richard. 1979. *Native American Art in the Denver Art Museum*. Denver: Denver Art Museum.

Conn, Steven. 1998. *Museums and American Intellectual Life, 1876–1926*. Chicago: University of Chicago Press.

Corley-Smith, Peter. 1985. *The Ring of Time: The Story of the British Columbia Provincial Museum*. BCPM Special Publications, no. 8. Victoria: British Columbia Provincial Museum.

———. 1989. *White Bears and Other Curiosities: The First 100 Years of the Royal British Columbia Museum*. Victoria: Royal British Columbia Museum.

Cosgrove, Patricia. 1985. Chief Scow's Winter Dwelling. *Landmarks* 4 (1): 19–22.

Coster, Esther A. 1916. Decorative Value of American Indian Art. *American Museum Journal* [American Museum of Natural History] 16:301–307.

Cotton, Peter Neive. 1981. *Vice Regal Mansions of British Columbia*. Victoria: Elgin Publications for the British Columbia Heritage Trust.

Cowling, Elizabeth. 1978. The Eskimos, the American Indians and the Surrealists. *Art History* 1 (4): 484–500.

Curtis, Edward S. 1915. *The Kwakiutl*. Vol. 10, *The North American Indian*. Norwood, Conn.: n.p.

Dall, William H. 1884. *On Masks, Labrets, and Certain Aboriginal Customs, with an Inquiry into the Bearing of Their Geographical Distribution*. Bureau of American Ethnology Annual Report for 1881–82, no. 3:67–202.

Darling, David, and Douglas Cole. 1980. Totem Pole Restoration on the Skeena, 1925–30: An Early Exercise in Heritage Conservation. *BC Studies*, no. 47:29–48.

Darnell, Regna D. 1976. The Sapir Years at the National Museum, Ottawa. In *The History of Canadian Anthropology*, ed. Jim Freedman. Proceedings of the Canadian Ethnology Society, no. 3:98–121.

———. 1990. *Edward Sapir: Linguist, Anthropologist, Humanist*. Berkeley: University of California Press.

———. 1999. Theorizing Americanist Anthropology: Continuities from the B.A.E. to the Boasians. In *Theorizing the Americanist Tradition*, ed. Lisa Philips Valentine and Regna Darnell, 38–51. Toronto: University of Toronto Press.

Dauenhauer, Nora Marks. 1995. Tlingit *At.oów*: Traditions and Concepts. In *The Spirit Within: Northwest Coast Native Art from the John H. Hauberg Collection*, ed. Helen Abbott et al., 20–29. New York: Rizzoli.

Davidson, Robert. 1978. Three Sides to a Coin: A Haida Viewpoint. *CCI, The Journal of the Canadian Conservation Institute*, no. 3:10–13.

Davidson, Susan J. 1980. Kerf-Bent Boxes: Woodworking Techniques and Carving Tools of the Northwest Coast. *Fine Woodworking*, no. 22:36–45.

Davis, Robert Tyler. 1949. *Native Arts of the Pacific Northwest, from the Rasmussen Collection of the Portland Art Museum*. Stanford: Stanford University Press.

Dawn, Leslie Allen. 1981. 'Ksan: Museum, Cultural and Artistic Activity among the Gitksan of the Upper Skeena, 1920–1973. Master's thesis, History in Art, University of Victoria.

Dawson, George M. 1887. Notes and Observations on the Kwakiool People of the Northern Part of Vancouver Island and Adjacent Coasts, Made during the Summer of 1885. . . . *Transactions of the Royal Society of Canada*, 1st. ser., 5 (2): 63–98.

de Laguna, Frederica. 1932. A Comparison of Eskimo and Paleolithic Art. Ph.D. diss., Anthropology, Columbia Unviersity. Published in *American Journal of Archaeology* [1932–1933], 36 (4)/37 (1): 77–107.

———. 1963. Mungo Martin: 1879–1962. *American Anthropologist* 65:894–896.

———. 1972. *Under Mount Saint Elias: The History and Culture of the Yakutat Tlingit*. Smithsonian Contributions to Anthropology, 7.

Deloria, Philip J. 1998. *Playing Indian*. New Haven: Yale University Press.

Demmert, Jane, and Dennis Demmert. 1972. Bringing in the Totems. *Museum News* 50 (8): 21–24.

DeMott, Barbara, and Maureen Milburn. 1989. *Beyond the Revival: Contemporary North West Coast Native Arts*. Vancouver: Charles H. Scott Gallery and Emily Carr College of Art and Design.

Dexter, Ralph W. 1966. Putnam's Problems Popularizing Anthropology. *American Scientist* 54 (3): 315–332.

d'Harnoncourt, René. 1939. North American Indian Arts. *Magazine of Art* 32 (3): 164–167.

———. 1941. Living Arts of the Indians. *Magazine of Art* 34 (2): 72–77.

Dickerson, Mary Cynthia. 1910. Herculean Task in Museum Education—Foreword Regarding the Ceremonial Canoe Scene in the North Pacific Hall. *American Museum Journal* [American Museum of Natural History] 10:227–228.

Dickson, Lovat. 1986. *The Museum Makers: The Story of the Royal Ontario Museum*. Toronto: Royal Ontario Museum.

Dilworth, Leah. 1996. *Imagining Indians in the Southwest: Persistent Visions of a Primitive Past*. Washington, D.C.: Smithsonian Institution Press.

Dockstader, Frederick J. 1985. *The Kachina and the White Man: The Influences of White Culture on the Hopi Kachina Cult*. Rev. and enlarged ed. (original, 1954). Albuquerque: University of New Mexico Press.

Dorsey, George A. 1901. Recent Progress in Anthropology at the Field Columbian Museum. *American Anthropologist* 3:737–750.

———. 1907. The Anthropological Exhibits of the American Museum of Natural History. *Science* 25:584–589.

Douglas, Frederic, and René d'Harnoncourt. 1941. *Indian Arts of the United States*. New York: Museum of Modern Art.

Downey, Roger. 1986. The Teacher Who Taught the Experts. *Historic Preservation* 38 (5): 50–53.

Drucker, Philip. 1940. Kwakiutl Dancing Societies. *University of California Anthropological Records* 2 (6): 201–230.

———. 1977. Commentary on "Continuity and Change in Northwest Coast Ceremonialism." *Arctic Anthropology* 14 (1): 89–93.

Drucker, Philip, and Robert F. Heizer. 1967. *To Make My Name Good: A Reexamination of the Southern Kwakiutl Potlatch*. Berkeley: University of California Press.

Dubin, Margaret. 2001. *Native America Collected: The Culture of an Art World*. Albuquerque: University of New Mexico Press.

Duff, Wilson. 1959. Mungo Martin, Carver of the Century. *Museum News* (Vancouver Museum) 1 (1): 3–8. Reprinted in *The World Is as Sharp as a Knife: An Anthology in Honour of Wilson Duff*, ed. Donald N. Abbott, 37–40, Victoria: British Columbia Provincial Museum.

———. 1963. *Thunderbird Park*. Rev. ed. Victoria: B.C. Government Travel Bureau.

———. 1965. *The Impact of the White Man*. Vol. 1, *The Indian History of British Columbia*. Anthropology in B.C., Memoir no. 5. Victoria: British Columbia Provincial Museum.

———. 1969. The Northwest Coast (La Côte Nord-Ouest). In *Masterpieces of Indian and Eskimo Art from Canada*. Paris: Société des amis du Musée de l'Homme.

———. 1981. The World Is as Sharp as a Knife: Meaning in Northern Northwest Coast Art. In *The World Is as Sharp as a Knife: An Anthology in Honour of Wilson Duff*, ed., Donald N. Abbott, 209–224. Victoria: British Columbia Provincial Museum.

Duff, Wilson, Bill Holm, and Bill Reid. 1967. *Arts of the Raven: Masterworks of the Northwest Coast Indian*. Vancouver: Vancouver Art Gallery.

Duffek, Karen. 1983a. The Contemporary Northwest Coast Indian Art Market. Master's thesis, Anthropology and Sociology, University of British Columbia.

———. 1983b. "Authenticity" and the Contemporary Northwest Coast Indian Art Market. *BC Studies*, no. 57:99–111.

———. 1983c. The Revival of Northwest Coast Indian Art. In *Vancouver: Art and Artists, 1931–1983*, 312–317. Vancouver: Vancouver Art Gallery.

———. 1986. *The Kwagiutl Collection*. Vancouver: Ethnic Art and Culture Ltd.

———. 1993. Northwest Coast Indian Art from 1950 to the Present. In *In the Shadow of the Sun: Perspectives on Contemporary Native Art*, 213–231. Canadian Ethnology Service, Mercury Series, paper no. 124. Hull: Canadian Museum of Civilization.

Eldredge, Charles C., Julie Schimmel, and William H. Truettner. 1986. *Art in New Mexico, 1900–1945: Paths to Taos and Santa Fe*. Washington, D.C.: National Museum of American Art.

Elsner, John, and Roger Cardinal, eds. 1994. *The Cultures of Collecting*. Cambridge, Mass.: Harvard University Press.

Eri, Istvan. 1985. A Brief History of the Show-Case. *Museum* 37 (2): 71–74.

Ernst, Alice Henson. 1952. *The Wolf Ritual of the Northwest Coast*. Eugene: University of Oregon Press.

Errington, Shelly. 1998. *The Death of Authentic Primitive Art and Other Tales of Progress*. Berkeley: University of California Press.

Ewers, John C. 1955. Problems and Procedures in Modernizing Ethnological Exhibits. *American Anthropologist* 57 (1): 1–12.

———. 1959. A Century of American Indian Exhibits in the Smithsonian Institution. *Annual Report of the Smithsonian Institution for 1958*:513–525.

———. 1982. Artists' Choices. *American Indian Art Magazine* 7 (2): 40–49.

———. 1983. Plains Indian Artists and Anthropologists: A Fruitful Collaboration. *American Indian Art Magazine* 9 (1): 36–49.

Fabian, Johannes. 1983. *Time and the Other: How Anthropology Makes Its Object*. New York: Columbia University Press.

Fagin, Nancy L. 1984. Closed Collections and Open Appeals: The Two Anthropology Exhibits at the Chicago World's Columbian Exposition of 1893. *Curator* 27 (4): 249–264.

Fahim, Hussein, and Katherine Helmer. 1980. Indigenous Anthropology in Non-Western Countries: A Further Elaboration. *Current Anthropology* 21 (5): 644–663.

Falk, Randolph. 1976. *Lelooska*. Millbrae, Calif: Celestial Arts.

Fane, Diana, Ira Jacknis, and Lise M. Breen. 1991. *Objects of Myth and Memory: American Indian Art at the Brooklyn Museum*. Seattle: University of Washington Press.

Faris, James C. 1988. "ART/artifact": On Museums and Anthropology. *Current Anthropology* 29 (5): 775–779.

———. 1990. *The Nightway: A History and a History of Documentation of a Navajo Ceremonial*. Albuquerque: University of New Mexico Press.

Fassett, E. C. B. 1911. New Mural Paintings. *American Museum Journal* [American Museum of Natural History] 11:129–137.

Feder, Norman. 1962. Collection Notes. In *Indian Art of the Northwest Coast*, by Norman Feder and Edward Malin. Denver Art Museum Quarterly, Winter 1962. Rev. and repr. 1968.

———. 1971. *Two Hundred Years of North American Indian Art*. New York: Praeger.

———. 1986. European Influences on Plains Indian Art. In *The Arts of the North American Indian: Native Traditions in Evolution*, ed. Edwin L. Wade, 93–104. New York: Hudson Hills Press.

Feest, Christian F. 1980. *Native Arts of North America*. New York: Oxford University Press.

Feintuch, Burt, ed. 1988. *The Conservation of Culture*. Lexington: University Press of Kentucky.

Fenton, William N. 1986. Sapir as Museologist and Research Director, 1910–1925. In *New Perspectives in Language, Culture, and Personality: Proceedings of the Edward Sapir Centenary Conference (Ottawa, 1–3 October 1984)*, ed. William Cowan, Michael K. Foster, and Konrad Koerner, 215–240. Amsterdam: John Benjamins.

———. 1989. Return of Eleven Wampum Belts to the Six Nations Iroquois Confederacy on Grand River, Canada. *Ethnohistory* 36 (4): 392–410.

Fienup-Riordan, Ann. 1990. *Eskimo Essays: Yup'ik Lives and How We See Them*. New Brunswick, N.J.: Rutgers University Press.

———. 1995. *Freeze-Frame: Alaska Eskimos in the Movies*. Seattle: University of Washington Press.

Fisher, Robin. 1992. *Vancouver's Voyage: Charting the Northwest Coast, 1791–1795*. Vancouver: Douglas and McIntyre.

Fitzhugh, William W. 1997. Ambassadors in Sealskins: Exhibiting Eskimos at the Smithsonian. In *Exhibiting Dilemmas: Issues of Representation at the Smithsonian*, ed. Amy Henderson and Adrienne L. Kaeppler, 206–245. Washington, D.C.: Smithsonian Institution Press.

Fitzhugh, William W., and Susan A. Kaplan. 1982. *Inua: Spirit World of the Bering Sea Eskimo*. Washington, D.C.: Smithsonian Institution Press.

Field Museum of Natural History (FMNH). 1982. Big Beaver Comes to Field Museum. *Field Museum of Natural History Bulletin* 53 (6): 3–8.

Fontein, Jan, ed. 1982. *Living National Treasures of Japan*. Tokyo: Committee of Exhibition of Living National Treasures of Japan.

Ford, Clellan S. 1941. *Smoke from Their Fires: The Life of a Kwakiutl Chief.* New Haven, Conn.: Yale University Press.

Fowler, Don D. 2000. *A Laboratory for Anthropology: Science and Romanticism in the Southwest, 1846–1930.* Albuquerque: University of New Mexico Press.

Francis, Daniel. 1992. *The Imaginary Indian: The Image of the Indian in Canadian Culture.* Vancouver: Arsenal Pulp Press.

Fraser, Douglas. 1968. *Early Chinese Art and the Pacific Basin.* New York: Intercultural Arts Press.

Freed, Stanley A., Donald Collier, and William Fenton. 1977. A Brief History of the Council. *Council for Museum Anthropology Newsletter* 1 (2): 11–14.

Frese, H. H. 1960. *Anthropology and the Public: The Role of Museums.* Mededelingen, no. 14. Leiden: Rijksmuseum voor Volkenkunde.

Frisbie, Charlotte J. 1987. *Navajo Medicine Bundles or Jish: Acquisition, Transmission, and Disposition in the Past and Present.* Albuquerque: University of New Mexico Press.

Frisbie, Theodore R. 1973. The Influence of J. Walter Fewkes on Nampeyo: Fact or Fancy? In *The Changing Ways of Southwestern Indians: A Historical Perspective,* ed. Albert H. Schroeder, 231–243. Glorieta, N.M.: Rio Grande Press.

Galois, Robert. 1994. *Kwakwaka'wakw Settlements, 1775–1920: A Geographical Analysis and Gazetteer.* Vancouver: University of British Columbia Press.

Gardner, George S. 1985. Old Show-Cases: Discard or Recycle? *Museum* 37 (2): 74–78.

Garfield, Viola, and Pamela T. Amoss. 1984. Erna Gunther (1896–1982). *American Anthropologist* 86:394–399.

Garfield, Viola, and Lin A. Forrest. 1961. *The Wolf and the Raven: Totem Poles of Southeastern Alaska.* Rev. ed. Seattle: University of Washington Press.

Gibson, Ann. 1983. Painting Outside the Paradigm: Indian Space. *Arts Magazine* 57 (6): 98–104.

Gidley, Mick. 1998. *Edward S. Curtis and the North American Indian, Incorporated.* Cambridge, England: Cambridge University Press.

Glass, Aaron. 1999. Cultural Salvage or Brokerage: The Emergence of Northwest Coast "Art" and the Mythologization of Mungo Martin. Ms.

Glueck, Grace. 1982. The Metropolitan Museum Goes Primitive—At Last. *Saturday Review,* February, 36–42.

Goldman, Irving. 1975. *The Mouth of Heaven: An Introduction to Kwakiutl Religious Thought.* New York: Wiley–Interscience.

Goldwater, Robert. 1967. *Primitivism in Modern Art.* Rev. ed. New York: Random House, Vintage Books.

Goodfellow, Rev. John C. [1924]. *The Totem Poles in Stanley Park.* Vancouver: Art, Historical, and Scientific Association.

———. 1926. The Secret of the Totem Pole. *Museum Notes,* 1st. series, 1 (3): 8–11. Vancouver: Art, Historical, and Scientific Association.

Gordon, Beverly, with Melanie Herzog. 1988. *American Indian Art: The Collecting Experience.* Madison: Elvehjem Museum of Art, University of Wisconsin.

Gordon, Robert J. 1992. *The Bushman Myth: The Making of a Namibian Underclass.* Boulder, Colo.: Westview Press.

Gough, Barry M. 1982. A Priest versus the Potlatch: The Reverend Alfred James Hall and the Fort Rupert Kwakiutl, 1878–1880. *Journal of the Canadian Church Historical Society* 24 (2): 75–89.

Graburn, Nelson H. H., ed. 1976. *Ethnic and Tourist Arts: Cultural Expressions from the Fourth World.* Berkeley: University of California Press.

———. 1977. The Museum and the Visitor Experience. In *The Visitor and the Museum,* ed. Linda Draper, 5–26. Seattle: Museum Educators of the American Association of Museums.

———. 1993. Ethnic Arts of the Fourth World: The View from Canada. In *Imagery and Creativity: Ethnoaesthetics and Art Worlds in the Americas,* ed. Dorothea S. Whitten and Norman E. Whitten, Jr., 171–204. Tucson: University of Arizona Press.

Greenfield, Jeanette. 1996. *The Return of Cultural Treasures.* 2d ed. Cambridge, England: Cambridge University Press.

Gruber, Jacob W. 1970. Ethnographic Salvage and the Shaping of Anthropology. *American Anthropologist* 72 (6): 1289–1299.

Grumet, Robert Steven, and Ronald L. Weber. 1982. Maritime Peoples of the Arctic and Northwest Coast at Field Museum of Natural History. *American Indian Art Magazine* 8 (1): 66–71.

Gunn, Sisvan W. A. 1965. *The Totem Poles in Stanley Park, Vancouver, B.C.* Totem Poles of British Columbia, series I. Vancouver: W. E. G. MacDonald.

———. 1966. *Kwakiutl House and Totem Poles at Alert Bay, B.C.* Totem Poles of British Columbia, series II. West Vancouver: Whiterocks.

Gunther, Erna. 1939. The Northwest Coast of America. In *Pacific Cultures: Official Catalog*, ed. Langdon Warner, 99–113. San Francisco: Department of Fine Arts, Division of Pacific Cultures, Golden Gate International Exposition.

———. 1961. Indian Craft Enterprise in the Northwest Coast. *Human Organization* 20 (4): 216–218.

———. 1962. *Northwest Coast Indian Art*. Seattle: Seattle World's Fair.

———. 1966. *Art in the Life of the Northwest Coast Indians*. Portland, Ore.: Portland Art Museum.

———. 1972. *Indian Life on the Northwest Coast of America, as Seen by the Early Explorers and Fur Traders during the Last Decades of the Eighteenth Century*. Chicago: University of Chicago Press.

Haberland, Wolfgang. 1979. *Donnervogel und Raubwal: Indianische kunst der Nordwestkuste Nordamerikas*. Hamburg: Hamburgisches Museum für Völkerkunde.

———. 1980. Thunderbird and Killer Whale. *American Indian Art Magazine* 5 (2): 36–39, 80.

———. 1987. Nine Bella Coolas in Berlin. In *Indians and Europe: An Interdisciplinary Collection of Essays*, ed. Christian F. Feest, 337–374. Aachen, Germany: Edition Herodot, Rader Verlag. Reprint, Lincoln: University of Nebraska Press, 1999.

Haeberlin, Herman K. 1918. Principles of Esthetic Form in the Art of the North Pacific Coast. *American Anthropologist* 20:258–264.

Haeberlin, Herman K., James A. Teit, and Helen Roberts. 1928. *Coiled Basketry in British Columbia and Surrounding Region*, under the direction of Franz Boas. Bureau of American Ethnology Annual Report for 1919–24, no. 41.

Hall, Edwin S. Jr., Margaret B. Blackman, and Vincent Rickard. 1981. *Northwest Coast Indian Graphics: An Introduction to Silk Screen Prints*. Seattle: University of Washington Press.

Hall, Judy. 1983. Canadian Ethnology Service, National Museum of Man, National Museums of Canada. *American Indian Art Magazine* 9 (1): 50–59.

Halliday, William May. 1935. *Potlatch and Totem*. London: J. M. Dent.

Halpin, Marjorie M. 1978a. William Beynon: Tsimshian, 1888–1958. In *American Indian Intellectuals*, ed. Margot Liberty, 141–158. Proceedings of the American Ethnological Society for 1976. St. Paul, Minn.: West.

———. 1978b. *Review:* The Twelve Thousand Year Gap, Archaeology in British Columbia and First Peoples, Indian Cultures in British Columbia. *Gazette* [Canadian Museums Association] 11 (1): 40–48.

———. 1981. *Totem Poles: An Illustrated Guide*. Museum Note, no. 3. Vancouver: University of British Columbia Press.

———. 1983. Anthropology as Artifact. In *Consciousness and Inquiry: Ethnology and Canadian Realities*, ed. Frank Manning, 262–275. National Museum of Man Mercury Series, Canadian Ethnology Service, paper no. 89E.

———. 1986. *Jack Shadbolt and the Coastal Indian Image*. Museum Note, no. 18. Vancouver: University of British Columbia Press.

———. 1991. *Fragments: Reflections on Collecting*. Museum Note, no 31. Vancouver: University of British Columbia Museum of Anthropology.

Handler, Richard. 1985. On Having a Culture: Nationalism and the Preservation of Quebec's *Patrimonie*. In *Objects and Others: Essays on Museums and Material Culture*, ed. George W. Stocking Jr., 192–217. Madison: University of Wisconsin Press.

———. 1986. Authenticity. *Anthropology Today* 2 (1): 2–4, 2 (3): 24.

———. 1988. *Nationalism and the Politics of Culture in Quebec*. Madison: University of Wisconsin Press.

———. 1991. Who Owns the Past? History, Cultural Property, and the Logic of Possessive Individualism. In *The Politics of Culture*, ed. Brett Williams, 63–74. Washington, D.C.: Smithsonian Institution Press.

Handler, Richard, and Jocelyn Linnekin. 1984. Tradition, Genuine and Spurious. *Journal of American Folklore* 97 (385): 273–290.

Handy, Moses P. 1893. *The Official Directory of the World's Columbian Exposition.* . . . Chicago: W. B. Conkey.

Hanson, Allan. 1989. The Making of the Maori: Culture Invention and Its Logic. *American Anthropologist* 91 (4): 890–902.

Hanson, James A. 1980. The Reappearing Vanishing American. *Museum News* 59 (2): 44–51.

Harkin, Michael. 1997. *The Heiltsuks: Dialogues of Culture and History on the Northwest Coast.* Lincoln: University of Nebraska Press.

Harner, Michael J., and Albert B. Elsasser. 1965. *Art of the Northwest Coast.* Berkeley: Lowie Museum of Anthropology.

Harris, Neil. 1978. Museums, Merchandising, and Popular Taste: The Struggle for Influence. In *Material Culture and the Study of American Life,* ed. Ian M. G. Quimby, 140–174. New York: W. W. Norton.

Harris, William Laurel. 1918. Native Sources for American Design: What We Can Learn from Our Northwest Indians. *Good Furniture* 10 (4): 225–232.

Hawthorn, Audrey. 1952. Totem Pole Carver, Mungo Martin. *The Beaver,* March, 3–6.

———. 1964. Mungo Martin: Artist and Craftsman. *The Beaver,* Summer, 18–23.

———. 1967. *Art of the Kwakiutl Indians, and Other Northwest Coast Indian Tribes.* Seattle: University of Washington Press.

———. 1974. Report of the Museum of Anthropology, from 1947 to 1974. Vancouver: Museum of Anthropology, University of British Columbia. Typescript.

———. 1979. *Kwakiutl Art.* Seattle: University of Washington Press.

———. 1993. *A Labour of Love: The Making of the Museum of Anthropology, UBC, The First Three Decades, 1947–1976.* Museum Note, no. 33. Vancouver: Museum of Anthropology, University of British Columbia.

Hawthorn, Harry B. 1961. The Artist in Tribal Society: The Northwest Coast. In *The Artist in Tribal Society,* ed. Marian Smith, 59–70. Occasional Paper, no. 15. London: Royal Anthropological Institute.

Hawthorn, Harry B., Cyril S. Belshaw, and S. M. Jamieson. 1958. *The Indians of British Columbia: A Study of Contemporary Social Adjustment.* Berkeley: University of California Press.

Healey, Elizabeth. 1958. *History of Alert Bay and District.* Alert Bay: Alert Bay Centennial Committee. Reprint, Alert Bay Museum, 1971.

Henrikson, Steve. 1994. A Link with the People: The Alaska State Museum. *Museum International* 46 (2): 6–10.

———. 1995. Henry Hunt. *American Indian Art Magazine* 21 (1): 72.

Herem, Barry. 1991. The Curse of the Tlingit Treasures: The Struggle for Possession of the Secret Masterpieces of North American Art. *Connoisseur* 221 (950): 86–91, 117.

Hill, Lynn A. 1995. *AlterNative: Contemporary Photo Compositions.* Kleinburg, Ont.: McMichael Canadian Art Collection.

Hill, Tom, ed. 1988. Museums and the First Nations. *Muse* [Canadian Museums Association]. Special issue, 6 (3).

Hillman, David. 1982. Ethics in Conservation: A Case Study. *Datum* [B.C. Provincial Government Heritage Conservation Branch] 7 (1): 16–19.

Hinsley, Curtis M., Jr. 1981. *Savages and Scientists: The Smithsonian Institution and the Development of American Anthropology, 1846–1910.* Washington, D.C.: Smithsonian Institution Press.

———. 1991. The World as Marketplace: Commodification of the Exotic at the World's Columbian Exposition in Chicago, 1893. In *Exhibiting Cultures: The Poetics and Politics of Museum Display,* ed. Ivan Karp and Steven D. Lavine, 344–365. Washington, D.C.: Smithsonian Institution Press.

Hinsley, Curtis M. Jr., and Bill Holm. 1976. A Cannibal in the National Museum: The Early Career of Franz Boas in America. *American Anthropologist* 78:306–16.

Hobsbawm, Eric, and Terence Ranger, eds. 1983. *The Invention of Tradition.* Cambridge, England: Cambridge University Press.

Holm, Bill. 1965. *Northwest Coast Indian Art: An Analysis of Form.* Seattle: University of Washington Press.

———. 1972a. *Crooked Beak of Heaven: Masks and Other Ceremonial Art of the Northwest Coast.* Seattle: University of Washington Press.

———. 1972b. Heraldic Carving Styles of the Northwest Coast. In *American Indian Art: Form and Tradition*, 73–83. New York: E. P. Dutton.

———. 1973. Notes for "The Kwakiutl of British Columbia: A Documentary Film by Franz Boas." Seattle: Audio Visual Services, University of Washington. Typescript.

———. 1974. The Art of Willie Seaweed: A Kwakiutl Master. In *The Human Mirror: Material and Spatial Images of Man*, ed. Miles Richardson, 59–90. Baton Rouge: Louisiana State University Press.

———. 1977. Traditional and Contemporary Kwakiutl Winter Dance. In "Continuity and Change in Northwest Coast Ceremonialism," ed. Margaret B. Blackman, 5–24. *Arctic Anthropology* 14 (1): 1–93.

———. 1979. *Review:* Objects of Bright Pride, by Allen Wardwell. *American Indian Art Magazine* 4 (3): 77–79.

———. 1983. *Smoky-Top: The Art and Times of Willie Seaweed*. Seattle: University of Washington Press.

———. 1985. Memories of the Old Museum. In "The First Hundred Years: A Century of Natural History at the Burke Museum," ed. Barbara Krohn. *Landmarks* 4 (1): n.p.

———. 1987. *Spirit and Ancestor: A Century of Northwest Coast Indian Art at the Burke Museum*. Seattle: University of Washington Press.

———. 1990a. The Newcombe Kwakiutl Collection of the Peabody Museum. In *The Hall of the North American Indian: Change and Continuity*, ed. Barbara Isaac, 8–14. Cambridge, Mass.: Peabody Museum Press.

———. 1990b. Kwakiutl: Winter Ceremonies. In *Northwest Coast*, ed. Wayne Suttles, 378–386. Vol. 7, *Handbook of North American Indians*, ed. William C. Sturtevant. Washington, D.C.: Smithsonian Institution.

———. 1990c. Art. In *Northwest Coast*, ed. Wayne Suttles, 602–632. Vol. 7, *Handbook of North American Indians*, ed. William C. Sturtevant. Washington, D.C.: Smithsonian Institution.

Holm, Bill, and George Quimby. 1980. *Edward S. Curtis in the Land of the War Canoes: A Pioneer Cinematographer in the Pacific Northwest*. Seattle: University of Washington Press.

Holm, Marty. 1958. Let's Meet Bill Holm. *American Indian Hobbyist* 4 (5/6): 48–49.

Holmes, William H. 1903. The Exhibit of the Department of Anthropology, Report on the Exhibits of the U.S. National Museum at the Pan-American Exposition, Buffalo, New York, 1901. *Annual Report of the U.S. National Museum for 1901*, 200–218. Washington, D.C.

Homer, William I. 1977. *Alfred Stieglitz and the American Avant-Garde*. Boston: New York Graphic Society.

Horse Capture, George P. 1981. *Some Observations on Establishing Tribal Museums*. Technical Leaflet, no. 134. Bound with *History News*, 30 (1). Nashville, Tenn.: American Association for State and Local History.

Horse Capture, George P., and Suzanne G. Tyler, eds. 1992. *Artifacts/Artifakes*. The Proceedings of the 1984 Plains Indian Seminar. Cody, Wyo.: Buffalo Bill Historical Center.

Hovey, Edmund O., ed. 1904. *A General Guide to the American Museum of Natural History*. Guide Leaflet, no. 13. New York: American Museum of Natural History.

Howatt-Krahn, Ann. 1988. Field Research in the Conservation of Ethnological Collections: An Ecological Approach Applied to Polychrome Monumental Sculpture. In *Symposium 86, Proceedings: The Care and Preservation of Ethnological Materials*, ed. R. Barclay, M. Gilberg, J. C. McCawley, and T. Stone, 156–169. Ottawa: Canadian Conservation Institute.

Hoxie, Frederick W. 1979. Red Man's Burden. *Antioch Review* 37 (3): 326–342.

Hufford, Mary, ed. 1994. *Conserving Culture: A New Discourse on Heritage*. Urbana: University of Illinois Press.

Hughes, Helen Francis. 1978. A History of the Development of the Makah Cultural and Research Center, Neah Bay, Washington. Master's thesis, Anthropology, University of Washington.

Hunt, Tony. 1983. [Interview, with Jo-Anne Birnie Danzker]. In *Vancouver: Art and Artists, 1931–1983*, 266–268. Vancouver: Vancouver Art Gallery.

Hymes, Dell. 1972 [1974]. The Use of Anthropology: Critical, Political, Personal. In *Reinventing Anthropology*, ed. Dell Hymes, 3–79. New York: Random House, Vintage Books.

Ignace, Ron, George Speck, and Renee Taylor. 1993. Some Native Perspectives on Anthropology and Public Policy. In *Anthropology, Public Policy, and Native Peoples in Canada*, ed. Noel Dyck and James B. Waldram, 166–191. Montreal: McGill-Queen's University Press.

Inglis, Gordon. 1975. Harry and Audrey Hawthorn: An Appreciation. In *Papers in Honour of Harry Hawthorn*, ed. Vernon C. Serl and Herbert C. Taylor, 1–9. Bellingham: Western Washington State College.

Inglis, Joy. 1964. The Interaction of Myth and Social Context in the Village of Cape Mudge. Master's thesis, Anthropology, University of British Columbia.

Inglis, Stephen. 1979. Cultural Readjustment: A Canadian Case Study. *Gazette* [Canadian Museums Association] 12 (3): 26–30.

Inverarity, Robert Bruce. 1950. *Art of the Northwest Coast Indians*. Berkeley: University of California Press.

Ivy, Marilyn. 1995. *Discourses of the Vanishing: Modernity, Phantasm, Japan*. Chicago: University of Chicago Press.

Jacknis, Ira. 1984. Franz Boas and Photography. *Studies in Visual Communication* 10 (1): 2–60.

———. 1985. Franz Boas and Exhibits: On the Limitations of the Museum Method of Anthropology. In *Objects and Others: Essays on Museums and Material Culture*, ed. George W. Stocking Jr., 75–111. Madison: University of Wisconsin Press.

———. 1989. The Storage Box of Tradition: Museums, Anthropologists, and Kwakiutl Art, 1881–1981. Ph.D. diss., Anthropology, University of Chicago.

———. 1990. Authenticity and the Mungo Martin House, Victoria, B.C: Visual and Verbal Sources. *Arctic Anthropology* 27 (2): 1–12.

———. 1991a. Northwest Coast Indian Culture and the World's Columbian Exposition. In *The Spanish Borderlands in Pan-American Perspective*, ed. David H. Thomas, 91–118. Vol. 3, *Columbian Consequences*. Washington, D.C.: Smithsonian Institution Press.

———. 1991b. George Hunt, Collector of Indian Specimens. In *Chiefly Feasts: The Enduring Kwakiutl Potlatch*, ed. Aldona Jonaitis, 177–224. Seattle: University of Washington Press.

———. 1992a. The Artist Himself: The Salish Basketry Monograph and the Beginnings of a Boasian Paradigm. In *The Early Years of Native American Art History: Essays on the Politics of Scholarship and Collecting*, ed. Janet C. Berlo, 134–161. Seattle: University of Washington Press.

———. 1992b. George Hunt, Kwakiutl Photographer. In *Anthropology and Photography, 1860–1920*, ed. Elizabeth Edwards, 143–151. New Haven, Conn.: Yale University Press.

———. 1996a. Repatriation as Social Drama: The Kwakiutl Indians of British Columbia, 1922–1980. *American Indian Quarterly* 20 (2): 274–286. Reprinted in *Repatriation Reader: Who Owns American Indian Remains?* ed. Devon A. Mihesuah, 266–281. Lincoln: University of Nebraska Press, 2000.

———. 1996b. The Ethnographic Object and the Object of Ethnology in the Early Career of Franz Boas. In *Volksgeist as Method and Ethic: Essays on Boasian Ethnography and the German Anthropological Tradition*, ed. George W. Stocking Jr., 185–214. Madison: University of Wisconsin Press.

———. 1998. Franz Boas and the Music of the Northwest Coast Indians. In *Constructing Cultures Then and Now: The Jesup North Pacific Expedition*, ed. Laurel Kendall, Marjorie M. Balzer, and Igor Krupnik. Anthropological Papers. New York: American Museum of Natural History. In press.

———. 2000. Visualizing Kwakwaka'wakw Tradition: The Films of William Heick, 1951–1963. *BC Studies*, nos. 125/126:99–146.

———. 2001. "A Magic Place": The Northwest Coast Indian Hall at the American Museum of Natural History. In *Coming Ashore: Northwest Coast Ethnology, Past and Present*, ed. Marie Mauzé, Michael E. Harkin, and Sergei Kan. Lincoln: University of Nebraska Press. In press.

Jacknis, Ira, and Margot Blum Schevill, eds. 1993. Museum Anthropology in California, 1889–1939. *Museum Anthropology* 17 (2): 3–71.

Jacobsen, Johan Adrian. 1977. *Alaskan Voyage, 1881–1883: An Expedition to the Northwest Coast of America*. Translation by Erna Gunther from the German of Adrian Woldt, 1884. Chicago: University of Chicago Press.

Jenkins, David. 1994. Object Lessons and Ethnographic Displays: Museum Exhibitions and the Making of American Anthropology. *Comparative Studies in Society and History* 36 (2): 242–270.

Jensen, Doreen. 1996. Metamorphosis. In *Topographies: Aspects of Recent B.C. Art*, by Grant Arnold, Monika Kin Gagnon, and Doreen Jensen, 91–124. Vancouver: Douglas and McIntyre.

Jensen, Doreen, and Polly Sargent. 1986. *Robes of Power: Totem Poles on Cloth*. Museum Note, no. 17. Vancouver: University of British Columbia Press.

Johnson, Harmer. 1975. The Auction Block. *American Indian Art Magazine* 1 (1): 18.

Johnson, Rossiter, ed. 1898. *A History of the World's Columbian Exposition, Held in Chicago in 1893.* Vol. 2: *Departments.* New York: D. Appleton and Co.

Jonaitis, Aldona. 1981. Creations of Mystics and Philosophers: The White Man's Perceptions of Northwest Coast Indian Art from the 1930s to the Present. *American Indian Culture and Research Journal* 5 (1): 1–45.

———. 1988. *From the Land of the Totem Poles: The Northwest Coast Indian Art Collection at the American Museum of Natural History.* Seattle: University of Washington Press.

———, ed. 1991. *Chiefly Feasts: The Enduring Kwakiutl Potlatch.* Seattle: University of Washington Press.

———. 1992a. Chiefly Feasts: The Enduring Kwakiutl Potlatch: From Salvage Anthropology to a Big Apple Button Blanket. *Curator* 35 (4): 255–267.

———. 1992b. Franz Boas, John Swanton, and the New Haida Sculpture at the American Museum of Natural History. In *The Early Years of Native American Art History: The Politics of Scholarship and Collecting,* ed. Janet Catherine Berlo, 22–61. Seattle: University of Washington Press.

———. 1993. Traders of Tradition: The History of Haida Art. In *Robert Davidson: Eagle of the Dawn,* ed. Ian M. Thom, 3–23. Seattle: University of Washington Press.

———. 1995. Introduction: The Development of Franz Boas's Theories on Primitive Art; The Boasian Legacy in Northwest Coast Art Studies. In *A Wealth of Thought: Franz Boas on Native American Art,* ed. Aldona Jonaitis, 3–37, 306–335. Seattle: University of Washington Press.

———. 1999a. Northwest Coast Totem Poles. In *Unpacking Culture: Art and Commodity in Colonial and Postcolonial Worlds,* ed. Ruth B. Philips and Christopher B. Steiner, 104–121. Berkeley: University of California Press.

———. 1999b. *The Yuquot Whalers' Shrine.* With Research Contributions by Richard Inglis. Seattle: University of Washington Press.

Jones, Anna Laura. 1993. Exploding Canons: The Anthropology of Museums. *Annual Review of Anthropology* 22:201–220.

Jones, Michael Owen. 1970. Folk Craft Production and the Folklorist's Obligation. *Journal of Popular Culture* 4:194–212.

Jones, Suzi. 1986. Art by Fiat, and Other Dilemmas of Cross-Cultural Collecting. In *Folk Art and Art Worlds,* ed. John Michael Vlach and Simon J. Bronner, 243–266. Ann Arbor: UMI Research Press.

Joseph, Robert. 1998. Behind the Mask. In *Down from the Shimmering Sky: Masks of the Northwest Coast,* by Peter Macnair, Robert Joseph, and Bruce Grenville, 18–35. Vancouver: Douglas and McIntyre.

Joseph, Bob [Robert], and George Mann. 1980. The Kwakiutl Museum. *Museum Round-Up* [B.C. Museums Association], no. 78:7–10.

Joyce, Daniel J. 1982. Houses of the Maritime People of the Northwest Coast. *Field Museum of Natural History Bulletin* 53 (3): 8–14.

Joyce, Rosemary O. 1986. "Fame Don't Make the Sun Any Cooler": Folk Artists and the Marketplace. In *Folk Art and Art Worlds,* ed. John Michael Vlach and Simon J. Bronner, 225–241. Ann Arbor: UMI Research Press.

Kaeppler, Adrienne L. 1978. *"Artificial Curiosities": Being an Exposition of Native Manufacturers Collected on the Three Pacific Voyages of Captain James Cook, R.N.* Special Publication, no. 65. Honolulu: Bernice P. Bishop Museum.

Kan, Michael, and William Wierzbowski. 1979. Native American Art Collection of the Detroit Institute of Arts. *American Indian Art Magazine* 4 (3): 57–59.

Karp, Ivan, and Steven D. Lavine, eds. 1991. *Exhibiting Cultures: The Poetics and Politics of Museum Display.* Washington, D.C.: Smithsonian Institution Press.

Karp, Ivan, Christine Mullen Kreamer, and Steven D. Lavine, eds. 1992. *Museums and Communities: The Politics of Public Culture.* Washington, D.C.: Smithsonian Institution Press.

Karttunen, Frances. 1994. *Between Worlds: Interpreters, Guides, and Survivors.* New Brunswick, N.J.: Rutgers University Press.

Kasfir, Sidney Littlefield. 1992. African Art and Authenticity: A Text with a Shadow. *African Arts* 25 (2): 40–53, 96–97.

Kasten, Erich. 1992. Masken, Mythen und Indianer: Franz Boas' Ethnographie und Museums-

methode. In *Franz Boas: Ethnologe-Anthropologe-Sprachwissenschaftler. Ein Wegbereiter der modernen Wissenschaft vom Menschen,* by M. Dürr, E. Kasten, and E. Renner, 79–102. Berlin: Staatsbibliothek zu Berlin, Preussischer Kulturbesitz.

Keithahn, Edward L. 1963. *Monuments in Cedar.* New York: Bonanza Books.

Kendon, Jennifer Doran, and Elena Perkins. 1983. The Copper That Came from Heaven. *Canadian Collector* 18 (4): 35–37.

King, Jonathan C. H. 1981. *Artificial Curiosities from the Northwest Coast of America: Native American Artefacts in the British Museum Collected on the Third Voyage of Captain James Cook and Acquired through Sir Joseph Banks.* London: British Museum.

———. 1999. *First Peoples, First Contacts: Native Peoples of North America.* Cambridge, Mass.: Harvard University Press.

Kingsbury, Martha. 1978. Four Artists in the Northwest Tradition. In *Northwest Traditions,* ed. Charles Cowles and Sarah Clark, 9–64. Seattle: Seattle Art Museum.

Kirk, Ruth. 1980. The Pompeii of the Northwest. *Historic Preservation* 32 (2): 2–9.

Kirshenblatt-Gimblett, Barbara. 1991. Objects of Ethnography. In *Exhibiting Cultures: The Poetics and Politics of Museum Display,* ed. Ivan Karp and Steven D. Lavine, 386–443. Washington, D.C.: Smithsonian Institution Press.

———. 1998. *Destination Culture: Tourism, Museums, and Heritage.* Berkeley: University of California Press.

Knapp, Marilyn R. 1980. *Carved History: The Totem Poles and House Posts of Sitka National Historical Park.* Anchorage: Alaska Natural History Association.

Knight, Rolf. 1978. *Indians at Work: An Informal History of Native Indian Labour in British Columbia, 1858–1930.* Vancouver: New Star Books.

Kopytoff, Igor. 1986. The Cultural Biography of Things: Commoditization as Process. In *The Social Life of Things: Commodities in Cultural Perspective,* ed. Arjun Appadurai, 64–91. Cambridge, England: Cambridge University Press.

Krech, Shepard, III, and Barbara A. Hail, eds. 1991. Art and Material Culture of the North American Subarctic and Adjacent Regions. *Arctic Anthropology* 28 (1): 1–149.

Krinsky, Carol Herselle. 1996. *Contemporary Native American Architecture: Cultural Regeneration and Creativity.* New York: Oxford University Press.

Kroeber, Alfred L. 1940. Stimulus Diffusion. *American Anthropologist* 42 (1): 1–20.

Kroeber, Theodora. 1961. *Ishi in Two Worlds: A Biography of the Last Wild Indian in North America.* Berkeley: University of California Press.

Krohn, Barbara, ed. 1985. The First Hundred Years: A Century of Natural History at the Burke Museum. *Landmarks* 4 (1).

Kubler, George. 1962. *The Shape of Time: Remarks on the History of Things.* New Haven, Conn.: Yale University Press.

Laforet, Andrea. 1988. The Wakas Pole: Its History and Context. In *Symposium 86, Proceedings: The Care and Preservation of Ethnological Materials,* ed. R. Barclay, M. Gilberg, J. C. McCawley, and T. Stone, 147–155. Ottawa: Canadian Conservation Institute.

———. 1992. *The Book of the Grand Hall.* Hull: Canadian Museum of Civilization.

———. 1993. Time and the Grand Hall of the Canadian Museum of Civilization. *Museum Anthropology* 17 (1): 22–32.

La Violette, Forrest E. 1973. *The Struggle for Survival: Indian Cultures and the Protestant Ethic in British Columbia.* Rev. ed. Toronto: University of Toronto Press.

Leechman, Douglas. 1928. Native Canadian Art of the West Coast. *The Studio* 96:331–333.

Leslie, Virginia A. 1982. Probing the Roots of the Lincoln Park Totem Pole. *Field Museum of Natural History Bulletin* 53 (6): 18–21.

Leuzinger, Elsy. 1978. *Kunst der Naturvolker.* Frankfurt: Propylaen Verlag.

Levin, Gail. 1984. American Art. In *"Primitivism" in 20th Century Art,* ed. William Rubin, 453–473. New York: Museum of Modern Art.

Lévi-Strauss, Claude. 1943. The Art of the Northwest Coast at the American Museum of Natural History. *Gazette des Beaux-Arts* 24:175–182.

———. 1963 [1945]. Split Representation in the Art of Asia and America. In *Structural Anthropology.*

Translation by Claire Jacobson and Brooke Grundfest Schoepf from the French (1958), 239–263. Garden City, N.Y.: Doubleday, Anchor Books.

———. 1966. *The Savage Mind*. Translation from the French (1962). Chicago: University of Chicago Press.

———. 1974. *Tristes Tropiques*. Translation by John and Doreen Weightman from the French (1955). New York: Atheneum.

———. 1982. *The Way of the Masks*. Translation by Sylvia Modelski from the French (1975). Vancouver: Douglas and McIntyre.

Lévi-Strauss, Claude, and Didier Eribon. 1991. *Conversations with Claude Lévi-Strauss*. Translation by Paula Wissing from the French (1988). Chicago: University of Chicago Press.

Liberty, Margot, ed. 1978. *American Indian Intellectuals*. Proceedings of the American Ethnological Society for 1976. St. Paul, Minn.: West.

Lincoln, Louise. 1986. Department of African, Oceanic, and New World Cultures. In *The Art of Collecting: Acquisitions of the Minneapolis Institute of Arts, 1980–1985*, ed. Louise Lincoln and Elisabeth Sovik, 12–19. Minneapolis, Minn.: Minneapolis Institute of Arts.

Lohse, E. S., and Frances Sundt. 1990. History of Research: Museum Collections. In *Northwest Coast*, ed. Wayne Suttles, 88–97. Vol. 7, *Handbook of North American Indians*, ed. William C. Sturtevant. Washington, D.C.: Smithsonian Institution.

Loo, Tina. 1992. Dan Cranmer's Potlatch: Law as Coercion, Symbol, and Rhetoric in British Columbia, 1884–1951. *Canadian Historical Review* 73 (2): 125–165.

Low, Jean. 1977. George Thornton Emmons. *Alaska Journal* 7 (1): 2–11.

———. 1982. Dr. Charles Frederick Newcombe. *The Beaver*, Outfit 312 (4): 32–39.

Lurie, Nancy Oestreich. 1971. The Contemporary American Indian Scene. In *North American Indians in Historical Perspective*, ed. Eleanor Burke Leacock and Nancy Oestreich Lurie, 418–480. New York: Random House.

———. 1981. Museumland Revisited. *Human Organization* 40 (2): 180–187.

———. 1983. *A Special Style: The Milwaukee Public Museum, 1882–1982*. Milwaukee, Wis.: Milwaukee Public Museum.

Lynes, Russell. 1973. *Good Old Modern: An Intimate Portrait of the Museum of Modern Art*. New York: Atheneum.

MacDonald, George F. 1984. Painted Houses and Woven Blankets: Symbols of Wealth in Tsimshian Art and Myth. In *The Tsimshian and Their Neighbors of the North Pacific Coast*, ed. Jay Miller and Carol M. Eastman, 109–136. Seattle: University of Washington Press.

MacDonald, George F., and Stephen Alsford. 1989. *A Museum for the Global Village: The Canadian Museum of Civilization*. Hull, Que.: Canadian Museum of Civilization.

McDonald, James A. 1984. Images of the Nineteenth-Century Economy of the Tsimshian. In *The Tsimshian: Images of the Past; Views for the Present*, ed. Margaret Seguin, 40–54. Vancouver: University of British Columbia Press.

———. 1992. Museum Exhibit and Book Review, "Chiefly Feasts: The Enduring Kwakiutl Potlatch." *American Anthropologist* 94:772–774.

McDowell, Jim. 1997. *Hamatsa: The Enigma of Cannibalism on the Pacific Northwest Coast*. Vancouver: Ronsdale Press.

McEachern, Shari. 1959. Introducing the Ikpoos. *American Indian Hobbyist* 5 (5/6): 51–52.

McFeat, Tom F. S. 1965. The Object of Research in Museums. *National Museum of Canada Bulletin*, no. 204; Anthropological Series, no. 70:91–99.

———. 1976. The National Museum and Canadian Anthropology. In *The History of Canadian Anthropology*, ed. Jim Freedman. Proceedings of the Canadian Ethnology Society, no. 3:148–174.

McGarry, Leslie. 1996. A Gift That Gave Back. *Discovery* 24 (8). Victoria: Royal British Columbia Museum.

McKillop, John. 1983. A Brief History of Sotheby's New York Indian Art Auctions. *The McKillop Report* 1 (4): 10–11.

McLoughlin, Moira. 1999. *Museums and the Representation of Native Canadians: Negotiating the Borders of Culture*. New York: Garland.

McMaster, Gerald R., and Lee-Ann Martin. 1990. The Contemporary Indian Art Collection at the Canadian Museum of Civilization, Hull, Quebec. *American Indian Art Magazine* 15 (4): 50–55.

———, eds. 1992. *Indigena: Contemporary Native Perspectives in Canadian Art.* Vancouver: Douglas and McIntyre.

Macnair, Peter L. 1973a. Kwakiutl Winter Dances: A Reenactment. Stones, Bones, and Skin: Ritual and Shamanic Art. *Artscanada* 30 (5/6): 94–114.

———. 1973b. Inheritance and Innovation: Northwest Coast Artists Today. Stones, Bones, and Skin: Ritual and Shamanic Art. *Artscanada* 30 (5/6): 182–189.

———. [1978]. Notes to "Man Frog Legend," Print by Douglas Cranmer. Leaflet. Vancouver: Canadian Native Prints, Ltd.

———. 1986. From Kwakiutl to Kwakwa̱ ka'wakw. In *Native Peoples: The Canadian Experience*, ed. R. Bruce Morrison and C. Roderick Wilson, 501–519. Toronto: McClellan and Stewart.

———. 1993. Trends in Northwest Coast Indian Art, 1880–1959: Decline and Expansion. In *In the Shadow of the Sun: Perspectives on Contemporary Native Art*, 47–70. Canadian Ethnology Service, Mercury Series, paper no. 124. Hull: Canadian Museum of Civilization.

———. 2000. Tim Paul: The Homeward Journey. In *Nuu-chah-nulth Voices, Histories, Objects, and Journeys*, ed. Alan L. Hoover, 363–373. Victoria: Royal British Columbia Museum.

Macnair, Peter L., and Alan L. Hoover. 1984. *The Magic Leaves: A History of Haida Argillite Carving.* Victoria: British Columbia Provincial Museum.

Macnair, Peter L., Alan L. Hoover, and Kevin Neary. 1980. *The Legacy: Continuing Traditions of Canadian Northwest Coast Indian Art.* Victoria: British Columbia Provincial Museum.

Macnair, Peter L., Robert Joseph, and Bruce Grenville. 1998. *Down From the Shimmering Sky: Masks of the Northwest Coast.* Vancouver: Douglas and McIntyre.

McShine, Kynaston. 1999. *The Museum as Muse: Artists Reflect.* New York: Museum of Modern Art.

Malin, Edward. 1978. *A World of Faces: Masks of the Northwest Coast Indians.* Portland, Ore.: Timber Press.

———. 1999. *Northwest Coast Indian Painting: House Fronts and Interior Screens.* Portland, Ore.: Timber Press.

Malraux, André. 1967. *Museum without Walls.* Translation by Stuart Gilbert and Francis Price from the French (1965). Garden City, N.Y.: Doubleday.

Maquet, Jacques. 1979. Art by Metamorphosis. *African Arts* 12 (4): 32–37, 90.

Marcus, George E., and Michael M. J. Fischer. 1986. *Anthropology as Cultural Critique: An Experimental Moment in the Human Sciences.* Chicago: University of Chicago Press.

Marcus, George E., and Fred R. Myers, eds. 1995. *The Traffic in Culture: Refiguring Art and Anthropology.* Berkeley: University of California Press.

Mark, Joan. 1982. Frances La Flesche: The American Indian as Anthropologist. *Isis* 73:497–510.

Masco, Joseph. 1995. "It Is a Strict Law That Bids Us Dance": Cosmologies, Colonialism, Death, and Ritual Authority in the Kwakwaka'wakw Potlatch, 1849 to 1922. *Comparative Studies in Society and History* 37 (1): 41–75.

———. 1996. Competitive Displays: Negotiating Genealogical Rights to the Potlatch at the American Museum of Natural History. *American Anthropologist* 98 (4): 837–852.

Mason, Otis T. 1887. The Occurrence of Similar Inventions in Areas Widely Apart. *Science* 9:534–535.

Massey, Vincent. 1951. *Report of the Royal Commission on National Development in the Arts, Letters, and Sciences, 1949–1951.* Ottawa: King's Printer.

Maurer, Evan. 1984. Dada and Surrealism. In *"Primitivism" in 20th Century Art*, ed. William Rubin, 535–593. New York: Museum of Modern Art.

Mauzé, Marie. [1983]. Le Kwakiutl Museum: Un essai de réappropriation du passe. Paper presented at the 11th International Congress of Anthropological and Ethnological Sciences, Vancouver, B.C.

———. 1984. Enjeux et jeux du prestige: Des Kwagul méridionaux aux Lekwiltoq (côte nord-ouest du Pacifique). Thèse pour le doctorat de troisième cycle, Ecole des Hautes Etudes en Sciences Sociales, Paris. Revised as *Les Fils de Wakai: Une Histoire des Indiens Lekwiltoq*, Paris: Editions Recherche sur les Civilisations, 1992.

———. 1990. In Honor of Lévi-Strauss. *European Review of Native American Studies* 4 (1): 51–53.

———. 1992. Exhibiting One's Culture: Two Case Studies: The Kwagiulth Museum and the U'Mista Cultural Centre. *European Review of Native American Studies* 6 (1): 27–30.

———, ed. 1997. *Present Is Past: Some Uses of Tradition in Native Societies.* Lanham, Md.: University Press of America.

Maxon, John. 1970. *The Art Institute of Chicago.* New York: Harry N. Abrams.

Mayer, Carol E., Lynn Maranda, and Ivan Sayers. 1982. *Cabinets of Curiosities: Collections of the Vancouver Museum, 1894–1981.* Vancouver: Vancouver Museum.

Mead, Margaret. 1972. *Blackberry Winter: My Earlier Years.* New York: William Morrow.

Mead, Sidney Moko. 1976. The Production of Native Art and Craft Objects in Contemporary New Zealand Society. In *Ethnic and Tourist Arts: Cultural Expressions from the Fourth World,* ed. Nelson H. H. Graburn, 285–298. Berkeley: University of California Press.

———. 1983. Indigenous Models of Museums in Oceania. *Museum* 35 (2): 98–101.

Mechling, Jay. 1989. The Collecting Self and American Youth Movements. In *Consuming Visions: Accumulation and Display of Goods in America, 1880–1920,* ed. Simon J. Bronner, 255–285. New York: W. W. Norton.

Merrill, William L., Edmund J. Ladd, and T. J. Ferguson. 1993. The Return of the Ahayu:da: Lessons for Repatriation from Zuni Pueblo and the Smithsonian Institution. *Current Anthropology* 34 (5): 523–567.

Messenger, Phyllis Mauch. 1999. *The Ethics of Collecting Cultural Property: Whose Culture? Whose Property?* 2d ed., updated and enlarged. Albuquerque: University of New Mexico Press.

Meyer, Karl E. 1973. *The Plundered Past.* New York: Atheneum.

Mihesuah, Devon A., ed. 2000. *Repatriation Reader: Who Owns American Indian Remains?* Lincoln: University of Nebraska Press.

Milburn, Maureen. 1986. Louis Shotridge and the Objects of Everlasting Esteem. In *Raven's Journey: The World of Alaska's Native People,* by Susan A. Kaplan and Kristin J. Barsness, 54–77. Philadelphia: University Museum, University of Pennsylvania.

Miner, H. Craig. 1972. The United States Government Building at the Centennial Exhibition, 1874–77. *Prologue* 4:203–218.

Morgan, Lewis H. 1881. *Houses and House-Life of the American Aborigines.* Contributions to North American Ethnology, 4. Washington, D.C.: Bureau of [American] Ethnology.

Morris, Rosalind C. 1994. *New Worlds from Fragments: Film, Ethnography, and the Representation of Northwest Coast Cultures.* Boulder, Colo.: Westview Press.

Morrison, Ann. 1991. Canadian Art and Cultural Appropriation: Emily Carr and the 1927 *Exhibition of Canadian West Coast Art—Native and Modern.* Master's thesis, University of British Columbia.

Mullin, Molly H. 2001. *Culture in the Marketplace: Gender, Art, and Value in the American Southwest.* Durham, N.C.: Duke University Press.

Narayan, Kirin. 1993. How Native Is a "Native" Anthropologist? *American Anthropologist* 95 (3): 671–686.

Nason, James D. 1987. The Determination of Significance: Curatorial Research and Private Collections. In *Material Anthropology: Contemporary Approaches to Material Culture,* ed. Barrie Reynolds and Margaret A. Stott, 31–67. Lanham, Md.: University Press of America.

———. 1999. Traditional Roots, Modern Preservation: Museums and Cultural Centers. *Common Ground: Archaeology and Ethnography in the Public Interest,* fall issue, 20–25. Washington, D.C.: Archaeology and Ethnography Program, National Park Service.

National Gallery of Canada (NGC). 1927. *Exhibition of Canadian West Coast Art.* Ottawa.

Neary, Kevin. 2000. *Richard Hunt: Through My Father's Eyes.* Victoria, B.C.: Art Gallery of Greater Victoria.

Neel, David. 1992. *Our Chiefs and Elders: Words and Photographs of Native Leaders.* Vancouver: University of British Columbia Press.

Neel, Ellen. 1948. [Mrs. Ellen Neel, Woodcarver, Vancouver]. In *Report of the Conference on Native Indian Affairs,* ed. Harry Hawthorn, 11–15. Vancouver: B.C. Indian Arts and Welfare Society.

Nemiroff, Diana. 1987. National Gallery Collects Contemporary Works by Artists of Native Ancestry. *Native Art Studies Association of Canada Newsletter* 2 (3): 3–4.

Nemiroff, Diana, Robert Houle, and Charlotte Townsend-Gault. 1992. *Land, Spirit, Power: First Nations at the National Gallery of Canada.* Ottawa: National Gallery of Canada.

Newman, Barnett. 1946. *Northwest Coast Indian Painting*. New York: Betty Parsons Gallery.

Newton, Douglas. 1978. Primitive Art: A Perspective. In *Masterpieces of Primitive Art: The Nelson A. Rockefeller Collection*, 27–47. New York: Alfred A. Knopf.

Newton, Douglas, Julie Jones, and Susan Vogel. 1975. The Stuff That Wasn't in the Metropolitan: Notes on Collecting Primitive Art. In *The Chase, the Capture: Collecting at the Metropolitan*, by Thomas Hoving et al., 181–194. New York: Metropolitan Museum of Art.

Nicks, Trudy. 1982. *The Creative Tradition: Indian Handicraft and Tourist Art*. Edmonton: Provincial Museum of Alberta.

———. 1990. Indian Handicrafts: The Marketing of an Image. *Rotunda* 23 (1): 14–20.

Nochlin, Linda. 1972. Museums and Radicals: A History of Emergencies. In *Museums in Crisis*, ed. Brian O'Doherty, 7–41. New York: George Braziller.

Nuytten, Phil. 1982. *The Totem Carvers: Charlie James, Ellen Neel, and Mungo Martin*. Vancouver: Panorama.

Oberg, Kalervo. 1973. *The Social Economy of the Tlingit Indians*. Seattle: University of Washington Press.

O'Neale, Lila M. 1932. *Yurok-Karok Basket Weavers*. University of California Publications in American Archaeology and Ethnology 32 (1).

Osgood, Cornelius. 1979. *Anthropology in Museums of Canada and the United States*. Publication in Museology, no. 7. Milwaukee, Wis.: Milwaukee Public Museum.

Ostrowitz, Judith. 1993. Trail Blazers and Ancestral Heroes: A Museum Collaboration. *Curator* 36 (1): 50–65.

———. 1999. *Privileging the Past: Reconstructing History in Northwest Coast Art*. Seattle: University of Washington Press.

Paalen, Wolfgang. 1943. Totem Art. *Dyn*. The Amerindian Issue [Coyoacan, Mexico], no. 4–5:7–39.

Pacific Science Center (PSC). 1981. *Sea Monster House: Origins of a Kwakiutl Family House*. Seattle.

Panofsky, Erwin. 1960. *Renaissance and Renascences in Western Art*. Stockholm. 2d rev. ed., Uppsala, 1965. New York: Harper and Row [1969].

Parezo, Nancy J. 1987. The Formation of Ethnographic Collections: The Smithsonian Institution in the American Southwest. In *Advances in Archaeological Method and Theory*, ed. Michael B. Schiffer, 10:1–47. New York: Academic Press.

Parr, Albert Edie. 1963. Habitat Group and Period Room. *Curator* 6 (4): 325–336.

Parsons, Lee A. 1962. The Salmon and Cedar People. *Lore* [Milwaukee Public Museum] 12 (2): 63–67.

Parsons, Lee A., and Stephen F. de Borhegyi. 1964. The Milwaukee Public Museum: Display of Collections. *Museum* 17 (1): 18–25.

Patt, Olney, Jr. 1994. The Museum at Warm Springs: The Story of Three Tribes. *American Indian Art Magazine* 19 (2): 42–49.

Pearce, Susan M. 1992. *Museums, Objects, and Collections: A Cultural Study*. Washington, D.C.: Smithsonian Institution Press.

Phillips, Ruth B. 1994. Fielding Culture: Dialogues between Art History and Anthropology *Museum Anthropology* 18 (1): 39–46.

———. 1998. *Trading Identities: The Souvenir in Native North American Art from the Northeast, 1700–1900*. Seattle: University of Washington Press.

Phillips, Ruth B., and Christopher B. Steiner, eds. 1999. *Unpacking Culture: Art and Commodity in Colonial and Postcolonial Worlds*. Berkeley: University of California Press.

Pineo, Peter. 1955. Village Migrations of the Modern Kwakiutl. Honours essay, Anthropology and Sociology, University of British Columbia.

Povey, John F., et al. 1976. Fakes, Fakers, and Fakery: Authenticity in African Art. *African Art* 9 (3): 21–31, 48–74.

Powell, Jay. 1994. The Kwak'wala Language. In *Kwakwaka'wakw Settlements, 1775–1920: A Geographical Analysis and Gazetteer*, by Robert Galois, 12–18. Vancouver: University of British Columbia Press.

Powers, William K. 1988. The Indian Hobbyist Movement in North America. In *History of Indian-White Relations*, ed. Wilcomb Washburn, 557–561. Vol. 4, *Handbook of North American Indians*, ed. William C. Sturtevant. Washington, D.C.: Smithsonian Institution.

Preziosi, Donald. 1989. *Rethinking Art History: Meditations on a Coy Science.* New Haven, Conn.: Yale University Press.

Price, Richard, and Sally Price. 1992. *Equatoria.* New York: Routledge.

———. 1995. *On the Mall: Presenting Maroon Tradition-Bearers at the 1992 Festival of American Folklife.* Folklore Institute, Special Publications, no. 4. Bloomington: Indiana University Press.

Price, Sally. 1989. *Primitive Art in Civilized Places.* Chicago: University of Chicago Press.

Raibmon, Paige. 2000. Theaters of Contact: The Kwakwaka'wakw Confront Colonialism at Home and at the Chicago World's Fair. *Canadian Historical Review* 81 (2): 157–190.

Raley, Reverend George H. 1935. Canadian Indian Art and Industries. *Journal of the Royal Society of Arts* (London) 83 (4320): 989–1001.

———. 1937. *Our Totem Poles: A Monograph of the Totem-Poles in Stanley Park, Vancouver, B.C.* Vancouver: n.p.

Rathburn, Robert A., and Carter Lupton. 1983. The Lands of Snow and Cedar. *Museum News* 61 (3): 54–63.

Ravenhill, Alice. 1938. *The Native Tribes of British Columbia.* Victoria: King's Printer.

———. 1944. *A Cornerstone of Canadian Culture.* Occasional Papers of the British Columbia Provincial Museum, no. 5.

———. 1951. *The Memoirs of an Educational Pioneer.* Toronto: J. M. Dent.

———. 1953. *Folklore of the Far West.* Victoria: British Columbia Indian Arts and Welfare Society.

Reichard, Gladys A. 1936. *Navajo Shepherd and Weaver.* New York: J. J. Augustin.

Reid, Bill. 1981a. Creativity and Inadvertence: An Interview with Bill Reid. *Raven,* no. 2: n.p.

———. 1981b. The Box Painting by the "Master of the Black Field." In *The World Is as Sharp as a Knife: An Anthology in Honour of Wilson Duff,* ed. Donald N. Abbott, 300–301. Victoria: British Columbia Provincial Museum.

Reid, Martine (née de Widerspach-Thor). 1981a. La Cérémonie Hamatsa des Kwagul: Approche Struturaliste des Rapports Mythe-Rituel. Ph.D. diss., Anthropology, University of British Columbia.

———. 1981b. The Equation of Copper. In *The World Is as Sharp as a Knife: An Anthology in Honour of Wilson Duff,* ed. Donald N. Abbott, 157–174. Victoria: British Columbia Provincial Museum.

———. 1986. The Significance of Colour among the Kwakiutl. In *Robes of Power: Totem Poles on Cloth,* by Doreen Jensen and Polly Sargent, 76–77. Museum Note, no. 17. Vancouver: University of British Columbia Press.

———. 1993. In Search of Things Past, Remembered, Retraced, and Reinvented. In *In the Shadow of the Sun: Perspectives on Contemporary Native Art,* 71–92. Canadian Ethnology Service, Mercury Series, paper no. 124. Hull: Canadian Museum of Civilization.

Richling, Barnett. 1990. Diamond Jenness and the National Museum of Canada. *Curator* 33 (4): 245–260.

———. 1998. Archaeology, Ethnology and Canada's Public Purse, 1910–1921. In *Bringing Back the Past: Historical Perspectives on Canadian Archaeology,* ed. Pamela Jane Smith and Donald Mitchell, 103–114. Archaeological Survey of Canada, Mercury Series, paper no. 158. Hull: Canadian Museum of Civilization.

Ridington, Robin, and Dennis Hastings (In'aska). 1997. *Blessing for a Long Time: The Sacred Pole of the Omaha Tribe.* Lincoln: University of Nebraska Press.

Ritchie, Margaret, ed. 1981. *Denver Art Museum: Major Works in the Collection.* Denver, Colo.: Denver Art Museum.

Ritzenthaler, Robert, and Lee A. Parsons, eds. 1966. *Masks of the Northwest Coast: The Samuel A. Barrett Collection.* Publications in Primitive Art, no. 2. Milwaukee, Wis.: Milwaukee Public Museum.

Roberts, Mary Nooter, and Susan Vogel. 1994. *Exhibition-ism: Museums and African Art.* New York: Museum for African Art.

Rogers, Edward S. 1976. The Children of the Raven: A Review. *Gazette* [Canadian Museums Association], 9 (1): 48–53.

Rohner, Ronald P. 1967. *The People of Gilford: A Contemporary Kwakiutl Village.* National Museum of Canada Bulletin, no. 225; Anthropological Series, no. 83.

Rohner, Ronald P., and Evelyn C. Rohner. 1970. *The Kwakiutl Indians of British Columbia.* New York: Holt, Rinehart and Winston.

Rose, Barbara. 1967. *American Art since 1900: A Critical History.* New York: Praeger.

Rosman, Abraham, and Paula G. Rubel. 1971. *Feasting with Mine Enemy: Rank and Exchange among Northwest Coast Societies.* New York: Columbia University Press.

Rubin, William, ed. 1984. *"Primitivism" in 20th Century Art.* New York: Museum of Modern Art.

Rumford, Beatrix T. 1980. Uncommon Art of the Common People: A Review of Trends in the Collecting and Exhibiting of American Folk Art. In *Perspectives in American Folk Art,* ed. Ian M. G. Quimby and Scott T. Swank, 13–53. New York: W. W. Norton.

Rushing, W. Jackson III. 1986. Ritual and Myth: Native American Culture and Abstract Expressionism. In *The Spiritual in Art: Abstract Painting, 1890–1985,* by Maurice Tuchman et al., 273–295. New York: Abbeville Press.

———. 1988. The Impact of Nietzche and Northwest Coast Indian Art on Barnett Newman's Idea of Redemption in the Abstract Sublime. *Art Journal* 47 (3): 187–195.

———. 1992. Marketing the Affinity of the Primitive and the Modern: René d'Harnoncourt and "Indian Art of the United States." In *The Early Years of Native American Art History: Essays on the Politics of Scholarship and Collecting,* ed. Janet C. Berlo, 191–236. Seattle: University of Washington Press.

———. 1995. *Native American Art and the New York Avant-Garde: A History of Cultural Primitivism.* Austin: University of Texas Press.

———, ed. 1999. *Native American Art in the Twentieth Century: Makers, Meanings, Histories.* London: Routledge.

Rydell, Robert W. 1984. *All the World's a Fair: Visions of Empire at American International Expositions, 1876–1916.* Chicago: University of Chicago Press.

Saunders, Barbara. 1995. Kwakwaka'wakw Museology. *Cultural Dynamics* 7 (1): 37–68.

———. 1997. Contested *Ethnie* in Two Kwakwaka'wakw Museums. In *Contesting Art: Art, Politics and Identity in the Modern World,* ed. Jeremy MacClancy, 85–130. Oxford: Berg.

Searing, Helen. 1982. *New American Art Museums.* Berkeley: University of California Press.

Schrader, Robert Fay. 1983. *The Indian Arts and Crafts Board: An Aspect of New Deal Indian Policy.* Albuquerque: University of New Mexico Press.

Seitz, William C. 1962. *Mark Tobey.* New York: Museum of Modern Art.

Seligman, Thomas K., and Kathleen Berrin. 1982. *The Bay Area Collects: Art from Africa, Oceania, and the Americas.* San Francisco: Fine Arts Museums of San Francisco.

Sewid-Smith, Daisy. 1979. *Prosecution or Persecution.* Cape Mudge, B.C.: Nuyumbalees Society.

Shadbolt, Doris, ed. 1974. *Bill Reid: A Retrospective Exhibition.* Vancouver: Vancouver Art Gallery.

———. 1986. *Bill Reid.* Seattle: University of Washington Press.

Shils, Edward. 1981. *Tradition.* Chicago: University of Chicago Press.

Shine, Carolyn R., and Mary L. Meyer. 1976. *Art of the First Americans, from the Cincinnati Art Museum.* Cincinnati, Ohio: Cincinnati Art Museum.

Shotridge, Louis. 1928. The Emblems of the Tlingit Culture. *The Museum Journal* [University of Pennsylvania] 19:350–377.

Simpson, Moira G. 2001. *Making Representations: Museums in the Post-Colonial Era.* Rev. ed. London: Routledge.

Skramstad, Harold K. 1978. Interpreting Material Culture: A View from the Other Side of the Glass. In *Material Culture and the Study of American Life,* ed. Ian M. G. Quimby, 175–200. New York: W. W. Norton.

Sloan, John, and Oliver La Farge, eds. 1931. *Introduction to American Indian Art.* New York: Exhibition of Indian Tribal Arts, Inc.

Smith, Don. 1958. Let's Meet Lelooska. *American Indian Hobbyist* 4 (9/10): 94–95.

Smith, Harlan I. 1893. "Man and His Works": The Anthropological Building at the World's Columbian Exposition. *American Antiquarian and Oriental Journal* 15:115–117.

———. 1917. The Use of Prehistoric Canadian Art for Commercial Design. *Science* 46 (1177): 60–61.

———. 1918. Prehistoric Canadian Art as a Source of Distinctive Design. *Transactions of the Royal Society of Canada,* 3d ser., 12 (2): 151–154.

———. 1923. *An Album of Prehistoric Canadian Art.* National Museum of Canada Bulletin, no. 37; Anthropological Series, no. 8.

Snow, Stephen Eddy. 1993. *Performing the Pilgrims: A Study of Ethnohistorical Role-Playing at Plimoth Plantation*. Jackson: University Press of Mississippi.

Spradley, James P., ed. 1969. *Guests Never Leave Hungry: The Autobiography of James Sewid, A Kwakiutl Indian*. New Haven, Conn.: Yale University Press.

Staniszewski, Mary Ann. 1998. *The Power of Display: A History of Exhibition Installations at the Museum of Modern Art*. Cambridge, Mass.: MIT Press.

Steiner, Christopher B. 1994. *African Art in Transit*. Cambridge, England: Cambridge University Press.

Stewart, Hilary. 1984. *Cedar: Tree of Life to the Northwest Coast Indians*. Vancouver: Douglas and McIntyre.

———. 1990. *Totem Poles*. Seattle: University of Washington Press.

Stewart, Jay, and Peter Macnair. 1999. *To the Totem Forests: Emily Carr and Contemporaries Interpret Coastal Villages*. Victoria: Art Gallery of Greater Victoria.

Stewart, Susan. 1984. *On Longing: Narratives of the Miniature, the Gigantic, the Souvenir, the Collections*. Baltimore, Md.: Johns Hopkins University Press.

Stocking, George W. Jr., ed. 1974. *The Shaping of American Anthropology, 1883–1911: A Franz Boas Reader*. New York: Basic Books.

———. 1976. Ideas and Institutions in American Anthropology: Toward a History of the Interwar Period. In *Selected Papers from the American Anthropologist, 1921–1945*, ed. George Stocking Jr., 1–50. Washington, D.C.: American Anthropological Association.

———. 1977. The Aims of Boasian Ethnography: Creating the Materials for Traditional Humanistic Scholarship. *History of Anthropology Newsletter* 4 (2): 4–5.

———, ed. 1985. *Objects and Others: Essays on Museums and Material Culture*. Madison: University of Wisconsin Press.

Stokes, Charlotte. 1987. The Thirteenth Chair: Max Ernst's *Capricorn*. *Arts Magazine* 62 (2): 88–93.

Sturtevant, William C. 1969. Does Anthropology Need Museums? *Proceedings of the Biological Society of Washington* 82:619–650.

———, ed. 1974. *Boxes and Bowls: Decorated Containers by Nineteenth Century Haida, Tlingit, Bella Bella, and Tsimshian Indian Artists*. Washington, D.C.: National Collection of Fine Arts, Smithsonian Institution.

———. 1977. *Guide to Field Collecting of Ethnographic Specimens*. 2d ed. Smithsonian Information Leaflet 503. Washington, D.C.: Smithsonian Institution Press.

Suttles, Wayne. 1979. *The Mouth of Heaven* and the Kwakiutl Tongue: A Comment on Walens on Goldman. *American Anthropologist* 81 (1): 96–98.

———. 1990. Introduction. In *Northwest Coast*, ed. Wayne Suttles, 1–15. Vol. 7, *Handbook of North American Indians*, ed. William C. Sturtevant. Washington, D.C.: Smithsonian Institution.

———. 1991a. The Spelling of Kwak'wala. In *Chiefly Feasts: The Enduring Kwakiutl Potlatch*, ed. Aldona Jonaitis, 15–17. New York: American Museum of Natural History; Seattle: University of Washington Press.

———. 1991b. Streams of Property, Armor of Wealth: The Traditional Kwakiutl Potlatch. In *Chiefly Feasts: The Enduring Kwakiutl Potlatch*, ed. Aldona Jonaitis, 71–134. New York: American Museum of Natural History; Seattle: University of Washington Press.

Suttles, Wayne, and Aldona Jonaitis. 1990. History of Research in Ethnology. In *Northwest Coast*, ed. Wayne Suttles, 73–87. Vol. 7, *Handbook of North American Indians*, ed. William C. Sturtevant. Washington, D.C.: Smithsonian Institution.

Sweet, Jill Drayson. 1983. Ritual and Theatre in Tewa Ceremonial Performances. *Ethnomusicology* 27 (2): 253–269.

Szasz, Margaret Connell, ed. 1994. *Between Indian and White Worlds: The Cultural Broker*. Norman: University of Oklahoma Press.

Taylor, Paul Michael, ed. 1994. *Fragile Traditions: Indonesian Art in Jeopardy*. Honolulu: University of Hawaii Press.

Tennant, Paul. 1990. *Aboriginal Peoples and Politics: The Indian Land Question in British Columbia, 1849–1989*. Vancouver: University of British Columbia Press.

Thom, Ian M., ed. 1993. *Robert Davidson: Eagle of the Dawn*. Seattle: University of Washington Press.

Thomas, Nicholas. 1991. *Entangled Objects: Exchange, Material Culture, and Colonialism in the Pacific*. Cambridge, Mass.: Harvard University Press.

Thoresen, Timothy H. H. 1977. Art, Evolution, and History: A Case Study of Paradigm Change in *Anthropology. Journal of the History of the Behavioral Sciences* 13:107–125.

Tippett, Maria. 1979. *Emily Carr: A Biography.* Toronto: Oxford University Press.

Trachtenberg, Alan. 1982. White City. In *The Incorporation of America: Culture and Society in the Gilded Age,* 208–234. New York: Hill and Wang.

Trennert, Robert A. Jr. 1974. A Grand Failure: The Centennial Indian Exhibition of 1876. *Prologue* 6 (2): 118–129.

Turner, Victor W. 1957. *Schism and Continuity in an African Society: A Study of Ndembu Village Life.* Manchester: University of Manchester Press.

Tutton, Hilda. 1994. *Life of the Copper: A Commonwealth of Tribal Nations.* Victoria: Alcheringa Gallery.

U'mista. 1975. *Potlatch: A Strict Law Bids Us Dance.* Film, 16 mm., sound, color, 55 minutes. Vancouver: Pacific Cinémathèque.

———. 1980. *U'mista Cultural Centre, Alert Bay, B.C.* Leaflet. Alert Bay: U'mista Cultural Society.

———. 1983. *Box of Treasures.* Film, 16 mm., sound, color, 28 minutes. Chicago: Chuck Olin Associates.

———. 1999. *Annual Report.* Alert Bay: U'mista Cultural Society.

University of California at Los Angeles (UCLA). 1968. *Ralph C. Altman Memorial Exhibition.* Los Angeles: Museum and Laboratories of Ethnic Arts and Technology.

VanStone, James W. 1972. *The First Peary Collection of Polar Eskimo Material Culture.* Fieldiana, Anthropology 63 (2): 31–80. Chicago: Field Museum of Natural History.

———. 1980. *The Bruce Collection of Eskimo Material Culture from Kotzebue Sound, Alaska.* Fieldiana, Anthropology, n.s. 1. Chicago: Field Museum of Natural History.

Varnedoe, Kirk. 1984. Abstract Expressionism. In *"Primitivism" in 20th Century Art,* ed. William Rubin, 615–659. New York: Museum of Modern Art.

Vastokas, Joan. 1975. Bill Reid and the Native Renaissance. *Artscanada,* no. 198/199:12–21.

———. 1976. Architecture as Cultural Expression: Arthur Erickson and the New Museum of Anthropology, University of British Columbia. *Artscanada,* no. 208/209:1–15.

Vincent, Gilbert T., Sherry Brydon, and Ralph T. Coe, eds. 2000. *Art of the North American Indians: The Thaw Collection.* Seattle: University of Washington Press.

Vlach, John Michael. 1985. Holger Cahill as Folklorist. *Journal of American Folklore* 98 (388): 148–162.

Vogel, Susan, et al. 1988. *ART/Artifact: African Art in Anthropological Collections.* New York: Center for African Art.

Wachtel, Eleanor. 1977. An Accessible Heritage: UBC's Museum of Anthropology, A Treasure House That Teaches. *University of British Columbia Alumni Chronicle* 31 (2): 8–13.

Wade, Edwin L. 1976. The History of the Southwest Indian Ethnic Art Market. Ph.D. diss., Anthropology, University of Washington.

———. 1981. The Ethnic Art Market and the Dilemma of Innovative Indian Artists. In *Magic Images: Contemporary Native American Art,* ed. Edwin L. Wade and Rennard Strickland, 9–17. Norman: University of Oklahoma Press.

———. 1985. The Ethnic Art Market in the American Southwest, 1880–1980. In *Objects and Others: Essays on Museums and Material Culture,* ed. George W. Stocking Jr., 167–191. Madison: University of Wisconsin Press.

Wade, Edwin L., and Lea S. McChesney. 1980. *America's Great Lost Expedition: The Thomas Keam Collection of Hopi Pottery from the Second Hemenway Expedition, 1890–1894.* Phoenix, Ariz.: Heard Museum.

Wade, Edwin L., and Rennard Strickland. 1981. *Magic Images: Contemporary Native American Art.* Norman: University of Oklahoma Press.

Waite, Deborah. 1966. Kwakiutl Transformation Masks. In *The Many Faces of Primitive Art,* ed. Douglas Fraser, 266–300. Englewood Cliffs, N.J.: Prentice-Hall.

Walens, Stanley. 1981. *Feasting with Cannibals: An Essay on Kwakiutl Cosmology.* Princeton, N.J.: Princeton University Press.

Walker Art Center (WAC). 1972. *American Indian Art: Form and Tradition.* New York: E. P. Dutton.

Ward, Philip. 1978. The State of Preservation of the Native Heritage on the Northwest Coast. *CCI, The Journal of the Canadian Conservation Institute* 3:4–9.

Wardwell, Allen. 1964. *Yakutat South: Indian Art of the Northwest Coast.* Chicago: Chicago Art Institute.

———. 1978. *Objects of Bright Pride: Northwest Coast Indian Art from the American Museum of Natural*

History. New York: Center for Inter-American Relations and the American Federation of Arts.

Washburn, Dorothy K. 1984. Dealers and Collectors of Indian Baskets at the Turn of the Century in California: Their Effect on the Ethnographic Sample. *Empirical Studies of the Arts* 2 (1): 51–74.

Webb, Jennifer, ed. 1999. *Objects and Expressions: Celebrating the Collections of the Museum of Anthropology at the University of British Columbia.* Museum Note, no. 35. Vancouver: Museum of Anthropology, University of British Columbia.

Weber, Ronald. 1982. Archaeology News: Maritime Peoples of the Arctic and Northwest Coast. *Archaeology* 35 (2): 66–69.

Weber, Ronald, and Constance Crane. 1982. Those Who Dwell beside the Sea. *Alaska Journal* 12 (2): 20–27.

Webster, Gloria Cranmer. 1980. U'mista Museum. *Museum Round-Up* [B.C. Museums Association] no. 78:13–15.

——. 1981. U'mista Cultural Centre. *Museum Round-Up* [B.C. Museums Association] no. 81:11–13.

——. 1988. The "R" World. *Muse* [Canadian Museums Associations] 6 (3): 43–46.

——. 1990a. Kwakiutl since 1980. In *Northwest Coast,* ed. Wayne Suttles, 387–390. Vol. 7, *Handbook of North American Indians,* ed. William C. Sturtevant. Washington, D.C.: Smithsonian Institution.

——. 1990b. The U'mista Cultural Centre. *Massachusetts Review* 31 (1/2): 132–143.

——. 1991. The Contemporary Potlatch. In *Chiefly Feasts: The Enduring Kwakiutl Potlatch,* ed. Aldona Jonaitis, 227–248. Seattle: University of Washington Press.

——. 1992a. From Colonization to Repatriation. In *Indigena: Contemporary Native Perspectives in Canadian Art,* ed. Gerald McMaster and Lee-Ann Martin, 25–37. Vancouver: Douglas and McIntyre.

——. 1992b. Chiefly Feasts. *Curator* 35 (4): 248–254.

——. 1995. Contemporary Kwakwaka'wakw Potlatches. In *The Spirit Within: Northwest Coast Native Art from the John H. Hauberg Collection,* ed. Helen Abbott et al., 193–201. New York: Rizzoli.

Weeks, Cliff W. [1972]. *'Ksan, Hazelton, British Columbia.* Hazelton: 'Ksan Association.

Weiss, Jeffrey. 1983. Science and Primitivism: A Fearful Symmetry in the Early New York School. *Arts Magazine* 57 (7): 81–87.

West, W. Richard et al. 1999. *The Changing Presentation of the American Indian: Museums and Native Cultures.* Seattle: University of Washington Press.

Wilson, Renate, and Thelma Dickman. 1964. They're Giving the Culture Back to the Indians. *Imperial Oil Review* 48 (2): 15–18.

Wingert, Paul S. 1949. *American Indian Sculpture: A Study of the Northwest Coast.* New York: J. J. Augustin.

——. 1951. Tsimshian Sculpture. In *The Tsimshian: Their Arts and Music,* by Viola Garfield, Paul S. Wingert, and Marius Barbeau, 73–94. American Ethnological Society, Publication no. 18, part 2. New York: J. J. Augustin.

Winter, Amy. 1992. The Germanic Reception of Native American Art: Wolfgang Paalen as Collector, Scholar, and Artist. *European Review of Native American Studies* 6 (1): 17–26.

Wright, Robin K. 1985. Bill Holm: A New Phase. *Pacific Currents, Newsletter of the Burke Museum* 1 (3): n.p.

Wyatt, Gary. 1994. *Spirit Faces: Contemporary Native American Masks from the Northwest.* Vancouver: Douglas and McIntyre; San Francisco: Chronicle Books, 1995.

——. 1999. *Mythic Beings: Spirit Art of the Northwest Coast.* Vancouver: Douglas and McIntyre.

Wyatt, Victoria. 1984. *Shapes of Their Thoughts: Reflections of Culture Contact in Northwest Coast Indian Art.* Norman: University of Oklahoma Press.

——. 1986. A Unique Attraction: The Alaskan Totem Poles at the St. Louis Exposition of 1904. *Alaska Journal* 16:14–23.

Zegas, Judy Braun. 1976. North American Indian Exhibit at the Centennial Exposition. *Curator* 19 (2): 162–173.

Ziff, Bruce H., and Pratima V. Rao, eds. 1997. *Borrowed Power: Essays in Cultural Appropriation.* New Brunswick, N.J.: Rutgers University Press.

Ziontz, Lenore. 1985. The State Museum Comes of Age. In "The First Hundred Years: A Century of Natural History at the Burke Museum," ed. Barbara Krohn, n.p. *Landmarks* 4 (1).

——. 1988. The Thomas Burke Memorial Washington State Museum: A Short History of 100 Years. *Curator* 31 (3): 187–194.

INDEX

178–179; on ethnography as salvage, 72; exhibits
by, 98–100, 107, 281; feast by, 61, **62;** funding of,
56–57; impact of, 393; Jesup Expedition, 25, 26,
27, 37, 61, 98; as minor collector, 23; orthog-
raphy of, 27, 77, 89, 340; *Primitive Art* publi-
cation, 74, 302; on reproductions, 53; students
of, 112–114; systematic research of, 43
Bonaparte, Prince Roland, 87
books, reliance on, 305–306
Boon, James, 2, 389
boxes: bent-boxes, 281, 303, 390–392; kerfed, **291,**
306, **390,** 390, 392; as metaphor, 3–4, 390;
storage, **vi, 3, 44, 389, 390, 391, 392**
Box of Treasures film, 369, 375, 376
Brabant, Gene, 204, 304
Brady, John G., 138
Brawne, Michael, 106
Breton, André, 127, 129
British Association for the Advancement of
Science, 24
British Museum, 95, 351
Brooklyn Institute, 38
Brooklyn Museum, 30, 183, 188, 189, 191–192
Brown, Charles, 144
Brown, Eric, 120
Brown, Steven, 199, 204, 260
Bruce, Stephen, 328
Bruner, Edward, 3, 375
Bumpus, Hermon C., 102
Bureau of Indian Affairs (U.S.), 85
Burke Museum, 293; collections, 212, 260, **314;**
Holm at, 197, 260; house displays, **237,** 238;
name changes of, 209; programs at, 224;
Quimby at, 252
Burlington Fine Arts Club (London), 120
Busa, Peter, 129
button blanket courses, 289, 290, 368

C

Cadwallader family, 35–36, 57
Campbell-Johnston, R. C., 139, 140, 145
Campbell River (village), **8** (map); community
house at, 324, 328–329; population of, 10, 374. *See
also* Campbell River Museum
Campbell River–Cape Mudge art style, 11, 386
Campbell River Museum: collections, 301; loan
programs, 293, 298; repatriation and, 362, 370;
shop, 185–186; Western style of, 374
Canadian Centennial (1967), 325
Canadian Confederation celebration, 207–209
Canadian Cultural Properties Export Act, 362
Canadian Geological Survey, 24, 29, 30, 103–104
Canadian Handicraft Guild, 179

Canadian Indian Act revision, 137
Canadian Museum of Civilization, 235–236;
exhibits, 240, **241;** name changes, 235; Native
involvement, 245–246; potlatch confiscations
and, 346; repatriation, 72; Webster at, 341, 342
Canadian National Railroad, 140
Canady, John, 176
cannibalism themes, 87, 88
Cape Mudge, **8** (map), 159. *See also* Kwagiulth
Museum
Cape Mudge–Campbell River region population,
374
Carpenter, Edmund, 71
Carr, Emily, **122,** 130, 131, **131,** 132
Carry, H. E., 139
Carter, Dudley, 132
carving: current economics of, 205; historical
stages of, 169–170; trends, 386
carving programs, 269–271, 286–287; Coastal
Indian Heritage Society and, 290; David Martin
and, 269, 286, 287; end of, 272; goals of, 280;
Henry Hunt and, 287, 294; Macnair and, 297;
Mungo Martin and, 269; at Provincial Museum,
173, 186, 268–269, 278, 286, 390; stages in, 278,
294; Tony Hunt and, 270, 294; at U'mista
Cultural Society, 338; at UBC, 286
cedar bark craft training, 290
Centennial Celebrations (1958), 346
Centennial Exposition, U.S. (Philadelphia, 1876),
20, 79–80, 96
ceremonialism, trends in, 374, 383
ceremonial use (of artifacts), 205, 297–298
change, cultural: exhibits and, 241, 244, 307;
recognition of, 9, 388; research on, 256, 259–260
Charlie, Simon, 271
Charnley, Donn, 194
Cherokee museum, 372
Cheslakees (village), **8** (map), 45
Cheslakees Campsite dedication, **333**
Chicago Art Institute, 187, 264
Chicago World's Fair (1893), 83–89; Boas and, 77,
107; collections of, 22, 71, 88; exhibits, 96, 106,
107, 236; film and sound recording at, 93;
importance of, 88–89; Native performances at,
81, 93–94
Chiefly Feasts exhibit, 264, 341
Church Missionary Society (London), 33
Cincinnati Art Museum, 188, 191, 192
Civilian Conservation Corps, 143
classical period (ca. 1880–1920), 262, 268, 281
Clavir, Miriam, 218
Clifford, James, 133, 134, 387, 388, 389
Clifton, Robert, 318
Clutesi, George, 181, 249, 336

E

N